Theory in Contemporary Art since 1985

Edited by

Zoya Kocur *and* Simon Leung

Blackwell
Publishing

Editorial material and organization © 2005 by Blackwell Publishing Ltd

BLACKWELL PUBLISHING
350 Main Street, Malden, MA 02148-5020, USA
9600 Garsington Road, Oxford OX4 2DQ, UK
550 Swanston Street, Carlton, Victoria 3053, Australia

First published 2005 by Blackwell Publishing Ltd

7 2008

Library of Congress Cataloging-in-Publication Data

Theory in contemporary art since 1985 / edited by Zoya Kocur and Simon Leung.
 p. cm.
Includes bibliographical references and index.
 ISBN 978-0-631-22868-4 (hardcover : alk. paper) — ISBN 978-0-631-22867-7 (pbk. : alk. paper)
 1. Art, Modern—20th century—Philosophy. I. Kocur, Zoya.
II. Leung, Simon, 1964–

 N66.T49 2005
 709'.04'5—dc22

 2003022098

A catalogue record for this title is available from the British Library.

Set in 10½/13pt Dante
by Graphicraft Ltd, Hong Kong
Printed and bound in Singapore
by Markono Print Media Pte Ltd

The publisher's policy is to use permanent paper from mills that operate a sustainable forestry policy, and which has been manufactured from pulp processed using acid-free and elementary chlorine-free practices. Furthermore, the publisher ensures that the text paper and cover board used have met acceptable environmental accreditation standards.

For further information on
Blackwell Publishing, visit our website:
www.blackwellpublishing.com

Contents

Notes on Contributors

Pierre Bourdieu (1930–2001) was at the time of his death Professor and Chair of Sociology at the Collège de France. He was author of more than 25 influential books, including *The Algerians* and *Distinction: A Social Critique of the Judgement of Taste*.

Michael Brenson is an art critic and Associate Professor in Curatorial Studies at Bard College, New York. He is the author of *Visionaries and Outcasts: The NEA, Congress, and the Place of the Visual Arts in America*.

Benjamin H. D. Buchloh is Professor of Art History at Barnard College, Columbia University. He is the author of *Neo-Avantgarde and Cultural History: Essays on European and American Art from 1955 to 1975*. He is an editor of the journal *October*.

Judith Butler is Maxine Elliot Professor in the Departments of Rhetoric and Comparative Literature at the University of California, Berkeley and the author of *Gender Trouble, Bodies that Matter, Antigone's Claim*, and *Excitable Speech*.

Juli Carson is Adjunct Assistant Professor in the Department of Art at the University of California, Los Angeles and publisher of Vel Press. She has contributed to *Sublimation and Symptom* (ed. Parveen Adams), *Alternative Art New York, 1965–85* (ed. Julie Ault), *Art Journal, Documents, Texte Zur Kunst*, and *October*.

Douglas Crimp is Fanny Knapp Allen Professor of Art History at the University of Rochester. He is the author of *On the Museum's Ruins* and *Melancholia and Moralism: Essays on AIDS and Queer Politics*.

Thierry de Duve, Visiting Professor at the University of Lille 3, France and the Hogeschool Sint Lucas Beeldende Kunst, Ghent, is the author of *Kant after Duchamp*,

Pictorial Nominalism: On Marcel Duchamp's Passage from Painting to the Readymade, Look: 100 Years of Contemporary Art, Clement Greenberg Between the Lines, and the editor of *The Definitively Unfinished Marcel Duchamp*.

Rosalyn Deutsche is Visiting Professor of Art History at Barnard College, Columbia University. She is the author of *Evictions-Art and Spatial Politics*.

Jean Fisher is Reader in Art and Transcultural Studies at Middlesex University, UK. She is the former editor of *Third Text*, editor of *Global Visions: Toward a New Internationalism in the Visual Arts* and *Reverberations*, and author of *Vampire in the Text*.

Andrea Fraser is an artist whose work has been associated with institutional critique since the 1980s. A collection of her writings, entitled *Museum Highlights*, is forthcoming from MIT Press.

James Gaywood's only previously published writing, the essay " 'yBa' as Critique," originally appeared in *Third Text*.

David Joselit is Professor of Art History at Yale University and author of *Infinite Regress: Marcel Duchamp 1910–1941* and *American Art Since 1945*.

Grant Kester is Associate Professor of Art History in the Visual Arts Department at the University of California, San Diego. He is the editor of *Art, Activism, and Oppositionality: Essays from Afterimage*.

Laura Kipnis is Professor of Radio/Television/Film at Northwestern University. Her most recent publication is *Against Love: A Polemic*.

Zoya Kocur is an independent scholar and adjunct faculty member of the Department of Art and Art Professions at New York University. She has also taught at the Rhode Island School of Design. She co-edited the volume *Contemporary Art and Multicultural Education* and has published articles on art pedagogy and museum education.

Liz Kotz, Assistant Professor of Cultural Studies and Comparative Literature, University of Minnesota, is co-editor, with Eileen Miles, of *The New Fuck You*. She has contributed to *Artforum, October, The Social Document in the American Photographic Tradition* (Los Angeles: Museum of Contemporary Art, 2000), and *The Passionate Camera* (ed. Deborah Bright).

Rosalind Krauss is Meyer Schapiro Professor of Modern Art and Theory in the Department of Art History and Archeology at Columbia University. She is founding editor of *October*. Among her books are *The Originality of the Avant-Garde and Other Modernist Myths, The Optical Unconscious*, and *A Voyage on the North Sea: Art in the Age of the Post-Medium Condition*.

Miwon Kwon is Associate Professor in Art History at the University of California, Los Angeles, and author of a book-length version of her contribution for this volume, also entitled *One Place After Another*. She is a founding editor of the journal *Documents*.

Nana Last, Assistant Professor at the School of Architecture, Rice University, is an architectural historian, critic, and architect. She has contributed to *ANY*, *Assemblage*, *CAA Reviews*, *Threshold*, and *Harvard Design Magazine*.

Lee Weng Choy is Artistic Co-Director of The Substation Arts Center in Singapore. Among his published essays are "Biennale Time and the Spectres of Exhibition" (FOCAS 4, Forum on Contemporary Art and Society, 2002) and "McNationalism in Singapore" (House of Glass, Institute of Southeast Asian Studies, 2001).

Simon Leung is an artist and Assistant Professor in the Department of Studio Art at the University of California, Irvine. His work has been exhibited at the Venice Biennale (2003) and the Whitney Biennial (1993).

Lev Manovich is Associate Professor in the Visual Arts Department at the University of California, San Diego. He is the author of *The Language of New Media*.

Kobena Mercer is a Research Associate in the Department of Visual Culture and Media, Middlesex University, UK. He writes and teaches on the visual arts of the black diaspora and is the author of *Welcome to the Jungle: New Positions in Black Cultural Studies*.

Gerardo Mosquera is Adjunct Curator at the New Museum of Contemporary Art in New York. He is editor of *Beyond the Fantastic: Contemporary Art Criticism from Latin America* and editor, with Jean Fisher, of *Over Here. International Perspectives on Art and Culture*.

Olu Oguibe is Associate Professor of Art in the Department of Art and Art History and the Institute for African American Studies at the University of Connecticut, and author of *The Culture Game*.

Adrian Piper is an artist and Professor of Philosophy at Wellesley College. A collection of her writings over the course of 25 years has been published as *Out of Order: Out of Sight*.

John Rajchman is Director of Modern Art MA Programs in the Department of Art History and Archeology at Columbia University. He is editor of *The Identity in Question* and the author of *Truth and Eros – Foucault, Lacan and the Question of Ethics*, and *Constructions*.

Nelly Richard, critic and writer, is the editor of the *Revista de Crítica Cultural* and Director of the Extensión Cultural of Arcis University, Santiago de Chile. She is the author of *The Insubordination of Signs: Political Changes, Cultural Transformation, and Poetics of the Crisis (Post-Contemporary Interventions)*.

Avital Ronell is Professor of German and Comparative Literature at New York University. She is author of *The Telephone Book*, *Crack Wars*, *Finitude's Score*, and *Stupidity*.

Trinh T. Minh-Ha, Professor of Women's Studies, Film Studies, and Rhetoric at the University of California, Berkeley, is the author of *Woman, Native, Other*; *Framer Framed*; and *When the Moon Waxes Red*.

Carole S. Vance is Professor of Public Health at Columbia University. She has authored numerous articles on sexual politics, feminism, censorship, and the arts. She is the editor of *Pleasure and Danger: Exploring Female Sexuality*.

Charles A. Wright, Jr. (d. 2000) was a curator at Hallwalls in Burralo, New York in the late 1980s and early 1990s. He was an independent scholar and curator at the time of his death.

Wu Hung is the Harrie A. Vanderstappen Distinguished Service Professor and Director of the Center for the Arts of East Asia at the University of Chicago. Among his publications is *Monumentality in Early Chinese Art and Architecture*.

Acknowledgments

We are grateful to Jayne Fargnoli for inviting us to edit this volume of essays; we truly enjoyed working with her and the staff at Blackwell. At the early stages of this project, we greatly benefited from the helpful advice of Russell Ferguson, Christopher Phillips, Carrie Cooperider, and Alejandro Anreus. We would like to thank all the contributors to this volume, but in particular those who were kind enough to offer suggestions beyond their own texts and who led us to areas of inquiry that enriched the selection for this volume. They are: Gerardo Mosquera, Olu Oguibe, Douglas Crimp, Rosalyn Deutsche, David Joselit, Miwon Kwon, Juli Carson, and Andrea Fraser. Many friends and colleagues responded to our direct inquiries and offered obliging counsel, and to them we are grateful: Bennett Simpson, Eric de Bruyn, Pamela M. Lee, Renee Green, Howard Singerman, Silvia Kolbowski, Maureen Connor, Kelly Dennis, Catalina Parra, Dipti Desai, Stephan Dillemuth, Isabelle Graw, Georges Pfruender, Daniel Canogar, Matthew Ngui, and Nils Norman. Lincoln Tobier was indispensable in his support during the preparation of the manuscript. In addition, our work would not have been possible without the help of Thi Bui, Lisa DiFillipo, and Kathleen MacQueen. Special thanks go to the artists and galleries that kindly allowed us to reproduce images and to the essayists who wrote new essays or revised old ones for this volume. This volume was conceived with the student in mind, so we would like to offer our final thanks to students in our seminars at New York University, the California Institute of the Arts, the Rhode Island School of Design, the University of California at Los Angeles, and the University of California at Irvine. Their energy, intellectual generosity, and love of learning contributed to this project in countless ways.

Text, Figure, and Plate Credits

he editor and publisher gratefully acknowledge the permission granted to reproduce the copyright material in this book:

Texts

1 Pierre Bourdieu, "The Intellectual Field: A World Apart," from *In Other Words* (Palo Alto: Stanford University Press, 1990), pp. 140–9. This is an interview with Karl-Otto Maue, for the *Norddeutscher Rundfunk*, recorded in Hamburg in December 1985. Used with the permission of Stanford University Press, <www.sup.org>

2 Thierry de Duve, "When Form Has Become Attitude – And Beyond," from Stephen Foster and Nicholas deVille (eds.), *The Artist and the Academy: Issues in Fine Art Education and The Wider Cultural Context* (Southampton, UK: John Hansard Gallery, 1994), pp. 23–40. Reproduced with permission of Stephen Foster. This paper was originally presented at a conference, "The Artist and the Academy: European Perspectives on Today's Fine Art Education," held at Chilworth Manor, University of Southampton, UK, on December 9 and 10, 1993.

3 Miwon Kwon, "One Place After Another: Notes on Site Specificity," from *October* 80 (spring 1997): 38–63. © 1997 by October Magazine Ltd and the Massachusetts Institute of Technology.

4 Michael Brenson, "The Curator's Moment," from *Art Journal* 57, 4 (winter 1998): 16–27. The version published here has been slightly abridged, with the approval of the author. Copyright © 1998, 2004 by Michael Brenson.

5 Andrea Fraser, "How to Provide an Artistic Service: An Introduction." This is published here in print and in English for the first time. It was first presented in conjunction with the "Services" exhibition in Vienna in 1994 and is available online at <http://adaweb.walkerart.org>

6 Grant H. Kester, "Conversation Pieces: The Role of Dialogue in Socially-Engaged Art." This is a revised version of a paper presented at a conference in Ireland in September 1998. An earlier version was published in *Variant* 9 (winter 1999–2000). This version is being published simultaneously in Grant H. Kester, *Conversation Pieces: Community and Communication in Modern Art* (University of California Press, 2004). Reproduced with permission of the author.

7 James Gaywood, "'yBa' as Critique: The Socio-Political Inferences of the Mediated Identity of Recent British Art," from *Third Text* 40 (autumn 1997): 3–12.

8 Liz Kotz, "Video Projection: The Space Between Screens." Published here for the first time. Reproduced with kind permission of the author.

9 Carole S. Vance, "The War on Culture," from *Art in America* 78, 5 (May 1990): 49–55. Copyright © by Carole S. Vance. Reproduced with kind permission of the author.

10 Carole S. Vance, "Feminist Fundamentalism: Women Against Images," from *Art in America* 81, 9 (September 1993): 35–9. Copyright © by Carole S. Vance. Reproduced with kind permission of the author.

11 Douglas Crimp, "AIDS: Cultural Analysis/Cultural Activism." First published in *October* 43 (winter 1987): 3–16. The slightly adapted version reproduced here was published in Douglas Crimp (ed.), *Melancholia and Moralism: Essays on AIDS and Queer Politics* (Cambridge, Mass.: MIT Press, 2002), pp. 27–41. Copyright © 1987 by October Magazine Ltd and the Massachusetts Institute of Technology.

12 Rosalyn Deutsche, "Architecture of the Evicted," from *Strategies* 3 (1990): 159–83. Reproduced with kind permission of Taylor & Francis Ltd, <www.tandf.co.uk/journals>. A version of this essay first appeared in the catalogue of *Krzysztof Wodiczko: New York City Tableaux and The Homeless Vehicle Project*, New York, Exit Art, September 23–October 28, 1989.

13 Judith Butler, "Gender is Burning: Questions of Appropriation and Subversion," from *Bodies That Matter* (New York and London: Routledge, 1993), pp. 121–40. Reproduced by permission of Routledge/Taylor & Francis Books, Inc.

14 Adrian Piper, "Cornered: A Video Installation Project," from *Movement Research Performance Journal* 4 (winter/spring 1992): 10.

15 Charles A. Wright, Jr., "The Mythology of Difference: Vulgar Identity Politics at the Whitney," from *Afterimage* 21 (September 1993): 4–8. Reprinted by permission of the publisher.

16 Avital Ronell, "Haunted TV," from *Artforum* 31, 1 (September 1992): 70–3. Reproduced with permission of *Artforum*. Copyright © 1992 by *Artforum*.

17 Gerardo Mosquera, "The Marco Polo Syndrome: Some Problems around Art and Eurocentrism," from *Third Text* 21 (winter 1992/3): 35–41, translated from the Spanish by Jaime Flórez. Reproduced with kind permission of *Third Text*.

18 Olu Oguibe, "In the 'Heart of Darkness'," from *Third Text* 23 (summer 1993): 3–8. Reproduced with kind permission of *Third Text*.

19 Jean Fisher, "The Syncretic Turn: Cross-Cultural Practices in the Age of Multiculturalism." This chapter is a slightly revised version of an essay that appeared in Lia Gangitano and Steven Nelson (eds.), *New Histories: The Institute of Contemporary Art* (Boston: The Institute, 1996), pp. 32–9. Reproduced with kind permission of ICA.

20 Lee Weng Choy, "Authenticity, Reflexivity, and Spectacle: or, the Rise of New Asia is not the End of the World." This is a shortened version of an essay published in Joan Kee (ed.), *Inhabiting the Intersection: New Issues in Contemporary Asian Visual Art*, a special issue of *Positions: East Asia Cultures Critique* 12, 1 (Durham: Duke University Press, 2004). Reproduced with kind permission of Duke University Press. All rights reserved.

21 Trinh T. Minh-Ha, "All-Owning Spectatorship," from *When the Moon Waxes Red* (New York and London: Routledge, 1991), pp. 81–105. This essay was first published in *Quarterly Review of Film & Video* 13, 1 and 2 (January 1991), while portions also appeared as "Black Bamboo," in *CineAction!* (Canada), a special issue on imperialism and film, no. 18 (fall 1989). Reproduced with permission of Taylor & Francis Ltd.

22 Benjamin H. D. Buchloh, "A Note on Gerhard Richter's *October 18, 1977*," from *October* 48 (spring 1989): 88–109. Copyright © 1989 by October Magazine Ltd and the Massachusetts Institute of Technology.

23 David Joselit, "Notes on Surface: Toward a Genealogy of Flatness," from *Art History* 23, 1 (March 2000): 19–34. Reproduced with permission of Blackwell Publishing Ltd.

24 Wu Hung, "Ruins, Fragmentation, and the Chinese Modern/Postmodern," from *Inside/Out: New Chinese Art* (Berkeley and Los Angeles: University of California Press, 1998), pp. 59–65. Copyright © by San Francisco Museum of Modern Art. Reproduced with permission of San Francisco Museum of Modern Art.

25 Nana Last, "Function and Field: Demarcating Conceptual Practices." Published here for the first time.

26 Juli Carson, "1989." Published here for the first time.

27 Nelly Richard, "Postmodernism and Periphery," from *Third Text* 2 (winter 1987/88): 5–12. Reproduced with permission of *Third Text*.

28 Kobena Mercer, "Looking for Trouble," from *Transition* 51 (1991): 184–97. Reproduced by permission of Duke University Press.

29 Laura Kipnis, "Repossessing Popular Culture," from *Ecstasy Unlimited: On Sex, Capital, Gender, and Aesthetics* (Minneapolis: University of Minnesota Press, 1993), pp. 14–32, 296. Reproduced with permission of University of Minnesota Press.

30 John Rajchman, "The Lightness of Theory," from *Artforum* 31 (September 1993): 165–6, 206, 211. Copyright © 1993 by *Artforum*. Reproduced with permission of *Artforum*.

31 Rosalind Krauss, "*Informe* without Conclusion," from *October* 78 (fall 1996): 89–105.

32 Lev Manovich, "The Database," from *The Language of New Media* (Cambridge, Mass.: MIT Press, 2001), pp. 218–43. Reproduced with permission of MIT Press.

Figures

3.1
Mierle Laderman Ukeles, *Hartford Wash: Washing Tracks, Maintenance Outside*, 1973. Performance at Wadsworth Atheneum, Hartford, CT, part of Maintenance Art Performance Series, 1973–4. Courtesy Ronald Feldman Fine Arts, New York.

3.2
Michael Asher, installation at Claire Copley Gallery, Los Angeles, 1974. View through gallery toward office and storage areas. Courtesy of the artist.

6.1
Jay Koh and Bon Fai, *E.T. (Exchanging Thought)* at Pak Tuk Kong Market, November 1995–January 1996, Chiang Mai Social Installation Art and Culture Festival, Chiang Mai, Thailand. Courtesy of Jay Koh.

6.2
Mama 'Toro Adeniran Kane, *A Better Life for Rural Women*, commissioned by Littoral Arts for ArtBarns: After Kurt Schwitters, Forest of Bowland, Lancashire, 1999. Courtesy of Littoral Arts and Mama 'Toro Adeniran Kane.

8.1
Stan Douglas, *Hors-champs*, 1992, two 2-sided CAV laser disks; 13:20 each rotation, edition of two, installation view at the ICA, London, September–October 1994. Courtesy of the artist and David Zwirner, New York.

12.1
Krzysztof Wodiczko, *Projection*, 1984. Astor Building/New Museum of Contemporary Art. Courtesy of Galerie Lelong, New York.

12.2
Krzysztof Wodiczko, *Proposal for Union Square*, 1986. Courtesy of Galerie Lelong, New York.

12.3
Krzysztof Wodiczko, *Homeless Vehicle in New York City*, 1988–9. Courtesy of Galerie Lelong, New York.

14.1
Adrian Piper, *Cornered*, 1988. Video installation with birth certificates, videotape, monitor, table, ten chairs; dimensions variable. Collection Museum of Contemporary Art, Chicago, Bernice and Kenneth Newberger Fund. Photo © MCA Chicago. Photo by Joe Ziolkowski.

19.1
Jimmie Durham, *Untitled*, 1992. Pencil on paper (22 × 15 in.) from a series of 14 drawings, JD65(f). Private collection, Belgium. Photo courtesy Nicole Klagsbrun Gallery, New York.

19.2

Santi Quesada, *Three Faces and One Ideology*, 1996. B/w photo (100 × 80 cm) and polyester sculpture (163 × 135 × 110 cm). Courtesy of the artist.

21.1

Film still from *Surname Viet Given Name Nam* by Trinh T. Minh-Ha, 1989, 108 min.

22.1

Gerhard Richter, *Confrontation 2 (Gegenuberstellung 2)* 44 × 40¼ in. (112 × 102 cm), from *October 18, 1977 (18. Oktober 1977)*, fifteen paintings, oil on canvas; installation variable, 1988. Courtesy Marian Goodman Gallery, New York.

22.2

Gerhard Richter, *Man Shot Down 1 (Erschossner 1)*, 39½ × 55¼ in. (100.5 × 140.5 cm) from *October 18, 1977 (18. Oktober 1977)*, fifteen paintings, oil on canvas; installation variable, 1988. Courtesy Marian Goodman Gallery, New York.

22.3

Gerhard Richter, *Hanged (Erhangte)* 6′7⅛″ × 55⅛″/201 × 140 cm from *October 18, 1977 (18. Oktober 1977)*, fifteen paintings, oil on canvas; installation variable, 1988. Courtesy Marian Goodman Gallery, New York.

22.4

Gerhard Richter, *Funeral (Beerdiggung)* 6′6¾″ × 10′6″ (200 × 320 cm) from *October 18, 1977 (18. Oktober 1977)*, fifteen paintings, oil on canvas; installation variable, 1988. Courtesy Marian Goodman Gallery, New York.

23.1

Jackson Pollock, *Autumn Rhythm*, 1950, oil on canvas, 105 × 207 in. The Metropolitan Museum of Art, George A. Hearn Fund, 1957 (57.92). © 2002 The Pollock-Krasner Foundation/Artists Rights Society (ARS), New York.

23.2

Jasper Johns, *Study for "Skin 1,"* 1962, charcoal on drafting paper, 22 × 34 in. © Jasper Johns/Licensed by VAGA, New York, NY. Photo by Dorothy Zeidman.

23.3

David Hammons, *Injustice Case*, 1970. Mixed media: body print (margarine, powdered pigment), and United States flag, 63 × 40½ in. Los Angeles County Museum of Art, Museum Acquisition Fund, M.71.7. Photograph © 2002 Museum Associates/ LACMA.

23.4

Kara Walker, *From the Bowels to the Bosom*, 1996, installation view. Courtesy Brent Sikkema, New York.

24.1

Untitled (Ruined streets), 1911. School of Oriental and African Studies, University of London.

24.2

Ruins of the Yuanming Yuan, gardens of the Manchu royal house outside Beijing, which were destroyed in 1860.

24.3

Wang Guangyi, *Mao Zedong No. 1*, 1988, oil on canvas, 59 × 141 in. (150 × 120 cm). Private collection.

24.4

Zhan Wang, *Ruin Cleaning Project '94*, 1994, action and installation in Beijing.

26.1

Richard Serra, *Tilted Arc*, 1981, weatherproof steel, 12′ × 120′ × 2¹⁄₂″. Collection: General Services Administration; installed Federal Plaza NYC, destroyed 1989. © 2002 Richard Serra/Artists Rights Society (ARS), New York. Photograph by Dith Prahn, NYC.

28.1

Robert Mapplethorpe, *Man in Polyester Suit*, 1980. Copyright © The Estate of Robert Mapplethorpe, used with permission.

28.2

Robert Mapplethorpe, *Derrick Cross*, 1983. Copyright © The Estate of Robert Mapplethorpe, used with permission.

31.1

Mike Kelley, *Craft Morphology Flow Chart*, 1991. Courtesy of the artist and Metro Pictures.

Plates

1

Group Material, *DaZiBaos*, 1982, poster project at Union Square, New York City. Photograph courtesy of Group Material; reprinted with permission of Doug Ashford.

2

Christian Philipp Müller, *Illegal Border Crossing Between Austria and Principality of Liechtenstein*, April 1993, performance view at border between Bangs, Austria and Ruggell, Liechtenstein, one of eight "border crossings" for the Austrian contribution to the Venice Biennale, 1993. Photo courtesy of American Fine Arts, New York.

3

Damien Hirst, *The Physical Impossibility of Death in the Mind of Someone Living*, 1991, glass, steel, silicone, shark, and 5% formaldehyde solution, 84 × 252 × 84 in. (213.4 × 1333.5 × 213.4 cm). Copyright © Damien Hirst c/o Science Ltd. Courtesy Jay Jopling/ White Cube (London). Photograph by Anthony Oliver.

4

Sarah Lucas, *Two Fried Eggs and a Kebab*, 1992, photograph, eggs, kebab, table. Courtesy Barbara Gladstone.

5

Doug Aitken, *Electric Earth*, 1999, installation view at Venice Biennale, 8-laserdisc installation, dimensions variable. Courtesy of 303 Gallery, New York; Galerie Hauser & Wirth & Presenhuber, Zurich; Victoria Miro Gallery, London.

6

Diana Thater, *Oo-Fifi: Five Days in Claude Monet's Garden*, 1992, 3-projector video installation at 1301, Santa Monica, California, August 1992: 3 video projectors; 1 laserdisc player; 1 laserdisc, film gels and existing architecture. Courtesy of the artist, 1301, Santa Monica and David Zwirner, New York.

7

Jane and Louise Wilson, *Stasi City*, 1997. 4-channel video installation, 5-minute loop. Courtesy of 303 Gallery, New York.

8

ACT UP (Gran Fury), *Let the Record Show . . .* , 1987, installation view, New Museum Window on Broadway. Collection of the New Museum of Contemporary Art, New York.

9

Gabriel Orozco, *Cats and Watermelons*, 1992, C-print, $21^1/_2 \times 27^3/_4$ in. (54.6×70.5 cm). Courtesy Marian Goodman Gallery, New York.

10

LEAR: A Japan Foundation Asia Center Production. Conceived and directed by ONG Keng Sen (Artistic Director, TheatreWorks (S) Ltd). Photo courtesy of TheatreWorks, 1998, Kallang Theatre, Singapore.

11

Simryn Gill, 1 from the series *A Small Town at the Turn of the Century*, 1999–2000, C-type print, 90×90 cm. Courtesy the artist.

12

Huang Yong Ping, *"A History of Chinese Painting" and "A Concise History of Modern Painting" Washed in a Washing Machine for Two Minutes*, 1987, installation view, paper pulp; approx. $31 \times 20 \times 20$ in. ($80 \times 50 \times 50$ cm); destroyed.

13

Wu Shan Zhuan, *Red Characters*, 1987.

14

Jorge Pardo, *4166 Sea View Lane*, 1998. Photo by Simon Leung.

15

Cindy Sherman, *Untitled #175*, 1987. Courtesy of the artist and Metro Pictures.

16
Mike Kelley, *Riddle of the Sphinx*, 1992. Courtesy of the artist and Metro Pictures.

Every effort has been made to trace copyright holders and to obtain their permission for the use of copyright material. The publisher apologizes for any errors or omissions in the above list and would be grateful if notified of any corrections that should be incorporated in future reprints or editions of this book.

How To Use This Book

*T*heory in Contemporary Art since 1985 brings together a broad selection of important contributions to the fields of contemporary art, culture, and theory from the mid-1980s onwards. Art and theory are approached in an interconnected fashion, with an emphasis on the flow and interchange of significant ideas between the visual and the textual – art in dialogue with theory. The essays have been selected with an eye toward achieving a balance between presenting established and emerging theorists and critics. The goal of the volume is to provide an overview of key theoretical and aesthetic issues in the field of contemporary art in their cultural, historical, and socio-political contexts. Its focus on contemporary art since 1985 makes it the only synthetic critical theory anthology of its kind.

Audience

This anthology serves a broad range of readers both in and outside an academic setting, including students in modern and contemporary art history, visual and cultural studies, museum studies, curatorial studies, critical studies, art education, American studies, and fine art/studio programs (studying for a BFA, MFA, and MA). In a classroom setting, this anthology can be used as a textbook in theory, history, and issues seminars at upper-undergraduate and graduate levels in all the academic disciplines listed above. The readers of this volume beyond academia will include museum and contemporary art audiences, artists, museum professionals (including curators and educators), collectors, gallerists, and anyone interested in contemporary

art. In essence, it is useful for all those interested in the interplay between contemporary art and its theoretical frameworks.

Organization

The book is structured to facilitate dialogue about significant theories, ideas, and trends within contemporary art practice and contexts since the mid-1980s. With a focus on mid-1980s through turn-of-the-millennium art and theory, the content is organized thematically according to major discourses, allowing for the consideration of simultaneously emerging (and possibly conflicting) ideas in dialogue with one another. That is, the essays within each section build on one another; the ideas in each point to ideas in the essay that follows. They are in rough but not strict chronological order, with the year of the first publication of each essay easily available to the reader at a quick glance. This allows for an immediate placement of each essay within a historical or discursive context, and can function as a guide for those wishing to use the essays chronologically and/or in conjunction with other readings.

The brief introductory chapter provides a general background and art-historical context for the period under consideration. It gives a general overview of the status of theory in art during the last two decades, outlines the structure and interdisciplinary approach of the volume, and describes the criteria for the selection and organization of the essays. Furthermore, each of the five major sections of the book is preceded by a brief general introduction and a summary of the main points of each essay.

The five main sections are:

1 *Contemporary Art Practices and Models:*
This section deals with the ways in which artistic conceptions and practices have developed and transformed since the mid-1980s, and provides examples of these new models.

2 *Culture/Identities/Political Fields:*
These essays provide an overview of the intersection of art, larger society, and political struggles during the 1980s and '90s.

3 *Postcolonial Critiques:*
This section presents a series of critiques on topics ranging from Eurocentrism to new forms of essentialism from postcolonial perspectives.

4 *Rethinking Aesthetics:*
These essays provide examples of how the conceptions of aesthetic forms and practices have been renegotiated within contemporary socio-political frameworks.

5 *Theories after Postmodernism:*
This group of writings presents a range of responses to, and updates and revisions of, "the postmodern" as constructed in the 1970s/early 1980s.

The book contains a total of 32 essays and a comprehensive index. The essays are accompanied by approximately 50 reproductions of art works.

In-class application

Each of the five major sections was conceived with a twofold purpose: first, to present a range of ideas around a major discourse and, second, to construct a loose narrative surrounding the discourse in order to facilitate teaching. The editors have used this collection of essays as the basis for courses designed for undergraduate as well as graduate students, under both a semester and quarter system. In addition to seminars, the essays as collected here have also been used as the basis of a lecture course on contemporary art.

Practically speaking, the thematic organization of essays is designed to fit into the constraints of the academic term at university level. Each section, ranging from five to eight essays, can be incorporated into either a 15-week semester or a 10-week quarter, addressing the thematically organized topics (e.g. Postcolonial Critiques, Contemporary Art Practices and Models . . .). More specific concerns, such as curatorial trends, institutional critique, race and ethnicity, sexuality and gender, media and technology, and formal developments in art, can also be devised using the short introduction for each section as a guide.

Introduction

The collection of essays in this book grows out of a specific need. Despite the fact that anthologies of critical theory from a variety of disciplines are published with steady frequency, we feel that what is lacking in the field of contemporary art is an overview and reassessment of contemporary theory as it is applied to art practice. Since the publication of such widely read foundational volumes as *The Anti-Aesthetic* (1983), edited by Hal Foster, and *Art After Modernism* (1984), edited by Brian Wallis, there has been a dearth of anthologies of theoretical essays on contemporary art, virtually none of which has been both synthetic in orientation and ideologically unconnected to specific publications and agendas. This volume, we hope, breaches this gap. It is addressed to students and educators, as well as artists and writers.

During the early 1980s, when we were students, critical theory came into general art discourse in the United States and soon became part of the everyday currency of the art world. The dissemination of "theory" – that is, writings on history, culture, and other forms of representation from a variety of disciplines and intellectual perspectives (continental philosophy, post-structuralism, feminism, psychoanalysis, literary studies, new historicism, and postcolonialism, among others) – was also for the first time systematically applied to the study of art. In the area of contemporary art and art history, learning to think from such perspectives felt urgent, necessary, and exciting. In our encounters with culture, politics, and art, we found ourselves dividing our thinking into before and after our introduction to the theoretical writings that seemed to illuminate them in ways that seemed both timely and essential. Theory was one of the names of the new territories we claimed in our art education, our place in the world of art; at times, our identity as students, artists, and then

teachers seemed dependent on whether we had taken a side in relation to the general term.

Since the early 1980s, "critical theory" has gone through a process of normalization. The application of theoretical ideas proliferated exponentially in the general lexicon of most art institutions. Yet there is still no consensus as to theory's status in contemporary art. Certainly, the word "theory" no longer reflects the intellectual gleam once associated with the new; but such a proposition is mitigated by the fact that it has become impossible to conceive of contemporary art education without theoretical terminology, ideas, and discussions. It is perhaps telling that several "fashionable," albeit retrograde, invocations of theory's replacement – such as a naive, pastoral "return to beauty" – have met their own obsolescence. But beside the obvious submission to commodity logic that these announcements portend, what they tend to overlook is that all forms of knowledge in art are intrinsically "theoretical," no matter how self-evident and commonsensical they may appear. Art is never divorced from the theorization of its meanings, and the claim to a transparency of meaning is no less ideological, no less "theoretical," than "theory" itself. As the contexts of art continue to shift and art approaches develop, as international exhibitions continue to be organized, as the role of art continues to be measured against political, economic, and technological transformations in society, so theoretical discourses continue to illuminate and ground the thinking of art. Since its incipient circulation in contemporary art discourse of the 1980s, we see not so much the erosion of critical theory as a continual acknowledgment of its indispensability as an intellectual terrain upon which we stand.[1]

But how is a collection of critical theory on art today different from a comparable theory anthology published in the 1980s? For one, had this volume been compiled 15 or 20 years ago, it would have been impossible for us not to generalize art and culture under the rubric of "the postmodern." We choose the year 1985 to inaugurate the chronological period covered here exactly because it comes right after the moment that critical theory, along with the term "postmodernism," entered into mainstream art discourse. The art of the early 1970s and early '80s – in particular critiques of modernism employing photographic appropriation – has been exhaustively and meticulously theorized, for such work is most closely associated with postmodernism. In contrast, the range of art that immediately followed did not enjoy the same conceptual unity.

The word postmodernism had, by the end of the 1980s, lost much of its critical resonance. In the United States, this was due in no small measure to a social/political context where culture wars and censorship, homelessness and AIDS, demographic shifts and the intensification of identity politics all contributed to the reformation of theoretical perspectives that grew more specific. In art, both theory and practice addressed needs that deviated from what can be explained under a general postmodern term. Elsewhere in the world, historical and societal transformations distinct from those in the US and Europe necessitated strategies more applicable to local contexts, and postmodernism became a designation redolent of a colonial West. If postmodernism is, as Jean-François Lyotard famously proclaimed, the name we give to the end of

Zoya Kocur and Simon Leung

all grand narratives, then the name had also run its course. The cultural and theoretical turns we began to discuss in the 1980s took us to new areas of aesthetic inquiry and divergent political sites. Developments such as "globalization" and "new media" signaled shifts in our consciousness, and new art practices began to address them. The essays collected here trace and reflect upon these shifts. Some engage postmodernism by name; all describe a postmodern condition in situ.

The texts in this collection are divided into five categories: Contemporary Art Practices and Models; Culture/Identities/Political Fields; Postcolonial Critiques; Rethinking Aesthetics; and Theories after Postmodernism. These categories were set up with the tendentious aim of facilitating intellectual and historical narratives, but they are of course also porous, and arguments can be made that all selections belong in more categories than one. A brief summary of each essay is provided in the relevant part introduction.

In selecting the essays for this volume, we gave ourselves the following guidelines and goals. First, we set out to create an anthology that deals directly with art. We gathered texts that focus on contemporary art practice and discourse, all of them dealing with subject matter that belongs to either a conventional or an expanded definition of contemporary art. Second, we looked for the strongest examples of influential ideas taken from relevant discourses operational since 1985. We believe that these texts are representative of the most creative critical theory; at the same time, we find them to be the most useful application of such theories to the field of contemporary art and culture. Third, in general, the writings included in this anthology are characterized by an interdisciplinarity and multiplicity of sources not typically drawn upon in art criticism and art history prior to this period. The areas of thought incorporated into these writings on art include sociology, architectural theory, postcolonial theory, anthropology, philosophy, feminist theory, queer theory, urban theory, cultural studies, film studies, and literary criticism. Fourth, we concentrated on incorporating intellectual perspectives and orientations that have developed from conditions since 1985; in particular, we wanted to juxtapose non-Western viewpoints with those that come from Western centers of art.

And finally, we chose texts from writers who have varied relationships to art; therefore the writings presented here come not only from academics, but also from curators, critics, and artists. In the end, our goal was not to advocate for particular theories or schools of thought, but to acknowledge and map out the role that critical theory in general has played in contemporary art. Theory for us, in other words, is a tool; a lens through which we see; a proposition; an opening of ourselves and our thinking onto the questions posed by art itself.

Note

1 On the history of critical theory's entry into the art academy, see "When Form Has Become Attitude – And Beyond," by Thierry de Duve (chapter 2 in this volume), and Howard Singerman, *Art Subjects: Making Artists in the American University* (Berkeley and Los Angeles: University of California Press, 1999).

Part I Contemporary Art Practices and Models

Introduction to Part I

This group of essays addresses shifts in the ways artists' work and the art world have been reconfigured since the mid-1980s. If the period of the 1960s and '70s can be said to have been dominated by minimal and conceptual practices, and the 1970s and early '80s by a return to gallery-based practices, art since the mid-1980s can be characterized by an expansion into other arenas of cultural and economic life. While artists through the early postmodernist period continued to draw upon the radical potential of gestures of resistance within their individual fields – whether via the implicit resistance to commodification in time-based work or through the practice of institutional critique – what was distinctive about this expansion of parameters is how contemporary art practices were now being framed. This framing can be seen in two contexts: within the often theoretically informed practice of the artist whose disregard of rules of medium gave rise to the term (borrowed from academic discourse) "interdisciplinary," and also from outside the artist, through being cast as a "cultural producer," a practitioner of one form of cultural authorship amongst many. In practice, the role of the artist/cultural producer often coincided with other roles – for example, curator, educator, or entrepreneur. In turn, the "art world" as such was increasingly seen as a "cultural field," one among many in which an interdisciplinary cultural producer operated.

The first text in this section, "The Intellectual Field: A World Apart," is an interview conducted with the French sociologist Pierre Bourdieu, whose writings first introduced a rigorous theorization of the "cultural field." For Bourdieu, the logic that makes up the cohesion of an autonomous "intellectual field" (for example, art) is formed by a complex set of relationships that can be compared to the political and economic fields, but are neither identical to nor containable within the realms of

economics and politics. Bourdieu emphasizes that the field of cultural production is a specialized realm in which "its subversive struggles and its mechanisms of production . . . assume within it an altogether specific form." Optimistic about the importance of the artist's work, Bourdieu contends that cultural producers, exactly because they are guaranteed a limited autonomy, can, in their ability to bring forth heretofore unimagined representations, invent models of resistance against the insidious and everyday forms of social and political domination.

In his essay "When Form Becomes Attitude – And Beyond," Thierry de Duve maps the historically specific pedagogy operative in the intellectual field of the contemporary artist who functions in the shadow of the historical avant-garde. For de Duve, the teaching of art since the nineteenth century has passed through three historical phases, each with a distinct model for the training of the artist: a traditional academic model based on the practice of a *métier*; a modern model, associated with the Bauhaus, where medium-specific innovation was the goal; and a contemporary model informed by critical theory and born from art institutions such as museums and art schools, whose primary attribute is one of "attitude." What de Duve ultimately challenges is the efficacy of this latest, once critical, model, when it devolves into a series of stances in the absence of any historical foundation.

In the same vein, Miwon Kwon traces the genealogy of the discourse of site-specificity since its inception in the 1960s. Her title, "One Place After Another," is a play on the description of the serial, industrially produced minimalist object as being "one thing after another." But whereas one can interpret the reproducibility of the minimal "specific object" as representative of its gestalt, reproducibility poses problems endemic to the *raison d'être* of site-specificity as it was historically conceived. Kwon's text can be divided into three parts. She begins with a synthetic overview of the first wave of site-specific work by artists such as Richard Serra, Michael Asher, and Robert Barry, whose discourse was based on a logic of performing a specific gesture in an actual, physical place, the "presence" of which potentially transformed it. This emphasis on the actual site, she explains, was jettisoned in the 1980s and '90s in favor of a physical mobilization of artists themselves in service of institutional and art world interests. Kwon traces the various modes of such practices in the second section of her text, unveiling their internal contradictions, while simultaneously outlining the social, economic, and political demands on the nomadic contemporary artist that pointed toward such a shift. The third part of the text contemplates the "unhinging" of artwork from site in contemporary versions of site-specificity where the emphasis on nomadism becomes a sign of the demand for mobilized labor in a global economy. Ultimately, Kwon advocates a rethinking of the potential of site as a form of mediation of the specificity of relationships within a global terrain.

The analogue to the mobilization of the nomadic artist, the curator of the international art exhibitions that have proliferated in the 1980s and '90s, is the nominal subject of Michael Brenson's article, "The Curator's Moment." Originally written as a report on a conference convened to discuss the increasingly primary role of the curator in the art world, Brenson expands his scope to address the development of cultural forces that have impacted on the field in recent years. The topics discussed

Zoya Kocur and Simon Leung

include the uneasy interaction of the European and US art world contexts with often "non-Western" local contexts in which the art must serve a multitude of roles, the growth of international biennials meant to facilitate state and economic interests, and the function of the same exhibitions as the ground upon which first and third world cultural and political relations are played out.

The legacies of institutional critique and site-specificity provide the art-historical backdrop for articles by Andrea Fraser and Grant Kester. Fraser, whose performance and conceptually based work since the late 1980s has been one of the most sustained engagements with the legacy of "institutional critique" associated with artists such as Hans Haacke and Louise Lawler, addresses the dynamics of the relationship between the institution (museum, corporation, foundation) and cultural producer (artist). In "How to Provide an Artistic Service: An Introduction," Fraser describes and theorizes situations particular to what can be identified as "project work," where the primary exchange between the two parties takes the form of a "service" performed by the latter (e.g. an artist whose "project" for the institution might consist of a service or labor normally performed by other professionals, such as a maintenance worker, educator, or consultant, etc.). Indebted to the writings of Pierre Bourdieu, her ana-lysis is at once a critique of the accepted conventions of organizing art exhibitions, which do not adequately address artists' interests, and a proposal to reframe the work of the artist and the stakes of her "autonomy."

Likewise, Kester takes up the work of artists, both individual and collective, who work outside the conventional conception of the transcendental art object, favor-ing a dialogic method based in an ethos of conversation and collaboration. Funda-mental to these process-directed art activities oriented toward the public sphere is a re-examination of the historical avant-garde's stance of withdrawal from the world. For Kester, the conception of the artist as a figure functioning outside the purview of dominant society has become untenable as a position or even an idealization under postmodern scrutiny. The artists and art collectives he describes in "Conversation Pieces: The Role of Dialogue in Socially-Engaged Art" embrace a "dialogic aesthetic" that not only challenges the ontological constraints of the conventional art object but also seeks to reformulate the concept of "community" with an eye toward theorizing an artistic and aesthetic practice based in goals of social change.

If resistance to the "corporatization" of the art world represents one strain of contemporary art, modes of art world practice embracing the culture of the spectacle were more common and dominated much of the art landscape from the 1990s through to the early years of the twenty-first century. James Gaywood's and Liz Kotz's texts examine two such phenomena: the meteoric rise of the "young British artist" ("yBa") and the proliferation of projected video in contemporary art. Gaywood's approach is a sociological critique of the "yBas" in their rhetorical claim to an "egalitarian" aesthetic. His primary position in "'yBa' as Critique: The Socio-Political Inferences of the Mediated Identity of Recent British Art" is that the "young British artist" was a calculated media invention, whose members appropriated and regurgitated signs of earlier forms of aesthetic ruptures and class-based counter-culture (Duchamp, situationism, punk rock, etc.), while maintaining conventional power relations and

social hierarchies. Gaywood proposes that the success of the "yBa" was due more to the successful promotion of a mythic rebellion in Thatcherite Britain, an entrepreneurial campaign of carefully staged and styled effects, than any politically grounded movement or truly subversive project.

For Kotz – who examines the sudden swell of projected video art since the early 1990s, when cheaper, higher-quality projectors became available – the claims of the work of successful video-projection artists (Stan Douglas, Diana Thater) as a continuation of earlier investigations into temporal phenomena seemed similarly mythical. Kotz sees the ubiquity of projected narrative videos in converted gallery spaces (white cubes turned into black boxes) as a sign of submission to the dominance of media (Hollywood) culture, where the technological exercise of ever grander, more spectacular video projection is coupled with a repression of the legacy of television – the historical basis for video art and its aesthetics of interruption, monotony, and formal degradation. Whereas earlier projected videos explored the disruption of familiar cinematic narrative conventions, Kotz's essay, "Video Projection: The Space Between Screens," shows how the current manifestations strive toward all-encompassing spectacular two-dimensional forms: panoramic painting, Hollywood, Times Square.

Zoya Kocur and Simon Leung

1 The Intellectual Field
A World Apart

Pierre Bourdieu

Q. Let's take a particular domain of the social space that you have discussed in an article in German: the literary field. "It is remarkable", you write, "that all those who have busied themselves scientifically with literary or artistic works . . . have always neglected to take into account the social space in which are situated those who produce the works and their value." An analysis which grasps this social space solely as a "milieu", "context" or "social background" seems to you insufficient. So what is a "literary field", what are its principles of construction?

A. The notion of field of cultural production (which is specified as artistic field, literary field, scientific field, etc.) allows one to break away from vague references to the social world (via words such as "context", "milieu", "social base", "social background") with which the social history of art and literature usually contents itself. The field of cultural production is this altogether particular social world referred to in the traditional notion of a republic of letters. But we must not remain on the level of what is merely a convenient image. And if one can observe all kinds of structural and functional homologies between the social field as a whole, or the political field, and the literary field, which, like them, has its dominated and its dominators, its conservatives and its avant-garde, its subversive struggles and its mechanisms of reproduction, the fact remains that each of these phenomena assumes within it an altogether specific

From *In Other Words* (Palo Alto: Stanford University Press, 1990), pp. 140–9. This is an interview with Karl-Otto Maue, for the *Norddeutscher Rundfunk*, recorded in Hamburg in December 1985. Used with the permission of Stanford University Press, <www.sup.org>

form. The homology may be described as a resemblance in difference. Talking of a homology between the political field and the literary field is to affirm the existence of structurally equivalent – which does not mean identical – characteristics in different groupings. This is a complex relation which those who have the habit of thinking in terms of all or nothing will hasten to demolish. From a certain point of view, the literary field (or the scientific field) is a field like all the others (this remark is directed against all forms of hagiography or, quite simply, against the tendency to think that social universes in which these exceptional realities, art, literature or science are produced cannot but be totally different, different from every point of view): it involves power – the power to publish or to refuse publication, for instance; it involves capital – the capital of the established author which can be partly transferred into the account of a young and still unknown author by a highly positive review or a preface; one can observe here, as in other fields, power relations, strategies, interests, etc. But there is not a single one of the characteristics designated by these concepts which does not assume in the literary field a specific and altogether irreducible function. For example, if it is true that the literary field is, like every field, the locus of power relationships (and of struggles aiming to transform or maintain them), the fact remains that the power relations which are imposed on all the agents entering the field – and which weigh with a particular brutality on the new entrants – assume a special form: they are, indeed, based on a very particular form of capital, which is both the instrument and the object of competitive struggles within the field, that is, symbolic capital as a capital of recognition or consecration, institutionalized or not, that the different agents or institutions have been able to accumulate in the course of previous struggles, at the cost of specific activities and specific strategies. One would still need to specify the nature of this recognition which can be measured neither by commercial success – it would be, rather, its opposite – nor by mere social recognition – belonging to academies, winning prizes, etc. – nor even by mere fame, which, if acquired for the wrong reasons, may discredit you. But what I have said will be enough to show you that I'm talking about something very particular. In short, with the notion of field, one gives oneself the means of grasping particularity in generality, and generality in particularity. One may demand of the most highly specialized monograph (on the French literary field at the time of Flaubert, on the revolution brought about by Manet within the artistic field, on struggles within the literary field at the end of the nineteenth century, studies which I am carrying out at present) that it provide general propositions on the functioning of the fields, and from a general theory of the functioning of the fields one can draw very powerful hypotheses on the functioning of a particular state of a particular field (for example, the field of producers of individual houses, which I am studying). But mental habits are so strong – and especially among those who deny their existence – that the notion of literary (or artistic) field is doomed to two reductions, each the opposite of the other: one can see in it a reaffirmation of the irreducibility of the world of art or literature, thus instituted as a universe apart, above the strategies, interests and struggles of everyday life; or, on the other hand, one can reduce it to the very thing against which it is constructed, by reducing these strategies, these interests or these struggles to those which take place in the political

field or in ordinary existence. To give you at least one example of these uncomprehending criticisms which destroy a complex notion by reducing it, often in all good faith, to the level of ordinary or scientific common sense in opposition to which it was erected – and such criticisms have every likelihood of receiving the approval of all those who are reassured by a return to the obvious – I would like to refer rapidly to an article by Peter Bürger, who writes: "Bourdieu, as opposed to [Adorno], defends a functionalist approach" [the labelling, which is the "scholarly" equivalent of the insult, is also a common strategy, and all the more powerful the more the label is, as here, both more of a stigma and more imprecise, thus irrefutable – P. B.]. "He analyzes the actions of subjects in what he calls the 'cultural field' by taking into account exclusively the chance of winning power and prestige and considers objects merely as strategic means which the producers employ in the struggle for power."[1] Peter Bürger accuses me of reductionism, a theory which he has himself taken the precaution of first reducing: he behaves as if I reduced the functioning of the literary field to that of the political field (by adding "exclusively" and "merely"). In reality, what I say is that, like the political field, or any other field, the literary field is the site of struggles (and who could deny it? Not Peter Bürger, in any case, given the strategy he has just employed against me . . .); but that these struggles have specific stakes, and that the power and prestige which they pursue are of an altogether particular type (if you have been following me, you have probably noticed that I've had to use, despite its lack of elegance, the adjective "specific" some twenty times!). In short, Peter Bürger reproaches me with leaving out the specificity of artistic struggles and of the interests that are engaged in them, the very thing, that is, that he began by excluding, by a strange blind spot on his part, from the notion of field which aimed precisely at explaining this specificity. This sort of selective blindness, of which my writings are often the victim, seems to me to bear witness to the resistances aroused by a scientific analysis of the social world.

To return to your question – but I think this critical preamble wasn't without its use – I would say that the literary field is a force-field as well as a field of struggles which aim at transforming or maintaining the established relation of forces: each of the agents commits the force (the capital) that he has acquired through previous struggles to strategies that depend for their general direction on his position in the power struggle, that is, on his specific capital. Concretely, these are, for example, the permanent struggles that oppose the ever-emergent avant-gardes to the recognized avant-garde (and which must not be confused with the struggle which sets the avant-garde in general against "bourgeois artists", as they said in the nineteenth century). Poetry is thus the locus, in France since the mid-nineteenth century, of a permanent revolution (the cycles of renewal of the dominant school are very short): the new entrants, who are also the youngest, question what was in the preceding revolution set up against the previous orthodoxy (you have, for instance, the revolt of the Parnassians against romantic "lyricism"). This incessant revolt against the establishment is expressed, on the level of works of literature, by a process of purification. Poetry is more and more completely reduced to its "essence", that is, to its quintessence, in the alchemical sense, the more it is stripped in successive revolutions of

everything which, although it is an accessory, seemed to define "the poetic" as such: lyricism, rhyme, metre, so-called poetic metaphor, etc.

As far as the question of limits is concerned, we must be wary of the positivist vision which, for the needs of statistics, for example, determines limits by a so-called operational decision which arbitrarily settles in the name of science a question which is not settled in reality, that of knowing who is an intellectual and who isn't, who are the "real" intellectuals, those who really realize the essence of the intellectual. In fact, one of the major issues at stake in the struggles that occur in the literary or artistic field is the definition of the limits of the field, that is, of legitimate participation in the struggles. Saying of this or that tendency in writing that "it just isn't poetry" or "literature" means refusing it a legitimate existence, excluding it from the game, excommunicating it. This symbolic exclusion is merely the reverse of the effort to impose a definition of legitimate practice, to constitute, for instance, as an eternal and universal essence a historical definition of an art or a genre corresponding to the specific interests of those who hold a certain specific capital. When it succeeds, this strategy which, like the competence it mobilizes, is inseparably artistic and political (in the specific sense), is of a nature to ensure that these people have power over the capital held by all the other producers, in so far as, through the imposition of a definition of legitimate practice, it is the rule of the game which will most favour the trumps that they hold which tends to be imposed on everybody (and especially, at least in the long run, on the consumers); it is their accomplishments which become the measure of all accomplishments. You see, in passing, that the aesthetic concepts that a certain aesthetic theory forces itself to ground in reason, deductively, on the Aristotelian model, and whose inconsistency, incoherence, or mere vagueness people have noted before me (here I could mention Wittgenstein), are, paradoxically, necessary only if one sets them back in the purely sociological logic of the field in which they are generated and have functioned as symbolic strategies in struggles for symbolic domination, that is, for control over a particular use of a particular category of signs and, thereby, over the way the natural and social world is envisaged.

This dominant definition imposes itself on everyone, and in particular on the new entrants, as a more or less absolute right of entry. And it is easy to understand that struggles over the definition of genres, of poetry at the turn of the century, of the novel since the Second World War and later with the defenders of the "nouveau roman", are something altogether different from futile wars of words: the overthrowing of the dominant definition is the specific form taken by revolutions in these universes. And it is easier to understand how confrontations which will become the object of academic analyses or debates, like all the quarrels between the Ancients and the Moderns and all revolutions, romantic or other, are experienced by the protagonists as questions of life or death.

Q. The field of power, in so far as it exercises its domination within the totality of fields, exercises an influence over the literary field. However, you grant to this field a "relative autonomy" whose historical process of formation you analyse. What, today, is the concrete situation with regard to the autonomy of this literary field?

A. The fields of cultural production occupy a dominated position in the field of power: that is a major fact ignored by ordinary theories of art and literature. Or, to retranslate this into a more common (but inadequate) language, I could say that artists and writers, and more generally intellectuals, are a dominated fraction of the dominant class. They are dominant, in so far as they hold the power and privileges conferred by the possession of cultural capital and even, at least as far as certain of them are concerned, the possession of a volume of cultural capital great enough to exercise power over cultural capital; but writers and artists are dominated in their relations with those who hold political and economic power. To avoid any mis-understanding, I have to emphasize that this domination is not exercised any longer, as it used to be, through personal relations (like that between a painter and the person who has commissioned a painting or between writer and patron), but takes the form of a structural domination exercised through very general mechanisms, such as those of the market. This contradictory position of dominant-dominated, of dominated among the dominant or, to make use of the homology with the political field, of the left wing of the right wing, explains the ambiguity of the positions they adopt, an ambiguity which is linked to this precariously balanced position. Despite their revolt against those they call the "bourgeois", they remain loyal to the bourgeois order, as can be seen in all periods of crisis in which their specific capital and their posi-tion in the social order are really threatened (one need think only of the positions adopted by writers, even the most "progressive", like Zola, when faced with the Commune).

The autonomy of the fields of cultural production, a structural factor which deter-mines the form of struggles internal to that field, varies considerably depending on different periods within the same society, and depending on different societies. And the relative strength, within the field, of the two poles, and the relative importance of the roles allotted to the artist or the intellectual, thereby also vary. With, on the one hand, at one extreme, the function of expert, or technician, offering his or her symbolic services to the dominant (cultural production also has its technicians, like the conveyor-belt producers of bourgeois theatre or the hack producers of pulp literature), and, on the other hand, at the other extreme, the role, won and defended against the dominant, of the free, critical thinker, the intellectual who uses his or her specific capital, won by virtue of autonomy and guaranteed by the very autonomy of the field, to intervene in the field of politics, following the model of Zola or Sartre.

Q. Intellectuals in West Germany define themselves, at least since the '68 move-ment, as being pretty much on the left; they think of themselves as being in opposi-tion to the dominant class. This is demonstrated by the relatively large impact of the "critical theory" of the Frankfurt School or of philosophers such as Ernst Bloch. You, however, assign to intellectuals, in relation to your analysis of symbolic struggles, a place within the dominant class. The theatre of these symbolic struggles, as you say, is "the dominant class itself"; it is thus a question of "fractional struggles" within a class of which intellectuals form a part. How do you come to this analysis? Shouldn't we raise the question of the possibilities for the literary field or for certain of its

sectors of acting on the field of power? Isn't this precisely the claim of a committed, active and realist literature?

A. Cultural producers hold a specific power, the properly symbolic power of showing things and making people believe in them, of revealing, in an explicit, objectified way, the more or less confused, vague, unformulated, even unformulable experiences of the natural world and the social world, and of thereby bringing them into existence. They may put this power at the service of the dominant. They may also, in the logic of their struggle within the field of power, put their power at the service of the dominated in the social field taken as a whole: it is well known that "artists", from Hugo to Mallarmé, from Courbet to Pissarro, have often identified their struggles of dominated-dominant against the "bourgeois" with the struggles of the dominated as such. But, and this is true also of the so-called "organic intellectuals" of revolutionary movements, alliances founded on the homology of position (dominant-dominated = dominated) are always more uncertain, more fragile, than solidarities based on an identity of position and, thereby, of condition and habitus.

The fact remains that the specific interests of cultural producers, in so far as they are linked to fields that, by the very logic of their functioning, encourage, favour or impose the transcending of personal interest in the ordinary sense, can lead them to political or intellectual actions that can be called universal.

Q. What change does your theory involve for the science of literature, the interpretation of the literary work, or for the traditional space of the science of literature? You reject both internal hermeneutics and intertextuality, both an essentialist analysis and the "philosophy of biography", to take up the critical terms you use to describe Sartre's work on Flaubert. When you grasp "the work of art as an expression of the field in its totality", what sort of consequences does that have?

A. The theory of the field does lead both to a rejection of the direct relating of individual biography to the work of literature (or the relating of the "social class" of origin to the work) and also to a rejection of the internal analysis of an individual work or even of intertextual analysis. This is because what we have to do is all these things at the same time. I postulate the existence of a pretty rigorous correspondence, a homology, between the space of works considered in their differences, their variations (in the manner of intertextuality), and the space of producers and institutions of production, reviews, publishing houses, etc. We have to note the different positions in the field of production as they may be defined by taking into account the genre being practised, rank in this genre, which can be decided by such factors as places of publication (publisher, review, gallery, etc.) and the signs of recognition or, quite simply, the length of time that has elapsed since they entered the game, but also by more external indicators, such as social and geographical origin, which can be retranslated into positions occupied within a field. To all these different positions correspond the positions adopted in the space of modes of expression, of literary or artistic forms (alexandrine or other metres, rhyme or free verse, sonnet or ballad,

etc.), of themes and, of course, of all sorts of more subtle signs that traditional literary analysis detected long ago. In other words, to read a work adequately, in the singularity of its textuality, one has to read it consciously or unconsciously in its intertextuality, that is, across the system of variants by which it is situated within the space of contemporary works; but this diacritical reading is inseparable from a structural apprehension of the relevant author who is defined, in his dispositions and the aesthetic positions he adopts, by the objective relations which define and determine his position in the space of production and which determine or guide the relations of competition that he entertains with other authors and the set of strategies, formal strategies especially, which make of him a "real" artist or a "real" writer – in opposition to the "naive" artist or writer, such as "le douanier" Rousseau or Brisset, who do not know, properly speaking, what they are doing. This doesn't mean that non-naive artists, whose paradigm, in my eyes, is Duchamp, are totally aware of everything that they are doing, which would amount to making of them cynics or impostors. It is necessary and sufficient for them to be "with it", for them to be up to date with what has happened and is happening in the field, for them to have a "historical feel" for the field, for its past and also its future, for its future developments, for all that still remains to be done. All of this is a form of the feel for the game, which excludes cynicism, which even demands that you get caught up in the game, taken up by the game to the point of being able to anticipate its future. But this doesn't at all imply a theory of the game as game (which would be enough to transform the *illusio* as an investment in the game or interest in the game, into an illusion pure and simple) nor even a theory of the game, of the laws according to which it functions and the rational strategies that are necessary to win in it. Non-naivety does not exclude a form of innocence . . . In short, the essentially diacritical nature of the production which occurs within a field means that one can and must read the whole field, both the field in which people adopt certain positions in order to make a stand and the field of positions as such, in every work produced in these conditions. This implies that all the oppositions habitually made between external and internal, hermeneutics and sociology, text and context, are totally fictitious; they are meant to justify sectarian refusals, unconscious prejudices (and in particular the aristocratism of the *lector* who doesn't want to get his hands dirty by studying the sociology of the producers) or, quite simply, the desire for the least expenditure of effort. This is because the method of analysis that I am proposing cannot really be put into operation other than at the cost of an enormous amount of work. It demands that you do everything done by the adepts of each of the methods known (internal reading, biographical analysis, etc.), in general on the level of one single author, and that everything that you also do has to be done in order to really construct the field of works and the field of producers and the system of relations established between these two sets of relations.

Q. What place, in your opinion, is occupied by the subject who produces literature or art? Does the old representation of the writer as a "creator of the symbolic", as the person who "names" or who "sees" in the sense Cassandra sees, that old but still

intact and active representation, still seem to you to be important? What use can a writer draw from your theory?

A. The author really is a creator, but in an entirely different sense from that understood by literary or artistic hagiography. Manet, for instance, brings about a real symbolic revolution, in the same way as do certain great religious or political prophets. He profoundly transforms our world-view, that is, the categories of perception and evaluation of the world, the principles of construction of the social world, the definition of what is important and what isn't, of what deserves to be represented and what doesn't. For example, he inaugurates and imposes the representation of the contemporary world, men wearing top hats and carrying umbrellas, the urban landscape, in its ordinary triviality. This is a rejection of all the hierarchies, both intellectual and social, which identify the most noble (worthy as such of being represented) with the most ancient – ancient costume, the plaster casts of painting studios, the obligatory subjects of the Greek or biblical tradition, etc. In this sense, the symbolic revolution, which overturns mental structures and deeply upsets people's minds – which explains the violence of the reactions of bourgeois critics and public – may be called the revolution *par excellence*. The critics, who perceive and denounce the avant-garde painter as a political revolutionary, aren't altogether wrong, even if the symbolic revolution is doomed, most of the time, to remain confined to the symbolic domain. The power of naming, in particular of naming the unnameable, that which is still unnoticed or repressed, is a considerable power. Words, said Sartre, can wreak havoc. This is the case, for instance, when they bring into public and thus official and open existence, when they show or half-show, things which existed only in an implicit, confused, or even repressed state. To represent, to bring to light, is no small task. And one can, in this sense, speak of creation.

Note

1 P. Bürger, "On Literary History", *Poetics* (August 1985): 199–207.

2　When Form Has Become Attitude – And Beyond

Thierry de Duve

I t used to be that the teaching of art was academic and proud of it. Rooted in the observation of nature and the imitation of previous art, the long apprenticeship of a would-be painter or sculptor was primarily an acquisition of skills put under specific cultural constraints. Life-drawing and its underlying discourse, anatomy, provided the basic skill ennobled with humanistic knowledge. Never, though, was art equated with skill. What deserved admiration in the accomplished artist was talent, not craftsmanship. Skill could be acquired, talent could not, since talent was thought of as a gift of nature – a gift, however, which could neither develop nor express itself outside the rules, conventions, and codes provided by the tradition. Tradition set the standards against which the production of art students was measured. Academic teaching had great ambitions as regards the maintenance of tradition and the passing on of quality standards; it had little vanity as regards its ability to "turn out" individual artists. All it could hope to do was nurture and discipline its students' gifts within the limits of nature's generosity, and to grant even the most ungifted students a technical know-how capable of securing them a recognised, if humble, place in society and a plausible, if modest, source of income. Between the work of the artisan and that of the genius the Academy recognised a leap in quality, but also the cultural continuity of one and the same trade in which everybody held his (or her) rank.

From Stephen Foster and Nicholas deVille (eds.), *The Artist and the Academy: Issues in Fine Art Education and The Wider Cultural Context* (Southampton, UK: John Hansard Gallery, 1994), pp. 23–40. Reproduced with permission of Stephen Foster. This paper was originally presented at a conference, "The Artist and the Academy: European Perspectives on Today's Fine Art Education," held at Chilworth Manor, University of Southampton, UK, on December 9 and 10, 1993.

All this was destroyed in less than a century. Reynolds was probably the last great academic pedagogue; a century after him, the Academy had withered into academicism. As industrialisation and the social upheaval, scientific progress and ideological transformations that went with it decomposed the hitherto stable social fabric and, on the whole, more or less destroyed all craftsmanship, the examples of the past lost their credibility, in art and elsewhere, and the chain of tradition was eventually broken. To the sensitive artist, academic art and training became just that, academic, and the new art began to look toward the future for its legitimation, with fear and hope alike. The avant-garde was launched. Painting and sculpture, progressively turning away from observation and imitation of outside models, turned inwards and started to observe and imitate their very means of expression. Instead of exerting their talent within relatively fixed conventions, the modernist artists put those conventions themselves to an aesthetic test and, one by one, discarded those by which they no longer felt constrained. Excellence in art came to be measured against the resistance of the medium, with, as yardstick, the honesty with which the artist yields to it. All tradition rejected, painting came to be seen as a sort of essence, present in all painting, past, present or future, as if the medium in its purity could set the rules by itself, command over skill, and provide a vessel for talent. Sculpture, architecture, photography, even cinema became similar essences.

Soon, art schooling was affected by the avant-garde. As the examples and standards of the past could no longer be trusted, as imitation and observation could no longer provide the basics for the apprenticeship of art, the teaching of art had to look elsewhere for roots in both nature and culture. This it achieved in two ways. The figure of Man – the universal measure of all things in nature – was relinquished as outer model for observation, but was recouped as inner subjective principle. Psychology replaced anatomy in its function as foundational discourse for a new artistic humanism. The new doctrine stated that all men are endowed with innate faculties which it is the function of education to allow to grow. Thus, specialisation in the visual arts meant the specific training and growth of the faculties of visual perception and imagination. How to train them became the pedagogical issue. Again, psychology – not the introspective kind but perception psychology, *Gestalt* theory, and so on – provided the idea that the ability to perceive is, by nature, already cultural, that perception is, so to speak, a basic reading skill. It followed from there that imagination was a basic writing skill of sorts. "Creativity" is the name, the modern name, given to the combined innate faculties of perception and imagination. Everybody is endowed with it, and the closer it remains to sheer, blank endowment, the greater is its potential. A child, a primitive, has more creativity than a cultivated adult. The ideal art student, the artist of the future, came to be dreamt of as an infant whose natural ability to read and write the visual world needs only to be properly tutored. The problem became to find the appropriate means. If only the practice of painting and sculpture could be broken into semantic "atoms", if only some elementary visual alphabet and syntax could be set up, then art – art itself, not merely skill – could be taught and taught without resorting to a now obsolete tradition. Talent, as such, no longer exists. It lies in a raw state in everyone's creativity, and skill lies, so to

speak, ready-made in the properties of the medium: in the linearity of drawing, in the two-dimensionality of the picture plane, in the volumetric properties of sculpture. In principle, if not in fact, the learning of art became simple: students should learn how to tap their unspoilt creativity, guided by immediate feeling and emotion, and to read their medium, obeying its immanent syntax. As their aesthetic sensibility and artistic literacy progressed, their ability to feel and to read would translate into the ability to express and to articulate. Nurtured perception and imagination would produce artworks of a new kind.

This pedagogical programme proved to be a self-fulfilling prophecy. All progressive pedagogues of this century, from Froebel to Montessori to Decroly; all school reformers and philosophers of education, from Rudolf Steiner to John Dewey, have based their projects and programmes on creativity, or rather, on the belief in creativity, on the conviction that creativity – not tradition, not rules and conventions – is the best starting point for education. Moreover, all great modern theorists of art, from Herbert Read to E. H. Gombrich to Rudolph Arnheim, have entertained similar convictions and devoted considerable energy to breaking up the "visual language" into its basic components and demonstrating the universality of its perceptive and psychological "laws". And finally, needless to say, there is not one pioneer of Modernist art, from Malevich to Kandinsky and Klee, or from Itten and Moholy-Nagy to Albers and Hofmann, who has not been actively involved in the creation of art schools and teaching programmes based on the reduction of practice to the fundamental elements of a syntax immanent to the medium. Kandinsky wrote *Von Punkt zur Linie zur Fläche* in 1924, and since then every art school in the world has a 2-D and a 3-D studio to prepare its students for painting and sculpture. If they had been strictly faithful to Kandinsky, if they had also taken their cue from Cubism, they would have a 1-D and a 4-D studio as well.

My point is not just to be ironic, and certainly not to dismiss this philosophy without further trial, but merely to stress that a philosophy it is, a biased one and a dated one. Let's call it the Bauhaus model. It was never carried out with the radical purity of my description, not even at the Bauhaus itself, which died under the pressure of its own contradictions as much as it did under the hand of the Nazis. But the Bauhaus model, more or less amended, more or less debased, has set a series of assumptions about art teaching upon which dozens of art and architecture schools around the world have been built, and which are, as of today, still underlying, often subliminally, almost unconsciously, most art curriculums, including (if I'm well informed) a great number of foundation courses across the UK. Moreover, it is seemingly the only model that pits itself coherently against the old academic model, such as it also survives, equally amended and often degenerated beyond recognition, not just in the very few Ecoles de Beaux-Arts that still defend it (actually, I don't know of any that still do), but also in the immense majority of art schools and academies around the world that seek to find a compromise between traditionalism and modernism.

I have sketched out an oversimplified picture, a caricature, even, of the postulates underlying the teaching of art up to recent years. But a caricature is all the more

truthful in that it is exaggerated, and I will not hesitate in exaggerating it even more forcibly, in order to make those postulates appear as postulates – that is, as mere postulates. Two models, even though in reality they contaminate each other, divide up the teaching of art conceptually. On the one hand, there is the academic model; on the other, there is the Bauhaus model. The former believes in talent, the latter in creativity. The former classifies the arts according to techniques, what I would call the *métier*; the latter according to the medium. The former fosters imitation; the latter invention. Both models are obsolete. The academic model entered a deep crisis as soon as it began to deserve the derogative label of academicism. Its decadence was accomplished under the pressure of modern art, which is why no return to the past is thinkable lest the blackout is pronounced on all the art and all the artists of modernity. The Bauhaus model also entered an open crisis. That phenomenon is more recent but it isn't new, dating from the Sixties, I would say. It, too, goes hand in hand with the art of its time, and it is contemporaneous with the deep loss of confidence that modernism has undergone since those years. Now, it is dramatic to have to teach according to postulates one doesn't believe in anymore. But in order to change them, one has to see them clearly. Let's review the evidence: do we have to choose between talent and creativity, between *métier* and medium?

Talent vs Creativity

The difference between talent and creativity is that the former is unequally distributed and the latter universally. In the passage from one word to the other, there is of course a complete reversal of ideologies, and it is not difficult to see that, historically, the progress of the ideology of creativity went hand in hand with that of the idea of democracy and of egalitarianism. The use of the word creativity in this elevated sense itself is relatively recent, but its germs were already present in the Romantic notion of the genius. Creativity is grounded in a utopian belief summarised by a slogan that repeats itself with clockwork regularity throughout the history of modernity, from Rimbaud to Beuys: everyone is an artist. Of course, it always meant: everyone is potentially an artist. Talent is also a potential but, on the one hand, it does not depend on some psychology of the faculties, and on the other, it is inseparable from the specific terrain where it is exerted, which in the last resort is always technical. One has talent for music, for carpentry or for cookery, but not talent in general. Creativity, by contrast, is conceived as an absolute and unformalised potential, a supply of energy prior to any division of labour. One has creativity, without qualification; one is creative, period.

Three major consequences derive from this for any art-educational project based on creativity. The first is that nothing should, in principle, restrict access to the study of art. The second is that art itself, and not just the technical means of art, can be taught. And the third is that initiation to art in general should precede every specialisation (that was the role of the *Grundkurs*, or foundation course, at the Bauhaus). The

contradiction between these principles is blatant: many art schools yield to the particularly perverse illusion (which, moreover, frequently backfires) that they produce or fabricate artists, while at the same time considering that their incoming students are artists already, even though only potentially. In fact, all teachers know by experience that talent exists and that creativity is a myth. On this point, the Academy saw things a lot more clearly than modernity. The myth is generous, and this is not a negligible quality when it comes to teaching. And as long as the myth functions, why denounce it? The problem is that it doesn't function anymore.

Métier vs Medium

The difference between *métier* and medium is that the former has a historical existence and the latter a transhistorical existence. The Academy classified the fine arts according to the *métier* and everything the notion entails: specialised skills, artisan habits, sleights of hand, rules of composition, canons of beauty, in short, a specific tradition. Modernism classifies the arts according to the medium and everything this notion entails: particular materials, supports, tools, gestures, technical procedures, and conventions of specificity. That an artist practised the *métier* of painter meant that he belonged to the guild of painters and had a place in a given affiliation. His definition of painting would have been, simply: what painters do. That an artist works in the medium of painting means that he questions painting for what it has to say about itself and hasn't said yet. His definition of painting might be: what no painter has done yet. The *métier* gets practised, the medium gets questioned; the *métier* gets transmitted, the medium communicates or gets communicated; the *métier* gets learnt, the medium gets discovered; the *métier* is a tradition, the medium is a language; the *métier* rests on experience, the medium relies on experimentation. From the former to the latter, a reversal occurred in the conception of history. The *métier* is always received from the past; even when regulated by ideals that are supposedly eternal, those ideals are situated upstream in history (like the antique). The medium is received from nowhere; it purports to actualise transcendentals, that is, *a priori* conditions of possibility, which, regulating the work, should lead to the revelation of the medium's essence, paradoxically situated downstream in history. Thus, for the academic model, to teach painting means to transmit its legacy and to allow the apprentice to find a place in a chain of affiliation of which he has a strong awareness and which he will have to pursue. For the Bauhaus model, to teach painting is to open access to a being called painting, supposedly immanent to all paintings from all times, but whose ultimate revelation is yet to come; it is to invite the student to subtract from the medium and thereby to subtract himself from the chain of affiliation.

Three major consequences derive from this. First, teaching the arts according to the medium cultivates distrust of technical skill because mastering the medium gets in the way of questioning the medium; what matters is not technical apprenticeship

but the discovery of those qualities that can be deduced from the medium itself. Second, in cutting off the arts from their specific affiliations and reorganising them according to the specificity of their perceptive properties, this teaching denies itself the possibility of conceiving that there is art in between the mediums. And third, it seeks to teach the future, which is of course impossible. The verdict should be more severe, even, for the myth of the medium than it was for the myth of creativity, with which, moreover, it is contradictory under certain aspects. It has had considerable pedagogical efficiency, but its perverse effects now outrun its benefits.

Imitation vs Invention

The difference between imitation and invention goes without saying. Whereas imitation reproduces, invention produces; whereas imitation generates sameness, invention generates otherness; whereas imitation seeks continuity, invention seeks novelty. The Academy was aware that artists worthy of the name invent. However, even though academic teaching spotted a sign of a student's talent in his capacity to invent, it was not on his capacity to invent that it judged him, nor was it through stimulating invention that it claimed to educate him. Quite the contrary. It was through imposing on him imitation, invention's antithesis: the imitation of nature, of the Ancients, of the master. The Bauhaus model, by contrast, fosters invention, because every progress in its expression indicates a liberation of the student's creativity, an actualisation of his artistic potential. The abandonment of naturalism, the break with the Ancients, the rejection of the master are the predictable results. Now, that a teaching system should systematically encourage the rejection of the master isn't without contradiction. Creativity being the source of invention, the medium its target, the teacher – who is no longer a master – owes his authority to the very constraints of the medium while he invites the student to transgress the medium's limits in order to prove his creativity. He sees it as his task to detect the student's invention and to value it for its own sake, while referring it to the medium and interpreting it within the limits of the medium's specificity.

Again, three major consequences derive from this. First, the kind of teaching that seeks to provoke invention tends to judge its students on a quasi-quantitative basis, on the basis of the frequency of invention as such, of its novelty, of its discontinuous and randomlike character, of its unforeseen freshness: all qualities that are real in an accomplished work of art but quite unsuitable when it comes to recording the students' progress. Second, such teaching systematically encourages the students to experiment with the medium, while containing their experimentation within boundaries that are seen not just as a terrain for apprenticeship, but as the limits of the field of practice itself. Finally, such teaching is loath to discuss the content of the students' work and cultivates formalism. These are the cumulative effects of the generosity of the ideology of creativity, and of a conception of the history of art that banks on the future for its legitimation. The trouble is that the myth of creativity is suspicious, and

that the future, from which the Bauhaus model expected its legitimation, belongs to our past.

In view of this cursory analysis, it may seem that I promote some return to the academic model of teaching. Not so, of course. In fact, I don't promote anything, not in this paper, anyway. My only intention is to gain a clearer view of the decline of the Bauhaus model, which is far more important for the proper understanding of the present crisis than the long-accomplished demise of the Academy. It is because the paradigm underlying the Bauhaus model, the creativity-medium-invention paradigm, still operates in most art schools, even in those – especially in those, I should say – that consciously bathe in its critique; it is because its three postulates are either inscribed in the structure of the institution, or linger more or less consciously in the heads of the teachers and of the students, that its perverse effects are so pervasive. Whether creativity exists or whether it is merely a useful illusion is for all practical purposes irrelevant as long as it works. Whether there is such a thing as a "visual language" specific to the medium or whether it is merely a pedagogical strategy is equally irrelevant as long as it works. The question is: does the Bauhaus model still work? Is it still useful?

We, who teach in art schools, all have mitigated answers to this, I'm sure. Who among us hears the word creativity without wearing an ironic smile? Who among us still dreams of a utopian visual language à la Kandinsky, some Esperanto composed of red squares, yellow triangles and blue circles? Who still believes in the purity or the specificity of the medium, in the manner of Greenberg? Who, perhaps with Warhol in mind, or Toroni, or Richter, or Steve Reich, will deny that as much contemporary art of quality has been produced through repetition as through invention? If the Bauhaus model still works, perhaps it is in spite of itself. Many of us have grown to value the perverse effects of a teaching method organised, if only nominally, in terms of the purity of the media and the separateness of the disciplines. Many of us have grown to praise the subversive students who do not behave as if they tapped the unspoilt creativity with which they are supposedly endowed, but who, instead, tap the pop culture with which they come equipped. Those of us who teach the "basic" courses know all too well that they can communicate only rules and conventions, and that significant art is art that overthrows, displaces, abandons or subverts rules and conventions. Who has not dreamt, if only secretly, of having students – the best students – forcing the teacher to give them an A+ because they transgressed the rules of the assignment so intelligently that they displayed a perfect awareness of what art-making is about? Those of us who teach "mixed media", "intermedia", "multi-media", or "experimental media" – whatever the name is of the no man's land that most art schools have ended up institutionalising as if it were a medium of its own – know all too well that if they did not assign subject matter or set technical constraints, formal limits, severe deadlines or whatever rules or conventions, they would not achieve much more than organised escapism. The fruits that the Bauhaus tree yielded and still yields are strange hybrids. We all know that. We have come to expect it, even foster it. The last art school with a strict Bauhaus ideology (though already considerably amended) was the Black Mountain

College, and its best "fruit" was Rauschenberg. Meanwhile, the Bauhaus itself, with all those great artists teaching there, did not produce a single student of a stature equal to that of the masters. Meanwhile, the most "advanced" art schools are those that, consciously entertaining this grim and disillusioned view of the Bauhaus legacy, openly bank on the perversions – they say the subversion – of this modernist model. The artists they produce – for they produce artists indeed – are people whose criterion is the derision of all the notions derived from that of creativity, such as originality and authenticity, without, for all that, necessarily displaying more talent; people who have pushed the rejection of both the *métier* and the medium to the point where their only technique is the appropriation of ready-mades or people who, through simulation, succeed in denying imitation and invention at the same time.

Such is the present situation. A paradigm has imploded, and though it might be that we are in the midst of a "paradigm shift" (if so, it will be for our successors to see it), what I believe is apparently organising the most advanced art schools is in fact the disenchanted, perhaps nihilistic, after-image of the old Bauhaus paradigm. Let me quickly review the evidence in relation to both the postulates of the academic model, talent-*métier*-imitation, and those of the Bauhaus model, creativity-medium-invention. What seems to have taken their place is a new triad of notions: attitude-practice-deconstruction.

Talent and Creativity vs Attitude

In the wake of the student upheaval of the late Sixties no one was ready to admit the inequality of talent, out of fear of seeming irredeemably reactionary. But the May '68 slogan, "all power to the imagination", didn't last very long, and soon creativity lost its aura, too. Philosophically speaking, the times were very suspicious of anything more or less resembling the old psychology of the faculties, and creativity, which is a neo-Romantic amalgam of the Kantian faculties of sensibility and imagination, became old hat. It had everything against itself: being universal, it could only be "bourgeois"; being transcendental, it could only be "metaphysical"; being natural, it could only be "ideological". But its greatest sin was that it could not be willed, and the most progressive art and art teaching of the Seventies thought that art had to be willed, whether it aligned itself with some political programme bathed in revolutionary rhetorics, or whether it saw itself as the relentless critique of the dominant ideology. Anyway, it had become hard to suppose that creativity was the potential of mankind in general, and equally hard to hope that it could be instilled through propaganda or education (think of Joseph Beuys, in this context: he certainly represents the last great and tragic hero of the modern myth of creativity, immolating himself on the altar of both pedagogy and "social sculpture"). Thus another concept took the place of creativity, that of "attitude". A concept that is a blank, actually: a sort of zero degree of psychology, a neutral point amidst ideological choices, a volition without content.

Of course, in order to be progressive – and how could art of any significance not be progressive? – attitude had to be critical. Lukács, Adorno, Althusser and others were called in to tell would-be artists that neither talent nor creativity were needed to make art but, instead, that "critical attitude" was mandatory. And the fact that not just artists but all "cultural workers" were thought to be in need of a critical attitude of course helped to shape a new, strongly politicised discourse about art and its relation to society, a discourse that, throughout the Seventies and part of the Eighties, became the dominant discourse, not in all art schools, admittedly, but certainly in the most progressive, the most avant-gardistic or – why not say it? – the most fashionable ones. Even if you turn to less politicised aspects of the dominant discourse about art in those years you will see the central position of the notion of attitude confirmed. It is towards the end of the Sixties that the concept of "aesthetic attitude" surfaced in art theory, thanks to Jerome Stolnitz in particular, but also, I should say, thanks to Duchamp's growing reputation as the first conceptual artist, a combination of influences that greatly helped in pushing aside aesthetics while retaining the notion of attitude. Finally – and this, I believe, clinches it, if only symbolically – it was in 1969 that Harald Szeemann organised the famous exhibition *When Attitudes Become Form*, at the Kunsthalle in Bern. Both the date and the title coined for this exhibition are symptomatic, for it was then and there that conceptual art was acknowledged for the first time by a major art institution (MoMA was to follow before long with the *Information* show, in 1970), providing a new model for advanced art soon to be emulated and disseminated by most art schools.

Everybody here, I'm sure, is familiar with what happened next. Linguistics, semiotics, anthropology, psychoanalysis, Marxism, feminism, structuralism and post-structuralism, in short, "theory" (or so-called "French theory") entered art schools and succeeded in displacing – sometimes replacing – studio practice while renewing the critical vocabulary and intellectual tools with which to approach the making and the appreciating of art. With considerable differences depending on national and local circumstances (the Anglo-Saxon world having the lead), this shift – whose first aspect is the shift from creativity to attitude – occurred in the mid- to late Seventies and was a *fait accompli* by the mid-Eighties. By then, to take just a few prominent examples, the Nova Scotia College of Art and Design in Halifax had its most prolific period behind itself, Cal Arts was launching a generation of successful alumni, and Goldsmiths' was the place to be. In those days attitude still had to be critical, which basically meant: critical of the social and political status quo. But soon the very success of these art schools began attracting students who went there because of the instant rewards they were seemingly able to promise them. For these students (with or without the conscious or unconscious complicity of their teachers, I can't tell), what had started as an ideological alternative to both talent and creativity, called "critical attitude", became just that, an attitude, a stance, a pose, a contrivance. This phenomenon, of course, widely exceeds the few art schools I just named; it even exceeds art schools in general, for it is rampant throughout the whole academic world, especially in the humanities. It can be summarised by saying that political commitment sank into political correctness. Meanwhile, what remains of the old

postulates – the academic postulate called talent and the modernist postulate called creativity – on which to ground a plausible art curriculum is the poorest, the most tautological notion of all: that of an artist's attitude.

Métier and Medium vs Practice

Dividing the arts according to the medium rather than to the *métier*; reading art history in terms of "a progressive surrender to the resistance of its medium" (Clement Greenberg); fostering the purity of the medium as a value in itself are the three strong points of formalist criticism and modernist doctrine in art. As is well known, formalism and modernism have been under heavy fire since the mid-Sixties, first in America, soon after in England, and then in the rest of the Western world. Just as with Harald Szeemann's show, *When Attitudes Become Form*, let me choose a symbolic event to pinpoint this, an event all the more symbolic in that it happened in 1966 at an art school. John Latham was a part-time instructor at St Martin's, in London, when he borrowed Clement Greenberg's *Art and Culture* from the school's library and, with the complicity of Barry Flanagan, then a student at St Martin's, organised an event entitled *Still & Chew*, when a number of pages of the book were chewed by the participants and spat into a jar, then submitted to a complex chemical treatment. You know the aftermath of this performance (or was it a happening?): a year or so later, when asked to return the book to the library, John Latham returned it indeed, but in the shape of a jar containing the unspeakable, let alone unreadable, mixture. He was fired the next day.

Today, needless to say, he could do the same performance with the principal's blessing, and the librarian wouldn't even bother to reorder *Art and Culture*. Events, happenings, and performances have long been absorbed into art schools, and even though most schools keep a painting studio, a sculpture studio, a printmaking studio, and so on, they have added to the list a "mixed media", an "interdisciplinary", or a "free-for-all" studio – whatever the name – which definitely indicates that the teaching of art no longer rests on an aesthetic commitment to the specificity or the purity of the medium. By 1970 Clement Greenberg and Michael Fried were already the last art critics to uphold the idea that no art of significance could be done that sits in between media, and that if something is neither painting nor sculpture, then it is not art. Against them, a whole generation of conceptual artists were relying on Duchamp in order to maintain that the art was in the concept, that it was dematerialised, that it did not cling to any medium, above all not to painting. They fought against the medium but, of course, didn't rehabilitate the *métier* for all that. Just as with the word "attitude", what was soon to replace both the *métier* and the medium was another magical word, "practice".

By 1975, the word "practice" was widely in use among all the people who had been in touch with "French theory", and since "French theory", after all, originated in France, it is there, in the writings of the Tel Quel people, in particular, that it

acquired a cluster of interesting meanings in the context of literature and art. One of its benefits was that it was charged with prestigious political connotations, Marxist, of course, and Althusserian. More important is that it is a general word not a specific one, or, to say this differently, that it puts the emphasis on the social, not on the technical, division of labour. Applied to painting, for example, it allowed us to conceive of painting not in terms of a specific skill (such as entailed by the notion of *métier*), nor in terms of a specific medium (such as the Greenbergian flatness), but in terms of a specific historical institution called "pictorial practice". This is the way both the painters belonging to the Support-Surface group, and their arch-enemy, Daniel Buren, used the word in defence of painting. Other artists, who were defending interdisciplinarity against specificity, began speaking of "artistic practice" or "practices", depending on whether the generic was thought of as being one or plural. But the most interesting – i.e. symptomatic – phenomenon is that the word art itself (simply, art) became taboo. It was guilty of conveying some faith in the "essence" of art, I mean, in the existence of some transhistorical and transcultural common denominator among all artistic practices. Our epoch being radically relativistic, it wouldn't allow such unorthodox belief. The orthodoxy of the times prescribed – and still prescribe – conceiving of art as being just one "signifying practice" (that expression was coined by Julia Kristeva) among others.

I have just said: "prescribed – and still prescribe". In fact, I'm not so sure. One of the things I expect from this conference is that it may help me understand to what extent the orthodoxy of discourse (what I nastily referred to as political correctness) fails to hide the reality of anxieties, disappointments, shattered beliefs, which, I suspect, have a hard time expressing themselves without giving the impression (as I most probably do) of wanting to go backwards and resorting to nostalgia. I hope that the discussion will bring these difficulties into the open, but meanwhile I would like to stress that what was in the Seventies an avant-gardistic discourse has, by now, been largely institutionalised. I know of at least one art school where the students have the choice of enrolling either in "Communication" or in "Artistic Practice". As always, the magic of changing names is a symptom: the expression "artistic practice" has become a ritual formula, conveying the vague suspicion that has come to surround the word art, while failing to designate referents in the world (that is, actual works) of which one could be sure that the word art has ceased to apply to them significantly.

Imitation and Invention vs Deconstruction

When the culture that fosters invention starts to doubt, it ceases to oppose itself to the culture fostering imitation that it claimed to supplant. Conversely, when the absence of models to be imitated begins to be felt as a loss and no longer as a liberation, this can only mean that this culture's capacity to invent without looking back has dried up. Once this point is reached (and God knows it has been reached:

look at all the neo- and all the post-movements; look at the endemic practices of quotation, second- or third-degree self-referentiality, replicas, and the like), then it is no longer enough to say that imitation repeats and that invention makes the difference. The very concepts of repetition and difference ought to be thought anew, transversally, so to speak. Towards the end of the Sixties, again, and sitting on the uneasy boundary between literature and philosophy, Jacques Derrida, but also Gilles Deleuze and others, began thinking about difference and repetition together. Between the live voice creating newness and the trace that supplants and supplements the missing origin, they showed the link dismantling their expected opposition. Derrida sought *écriture* in creation and *différance* in reproduction, while Deleuze showed that the eternal return of sameness inhabited the production of difference. Traditional concepts such as presence versus absence, immediacy versus mediation, originality versus secondarity, were no longer secure oppositions, and had to be deconstructed.

The success of deconstruction is not simply explained – let alone explained away – by the quality of the philosophical work done under its name, and even less so by the mere influence of Derrida – and of Paul de Man on the other side of the Atlantic – on literary criticism. If it had not resonated at a very precise stage in the crisis of modernity, it would not have achieved success at all. But, as we all know, it has, to the point where deconstructionism – and that's the last straw, really – became the banner under which an architecture movement developed, after having invaded art criticism and, more recently, the teaching of art itself. Rather misunderstood and badly assimilated, deconstruction has apparently become, in the Eighties, a method by which to produce art and to teach it. As such, however, rather misunderstood and badly assimilated, deconstruction is merely the symptom of the disarray of a generation of art teachers who have lived through the crisis of invention and have never themselves been submitted to the discipline of imitation. The result is that students who haven't had the time to construct an artistic culture of any kind are being tutored in the deconstructive suspicion proper to our time. I have seen one art school (not that long ago) where the first year course (what used to be the foundation course) had been transformed into a seminar in which the point was to "deconstruct" anything entering the classroom. One week it was an advertisement, another week it was the policy of this or that public art institution, and yet another week it was a student's work – a work done at home, that is, as if no assignment had been given to her beside the unspoken injunction to produce material to be deconstructed in the classroom. The ensuing paralysis was not just sad, it was revolting.

Of course, as I warned you at the beginning of my talk, I have simplified matters, and I have turned the world of present-day art schools into a caricature, just as I did with the old Academy and with the somewhat younger Bauhaus model. In the everyday reality of art schools things are a lot more complex, more subtle, more ambiguous. But since all of us, here, are gathered around the problematic and general issues of "perspectives in fine art education", I hope you understand that it is not on the level of our everyday endeavours that I have situated my remarks but on that of the historical ideological paradigms that we inherit from our institutions or with which, willy-nilly, we have to work. It is thus my contention, which I really

want to offer as an open basis for discussion, that the triad of notions, "attitude-practice-deconstruction", is not the post-modern paradigm that supposedly substituted for the modern paradigm, "creativity-medium-invention". It is the same one, minus faith, plus suspicion. I tend to see it as a mere after-image, as the negative symptom of a historical transition whose positivity is not clear yet. As such it is quite interesting, and it can yield strong works of art. But for the teaching of art it is sterile. Once it is possible to put it down on paper, as I have just done, this means that its potential for negation has already become conventional (deconstruction is today's good taste), that its anguish is no longer of the kind that nourishes true artists (it is fake, because it is reconciled with the present); and that its suspicion is, unlike Descartes's doubt, not fruitful (it is aimed at the other and not at oneself).

I shall stop here, rather abruptly, on purpose. Having offered a diagnosis, I refuse to suggest a cure – which is not to say that the cure interests me less than the diagnosis. Quite the contrary. As some of you might know, I spent the past three years conceiving the project of a new art school on behalf of the City of Paris, until it was abandoned by the very same City of Paris for financial reasons. In the process I had dozens of meetings with artists, teachers, critics, intellectuals, technicians; I wrote a book on the issue of art schools, of which you have just heard the first fifteen pages; and I was lucky enough to be able to organise a one-month summer school for thirty-two students, as a sort of "dry-run" test of the future school, just before the project went down the drain. In the process I also learnt that there is no ready-made solution to the crisis in art schools; that the first thing to do was patiently to reconstitute a community of good artists who love art, who respect each other and their students, and who take their task as transmitters seriously; and that the last thing to do was to want to unite them around a banner, a programme or an ideology. I hope you will pardon me for refusing even to suggest that I might hold such a banner.

3 One Place After Another

Notes on Site Specificity

Miwon Kwon

Site specificity used to imply something grounded, bound to the laws of physics. Often playing with gravity, site-specific works used to be obstinate about "presence," even if they were materially ephemeral, and adamant about immobility, even in the face of disappearance or destruction. Whether inside the white cube or out in the Nevada desert, whether architectural or landscape-oriented, site-specific art initially took the "site" as an actual location, a tangible reality, its identity composed of a unique combination of constitutive physical elements: length, depth, height, texture, and shape of walls and rooms; scale and proportion of plazas, buildings, or parks; existing conditions of lighting, ventilation, traffic patterns; distinctive topographical features. If modernist sculpture absorbed its pedestal/base to sever its connection to or express its indifference to the site, rendering itself more autonomous and self-referential, and thus transportable, placeless, and nomadic, then site-specific works, as they first emerged in the wake of minimalism in the late 1960s and early 1970s, forced a dramatic reversal of this modernist paradigm.[1] Antithetical to the claim, "If you have to change a sculpture for a site there is something wrong with the sculpture,"[2] site-specific art, whether interruptive or assimilative, gave itself up to its environmental context, being formally determined or directed by it.[3]

In turn, the uncontaminated and pure idealist space of dominant modernisms was radically displaced by the materiality of the natural landscape or the impure and ordinary space of the everyday. The space of art was no longer perceived as a blank slate, a tabula rasa, but a *real* place. The art object or event in this context was to be

From *October* 80 (spring 1997): 38–63. © 1997 by October Magazine Ltd and the Massachusetts Institute of Technology.

singularly *experienced* in the here-and-now through the bodily presence of each view-ing subject, in a sensorial immediacy of spatial extension and temporal duration (what Michael Fried derisively characterized as theatricality), rather than instantan-eously "perceived" in a visual epiphany by a disembodied eye. Site-specific work in its earliest formation, then, focused on establishing an inextricable, indivisible relation-ship between the work and its site and demanded the physical presence of the viewer for the work's completion. The (neo-avant-garde) aspiration to exceed the limitations of traditional media, like painting and sculpture, as well as their institutional setting; the epistemological challenge to relocate meaning from within the art object to the contingencies of its context; the radical restructuring of the subject from an old Cartesian model to a phenomenological one of lived bodily experience; and the self-conscious desire to resist the forces of the capitalist market economy, which circulates artworks as transportable and exchangeable commodity goods – all these imperatives came together in art's new attachment to the actuality of the site.

In this frame of mind, Robert Barry declared in a 1969 interview that each of his wire installations was "made to suit the place in which it was installed. They cannot be moved without being destroyed."[4] Similarly, Richard Serra wrote fifteen years later in a letter to the director of the Art-in-Architecture Program of the General Services Administration in Washington, DC, that his 120-foot, Cor-Ten steel sculp-ture *Tilted Arc* was "commissioned and designed for one particular site: Federal Plaza. It is a site-specific work and as such not to be relocated. To remove the work is to destroy the work."[5] He further elaborated his position in 1989:

> As I pointed out, *Tilted Arc* was conceived from the start as a site-specific sculpture and was not meant to be "site-adjusted" or . . . "relocated." Site-specific works deal with the environmental components of given places. The scale, size, and location of site-specific works are determined by the topography of the site, whether it be urban or landscape or architectural enclosure. The works become part of the site and restructure both conceptually and perceptually the organization of the site.[6]

Barry and Serra echo one another here. But whereas Barry's comment announces what was in the late 1960s a new radicality in vanguard sculptural practice, marking an early stage in the aesthetic experimentations that were to follow through the 1970s (i.e., land/earth art, process art, installation art, conceptual art, performance/body art, and various forms of institutional critique), Serra's statement, spoken twenty years later within the context of public art, is an indignant defense, signaling a crisis point for site specificity – at least for a version that would prioritize the *physical* inseparability between a work and its site of installation.[7]

Informed by the contextual thinking of minimalism, various forms of institutional critique and conceptual art developed a different model of site specificity that implicitly challenged the "innocence" of space and the accompanying presumption of a universal viewing subject (albeit one in possession of a corporeal body) as espoused in the phenomenological model. Artists such as Michael Asher, Marcel Broodthaers, Daniel Buren, Hans Haacke, and Robert Smithson, as well as many women artists, including

Mierle Laderman Ukeles, have variously conceived the site not only in physical and spatial terms but also as a *cultural* framework defined by the institutions of art. If minimalism returned to the viewing subject a physical corporeal body, institutional critique insisted on the social matrix of class, race, gender, and sexuality of the viewing subject.[8] Moreover, while minimalism challenged the idealist hermeticism of the autonomous art object by deflecting its meaning to the space of its presentation, institutional critique further complicated this displacement by highlighting the idealist hermeticism of the space of presentation itself. The modern gallery/museum space, for instance, with its stark white walls, artificial lighting (no windows), controlled climate, and pristine architectonics, was perceived not solely in terms of basic dimensions and proportion but as an institutional disguise, a normative exhibition convention serving an ideological function. The seemingly benign architectural features of a gallery/museum, in other words, were deemed to be coded mechanisms that *actively* disassociate the space of art from the outer world, furthering the institution's idealist imperative of rendering itself and its hierarchization of values "objective," "disinterested," and "true."

As early as 1970 Buren proclaimed, "Whether the place in which the work is shown imprints and marks this work, whatever it may be, or whether the work itself is directly – consciously or not – produced for the Museum, any work presented in that framework, if it does not explicitly examine the influence of the framework upon itself, falls into the illusion of self-sufficiency – or idealism."[9] But more than just the museum, the site comes to encompass a relay of several interrelated but different spaces and economies, including the studio, the gallery, the museum, art criticism, art history, the art market, etc., that together constitute a system of practices that is not separate from but open to social, economic, and political pressures. To be "specific" to such a site, in turn, is to decode and/or recode the institutional conventions so as to expose their hidden yet motivated operations – to reveal the ways in which institutions mold art's meaning to modulate its cultural and economic value and to undercut the fallacy of the "autonomy" of art and its institutions by making apparent their imbricated relationship to the broader socioeconomic and political processes of the day. Again in Buren's somewhat militant words from 1970:

> Art, whatever else it may be, is exclusively political. What is called for is the *analysis of formal and cultural limits* (and not one *or* the other) within which art exists and struggles. These limits are many and of different intensities. Although the prevailing ideology and the associated artists try in every way to *camouflage* them, and although it is too early – the conditions are not met – to blow them up, the time has come to *unveil* them.[10]

In nascent forms of institutional critique, in fact, the physical condition of the exhibition space remained the primary point of departure for this unveiling. For example, in works such as Haacke's *Condensation Cube* (1963–5), Mel Bochner's *Measurement* series (1969), Lawrence Weiner's wall cutouts (1968), and Buren's *Within and Beyond the Frame* (1973), the task of exposing those aspects that the institution would obscure was enacted literally in relation to the architecture of the exhibition space

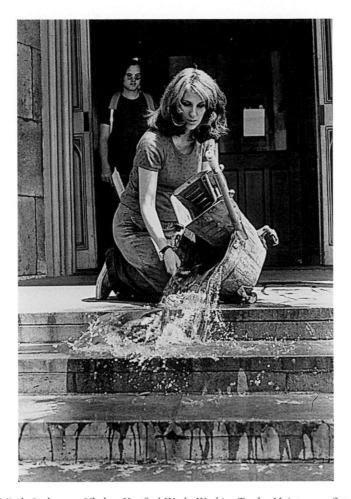

Figure 3.1 Mierle Laderman Ukeles, *Hartford Wash: Washing Tracks, Maintenance Outside*, 1973. Performance at Wadsworth Atheneum, Hartford, CT, part of Maintenance Art Performance Series, 1973–4. Courtesy Ronald Feldman Fine Arts, New York.

– highlighting the humidity level of a gallery by allowing moisture to "invade" the pristine minimalist art object (a mimetic configuration of the gallery space itself); insisting on the material fact of the gallery walls as "framing" devices by notating their dimensions directly on them; removing portions of a wall to reveal the base reality behind the "neutral" white cube; and exceeding the physical boundaries of the gallery by having the artwork literally go out the window, ostensibly to "frame" the institutional frame. Attempts such as these to expose the cultural confinement within which artists function – "the apparatus the artist is threaded through" – and the impact of its forces upon the meaning and value of art became, as Smithson had predicted in 1972, "the great issue" for artists in the 1970s.[11] As this investigation extended into the 1980s, it relied less and less on the physical parameters of the gallery/museum or other exhibition venues to articulate its critique.

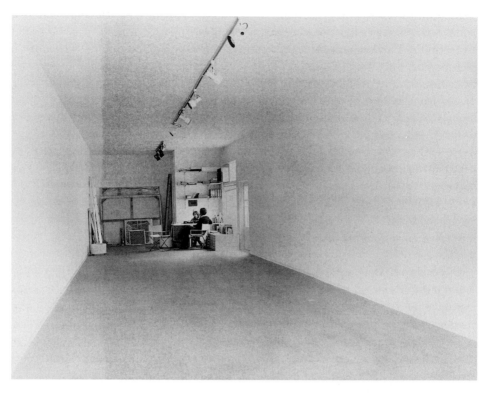

Figure 3.2 Michael Asher, installation at Claire Copley Gallery, Los Angeles, 1974. View through gallery toward office and storage areas. Courtesy of the artist.

In the paradigmatic practice of Hans Haacke, for instance, the site shifted from the physical condition of the gallery (as in the *Condensation Cube*) to the system of socio-economic relations within which art and its institutional programming find their possibilities of being. His fact-based exposés through the 1970s, which spotlighted art's inextricable ties to the ideologically suspect if not morally corrupt power elite, recast the site of art as an institutional frame in social, economic, and political terms, and enforced these terms as the very content of the artwork. Exemplary of a different approach to the institutional frame are Michael Asher's surgically precise displacement projects, which advanced a concept of site that was inclusive of historical and conceptual dimensions. In his contribution to the *73rd American Exhibition* at the Art Institute of Chicago in 1979, for instance, Asher revealed the sites of exhibition or display to be culturally specific situations generating particular expectations and narratives regarding art and art history. Institutional siting of art, in other words, not only distinguishes qualitative and economic value, it also (re)produces specific forms of knowledge that are historically located and culturally determined – not at all universal or timeless standards.[12]

In these ways, the "site" of art evolves away from its coincidence with the literal space of art, and the physical condition of a specific location recedes as the primary

element in the conception of a site. Whether articulated in political and economic terms, as in Haacke's case, or in epistemological terms, as in Asher's, it is rather the art institution's *techniques* and *effects* as they circumscribe the definition, production, presentation, and dissemination of art that become the sites of critical intervention. Concurrent with this move toward the dematerialization of the site is the ongoing de-aestheticization (i.e., withdrawal of visual pleasure) and dematerialization of the artwork. Going against the grain of institutional habits and desires, and continuing to resist the commodification of art in/for the marketplace, site-specific art adopts strategies that are either aggressively antivisual – informational, textual, expositional, didactic – or immaterial altogether – gestures, events, or performances bracketed by temporal boundaries. The "work" no longer seeks to be a noun/object but a verb/process, provoking the viewers' *critical* (not just physical) acuity regarding the ideological conditions of that viewing. In this context, the guarantee of a specific relationship between an artwork and its "site" is not based on a physical permanence of that relationship (as demanded by Serra, for example), but rather on the recognition of its unfixed *impermanence*, to be experienced as an unrepeatable and fleeting situation.

But if the critique of the cultural confinement of art (and artists) via its institutions was once the "great issue," a dominant drive of site-oriented practices today is the pursuit of a more intense engagement with the outside world and everyday life – a critique of culture that is inclusive of non-art spaces, non-art institutions, and non-art issues (blurring the division between art and non-art, in fact). Concerned to integrate art more directly into the realm of the social, either in order to redress (in an activist sense) urgent social problems such as the ecological crisis, homelessness, AIDS, homophobia, racism, and sexism, or more generally in order to relativize art as one among many forms of cultural work, current manifestations of site specificity tend to treat aesthetic and art-historical concerns as secondary issues. Deeming the focus on the social nature of *art*'s production and reception to be too exclusive, even elitist, this expanded engagement with culture favors "public" sites outside the traditional confines of art in physical and intellectual terms.[13]

Furthering previous (at times literal) attempts to take art out of the museum/gallery space-system (recall Buren's striped canvases marching out the gallery window or Smithson's adventures in the wastelands of New Jersey or isolated locales in Utah), contemporary site-oriented works occupy hotels, city streets, housing projects, prisons, schools, hospitals, churches, zoos, supermarkets, etc., and infiltrate media spaces such as radio, newspapers, television, and the Internet. In addition to this spatial expansion, site-oriented art is also informed by a broader range of disciplines (including anthropology, sociology, literary criticism, psychology, natural and cultural histories, architecture and urbanism, computer science, and political theory) and is sharply attuned to popular discourses (such as fashion, music, advertising, film, and television). But more than these dual expansions of art into culture, which obviously diversify the site, the distinguishing characteristic of today's site-oriented art is the way in which the artwork's relationship to the actuality of a location (as site) *and* the social conditions of the institutional frame (as site) are both *subordinate* to a *discursively* determined site that is delineated as a field of knowledge, intellectual

exchange, or cultural debate. Furthermore, unlike previous models, this site is not defined as a *precondition*. Rather, it is *generated* by the work (often as "content"), then *verified* by its convergence with an existing discursive formation.

For example, in Mark Dion's 1991 project *On Tropical Nature*, several different definitions of the site operated concurrently. First, the initial site of Dion's intervention was an uninhabited spot in the rain forest near the base of the Orinoco River outside Caracas, Venezuela, where the artist camped for three weeks collecting specimens of various plants and insects, as well as feathers, mushrooms, nests, and stones. These specimens, picked up at the end of each week in crates, were delivered to the second site of the project, Sala Mendoza, one of the two hosting art institutions back in Caracas. In the gallery space of the Sala, the specimens, which were uncrated and displayed like works of art in themselves, were contextualized within what constituted a third site – the curatorial framework of the thematic group exhibition.[14] The fourth site, however, although the least material, was the site with which Dion intended a lasting relationship. *On Tropical Nature* sought to become a part of the discourse concerning cultural representations of nature and the global environmental crisis.[15]

Sometimes at the cost of a semantic slippage between content and site, other artists who are similarly engaged in site-oriented projects, operating with multiple definitions of the site, in the end find their "locational" anchor in the discursive realm. For instance, while Tom Burr and John Lindell have each produced diverse projects in a variety of media for many different institutions, their consistent engagement with issues concerning the construction and dynamics of (homo)sexuality and desire has established such issues as the "site" of their work. And in projects by artists such as Lothar Baumgarten, Renée Green, Jimmie Durham, and Fred Wilson, the legacies of colonialism, slavery, racism, and the ethnographic tradition as they impact on identity politics has emerged as an important "site" of artistic investigation. In some instances, artists, including Green, Silvia Kolbowski, Group Material [see plate 1], and Christian Philipp Müller [see plate 2], have reflected on aspects of site-specific practice itself as a "site," interrogating its currency in relation to aesthetic imperatives, institutional demands, socioeconomic ramifications, or political efficacy. In this way different cultural debates, a theoretical concept, a social issue, a political problem, an institutional framework (not necessarily an art institution), a community or seasonal event, a historical condition, and even particular formations of desire are deemed to function as sites now.[16]

This is not to say that the parameters of a particular place or institution no longer matter, because site-oriented art today still cannot be thought or executed without the contingencies of locational and institutional circumstances. But the *primary* site addressed by current manifestations of site specificity is not necessarily bound to, or determined by, these contingencies in the long run. Consequently, although the site of action or intervention (physical) and the site of effects/reception (discursive) are conceived to be continuous, they are nonetheless pulled apart. Whereas, for example, the sites of intervention and effect for Serra's *Tilted Arc* were coincident (Federal Plaza in downtown New York City), Dion's site of intervention (the rain forest in

Venezuela or Sala Mendoza) and his projected site of effect (discourse of nature) are distinct. The former clearly serves the latter as material source and "inspiration," yet does not sustain an indexical relationship to it.

James Meyer has distinguished this trend in recent site-oriented practice in terms of a "functional site": "[The functional site] is a process, an operation occurring between sites, a mapping of institutional and discursive filiations and the bodies that move between them (the artist's above all). It is an informational site, a locus of overlap of text, photographs and video recordings, physical places and things. . . . It is a temporary thing; a movement; a chain of meanings devoid of a particular focus."[17] Which is to say, the site is now structured (inter)textually rather than spatially, and its model is not a map but an itinerary, a fragmentary sequence of events and actions *through* spaces, that is, a nomadic narrative whose path is articulated by the passage of the artist. Corresponding to the pattern of movement in electronic spaces of the Internet and cyberspace, which are likewise structured to be experienced *transitively*, one thing after another, and not as synchronic simultaneity,[18] this transformation of the site textualizes spaces and spatializes discourses.

A provisional conclusion might be that in advanced art practices of the past thirty years, the operative definition of the site has been transformed from a physical location – grounded, fixed, actual – to a discursive vector – ungrounded, fluid, and virtual. But even if the dominance of a particular formulation of site specificity emerges at one moment and wanes at another, the shifts are not always punctual or definitive. Thus, the three paradigms of site specificity I have schematized here – phenomenological, social/institutional, and discursive – although presented somewhat chronologically, are not stages in a linear trajectory of historical development. Rather, they are competing definitions, overlapping with one another and operating simultaneously in various cultural practices today (or even within a single artist's single project).

Nonetheless, this move away from a literal interpretation of the site and the multiplicitous expansion of the site in locational and conceptual terms seems more accelerated today than in the past. And the phenomenon is embraced by many artists and critics as an advance offering more effective avenues to resist revised institutional and market forces that now commodify "critical" art practices. In addition, current forms of site-oriented art, which readily take up social issues (often inspired by them) and which routinely engage the collaborative participation of audience groups for the conceptualization and production of the work, are seen as a means to strengthen art's capacity to penetrate the sociopolitical organization of contemporary life with greater impact and meaning. In this sense the possibilities to conceive the site as something more than a place – as repressed ethnic history, a political cause, a disenfranchised social group – is a crucial conceptual leap in redefining the "public" role of art and artists.[19]

But the enthusiastic support for these salutary goals needs to be checked by a serious critical examination of the problems and contradictions that attend all forms of site-specific and site-oriented art today, which are visible now as the artwork is becoming more and more "unhinged" from the actuality of the site once again – unhinged both in a literal sense of physical separation of the artwork from the location of its initial installation and in a metaphorical sense as performed

in the discursive mobilization of the site in emergent forms of site-oriented art. This "unhinging," however, does not indicate a retroversion to the modernist autonomy of the siteless, nomadic art object, although such an ideology is still predominant. Rather, the current unhinging of site specificity is reflective of new questions that pressure its practices today – questions engendered by both aesthetic imperatives and external historical determinants, which are not exactly comparable to those of thirty years ago. For example, what is the status of traditional aesthetic values such as originality, authenticity, and uniqueness in site-specific art, which always begins with the particular, local, unrepeatable preconditions of a site, however it is defined? Is the artist's prevalent relegation of authorship to the conditions of the site, including collaborators and/or reader-viewers, a continuing Barthesian performance of "death of the author" or a recasting of the centrality of the artist as a "silent" manager/director? Furthermore, what is the commodity status of anti-commodities, that is, immaterial, process-oriented, ephemeral, performative events? While site-specific art once defied commodification by insisting on immobility, it now seems to espouse fluid mobility and nomadism for the same purpose. But curiously, the nomadic principle also defines capital and power in our times.[20] Is the unhinging of site specificity, then, a form of resistance to the ideological establishment of art or a capitulation to the logic of capitalist expansion?

Mobilization of Site-Specific Art

The "unhinging" of site-specific artworks first realized in the 1960s and 1970s is a separation engendered not by aesthetic imperatives but by pressures of the museum culture and the art market. Photographic documentation and other materials associated with site-specific art (preliminary sketches and drawings, field notes, instructions on installation procedures, etc.) have long been standard fare of museum exhibitions and a staple of the art market. In the recent past, however, as the cultural and market values of works from the 1960s and 1970s have risen, many of the early precedents in site-specific art, once deemed so difficult to collect and impossible to reproduce, have reappeared in several high-profile exhibitions, such as *L'art conceptuel, une perspective* at the Musée d'art moderne de la ville de Paris (1989) and *The New Sculpture, 1965–75: Between Geometry and Gesture* (1990) and *Immaterial Objects* (1991–2), both at the Whitney Museum.[21]

For exhibitions like these, site-specific works from decades ago are being relocated or refabricated from scratch at or near the location of their re-presentation, either because shipping is too difficult and its costs prohibitive or because the originals are too fragile, in disrepair, or no longer in existence. Depending on the circumstances, some of these refabrications are destroyed after the specific exhibitions for which they are produced; in other instances, the re-creations come to coexist with or replace the old, functioning as *new* originals (some even finding homes in permanent collections of museums).[22] With the cooperation of the artist in many cases, art audiences are now offered the "real" aesthetic experiences of site-specific copies.

The chance to re-view "unrepeatable" works such as Serra's *Splash Piece: Casting* (1969–70) or Alan Saret's *Sulfur Falls* (1968) offers an opportunity to reconsider their historical significance, especially in relation to the current fascination with the late 1960s and 1970s in art and criticism. But the very process of institutionalization and the attendant commercialization of site-specific art also overturn the principle of place-boundedness through which such works developed their critique of the ahistorical autonomy of the art object. Contrary to the earlier conception of site specificity, the current museological and commercial practices of refabricating (in order to travel) once site-bound works make transferability and mobilization new norms for site specificity. As Susan Hapgood has observed, "The once-popular term 'site-specific' has come to mean 'movable under the right circumstances,'"[23] shattering the dictum that "to remove the work is to destroy the work."

The consequences of this conversion, effected by object-oriented *de*contextualizations in the guise of historical *re*contextualizations, are a series of normalizing reversals in which the specificity of the site is rendered irrelevant, making it all the easier for autonomy to be smuggled back into the artwork, with the artist allowed to regain his or her authority as the primary source of the work's meaning. The artwork is newly objectified (and commodified), and site specificity is redescribed as the personal aesthetic choice of an artist's *stylistic* preference rather than a structural reorganization of aesthetic experience.[24] Thus, a methodological principle of artistic production and dissemination is recaptured as content; active processes are transformed into inert objects once again. In this way, site-specific art comes to *represent* criticality rather than perform it. The "here-and-now" of aesthetic experience is isolated as the signified, severed from its signifier.

If this phenomenon represents another instance of domestication of vanguard works by the dominant culture, it is not solely because of the self-aggrandizing needs of the institution or the profit-driven nature of the market. Artists, no matter how deeply convinced of their anti-institutional sentiment or how adamant their critique of dominant ideology, are inevitably engaged, self-servingly or with ambivalence, in this process of cultural legitimation. For example, in spring 1990, Carl Andre and Donald Judd both wrote letters of indignation to *Art in America* to publicly disavow authorship of two sculptures, attributed to each of them, that were included in a 1989 exhibition at the Ace Gallery in Los Angeles.[25] The works in question were re-creations: Andre's forty-nine-foot steel sculpture *Fall* from 1968 and an untitled iron "wall" piece by Judd of 1970, both from the Panza Collection. Because of the difficulties and high cost of crating and shipping such large-scale works from Italy to California, Panza gave permission to the organizers of the exhibition to refabricate them locally following detailed instructions. The works being industrially produced in the first place, the participation of the artists in the refabrication process seemed of little consequence to the director of the Ace Gallery and to Panza. The artists, however, felt otherwise. Not having been consulted on the (re)production and installation of these surrogates, they denounced each of the refabrications as "a gross falsification" and a "forgery," despite the fact that the sculptures appeared identical to the "originals" in Italy and were reproduced as one-time exhibition copies, not to be sold or exhibited elsewhere.

More than a mere case of ruffled artistic egos, this incident exposes a crisis concerning the status of authorship and authenticity as site-specific art from years ago finds new contexts in the 1990s. For Andre and Judd, what made the refabricated works illegitimate was not that each was a reproduction of a singular work installed in Varese, which in principle cannot be reproduced anywhere else anyway, but that the artists themselves did not authorize or oversee the refabrication in California. In other words, the re-creations are inauthentic not because of the missing site of its original installation but because of the absence of the artist in the process of their (re)production. By reducing visual variations within the artwork to a point of obtuse blankness and by adopting modes of industrial production, minimal art had voided the traditional standards of aesthetic distinction based on the handiwork of the artist as the signifier of authenticity. However, as the Ace Gallery case amply reveals, despite the withdrawal of such signifiers, authorship and authenticity remain in site-specific art as a function of the artist's "presence" at the point of (re)production. That is, with the evacuation of "artistic" traces, the artist's *authorship* as producer of objects is reconfigured as his or her *authority to authorize* in the capacity of director or supervisor of (re)productions. The guarantee of authenticity is finally the artist's sanction, which may be articulated by his or her actual presence at the moment of production-installation or via a certificate of verification.[26]

While Andre and Judd once problematized authorship through the recruitment of serialized industrial production, only to cry foul years later when their proposition was taken to one of its logical conclusions,[27] artists whose practices are based in modes of "traditional" manual labor have registered a more complex understanding of the *politics* of authorship. A case in point: for a 1995 historical survey of feminist art titled *Division of Labor: "Women's Work" in Contemporary Art* at the Bronx Museum, Faith Wilding, an original member of the Feminist Art Program at the California Institute of the Arts, was invited to re-create her room-sized site-specific installation *Crocheted Environment* (also known as *Womb Room*) from the 1972 *Womanhouse* project in Los Angeles. The original piece being nonexistent, the project presented Wilding with a number of problems, least of which were the long hours and intensive physical labor required to complete the task. To decline the invitation to redo the piece for the sake of preserving the integrity of the original installation would have been an act of self-marginalization, contributing to a self-silencing that would write Wilding and an aspect of feminist art out of the dominant account of art history (*again*). But on the other hand, to re-create the work as an independent art object for a white cubic space in the Bronx Museum also meant voiding the meaning of the work as it was first established in relation to the site of its original context. Indeed, while the cultural legitimation as represented by the institutional interest in Wilding's work allowed for the (temporary) unearthing of one of the neglected trajectories of feminist art, in the institutional setting of the Bronx Museum and later at the Los Angeles Museum of Contemporary Art, *Crocheted Environment* became a beautiful but innocuous work, its primary interest formal, the handicraft nature of the work rendered thematic (feminine labor).[28]

But even if the efficacy of site-specific art from the past seems to weaken in its representations, the procedural complications, ethical dilemmas, and pragmatic

headaches that such situations raise for artists, collectors, dealers, and host institutions *are* still meaningful. They present an unprecedented strain on established patterns of (re)producing, exhibiting, borrowing/lending, purchasing/selling, and commissioning/executing artworks in general. At the same time, despite some artists' regression into authorial inviolability in order to defend their site-specific practice, other artists are keen on undoing the presumption of criticality associated with principles such as immobility, permanence, and unrepeatability. Rather than resisting mobilization, these artists are attempting to reinvent site specificity as a *nomadic* practice.

Itinerant Artists

The increasing institutional interest in site-oriented practices that mobilize the site as a discursive narrative is demanding an intensive physical mobilization of the artist to create works in various cities throughout the cosmopolitan art world. Typically, an artist (no longer a studio-bound object maker, primarily working on call) is invited by an art institution to execute a work specifically configured for the framework provided by the institution (in some cases the artist may solicit the institution with a proposal). Subsequently, the artist enters into a contractual agreement with the host institution for the commission. There follow repeated visits to or extended stays at the site; research into the particularities of the institution and/or the city within which it is located (its history, constituency of the [art] audience, the installation space); consideration of the parameters of the exhibition itself (its thematic structure, social relevance, other artists in the show); and many meetings with curators, educators, and administrative support staff, who may all end up "collaborating" with the artist to produce the work. The project will likely be time-consuming and in the end will have engaged the "site" in a multitude of ways, and the documentation of the project will take on another life within the art world's publicity circuit, which will in turn alert another institution for another commission.

Thus, if the artist is successful, he or she travels constantly as a freelancer, often working on more than one site-specific project at a time, globe-trotting as a guest, tourist, adventurer, temporary in-house critic, or pseudoethnographer[29] to São Paulo, Munich, Chicago, Seoul, Amsterdam, New York, and so on. Generally, the in situ configuration of projects that emerge out of such a situation is temporary, ostensibly unsuitable for re-presentation anywhere else without altering its meaning, partly because the commission is defined by a unique set of geographical and temporal circumstances and partly because the project is dependent on unpredictable and unprogrammable on-site relations. But such conditions, despite appearances to the contrary, do not circumvent the problem of commodification entirely, because there is a strange reversal now wherein the artist approximates the "work" instead of the other way around, as is commonly assumed (that is, artwork as surrogate of the artist). Perhaps because of the "absence" of the artist from the physical manifestation of the work, the *presence* of the artist has become an absolute *prerequisite* for the

execution/presentation of site-oriented projects. It is now the *performative* aspect of an artist's characteristic mode of operation (even when collaborative) that is repeated and circulated as a new art commodity, with the artist functioning as the primary vehicle for its verification, repetition, and circulation.[30]

For example, after a year-long engagement with the Maryland Historical Society, Fred Wilson finalized his site-specific commission *Mining the Museum* (1992) as a temporary reorganization of the institution's permanent collection. As a timely convergence of institutional museum critique and multicultural identity politics, *Mining the Museum* drew many new visitors to the society, and the project received high praise from both the art world and the popular press. Subsequently, Wilson performed a similar excavation/intervention at the Seattle Art Museum in 1993, a project also defined by the museum's permanent collection.[31] Although the shift from Baltimore to Seattle, from a historical society to an art museum, introduced new variables and challenges, the Seattle project established a repetitive relationship between the artist and the hosting institution, reflecting a broader museological fashion trend – commissioning of artists to rehang permanent collections. The fact that Wilson's project in Seattle fell short of the Baltimore "success" may be evidence of how ongoing repetition of such commissions can render methodologies of critique rote and generic. They can easily become extensions of the museum's own self-promotional apparatus, and the artist becomes a commodity with a purchase on "criticality." As Isabelle Graw has noted, "[T]he result can be an absurd situation in which the commissioning institution (the museum or gallery) turns to an artist as a person who has the legitimacy to point out the contradictions and irregularities of which they themselves disapprove." And for artists, "[s]ubversion in the service of one's own convictions finds easy transition into subversion for hire; 'criticism turns into spectacle.'"[32]

To say, however, that this changeover represents the commodification of the artist is not completely accurate because it is not the figure of the artist per se, as a personality or a celebrity à la Warhol, that is produced/consumed in an exchange with the institution. What the current pattern points to, in fact, is the extent to which the very nature of the commodity as a cipher of production and labor relations is no longer bound to the realm of manufacturing (of things) but is defined in relation to the service and management industries.[33] The artist as an overspecialized aesthetic object maker has been anachronistic for a long time already. What they *provide* now, rather than *produce*, are aesthetic, often "critical-artistic," services.[34] If Richard Serra could once distill artistic activities down to their elemental physical actions (to drop, to split, to roll, to fold, to cut . . .),[35] the situation now demands a different set of verbs: to negotiate, to coordinate, to compromise, to research, to organize, to interview, etc. This shift was forecasted in conceptual art's adoption of what Benjamin Buchloh has described as the "aesthetics of administration."[36] The salient point here is how quickly this aesthetics of administration, developed in the 1960s and 1970s, has converted to the administration of aesthetics in the 1980s and 1990s. Generally speaking, the artist used to be a maker of aesthetic objects; now he or she is a facilitator, educator, coordinator, and bureaucrat. Additionally, as artists have adopted managerial functions of art institutions (curatorial, educational, archival) as an integral part of

their creative process, managers of art within institutions (curators, educators, public program directors), who often take their cues from these artists, now function as authorial figures in their own right.[37]

Concurrent with, or because of, these methodological and procedural changes, there is a reemergence of the centrality of the artist as the progenitor of meaning. This is true even when authorship is deferred to others in collaborations, or when the institutional framework is self-consciously integrated into the work, or when an artist problematizes his or her own authorial role. On the one hand, this "return of the author" results from the thematization of discursive sites that engenders a misrecognition of them as "natural" extensions of the artist's identity, and the legitimacy of the critique is measured by the proximity of the artist's personal association (converted to expertise) with a particular place, history, discourse, identity, etc. (converted to thematic content). On the other hand, because the signifying chain of site-oriented art is constructed foremost by the movement and decisions of the artist,[38] the (critical) elaboration of the project inevitably unfolds around the artist. That is, the intricate orchestration of literal and discursive sites that make up a nomadic narrative *requires* the artist as a narrator-protagonist. In some cases, this renewed focus on the artist leads to a hermetic implosion of (auto)biographical and subjectivist indulgences, and myopic narcissism is misrepresented as self-reflexivity.

This being so, one of the narrative trajectories of all site-oriented projects is consistently aligned with the artist's prior projects executed in other places, generating what might be called a fifth site – the exhibition history of the artist, his or her vitae. The tension between the intensive mobilization of the artist and the recentralization of meaning around him or her is illustrated by Renée Green's 1993 *World Tour*, a group reinstallation of four site-specific projects produced in disparate parts of the world over a three-year period.[39] By bringing several distinct projects together from "elsewhere," *World Tour* sought to reflect on the problematic conditions of present-day site specificity, such as the ethnographic predicament of artists who are frequently imported by foreign institutions and cities as expert/exotic visitors. *World Tour* also made an important attempt to imagine a productive convergence between specificity and mobility, where a project created under one set of circumstances might be redeployed in another without losing its impact – or, better, finding new meaning and gaining critical sharpness through recontextualizations.[40] But these concerns were not available for viewers whose interpretive reaction was to see the artist as the primary link between the projects. Indeed, the effort to redeploy the individual site-oriented projects as a conceptually coherent ensemble eclipsed the specificity of each and forced a relational dynamic between discrete projects. Consequently, the overriding narrative of *World Tour* became Green's own creative process as an artist in and through the four projects. And in this sense, the project functioned as a fairly conventional retrospective.

Just as the shifts in the structural reorganization of cultural production alter the form of the art commodity (to services) and the authority of the artist (to "reappeared" protagonist), values like originality, authenticity, and singularity are also reworked in site-oriented art – *evacuated from the artwork and attributed to the site*

– reinforcing a general cultural valorization of places as the locus of authentic experience and a coherent sense of historical and personal identity.[41] An instructive example of this phenomenon is *Places with a Past*, a 1991 site-specific exhibition organized by Mary Jane Jacob, which took the city of Charleston, South Carolina, as not only the backdrop but also a "bridge between the works of art and the audience."[42] In addition to breaking the rules of the art establishment, the exhibition wanted to further a dialogue between art and the sociohistorical dimension of places. According to Jacob, "Charleston proved to be fertile ground" for the investigation of issues concerning "gender, race, cultural identity, considerations of difference . . . subjects much in the vanguard of criticism and art-making. . . . The actuality of the situation, the fabric of the time and place of Charleston, offered an incredibly rich and meaningful context for the making and siting of publicly visible and physically prominent installations that rang true in [the artists'] approach to these ideas."[43]

While site-specific art continues to be described as a refutation of originality and authenticity as intrinsic qualities of the art object or the artist, this resistance facilitates the translation and relocation of these qualities from the artwork to the place of its presentation, only to have them *return* to the artwork now that it has become integral to the site. Admittedly, according to Jacob, "locations . . . contribute a specific identity to the shows staged by injecting into the experience the uniqueness of the place."[44] Conversely, if the social, historical, and geographical specificity of Charleston offered artists a unique opportunity to create unrepeatable works (and by extension an unrepeatable exhibition), then the programmatic implementation of site-specific art in exhibitions like *Places with a Past* ultimately utilizes art to *promote* Charleston as a unique place. What is prized most of all in site-specific art is still the singularity and authenticity that the presence of the artist seems to guarantee, not only in terms of the presumed unrepeatability of the work but in the ways in which the presence of the artist also *endows* places with a "unique" distinction.

Certainly, site-specific art can lead to the unearthing of repressed histories, provide support for greater visibility of marginalized groups and issues, and initiate the re(dis)covery of "minor" places so far ignored by the dominant culture. But inasmuch as the current socioeconomic order thrives on the (artificial) production and (mass) consumption of difference (for difference's sake), the siting of art in "real" places can also be a means to *extract* the social and historical dimensions *out* of places to variously serve the thematic drive of an artist, satisfy institutional demographic profiles, or fulfill the fiscal needs of a city.

Significantly, the appropriation of site-specific art for the valorization of urban identities comes at a time of a fundamental cultural shift in which architecture and urban planning, formerly the primary media for expressing a vision of the city, are displaced by other media more intimate with marketing and advertising. In the words of urban theorist Kevin Robins, "As cities have become ever more equivalent and urban identities increasingly 'thin,' . . . it has become necessary to employ advertising and marketing agencies to manufacture such distinctions. It is a question of distinction in a world beyond difference."[45] Site specificity in this context finds new importance because it supplies distinction of place and uniqueness of locational

identity, highly seductive qualities in the promotion of towns and cities within the competitive restructuring of the global economic hierarchy. Thus, site specificity remains inexorably tied to a process that renders particularity and identity of various cities a matter of product differentiation. Indeed, the exhibition catalog for *Places with a Past* was a "tasteful" tourist promotion, pitching the city of Charleston as a unique, "artistic," and meaningful place (to visit).[46] Under the pretext of their articulation or resuscitation, site-specific art can be mobilized to expedite the *erasure* of differences via the commodification and serialization of places.

The yoking together of the myth of the artist as a privileged source of originality with the customary belief in places as ready reservoirs of unique identity belies the compensatory nature of such a move. For this collapse of the artist and the site reveals an anxious cultural desire to assuage the sense of loss and vacancy that pervades both sides of this equation. In this sense, Craig Owens was perhaps correct to characterize site specificity as a melancholic discourse and practice,[47] as was Thierry de Duve, who claimed that "sculpture in the last 20 years is an attempt to reconstruct the notion of site from the standpoint of having acknowledged its disappearance."[48]

> The bulldozing of an irregular topography into a flat site is clearly a technocratic gesture which aspires to a condition of absolute *placelessness*, whereas the terracing of the same site to receive the stepped form of a building is an engagement in the act of "cultivating" the site. . . . This inscription . . . has a capacity to embody, in built form, the prehistory of the place, its archeological past and its subsequent cultivation and transformation across time. Through this layering into the site the idiosyncrasies of place find their expression without falling into sentimentality. (Kenneth Frampton, "Towards a Critical Regionalism")

> [T]he elaboration of place-bound identities has become more rather than less important in a world of diminishing spatial barriers to exchange, movement and communication. (David Harvey, "From Space to Place and Back Again")

It is significant that the mobilization of site-specific art from decades ago is *concurrent* with the nomadism of current site-oriented practices. Paradoxically, while foregrounding the importance of the site, they together express the dissipation of the site, caught up in the "dynamics of deterritorialization," a concept most clearly elaborated in architectural and urban discourses today.

Within the present context of an ever-expanding capitalist order, fueled by an ongoing globalization of technology and telecommunications, the intensifying conditions of spatial indifferentiation and departicularization exacerbate the effects of alienation and fragmentation in contemporary life.[49] The drive toward a rationalized universal civilization, engendering the homogenization of places and the erasure of cultural differences, is in fact the force against which Frampton proposes a practice of Critical Regionalism as already described – a program for an "architecture of resistance." If the universalizing tendencies of modernism undermined the old divisions of power based on class relations fixed to geographical hierarchies of centers and margins, only to aid in capitalism's colonization of "peripheral" spaces, then the articulation and

cultivation of diverse local particularities are a (postmodern) reaction against these effects. Henri Lefebvre has remarked: "[I]nasmuch as abstract space [of modernism and capital] tends towards homogeneity, towards the elimination of existing differences or peculiarities, a new space cannot be born (produced) unless it accentuates differences."[50] It is perhaps no surprise, then, that the efforts to retrieve lost differences, or to curtail the waning of them, become heavily invested in reconnecting to "uniqueness of place" – or more precisely, in establishing authenticity of meaning, memory, histories, and identities as a *differential function* of places. It is this differential function associated with places, which earlier forms of site-specific art tried to exploit and the current incarnations of site-oriented works seek to reimagine, that is the hidden attractor in the term *site specificity*.

It seems inevitable that we should leave behind the nostalgic notions of a site as being essentially bound to the physical and empirical realities of a place. Such a conception, if not ideologically suspect, often seems out of sync with the prevalent description of contemporary life as a network of unanchored flows. Even such an advanced theoretical position as Frampton's Critical Regionalism seems dated in this regard, for it is predicated on the belief that a particular site/place exists with its identity-giving or identifying properties always and already *prior* to what new cultural forms might be introduced to it or emerge from it. In such a pre- (or post-) poststructuralist conception, all site-specific gestures would have to be understood as reactive, "cultivating" what is presumed to be there already rather than generative of new identities and histories.

Indeed the deterritorialization of the site has produced liberatory effects, displacing the strictures of fixed place-bound identities with the fluidity of a migratory model, introducing the possibilities for the production of multiple identities, allegiances, and meanings, based not on normative conformities but on the nonrational convergences forged by chance encounters and circumstances. The fluidity of subjectivity, identity, and spatiality as described by Gilles Deleuze and Félix Guattari in their rhizomic nomadism,[51] for example, is a powerful theoretical tool for the dismantling of traditional orthodoxies that would suppress differences, sometimes violently.

However, despite the proliferation of discursive sites and "fictional" selves, the phantom of a site as an actual place remains, and our psychic, habitual attachments to places regularly return as they continue to inform our sense of identity. And this persistent, perhaps secret, adherence to the actuality of places (in memory, in longing) is not necessarily a lack of theoretical sophistication but a means for survival. The resurgence of violence in defense of essentialized notions of national, racial, religious, and cultural identities in relation to geographical territories is readily characterized as extremist, retrograde, and "uncivilized." Yet the loosening of such relations, that is, the destabilization of subjectivity, identity, and spatiality (following the dictates of desire), can also be described as a compensatory fantasy in response to the intensification of fragmentation and alienation wrought by a mobilized market economy (following the dictates of capital). The advocacy of the continuous mobilization of self- and place-identities as discursive fictions, as polymorphous "critical" plays on fixed generalities and stereotypes, in the end may be a delusional alibi for short attention spans, reinforcing the ideology of the new – a temporary antidote for

the anxiety of boredom. It is perhaps too soon and frightening to acknowledge, but the paradigm of nomadic selves and sites may be a glamorization of the trickster ethos that is in fact a reprisal of the ideology of "freedom of choice" – the choice to forget, the choice to reinvent, the choice to fictionalize, the choice to "belong" anywhere, everywhere, and nowhere. This choice, of course, does not belong to everyone equally. The understanding of identity and difference as being culturally constructed should not obscure the fact that the ability to deploy multiple, fluid identities in and of itself is a privilege of mobilization that has a specific relationship to power.

What would it mean now to sustain the cultural and historical specificity of a place (and self) that is neither a simulacral pacifier nor a willful invention? For architecture, Frampton proposes a process of "double mediation," which is in fact a double negation, *defying* "both the optimization of advanced technology and the ever-present tendency to regress into nostalgic historicism or the glibly decorative."[52] An analogous double mediation in site-specific art practice might mean finding a terrain between mobilization and specificity – to be *out* of place with punctuality and precision. Homi Bhabha has said, "The globe shrinks for those who own it; for the displaced or the dispossessed, the migrant or refugee, no distance is more awesome than the few feet across borders or frontiers."[53] Today's site-oriented practices inherit the task of demarcating the *relational specificity* that can hold in tension the distant poles of spatial experiences described by Bhabha. This means addressing the differences of adjacencies and distances *between* one thing, one person, one place, one thought, one fragment *next* to another, rather than invoking equivalencies via one thing *after* another. Only those cultural practices that have this relational sensibility can turn local encounters into long-term commitments and transform passing intimacies into indelible, unretractable social marks – so that the sequence of sites that we inhabit in our life's traversal does not become genericized into an undifferentiated serialization, one place after another.

Notes

This essay is part of a larger project on the convergence of art and architecture in site-specific practices of the past thirty years, especially in the context of public art. I am grateful to those who provided encouragement and critical commentaries: Hal Foster, Helen Molesworth, Sowon and Seong Kwon, Rosalyn Deutsche, Mark Wigley, Doug Ashford, Russell Ferguson, and Frazer Ward. Also, as a recipient of the Professional Development Fellowship for Art Historians, I am indebted to the College Art Association for its support.

1 Douglas Crimp has written: "The idealism of modernist art, in which the art object *in and of itself* was seen to have a fixed and transhistorical meaning, determined the object's placelessness, its belonging in no particular place. . . . Site specificity opposed that idealism – and unveiled the material system it obscured – by its refusal of circulatory mobility, its belongingness to a *specific* site" (*On the Museum's Ruins* (Cambridge: MIT Press, 1993), p. 17). See also Rosalind Krauss, "Sculpture in the Expanded Field" (1979), in *The Anti-Aesthetic: Essays on Postmodern Culture*, ed. Hal Foster (Port Townsend, Wash.: Bay Press, 1983), pp. 31–42.

2 William Turner, as quoted in Mary Miss, "From Autocracy to Integration: Redefining the Objectives of Public Art," in *Insights/On Sites: Perspectives on Art in Public Places*, ed. Stacy Paleologos Harris (Washington, DC: Partners for Livable Places, 1984), p. 62.

3 Rosalyn Deutsche has made an important distinction between an assimilative model of site specificity – in which the artwork is geared toward *integration* into the existing environment, producing a unified, "harmonious" space of wholeness and cohesion – and an interruptive model in which the artwork functions as a critical *intervention* into the existing order of a site. See her essays *"Tilted Arc* and the Uses of Public Space," *Design Book Review* 23 (winter 1992): 22–7, and "Uneven Development: Public Art in New York City," *October* 47 (winter 1988): 3–52.

4 Robert Barry, in Arthur R. Rose (pseud.), "Four Interviews with Barry, Huebler, Kosuth, Weiner," *Arts Magazine* (February 1969): 22.

5 Richard Serra, letter to Donald Thalacker, January 1, 1985, published in *The Destruction of "Tilted Arc": Documents*, ed. Clara Weyergraf-Serra and Martha Buskirk (Cambridge: MIT Press, 1991), p. 38.

6 Richard Serra, *"Tilted Arc* Destroyed," *Art in America* (May 1989): 34–47.

7 The controversy over *Tilted Arc* obviously involved other issues besides the status of site specificity, but, in the end, site specificity was the term upon which Serra hung his entire defense. Despite Serra's defeat, the legal definition of site specificity remains unresolved and continues to be grounds for many juridical conflicts. For a discussion concerning legal questions in the *Tilted Arc* case, see Barbara Hoffman, "Law for Art's Sake in the Public Realm," in *Art in the Public Sphere*, ed. W. J. T. Mitchell (Chicago: University of Chicago Press, 1991), pp. 113–46. Thanks to James Marcovitz for discussions concerning the legality of site specificity.

8 See Hal Foster's seminal essay, "The Crux of Minimalism," in *Individuals: A Selected History of Contemporary Art, 1945–1986*, ed. Howard Singerman (Los Angeles: Museum of Contemporary Art, 1986), pp. 162–83. See also Craig Owens, "From Work to Frame; or, Is There Life after 'The Death of the Author'?" in *Beyond Recognition* (Berkeley: University of California Press, 1992), pp. 122–39.

9 Daniel Buren, "Function of the Museum," *Artforum* (September 1973).

10 Daniel Buren, "Critical Limits," in *Five Texts* (New York: John Weber Gallery, 1973), p. 38.

11 See "Conversation with Robert Smithson," ed. Bruce Kurtz, in *Writings of Robert Smithson*, ed. Nancy Holt (New York: New York University Press, 1979), p. 200.

12 This project involved the relocation of a bronze replica of an eighteenth-century statue of George Washington from its normal position outside the entrance in front of the Art Institute to one of the smaller galleries inside devoted to eighteenth-century European painting, sculpture, and decorative arts. Asher stated his intention as follows: "In this work I am interested in the way the sculpture functions when it is viewed in its 18th-century context instead of in its prior relationship to the façade of the building. . . . Once inside Gallery 219 the sculpture can be seen in connection with the ideas of other European works of the same period" (quoted in Anne Rorimer, "Michael Asher: Recent Work," *Artforum* (April 1980): 47). See also Benjamin H. D. Buchloh, ed., *Michael Asher: Writings 1973–1983 on Works 1969–1979* (Halifax, Nova Scotia: The Press of the Nova Scotia College of Art and Design; Los Angeles: Museum of Contemporary Art, 1983), pp. 207–21.

13 These concerns coincide with developments in public art, which has reprogrammed site-specific art to be synonymous with community-based art. As exemplified in projects

such as *Culture in Action* in Chicago (1992–3) and *Points of Entry* in Pittsburgh (1996), site-specific public art in the 1990s marks a convergence between cultural practices grounded in leftist political activism, community-based aesthetic traditions, conceptually driven art borne out of institutional critique, and identity politics. Because of this convergence, many of the questions concerning contemporary site-specific practices apply to public art projects as well, and vice versa. Unfortunately, an analysis of the specific aesthetic and political problems in the public art arena, especially those pertaining to spatial politics of cities, will have to await another venue. In the meantime, I refer the readers to Grant Kester's excellent analysis of current trends in community-based public art in "Aesthetic Evangelists: Conversion and Empowerment in Contemporary Community Art," *Afterimage* (January 1995): 5–11.

14 The exhibition, *Arte Joven en Nueva York*, curated by José Gabriel Fernandez, was hosted by Sala Mendoza and Sala RG in Caracas, Venezuela (June 9–July 7, 1991).

15 This fourth site, to which Dion would return again and again in other projects, remained consistent even as the contents of one of the crates from the Orinoco trip were transferred to New York City to be reconfigured in 1992 to become *New York State Bureau of Tropical Conservation*, an installation for an exhibition at American Fine Arts Co. See the conversation "The Confessions of an Amateur Naturalist," *Documents* 1/2 (fall/winter 1992): 36–46. See also my interview with the artist in the monograph *Mark Dion* (London: Phaidon Press, 1997).

16 See the roundtable discussion "On Site Specificity," *Documents* 4/5 (spring 1994): 11–22. Participants included Hal Foster, Renée Green, Mitchell Kane, John Lindell, Helen Molesworth, and me.

17 James Meyer, "The Functional Site," in *Platzwechsel*, exhibition catalog (Zurich: Kunsthalle Zurich, 1995), p. 27. A revised version of the essay appears in *Documents* 7 (fall 1996): 20–9. Meyer's narrative of the development of site specificity is indebted, as mine is, to the historical and theoretical work of Craig Owens, Rosalind Krauss, Douglas Crimp, Hal Foster, and Benjamin Buchloh, among others. It will become clear, however, that while I concur with Meyer's description of recent site-oriented art, our interpretive analyses lead to very different questions and conclusions.

18 Despite the adoption of various architectural terminology in the description of many new electronic spaces (Web sites, information environments, program infrastructures, construction of home pages, virtual spaces, etc.), the spatial experience on the computer is structured more as a sequence of movements and passages and less as the habitation or durational occupation of a particular "site." Hypertext is a prime example. The (information) superhighway is a more apt analogy, for the spatial experience of the highway is one of transit between locations (despite one's immobile body behind the wheel).

19 Again, it is beyond the scope of this essay to attend to issues concerning the status of the "public" in contemporary art practices. On this topic, see Rosalyn Deutsche, *Evictions: Art and Spatial Politics* (Cambridge: MIT Press, 1996).

20 See, for example, Gilles Deleuze, "Postscript on the Societies of Control," *October* 59 (winter 1992): 3–7, and Manuel Castells, *The Informational City* (Oxford: Basil Blackwell, 1989).

21 For an overview of this situation, see Susan Hapgood, "Remaking Art History," *Art in America* (July 1990): 115–23, 181.

22 *The New Sculpture, 1965–75: Between Geometry and Gesture* at the Whitney Museum (1990) included fourteen re-creations of works by Barry Le Va, Bruce Nauman, Alan Saret,

Richard Serra, Joel Shapiro, Keith Sonnier, and Richard Tuttle. Le Va's re-creation of *Continuous and Related Activities: Discontinued by the Act of Dropping* from 1967 was then purchased by the Whitney for its permanent collection and subsequently reinstalled in several other exhibitions in many different cities. With some of these works, there is an ambiguous blurring between ephemerality (repeatable?) and site specificity (unrepeatable?).

23 Hapgood, "Remaking Art History," p. 120.

24 This was the logic behind Richard Serra's defense of *Tilted Arc*. Consequently, the issue of relocation or removal of the sculpture became a debate concerning the creative rights of the artist.

25 See the March and April 1990 issues of *Art in America*.

26 Sol LeWitt, with his *Lines to Points on a Six Inch Grid* (1976), for example, serialized his wall drawing by relinquishing the necessity for his involvement in the actual execution of the work, allowing for the possibility of an endless repetition of the same work reconfigured by others in a variety of different locations.

27 See Rosalind Krauss, "The Cultural Logic of the Late Capitalist Museum," *October* 54 (fall 1990): 3–17.

28 For Faith Wilding's description of this dilemma, as well as her assessment of recent revisits of 1960s feminist art, see her essay "Monstrous Domesticity," *M/E/A/N/I/N/G* 18 (November 1995): 3–16.

29 See Hal Foster, "Artist as Ethnographer," in *The Return of the Real* (Cambridge: MIT Press, 1996), on the complex exchange between art and anthropology in recent art.

30 It may be that current modes of site-oriented practices can be mapped along a genealogy of performance art, too. Consider, for example, Vito Acconci's comments on performance art as a publicity-oriented, contract-based practice: "On the one hand, performance imposed the unsaleable onto the store that the gallery is. On the other hand, performance built that store up and confirmed the market-system: It increased the gallery's sales by acting as window-dressing and by providing publicity. . . . There was one way I loved to say the word 'performance,' one meaning of the world [*sic*] 'performance' I was committed to: 'Performance' in the sense of performing a contract – you promised you would do something, now you have to carry that promise out, bring that promise through to completion." Acconci, "Performance after the Fact," *New Observations* 95 (May–June 1993): 29. Thanks to Frazer Ward for directing my attention to this text.

31 See Fred Wilson's interview with Martha Buskirk in *October* 70 (fall 1994): 109–12.

32 Isabelle Graw, "Field Work," *Flash Art* (November/December 1990): 137. Her observation here is in relation to Hans Haacke's practice but is relevant as a general statement concerning the current status of institutional critique. See also Frazer Ward, "The Haunted Museum: Institutional Critique and Publicity," *October* 73 (summer 1995): 71–90.

33 See Saskia Sassen, *The Global City: New York, London, Tokyo* (Princeton, NJ: Princeton University Press, 1991).

34 Andrea Fraser's 1994–5 project in which she contracted herself out to the EA-Generali Foundation in Vienna (an art association established by companies belonging to the EA-Generali insurance group) as an artist/consultant to provide "interpretive" and "interventionary" services to the foundation is one of the few examples I can think of that self-consciously play out this shift in the conditions of artistic production and reception both in terms of content and structure of the project. It should be noted that the artist herself initiated the project by offering such services through her "Prospectus for

Corporations." See Fraser's *Report* (Vienna: EA-Generali Foundation, 1995). For a more general consideration of artistic practice as cultural service provision, see Andrea Fraser, "What's Intangible, Transitory, Mediating, Participatory, and Rendered in the Public Sphere?" *October* 80 (spring 1997): 111–16. Proceedings of working-group discussions organized by Fraser and Helmut Draxler in 1993 around the theme of services, to which Fraser's text provides an introduction, are also of interest and appear in the same issue of *October*.

35 Richard Serra, "Verb List, 1967–68," in *Writings Interviews* (Chicago: University of Chicago Press, 1994), p. 3.

36 Benjamin H. D. Buchloh, "Conceptual Art, 1962–1969: From the Aesthetics of Administration to the Critique of Institutions," *October* 55 (winter 1991): 105–43.

37 For instance, the *Views from Abroad* exhibition series at the Whitney Museum, which foregrounds "artistic" visions of European curators, is structured very much like site-specific commissions of artists that focus on museum permanent collections, as described earlier.

38 According to James Meyer, a site-oriented practice based on a functional notion of a site "traces the *artist's* movements through and around the institution"; "reflect[s] the specific interests, educations, and formal decisions of the producer"; and "in the process of deferral, a signifying chain that traverses physical and discursive borders," the functional site "incorporates the body of the artist." See Meyer, "The Functional Site," pp. 29, 33, 31, 35; emphasis added.

39 The installation consisted of *Bequest*, commissioned by the Worcester Art Museum in Massachusetts in 1991; *Import/Export Funk Office*, originally shown at the Christian Nagel Gallery in Cologne in 1992 and then reinstalled at the 1993 Biennial at the Whitney Museum of American Art; *Mise en Scène*, first presented in 1992 in Clisson, France; and *Idyll Pursuits*, produced for a group exhibition in 1991 in Caracas, Venezuela. As a whole, *World Tour* was exhibited at the Museum of Contemporary Art in Los Angeles in 1993, then traveled to the Dallas Museum of Art later the same year. See Russell Ferguson, ed., *World Tour*, exhibition catalog (Los Angeles: Museum of Contemporary Art, 1993).

40 This endeavor is not exclusive to Green. Silvia Kolbowski, for instance, has proposed the possibility of working with sites as generic and transferability as specific in projects. See her *Enlarged from the Catalogue: "The United States of America"* (1988). See the project annotations and Johanne Lamoureux's essay, "The Open Window Case: New Displays for an Old Western Paradigm," in *Silvia Kolbowski: XI Projects* (New York: Border Editions, 1993), pp. 6–15, 34–51.

41 This faith in the authenticity of place is evident in a wide range of disciplines. In urban studies, see Dolores Hayden, *The Power of Place: Urban Landscapes as Public History* (Cambridge: MIT Press, 1995). In relation to public art, see Ronald Lee Fleming and Renata von Tscharner, *PlaceMakers: Creating Public Art That Tells You Where You Are* (Boston: Harcourt Brace Jovanovich, 1981). See also Lucy Lippard, *The Lure of the Local: The Sense of Place in a Multicultural Society* (New York: New Press, 1997).

42 See *Places with a Past: New Site-Specific Art at Charleston's Spoleto Festival*, exhibition catalog (New York: Rizzoli, 1991), p. 19. The exhibition took place May 24–August 4, 1991, with site-specific works by eighteen artists, including Ann Hamilton, Christian Boltanski, Cindy Sherman, David Hammons, Lorna Simpson and Alva Rogers, Kate Ericson and Mel Ziegler, and Ronald Jones. The promotional materials, especially the exhibition catalog, emphasized the innovative challenge of the exhibition format over the individual projects, and foregrounded the authorial role of Mary Jane Jacob over that of the artists.

43 Ibid., p. 17.

44 Ibid., p. 15.

45 Kevin Robins, "Prisoners of the City: Whatever Can a Postmodern City Be?" in *Space and Place: Theories of Identity and Location*, ed. Erica Carter, James Donald, and Judith Squires (London: Lawrence and Wishart, 1993), p. 306.

46 Cultural critic Sharon Zukin has noted, "[I]t seemed to be official policy [by the 1990s] that making a place for art in the city went along with establishing a marketable identity for the city as a whole." Zukin, *The Culture of Cities* (Cambridge: Blackwell, 1995), p. 23.

47 Addressing Robert Smithson's *Spiral Jetty* and the *Partially Buried Wood Shed*, Craig Owens has made an important connection between melancholia and the redemptive logic of site specificity in "The Allegorical Impulse: Toward a Theory of Postmodernism," *October* 12 (spring 1980): 67–86.

48 Thierry de Duve, "Ex Situ," *Art & Design* 8, 5/6 (May–June 1993): 25.

49 See Fredric Jameson, *Postmodernism; or, The Cultural Logic of Late Capitalism* (Durham, NC: Duke University Press, 1991); David Harvey, *The Condition of Postmodernity* (Cambridge, Mass.: Blackwell, 1990); Margaret Morse, "The Ontology of Everyday Distraction: The Freeway, the Mall, and Television," in *Logics of Television: Essays in Cultural Criticism*, ed. Patricia Mellencamp (Bloomington: Indiana University Press, 1990), pp. 193–221; Michael Sorkin, ed., *Variations on a Theme Park: The New American City and the End of Public Space* (New York: Noonday Press, 1992); and Edward Soja, *Postmodern Geographies: The Reassertion of Space in Critical Theory* (London: Verso Books, 1989). For a feminist critique of some of these urban spatial theories, see Rosalyn Deutsche, "Men in Space," *Strategies* 3 (1990): 130–7, and "Boys Town," *Environment and Planning D: Society and Space* 9 (1991): 5–30. For a specific critique of Sorkin's position, see Miwon Kwon, "Imagining an Impossible World Picture," in *Sites and Stations: Provisional Utopias*, ed. Stan Allen and Kyong Park (New York: Lusitania Press, 1995), pp. 77–88.

50 Henri Lefebvre, *The Production of Space*, trans. Donald Nicholson-Smith (Oxford: Blackwell, 1991), p. 52.

51 Gilles Deleuze and Félix Guattari, *A Thousand Plateaus: Capitalism and Schizophrenia*, trans. Brian Massumi (Minneapolis: University of Minnesota Press, 1987).

52 Kenneth Frampton, "Towards a Critical Regionalism," in *The Anti-Aesthetic*, ed. Hal Foster (Port Townsend, Wash.: Bay Press, 1983), p. 21.

53 Homi K. Bhabha, "Double Visions," *Artforum* (January 1992): 88.

4 The Curator's Moment

Michael Brenson

I n August 1997 fifteen curators from Africa, Asia, Australia, Latin America, Europe, and the United States met at the Rockefeller Foundation's Conference and Study Center in Bellagio, Italy, to consider the rapidly developing field of international contemporary art exhibitions. Conceived by Noreen Tomassi, director of Arts International, and Tomás Ybarra-Frausto, associate director of Arts & Humanities at the Rockefeller Foundation, the conference was designed to enable curators struggling with the extraordinary and in some ways unprecedented challenges posed by international contemporary art exhibitions to share their ideas and concerns. The moderator was Kinshasha Holman Conwill, director of the Studio Museum in Harlem, who helped shape the program. Each curator made a presentation, as did Betye Saar, representing the artists' perspective, and Saskia Sassen, professor of urban planning at the University of Chicago and an expert on globalism. Tomassi asked if I would be interested in attending the conference and then writing a report that would be made available that fall to the participants, as well as to other curators and funders. Tomassi knew of my interest in international exhibitions when I worked for the *New York Times* (1982–91). In Barcelona in 1993 I had attended Crossing Cultures, one of several international conferences Arts International has organized to consider pressing issues in art and culture. I had written on the issue of art and community and had worked as a consultant for the Rockefeller Foundation, which financed the Bellagio conference, an event that was remarkable in its thoughtfulness, intensity, and candor.

The version published here has been slightly abridged, with the approval of the author. Copyright © 1998, 2004 by Michael Brenson.

Introduction

After listening to heads of international biennials and triennials speak with one another for three days about their hopes and concerns, it was clear to me that the era of the curator has begun. The organizers of these exhibitions, as well as other curators around the world who work across cultures and are able to think imaginatively about the points of compatibility and conflict among them, must be at once aestheticians, diplomats, economists, critics, historians, politicians, audience developers, and promoters. They must be able to communicate not only with artists but also with community leaders, business executives, and heads of state. They must be comfortable with people who have devoted their lives to art and culture, with people who neither like nor trust art, and with people who may be willing, if they are convinced that art serves their interests or is sufficiently connected to their lives, to be won over by an artist or an exhibition. As much as any artist, critic, or museum director, the new curator understands, and is able to articulate, the ability of art to touch and mobilize people and encourage debates about spirituality, creativity, identity, and the nation. The texture and tone of the curator's voice, the voices it welcomes or excludes, and the shape of the conversation it sets in motion are essential to the texture and perception of contemporary art. The focus on Catherine David throughout the one hundred days of her 1997 Documenta X was not an aberration. For the foreseeable future, the ambitions, methodologies, and personal styles of the curators responsible for major international contemporary art exhibitions will be as essential to their content as any artist's work.

In the midst of the recent chapter in the history of museums that was largely defined by the ethnic- and identity-based exhibition, Mari Carmen Ramírez, curator of Latin American art at the Jack S. Blanton Museum of Art in Austin, Texas, and another participant in the Bellagio meetings, recognized the importance of curators working across and between cultures. In her 1994 essay "Brokering Identities: Art Curators and the Politics of Cultural Representation," an analysis of the history of Latin American and Latino exhibitions in the United States, she noted the "transformation of the curator of contemporary art from behind-the-scenes aesthetic arbiter to central player in the broader stage of global cultural politics." If this transformation was evident to her in 1994, how much more complete it must have been in 1997, the year of five international biennials – Cairo, Havana, Venice, Istanbul, and Johannesburg – as well as Documenta. Look at the issues embedded in these exhibitions: nationalism versus internationalism or transnationalism; indigenous cultures versus global media; handmade traditions versus technological networks; respect for the intimate experience of art versus a belief in curatorial interventions that can make the artistic message, and sometimes even that intimacy itself, broadly accessible; belief in the intrinsic value of art versus an obligation to put art in the service of extraordinary social and political needs. The urgency of these issues underlines the challenges facing the curatorial profession to think deeply about multiple audiences and to allow individual curatorial perspectives to be invigorated by radically, even shockingly, different experiences of

space and time, memory and history. These unframable high stakes biennial projects do not reward curatorial business as usual. Like the independent curator Mary Jane Jacob, whose public art projects outside galleries and museums propose reimagining the site, the audience for, and perhaps even the nature of the art experience, the biennial curator cannot succeed without a hands-on involvement in every aspect of his or her program. For the new curator, the clear-cut division of responsibilities between the curatorial, administrative, education, marketing, and public information departments that has been a reality in large museums in the United States for well over a decade – a division that has tended to detach many curators from their audiences and blind them to the nonaesthetic interests their museums are serving – is inconceivable. If this division exists, meeting their responsibilities is impossible.

While large international contemporary art exhibitions are helping to expand the roles and responsibilities of the curator, many artists find themselves having to develop in aesthetic and political climates of increasing suspicion and constraint. Throughout the United States the political right is ridiculing artists, and even the idea of the artist; within the art community, there is widespread contempt for any tendency to romanticize the individuality, personality, hand, and heroism of the artist. Monograph and biography are now the most disparaged forms of art history. Not surprisingly, much of the most respected new art in Europe and the United States is defined by a noticeable degree of self-effacement. It is intended to draw attention to ideas, processes, and situations – not to itself as an object (if that is what it is) or to its makers. In October 1997 I heard Kristaps Gelzis, a young sculptor in Riga, Latvia, say that he liked Documenta X because "it was not concerned with the artist but with process," and Andy Goldsworthy, an English landscape sculptor, remark, while constructing one of his delicate, undulating walls of unattached stones, at the Storm King Art Center in upstate New York, that he wanted to make work that "would take credit for itself." In other words, as the curator becomes a more and more visible player in the world of contemporary art, more artists are concealing their egos to prove to the art community, to the general public, and to themselves that they are worthy of respect.

At the same time, the presentation of art is more dependent on the curator than ever. There seems to be a consensus that when art from one culture is shown in another, it cannot speak for itself. Because of the inevitably loaded nature of the responses of a museum-goer in New York, let's say, or Washington, DC, to contemporary art from Zaire, Colombia, or Cambodia, the idea of a museum's presenting an object from one culture in such a way that it would offer an intensely private object-to-visitor encounter to someone from another culture, in which no one or nothing else is welcome and viewers are free to respond as they please, is increasingly unacceptable in the United States. Sufficient clues must be given to enable viewers to orient themselves to the work and to provide viewers unfamiliar with the conditions in which it was created at least some sense of what it means to appreciate it on its own terms. Hand in hand with an awareness of the challenges of presenting art from one culture in a very different cultural context is a growing awareness within museums that art exhibited in any museum is seen by many people who feel they

have little or no access to it and that they need to be encouraged to feel that the aesthetic experience belongs to them as much as to anyone else. The perplexing combination of curiosity and distrust, respect and exploitation, that defines many institutional approaches to audience cannot be explored here. What needs to be stated is that the increasing institutional awareness of the importance of the audience has made curators more visible as mediators between art and its publics.

The increasing centrality of the curator has also been reinforced by the emergence of installation as the standard form in which contemporary artists around the world are working. Installations involve selecting and arranging in a space often shared by visitors. They may also involve writing and educating. Installations were designed, in part, to contextualize and therefore empower themselves by inscribing within them an awareness and even the look of a gallery or museum. By so doing, however, they implicitly acknowledge the curator's inescapable authority. Blurring the line between artist and curator builds into the experience of art a heightened awareness of the curator's reality.

Yet I have so many questions. How did we reach the point where we expect art to respond to the needs and aspirations of peoples and nations? Are there limits to what art can be asked to do? Why have the expectations for art increased at a time when the individual artist is feared, not only in the United States but in many other countries as well, and the artist's voice is being systematically deconstructed? What are the political implications of approaching art as a means to an end, rather than an end in itself, or both a means and an end? What is the responsibility of the curator to ensure respect for the integrity of a work of art, which can survive, miraculously, even if the art points everywhere but toward itself and all the walls between it and the world around it seem dissolved? At what point does approaching a work of art in terms of what it can do, rather than in terms of what makes it unlike any other work, or indeed anything else, bring to mind nightmares of instrumental thinking?

Transparency

The discussions in Bellagio underlined the importance of several related constellations of words. The constellation that includes impurity, partiality, and incompleteness suggests the rejection of any assumption of absolute authority, conclusive knowledge, or human or cultural essence. Another constellation includes words like hybridity, reciprocity, negotiation, and reconciliation, suggesting the pressing need many people feel to listen to one another and to acknowledge and communicate with realities different from their own. These constellations are familiar and, among many cultural communities in the United States, widely accepted. Their usefulness in helping people to consider themselves and their relationships to others in an increasingly decentralized yet interconnected world is, to me, incontestable. These constellations of words clarify not only the attitudes of curators but also the complexity and the general goals of many of the big international contemporary art exhibitions. It was

apparent from the meetings that all the biennials are hybrids, shaped by different interests, some of them competing. Many are conceived within a nationalistic framework intended to develop national confidence and pride, yet the art they present may argue against nationalism and even against the idea of a nation. It was also apparent that if it were possible to produce a cross section of the structure of any of these exhibitions, it would show layer upon layer of negotiation and reconciliation. And many of the curators want the actual exhibitions to inspire both local dialogues and dialogues with other biennials and nations.

What concerns me here is a third constellation. It includes words like self-consciousness, openness, and transparency and phrases such as "declaring yourself." Several of the curators emphasized the importance of self-consciousness, which implies a sophisticated awareness of the histories and implications of the ideas they are working with and of the economic and political systems they are working within, as well as an ability to build this awareness into their curatorial presentations. Vishakha N. Desai, director of the galleries at the Asia Society in New York, asserted that curators must "own up to taste," define their positions, and explain where they are coming from and what they cannot yet understand. She spoke about "recognizing our own fallibility" and sharing that recognition with audiences. "We are as much products as creators," she said. For Okwui Enwezor, the artistic director of the 1997 Johannesburg Biennale, "part of the responsibility of the curators is to say, This is what I am doing, and it is not the final word." In a private conversation, Enwezor spoke about "creating a space of vulnerability." This wonderful phrase reflects the wish of many of these curators to conceive an exhibition experience in which intimacy, accessibility, and self-disclosure are welcomed, and audiences are encouraged to express their ideas and feelings by participating in the collective production of meaning. The importance of participation and interactivity in Documenta X helped convince some of the curators in Bellagio that, in the words of Virginia Pérez-Ratton, the director of the Museo de Arte y Diseño Contemporáneo in San Jose, Costa Rica, "Documenta was coming into another century with this show." This constellation of words indicates how much the generation of curators now coming into power believes in responsibility and generosity. It also reveals how essential hospitality and trust have become to the success of most ambitious cross-cultural curatorial endeavors.

The issue for me is not the spirit of these words or their importance to this artistic moment. The issue is ensuring that the difficulty of being self-conscious, of making oneself transparent, of declaring oneself, is understood. When I recently heard US politicians at an economic conference talk about the need to be more "open and transparent," it was clear to me how easily these words can become conventions. One of the problems is that words or phrases calling for greater openness and transparency tend to be understood politically, economically, sociologically, or aesthetically. Rarely are they understood to be meaningful within all of these frameworks. Even more important, rarely are they understood psychologically. The confidence with which the words are now being used in the field suggests less an unending process in which any sense of control is ultimately illusory than finality, as if it is possible to

declare oneself once and for all in that moment, or as if it is enough to be able to declare oneself in such a way as to get what one desires from a specific situation. As a result, these words tend to promise the relinquishing of authority without delivering it. If the difficulty of the words is not acknowledged, then their use can become pat and manipulative. When this is the case, they do not become a way of sharing power – or, in the words of the Brazilian artist Mauricio Dias, of "exchanging territories" – but rather simply of reinforcing power at the curatorial, institutional, or political end.

The currency of words like openness and transparency leads me to ask: How much can we reveal and how much must we hide, and how does the line between revealing and concealing structure the tone and conversation curators are trying to create? How much does being open and transparent challenge power and how much does it reinforce it? What is the relation between transparency and mastery? What kind of sharing of power is really desirable, or possible, within an exhibition that must communicate authority to be credible? Which artists, curators, and peoples are likely to support these words, and which are not? Is a curator trying to put a biennial on the map in a part of the world largely removed from the immediate possibility of economic and political power more or less likely to argue for these words than a curator in a country where such power is taken for granted?

What does it mean to "declare yourself"? Does it mean being up front about the goals of a show? And is that possible when the goals of these exhibitions may be manifold, from supporting art and artists in one place, to providing an overview of the contemporary art situation, to putting an entire culture, country, or even part of the world on the international art map? Does "declaring yourself" mean defining taste when an exhibition driven by both transnational awareness and national needs will always go beyond individual taste? Does it mean sharing with audiences the ideological premises and aims of an exhibition likely to overflow any ideological framework in which anyone tries to put it? Arguing for a particular kind of art and for thinking about it? Situating the exhibition within the history of exhibition approaches and curatorial methodologies? Historicizing the exhibition and its place within the tradition of that biennial and of the city itself, as Paulo Herkenhoff did in Bellagio in his cogent overview of the 1998 São Paulo Bienal, of which he is chief curator? Discussing funding sources and defining the problems and compromises that are inevitable in biennials, and how these compromises end up shaping the show?

What about the personal implications of openness and transparency? Do these words mean defining oneself in race, class, and gender terms – terms that are evolving all the time? Do they mean defining oneself in terms of geography, of family history, of the psychological and social formation of one's style? What about individual ambition? How is that talked about? And the kind of obsessiveness and narcissism that, as Herkenhoff indicated, are inextricable and indeed necessary components of most meaningful curatorial ventures?

In short, while words and phrases like "declaring yourself" and "making yourself transparent" can help establish a climate of exchange and engagement, they do not, in themselves, lead to what I think most of the curators want to encourage but are

also somewhat wary of encouraging: risk. In addition, they do not, by themselves, acknowledge that the candor and honesty many of the curators were calling for depend not only on introspection and goodwill but on performance and style. In the best memoirs, which have become one of the dominant literary forms of this time, candor is always both exposure and creation. Openness and transparency must have a form to inspire people to believe in them, and when they have that form they are already both an unmasking and a transformation. Just as important as the will to be open, then, is the form in which a curator is able to be open. This form, in turn, will affect the tone and texture of the exhibition. The ability to be open and transparent in ways that inspire trust and risk is one of the talents that can link curatorial and artistic creation. The ultimate test of the form may be whether, and in what ways, it allows itself to be open to question.

As Desai recognized, these words lead directly into the identity issue. "Making transparent and self-conscious brings identity to the fore," she said. At the same time, the words expose the immense complexity of the concept of identity. Anyone using this constellation of words is, in effect, acknowledging this complexity. He or she is also suggesting that words like negotiation, reconciliation, and hybridity apply not just to people's relations to others and to the world around them but to the processes of everyone's inner life. These words and phrases – openness, transparency, self-consciousness, declaring yourself – therefore have the potential to restore the radicality that has been largely lost from the other two constellations of words. When the difficulties of these words emerge, the meanings of hybridity, negotiation, reciprocity, and partialness become dramatic. Self-consciousness, openness, and transparency call attention to an instability and danger that seems so much of the moment and yet so basic to the human condition that it is both topical and primal. At the same time, these words pose a question many artists and curators are struggling with: How can awareness and acceptance of instability and uncertainty become a source of community, knowledge, wonder, and revelation?

Heroic/Nonheroic

Although the constellations of words that shaped the discussions of curatorial identity in Bellagio are insistently, even adamantly, nonheroic, the exhibitions discussed are, with the exception of the Venice Biennale and the Carnegie International, both of which have been around since the nineteenth century, heroic at their cores. In the biennials that have emerged since the Havana Bienal was inaugurated in 1984, art is a means that enables curators to work toward breaking the isolation of their peoples and regions and redefining national and international relationships. In most of these exhibitions, art is also seen as a means of improving society and making the world better. Enwezor expressed his hope that the Second Johannesburg Biennale would be "a celebration of South African independence" that worked toward the "reconnection of South Africa to the world." Remi Sagna, the secretary general of the 1998 Dakar

Biennial, defined one aim of his show as making Dakar a pan-African center. Herkenhoff said the goals of his 1998 Bienal included "the formation of the gaze of young Brazilians" and reforming São Paulo's institutions. "It's not for art's sake," he said. "It's for the sake of the education of society." Caroline Turner, the director of the first Asia-Pacific Triennial of Contemporary Art in 1993, in Brisbane, spoke of the importance of educating Australians about the changing identity of Australia, "which is no longer a Western outpost," and, by so doing, to "change the way Australians see the region through the art." For Llilian Llanes Godoy, the director of the Centro Wifredo Lam in Havana and the organizer of all five Havana biennials, "art is very important for the survival of humanity." She is convinced her biennial and other exhibitions of this genre can contribute to "the construction of a more balanced world."

For the curators in Bellagio, as a group, a more balanced world is not possible without more equal representation in the corridors of cultural power. Margaret Archuleta, curator of fine arts at the Heard Museum in Phoenix, made clear that her responsibility at the meetings, "and it's a heavy responsibility," was to speak for Native Americans who are almost always excluded from the most prominent international artistic events. "How do they get to participate in this arena?" she asked. This was a question, she said, that she had to answer to her people. Ramírez, too, like several others, raised the issue of representation. Part of her job as a curator and scholar, she said, is to understand why artists from Brazil, let's say, are often included in these shows while artists from Bolivia are left out. For her, it is imperative to render visible the dynamics of those international circuits that give artists in some countries, and from certain ethnic backgrounds, a greater chance of being recognized internationally than others.

Curators did communicate their passion for art and the importance of standards. Llanes: "Our aim is to show the best art in our country." Pérez-Ratton: "I have been traveling for years, and I am sick of all the bad Central American art I saw. . . . We have to try and get the quality people into these shows." Enwezor: "We have to deal with issues of art." His responsibilities in Johannesburg, Enwezor said, included making distinctions in quality and clarifying the different ways in which "artist" is defined. Being an artist is not the same in Africa as it is in the United States, he said, and not the same in Nigeria, where he was born, as it is in South Africa, which he described as "a divided country, horribly wounded," where the "situation of the artist is a life-and-death matter." Enwezor indicated his discomfort with any curatorial or critical language that does not allow for the possibility of using passionate words, like love and beauty, to describe the encounter with art.

One of the reasons that the Havana Bienal is so widely respected among biennial curators is that the aesthetic and the political were inseparable and equal in it from its inception. Llanes believed in Cuban and other Latin American artists. She wanted to provide a space for artists "who do not have space in the world." She wanted to enable countries and regions that were strangers to understand one another better. In biennials that emerged in the nineties, however, the relationship between aesthetic and political needs has been less seamless. The need to empower and connect regions and peoples can seem so great, in fact, that the first message sent out by recent

biennials as a group is not: see what the art in them and in their countries or regions has achieved and has to say to the world, but rather: consider what the art in them is intended to do. The issue here is tricky. The same political needs and circumstances that define the urgency of these exhibitions – if they were just surveys of good art, few people in other countries, and perhaps even in the countries where the exhibitions were held, would feel a desire to visit them – can also make them seem contrived and manipulative. The same needs that convince some people to take these exhibitions seriously make others uneasy with them.

The conflict between a commitment to art and a commitment to using art to serve other agendas is not just a biennial issue. In the fiercely contested yet unforgettable "Magiciens de la terre," in Paris in 1989, its curator, Jean-Hubert Martin, in his effort to reveal to the West the continuing vitality of artistic traditions in non-Western cultures, installed almost all the non-Western works in an exhibition context that had little or nothing to do with the intentions of the artists who created the works and the traditions they served. In many of the multicultural, identity-based exhibitions of the early nineties, there were layers of disjunctiveness: between the art (non-Western in origin) and the site (often designed for modernism), between the art and many of its audiences, between the personal nature of some of the art and the representational or liberation causes the curators were asking the exhibition to serve.

While the new biennials grow out of the climate that produced exhibitions like these, they also reflect the conflict between the commitment to and the use of art in museums whose narrowness helped make multicultural exhibitions necessary. In New York, hardly anyone informed about art institutions is under the illusion that any of the city's big museums cares first and foremost for art, no matter how brilliant and sustaining their exhibitions may be or how exemplary they may be in caring for the art entrusted to them. Curatorial programs serve institutional and board interests and agendas that are economic, social, and political as much as they are aesthetic. These interests, more than the needs of artists, or of contemporary art, are at the forefront of exhibition programming in powerhouse museums in the United States. Using art in the service of causes that may not be its own is a complicitly accepted part of US museum life. The news media not only refuse to question the ideological structures of big museums, but hold up some of them as models of aesthetic responsibility. The more blatant conflict that can exist in biennials between commitment to art and commitment to using art should be considered with this recent exhibition history and with museums in mind.

The first biennial issue is legitimation. "The entire debate about legitimation is at the center of what international biennials are trying to do," Enwezor said. What is being legitimated? Art? Artists? Curators? Institutions? Traditions? Cultures? Communities? Cities? Regions? Nations? What is the process of legitimation? It certainly involves giving exhibition space to local and national artists and showing the people who live in those locations what the artists can do. It involves showing people from different parts of a continent and from other continents what the artists, cultures, and inhabitants of a region are capable of. By becoming a recognized event, covered by newspapers and art magazines and attended by people from the region and perhaps

from all over the world, the local is validated in a way in which few local cultures anywhere – not even in urban centers like New York, Los Angeles, Berlin, or Tokyo – can now validate themselves. While perceiving the local's desire and claim for international recognition, international and transnational communities are not only pressured into focusing attention on the local but they are also given evidence of their own authority by recognizing the power of their legitimizing machinery in the local's eyes. In this astonishingly complex and frequently collusive game that demands as much self-consciousness as possible, the local, the regional, and the international can legitimate one another.

What legitimates most? Is it that art from a region appears in an international exhibition? Is it that a region that may have been previously unidentified in technologically advanced nations with contemporary art, and, as a result, with modernity, mounts such an exhibition and therefore takes its place in its own eyes, and in the eyes of the world, as a nation with a rightful claim to the present? Is it critical acceptance and appreciation? By whom? Is it market interest that enables local and regional artists unknown before a biennial to enter major collections and participate in other international exhibitions? Is it the effect of the exhibition two, five, and ten years later on the artistic life of the region? If the Dakar Biennial, as Sagna defined it, has multiple goals – including making known the art in Africa without ghettoizing Africans, providing a place where African artists can meet and debate with one another, and generating interest in African art outside Africa – what most determines success or failure? If the Havana Bienal is, in Pérez-Ratton's words, a "legitimator of Latin American art" – an exhibition many artists from Africa and Latin America attend to understand what other artists from these regions are doing – with minimal attention from the mainstream Western news and art media, is the biennial nevertheless enough of a legitimating force that it should require, in its own eyes and in the eyes of all those who depend on it, no other form of legitimation? What does the value still placed on the machinery of recognition in Western Europe and the United States mean in postcolonial exhibitions born from liberation struggles?

"What is it we are making?" Madeleine Grynsztein, curator of twentieth-century art at the Carnegie Museum of Art and the director of the 1999 Carnegie International, a triennial exhibition, asked. "Why? For whom?"

While the burden of legitimation is enough by itself to suggest the heroic nature of the new biennials, just putting these shows together is heroic as well. The legwork, tenacity, tact, forbearance, flexibility, assertiveness, and cunning demanded of a biennial curator are startling. Many must negotiate with unreliable funders and fight for their artists and ideas within chronically unstable political conditions. "Every day the government changes," N. Fulya Erdmeci, director of the International Istanbul Biennial, said. In every city that is the site of a developing biennial, the art infrastructure is limited at best. Erdmeci spoke about asking for help from everyone, including her brother and other family members. Her photographer was her best friend. She herself helped to pack the art "like babies." Llanes spoke about the absence of a budget from the Cuban ministry of culture in the last two Havana biennials and "solving problems day by day." She got help from the mayor, institutions, the army.

After listening to her talk about the physical and mental exhaustion she has felt after her biennials ended, describing her effort as heroic seems like an understatement.

While trying to understand the nature of biennials, it is important to consider the contrast between the heroic nature of most of these exhibitions and the language of modesty and humility curators use to define an appropriate curatorial style. It is also important to consider the contrast between a profound suspicion of religious responses to art in some of the curatorial presentations – and of the kind of theological language that was commonplace not too long ago to describe the encounter with a painting or sculpture – and the widespread faith in the transformative, even healing power of biennials. Herkenhoff, who was incredulous when he cited an example of the eucharistic language with which the encounter with modernist art has sometimes been described, nevertheless asserted that the São Paulo Bienal has the ability to give its city a "soul." Many of the curators would be extremely wary of any messianic view within an artist's work, yet many biennials have a messianic dimension. While the art many of the curators in Bellagio support is conscious of itself as art and limited in its spiritual claims, the causes the art is intended to serve may be as idealistic and grand as those served by early and mid-twentieth-century paintings and sculptures inspired by spiritual or utopian beliefs.

Is the conflict between faith and knowledge still appropriate in an age in which the nearly irresistible appeal of the new technology seems to be its combination of information and magic? Any large overview of contemporary art is likely to swing between faith and consciousness, balancing either toward skepticism or belief but never entirely eliminating the other side. Certainly no biennial can afford to dismiss the spiritual and hope to appeal to multiple audiences. Soon after the Bellagio conference, I visited a sculpture park near Vilnius built after Lithuania's independence in 1991 called the Sculpture Museum of the Centre of Europe. On a Saturday afternoon, two couples came to the park directly after their weddings. They wanted to touch the sculptures and be photographed around them. Clearly they believed the sculptures and the park blessed them. I asked its founding director, thirty-year-old Gintaras Karosas, how often this occurred. He answered, "All the time." Whether it is in the art shown or in the belief in what art can accomplish, the biennial curator, however strong his or her insistence on self-consciousness and context, takes the human faith in artistic magic seriously.

The contrasts, or tensions, within the languages of the curators, or between their words and their exhibitions, lead me to what I see as one of the major unresolved issues in the new biennials: modernism. In the three days of meetings at Bellagio, modernism was a purely negative presence. It was acknowledged as the driving cultural force when the Venice Biennale, the Carnegie International, the São Paulo Bienal, and Documenta were founded. Once this acknowledgment was made, declaring the need for a new biennial model inevitably followed. The kind of faith that characterized the responses to a great deal of modernist art by many people devoted to it was assumed to be antithetical to the kind of engaged, questioning response many of the biennial curators are after. Modernist exhibitions like "Qu'est-ce que la sculpture moderne?" in Paris in 1986 were cited as examples of the kinds of narrow

and exclusionary museum surveys unacceptable now. For these curators as a group, modernism, with its essentialism and its totalizing, unifying impulses, was so objectionable in today's postmodern world that it had to be either ostracized or singled out as an enemy to be overcome.

But I can't imagine these shows without modernism. Only in modernism do I find a comparable concentration of belief in progress, education, healing, and transformation. Only in modernism do I consistently find that acute awareness of vulnerability and limits combined with heroic ambition and will that is shaping the identities of a number of the biennial curators. This combination has been a decisive feature in some of the best European and US art from Paul Cézanne and Jackson Pollock through Bruce Nauman and Felix Gonzalez-Torres.

By raising the issue of modernism, I mean to be neither provocative nor accusatory. My aim here is to try and make it easier for curators at the end of the century to use whatever art and ideas are available to help them develop and clarify their positions. I don't think it is possible to understand the level of hope and faith in these shows – to understand how curators reached the point where they believe art can meet such overwhelming needs – without being open to the many sides of modernism. The curators of these extraordinarily hybrid shows cross many worlds. Any attitude or position that prevents them from using any of the art in this century to clarify their aims and develop their ideas, and to make sure this hybridity can be rendered visible and approached as a source of knowledge and strength, particularly in countries where modernism has never been seen in depth, is not helpful.

The Future

Despite all the crucial questions they raise, and also *because* of these crucial questions, biennials born from deep cultural and political needs will make a difference. They will be festivals for art in which all those who attend will find something that pleases or moves them. They will create new audiences and new bases of information. They will introduce different regions to unfamiliar approaches to art and people in art-world centers to unfamiliar regions. They will foster debate about the meanings of national and international and about what it means to be an artist at the end and at the beginning of a millennium. They will encourage other cities and countries to consider building artistic and cultural infrastructures. They will make clear that many cities and countries are capable of being seats of cultural power.

These exhibitions will also help build respect for art and culture throughout the world. Perhaps the most important message of the biennials as a phenomenon is that the curators who organize them and the organizations that sponsor them believe in the future. The newer biennials argue implicitly that the places and countries that house them have a future, that the future is there to be built collectively by people of goodwill everywhere who want to join in, and that in the process of conceptualizing the future, art matters.

If this message is so moving to me, it is partly because my country does not seem to believe either in art or in the future. In the United States, only a relatively small number of people believe that art can have an impact on the world. The assault against the National Endowment for the Arts, the government agency that has given a limited but decisive amount of funding to the arts since 1965, has been relentless for nine years. The United States Information Agency, which for years sent US artists abroad and enabled them to establish connections with other artists and bring the lessons they learned from their contacts back home, now provides almost no money for cultural programming and largely defines US culture in terms of Hollywood and the entertainment industry. The assault on art and artists in the US media, and the exploitation of the anxieties about artists by conservative political interests, has made it impossible for the United States, as a nation, to view art with confidence. It will be a long time before the United States is remotely comfortable with artists, contemporary art, and the artistic imagination.

In short, at the moment when many other countries with little or no immediate possibility of economic and political power have set out to realize dreams of gaining power through art, the government and mass media of the United States have been trying to evict art and artists from the American Dream. One of the telling ironies of this discomfort with art and artists is that it is helping to level the playing field internationally. By inhibiting the ability of US art to function as an aesthetic, economic, and political force, the government and media have ended up serving postcolonial cultural aspirations outside the United States. As a citizen of this country who believes in the artists here, who has spent years fighting for them, and who will always fight for them, I find this situation painful on many levels. But it must be acknowledged. And curators in other countries must know that while there is an extraordinary breadth of knowledge and experience among art professionals in the United States, and while art and artists here will continue to be essential players on the world's artistic and cultural stages, the art system in the United States can no longer dominate as it did. The eruption of biennials is evidence of a historic change.

Three interrelated issues must continue to be debated if the new biennials are going to be clear about what they are and what they want to achieve. The first issue is legitimation. To what degree are the sources of legitimation for the biennials that have emerged since 1984 determined by geopolitical conditions? By practical necessity? By emotional and psychological needs? If exhibitions do not depend at all on Western goodwill and support, like the Asia-Pacific Triennial, which looks toward Asia, do they become more or less necessary and desirable in other parts of the world? Where? To whom? Can biennials with shared histories and goals help legitimate one another? What legitimates most? What needs most to be legitimated?

The second issue is audience. It came up constantly in Bellagio without ever being engaged. It inspired some fertile remarks. Llanes's statement – "a lot of artists I detest, but I respect the audience" – made sense on many levels. It reminded me of all the artists I now value whose work I did not like or respond to for years, but whom I kept in the back of my mind because of my respect for their supporters. It reminded me that art cannot gain a real foothold anywhere unless it is engaged by

the communities who live with and around it, regardless of whether the curators are sympathetic with the tastes and aesthetic assumptions of community members. Is it possible for curators to have candid, even contentious discussions with colleagues about the many audiences they are trying to reach, which ones they feel most and least responsible to and why, how to build lasting relationships with them, and how these relationships shape the understanding and possibilities of art within an exhibition or museum?

The final issue is the one that will not go away: quality. The language in which art from non-Western cultures is being defended is still often one of representation. The focus of attention is not on what a work has to offer – poetically, thematically, psychologically, philosophically, and politically – but the cause the artist serves and the political struggle with which he or she is identified. Biennials offer an opportunity to transform the chasm between the language of representation and the language of quality into a space in which many of the people demoralized by this split can make a place for themselves. We have to begin to talk about art in ways in which everyone has something to lose. People have to write and lecture about art in ways that leave them exposed. If a critic were asked to argue for an artist in a public event in an unfamiliar country, it would all but oblige him or her to think in terms of issues and words that could cross cultures. Both the positive and negative responses to the presentation and to the artist would be revealing. If cross-cultural debates about art and artists continue to be part of the programs of biennials, and if these debates are published, perhaps in some collective biennial publication, they could help locate the words and the approaches to language that now carry maximum feeling and thought. The biennials can help develop a poetics for contemporary art that has not been recognized or that does not yet exist.

5 How to Provide an Artistic Service

An Introduction

Andrea Fraser

n our initial proposal for the "working-group exhibition" *Services*, Helmut Draxler and I offered the term "service" to describe what appeared to be a determining feature of what has come to be called "project work." We wrote:

> It appears to us that, related variously to institutional critique, productivist, activist and political documentary traditions as well as post-studio, site-specific and/or public art activities, the practices currently characterized as "project work" do not necessarily share a thematic, ideological or procedural basis. What they do seem to share is the fact that they all involve an amount of labor which is either in excess of, or independent of, any specific material production and which cannot be transferred as a product. This labor, which in economic terms would be called service provision (as opposed to goods production), may include:
>
> - the work of the interpretation or analysis of sites and situations in and outside of cultural institutions;
> - the work of presentation and installation;
> - the work of public education in and outside of cultural institutions;
> - advocacy and other community based work, including organizing, education, documentary production and the creation of alternative structures.[1]

"Providing a service," in the sense described in our proposal, is neither an intention (such as benefiting society) attributed to particular artists nor a content (such as

This is published here in print and in English for the first time. It was first presented in conjunction with the "Services" exhibition in Vienna in 1994 and is available online at <http://adaweb.walkerart.org>

museum education or security) characterizing a group of works. Rather, we proposed "service provision" to describe the economic condition of project work as well as the nature of the social relations under which it is carried out. On the most basic level we could even claim that the prevalence of practices such as the payment of fees to artists by cultural institutions indicates that the emergence of art-as-service-provision is simply an economic fact.

We went on to write:

> there seems to be a growing consensus among both artists and curators that the new set of relations [emerging around project work] . . . needs clarification. While curators are increasingly interested in asking artists to produce work in response to specific existing or constructed situations, the labor necessary to respond to those demands is often not recognized or adequately compensated. Conversely, many curators committed to project development are frustrated by finding themselves in the role of producers for commercial galleries, or a "service department" for artists.[2]

The project *Services* was organized as an occasion to consider some of these practical and material problems, as well as the historical developments which may have contributed to the emergence of artistic service provision, and to provide a forum for discussion of the impact of this development on the relations among artists, curators, and institutions.

As an artist I have a particular interest in these questions. My motive for initiating *Services* came from the complications and conflicts I experienced as a result of entering into relations with curators and organizations for which there were no accepted standards of professional practice, as well as from the frustration of working full time and for very prestigious exhibitions, yet still not being able to make a living. *Services* – and related activities I was involved in as I prepared the proposal – represented an effort by myself and other artists to represent and safeguard our practical and material interests by creating forums for the discussion of those interests, by collecting information from a range of artists about their preferred working arrangements in order to prepare a set of general guidelines and perhaps a basic contract, and by combining to form some sort of association.

What is implied in all of these activities is less a trade-union model of collective bargaining than a professional model of collective self-regulation. Like collective bargaining, this latter model could also, potentially, provide a certain leverage for artists in dealing with cultural institutions and other commissioning organizations, but achieving that would require a clarification of procedure and, perhaps, the development of a basic methodology according to which legitimate needs and demands could be collectively determined. For example, the fact that some artists collect fees from an institution and then sell work resulting from the project undermines the legitimacy of demands for fees. Should fees be opposed to sales? How should the integrity of project work be conceived? Do projects which require a high degree of participation by the institution give that institution some rights to alter the work or determine its disposition?

Andrea Fraser

As Helmut Draxler and I wrote in our proposal, "resolutions on practical problems often represent political decisions which may impact not only the working conditions of artists but also the function and meaning of their activity."

I am speaking only for myself (and not for the project *Services*) when I say that my interest in all of these organizational activities derived as much from the possibility of artistic practice developing into something like a self-regulating profession as from the hope of gaining leverage in dealing with art institutions. Professional self-regulation is a matter of professional ethics as well as professional interests. In the artistic field, it is also a matter of the ethics of cultural practice. And, because of the reach of cultural practice from private homes to public buildings and streets, it is a matter of the ethics of the social and subjective relations manifest in and through cultural practices.

Proposing to talk about "How to Provide an Artistic Service" is part of an experiment I want to undertake to see if it's possible to develop a methodology which could function as a basis for something like a self-regulating profession of artistic service provision. This experiment could take the form of a book – called "How to Provide an Artistic Service" – the model for which would be handbooks of professional conduct and technique common in other fields, books like *The Psychiatric Interview* or *Organizational Diagnosis* or Freud's papers on technique, to name some I have found particularly useful.

What I'm presenting tonight would be something like the introduction to such a book, or an argument for why such a book might be necessary.

In addition to the material concerns motivating the project *Services*, a central question it sought to address was the potential loss of autonomy consequent to appropriating models from other professional fields – such as contracts and fee structures – as a means of resolving practical problems. Critical acceptance had created a demand for projects within cultural organizations that was clearly not only a demand for the works of individual artists. This demand provided for the possibility of acting collectively to determine and defend our interests – particularly economic interests – as well as to consider the history of that kind of action. But it was also clear that this demand, expressed in invitations to undertake projects in response to situations and under conditions explicitly defined by others, represented something of a threat to artistic autonomy. Designing contracts to safeguard our practical and material interests, or even simply demanding fees in compensation for our services, might further compromise our independence by turning us into functionaries of "client" organizations.

While many of us had taken up, in our work, the positions and activities of curators, gallerists, educators, public relations and employee-management relations consultants, security consultants, architects and exhibition designers, researchers, archivists, et cetera, we certainly did not do so to have our practices reduced to the *functions* of these professions. What would – should – differentiate our practices from the functions we appropriated is precisely our autonomy. That autonomy is represented, most importantly, in our relative freedom from the rationalization of our activity in the service of specific interests defined by the individuals or organizations with which we work. Included in this is freedom from the rationalization of the language and

forms we use – a freedom which may or may not manifest itself in recognizably "aesthetic" forms. Also included is the freedom of speech and conscience – guaranteed by accepted professional practice – which is supposed to safeguard our right to express critical opinions and engage in controversial activity.

We are demanding fees as compensation for work within organizations. Fees are, by definition, payment for services. If we are, then, accepting payment in exchange for our services, does that mean we are serving those who pay us? If not, who are we serving and on what basis are we demanding payment? (Should we be demanding payment?) Or, if so, how are we serving them? (And what are we serving?)

It is important to say, however, that these questions are not exclusive to project-based practice, whether or not such practice is defined as a service. Project-based practice simply makes it necessary to pose them. I would say that we are all always already serving. Studio practice conceals this condition by separating production from the interests it meets and the demands it responds to at its point of material or symbolic consumption. As a service can be defined, in economic terms, as a value which is consumed at the same time as it is produced, the service element of project-based practice eliminates such separation.

An invitation to produce a specific work in response to a specific situation is a very direct demand, the motivating interests of which are often barely concealed and difficult to ignore. I know that if I accept that invitation I will be serving those interests – unless I work very hard to do otherwise. The interests contained in any demand for art, whether it is expressed in an invitation to undertake a project or not, would make up a very large section of a book on "How to Provide an Artistic Service." It would begin with a discussion of the objective character of the demand for art. Elaborating this would be necessary in order to dispel the subjective experience I believe most artists have of the purely individual nature of demand (addressed to themselves or others): the myth that there's no demand for art as such, but only for individual artists of particular genius, et cetera, and, in the absence of such artists, the entire contemporary art apparatus would just disappear. Of course, this is not the case. Museums have been built and must be filled. Critics and curators are trained and have an interest in being employed, gallerists need new art to show and sell. Investments have been made and the field must reproduce itself.

This primary demand to supply the reproduction of the field is conditioned by a second level of demand: that invested with interests related to competitive struggles between and among artists, curators, critics, gallerists, et cetera. Struggles to maintain and improve one's professional status vis-à-vis one's peers and to impose the principle of status (that is, of legitimacy) and the criteria of value by which the position of others will be defined: such struggles are the dynamics through which the field reproduces itself. The demand for art addressed to artists is often also directly related to competition between institutions themselves: competition for funding, for press, for audiences, and all the other indices of influence over the popular and professional perception of legitimate culture and legitimate cultural discourse.

But cultural institutions are not unitary entities. They are composed of different sectors – for example, professional and voluntary – which are themselves in conflict.

As a practitioner of what is often called institutional critique, I have often been asked, "Well, if you're so critical, why do they invite you?" It took me some time to realize that I was invited by one sector to produce a critique of the other.

Pierre Bourdieu writes:

> products developed in the competitive struggles of which . . . [the field] is the site, and which are the source of the incessant changing of [its] products, meet, without having expressly to seek it, the demand which is shaped in the objectively or subjectively antagonistic relations [that is, competitive struggles] between the different classes or class fractions over material or cultural consumer goods.

This is why, he continues,

> producers can be totally involved and absorbed in their struggles with other producers, convinced that only specific artistic interests are at stake . . . while remaining unaware of the social functions they fulfill, in the long run, for a particular audience, and without ever ceasing to respond to the expectations of a particular class.[3]

The demand an art work meets when consumed materially by an art collector, or symbolically by a museum visitor, may thus be conditioned by the struggles constitutive of the field of cultural production – where "supply," Bourdieu writes, "always exerts an effect of symbolic imposition." But as far as the interests, the needs, the wants invested in that demand are concerned, the object is indifferent, as the demand itself is subject to perpetual displacement following the course of particular struggles within the field. I would even say that the demand generated by the competition among and between art collectors and museum visitors over the quantity and quality of cultural consumption is itself displaced from another locus, and could just as easily attach itself to another field.

The cynical, debased version of this kind of analysis is that the artistic field is no different from any other market in luxury goods. They all serve social competition for status and prestige. But status is not a matter of status symbols, and prestige is not a luxury. The pursuit of prestige is only the dominant form of struggles for legitimacy of which culture is a primary site. The intimate character of the adequacy and competence at stake in these struggles is evident in the anxiety even the most socially dominant person may exhibit when confronted with an institutionally consecrated work of art. Nor does one enter into these struggles voluntarily, as if as a result of some kind of vanity. Participation is more often mandated: for example, by museums which, as public institutions, impose the competencies necessary to comprehend the culture they define as legitimate as a condition of adequacy within the cities or states which support them.

There are no artists I can think of who could credibly suggest that the functions their works serve have nothing to do with them or their artistic activity, as all artists are called upon to augment these functions for organizations and individuals at openings, cocktail parties, press conferences, et cetera. They would be correct, in any

case, to say that they serve no one, if – as Bourdieu writes – "they serve objectively only because, in all sincerity, they serve their own interests, specific, highly sublimated and euphemized interests."[4]

Am I really serving my own interests? According to the logic of artistic autonomy, we work only for ourselves; for our own satisfaction, for the satisfaction of our own criteria of judgment, subject only to the internal logic of our practice, the demands of our consciences or our drives. It has been my experience that the freedom gained in this form of autonomy is often no more than a basis for self-exploitation. Perhaps it is because the privilege of recognizing ourselves and being recognized in the products of our labor must be purchased (like the "freedom" to labor as such, according to Marx), at the price of surplus labor, generating surplus value, or profit, to be appropriated by another. In our case, it is primarily symbolic profit that we generate. And it is conditioned precisely on the freedom from economic necessity we express in our self-exploitation.

Because we are working for our own satisfaction, our labor is supposed to be its own compensation. It often seems to me that our professional relations are organized as if the entire art apparatus – including cultural institutions and galleries – was established to generously provide us with the opportunity to fulfill our exhibitionistic desires in a public display. It isn't difficult to see what kind of labor market we provide with ideological justification by investing in such a representation.

It seems that subjective freedom, autonomy of conscience, and the empowerment of individual will are matched to an inverse degree by economic and social dependence. This dependence is only partly a result of the atomization of the artistic field: the individualism and competition which consigns each producer to conducting her or his business in isolation, if not in a kind of secrecy. Attempts by artists to form associations – some of which are documented in the project *Services* – can only go a short way in alleviating such atomization and the dependence it produces. Its greater part lies not in material conditions of production but in the mechanisms of the system of belief which produce the value of works of art as well as the legitimacy of artistic activity. The divisions of labor within the field between production, distribution, and reception are effectively divisions of interest. The Kantian model is alive and well: these divisions of interest are necessary to create the appearance of disinterest essential to the production of belief in the judgment of artistic value. It is a system of belief that requires the judgment of others: people whose interests do not coincide with ours and do not include serving us with their evaluations. If curators and dealers appear to be working for artists their judgment loses its "disinterested" character and thus its value – and they lose their powers to consecrate and sell. Similarly, while under the normal conditions of competition the judgment by artists of their peers has a high degree of credibility, if those same evaluations appear to be based, rather, on an identification of interests (as has been the case, for example, with cooperative galleries), they become less than worthless.

The contradictory principle of our professional lives can thus be articulated as follows: dependence is the condition of our autonomy. We may work for ourselves,

for our own satisfaction, responding only to internal demands, following only an internal logic, but in doing so we forfeit the right to regulate the social and economic conditions of our activity. In forfeiting the right to regulate our activity according to our professional interests, we also forfeit the ability to determine the meaning and effects of our activity according to our interests as social subjects also subject to the effects of the symbolic system we produce and reproduce. As long as the system of belief on which the status of our activity depends is defined according to a principle of autonomy which bars us from pursuing the production of specific social use value, we are consigned to producing only prestige value.

If we are always already serving, artistic freedom can only consist in determining for ourselves – to the extent that we can – who and how we serve. This is, I think, the only course to a less contradictory principle of autonomy.

Notes

1 Helmut Draxler and Andrea Fraser, "Services: A Proposal for an Exhibition and a Topic of Discussion," 1993.
2 Ibid.
3 Pierre Bourdieu, *Distinction: A Social Critique of the Judgment of Taste*, trans. Richard Nice (Cambridge, Mass.: Harvard University Press, 1984), pp. 230, 234.
4 Ibid., p. 240.

6 Conversation Pieces

The Role of Dialogue in Socially-Engaged Art

Grant Kester

Introduction

W riting in the shadow of the September 11 attacks, it is impossible to predict their ultimate repercussions. It is clear, however, that one of the gravest dangers is that these events (and subsequent reactions to them) may further aggravate a global climate of belligerence, hostility, and closure based on differences of culture, religion, and nationality. Equally alarming is the fact that the currently dominant framework for exchange across these boundaries is a market system that generates its own divisive schisms, based on class and economic status. In this fraught historical moment the situation of art may seem a relatively minor concern. There are, however, a number of contemporary artists and art collectives that have defined their practice precisely around the facilitation of dialogue among diverse communities. Parting from the traditions of object-making, these artists have adopted a performative, process-based approach. They are "context providers" rather than "content providers," in the words of British artist Peter Dunn, whose work involves the creative orchestration of collaborative encounters and conversations well beyond the institutional boundaries of the gallery or museum.

This is a revised version of a paper presented at a conference in Ireland in September 1998. An earlier version was published in *Variant 9* (winter 1999–2000). This version is being published simultaneously in Grant H. Kester, *Conversation Pieces: Community and Communication in Modern Art* (University of California Press, 2004). Reproduced with permission of the author.

These exchanges can catalyze surprisingly powerful transformations in the consciousness of their participants. The questions that are raised by these projects clearly have a broader cultural and political resonance. How do we form collective or communal identities without scapegoating those who are excluded from them? Is it possible to develop a cross-cultural dialogue without sacrificing the unique identities of individual speakers?

I'll start with two examples. The first project is drawn from the work of the Austrian arts collective Wochenklausur. It began on a warm spring day in 1994 as a small pleasure boat set off for a three-hour cruise on Lake Zurich. Seated around a table in the main cabin was an unusual gathering of politicians, journalists, sex workers, and activists from the city of Zurich. They had been brought together by Wochenklausur as part of an "intervention" in drug policy. Their task was simple: to have a conversation. The topic of this conversation was the difficult situation faced by drug-addicted prostitutes in Zurich, many of whom lived in a condition of virtual homelessness. Stigmatized by Swiss society, they were unable to find any place to sleep and were subjected to violent attacks by their clients and harassment by the police.

Over the course of several weeks, Wochenklausur organized dozens of these floating dialogues involving almost 60 key figures from Zurich's political, journalistic, and activist communities. Normally, many of the participants in these boat talks would position themselves on opposite sides of the highly charged debate over drug use and prostitution, attacking and counter-attacking with statistics and moral invective. But for a short period of time, with their statements insulated from direct media scrutiny, they were able to communicate with each other outside the rhetorical demands of their official status. Even more remarkably, they were able to forge a consensus of support for a modest, but concrete, response to this problem: the creation of a *pension* or boarding house in which drug-addicted sex workers could have a safe haven, access to services, and a place to sleep (eight years later it continues to house 20 women a day).

At around the same time that Wochenklausur was staging its "boat colloquies," more than 200 high school students were having their own conversations on a roof-top parking garage in downtown Oakland, California. Seated in parked cars under a twilight sky, they enacted a series of unscripted dialogues on the problems faced by young people of color in California: media stereotypes, racial profiling, underfunded public schools, and so on. They were surrounded by more than 1,000 Oakland residents, who, along with representatives of local and national news media, had been invited to "overhear" these conversations. In this event, organized by the California artist Suzanne Lacy, along with Annice Jacoby and Chris Johnson, Latino and African-American teenagers were able to take control of their self-image and to transcend the one-dimensional clichés promulgated by mainstream news and entertainment media (e.g., the young person of color as sullen, inarticulate gang-banger). These dialogues led in turn to other collaborations and other conversations, including a six-week-long series of discussions between high school students and members of the Oakland Police Department (OPD) that resulted in the creation of a videotape used by the OPD as part of its community policing training program.

These projects mark the emergence of a body of contemporary art practice concerned with collaborative, and potentially emancipatory, forms of dialogue and conversation. While it is common for a work of art to provoke dialogue among viewers, this typically occurs in response to a finished object. In these projects conversation becomes an integral part of the work itself. It is reframed as an active, generative process that can help us speak and imagine beyond the limits of fixed identities and official discourse. While this collaborative, consultative approach has deep and complex roots in the history of art and cultural activism (e.g., Helen and Newton Harrison in the US, Artists Placement Group in the UK, and the tradition of community-based art practice) it has also energized a younger generation of practitioners and collectives, such as Ala Plastica in Buenos Aires, Superflex in Denmark, Maurice O'Connell in Ireland, MuF in London, Huit Facettes in Senegal, Ne Pas Plier in Paris, and Temporary Services in Chicago, among many others. Although global in scope, this work exists largely (albeit not entirely) outside the international network of art galleries and museums, curators and collectors.[1] Thus, Iñigo Manglano Ovalle's *Tele Vecindario* project was developed on the south side of Chicago; Littoral has been active in the hill-farming regions of the Bowland Forest in the north of England; and the Singapore-born artist Jay Koh has produced works in Thailand, Burma, and Tibet.

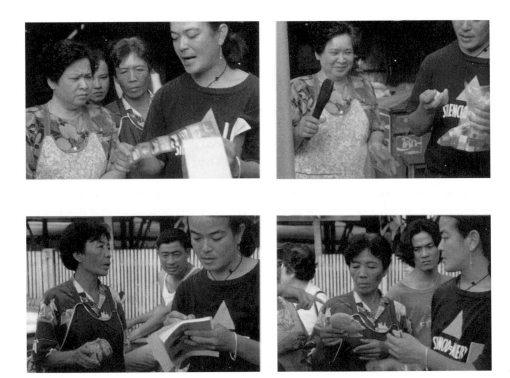

Figure 6.1 Jay Koh and Bon Fai, *E.T. (Exchanging Thought)* at Pak Tuk Kong Market, November 1995–January 1996, Chiang Mai Social Installation Art and Culture Festival, Chiang Mai, Thailand. Courtesy of Jay Koh.

What unites this disparate network of artists and arts collectives is a series of provocative assumptions about the relationship between art and the broader social and political world, and about the kinds of knowledge that aesthetic experience is capable of producing. For Lacy, who is also active as a critic, this work represents a "new genre" of public art. UK-based artists/organizers Ian Hunter and Celia Larner employ the term "Littoral" art to evoke the hybrid or in-between nature of these practices. French critic Nicolas Bourriaud has coined the term "relational aesthetic" to describe works based around communication and exchange. Homi K. Bhabha writes of "conversational art," and Tom Finkelpearl refers to "dialogue-based public art."[2] For reasons that will become apparent I will be using the term "dialogical" to describe these works. The concept of a dialogical art practice is derived from the Russian literary theorist Mikhail Bakhtin, who argued that the work of art can be viewed as a kind of conversation; a locus of differing meanings, interpretations, and points of view.[3]

The interactions that are central to these projects all require some provisional discursive framework through which the various participants can exchange insights and observations. It may be spoken or written, or it may involve some form of physical or conceptual collaboration. But the idea that a work of art should solicit participation and involvement so openly, or that its form should be developed in consultation with the viewer, is antithetical to dominant beliefs in modern and postmodern art theory.[4] By the early twentieth century the consensus among advanced artists and critics was that, far from communicating with viewers, the avant-garde work of art should radically challenge their faith in the very possibility of rational discourse. This tendency is based on the assumption that the shared discursive systems on which we rely for our knowledge of the world (linguistic, visual, etc.) are dangerously abstract and violently objectifying. Art's role is to shock us out of this perceptual complacency, to force us to see the world anew. This shock has borne many names over the years: the sublime, alienation effect, *L'Amour fou*, and so on. In each case the result is a kind of somatic epiphany that catapults the viewer outside of the familiar boundaries of a common language, existing modes of representation, and even their own sense of self.

Lying behind this rhetoric of shock was a more complex (and occasionally paradoxical) motive: to make the viewer more sensitive and responsive to the specific characteristics of nature, other beings, and to otherness in general. Avant-garde artists of various stripes believed that Western society (especially its urban middle class) had come to view the world in a violently objectifying manner associated with the growing authority of positivistic science and the profit-driven logic of the marketplace. The rupture provoked by the avant-garde work of art was necessary to shock viewers out of this perspective and prepare them for the nuanced and sensitive perceptions of the artist, uniquely open to the natural or social world.

Jean-François Lyotard, like Clement Greenberg earlier in the century, defines avant-garde art as the other of kitsch. If kitsch traffics in reductive or simple concepts and sensations, then avant-garde art will be difficult and complex; if kitsch's preferred mode is a viewer-friendly "realism," then avant-garde art will be abstract, "opaque," and "unpresentable." In each case the anti-discursive orientation of the avant-garde

artwork, its inscrutability and resistance to interpretation, is juxtaposed to a cultural form that is perceived as easy or facile (advertising, propaganda, etc.). Lyotard can't conceive of a discursive form that is not always already contaminated by the problematic model of "communication" embodied in advertising and mass-media. The viewer or audience-member is, in turn, always defined by their epistemological lack: their susceptibility to the siren song of vulgar and facile forms of culture.

This tradition has both enabled and constrained the possibilities of art practice in the modern period. The tension that exists between the movement towards openness, sensitivity to difference and vulnerability, and the paradoxical drive to "master" the viewer through a violent attack on the semantic systems through which they situate themselves in the world, remains unresolved. The artists and groups I'm examining here ask whether it's possible to reclaim a less aggressive relationship with the viewer while also preserving the critical insights that aesthetic experience can offer into objectifying forms of knowledge. While they encourage their collaborators to question fixed identities, they do so through a cumulative process of exchange and dialogue rather than a single, instantaneous shock of insight precipitated by an object.

Dialogical Aesthetics

If the evaluative framework for these projects is no longer centered on the physical object, then what is the new locus of judgment? It resides in the condition and character of dialogical exchange itself. Given this focus, Jürgen Habermas's work is an important resource for the development of a dialogical model of the aesthetic, especially his attempt to construct a model of subjectivity based on communicative interaction. Habermas differentiates "discursive" forms of communication, in which material and social differentials (of power, resources, and authority) are bracketed, from more instrumental or hierarchical forms of communication (e.g., those found in advertising, business negotiations, religious sermons, and so on). These self-reflexive forms of interaction are not intended to result in universally binding decisions, but simply to create a provisional understanding (the necessary precondition for decision-making) among the members of a given community when normal social or political consensus breaks down. Thus their legitimacy is not based on the universality of the knowledge produced through discursive interaction, but on the perceived universality of the process of discourse itself.

The encounters theorized by Habermas take place in the context of what he famously defined as the "public sphere." Participants in a public sphere must adhere to certain rules necessary to insulate this discursive space from the coercion and inequality that constrain human communication in normal daily life. Thus, according to Habermas, "every subject with the competence to speak is allowed to take part in discourse," "everyone is allowed to question any assertion whatsoever," "everyone is allowed to introduce any assertion whatsoever," and "everyone is allowed to express his or her attitudes, desires and needs."[5] This egalitarian interaction cultivates a sense

of "solidarity" among discursive participants, who are, as a result, "intimately linked in an intersubjectively shared form of life."[6] While there is no guarantee that these interactions will result in a consensus, we nonetheless endow them with a provisional authority that moves us toward mutual understanding and reconciliation. Further, the very act of participating in these exchanges makes us better able to engage in discursive encounters and decision-making processes in the future.[7]

While I don't want to suggest that the dialogical projects I've outlined illustrate Habermas's discourse theory, I do believe it can be productively employed as one component of a larger analytic system. First, Habermas's concept of an identity forged through social and discursive interaction can help us understand the position taken up by groups like Wochenklausur. We typically view the artist as a kind of exemplary bourgeois subject, actualizing his or her will through the heroic trans- formation of nature or the assimilation of cultural difference – alchemically elevating the primitive, the degraded, and the vernacular into great art. Throughout, the locus of expressive meaning remains the radically autonomous figure of the individual artist. A dialogical aesthetic suggests a very different image of the artist; one defined in terms of openness, of listening and a willingness to accept dependence and intersubjective vulnerability. The semantic productivity of these works occurs in the interstices between the artist and the collaborator.

Habermas's concept of an "ideal speech situation" captures an important, and related, aspect of these works, which we can see in Wochenklausur's boat trips on Lake Zurich. The collaborators in this project (the attorneys, councilors, activists, editors, and so on who embarked on these short journeys) are constantly called upon to speak in a definitive and contentious manner in a public space (the courtroom, the editorial page, the parliament) in which dialogue is viewed as a contest of the wills (cf. Lyotard's model of "agonistic" communication). On the boat trips they were able to speak, and listen, not as delegates and representatives charged with defending a priori "positions," but as individuals sharing an extensive collective knowledge of the subject at hand; at the least, these external forces were considerably reduced by the demand for self-reflexive attention created by the ritual and isolation of the boat trip itself. Moreover, the consensus they reached on a response to the drug problem in Zurich was not intended as a universally applicable solution to the "drug crisis," but rather, as a pragmatic response to a very specific aspect of that problem: the home- lessness experienced by prostitutes.

Drawing on Habermas's concept of discourse, there are two areas in which I would differentiate a dialogical aesthetic from a more traditional aesthetic model. The first area concerns claims of universality. Early modern philosophers rejected the idea of an aesthetic consensus achieved through actual dialogue with other sub- jects because it would fail to provide a sufficiently "objective" standard of judgment or communicability. In large measure this was due to the fact that they were writing in the epistemological shadow of a declining, but still resonant, theological world view. As a result, the philosophical systems that hoped to compete with this perspect- ive tended to simply replace one form of reassuringly transcendent authority (God) with another (reason, *sensus communis*, etc.). A dialogical aesthetic does not claim to

provide, or require, this kind of universal or objective foundation. Rather, it is based on the generation of a local consensual knowledge that is only provisionally binding and that is grounded precisely at the level of collective interaction. Thus, the insights that are generated from the conversations of the high school students in *The Roof is on Fire* or Wochenklausur's boat talks are not presented as emblematic of some timeless humanist essence, in the manner of ancient or even modern art.

The second difference between a dialogical and a conventional model of aesthetics concerns the specific relationship between identity and discursive experience. In the Enlightenment model of aesthetics, the subject is prepared to participate in dialog through an essentially individual and somatic experience of "liking." It is only after passing through, and being worked on by, the process of aesthetic perception that one's capacity for discursive interaction is enhanced (one literally becomes more open-minded following an encounter with a work of art, and, thus, a more competent participant in social discourse). In a dialogical aesthetic, on the other hand, subjectivity is formed *through* discourse and inter-subjective exchange itself. Discourse is not simply a tool to be used to communicate an a priori "content" with other already formed subjects, but is itself intended to model subjectivity. This brings us to a complex point regarding the specific way in which Habermas defines discursive interaction.

There are a number of criticisms one might make of Habermas's model, several of which relate to the bracketing of difference that is a precondition for participation in the public sphere. The most relevant criticism of Habermas, from the perspective of dialogical art practice, relates to his definition of the public sphere as a space of contending opinions and interests, in which the clash of forceful argumentation results in a final winning position that can compel the assent of the other parties. Discursive participants may have their opinions challenged, and even changed, but they enter into, and depart from, discourse as ontologically stable agents. Habermas implies that as rational subjects we respond only to the "illocutionary force" of the better argument or "good reasons."[8]

But what precisely makes an argument "good"? With reference to what, or whose, standard, values, or interest is this superior strength or legitimacy determined? Further, what incentive do all these forceful speakers have to suspend their suasive campaigning in order to simply listen? How do we differentiate an assent won by rhetorical attrition from true understanding? One set of answers can be found in attempts to define a distinctly feminist model of epistemology. In their study *Women's Ways of Knowing* (1986) Mary Field Belenky and her co-authors identify what they term "connected knowing"; a form of knowledge based not on counterposed arguments, but on a conversational mode in which each interlocutor works to identify with the perspective of the others.[9] This "procedural" form of knowledge is defined by two interrelated elements. First, it is concerned with recognizing the social imbeddedness and context within which others speak, judge, and act. Rather than holding them accountable to some ideal or generalized standard, it attempts to situate a given discursive statement in the specific material conditions of the speaker. This involves a recognition of the speakers' history and their positions relative to modes of social, political, and cultural power both within the discursive situation and

outside it (thus acknowledging the operative force of the oppression and inequality that is ostensibly bracketed – and hence disavowed – in the Habermasian public sphere).

The second characteristic of connected knowing involves the redefinition of discursive interaction in terms of empathetic identification. Rather than entering into communicative exchange with the goal of representing "self" through the advancement of already formed opinions and judgments, a connected knowledge is grounded in our capacity to identify with other people. It is through empathy that we can learn literally to redefine self: to both know and feel our connectedness with others. In a follow-up volume to *Women's Ways of Knowing* (*Knowledge, Difference and Power*, 1996), Patrocinio Schweickart notes Habermas's tendency to "overvalue" argumentation as a form of knowledge production, pointing to his inability to conceive of listening itself as as active, productive, and complex as speaking: "there is no recognition of the necessity to give an account of listening as doing something . . . the listener is reduced in Habermas's theory to the minimal quasi-speaking role of agreeing or disagreeing, silently *saying* yes or no."[10]

Empathy is, of course, subject to its own kind of ethical and epistemological abuse. However, a concept of empathetic insight is a necessary component of a dialogical aesthetic. Precisely the pragmatic, physical process of collaborative production that occurs in the works I'm discussing (involving both verbal and bodily interaction) can help to generate this insight, while at the same time allowing for a discursive exchange that can acknowledge, rather than exile, the non-verbal. This empathetic insight can be produced along a series of axes. The first occurs in the rapport between artists and their collaborators, especially in those situations in which the artist is working across boundaries of race, ethnicity, gender, sexuality, or class. These relationships can be quite difficult to negotiate equitably, as the artist often operates as an outsider, occupying a position of perceived cultural authority. This second axis of empathetic insight occurs among the collaborators themselves (with or without the mediating figure of the artist). Here the dialogical project can function to enhance solidarity among individuals who already share a common set of material and cultural circumstances (e.g., work with trade unions by artists such as Fred Lonidier in California or Carole Condé and Karl Beveridge in Canada). The final axis is produced between the collaborators and other communities of viewers (often subsequent to the actual production of a given project). Dialogical works can challenge dominant representations of a given community, and create a more complex understanding of, and empathy for, that community among a broader public. Of course, these three functions – solidarity creation, solidarity enhancement, and the counter-hegemonic – seldom exist in isolation. Any given project will typically operate in multiple registers.

Suzanne Lacy's *The Roof is on Fire* project, which I discussed earlier, provides a useful example of collaboratively generated empathetic insight. In *The Roof is on Fire*, the space of the car, and the performative nature of the piece itself, provided the students with a stage on which to speak to each other as co-inhabitants of a specific culture and environment and, implicitly, to a generalized audience (whether the actual audience of more than 1,000 residents who attended the performance or the

viewing public that saw coverage of the piece in the local and national media) that could function as a rhetorical stand-in for a dominant culture that is far more comfortable telling young people of color what to think than it is with hearing what they have to say. The process of listening that is of such central importance in dialogical projects is evidenced here both in Lacy's extensive discussions with the students in developing the project and in the attitude of openness encouraged in the viewer/ overhearer by the work itself.

On the one hand, this project demonstrates the empathetic and collaborative insight generated between Lacy and young people from quite different cultural backgrounds (and among the young people themselves). At the same time, it provides a space for identification between the students and the viewers of the work. One of the by-products of the performance, in which Lacy's collaborators consistently expressed their concern over confrontations with the police in their daily lives, was a series of discussions between police and young people in Oakland that took place over several weeks. Lacy's goal was to create a "safe" discursive space (somewhat reminiscent of Wochenklausur's boat trips) in which young people could speak honestly to the police about their fears and concerns, and in which both police and young people could begin to identify with each other as individuals rather than abstractions (the "gangsta" or the "cop"). As Lacy writes: "The changes in body language of the ten officers and fifteen youth who met weekly over two months marked a transition from stereotypes to dimensional personalities. I found my own perceptions changing as I encountered police in cars and young people in baggy jeans. Were they one of my friends, someone I know?"[11]

Criticism and Collectivity

Dialogical practices require a common discursive matrix (linguistic, textual, physical, etc.) through which participants can share insights, and forge a provisional sense of collectivity. As I pointed out in the introduction, however, forms of collective identity are anathema to the avant-garde tradition. "The idea of community," according to Critical Art Ensemble, "is without doubt the liberal equivalent of the conservative notion of 'family values' – neither exists in contemporary culture and both are grounded in political fantasy."[12] There is, of course, good reason to remain skeptical of essentialist models of community that require the assertion of a monolithic collectivity over and against the specific identities of its constituent members, and those who are seen as outside its (arbitrary) boundaries. There is a somewhat Manichean quality to some of these criticisms, however, as they establish an extremely stringent standard for politically acceptable models of collective experience and action. Any attempt to operate through a shared identity (the "Gay Community," the "Chicano Community," etc.) is condemned as a surrender to the ontological equivalent of kitsch. In her recent book *One Place after Another*, critic Miwon Kwon evokes a stark contrast between "bureaucratic" community art projects that engage in

proscribed forms of political representation and agency (the "community of mythic unity" as she describes it), and an art practice that is concerned precisely with calling community into question through a critical epiphany intended to produce non-essentialist subjects.[13]

If all collective identities are inherently corrupt, then the only legitimate goal of collaborative practice is to challenge or unsettle the viewer's reliance on precisely such forms of identification. I would contend that identity is somewhat more complex than this formulation allows, and that it is possible to define oneself through solidarity with others while at the same time recognizing the contingent nature of this identification. A recent project by the Nigerian artist Toro Adeniran Kane (Mama 'Toro) demonstrates the capacity of tightly knit communities to approach difference from a position of dialogical openness rather than defensive hostility, forming provisional alliances across boundaries of race, ethnicity, and geography. The project, *A Better Life for Rural Women*, was created as part of the "ArtBarns: After Kurt Schwitters" exhibition organized in the UK by Projects Environment (now Littoral) in the summer of 1999. 'Toro was born and raised in Nigeria, but has been living in Manchester for many years. The ArtBarns project was inspired by the existence of a Kurt Schwitters installation, produced during his exile in England during WWII, in a barn located on a Lancashire farm. A number of artists were given the opportunity to produce site-specific works in barns in the hill-farming region of the Bowland Forest. For her

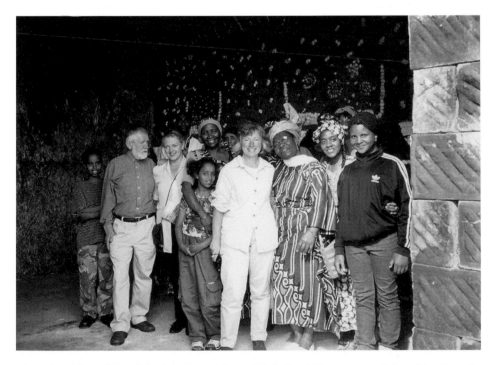

Figure 6.2 Mama 'Toro Adeniran Kane, *A Better Life for Rural Women*, commissioned by Littoral Arts for ArtBarns: After Kurt Schwitters, Forest of Bowland, Lancashire, 1999. Courtesy of Littoral Arts and Mama 'Toro Adeniran Kane.

ArtBarns project, 'Toro (working with Manchester artist Nick Fry) used the traditions of Nigerian wall painting to transform the barn interior into a performance space which was used for a variety of dances and other activities by African women who traveled to Bowland from Manchester during the course of the exhibition (Manchester has a large African immigrant population).

It is important to note that 'Toro defined her role as an artist not simply in terms of the creation of the wall painting, but also through the facilitation of dialogical exchange. This performative dimension was amplified through a series of conversations that took place between women from Manchester's African community and the hill-farming families. These dialogues, which were held in the kitchen of one of the farms, led to the shared recognition that the hill-farming community and the African immigrant community had much in common. Many of the women came from small farming villages in Somalia, Nigeria, and the Sudan and were more familiar with the rhythms of work and life in the Bowland Forest than they were with the urbanized lifestyle of Manchester. In this exchange neither the hill farmers nor the women from Manchester felt compelled to surrender their existing identities (of nationality, race, ethnicity, etc.) in order to constitute a new, provisional community based around their shared material circumstances and experiences (the spatio-cultural context of the farming village).

A frequent topic of discussion in these dialogues was the limited access that the African women had to fresh produce. Living in Manchester, they were often forced to shop at over-priced grocery stores filled with pre-packaged and refined food, and little in the way of fresh vegetables and other staples that would have formed the core of their diet back home. They were particularly concerned about growing health problems in Manchester's African immigrant community due to this restricted diet. One of the concrete outcomes of their conversations in Bowland was the formation of a buying cooperative that would allow them to purchase food directly from the farming community there, thus saving the farmers the money that would have been lost to middle-men, and insuring the women access to fresh produce at a reasonable cost.[14] Collective identities are not only, or always, essentializing. In this project the African immigrant and hill-farming communities were able to retain a coherent sense of cultural and political identity while also remaining open to the transformative effects of difference through dialogical exchange. 'Toro's project, along with recent works by Ala Plastica, Ernesto Noriega, Littoral, Temporary Services, and Wochenklausur, among others, suggest a more nuanced model of collective identity and action; one that steers cautiously between the Scylla of essentialist closure and the Charybdis of a rootless skepticism.

Notes

1 In recent years this work has begun to attract the attention of the mainstream art world, as evidenced by curator Okwui Enwezor's inclusion of the Senegalese collective Huit Facettes in Documenta XI (2002).

2 Lacy develops the idea of "new genre" public art in *Mapping the Terrain: New Genre Public Art* (Seattle: Bay Press, 1995). The term "Littoral" is taken from a series of conferences organized over the last several years. For more information, see the Littoral website: <http://www.littoral.org.uk/index.htm>. Also see Nicolas Bourriaud, *L'Esthétique relationnelle* (Dijon: Les Presses du Réel, 1998), Homi K. Bhabha, "Conversational Art," in *Conversations at the Castle: Changing Audiences and Contemporary Art*, ed. Mary Jane Jacobs, with Michael Brenson (Cambridge: MIT Press, 1998), pp. 38–47, and Tom Finkelpearl, "Five Dialogues on Dialogue-Based Public Art Projects," in *Dialogues in Public Art* (Cambridge: MIT Press, 2000), pp. 270–5.

3 See Mikhail Bakhtin, "Author and Hero in Aesthetic Activity" and "Art and Answerability," in *Art and Answerability: Early Philosophical Essays* by M. M. Bakhtin, ed. Michael Holquist and Vadim Liapunov, trans. and notes by Vadim Liapunov, supplement trans. Kenneth Brostrom (Austin: University of Texas Press, 1990). Critic Suzi Gablik develops the concept of a "dialogical" approach to art-making in her book *The Reenchantment of Art* (New York: Thames and Hudson, 1991).

4 This attitude is not confined to writing on more conventional media. Here is critic Gene Youngblood discussing the aesthetics of digital video: "we need only remember that art and communication are fundamentally at cross-purposes . . . art is always non-communicative: it is about personal vision and autonomy; its aim is to produce non-standard observers." Gene Youngblood, "Video and the Cinematic Enterprise" (1984) in *Ars Electronica: Facing the Future, a Survey of Two Decades*, ed. Timothy Druckrey with Ars Electronica (Cambridge: MIT Press, 1999), p. 43.

5 Jürgen Habermas, "Discourse Ethics: Notes on a Program of Philosophical Justification," in *Moral Consciousness and Communicative Action*, trans. Christian Lenhardt and Shierry Weber Nicholson (Cambridge, MA: MIT Press, 1991), p. 89. In his essay "The Gift in Littoral Art Practice," Bruce Barber uses Habermas's concept of "communicative action" to elucidate recent projects by Wochenklausur, REPO History, Istvan Kantor, and others. Versions of this essay have been published in *Fuse* 19, 2 (Winter 1996) and in *Intervention: Post-Object and Performance Art in New Zealand in 1970 and Beyond*, ed. Jennifer Hay (Christchurch: Robert MacDougall Art Gallery and Annex Press, 2000), pp. 49–58.

6 Jürgen Habermas, "Justice and Solidarity," *Philosophical Forum* 21 (1989–90): 47.

7 Mark Warren describes this as the "self-transformation" thesis in Habermas's work. Mark E. Warren, "The Self in Discursive Democracy," in *The Cambridge Companion to Habermas*, ed. Stephen K. White (Cambridge: Cambridge University Press, 1995), pp. 172, 178.

8 See Jürgen Habermas, "Some Distinctions in Universal Pragmatics," *Theory and Society* 3 (1976): 155–67, and "Discourse Ethics: Notes on a Program of Philosophical Justification," p. 90.

9 Mary Field Belenky, Blythe McVicker Clinchy, Nancy Rule Goldberger, and Jill Mattuck Tarule, *Women's Ways of Knowing: The Development of Self, Voice and Mind* (New York: Basic Books, 1986).

10 Patrocinio P. Schweickart, "Speech is Silver, Silence is Gold: The Asymmetrical Intersubjectivity of Communicative Action," in *Knowledge, Difference and Power: Essays Inspired by Women's Ways of Knowing*, ed. Nancy Rule Goldberger, Jill Mattuck Tarule, Blythe McVicker Clinchy, and Mary Field Belenky (New York: Basic Books, 1996), p. 317.

11 Suzanne Lacy, "The Roof is on Fire," at the National Endowment for the Arts website: <http://204.178.35.192/artforms/Museums/Lacy.html>

12 Critical Art Ensemble, "Observations on Collective Cultural Action," *Variant* 15 (summer 2002): <http://www.variant.ndtilda.co.uk/15texts/cae.html>

13 Miwon Kwon, *One Place After Another: Site Specific Art and Locational Identity* (Cambridge: MIT Press, 2002), p. 118.

14 The Bowland Initiative, a government-funded hill-farming support agency, has given Littoral and 'Toro a contract to develop "Healthy Farms and Healthy Foods," a marketing and cultural exchange program designed to expand on the urban/rural exchanges that 'Toro initiated with her ArtBarns work. See the Littoral website: <http://www.littoral.org.uk/>

7 "yBa" as Critique

The Socio-Political Inferences of the Mediated Identity of Recent British Art

James Gaywood

T his text aims to expose some of the mechanisms and premeditations that organise the scene of the "yBa" ("young British artist") prior to its reception by an audience of consumers.

I am suggesting that in relation to "other realities" the "yBa" is a critique upon itself: relying on "endgame" aesthetics bound up in a "postmodern" cycle, the presence of "others" undoes the westernist "endgame" concept necessitating critical analysis of the construction of the generalising term "yBa" and its appropriation of a transformational "readymade" aesthetic (after Duchamp). That "yBa" is socially inactive, but employs a pastiche referring to "egalitarian" art, is problematic.

Introduction

The thing about "Freeze" is you have to question a lot of people to find anyone who actually saw the shows!

(M. Currah, interviewed)

That the "Freeze" shows, of which there were actually three ("Freeze", "Modern Medicine" and "Gambler", set in empty industrial London dockland sites, restored for the short durations of the self-curated events), have become mythologised as the take-off point for the first generation of "yBa" is representative of much in their

From *Third Text* 40 (autumn 1997): 3–12.

mediated history. At that time, in 1988, a consolidated "Thatcher's Britain" comprising the reintegration of the ideological principles of the bourgeois lexicon in the form of neo-liberal individualism[1] was the setting that told the "Freeze" participants that "there was a market for art".[2] The demise of the welfare state and art's public funding supplanted the sense of social and moral responsibility to make "egalitarian" or socially critical artworks,[3] and engendered a shyness on the part of the galleries faced with cutbacks to risk further "punishment" by showing politically contentious work.

Into this arena emerged the highly motivated and self-organising students concentrated around Goldsmiths' College Fine Art department, realising the need for self-promotion, and putting the emphasis on being "professional not 'alternative'".[4] Their neo-Formalist return to a "white cube" situation reintroduced a stylish aspect to their work for metropolitan audiences confronted by its explicitly commodified aesthetic; thus the sociopolitical environment had engendered a new wave of attention-seeking survivalists.

As an overtly publicising group it is hardly surprising that such a breadth of media reference to them now exists. Perhaps that has been one of the motivations behind propagating the generalising term "yBa" used in their mediation with audiences.

But as a mediated term, "yBa" is not impotent, and indeed has come to embody a range of contextual associations implicit in the phenomenalisation: '60s youth culture and pop music; kitsch; "Punk" and subculturalism; the characterisation of "bad boys" and "bad girls"; all of this the product of a mediated codification, at a time of rampant consumerism. The mediation of art has the potential to increase the orbit of visibility of an "object" in relation to its reception by audiences. Mediation is a commercial exercise and as such "images" are its commodities. Logically, then, the relationship between art and consumerism is obvious and overt; however, the processes involved are highly convoluted and contradictory, relating art history, a-historical postmodern theory, consumerism and so on, and indeed it is often those very contradictions that become utilised in the justification of the "error".

To avoid making specific value judgements in relation to individual artists and works of art (a subjective flaw of art criticism) an anthropological perspective provides a more general sociocultural analysis. Therefore, rather than reproducing the phenomenalisation embodied in the highly connoted "yBa" term, I shall refer to those artists of the "Freeze" exhibitions as the "Boomers". However, in order to distinguish them from the similarly characterised 1950s baby-boom generation, but concurrently to acknowledge their presence (in that many of those babies, born into a transitional and declining modernism, are now contemporarily influential and fully-fledged postmodern semiologists!) I will describe them as the "New-Boomers" ("NBs").

Readymade History

In 1917, Marcel Duchamp's infamous placing of a "readymade" object of mass production, a ceramic urinal, into the context of a gallery was a determined challenge to

the structure of art's epistemology. Entitled *Fountain* and signed "R. Mutt" by the artist, the commonplace urinal was attributed an artistic value, exposing mechanisms by which art even renders irreproducible the mass-reproduced objects of Fordist modernity.[5] Lévi-Strauss describes this act of juxtaposing the signified aspect of the mass-produced urinal against the gallery context as a "semantic fission", thus the object's (sign's) signified aspect is encoded as a new set of relevances.[6] The question, "what constitutes Art?"[7] was a strategic counter to modernism's reductive ideology, exposing its practice of objectifying and valorising "auratic" art.

Duchamp's work is often cited as having particular reference to that of the "NBs". However, one observes discrepancies in the relationship between the motivations behind their more recent appropriation compared with Duchamp's prior model. In *Technique Anglaise* (a text now synonymous with the first generation "NBs" work), Lynne Cook suggests that "For many artists the key starting points are somewhere around Duchamp, but not Duchamp who questions what art is".[8] Since the "NBs" work is embedded in the very corporate system that Duchamp was attempting to subvert, the appropriation of the "readymade" rather expresses its manifest aesthetic appearance as an object of mass-production that today superimposes the notion of originality, reality or historical identity. A second aspect of the "readymade", its "transgressive" mode (emanating from Surrealist and Dadaist "avant-gardist" referral to non-western "Mentalite Primitive" [sic][9] with its suggested potential to access some liberated sense of "self", ideologically repressed by secular western economies) is more frequently retained in the "NBs" work, articulating the sense of uncertainty[10] that is perhaps an inherent aspect of (non)participation within a postmodern pluralist society. Again, however, overt appropriation of avant-garde technique, brought back into the fold of consumable art, could be criticised for its misrepresentation of the former practice. Cynically one could suggest that the "value" of the alignment with a historical genre justifies the current work, prior to any analysis of its "usefulness" in relation to that history. To infer "Duchamp-ianism" is to manipulate his own authorship-denying intentions.

Such contradictions seem to emerge from the organising mechanisms of the postmodern matrix of commercialism and mediation, and indeed the phenomenalisation of the "NBs" as "yBas" provides an explicit example of the reproducing nature of the postmodern beast: the epoch and its mediational agent symbiotically thriving off each other's nurturing of their phenomenalised constructions.

Postmodernity's (dis)organising terminology has not been exempt from commodification. As a philosophical deviation espousing the language of fashion, capitalism and image, the commercial motivations manifesting this mediated culture have engendered an image-oriented aesthetic focusing upon surface and pastiche. "Style" is one dominant feature relative to the commodity potential of images. However, insofar as "style is a refusal"[11] – a counter-hegemonic sub-cultural subversion to ideological power – and insofar as postmodernity is also characterised as "relativist" (denying oppositionality), so the appropriation of styles is the means by which images are constructed in a period "devoid of ideological antagonism".[12] So to stylise "NBs" as "yBas", to refer to subcultural, situationist and "punkish" practice, is to

valorise their mediated representation of "youth culture" through the misapplication of essences of "avant-gardism". Original avant-gardist exemplars the Dadaists and Surrealists were implicitly anti-style, rejecting the teleological succession of styles and techniques "à la Modernism", replacing it with a "simultaneity of the radically different".[13] A postmodern replication of non-stylistic intent is the signifying memory of its prior example rather than the "refusal" or rejection of style by "avant-gardism". Style's critical essence is covertly glossed through mediation, replaced by a suggestion of radicalism, innovation and fashion.

Furthermore, it has been suggested that avant-gardism is incommensurable with postmodernism.[14] Contemporary relativist intent contradicts avant-gardism's appositional politics of art invoked in culture. Such theoretical conclusions are thoroughly ignored in those (non)critical analyses that refer to "NBs" "avant-gardist" technique; presumptions purporting to analyse a group imbibed with contextual reference through the utilisation of "kitsch" and the style relation have little to do with the very currency of signs and ideas that give the group its referential form. Either the artist's a-historical approach has engendered a superficial pastiche of the signifying aspect of the sign (the artwork) (a naive representation, or a covert manipulation of their own historical reference the latter context denied in overt terms in order to provide justification for the commercially ripe postmodern pastiche); or else the mediated representation of that history has been thoroughly unrepresentative of the original mandate of "avant-gardism" and its unsuitability for application today. This suggests that perceptions of fresh innovation have been constructed in the media and not validated in the field. Interestingly, journalists are those perhaps most likely to benefit from an a-historical approach. Regular turn-overs of non-truths engender the space for creating media characters with fictional histories represented in only the most superficial, scandalous and sellable ways. Damien Hirst's bypassing of the critics in the promotion of "Freeze" toward populist mediation and private funding resources was a highly astute move on his part, sensing perhaps the demise of "genuine" art criticism, in the face of increasing popularism, and at a time of late '80s "booming" optimism. Hirst's subsequent success as a media figure has been extraordinary; they love him, and his naughty ways . . . WE ALL DO! [See plates 3 and 4.]

Reproducing Signs

The saturation of our material lives by the objects of mass culture ensures that the appropriation of a "readymade" aesthetic is reproductive of that cultural predicament. Objects' relative values refer partly to individual taste, social distinction, and the valorising influence of institutional acknowledgement. Bourdieu has highlighted the relationship between consumers' social positions, their ambitions on the hierarchical scale, and their *habitus* or "sense of place". Materialism, *habitus* and distinctions of taste are rendered interactive aspects of society and its culture. This situation provides an opportunity for low-value kitsch to be recoded as an object of high value

under the auspices of institutional appropriation and reinterpretation. The readymade, originally a tool for exposing this arbitrary attribution of aesthetic and commercial value, is used differently in the art of the "NBs"; their interpretative manipulation utilises the very commodity potential of which the readymade was the critique.

Collage, described by Damien Hirst as one of the "great and defining ideas of twentieth century art (originally by Kurt Schwitters), an organisation of already organised elements",[15] was again a drawing of attention to other realities beyond the ideocentric rationalism of reductive western modernism. Schwitter's manipulation of the commonplace and the everyday brings to mind the practice of Lévi-Strauss's non-progressivist *bricoleur*, and indeed collage techniques employed by Cubism and Duchamp's readymade were influences upon the development of that more recent anthropological conceptualisation. The characteristically pre-modern bricoleur and the modernist artist deal with signs: the latter in a gratuitous way "the autonomous signage of abstraction",[16] interiorising into "pure" painting the conceptual embodiment of the presence of the artist;[17] conversely the former's finite universe[18] renders found objects charged with the potential for more cultural significance engendering a "superabundance of objects, heavier, denser, and imbued with many things that we have eliminated from them".[19] Lévi-Strauss suggests that this culturally restricted sign currency communicates at a deep structural level the significances that preserve identity within and identification with that society through "conscious" symbolic signifying artworks.

The transgressive ambition of the readymade reiterates this desire to replace reductive modernist sociocultural determinants with some broader sense of "identity" within a deep structural matrix of social interactions, inferring unconscious "being". However, in the context of postmodernism, art production invokes the cultural superimposition of reproductions, where what is signified can only refer to a sign itself (in essence Baudrillard's "simulacrum"), disengaging the object from any historical precedent, engendering the justification for a multi-variety of surface interpretation. That "kitsch" may be aligned alongside a prior confrontational exercise is true, but its current usage is hardly "bricolage". Since transgression is confused in postmodern situations where the abolition of the subject renders a "sense of loss"[20] rather than an access to structural cohesion apocalyptic rather than generative the appropriation of signs engenders postmodern pastiche: "art as a complete imitation of objects incurring the loss of its (structural) sign function."[21]

Trash Art

Some of the mechanisms by which the economically durable category of institutionalised art is able to rarefy and subsume culturally devalued objects of kitsch are highlighted in Michael Thompson's "Rubbish Theory" (1979). Briefly the socially covert category of rubbish is hierarchically located amongst the conceptual order of overt commodities described as "durable" (of high value, relative scarcity and ideally

infinite life expectancy), and "transient" (of low value, being relatively common and of finite life expectancy). Thompson proposes that rubbish generates the displacement of objects on the relative value gradient and thus stimulates exchanges and shifts between value categories.[22] We have already seen how the art establishment's traditional puritanism and supposed ambivalence to commerciality was challenged by Duchamp's readymades. "Rubbish Theory" renders Duchamp's egalitarian practice bound to inevitable failure and commercial subsumation by that system he "subverts". Art's objects and its hierarchy of ideas exist relative to its epistemological orientation, thus all things called "Art" come under its discerning valorising gaze within this schema of the (re)production of durable commodities. Duchamp's application of displacement tactics, described by Thompson as "anomaly technique" (corresponding to Lévi-Strauss's "semantic fission"), is doomed to institutional absorption by its structural coexistence with the incorporative tactics of bourgeois appropriation; the "saming of the other".[23] By contrast, the "NBs" commodification of kitsch is overt.

To their credit, their recognition of the reaching of an "endgame terminus" that embodied the individualist ethics of the late '80s is concurrently representative of the failure of avant-garde attempts to destroy art with art. The neo-Formalism apparent in their group shows at that time takes the corporate bull by the horns and glorifies in its participation within the private sector, exposing the guts of the sacred cow (as it were) that "is", that always was, "Art". However, insofar as our deconstructed oxymoron of "egalitarian art" had been appropriated and reinterpreted as "popularism" during those socio-culturally disenfranchising years of late-Thatcherism, surely one must ask whether this manipulation of an intellectual stance, now released from historical determinacy, public support or social responsibility, is "acceptable"! As much as the "NBs" have been mediated by a distorting and manipulative commercial system that thrives off the image, and indeed the philosophical inevitability of the cultural saturation of images, they also present a disturbing ambivalence to the broader asocial inferences to which they are party. In a "globalising" world, reference only to the epistemic condition of western art and its frame of "post-industrial social and ideological disintegration", is unnervingly internalised.

Artist Susan Hiller describes the overwhelming western orientation of postmodernism's a-historicity, that although artists have never really been politically instrumental, just reflective, journalistic even, they should resist the temptation to caricature this aspect of their practice in favour of a genuinely meaningful critical art.[24]

Cash and *Habitus*

Bourdieu's analysis of the organising mechanisms perpetuating class hierarchy in society in relation to distinctions of taste is rooted in that most dense site of subjectivity, namely "Art". Works of art that are "legitimated" by taste distinctions maintain a reproducing system of interrelated economic and cultural capital. This latter, socially oriented value relation is manifested through class-associated qualities of

education and *habitus* that apexes with the intellectual class responsible for the epistemological acknowledgement and overt valorisation of that art termed exceptional and of historical importance. *Habitus* (best characterised in the idea of the family) engenders the "commonsense-ness" and the "naturalness" of one's standards of taste, thus cultural manifestations that we sense we "admire" structurally refer to this relation between those social experiences determining taste "preferences" and the class organisation of our social experience. For instance, in generalising terms, whereas the bourgeois "expresses" financially in terms of a capitalist "exoticisation" (appropriating the "other", thus at once defining its "otherness" and concurrently inducing a "saming" within a culturally centripetal consumption process), the "connoisseur" of legitimate arts scorns the objectifying manner of bourgeois taste, having benefited from that self-perpetuating, élitist, unequal power-bias gained by generationally recurring good education and wealth.

The 1980s in Britain represented a period of most discernible financial reward to the middle classes. Their heightened social candidacy was "naturally" expressed through the purchase of rarefied cultural artefacts. However, in that the bourgeois *habitus* is rooted in low-brow culture associated with its objects of mass reproduction, their financial expression is the means by which such manifestations of their taste preferences are able to perform as "high art". In their utilisation of a kitsch aesthetic the "NBs" were participants within these organising mechanisms, relating a valorising art epistemology to capitalist appropriation, and so to the socio-economic power embodied within the socio-cultural experiences during a particular "a-historical present" that selectively mediates "styles" over depth of study. The "neo-bourgeois" simultaneously acknowledge their own structural *habitus*, and align themselves alongside a high-brow epistemology that has subsumed the "NBs" ironic postmodern snub to intellectuality, ideologically homogenising a structurally multi-perspectival audience to an appreciation of objectified surface pastiche an embodiment of those reproducing signs of late consumer capitalism.

Commerce's "green light" given in the 1980s provided the market with the means to subsume what it saw as "innovation" what the "NBs" produced as potential "opportunity". The determined commodification of their artwork describes a restriction upon "organic" creativity to its representative manifestation in the "sign-homology" (the idea of the nature of "Art", and of artist's signatory presence in the art object).[25]

The notion of the "NBs" counter-ideological subculturalism is clearly illusory. Those aspects presuming to acknowledge the "postmodern condition" of superficial communication are a form of persuasion invoked within a commodity system: that ideology of consumer capitalism. Trash is formalised via pop into disseminating "Art"; semiotics "a particular means for maintaining power".[26] This is not to suggest that the "NBs" are complicit in some grand ideological conspiracy, rather that the situation (of post-Thatcherite "individualism") imbues the notion of the inherent benefits of systemic participation.

"Style's" transient manifestation of pure signs engenders participants within this commercial matrix (by regression to the terms of an exoticising capitalist agenda) more vulnerable to succession by "newer" forms, as their own capacity to sustain a

supply to the "durable" category of art is called into question: superficially, when art that is representative of an explicit style orientation is challenged by a style change in the cultural environment.

Persuasive ideologies, invisibly embodied in systems of commerce, become explicated at Art's representational level. Postmodernism rejects ideology as false consciousness on the basis of there being no "truth criteria"; "authorial death" renounces autonomous representations of power and subjectivity, so "ideology" is deemed incommensurate with an epoch devoid of the essential motivational aspects of individual consciousness. However, the postmodern and intersupportive interests of consumer capitalism shield the power that creates the illusion of freedom in contemporary society; their presence necessitates awareness of its ideological influence.[27] The deconstruction of "NB's" practice, I suggest, clearly reiterates mediation's determined participation in this process.

Media Myths

That so many critics identify the non-identifiable nature of the "yBa" is perhaps typical of the situation. Sarah Kent in *Shark Infested Waters: The Saatchi Collection of British Art in the '90s* (1994) describes the group's diversity, having "no cosy coterie";[28] and in an *Art Monthly* text on the "yBa" Simon Ford notes, "as this fully formed mythological reading attests, commentary on the myth of the 'yBa' becomes part of the myth of the 'yBa'".[29] This condition of critical quasi-instability preserves the audience's attention, regenerating the sense of the group's volatility, its "chaotic" nature (operating within a slick formalised supporting framework).

Charles Saatchi's establishment of the selected "Young British Artist" shows since 1992 has been crucial to this mediated notion (and who better to mediate!) of a cohesive moment; "maybe the first movement to be created by a collector?" Ford suggests.[30] One would be forgiven for thinking that Saatchi's own preferred aesthetic would be affected by his advertising expertise, the epitome of a largely visual language of high resolution signification: an iconic format highly appropriate to broad dissemination. Saatchi's undoubted dedication to contemporary art practice should not detract from this influence in the world of information networking, dissemination and control. His cultural role embodies the relationship between the media's epistemology, commerce and art production. The conditions denoted by art in a mediated culture tend in a post-"modernist" society (exhausted of experimentation) to engender pastiche "our ubiquitous code".[31] Louisa Buck notes, "present day entrepreneurs may be nostalgic for some notion of the 'avant-garde' experimental in art, but that art often now has the status of orthodoxy".[32]

One recurrent theme of reported "NB" developments involves their use of "shock tactics", the "bad boy/girl" syndrome, referring to "avant-gardist" practice, and subcultural quasi-punk nostalgia. In *Technique Anglaise* Renton suggests that "a certain kind of irresponsibility seems to me to be a very key concept that brings all of these

people together".[33] Similarly, "pop" culture and the 1960s provides a "youth history" that is frequently appropriated. Like "Britpop", "yBa" determines a popular, nationalised identity. In *General Release*, the catalogue for the British Council supported "Young British Artist '95" show in Venice, we read: "For those in their 20s and early 30s the phenomenon of the 1960s . . . has a particular relevance for British cultural identity marking the point when Britain was acknowledged as possessing a contemporary culture."[34] Critically, Harvey describes the 1960s acting as a resource for contemporary cultural entrepreneurialism: "The cultural mass drew heavily upon the working class movement for its cultural identity . . . but the attack upon and decline of the latter from the early 1970s onwards cut loose the cultural mass which then shaped its own identity around its concerns with money, power, individualism, entrepreneurialism."[35] Harvey's statement unravels the underlying attempt by a national institution (the British Council) to extol an art's nationhood to overseas audiences. An art that has been re-appropriated a-historically, conditioned by mediation, and extolled by a governmental body: this is "subcultural", or "avant-garde"? Even the term "shocking" seems provisional upon prior vetting that is, after all, what the "selection" for shows is all about.

The pro-nationalising motivations behind art's postmodern epistemology subdue the given status of culturally diverse practice. "yBRITISHa's" categorisation precludes satisfactory multicultural representation. For instance, in *Shark Infested Waters*,[36] of 34 artists' photographs none represent any non-white racial group. Art's inherently élitist expression of social distinction describes its failure to portray British society correctly. Rather, ethnic representation upon the London art circuit is notoriously tokenist: a "parallel conjunction",[37] neo-exoticising "other's" marginalised practice apart from the "yBa" hub. Postmodernism's westernist hermeneutic overview excuses depoliticisation, contrary to the absolute need for a new multicultural politic.

Similarly reductive is the epistemological classification of "women's art". The "bad girls" characterise the most visible, mediated and objectifiable of "yBa" women's practice. Objectified women performing a "girlie" caricature through exaggeration of the androcentric excesses of tabloid imagery hardly energise an emancipatory feminist critique to which their work professes to refer. Excessive reproduction of such characterisations of women negates their critical faculty in a culture already thriving on excess, where covert mediational interest in objectifiable "packages" underlies the promotion of such (quasi)critical images.

Here, the Situationist notion of "spectacle" – "the guardian of sleep"[38] – emerges as another misappropriated subversive subcultural "yBa" reference. The Situationist's original mandate was to counter corporate urbanist cultural hegemony (capitalism's anaesthetising effect upon society through the mediated control of experience) by acts of revolutionary anti-establishmentarianism: to fight "spectacle" with (anti) "spectacle". However, whereas the original Situationist's spectacle intended anarchy, the glamorous theatricality of, for instance, Damien Hirst, is hardly truly subversive, but is, rather, reproductive of his stylised self-image.

Auge's critical analysis of the contemporary acceptance of this reproduction of the "non-place" – the world of illustration and quotation through which one passes to

reach the consumable – textually characterises the supermodernist "passeur" who surrenders identity to the "playing of roles" that "creates neither the singular identity nor relations, only solitude and similitude".[39] This threat of experientiality, the "Disneyland" of experience, in a (dys)utopian dream world, aims to subsume the interpretation of experience by superimposition of the expressive seductivity of objects. Coexisting with the power of mediated commodities, art is at once vulnerable to "precuperation" (covert recuperation prior to its materialisation, i.e. motivated by an external ideological force of which it is a part) as a commodified gesture of (non)refusal and (un)suggestion, and applied as a saturation of the image (prefigured by the "hype", mediation and market targeting) where that image is formulaic and the sign "all on the surface"; where the saturation is postmodern culture, shrouding capitalist, near-hegemonic intent.

Although far from the bubbly personalities of the "NBs", the "logical" limit of their practice materialises sub-expressive ideologies. Neil Postman's description of a media-saturated Huxleyan burlesque, where "we watch big brother"[40] via "infotainment", portrays the removal of any dialogical recourse to audience criticism, replaced by the simplified flow from the mediated expression of experience to the "viewer receiver". Postman's call for an understanding of the media's political and epistemological organisation is transferable to the popularist situation of the "NBs". That their mischievous grins seem, on the face of it, contemporarily autonomous, is challenged by their historical contradictions; embodied within their art's theoretical a-historical acknowledgement of pastiche, these contradictions are only challengeable upon recognition of the covert role of mediation. However inevitable the commercial recuperation of popular socially communicative art may seem into what is by definition a public arena, the critical energy provoking resistance to centripetal westernist epistemologies is the important governor upon reaching the terrifyingly "gleeful haze" of some supersaturated mediascape.

Conclusion

This broad analytical overview of the relative socio-cultural environment of current popular art practice has attempted to imply that the pressures of market processing (the mediational orientation both of the commercial popularity of the mythologised group and the idea of its group identity) to a large extent override the historical credibility of that work. Inconsistencies to misappropriated historical references are defined on the theoretical grounds of the "currency" of the view supporting a-historical cultural relativism. To suggest that the final contribution of "yBa" is in its reiteration, indeed embodiment of "endgame" is hardly culturally productive. However, that "endgame" itself is no solution; "yBa" offers no source for a solution, since the term's lack of "meaning", in the face of its forceful identification, can have no role other than as a mythologising badge of recognition. Clearly mediation's commercial orientation is fuelled by the accessibility of reduced "icons"; just as the significance of

much "good" art of the "NBs" is diluted by association with the bandwagonesque mass, so association with good art raises the perceived credibility of the poor.

This essay reiterates the solubility of the superficial face of cultural constructions in relation to their epistemological determinants, comprising relationships among social "givens": our acceptance of culture's "naturalness", and the value to commerce of such ideological imposition as a tool readily employed by those market forces that manipulate and replicate ideology by persuasive and coercive means. That Liam Gillick (from within the group) suggests "yBa" should be exempt from criticism on the grounds that criticism equals cynicism (and this comes from a "critic" remember!)[41] so not conducive to creativity[42] is both a highly traditional mythologisation of artists' practice, and a complicitous reiteration of (blind) faith in the motivations of the power set.

Epistemological analysis of mediation[43] is perhaps the only remaining governor over the supermodernist slide into an ever conflating experiential world of static, objectified, pure, commodified seduction. "Transfomation", then, has come a long way since Duchamp's early failure to perceive the depth of the structural connections between art and commerce, embodying as they do an inherent anti-egalitarian force (egalitarianism being a tenet of Duchamp's conceptualisation). That egalitarianism is a highly necessary ideal in the contemporary ubiquitous non-place is not in question. Social transformation's conflict with the constructed categories of capitalist culture necessitates critical deconstruction of its epistemological core. In that case, art within that scrutinises from without is an ambition that only a genuine non-local and critical practice could entertain.

Notes

1 Stuart Hall, *Critical Dialogues in Cultural Studies* (Routledge, London, 1996), p. 34.
2 A. Renton, *Technique Anglaise* (Thames and Hudson, London, 1991), p. 13.
3 R. Gott, "Where the Art is", *Weekend Guardian*, October 7, 1995, p. 36.
4 A. Gallaccio, "Meltdown", *Art Monthly* 4 (1996): 4.
5 D. Harvey, *The Condition of Post-Modernity* (Blackwells, USA, 1990), p. 125.
6 G. Charbonnier, *Conversations with Claude Lévi-Strauss* (Jonathan Cape, London, 1969), p. 93.
7 See R. E. Krauss, *Passages in Modern Sculpture* (MIT Press, Cambridge, MA, and London); first published in 1977 by the Viking Press; published simultaneously by Penguin Books Canada Ltd, p. 73.
8 Renton, *Technique Anglaise*, p. 20.
9 R. Krauss, *The Originality of the Avant-Garde and Other Modernist Myths* (MIT Press, Cambridge, MA, 1985), p. 75.
10 A. Wilson, "Out of Control", *Art Monthly* 6 (1994): 4.
11 D. Hebdige, *Subculture: The Meaning of Style* (Methuen, London, 1979), p. 2.
12 F. Jameson, "Postmodernism and Consumer Society", in H. Foster (ed.), *Postmodern Culture* (Pluto, London, 1993), p. 115.
13 M. Sarup, *Poststructuralism and Postmodernism* (Harvester Wheatsheaf, Hemel Hempstead, 1988), p. 142.

14 See J. Drucker, "Simulation/Spectacle: Beyond the Boundaries of the Old Avant-Garde and Exhausted Modernism", *Third Text* 22 (spring 1993): 3–16.

15 Wilson, "Out of Control", p. 7.

16 Charbonnier, *Conversations with Claude Lévi-Strauss*, p. 120.

17 M. Sarup, *Poststructuralism and Postmodernism*, p. 172.

18 C. Lévi-Strauss, *The Savage Mind* (Weidenfeld & Nicholson, London, 1989), p. 17.

19 Charbonnier, *Conversations with Claude Lévi-Strauss*, p. 84.

20 S. Kent, *Shark Infested Waters: The Saatchi Collection of British Art in the '90s* (Zwemmers, London, 1994), p. 9.

21 Charbonnier, *Conversations with Claude Lévi-Strauss*, p. 108.

22 Ibid., p. 117.

23 Hebdige, *Subculture*, p. 94.

24 See Susan Hiller, *Thinking About Art* (Manchester University Press, 1997).

25 Hebdige, *Subculture*, p. 113.

26 Charbonnier, *Conversations with Claude Lévi-Strauss*, p. 63.

27 D. Hawkes, *Ideology* (Routledge, London, 1996), p. 12.

28 Ibid., p. 6.

29 S. Ford, "Myth Making", *Art Monthly* 3 (1996): 5.

30 Ibid., p. 5.

31 H. Foster (ed.), *Postmodern Culture* (Pluto, London, 1993), p. xii; see also Jameson, "Postmodernism and Consumer Society", p. 111.

32 L. Buck and P. Dodd, *Relative Values* (BBC Publications, London, 1991), p. 74.

33 Renton, *Technique Anglaise*, p. 17; see also G. Burn, 'Hirst World", *Weekend Guardian*, September 1, 1996; J. Roberts, "Never Had it so Good", in *General Release* (British Council, London, 1995).

34 J. Roberts, "Never Had it so Good", p. 53.

35 Harvey, *The Condition of Postmodernity*, p. 348.

36 Kent, *Shark Infested Waters*.

37 M. Flecha, "Parallel Conjunctions", in *Art & Design*, profile 41 (Academy Group, London, 1995), p. 87.

38 H. Foster, *Recodings* (Bay Press, Seattle, 1985), p. 91.

39 M. Auge, *Non-Places: Introduction to the Anthropology of Supermodernity* (Verso, London, 1995), p. 103; see A. Wilson, "The Art Experience", in *Art Monthly* 10 (1995): 6.

40 N. Postman, *Amusing Ourselves to Death* (Methuen, London, 1995), p. 160.

41 L. Gillick, "When Are You Leaving?", in *Art & Design*, profile 41 (Academy Group, London, 1995), pp. 77, 81.

42 Ford, "Myth Making", p. 5.

43 Postman, *Amusing Ourselves to Death*, p. 160.

8 Video Projection

The Space Between Screens

Liz Kotz

How can we theorize the medium of video now, in the moment of its technological transformation – perhaps even its technical evanescence? Several years ago, I overheard a prominent curator acclaim the recent work of Tony Oursler, which used newly available data projectors to project footage of obsessively talking heads onto small, puppet-like props, making the animated figures eerily appear to chant and rant. In effect, Oursler's flickering sculptures took the small puppet-show dramas of his earlier videotapes, and moved them out into the gallery, where viewers could walk among the figures and encounter them in three-dimensional space and nearly lifelike scale. For the curator, Oursler's new projections succeeded in getting "beyond the box" – freeing video from its historical containment in the monitor or TV set. This long-standing desire of video art is not hard to understand: monitors are awkward, badly designed, and a constant reminder of the medium's links to broadcast television, domestic furniture, and all the degraded industrial uses of video technology. Mounted on the ubiquitous gray utility cart in institutional settings, monitors disrupt the gallery or museum space. Is it any wonder video is so often confined to the basement or the stairwell? Who among us would not prefer the luminous image freed from its ungainly technical support?

Although largely invisible in gallery-based art of the 1980s, by the mid-1990s video suddenly appeared everywhere, as increasingly monumental installations supplanted older, more modest forms like single-channel videotapes. In museum exhibitions, the divide became clear: while conventional tapes remain marginalized in physically segregated "screenings," installational and sculptural projects claim space on the main

Published here for the first time. Reproduced with kind permission of the author.

floor. Strolling through galleries, museum exhibitions, and the ubiquitous international festivals, artworld viewers now encounter all manner of electronically produced moving and still images that we refer to or recognize as "video." In physical presentation, these range from miniaturized hand-held gadgets and computer displays to closed-circuit systems and multi-screen projections that immerse viewers in room-sized image environments.

Projection – from the Latin *projectionem*, "a throwing forward, extension, projection" – indicates displacement, dislocation, transfer.[1] At its core, projection is a form of geometry modeled on properties of light rays: it allows us to plot, from a fixed point, any number of regulated correspondences between two planes or between a two-dimensional picture plane and three-dimensional space. As a means of rationalizing vision and space, projective geometry underpins perspectival rendering, cartography, and architecture. Yet the concept of projection can imply a relation in both space and time, and the term carries old figural resonances of changing and transmutation, as well as scheming and planning. Like light, projection carries inherent capacities for distortion and illusion as well as rational correspondence (by extension, the psycho-analytic concept implies a confusion between inside and outside, between interior psychic life and external reality). With roots going back to the seventeenth century, modern forms of "screen entertainment" rest on these ambivalences, harnessing what film historian Charles Musser terms those "magical arts in which observers confused the 'lifelike' image with life itself."[2] By their nature, projected images elicit fantasy: we see things that are not there. And they elicit specific forms of spectatorship, engendering a psychic mobility paradoxically dependent on physical immobility.

In effect, techniques of projection offer ways of joining a space, an image and a subject. This relationship is curiously intertwined: not only does the fixed position of the viewer stabilize a system of visual relations, but decades of film theory have argued that the apparent unity and stability of this subject is itself a property of the optical system. While cinema most visibly demonstrates the power of this orchestration, its effects are everywhere in our culture. And while film exhibition remains confined to theatrical formats, severing the space of the image from other lived spaces, projected video potentially intersects these domains. With their greater mobility and technical flexibility, emerging video-based "screen practices" would seem to offer rich possibilities for rethinking and restructuring these core relationships – between viewing subject, moving or still image, architectural space, and time – that are so fundamental to modern visual culture.

In New York, the re-emergence of video projection reached a threshold around 1993, with a pair of exhibitions at David Zwirner Gallery that announced the spatial and sculptural ambitions of new work in video. In May, the Vancouver-based artist Stan Douglas presented *Hors-champs* (1992), an installation projecting two separate recordings of a free-jazz session onto opposite sides of a thin screen hanging diagonally across the middle of a room, empty except for two three-beam projectors mounted near the ceiling in opposite corners. It takes a viewer several minutes of circling around the work to register the differences between the two projections, which are loosely modeled on French verité-style television documentaries. As Scott

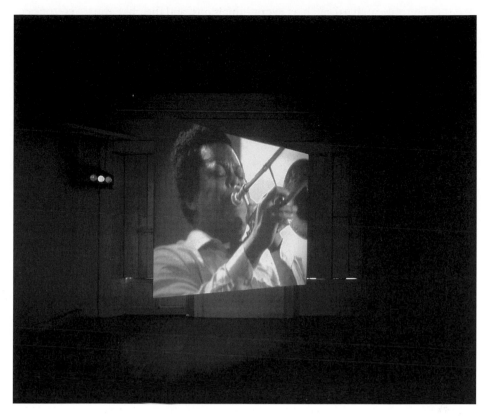

Figure 8.1 Stan Douglas, *Hors-champs*, 1992, two 2-sided CAV laser disks; 13:20 each rotation, edition of two, installation view at the ICA, London. September–October 1994. Courtesy of the artist and David Zwirner, New York.

Watson glosses the piece: "On one side is Douglas's film of a session shot in 1960s style. The camera tracks each musician as the individual players take up the themes of the music and play. For the other side of the screen Douglas made a tape of what look like out-takes, the camera dwelling on players at rest."[3] The work's title translates as "out of field" or "out of range," and as Douglas notes, the bifurcated screening "presents the spatialization of montage."[4]

In *Evening* (1994), Douglas continued the spatial juxtaposition of simultaneous tracks, projecting three fictional late 1960s newscasts side-by-side, causing their sound tracks to bleed and partly drown out one another. Using multiple screens to demarcate irreconcilable cultural spaces, both *Hors-champs* and *Evening* activate site and viewing position as spatial analogues of larger social topographies. Yet as subsequent projects attest, Douglas's deeper interest lies in recreating the codes and conventions of dominant media. Like photographer Jeff Wall, Douglas carefully restages and films scenes crafted to resemble historical artifacts, rather than using found footage. Over time, the technical virtuosity of these re-creations has propelled Douglas toward filmmaking proper. In a 1997 interview, he describes *Hors-champs* and *Evening* as his

"most sculptural . . . in as much as everything is in the room, like the three zones of sound in *Evening,* and the screen that you walk around in *Hors-champs,*" noting that his subsequent video projections have become "more like pictures, like old-time screen practice."[5] Douglas's more conventionally cinematic projects, from *Subject to Film: Marnie* (1989) to *Win, Place or Show* (1998), reveal his investments in the narrative and formal preoccupations of Hollywood, and stagier works, like *Der Sandmann* (1995), show pictorial preoccupations that lie closer to the staged photographic tableaux of Wall or Gregory Crewsdon than to the spatial or conceptual concerns of post-minimalist visual art.

Later that year, the Los Angeles-based artist Diana Thater presented *Late and Soon, Occident Trotting* (1993), a two-part projection that replicated the structure of her installation *Oo Fifi: Five Days in Claude Monet's Garden* (1992), shown in Santa Monica the previous fall [see plate 5]. In Zwirner's front room, psychedelically tinged landscape footage projected onto the gallery walls and out of the front windows toward the street. Covered in semi-transparent neutral density gels, the windows allowed ambient light in during the daytime – sometimes nearly washing out the projected footage – and permitted the projections to be glimpsed from outside. After nightfall, the silent pulsing patterns initially seemed to emanate from an empty club or dance space. As has become her custom, Thater threw the red, green, and blue beams of the projector out of calibration, distorting the colors and abstracting the image into overlapping series of monochrome fragments. In the back room, the second part of the installation inverted this schema, as three single-color projections converged to produce an off-kilter composite image.

Despite repeated nods to structural film, Thater's underlying formal and historical referents are closer to panoramic landscape painting. Using off-registration projection to render a sort of day-glow impressionism, Thater plays with the formal possibilities of ambient light and existing architecture. In contrast to the outdoor works of Krzystof Wodiczko, who in the 1980s was known for projecting politically charged transparencies onto buildings and monuments, Thater's "natural," landscape and quasi-pastoral motifs exclude public urban space and overt historical referents. While her projections explore the interpenetration of interior and exterior spaces in industrial architecture, they largely employ these as scenic backdrops rather than as historical sites or structural parameters. The displaced bourgeois interior of Monet's garden is emblematic of Thater's installations, which often orchestrate dispersed interactions with those who move through the space. Yet while writers celebrate the "built-in instabilities" that disrupt Thater's system – the "skewed projector lenses," "strobing color separations," and "'defective' optical apparatus" and "distorted image"[6] – they neglect the extent to which these instabilities are programmed, controlled, and designed to generate pictorial effects. Like Oursler, Thater insistently foregrounds her technical apparatus – strewing monitors, projectors, cables, and equipment throughout the space – precisely because these function as props. Although viewers' bodies may temporarily block the projected images, throwing shadows onto the wall, such interruptions do not alter the work in any significant way. Despite a certain minimalist-derived rhetoric, these "interactive" elements have little in common

with, for instance, early video sculptures like Bruce Nauman's 1970–1 corridors, which required viewers to enter a pared-down architectural structure in order to activate the work.

Nonetheless, in recent years sympathetic critics and curators have aggressively sought to position new work in video projection as reinvestigations of the phenomenological models articulated by artists of the late 1960s and early 1970s like Vito Acconci, Peter Campus, Dan Graham, and Nauman. While Douglas and Thater incorporate three-dimensional space and mobile spectators into their installations, their underlying structures derive from two-dimensional pictorial media (photography and painting, respectively) and not the procedural or durational structures that animated early video. Despite certain momentary resemblances to this earlier historical project, the pictorial and narrative orientation of artists like Douglas, Thater, Doug Aitken, and Douglas Gordon, for instance, aligns them all with the monumentally scaled color photographs of Jeff Wall, Cindy Sherman, or even Andreas Gursky [see plate 6]. It is no coincidence that Wall's work with enormous light boxes – staging a return to older pictorial functions with all the means of the contemporary mass media – is a touchstone for so many younger artists. With their carefully staged and mawkish "cinematic" tableaux, both large-scale photography and video projection are strategically suspended between the high culture aspirations of painting and the pop culture appeal of Hollywood. And both trajectories vector toward the large flat panel monitor or plasma screen – technical means of presenting luminescent fields of color that are, ultimately, high-tech paintings.

This proximity to painting and cinema is among the key attributes of video projection that make it such an appealing choice for contemporary artists. Technically, this shift was facilitated by the availability of smaller, cheaper portable video and data projectors in the early 1990s. Designed for sales and display applications, these devices no longer entailed the visual distortion, fully darkened rooms, and quasi-theatrical exhibition spaces associated with older three-beam systems. In effect, the new projectors freed the video image from its historical container, the box-like television monitor – and from its secondary siting, in box-like viewing rooms modeled on cinema. Unhinged from these sites and the spectatorial conventions they inscribe, video footage proliferated in all manner of new and hybrid configurations. For artists like Oursler, the new devices were a crucial enabling condition, allowing the projected image to go beyond the box that had so long contained it. And although both Douglas and Thater used older, three-beam systems, their installations dislodged projection from conventional "theatrical" settings and viewing conventions.[7]

Thater herself has called for work that would "allow video to speak about itself – in a language endemic to it. Just as the structuralist film makers used 'film' in such a way as to reveal a materiality, a shape and a form that characterize it, so we must be able to make the material 'video' speak of a signal, tape, camcorders, monitors and projectors."[8] Resorting to older modernist discourses of medium-specificity, Thater protests that video "played on a monitor like television . . . subordinates itself to the codes of another medium"[9] – strangely ignoring that TV founded video's "history and its language," even as video's forms and uses now extend far beyond the televisual.

This repression of the TV monitor and the medium's rather long entanglement with mass communication haunts work in video projection. While broadcast television derived from radio, not film, speech is curiously absent from what has become an emphatically pictorial practice. By configuring exhibition architecture to the size of the projection, artists de-emphasize the rectangular structure of the image, sidestepping their use of video as a surrogate "painting." The shift to the wall as a pre-existing frame not only naturalizes the rectangle via architecture, but also effaces the extent to which the structure of the tableau remains embedded in the very technology of video. Replacing a small box – the monitor – with a larger one – the room – hardly allows one to escape from the logic of the apparatus. By moving the mechanical device out of sight, projection routinely effaces the technology manifested in the monitor. Yet we can no longer convincingly turn to an older modernist strategy of "laying bare the device" as an antidote, since such displays have become mere mannerist gestures. As video technology moves toward incorporation into the wall and architectural container, artistic investigation of the medium must take this on.

However, the majority of recent video projections have moved toward cinema as content and form. For many artists, video itself is incidental, an efficient tool for delivering images, but not a medium per se. The narrative works of Eija Liisa Ahtila, Shirin Neshat, Sam Taylor-Wood, and Jane and Louise Wilson, for instance, harness video to generate new permutations of simultaneous, multi-screen cinema [see plate 7]. In recent years, critics have regularly bemoaned the confusing array of awkwardly partitioned and darkened rooms in which video is shown – most memorably in the complaints about the mazes of darkened cubicles with increasingly indistinguishable projection pieces that greeted the 1999 Venice Biennale. The ubiquitous "black box" format of contemporary exhibitions suggests that video technology has been assimilated back into older filmic conventions – while simultaneously assimilating film to mobile and ongoing, rather than stationary and event-based, forms of spectatorship.

Equipped with slow-scan and single-frame pause, video viewing invites us to re-read and reconstruct cinema – to break down the filmic flow, bring ephemeral passing frames to our attention, and recompose its pieces into other forms. Ken Jacobs's legendary *Tom, Tom, the Piper's Son* (1969/71) – a projection performance later concretized as a rephotographed found footage film – required years of painstaking labor with an analytic projector and optical printer. Contemporary technology now renders such procedures vastly easier, yet so many current projects of time-based "rephotography" – the countless British and Canadian artists reshooting or restaging fetishized moments in classical cinema, or replaying the outdated codes of postwar documentary photography in newer electronic media – remain banal academic exercises.

Gordon's *24-Hour Psycho* (1993) is perhaps emblematic of artworks that employ video technology to dissect classic films – in effect, replaying the classic moves of early 1980s photo-appropriation in a time-based medium. If the appeal of "postmodern" photography rested on its partial spectacularization of earlier conceptual practices, electronic image technologies allow artists to go all the way. Using his low-tech "eight track mix" (cropping, color-shifting, shooting out-of-focus, and so forth), Richard Prince framed and resequenced generic images from advertisements and amateur

sources. Working with familiar materials, he produced real discoveries. With projects drawn from John Ford's *The Searchers* (*Five Year Drive-By*, 1995) and Martin Scorsese's *Taxi Driver* (*through a looking glass*, 1999), Gordon has used video to arrest narrative and render its flow as a series of graspable instants and sustained durations. But these moves become formulaic, as Gordon brought increasingly arbitrary procedures to already canonical films – before his recent shift to original footage in *Play Dead; Real Time* (2003, shot *in situ* at Gagosian Gallery and projected life size). In a marked departure from his peers' aversion to more difficult "process" oriented operations, Steve McQueen's Documenta installation *Western Deep* (2002) compellingly introduced present-day historical experience (a nearly 25-minute descent into a Southern African diamond mine) into durational models drawn from experimental film and early video. In comparison, *24-Hour Psycho* reads like the fortuitous discovery of a late-night VCR addict. And Gordon's cultish ignorance of the avant-garde precedents that made his work possible furthers their institutional erasure.[10]

Besides providing a way to remake cinema, video allows artists to investigate projection itself as a kind of medium or material. Projection offers a seductive immateriality: the projected image both is and is not there. Recounting an early program of expanded cinema at the Film-Makers Cinematheque in 1965, Jonas Mekas noted the "almost mythic drive toward pure motion, color, light experience" that animated the work.[11] In video too, glowing beams of light spray color onto surfaces, yielding evanescent images seemingly freed from any technical support. And while TV monitors and theatrical film projection tend to position viewers in a relatively fixed, frontal relation to the image, environmentally scaled projections envelop viewers, allowing them to enter image spaces not overtly mediated by the formality of frame or screen.

In so doing, the immersive environments produced by video projection and new imaging technologies extend and reconfigure 1960s projects of "expanded cinema" that arose out of work in performance, experimental film, and kinetic sculpture. Coming out of multimedia happenings and environments, dancers and artists affiliated with New York's Judson Church used films, slides, and projections to accompany movement; their collage-based aesthetics tended to favor a profusion of images and overlays. At the same time, "structural" filmmakers like Tony Conrad, Ken Jacobs, Paul Sharits, and Michael Snow explored basic properties of the cinematographic apparatus, isolating every aspect – grain, filmstrip, frame, flicker, motion, screen, etc. – and subjecting them to sustained analysis and attention. In contrast to this medium-specific investigation of film, new "multimedia" artists like Stan Vanderbeek, Jordan Belson, and Scott Bartlett used multiple means – film, slides, light, motion, sound – to produce maximum sensory impact. In an optimistic embrace of new perceptual capacities that merged McLuhan-esque techno-futurism with hippie drug culture, 1960s light shows harnessed projection to create audio-visual analogues of hallucinatory states, collapsing exterior and interior worlds. Championing "the intermedia network of cinema and television, which now functions as nothing less than the nervous system of mankind," Gene Youngblood foresaw the perceptually enhanced synaesthesia of new electronic technologies replacing older art forms like painting,

and facilitating new forms of subjectivity in their wake: "when we say expanded cinema we actually mean expanded consciousness."[12]

As film historian David James has argued, the expanded cinema movement was organized around two poles: more formally oriented films providing "meditational practice or visionary experience" and ritualistic works "integrated into social situations more dynamic than those of the conventional theater."[13] Both these "visionary" and "social situation" models resurface forcefully in the present – witness the integration of video into the kinds of recreated social spaces that periodically inhabit art fairs, museums, and alternative spaces. Yet unlike their 1960s precursors, who sought technical means to generate new forms of collective life, current multimedia artists have largely appropriated pre-existing narrative models, commodity forms, and gallery-based exhibition formats.

However nostalgic they may seem, James's accounts of 1960s expanded cinema resonate uncannily with claims made for present-day video and multimedia: "Projection itself becomes the site of creativity," he asserts, "where the somatic passivity of theatrical consumption is replaced by ecstatic engagement."[14] "In place of the confining rectangle of the film frame and the closure of narrative . . . light shows offered a three-dimensional visual field, matrixed neither spatially nor temporally, which dispersed rather than unified subjectivity."[15] In this view, the new participatory spectacles held at counterculture venues and underground film spaces provided an atmosphere of collective improvisation and sensorial overload: "all combined in a continuously transforming, enveloping, pan-sensual experience that could be entered and exited at will" indistinguishable from "the interior projection of hallucination."[16] Nearly identical statements could be culled from critical texts on video installation, which unquestioningly assume that newly immersive media spectacles provide genuine forms of desubliminatory, anti-disciplinary experience. Repressing the very psychoanalytic and theoretical models they cite, recent art-critical accounts employ emphatically reductive understandings of the filmic apparatus, equating spectatorial position with a viewer's literal physical position – mobile, stationary, throwing a shadow on the image, etc.[17]

By now, we are perhaps all too familiar with the contradictions Walter Benjamin diagnosed more than 60 years ago between "exhibition value" and the aura-producing attributes of the fine art object. Yet the situation of video vis-à-vis the museum manifests a new set of structural conflicts, arising among different historical modes of "exhibition." As curator Chris Dercon suggests, part of the appeal that "media-oriented displays" hold for museums is their capacity to attract different audiences addressed as spectators by techniques drawn from popular entertainment, retail display, and information delivery.[18] But as museums stretch to accommodate new media forms, transforming conventional white cubes into ubiquitous black boxes, the high-tech formats of modern display culture merge awkwardly with the older forms of connoisseurship and exhibition value associated with unique objects. Presented by growing museum education and publicity industries as technological supplements to conventional exhibitions, an ever-expanding apparatus of audio tours, exhibition web sites, publications, and guides gradually supplant the objects on view.[19]

If earlier experimental film, video, and performance practices ostensibly sought to disturb the form and function of the gallery and museum – replacing a collectible unique object with a temporal experience that could be completely ephemeral or endlessly reproducible – newer, media-savvy art (including painting and sculpture) is designed for reproduction and display. Artists produce mural-sized video projections to fill the giant industrial spaces of contemporary museums, spaces themselves scaled to hold minimal and post-minimal sculpture. Of course, this move – art's active incorporation into the display apparatus of industry and media culture – is hardly new. It was Dan Graham, after all, who targeted art magazines as one of the crucial sites of contemporary art practice; and the reproductive- and publication-based forms of late 1960s conceptual and post-minimal art systematically set out to unravel the hierarchy between what the art dealer Seth Seigelaub once termed "primary information" (the actual art) and "secondary information" (its circulated representations). Yet in a publicity-driven artworld without any means of determining value except the market, a shrewd joining of technical skill, mannerist sensibility, and photogenic appeal prevails. It is hardly a coincidence that media artists often rely on "secondary" products, particularly color photographs, to subsidize their large-scale installations. Acutely stylized and designed for display, many recent video projections look staged to produce the striking color photos that will appear in magazines, catalogues and gallery back rooms. Present-day "ephemeral," "environmental," and "site-specific" art forms have their bases covered: like all good tourist attractions, they offer a complete line of subsidiary products for collectors to take home.

The awkward incorporation of video into the gallery and museum attests to a deeper shift: the larger assimilation of media art to display culture. It is perhaps a telling historical irony that the press response to Documenta XI (2002) so often berated the abundant films and videos as part of what one French critic termed "a very politically correct and fatally austere exhibition."[20] Despite the long association of media-based forms with some type of "critical" or politically oriented practice, current gallery-based video art is all too eager to please – even as this requires total submission to the dictates of spectacle culture. Early projects by artists like Acconci and Nauman re-enacted the subjective experience of late capitalism as endurance, submission, and disciplinary subjection. But when recycled by contemporary artists like Matthew Barney, even these durational tropes can be cleaned up, prettified, and made entertaining. The very reproductive media typically seen – in art critical discourses of the 1980s – to offer possibilities for a more critical, reflexive, and "demystifying" art practice may now be the avatars of the total embrace of spectacle (since entry into public art-critical discourse requires some degree of market success, in the 1990s even Martha Rosler started showing giant color prints). This trajectory for new work in video projection, however, was not initially apparent – nor is it as exclusive as the all-too-visible success of certain types of work might imply. After all, the early, lower-tech works of artists like Aitken, Barney, and Thater were initially embraced as efforts to integrate procedural and pictorial dimensions. And despite the rapid turn to monumentality, the period of 1993–4 also saw exhibitions of more demanding, durationally based video projections by Lutz Bacher, Steve McQueen, and Gillian

Wearing, whose work evidences deeper links with earlier minimalist and conceptual projects.

In an essay on video first published in the mid-1980s, the critic Fredric Jameson proposed that a "medium" is defined by the conjunction of three distinct components: "an artistic mode or specific form of aesthetic production"; "a specific technology, generally organized around a central apparatus or machine"; and "a social institution," including a set of vernacular forms, functions, or uses.[21] Unlike older forms such as painting, whose historically entrenched role stabilizes a relatively coherent field, for newer media these conditions perpetually go in and out of sync, producing different momentary formations of "video" that soon dissolve into technical obsolescence. The incessant technical mutations of what we might call its "material support" render efforts to define or theorize video particularly precarious – especially now, as videotape, monitor, and cathode-ray tube give way to DVDs, digital storage devices, and electronic screens. In the emerging world of "digital cinema," the differential specificity of video vis-à-vis film (and vice versa) all but disappears, as the necessary relations between recording, storage, editing, and release formats are eroded. How can video be a medium if it no longer has a central apparatus or machine, much less a specific form of aesthetic production or set of social/vernacular uses? We might follow Rosalind Krauss's early diagnosis and decide that video is not a medium at all, but merely a structure, the way that narcissism is a psychic structure.[22] Yet to do so seems to prematurely close down a still emerging form.

For anyone who has studied the history of early cinema – sometimes provocatively generalized into a "history of screen practice" – the present moment indeed seems uncannily familiar. As Charles Musser notes, moments of profound technological transformation and disruption tend to provoke trafficking with other media: "when the screen enters a period of flux, it is particularly receptive to new influences from other cultural forms."[23] Early in the twentieth century, the new motion picture adopted myriad exhibition formats, from panoramas and vaudeville shows to individualized, jukebox-like booths. Initially oscillating between peephole devices and projective formats, and between private viewing and collective spectatorship, cinema gradually achieved the codification of exhibition formats that grounds its current form. Musser argues that by its second decade, American narrative cinema "established a relation between producer, image and audience that has remained fundamentally unaltered ever since"[24] – a relation whose structure and limits are now rendered more apparent through the incursions of "interactive" and computer game models.

As Krauss has proposed in recent texts on "the post-medium condition" of contemporary artmaking, cinema manifests a fundamentally "aggregate" condition that cannot be reduced to its physical support:

> The medium or support for film being neither the celluloid strip of the images, nor the camera that filmed them, nor the projector that brings them to life in one motion, nor the beam of light that relays them to the screen, nor that screen itself, but all of these taken together, including the audience's position caught between the source of the light behind it and the image projected before our eyes.[25]

Precisely because of its internal complexity and variability, the cinematic apparatus offers a non-reductive means of understanding a medium as a set of procedures, structures, and operations – a kind of relation to the viewer – that allows artists to probe and articulate its structures in critical, compelling yet self-referential ways. This may be precisely what contemporary video lacks, in its quest for maximum "aesthetic impact" of a very different sort, one that harnesses the televisual capacity for the profuse diffusion of images – what Richard Dienst terms TV's "all encompassing putting-into-view of the world," producing "a field of near total instantaneous visibility"[26] – and that uses new digital and projective technologies to proliferate these throughout architectural space.

Such images find their natural home in the emerging world of "information architecture," in which every building functions as a kind of image, and every built surface promises to contain some type of networked display. As the newer flat screen technologies allow the picture to return to the space of the wall from which it had long ago been detached, it does not reinsert this image into a wall whose architectonic solidity and immobility remain intact. Indeed, one of the key lessons of decades of "experimental" architecture has been the historical interpenetration of the tectonic and the semiotic. A host of functions for the transmission of information, light, heat (properties of signage, windows, corporate logos, transparency, etc.) once peripheral to the structural, load-bearing capacities of the wall, have now been integrated into the building's interior and exterior surfaces. The emergence of public urban space as a computerized convergence of surveillance, communication, and entertainment might propel other critical projects in video, as artists attempt to address the internal structure of the electronic image and its mutating relation to new forms of architectural space and subjectivity.

New media theorist Lev Manovich argues that transcoding – the technical possibility of transferring an image or composition or "work" from one format to another – is "the most substantial consequence of the computerization of media."[27] Despite the lure of electronic transfer without loss, Manovich acknowledges the technical impossibility of absolute fidelity. What artists since John Cage have understood, however, is not merely that transfer and transcoding entail distortion, but that this breakdown, reprocessing, and information loss (which occurs across digital and analogue modes) is remarkably generative and productive. In Lutz Bacher's *Olympiad* (1997), for instance, a modestly scaled projection of a "corrupted" tape of a walk through the Olympic Stadium in Berlin displays myriad tracking problems and signal disruptions that erratically destabilize the video image. As the artist recounts, the resulting tape was "'resurrected' through reprocessing by a time-base corrector," leaving it playable only in black and white due to signal loss.[28] Drawing on the Cagean principle that "once anything happens it authentically is," Bacher embraces the artwork as a structure that can incorporate accident, damage, and decay. The difficulty of the work – its jarring perceptual disruption – results from the unanticipated investigation of the "degraded" video image and video signal, and "the ways in which these recurring technical breakdowns both enhance and disrupt the classical aspirations of the site." Nothing could be further from the mannerism of Thater's increasingly contrived

projection distortions, or Aitken's over-produced spectacles of post-apocalyptic collapse and decay, in which his own technology (after a crucial early piece) never fails or falters.[29]

In *Olympiad*, signal breakdown foregrounds the video image as a pixelated grid structure – technically termed the "raster" – bringing to mind visual art analogues like Sigmar Polke's 1960s "rasterbilder" ("dot paintings") or Warhol's early silkscreens, which systematically explore the strange poignancy produced by the image degradation. No mere pictorial device, the pixelated grid is the structure of the transmissible image. It is the matrix through which images must pass before they can inhabit the same surface as printed text; pixels also comprise the screen through which the two-dimensional image must pass before it can be transmitted electronically. As Dienst notes, the "transmission of a moving picture," by broadcast, metal wire, or laser technology, entails "the *de-screening* and *re-screening* of light through a video signal":

> What is transmitted, at the simplest level, is simply a stream of pulses that scan a field at a certain speed: light entering the camera hits a plate where it can be registered line by line, translating a two-dimensional spatial arrangement of light into a sequential signal. When this signal reaches the other end, it is translated back into a field by projecting the electrical intensities line by line onto another screen.[30]

In video, scanning and projection are means of translating electronic signals into a two-dimensional picture: what was previously inside the monitor (phosphorescent pixels on an enclosed glass screen) is now transferred to the larger container of the room/screen. As Dienst notes, "scanning mediates at both ends between visible screens and electrical currents; it is above all a way of translating and framing light as information."[31] Thus the pixel and scan lines are the visible mark of the intervention of technology and its abstracting effects (hence the very goal of "high definition" television is to repress this structure, to make video look more like film by reducing pixelation below the threshold of visibility). Video, as a temporally generated grid, produces a continual transformation of the image. Signal interference and disruption are integral to its workings, as are the decays and distortions introduced by recording and storage processes. It is in the interplay between this screen of scanning – that translates electrical signals into moving images – and the screen of projection – that transmits these optical images into architectural space – that video occurs. As we continue to wait for more artists to explore the many unpredictable things that happen there, perhaps we are beginning to see that the video projection work that was so celebrated during the last decade was less of a disruption of mass-media signal than a sign of the times.[32]

Notes

1 *Oxford English Dictionary*, 2nd edn. (1989), from *proicere*, *projicere* to throw forth, stretch out, expel, reject, give up, etc., from *pro* + *jacere* to throw.

2 *The Emergence of Cinema: The American Screen to 1907* (New York: Scribner, 1990), p. 16.

3 Scott Watson, "Against the Habitual," in *Stan Douglas* (London and New York: Phaidon, 1998), p. 59.

4 Stan Douglas, "Interview: Diana Thater in Conversation with Stan Douglas," in *Stan Douglas*, p. 12.

5 Ibid., p. 15.

6 See, for instance, Colin Gardner, "No Guarantees, They're Wolves: Structure, Movement and the Dystopic in Diana Thater's *China*," and Timothy Martin, "What Cyan said to Magenta about Yellow," in *Diana Thater: China* (Chicago: Renaissance Society, 1996).

7 Despite the limits of purely technical explanations, the availability of consumer equipment has been crucial. No longer requiring specialized technical training or expertise, video becomes "a tool like any other." Just as the postwar profusion of cheap 16 mm equipment and educational devices like analytic projectors opened a space for amateur and experimental filmmaking in the 1950s and 1960s, and the late 1970s availability of consumer-grade cameras and photo-processing helped liberate "artists using photography" (like Cindy Sherman and Richard Prince) from the codified domains of "fine art photography," the new array of camcorders, VCRs, and desktop editing systems helped propel video outside the ghettoized domains of "video art" that had consolidated by the 1980s in isolation from wider visual art practice.

8 Diana Thater, "I wanna be your dog," in *Diana Thater: China* (Chicago: Renaissance Society, 1996), p. 12.

9 Ibid., p. 11.

10 Particularly in the UK, a studied ignorance of the recent past seems to provide endless license to refashion viewer-friendly knockoffs in the present. While a degree of historical amnesia can sometimes free artists from blatant academicism, it also deprives them of the conceptual underpinnings of the strategies they use. For all the protests surrounding Martin Creed's 2001 Turner Prize for his installation *The Lights Going On and Off*, no one in the art press even noted the work's resemblance to early 1960s projects by artists George Brecht or David Tudor – both close affiliates of John Cage, who of course cleared the ground for such durational acts of emptiness. Embracing ignorance, successful younger artists all too often demonstrate their complicity with these patterns of historical erasure. It would be hard to imagine Los Angeles's Museum of Contemporary Art, which recently sponsored a retrospective of Douglas Gordon (then only 34), mounting career retrospectives of generative artists like James Benning, Simone Forti, or Yvonne Rainer. See Russell Ferguson, et al., *Douglas Gordon* (Los Angeles: Museum of Contemporary Art / Cambridge, MA: MIT Press, 2001).

11 Jonas Mekas, *Movie Journal: The Rise of a New American Cinema 1959–1971* (New York: Collier Books, 1972), p. 209.

12 Gene Youngblood, *Expanded Cinema* (New York: Dutton, 1970), p. 41.

13 David James, *Allegories of Cinema: American Film in the Sixties* (Princeton, NJ: Princeton University Press, 1989), p. 127. For James, the reconfigured exhibition formats and radically altered viewing experiences of the 1960s avant-garde represented a necessary extension of the New American Cinema's utopian project. Yet James's tendency to equate physical arrangements with social and psychic relations leads him to overestimate the liberatory potential of these "expanded" modes. Decrying the constrictive viewing booths that Austrian filmmaker Peter Kubelka designed for Anthology Film Archives, that "immobilized and imprisoned the spectator as a monadic visual consumer, repressing

even the social interaction allowed in the commercial theater," James applauds the improvisatory, utopian dimensions of expanded cinema: "Interrupting the history of cinema as authority and discipline, the multimedia light show discovered itself in a dance against somatic repression" (p. 132).

14 Ibid., p. 132.

15 Ibid., p. 134. Despite his apparent embrace of such liberatory rhetoric, James is well aware of the complex techno-futurist entanglements of expanded cinema: "The opening of the optical field, and the conceptual and kinetic liberation of the spectator within it, was often constructed as either analogous to or premonitory of" shifts in which "the engineering of consciousness would parallel developments in the electronic communications industries" (ibid.).

16 Ibid., p. 135.

17 Daniel Birnbaum, for instance, suggests that Doug Aitken's mobile camera work "pushes the viewer's subjectivity to the point where the phenomenological model of experience breaks down," arguing that, in Aitken's multi-screen installations: "This more complex space allows for the participation of the viewer but also brings the viewer's unity and stability into question. In works such as *electric earth* and *into the sun*, the complexity not only has to do with the multiple projections, but with the active involvement of viewers who decide their own pace when moving through the installations. Such kinesthetic and perceptual multiplicity can no longer be thought of in terms of a harmonious experiencing subject." ("That's the Only Now I Get: Space and Experience in the Work of Doug Aitken," in *Doug Aitken* (London: Phaidon, 2001), p. 67.) That even the most normative products of classical Hollywood cinema can hardly be said to produce such a "harmonious experiencing subject" seems to have escaped such commentators.

18 As Dercon notes, many museums prefer to collect the secondary pictorial and photographic objects of media-based artists, rather than their more complicated (and more physically demanding) media installations. He mentions Douglas and Barney in this context, and one could add many others. "Still A Novel," in *Still/MOVING* (Rotterdam and Tokyo: Foto Institut Netherland, 2001), pp. 28–31. Just as the current ascendance of photo-based art depended on escaping the narrow purviews (and limited budgets) of museum photography departments, a more central role for video, film, sound, and other media arts would require institutional reorganization as well as architectural reconfiguration.

19 As the Guggenheim organization circulates its old-fashioned assets (collections of unique objects) to generate new forms of exhibition and sign exchange value, it appears that a suitably glamorous architectural container – that ideal fusion of exhibition value and unique aura – outpaces whatever objects it happens to house at the moment. With star-driven programming clumsily modeled on the blockbuster logic and entertainment values of Hollywood movies and big-ticket amusement parks, museum exhibitions must either fully differentiate themselves from the disposable novelty of the mass media, or mimic their spectacular effects. Of course, the most reliable best-sellers – Van Gogh, Impressionist painters, or the semi-annual David Hockney exhibitions that are a fixture in Los Angeles – always succeed in having it both ways at once. For video art, the viewer-friendly technological sublime of Bill Viola and Gary Hill has long filled a similar role, albeit to smaller audiences.

20 Geneviève Breerette, "La Documenta ne rigole pas avec l'art, miroir des malheurs contemporains," *Le Monde*, June 19, 2002.

21 "Reading without Interpretation: Postmodernism and the Video-text" (1986), reprinted in *Postmodernism: Or the Cultural Logic of Late Capitalism* (Durham, NC: Duke University Press, 1991).

22 "Video: The Aesthetics of Narcissism," *October* 1, 1 (spring 1976), reprinted in Gregory Battcock, ed., *New Artists Video: A Critical Anthology* (New York: Dutton, 1978).

23 Musser, *The Emergence of Cinema: The American Screen to 1907*, p. 16.

24 Ibid., p. 19.

25 *"A Voyage on the North Sea"*: Art in the Age of the Post-Medium Condition (London: Thames & Hudson, 1999), pp. 24–5.

26 Richard Dienst, *Still Life in Real Time: Theory After Television* (Durham, NC: Duke University Press, 1994), pp. 4, 5.

27 Lev Manovich, *The Language of New Media* (Cambridge, MA: MIT Press, 2001), p. 45.

28 Bacher, unpublished notes (1998).

29 In *inflection* (1992), Aitken launched a small rocket with a film camera attached; the footage, played back on slow motion, records the blurry and enigmatic landscape viewed from the rocket's flight. As Daniel Birnbaum notes, "Here, essential elements of Aitken's work are already present: a moving vehicle; speed made tangible; an abstract landscape unfolding through contemporary technologies of vision" ("That's the Only Now I Get," p. 40). What he fails to note is that after this piece, accidental and process elements drop out of Aitken's work, replaced by the aestheticization of the ruin. And while Thater's early projects appear organized around unforeseen accidents introduced by process, technology, and site, such disruptions seem to recede in her recent, more technically polished works.

30 Dienst, *Still Life in Real Time*, p. 17.

31 Ibid., p. 21.

32 My thanks to Eric DeBruyn, Simon Leung, and Federico Windhausen for discussing these materials with me.

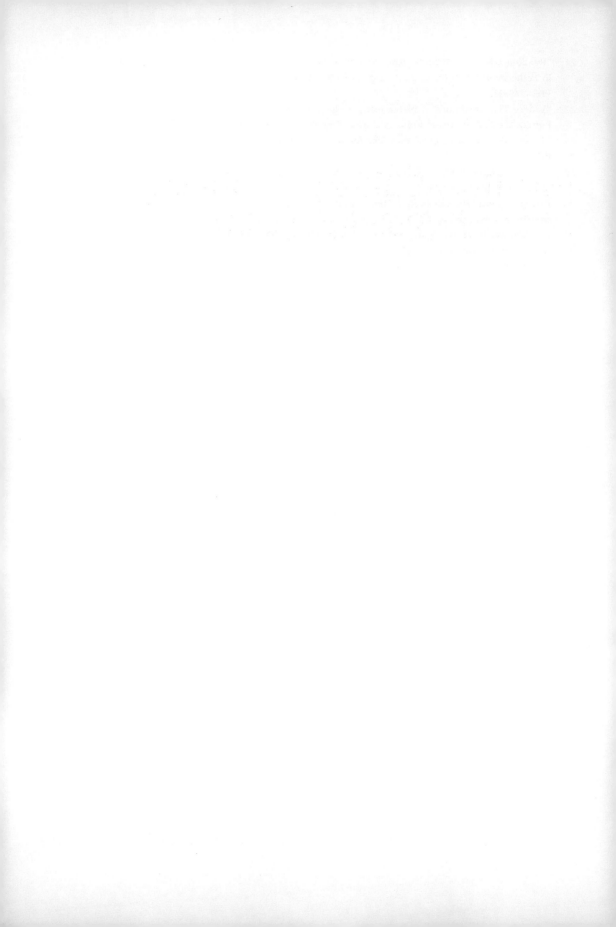

Part II Culture/Identities/ Political Fields

Introduction to Part II

For much of the art world within the US, the debates around the politics of representation so prevalent in the early 1980s had an uncanny political corollary in Ronald Reagan, the perfect 1950s throwback president in a postmodern age. But the division between the politics of representation and "real politics," fallacious at best, quickly became untenable as the decade moved on. By the middle of the decade the postmodern politics of representation, in the form of far-right cultural backlash, quickly became part of the everyday currency of "realpolitik" within the art world itself. For many, that was when the 1980s became the decade of AIDS and homelessness, heralding the felt effects of an all-encompassing conservative hegemony and the point at which the use of postmodern theory as an umbrella critique of the remains, failures, and utopianism of modernism became inadequate. Instead, postmodernism was recast as the theory of an operative ground for political agency in the transformation of culture, identities, and political fields.

Two of Carole Vance's "Four Essays on Art, Sexuality, and Cultural Politics" are republished here; they trace the trajectory of the conservative attack on art and sexual expression as they came to pass in the late 1980s and early '90s. The first, "The War on Culture," focuses on the manufacturing of controversies by conservative forces in highly publicized attacks on the National Endowment for the Arts (NEA). Vance identifies the motives of such attacks on the floor of the United States Senate and beyond as the right's waging of a cultural war in the court of public opinion, whereby conservative populist sentiments organized under catch phrases such as "traditional American values" were deployed to build popular and political opposition to the NEA, the art world, and the circulation of "objectionable," i.e. sexually explicit or religious, images.

The second essay, "Feminist Fundamentalism: Women Against Images," tracks the ideological parallel between anti-pornography feminists' support of censorship and the fundamentalist attacks on art. Arguing against the anti-porn discourse of Catharine MacKinnon and Andrea Dworkin, Vance presents vociferous critiques of this position by other feminists. For Vance, the fight for the right to create and exhibit sexually explicit images, be they in art or pornography, is a struggle for symbolic politics, for fundamental political and cultural representation, for public space. She calls forth "a vigorous defense of art and images begin[ning] from this insight."

During the controversies surrounding the NEA and the works of Andres Serrano and Robert Mapplethorpe in the 1980s, the appointment of cultural conservatives to the advisory board of the NEA revealed a key part of the Reagan-era agenda: the attack on minority sexualities. This strategy became the conservatives' most sensational and effective means of vilifying art. Critical to the understanding of the larger context in the struggle for representation of minority sexualities is the most momentous event in modern sexuality: AIDS. The development of the AIDS pandemic moved into the forefront of the discussions in art by the middle of the decade. Heavily impacting the art world, the intellectual responses to AIDS took an important turn in the winter of 1987 with the publication of a special AIDS issue of the journal *October*. Its editor, Douglas Crimp, devoted the entirety of his work during this time to activism toward stopping the AIDS crisis, linked to theorization of the politics of AIDS representation. "AIDS: Cultural Analysis/Cultural Activism" was a call to action, a critique of both the virulently homophobic failures of the government to address the crisis, and the insufficiency of the personal, expressional responses to AIDS prevalent at the time. Crimp advocates for the activist artwork of Gran Fury, an artist group formed within ACT UP (the AIDS Coalition to Unleash Power), as a model for the practice of bridging art and activism, aesthetics and politics.

In her essay "Architecture of the Evicted" Rosalyn Deutsche discusses the work of Krzysztof Wodiczko as a model of activist artwork that resists the commodification of public space and challenges basic assumptions of the foundations of social life. Carefully outlining New York City's program of real-estate redevelopment as the dialectical twin to the production of homelessness, Deutsche describes the uneven development of both real and symbolic space as a structural condition of the growth of late capitalism, where the expulsion, confinement, and displacement of the dispossessed who have become the homeless (more properly termed "the evicted") become a widespread system of profiting from the commodification of space. Against this backdrop, the public projection, proposal, and gallery installation work of Wodiczko, Deutsche contends, functions to expose and challenge the confluence of state and economic power, picturing both the promise and erosion of an open public sphere.

Like Douglas Crimp, the philosopher Judith Butler became an important contributor to the development of "queer theory" in the early 1990s. Queer theory, an interdisciplinary form of critical theory informed by feminism, psychoanalysis, post-structuralism, philosophy, and AIDS/queer activism, was born out of the tremendous energy generated defending and re-evaluating the cultures of sexual liberation movements (second-wave feminism, gay and lesbian liberation, etc.) under

attack from the far right. During this period Butler advanced the notion of the "performance" of gender, by which she does not mean that the taking on of gender is a matter of choice, as was often misunderstood. Rather, gender for Butler is a form of compulsory performance, constrained by a dynamic of privilege (race, class, education, etc.) from which no one is exempt. In "Gender is Burning," she analyzes the politics and pathos of gender performance using the stories of drag queens from *Paris Is Burning*, Jennie Livingston's 1991 documentary film of the "voguing balls" in Latin and African American communities in New York City in the 1980s. While acknowledging the difficulties wrought on those who practice "disobedience" against gender normativity, Butler suggests that subversion and resignification of normative gender terms is inevitable, and affirms its efficacy as a mode of ethical and political resistance.

Like the previous essays dealing with the debates that arose from the struggles around AIDS, class, gender, and sexuality in the 1980s and early '90s, the texts by Adrian Piper and Charles Wright on the politics of race were written from the general context of an "identity politics." The focus on identity in mainstream art discourse came to an unprecedented fore in the 1980s. Liberal advances made possible since the 1960s by the Civil Rights Movement, such as affirmative action, were steadily being eroded by the policies enacted under the Reagan and Bush administrations. At the same time there was a cresting demand by immigrant, gender, sexual, and racial minority groups for recognition in the public sphere. In the art world, discussions of representation in postmodernism evolved from an abstract critique of the ruins of the modern toward negotiation of the stakes of representation of embodied subjects. In this sense, both definitions of the word "representation" – political representation in society as well as depiction in terms of the reproduction of images – were submitted to a contentious re-evaluation.

Adrian Piper's text, "Cornered," is the script from a video installation of the same name exhibited widely in the early 1990s. Speaking from a video monitor, Piper confronts an imaginary audience regarding their assumptions about being "black," interrogating the historical and contemporary undercurrents of racism the word evokes. Piper, who often uses the visual ambiguity of her racial identity as subject matter, implicates the viewer in the text regardless of his or her identification, therefore pointing out that the representation of a "black" subject is dependent on a network of power relations, often the result of socially ingrained, fictional assumptions.

If Piper's text can be interpreted as a deconstruction of racist essentialism, Charles Wright's essay, "The Mythology of Difference: Vulgar Identity Politics at the Whitney," originally written as a review of the 1993 Biennial of the Whitney Museum of American Art, can be read as a critique of essentialist reason. The 1993 Whitney Biennial, in a break from past biennials, foregrounded politics, especially identity politics, and was among the most controversial art exhibitions in the last 20 years. Wright's critique of the exhibition is not directed toward the individual works in the show, but rather toward the institutional framing of identity and difference. Although partly sympathetic to the corrective impulse that generated such an exhibition, Wright nonetheless points to the binary logic of the exhibition that ultimately

stabilizes the meaning of complex works and reinforces the existing hierarchy of the art world.

While Wright's subtle critique is generated from within the intellectual left, many of the attacks on the 1993 Whitney Biennial represented a culturally conservative perspective. Besides the ridicule the mainstream press marshaled against identity politics in the exhibition, much of the hostility directed against it, often patronizing in tone, suggested that what was exhibited was "not art." A primary target of this argument was the inclusion of a videotape in the exhibition, a piece of footage broadcast countless times the previous year all over the world. Made by a passer-by, George Holliday, the video of the beating of an unarmed African-American motorist named Rodney King by members of the Los Angeles Police Department came to symbolize the structural racial injustice in American society. The "Rodney King incident" epitomized the boiling racial tension in American society and dominated political debates in the early 1990s, culminating in what became known as the "LA Riots" in the spring of 1992, after the four policemen shown beating King were acquitted of the use of excessive force.

The last essay in this section, "Haunted TV" by Avital Ronell, examines the matrix of trauma, violence, and representation through which we have come to "know" this historical moment. The events surrounding Rodney King that have brought forth a collective existential crisis are for Ronell a symbol for the structural violence of our televisual age. Following Jacques Lacan's proposition that television is a primary site for the production of racism, Ronell interprets the videotape of the beating of King as a video testimonial, an "ethical scream" of conscience that interrupted the domination of the public psyche by mass media. Provocatively placing this video footage against the backdrop of the Gulf War, where all images of Iraqi bloodshed were systematically censored by the United States government, and where the television viewer was instead given a fetishization of the technology of warfare ("smart bombs," etc.), Ronell insists that the two metonymically linked events – war at home and abroad – must be read together so that we may bring forth the potential of ethical opposition to an architecture of mass media violence, and the excessive force of the state.

9 The War on Culture

Carole S. Vance

T he storm that had been brewing over the National Endowment for the Arts (NEA) funding broke on the Senate floor on May 18, as Senator Alfonse D'Amato rose to denounce Andres Serrano's photograph *Piss Christ* as "trash." "This so-called piece of art is a deplorable, despicable display of vulgarity," he said. Within minutes over 20 senators rushed to join him in sending a letter to Hugh Southern, acting chair of the NEA, demanding to know what steps the agency would take to change its grant procedures. "This work is shocking, abhorrent and completely undeserving of any recognition whatsoever," the senators wrote.[1] For emphasis, Senator D'Amato dramatically ripped up a copy of the exhibition catalogue containing Serrano's photograph.

Not to be outdone, Senator Jesse Helms joined in the denunciation: "The Senator from New York is absolutely correct in his indignation and in his description of the blasphemy of the so-called art work. I do not know Mr. Andres Serrano, and I hope I never meet him. Because he is not an artist, he is a jerk." He continued, "Let him be a jerk on his own time and with his own resources. Do not dishonor our Lord."[2]

The object of their wrath was a 60-by-40-inch Cibachrome print depicting a wood-and-plastic crucifix submerged in yellow liquid – the artist's urine. The photograph had been shown in an uneventful three-city exhibit organized by the Southeastern Center for Contemporary Art (SECCA), a recipient of NEA funds. A juried panel appointed by SECCA had selected Serrano and nine others from some 500 applicants to win $15,000 fellowships and appear in the show, "Awards in the Visual Arts 7."

From *Art in America* 78, 5 (May 1990): 49–55. Copyright © by Carole S. Vance. Reproduced with kind permission of the author.

How the senators came to know and care about this regional show was not accidental.

Although the show had closed by the end of January 1989, throughout the spring the right-wing American Family Association, based in Tupelo, Mississippi, attacked the photo, the exhibition and its sponsors. The association and its executive director, United Methodist minister Rev. Donald Wildmon, were practiced in fomenting public opposition to allegedly "immoral, anti-Christian" images and had led protests against Martin Scorsese's film *The Last Temptation of Christ* the previous summer. The AFA newsletter, with an estimated circulation of 380,000 including 178,000 churches, according to association spokesmen,[3] urged concerned citizens to protest the art work and demand that responsible NEA officials be fired. The newsletter provided the relevant names and addresses, and letters poured in to congressmen, senators and the NEA. A full-fledged moral panic had begun.

Swept up in the mounting hysteria was another photographic exhibit scheduled to open on July 1 at the Corcoran Gallery of Art in Washington, DC. The 150-work retrospective, "Robert Mapplethorpe: The Perfect Moment," was organized by the University of Pennsylvania's Institute of Contemporary Art (ICA), which had received $30,000 for the show from the NEA. The show included the range of Mapplethorpe's images: formal portraiture, flowers, children and carefully posed erotic scenes – sexually explicit, gay and sadomasochistic. The show had been well received in Philadelphia and Chicago, but by June 8, Representative Dick Armey (R-Tex) sent Southern a letter signed by over 100 congressmen denouncing grants for Mapplethorpe as well as Serrano, and threatening to seek cuts in the agency's $170-million budget soon up for approval. Armey wanted the NEA to end its sponsorship of "morally reprehensible trash,"[4] and he wanted new grant guidelines that would "clearly pay respect to public standards of taste and decency."[5] Armey claimed he could "blow their budget out of the water"[6] by circulating the Mapplethorpe catalogue to fellow legislators prior to the House vote on the NEA appropriation. Before long, about 50 senators and 150 representatives had contacted the NEA about its funding.[7]

Amid these continuing attacks on the NEA, rumors circulated that the Corcoran would cancel the show. Director Christina Orr-Cahall staunchly rejected such rumors one week, saying, "This is the work of a major American artist who's well known, so we're not doing anything out of the ordinary."[8] But by the next week she had caved in, saying, "We really felt this exhibit was at the wrong place at the wrong time."[9] The director attempted an ingenious argument in a statement issued through a museum spokesperson: far from being censorship, she claimed, the cancellation actually protected the artist's work. "We decided to err on the side of the artist, who had the right to have his work presented in a non-sensationalized, non-political environment, and who deserves not to be the hostage for larger issues of relevance to us all," Orr-Cahall stated. "If you think about this for a long time, as we did, this is not censorship; in fact, this is the full artistic freedom which we all support."[10] Astounded by the Corcoran decision, artists and arts groups mounted protests, lobbied and formed anticensorship organizations, while a local alternative space, The Washington Project for the Arts (WPA), hastily arranged to show the Mapplethorpe exhibition.

The Corcoran cancellation scarcely put an end to the controversy, however. Instead, attacks on NEA funding intensified in the House and Senate, focusing on the 1990 budget appropriations and on new regulations that would limit or possibly end NEA subcontracts to arts organizations.[11] Angry representatives wanted to gut the budget, though they were beaten back in the House by more moderate amendments which indicated disapproval of the Serrano and Mapplethorpe grants by deducting their total cost ($45,000) from next year's allocation. By late July, Sen. Jesse Helms introduced a Senate amendment that would forbid the funding of "offensive," "indecent" and otherwise controversial art and transfer monies previously allocated for visual arts to support "folk art" and local projects. The furor is likely to continue throughout the fall, since the NEA will be up for its mandated, five-year reauthorization, and the right-wing campaign against images has apparently been heartened by its success. In Chicago, for example, protestors assailed an Eric Fischl painting of a fully clothed boy looking at a naked man swinging at a baseball on the grounds that it promotes "child molestation" and is, in any case, not "realistic," and therefore, bad art.[12]

The arts community was astounded by this chain of events – artists personally reviled, exhibitions withdrawn and under attack, the NEA budget threatened, all because of a few images. Ironically, those who specialize in producing and interpreting images were surprised that any image could have such power. But what was new to the arts community is, in fact, a staple of contemporary right-wing politics.

In the past ten years, conservative and fundamentalist groups have deployed and perfected techniques of grass-roots and mass mobilization around social issues, usually centering on sexuality, gender and religion. In these campaigns, symbols figure prominently, both as highly condensed statements of moral concern and as powerful spurs to emotion and action. In moral campaigns, fundamentalists select a negative symbol which is highly arousing to their own constituency and which is difficult or problematic for their opponents to defend. The symbol, often taken literally, out of context and always denying the possibility of irony or multiple interpretations, is waved like a red flag before their constituents. The arousing stimulus could be an "un-Christian" passage from an evolution textbook, explicit information from a high school sex-education curriculum or "degrading" pornography said to be available in the local adult bookshop. In the antiabortion campaign, activists favor images of late-term fetuses or better yet, dead babies, displayed in jars. Primed with names and addresses of relevant elected and appointed officials, fundamentalist troops fire off volleys of letters, which cowed politicians take to be the expression of popular sentiment. Right-wing politicians opportunistically ride the ground swell of outrage, while centrists feel anxious and disempowered to stop it – now a familiar sight in the political landscape. But here, in the NEA controversy, there is something new.

Fundamentalists and conservatives are now directing mass-based symbolic mobilizations against "high culture." Previously, their efforts had focused on popular culture – the attack on rock music led by Tipper Gore, the protests against *The Last Temptation of Christ* and the Meese Commission's war against pornography.[13] Conservative and neoconservative intellectuals have also lamented the allegedly liberal

bias of the university and the dilution of the classic literary canon by including "inferior" works by minority, female and gay authors, but these complaints have been made in books, journals and conferences, and have scarcely generated thousands of letters to Congress. Previous efforts to change the direction of the NEA had been made through institutional and bureaucratic channels – by appointing more conservative members to its governing body, the National Council on the Arts, by selecting a more conservative chair and in some cases by overturning grant decisions made by professional panels. Although antagonism to Eastern elites and upper-class culture has been a thread within fundamentalism, the NEA controversy marks the first time that this emotion has been tapped in mass political action.

Conservative columnist Patrick Buchanan sounded the alarm for this populist attack in a *Washington Times* column last June, calling for "a cultural revolution in the '90s as sweeping as the political revolution in the '80s."[14] Here may lie a clue to this new strategy: the Reagan political revolution has peaked, and with both legislatures under Democratic control, additional conservative gains on social issues through electoral channels seem unlikely. Under these conditions, the slower and more time-consuming – though perhaps more effective – method of changing public opinion and taste may be the best available option. For conservatives and fundamentalists, the arts community plays a significant role in setting standards and shaping public values: Buchanan writes, "The decade has seen an explosion of anti-American, anti-Christian, and nihilist 'art.' . . . [Many museums] now feature exhibits that can best be described as cultural trash,"[15] and "as in public television and public radio, a tiny clique, out of touch with America's traditional values, has wormed its way into control of the arts bureaucracy."[16] In an analogy chillingly reminiscent of Nazi cultural metaphors, Buchanan writes, "As with our rivers and lakes, we need to clean up our culture: for it is a well from which we must all drink. Just as a poisoned land will yield up poisonous fruits, so a polluted culture, left to fester and stink, can destroy a nation's soul."[17] Let the citizens be warned: "We should not subsidize decadence."[18] Amid such archaic language of moral pollution and degeneracy, it was not surprising that Mapplethorpe's gay and erotic images were at the center of controversy.

The second new element in the right's mass mobilization against the NEA and high culture has been its rhetorical disavowal of censorship per se and the cultivation of an artfully crafted distinction between absolute censorship and the denial of public funding. Senator D'Amato, for example, claimed, "This matter does not involve freedom of artistic expression – it does involve the question whether American taxpayers should be forced to support such trash."[19] In the battle for public opinion, "censorship" is a dirty word to mainstream audiences, and hard for conservatives to shake off because their recent battles to control school books, libraries and curricula have earned them reputations as ignorant book-burners. By using this hairsplitting rhetoric, conservatives can now happily disclaim any interest in censorship, and merely suggest that no public funds be used for "offensive" or "indecent" materials.[20] Conservatives had employed the "no public funds" argument before to deny federal funding for Medicaid abortions since 1976 and explicit safe-sex education for AIDS more recently. Fundamentalists have attempted to modernize their rhetoric in other

social campaigns, too – antiabortionists borrow civil rights terms to speak about the "human rights" of the fetus, and antiporn zealots experiment with replacing their language of sin and lust with phrases about the "degradation of women" borrowed from antipornography feminism. In all cases, these incompatible languages have an uneasy coexistence. But modernized rhetoric cannot disguise the basic, censorious impulse which strikes out at NEA public funding precisely because it is a significant source of arts money, not a trivial one.

NEA funding permeates countless art institutions, schools and community groups, often making the difference between survival and going under; it also supports many individual artists. That NEA funds have in recent years been allocated according to formulas designed to achieve more democratic distribution – not limited to elite art centers or well-known artists – makes their impact all the more significant. A require- ment that NEA-funded institutions and artists conform to a standard of "public taste," even in the face of available private funds, would have a profound impact. One obvious by-product would be installing the fiction of a singular public with a univer- sally shared taste and the displacement of a diverse public composed of many con- stituencies with different tastes. In addition, the mingling of NEA and private funds, so typical in many institutions and exhibitions, would mean that NEA standards would spill over to the private sector, which is separate more in theory than in practice. Although NEA might fund only part of a project, its standards would prevail, since noncompliance would result in loss of funds.

No doubt the continuous contemplation of the standards of public taste that should obtain in publicly funded projects – continuous, since these can never be known with certainty – will itself increase self-censorship and caution across the board. There has always been considerable self-censorship in the art world when it comes to sexual images, and the evidence indicates that it is increasing: reports circulate about curators now examining their collections anew with an eye toward "disturbing" material that might arouse public ire, and increased hesitation to mount new exhibitions that contain unconventional material. In all these ways, artists have recognized the damage done by limiting the types of images that can be funded by public monies.

But more importantly, the very distinction between public and private is a false one, because the boundaries between these spheres are very permeable. Feminist scholar- ship has shown how the most seemingly personal and private decisions – having a baby, for example – are affected by a host of public laws and policies, ranging from available tax benefits to health services to day care. In the past century in America and England, major changes in family form, sexuality and gender arrangements have occurred in a complex web spanning public and private domains, which even historians are hard put to separate.[21] In struggles for social change, both reformers and tradi- tionalists know that changes in personal life are intimately linked to changes in public domains – not only through legal regulation, but also through information, images and even access to physical space available in public arenas.

This is to say that what goes on in the public sphere is of vital importance for both the arts and for political culture. Because American traditions of publicly supported

culture are limited by the innate conservatism of corporate sponsors and by the reduction of individual patronage following changes in the tax laws, relegating controversial images and art work to private philanthropy confines them to a frail and easily influenced source of support. Even given the NEA's history of bureaucratic interference, it is paradoxically public funding – insulated from the day-to-day interference of politicians and special-interest groups that the right wing would now impose – that permits the possibility of a heterodox culture. Though we might reject the overly literal connection conservatives like to make between images and action ("When teenagers read sex education, they go out and have sex"), we too know that diversity in images and expression in the public sector nurtures and sustains diversity in private life. When losses are suffered in public arenas, people for whom controversial or minority images are salient and affirming suffer a real defeat. Defending private rights – to behavior, to images, to information – is difficult without a publicly formed and visible community. People deprived of images become demoralized and isolated, and they become increasingly vulnerable to attacks on their private expressions of nonconformity, which are inevitable once sources of public solidarity and resistance have been eliminated.

For these reasons, the desire to eliminate symbols, images and ideas they do not like from public space is basic to contemporary conservatives' and fundamentalists' politics about sexuality, gender and the family. On the one hand, this behavior may signal weakness, in that conservatives no longer have the power to directly control, for example, sexual behavior, and must content themselves with controlling a proxy, images of sexual behavior. The attack on Mapplethorpe's images, some of them gay, some sadomasochistic, can be understood in this light. Indeed, the savage critique of his photographs permitted a temporary revival of a vocabulary – "perverted, filth, trash" – that was customarily used against gays but has become unacceptable in mainstream political discourse, a result of sexual liberalization that conservatives hate. On the other hand, the attack on images, particularly "difficult" images in the public domain, may be the most effective point of cultural intervention now – particularly given the evident difficulty liberals have in mounting a strong and unambivalent response and given the way changes in public climate can be translated back to changes in legal rights – as, for example, in the erosion of support for abortion rights, where the image of the fetus has become central in the debate, erasing the image of the woman.

Because symbolic mobilizations and moral panics often leave in their wake residues of law and policy that remain in force long after the hysteria has subsided,[22] the fundamentalist attack on art and images requires a broad and vigorous response that goes beyond appeals to free speech. Free expression is a necessary principle in these debates, because of the steady protection it offers to all images, but it cannot be the only one. To be effective and not defensive, the art community needs to employ its interpretive skills to unmask the modernized rhetoric conservatives use to justify their traditional agenda, as well as to deconstruct the "difficult" images fundamentalists choose to set their campaigns in motion. Despite their uncanny intuition for culturally disturbing material, their focus on images also contains many sleights of hand

(Do photographs of nude children necessarily equal child pornography?), and even displacements,[23] which we need to examine. Images we would allow to remain "disturbing" and unconsidered put us anxiously on the defensive and undermine our own response. In addition to defending free speech, it is essential to address why certain images are being attacked – Serrano's crucifix for mocking the excesses of religious exploitation[24] (a point evidently not lost on the televangelists and syndicated preachers who promptly assailed his "blasphemy") and Mapplethorpe's photographs for making minority sexual subcultures visible. If we are always afraid to offer a public defense of sexual images, then even in our rebuttal we have granted the right wing its most basic premise: sexuality is shameful and discrediting. It is not enough to defend the principle of free speech, while joining in denouncing the image, as some in the art world have done.[25]

The fundamentalist attack on images and the art world must be recognized not as an improbable and silly outburst of Yahoo-ism, but as a systematic part of a right-wing political program to restore traditional social arrangements and reduce diversity. The right wing is deeply committed to symbolic politics, both in using symbols to mobilize public sentiment and in understanding that, because images do stand in for and motivate social change, the arena of representation is a real ground for struggle. A vigorous defense of art and images begins from this insight.

Notes

Thanks to Ann Snitow, Daniel Goode, Sharon Thompson and Edna Haber for conversations which helped shape my thoughts (though none of the individuals are responsible for the ideas expressed here).

1 Senator D'Amato's remarks and the text of the letter appear in the *Congressional Record*, vol. 135, no. 64, May 18, 1989, S5594.

2 Senator Helms's remarks appear in the *Congressional Record*, vol. 135, no. 64, May 18, 1989, S5595.

3 William H. Honan, "Congressional Anger Threatens Arts Endowment's Budget," *New York Times*, June 20, 1989, p. C20.

4 "People: Art, Trash and Funding," *International Herald Tribune*, June 15, 1989, p. 20.

5 Ibid.

6 Honan, "Congressional Anger," p. C20.

7 Elizabeth Kastor, "Funding Art that Offends," *Washington Post*, June 7, 1989, p. C1.

8 Ibid., p. C3.

9 Elizabeth Kastor, "Corcoran Cancels Photo Exhibit," *Washington Post*, June 13, 1989, p. C1.

10 Elizabeth Kastor, "Corcoran Decision Provokes Outcry," *Washington Post*, June 14, 1989, p. B1.

11 Barbara Gamarekian, "Legislation Offered to Limit Grants by Arts Endowment," *New York Times*, June 21, 1989; Carla Hall, "For NEA, an Extra Step," *Washington Post*, June 22, 1989; Elizabeth Kastor, "Art and Accountability," *Washington Post*, June 30, 1989.

12 The Fischl painting *Boys at Bat*, 1979, was part of a traveling exhibition, "Diamonds Are Forever," on view at the Chicago Public Library Cultural Center. Ziff Fistrunk, executive

director of the Southside Chicago Sports Council, organized the protest. He objected that "I have trained players in Little League and semi-pro baseball, and at no time did I train them naked." *In These Times*, Aug. 1, 1989, p. 5. Thanks to Carole Tormollan for calling this incident to my attention.

13 Carole S. Vance, "The Meese Commission on the Road: Porn in the USA," *The Nation*, Aug. 29, 1986, pp. 65–82.

14 Patrick Buchanan, "How Can We Clean Up Our Art Act?" *Washington Post*, June 19, 1989.

15 Ibid.

16 Ibid.

17 Ibid.

18 Ibid.

19 *Congressional Record*, vol. 135, no. 64, May 18, 1989, S5594.

20 Another ploy is to transmute the basic objection to Serrano's photograph, the unfortunately medieval-sounding "blasphemy," to more modern concerns with prejudice and civil rights. Donald Wildmon, for example, states, "Religious bigotry should not be supported by tax dollars." *Washington Times*, Apr. 26, 1989, p. A5.

The slippage between these two frameworks, however, appears in a protest letter written to the *Richmond News-Leader* concerning Serrano's work: "The Virginia Museum should not be in the business of promoting and subsidizing hatred and intolerance. Would they pay the KKK to do work defaming blacks? Would they display a Jewish symbol under urine? Has Christianity become fair game in our society for any kind of blasphemy and slander?" (Mar. 18, 1989).

21 For 19th-century American history regarding sex and gender, see John D'Emilio and Estelle Freedman, *Intimate Matters* (New York: Harper and Row, 1988); for British history, see Jeffrey Weeks, *Sex, Politics and Society: The Regulation of Sexuality Since 1800* (New York: Longman, 1981).

22 The 19th-century Comstock Law, for example, passed during a frenzied concern about indecent literature, was used to suppress information about abortion and birth control in the United States well into the 20th century. For accounts of moral panics, see Weeks, *Sex, Politics and Society*; Judith Walkowitz, *Prostitution and Victorian Society: Women, Class, and the State* (Cambridge: Cambridge University Press, 1980); and Gayle Rubin, "Thinking Sex: Notes for a Radical Theory of the Politics of Sexuality," in Carole S. Vance, ed., *Pleasure and Danger: Exploring Female Sexuality* (Boston: Routledge & Kegan Paul, 1984), pp. 267–319.

23 Politically, the crusade against the NEA displaces scandal and charges of dishonesty from the attackers to those attacked. Senator Alphonse D'Amato took on the role of the chief NEA persecutor at a time when he himself is the subject of embarrassing questions, allegations and several inquiries about his role in the misuse of HUD low-income housing funds in his Long Island hometown.

The crusade against "anti-Christian" images performs a similar function of diverting attention and memory from the recent fundamentalist religious scandals involving Jim and Tammy Bakker and Jimmy Swaggart, themselves implicated in numerous presumably "un-Christian" acts. Still unscathed fellow televangelist Pat Robertson called upon followers to join the attack on the NEA during a June 9 telecast on the Christian Broadcasting Network.

24 Andres Serrano described his photograph as "a protest against the commercialization of sacred imagery." See Honan, "Congressional Anger," p. C20.

25 For defenses of free speech that agree with or offer no rebuttal to conservative character-
izations of the image, see the comments of Hugh Southern, acting chair of the NEA, who
said, "I most certainly can understand that the work in question has offended many
people and appreciate the feelings of those who have protested it. . . . I personally found
it offensive" (quoted in Kastor, "Funding Art That Offends," p. C3), and artist Helen
Frankenthaler, who stated in her op-ed column, "I, for one, would not want to support
the two artists mentioned, but once supported, we must allow them to be shown" ("Did
We Spawn an Arts Monster?" *New York Times*, July 17, 1989, p. A17).

10 Feminist Fundamentalism
Women Against Images

Carole S. Vance

The seeming resolution of an art-censorship case at the University of Michigan Law School last spring has done little to quiet artists' fears about the new directions that attacks on sexual imagery are taking. In the midst of a four-year furor over National Endowment for the Arts funding of "offensive" images, antipornography feminists have now stepped into the fray, adopting tactics that strongly parallel those employed by conservatives and fundamentalists. By piggybacking their own views onto notions put into wide circulation by right-wing groups – for example, that virtually any visual imagery about sex is "pornographic" – antipornography feminists managed to shut down an art exhibition focusing on the work of women and feminists and to redefine notions of pornography and free expression.

The flap started late last fall when critics assailed a multimedia exhibition about prostitution, claiming that the installation was "pornographic" and a "threat." This time, opponents wasted no time in disputes about art funding. Instead, they physically removed the offending art, and ultimately closed down the entire show. The censors were feminists opposed to pornography and law students who claimed they weren't engaging in censorship; their goal was to protect viewers from videos which made people "uncomfortable" and "created feelings of anxiety"[1] and from images "used to get men pumped."[2] The dean of the law school, a specialist in First Amendment law, initially seemed to agree, suggesting that the students were merely exercising their First Amendment rights by removing art from a gallery. The startling incident in Ann

From *Art in America* 81, 9 (September 1993): 35–9. Copyright © by Carole S. Vance. Reproduced with kind permission of the author.

Arbor signals the fluidity with which sexual panics move around the culture, here spreading far beyond federal agencies and moral-conservative pressure groups.

What visual images set off such a ruckus? The works were part of an exhibition called "Porn'im'age'ry: Picturing Prostitutes," curated by feminist artist and videographer Carol Jacobsen, and featuring documentary photography and videos by seven artists, five of them women. The show included the work of Paula Allen, Susana Aikin and Carlos Aparicio, Carol Leigh, Veronica Vera, Randy Barbato and Carol Jacobsen. The work was diverse, including Allen's *Angelina Foxy* (1986–), an ongoing phototext essay documenting the life of a Jersey City prostitute; Aikin and Aparicio's *The Salt Mines* (1990), a critically acclaimed documentary about homeless transvestite hustlers in New York City; Jacobsen's *Street Sex* (1989), candid video interviews with Detroit prostitutes just released from jail; and Leigh's *Outlaw Poverty, Not Prostitutes* (1991), an activist video chronicling prostitutes' international organizing to improve working conditions.

The exhibition was commissioned as part of a two-day conference called "Prostitution: From Academia to Activism," held at the University of Michigan Law School, Oct. 30–31, 1992. Sponsored by the law school and by its new publication, the *Michigan Journal of Gender and Law*, the conference gave center stage to the views of leading antipornography theorists Andrea Dworkin and Catharine MacKinnon, the latter a professor at the law school; they regard both prostitution and pornography as central – and interrelated – causes of women's inequality. Because feminist opinion on these questions is quite divided,[3] student organizers initially wanted the conference to explore diverse perspectives, and the exhibition was part of this approach. They soon found, however, that antipornography advocates – following a now-familiar maneuver – refused to appear if feminists holding different views were invited.[4] "Some of the key anti-prostitution people accepted on the condition that they wouldn't speak if there were people from the other side there," conference organizer Lisa Lodin told the *New York Times*. "We agonized about it, because we felt we were being manipulated, but we went ahead anyway."[5] The successful attempt to restrict the content of the conference soon spilled over to the art exhibition with more mixed results.[6]

The complete installation was on view for no more than a few hours on Oct. 30 before some conference speakers, objecting to sexual imagery in the show, complained to MacKinnon, who conveyed the complaints to the student organizers.[7] Reports have variously identified those objecting to the show as John Stoltenberg, antipornography activist and close associate of Dworkin, and Evelina Giobbe, director of an antiprostitution group in St Paul and a longtime member (under the name Evelina Kane) of Women Against Pornography in New York.[8] According to law student and conference organizer Laura Berger, some speakers had "expressed fear for their personal safety. Some speakers had attended prior conferences where pro-pornography groups had shown pornography to incite groups of people to protest alternative views. Such protests had resulted in the harassment of speakers in the past."[9]

Evidently panicked by the charge that some of the art works were pornographic or dangerous, student organizers immediately removed most of the videos from the installation – sight unseen, and without consulting or even informing the curator.

What the students seemed to regard as a minor adjustment ("we agreed to take out a portion [of the show]"[10]) in fact eliminated the work of five of the seven artists.

The next day, curator Carol Jacobsen discovered that the videos were missing; when she learned the reasons for their removal, she objected strongly. "I told them they couldn't just pick out selected artwork and remove it from the exhibit, but they didn't seem to get it," Jacobsen told the *New York Times*. "They said it wasn't censorship; they were just trying to prevent people from getting their feelings upset. I said if they wished to censor any part, they would have to censor the whole thing. They came back and said, 'Take it down.' And that's what happened."[11]

In the ensuing months, Jacobsen waged an uphill battle at considerable personal cost to compel the university to redress the censorship.[12] She demanded reinstallation of the show, as well as a campus forum to address issues of feminism, representation, sexuality and censorship. At first, officials suggested they had no responsibility for the law students' actions, although the university funded the conference which had commissioned the exhibition and the art was removed from a university-owned gallery. In crafting this argument, university administrators attempted to narrow the question to one of strict legal liability: did the university violate the First Amendment rights of the artists? This framing diverted attention from a second, quite separate question: did censorship occur at the university, and did educators have a responsibility to examine the circumstances and speak out about the event?

Controversy raged across the campus, with students, Jacobsen and MacKinnon weighing in; Jacobsen's attorneys, disturbed at unauthorized reproduction and circulation of the artists' videos by school officials and students, threatened to sue the university for copyright violation, while MacKinnon vowed to sue the ACLU for alleged defamation over their press release about the incident.[13] The faculty at Michigan, however, was largely silent about the case, including professors in art, law and women's studies. The threat of legal action by the ACLU Arts Censorship Project, combined with widespread news coverage and a major protest by arts-advocacy, feminist and free-speech groups, led to a March 17 agreement between the university and the artists to reinstall the exhibition and sponsor an educational forum on sexuality and freedom of expression.[14] Months after the agreement, however, plans for the reinstallation and forum are proceeding at a snail's pace.

The incident suggests several startling similarities to recent fundamentalist campaigns against art and the NEA. Most striking is the use of the term "pornography" to describe any material with a sexual content or theme of which the viewer disapproves. Since "pornography" carries an unmistakably pejorative connotation, the use of this word to describe any visual image involving sex or nudity serves aggressively to demote the status of the image or art work and, with no overt discussion, to bias the viewer's ability to consider it. This rhetorical sleight of hand, too, suggests that sexuality per se is inherently pornographic, a contention many would question if it were explicitly stated.[15]

Over the past four years, moral conservatives have put into wide circulation terms like "pornographic" and "obscene art" to describe performance art and photography

which explores homosexuality, sexism and the body in ways they find threatening. In a similar tactic, antipornography feminists are now hurling the term "pornography" at art videos which dissent from their favored position on prostitution – that prostitution victimizes women and that women can never freely choose to participate in that work. Ironically, antiporn feminists wish to banish these videos specifically because of the *political ideas* they convey, yet their characterization of the videos as pornography – seemingly mindless, masturbatory vehicles – implies that they are devoid of meaning or ideas.

These arguments produced an elision between "porn" and "video" which has fueled the controversy in other ways. As in the NEA episode, this debate centered on newer art forms, here photography and video, which have shorter histories, less prestige and legitimacy, and less cultural protection than more traditional forms of art such as painting or sculpture. The widespread circulation of photography and video in popular and commercial culture renders them vulnerable. For students, removing a painting from a gallery wall might still be unthinkable, or at least clearly understood as an act of censorship, but removing a videotape from a VCR can perhaps conveniently be assimilated into a routine, everyday act of personal preference.

The decontextualized way of viewing images which was prominent in the NEA debates reappeared in the controversy at the University of Michigan. Antipornography feminist critics assailed Veronica Vera's 30-minute video *Portrait of a Sexual Evolutionary* (1987) as "pornography" because it contains – among many other things – short, sexually explicit excerpts from adult films in which she appeared. This makes as much sense as calling the video religious because it incorporates Catholic iconography as it traces her development from obedient daughter to sexually curious porn performer to video maker and sex advocate. Critics ignore the video's many framing devices; the narrative is filled with irony, camp and good girl/bad girl melodrama, interspersed with critiques of censorship, the most winning being Vera's 1984 testimony against MacKinnon-Dworkin-style antiporn ordinances before a US Senate subcommittee and the clearly flabbergasted and uncomfortable Sen. Arlen Specter. This video, like all others, can be read many ways; it may be that some viewers are discomfited by Vera's shifting, unstable perspective that lurches between seriousness and camp, her largely upbeat account of her experiences in the sex industry or her refusal to work within the genre of earnest documentary. Yet none of these issues – esthetic, intellectual and political – merits dismissal with the reductionistic epithet "pornography."

Antipornography feminists have always favored a single and universal reading of sexual imagery. They have elaborated a mechanistic theory about the myriad ways in which sexually explicit materials cause enormous harm, from promoting misogynist ideas and male dominance to directly inspiring rape. Just like moral conservatives, they reject interpretive schemes that admit the complexity and ambiguity of images, as well as the diverse responses of viewers. In this incident, the assertion by a few conference participants that the sexual imagery in the videos was pornographic and a menace, coupled with law students' gullible acceptance of such claims, seemed to establish that all viewers, especially women, would read the visual images identically. Yet the extensive debates within feminism over the past decade, focusing on precisely

such issues as women's sexuality, subjectivity and interpretive authority, make this particular contention on the part of MacKinnon and her students laughable.

Also comic were the earnest avowals of both law students and antiporn feminists that their actions did not constitute censorship. Here, too, they adopted the rhetorical technique of fundamentalist groups in the NEA controversy, who intuited that an explicit defense, and therefore acknowledgment, of censorship is a liability in public debate. The statements of future lawyers were especially dismaying, as they seemed to reflect the speakers' shallow legal training and hypertrophic credulousness. Bryan Wells, a law student and one of the exhibition's organizers, said, "We really didn't think of it as a censorship issue, but as a safety issue. . . . It wasn't our place to assess that threat. It was our position to trust our speakers."[16] The dean of the law school, Lee Bollinger, also engaged in some creative reasoning over the course of the controversy, though his imaginative explanations perhaps make more sense when seen in light of the ACLU's threatened lawsuit. Against concerns about artists' freedom of speech, Bollinger raised issues of student rights – "that includes the right to be unreasonable as well as the right to be reasonable."[17] Bollinger argued that students, too, were entitled to free expression: "Student organizations can invite or disinvite people to speak at conferences, and it's within their legal and constitutional rights."[18] This spurious analogy between planning conferences and removing art from a gallery is unconvincing, since it would propose a rather Orwellian definition of "free expression" – the right to eliminate any speech or art one doesn't like.[19]

The parallels between the antipornography feminist and fundamentalist attacks on art extend beyond tactics and rhetoric. Both share a powerful desire to reshape cultural attitudes toward sexual imagery as part of a larger program of political, social and legal reform. It is no accident that this incident occurred at the University of Michigan Law School, where Catharine MacKinnon has been elaborating legal theory about the harm of pornography and training enthusiastic students in innovative ways to erode First Amendment protections for sexual images and speech. Though interpretations differ about the degree of MacKinnon's involvement in this episode (she claims that she did not see the videotapes and only conveyed to the exhibition organizers various speakers' objections to the tapes), she has publicly supported the students' actions: "It is one thing to talk about trafficking women, and it is another thing to traffic women. There is nothing in the First Amendment to require that this school, or students in it, be forced to traffic women. If these materials are pornography – and I haven't seen them, so I can't say – it is not a question of their offensiveness, but of safety and equality for women. Showing pornography sets women up for harassment and rape."[20]

These parallels should come as no surprise. Like fundamentalists, antipornography feminists have long embraced a two-step strategy that melds cultural and legal activism. Both employ cultural campaigns to enlarge the popularly understood definition of pornography (the pejorative category for bad, harmful or immoral material) to include virtually all sexual imagery. In addition, because current law prohibits only sexual material which is obscene, both are crafting innovative legal strategies to

expand the definition of obscenity and, hence, the scope of obscenity law. In their efforts to disable their political opponents, both groups are skilled in deploying demagogic charges of "pornography" and mobilizing sex panics in order to eliminate expression, images and perspectives that counter their own agenda.

The antipornography feminist agenda has been vociferously criticized by other feminists because of its impoverished perspective on both sexual imagery and social change. The single-minded effort to eliminate a broad range of sexual imagery erases the actual diversity in these images, as well as women's complex, sometimes contradictory reactions. The confinement of all sexual imagery to the demonized category "pornography" makes it unlikely that the most intriguing questions about the relationship between sexuality, women and imagery will ever be asked. Moreover, this agenda suggests that sexism and misogyny originate in the sexually explicit, a relatively small domain, rather than being part of the deep cell structure of every institution in our culture.[21]

The solution the antiporn feminists propose is at once too small and too big. It is too small in that it narrows feminism's broad-based response to sexist imagery to an attack on the sexually explicit. This severely limits and misrepresents feminism's wide-ranging critique of all sexist visual conventions, which has historically been coupled with encouragement for women to produce innovative, challenging and subversive alternatives. But the antiporn response is also too big in that it adopts a totalitarian program of physically eliminating objectionable images and symbols as a means to change the culture that produced them, a tactic that would be utterly implausible were it proposed to combat anything but sexually explicit imagery. Behind these polar extremes lies the inability or unwillingness to address the larger theoretical questions: Where does sexual culture come from? And, by implication, how can it be transformed?

Antipornography feminists are entering the public debate about art and sexual imagery after years of their own silence during the NEA controversy, when many feminist, gay and lesbian artists along with innovative work about sex and gender were attacked. They enter in the wake of serious fundamentalist incursions designed to limit artistic expression, curtail exploration of sexuality and promote self-censorship. The extent to which antipornography feminist campaigns against visual imagery and art will grow remains to be seen; admittedly, they begin with a more modest organizational base than highly funded right-wing groups, and they have acquired vocal opponents within the feminist movement. Yet their stated goal – restricting imagery to allegedly promote equality – can strike a sympathetic nerve in women who would be unmoved by more recognizably protectionist and fundamentalist efforts. The prevailing sexual culture – often hostile and deprecating to women – generates an outrage easily mobilized toward reactionary as well as progressive ends. This case, as well as the landmark 1992 *Butler* decision in Canada (in which traditional obscenity law was upheld and expanded with new, feminist arguments provided by MacKinnon and her allies[22]), shatters the illusion that restricting sexual imagery for feminist purposes is distinguishable from fundamentalist censorship – either in method or consequence.

While conservative campaigns can be easily derided as efforts to punish and restrict women, ironically, antipornography feminist crusades have attacked women, too: in Michigan, feminist and women's art is removed, while in Canada, the first post-Butler obscenity prosecution targeted the lesbian-feminist erotic magazine *Bad Attitude.*[23] The query, "What do women want?" remains a provocative question – in regard to art, imagery and sexual culture. And it is not a question that can be easily answered in a sexist society. Still, these recent skirmishes show that the answer lies in expansion, not closure, and in increasing women's power and autonomy in art as well as sex.

Notes

I am grateful to Frances Doughty, Nan Hunter, Ann Snitow, Gayle Rubin, Robert Glück, Sharon Thompson and Barbara Kerr for helpful conversations. I also benefited from a writing residency at the MacDowell Colony.

1 Erin Einhorn, "Law Journal Censors Video, Citing Pornographic Content," *Michigan Daily*, Nov. 2, 1992, p. 1.

2 Statement of law student and conference organizer Laura Berger in Reed Johnson, "Sex, Laws and Videotapes," *Detroit News*, Dec. 7, 1992, p. 2E. Berger went on to say that "women such as this speaker [who complained about the videos] have been harassed by people who have watched pornography in the past."

3 For the antipornography feminist analysis, see Laura Lederer, ed., *Take Back the Night* (New York: William Morrow, 1980); Andrea Dworkin, *Pornography: Men Possessing Women* (New York: G. P. Putnam, 1979); Catharine MacKinnon, "Pornography, Civil Rights, and Speech," *Harvard Civil Rights-Civil Liberties Law Review*, vol. 20 (1985), pp. 1–70; Dorchen Leidholdt and Janice G. Raymond, *The Sexual Liberals and the Attack on Feminism* (New York: Pergamon, 1990).

 For feminist critiques of the antipornography position, see Kate Ellis et al., eds., *Caught Looking: Feminism, Pornography, and Censorship* (East Haven, Conn.: Long River Books, 3rd edn., 1992); Carole S. Vance, ed., *Pleasure and Danger: Exploring Female Sexuality* (London: Pandora, 2nd edn., 1992); Lynne Segal and Mary McIntosh, eds., *Sex Exposed: Sexuality and the Pornography Debate* (New Brunswick, NJ: Rutgers University Press, 1993); Nan Hunter and Sylvia Law, "Brief Amici Curiae of FACT (Feminist Anti-Censorship Taskforce) et al. in American Booksellers Association v. Hudnut," *Michigan Journal of Law Reform*, vol. 21 (Fall 1987–Winter 1988), pp. 69–135.

4 For feminist views favoring decriminalization and efforts to improve the situation of prostitutes, see Gail Pheterson, ed., *A Vindication of the Rights of Whores* (Seattle: Seal Press, 1989); Frederique Delacoste and Priscilla Alexander, eds., *Sex Work: Writings by Women in the Sex Industry* (San Francisco: Cleis Press, 1987).

5 Tamar Lewin, "Furor on Exhibit at Law School Splits Feminists," *New York Times*, Nov. 13, 1992, p. B16; see also comments describing the process by which organizers reluctantly decided to exclude opposing viewpoints in Johnson, "Sex, Laws and Videotape," p. 2E.

6 Local reports and commentary include Ami Walsh, "The World of Prostitutes," *Ann Arbor News*, Oct. 28, 1992, pp. B1–B2; Einhorn, "Law Journal Censors Video," pp. 1–2;

Ami Walsh, "Prostitution Exhibit's Artist Removes It After 'Censorship,'" *Ann Arbor News*, Nov. 3, 1992, pp. C1, C3; Carol Jacobsen, "Issues Forum: First Amendment Rights Need to Be Upheld," *Michigan Daily*, Nov. 6, 1992, p. 4; Laura Berger, "Issues Forum: Exhibit Caused People to Fear for Their Safety," *Michigan Daily*, Nov. 6, 1992, p. 4; "Freedom from Speech" (editorial), *Michigan Daily*, Nov. 6, 1992, p. 4; Stephen Jones, "Art Exhibit Ejection Fuels Debate on Speech, Porn," *Detroit Free Press*, Nov. 12, 1992, p. 6B; "Prostituting Feminism" (editorial), *Detroit News*, Nov. 19, 1992, p. 14A; Laura Dermer, "ACLU to Aid Artist in Fighting Censorship," *Michigan Daily*, Nov. 20, 1992, p. 7; Veronica Vera, "Censored Artist, Activist Speaks Out" (open letter by Vera), *Michigan Daily*, Nov. 30, 1992, p. 4; Anne Sharp, "A Look at the Oldest Profession," *Ann Arbor News – Spectator Magazine*, Dec. 3, 1992, p. 26; Johnson, "Sex, Laws and Videotape," pp. 1E–2E, 4E; Andrew Taylor, "Censored Film Presents Scenes of Prostitution," *Michigan Daily*, Dec. 7, 1992, pp. 1–2; Marsha Miro, "Freedom of Expression," *Detroit Free Press*, Dec. 20, 1992, pp. M7, M11.

7 Johnson, "Sex, Laws and Videotape," p. 2E.

8 Ibid. See also Lewin, "Furor on Exhibit at Law School," p. B16. For Giobbe's view of prostitution, authored under the name Sarah Wynter, see "Whisper: Women Hurt in Systems of Prostitution Engaged in Revolt," in Delacoste and Alexander, eds., *Sex Work*.

9 Berger, "Exhibit Caused People to Fear," p. 4.

10 Bryn Mickle, "'U' Avoids Court Case, Settles Disagreement with Local Artists," *Michigan Daily*, Mar. 18, 1993, p. 3.

11 Lewin, "Furor on Exhibit at Law School," p. B16.

12 Reflecting widespread impatience in the arts community with the university's foot-dragging actions in this case, almost two months after the original incident art writer Elizabeth Hess encouraged readers to launch a "fax attack" to "remind Dean Bollinger that it's time to get on with the forum and on with the show," *Village Voice*, Jan. 20, 1993; his rejoinder follows, *Village Voice*, Feb. 23, 1993.

13 See *Arts Censorship Project Newsletter*, vol. 2 (Winter 1993), p. 6.

14 Jacobsen was represented by Marjorie Heins of the ACLU Arts Censorship Project and Robert Carbeck, president of the Washtenaw County (Michigan) branch of the ACLU and cooperating attorney. For press coverage, see Lewin, "Furor on Exhibit at Law School"; Laura Fraser, "Hear No Evil: Anti-porn Feminists Censor Voices of Prostitutes," *San Francisco Weekly*, Nov. 11, 1992, p. 11; Joyce Price, "Feminists in Free-Speech Seat," *Washington Times*, Nov. 13, 1992, pp. A1, A6; "In Box," *Chronicle of Higher Education*, Nov. 25, 1992, p. A11; Laura Fraser, "Pornography – Free Speech or Sex Crime?" *San Francisco Examiner*, Nov. 29, 1992; Catharine MacKinnon, "An Act of Violence Against Women," *San Francisco Examiner*, Nov. 29, 1992; "Porn Fight," *National Law Journal*, Dec. 14, 1993; "University – Ann Arbor, Michigan," *American Library Association Newsletter on Intellectual Freedom*, Jan. 1993; editorial, *New Art Examiner*, Feb. 1993, p. 7; Ami Walsh, "Michigan Law Students Shutter Exhibition on Prostitution," *Independent*, vol. 16, no. 2 (Mar. 1993), pp. 12–13.

 Protests were mounted by the National Campaign for Freedom of Expression, College Art Association, National Association of Artists Organization, National Coalition Against Censorship, American Civil Liberties Union, FACT (Feminist Anti-Censorship Task Force), PONY (Prostitutes of New York) and COYOTE, the prostitutes' rights organization. A petition protesting the closing of the exhibition and requesting reinstallation and an educational forum designed to air issues raised by the incident was signed by over 500 individuals.

For coverage of the "resolution" of the case, see Mickle, "'U' Avoids Court Case," p. 3; Rosalva Hernandez, "U-M Agrees to Permit Art Exhibit on Prostitution," *Detroit News*, Mar. 18, 1993, p. 3B; Julie Wiernik, "Exhibit on Prostitutes Returning to U-M," *Ann Arbor News*, Mar. 17, 1993, pp. A1, A10.

15 Frances Doughty, personal communication.

16 Lewin, "Furor on Exhibit at Law School," p. B16.

17 "Porn Fight," *National Law Journal*, Dec. 14, 1992.

18 Wiernik, "Exhibit on Prostitutes Returning," p. A10.

19 Bollinger does admit that the students acted "unfortunately" when they removed the videotape, and he is eager to portray himself as a supporter of the reinstallation and educational forum (Wiernik, "Exhibit on Prostitutes Returning," pp. A1, A10); plans for such events remain vague. According to his comments, however, Bollinger envisions this public forum on a considerably smaller scale than the first conference, taking place in a University of Michigan classroom and lasting "just one afternoon" (see Johnson, "Sex, Laws and Videotape," p. 4E).

20 Lewin, "Furor on Exhibit at Law School," p. B16. According to the *Detroit News*, MacKinnon passed on Stoltenberg's complaint to law student Julia Ernst, "without recommending what should be done about the video." MacKinnon herself said, "It was so clearly up to the students to handle it in some kind of way or other. It wasn't something to which I directed my attention because it wasn't up to me" (Johnson, "Sex, Laws and Videotape," p. 2E). In a letter to the *New York Times* on Dec. 12, 1992, MacKinnon stated, "They [the students] acted on their own." See also Jacobsen, "Issues Forum: First Amendment Rights," p. 4; and Lewin, "Furor on Exhibit at Law School," p. B16.

21 In place of the imprecise term "pornography," I am employing the phrase "sexually explicit imagery," a construction that both eliminates the intrinsically pejorative meaning and forces the speaker to define what it is about the imagery that he or she finds offensive.

22 In the Butler case, an adult-bookstore owner convicted under Canadian obscenity statutes challenged the law, claiming restriction of free expression. The court rejected his claims and upheld the obscenity law, citing traditional state interest in preserving morality and, for the first time, in protecting citizens, particularly women, from the violence and degradation allegedly caused by pornography. Key sources which the court used to establish the harms of pornography were the writings of antipornography feminists like MacKinnon and the report of the Reagan-appointed attorney general's committee on pornography, widely criticized for its biased procedures and conservative leanings. See *R. v. Butler*, Supreme Court of Canada, S.C.J. no. 15, 1992. Also, "Law on Pornography Upheld by Supreme Court," *Globe and Mail* (Toronto), Feb. 28, 1992; "Top Court Upholds Law on Obscenity," *Toronto Star*, Feb. 28, 1992.

23 See Camilla Gibb, "Project P Targets Lesbian Porn," *Quota Magazine*, May 1992; and "News in Brief – Canada," *The Advocate*, June 2, 1992, p. 34.

11 AIDS

Cultural Analysis/Cultural Activism

Douglas Crimp

"I assert, to begin with, that 'disease' does not exist. It is therefore illusory to think that one can 'develop beliefs' about it to 'respond' to it. What does exist is not disease but practices." Thus begins François Delaporte's investigation of the 1832 cholera epidemic in Paris.[1] It is a statement we may find difficult to swallow, as we witness the ravages of AIDS in the bodies of our friends, our lovers, and ourselves. But it is nevertheless crucial to our understanding of AIDS because it shatters the myth so central to liberal views of the epidemic: that there are, on the one hand, the scientific facts about AIDS, and, on the other hand, ignorance or misrepresentation of those facts standing in the way of a rational response. I will therefore follow Delaporte's assertion: AIDS does not exist apart from the practices that conceptualize it, represent it, and respond to it. We know AIDS only in and through those practices. This assertion does not contest the existence of viruses, antibodies, infections, or transmission routes. Least of all does it contest the reality of illness, suffering, and death. What it *does* contest is the notion that there is an underlying reality of AIDS, on which are constructed the representations, or the culture, or the politics of AIDS. If we recognize that AIDS exists only in and through these constructions, then the hope is that we can also recognize the imperative to know them, analyze them, and wrest control of them.

First published in *October* 43 (winter 1987): 3–16. The slightly adapted version reproduced here was published in Douglas Crimp (ed.), *Melancholia and Moralism: Essays on AIDS and Queer Politics* (Cambridge, Mass.: MIT Press, 2002), pp. 27–41. Copyright © 1987 by October Magazine Ltd and the Massachusetts Institute of Technology.

Within the arts, the scientific explanation and management of AIDS is largely taken for granted, and it is therefore assumed that cultural producers can respond to the epidemic in only two ways: by raising money for scientific research and service organizations or by creating works that express the human suffering and loss. In an article for *Horizon* entitled "AIDS: The Creative Response," David Kaufman outlined examples of both, including benefits such as "Music for Life," "Dancing for Life," and "Art against AIDS," together with descriptions of plays, literature, and paintings that take AIDS as their subject.[2] Regarding these latter "creative responses," Kaufman rehearses the clichés about art's "expressing feelings that are not easily articulated," "shar[ing] experiences and values through catharsis and metaphor," "demonstrating the indomitability of the human spirit," "consciousness raising." Art is what survives, endures, transcends; art constitutes our legacy. In this regard, AIDS is even seen to have a positive value: Kaufman quotes Michael Denneny of St Martin's Press as saying, "We're on the verge of getting a literature out of this that will be a renaissance."[3]

In July 1987, PBS's *McNeil/Lehrer Newshour* devoted a portion of its program to "AIDS in the Arts." The segment opened with the shibboleth about "homosexuals" being "the lifeblood of show business and the arts" and went on to note the AIDS-related deaths of a number of famous artists. Such a pretext for a special report on AIDS is highly problematic, and on a number of counts: First, it reinforces the equation of AIDS and homosexuality, neglecting even to mention the possibility that an artist, like anyone else, might contract HIV heterosexually or by sharing needles when shooting drugs. Second, it suggests that gay people have a *natural* inclination toward the arts, the homophobic flip side of which is that "homosexuals control the arts" (ideas perfectly parallel with anti-Semitic attitudes that see Jews as, on the one hand, "making special contributions to culture," and, on the other, "controlling capital"). But most pernicious of all, it implies that gay people "redeem" themselves by being artists, and therefore that the deaths of other gay people are less tragic.[4] The message is that art, because it is timeless and universal, transcends individual lives, which are time-bound and contingent.

Entirely absent from the news report – and the *Horizon* article – was any mention of *activist* responses to AIDS by cultural producers. The focus was instead on the dramatic effect of the epidemic on the art world, the coping with illness and death. Extended interviews with choreographers Bill T. Jones and his lover Arnie Zane, who had been diagnosed with AIDS, emphasized the "human face" of the disease in a way that was far more palatable than is usual in broadcast television, simply because it allowed the positive self-representation of both a person with AIDS and a gay relationship. Asked whether he thought "the arts are particularly hit by AIDS," Zane replied, "That's the controversial question of this month, right?" but then went on to say, "Of course I do. I am in the center of this world, the art world. . . . I am losing my colleagues." Colleen Dewhurst, president of Actors Equity, suggested rather that "AIDS-related deaths are not more common among artists, only more visible," and continued, "Artists are supposed to represent the human condition . . ." (a condition that is, of course, assumed to be universal).

"Art lives on forever" – this idealist platitude came from Elizabeth Taylor, National Chairman of the American Foundation for AIDS Research, shown addressing the star-studded crowd at the gala to kick off "Art against AIDS." But strangely it was Richard Goldstein, writer for the *Village Voice* and a committed activist on the subject of AIDS, who contributed the broadcast's most unabashed statement of faith in art's transcendence of life: "In an ironic sense, I think that AIDS is good for art. It think it will produce great works that will outlast and transcend the epidemic."

It would appear from such a statement that what is at stake is not the survival of people with AIDS and those who might now be or eventually become infected with HIV, but rather the survival, even the flourishing, of art. For Goldstein, this is surely less a question of hopelessly confused priorities, however, than a failure to recognize the alternatives to this desire for transcendence – a failure determined by the intractability of the traditional idealist conception of art, which entirely divorces art from engagement in lived social life.

Writing in the catalog of "Art against AIDS," Robert Rosenblum affirms this limited and limiting view of art and the passivity it entails: "By now, in the 1980s, we are all disenchanted enough to know that no work of art, no matter how much it may fortify the spirit or nourish the eye and mind, has the slightest power to save a life. Only science can do that. But we also know that art does not exist in an ivory tower, that it is made and valued by human beings who live and die, and that it can generate a passionate abundance of solidarity, love, intelligence, and most important, money."[5] There could hardly be a clearer declaration of the contradictions inherent in aesthetic idealism than one that blandly accepts art's inability to intervene in the social world and simultaneously praises its commodity value. To recognize this as contradictory is not, however, to object to exploiting that commodity value for the purpose of fundraising for AIDS research and service. Given the failure of government at every level to provide the funding necessary to combat the epidemic, such efforts as "Art against AIDS" have been necessary, even crucial to our survival. I want, nevertheless, to raise three caveats.

1. Scientific research, health care, and education are the *responsibility and purpose* of government and not of so-called private initiative, an ideological term that excuses and perpetuates the state's irresponsibility. Therefore, every venture of this nature should make clear that it is necessitated strictly because of criminal negligence on the part of government. What we find, however, is the very opposite: "Confronting a man-made evil like the war in Vietnam, we could assail a government and the people in charge. But how do we confront a diabolically protean virus that has been killing first those pariahs of grass-roots America, homosexuals and drug addicts, and has then gone on to kill, with far less moral discrimination, even women, children, and heterosexual men? We have recourse only to love and to science, which is what *Art against AIDS* is all about."[6]

2. Blind faith in science, as if it were entirely neutral and uncontaminated by politics, is naive and dangerous. It must be the responsibility of everyone contributing to fundraisers to know enough about AIDS to determine whether the

beneficiary will put the money to the best possible use. How many artists and art dealers contributing to "Art against AIDS," for example, know precisely what kinds of scientific research are supported by the American Foundation for AIDS Research? How many know the alternatives to AmFAR's research agenda, alternatives such as the Community Research Initiative, an effort at testing AIDS treatments initiated at the community level by people with AIDS themselves? As anyone involved in the struggle against AIDS knows, we cannot afford to leave anything up to the "experts." We must become our own experts.[7]

3. Raising money is the most passive response of cultural practitioners to social crisis, a response that perpetuates the idea that art itself has no social function (aside from being a commodity), that there is no such thing as an engaged, activist aesthetic practice. It is this third point that I want to underscore by insisting, against Rosenblum, that art *does* have the power to save lives, and it is this very power that must be recognized, fostered, and supported in every way possible. We don't need a cultural renaissance; we need cultural practices actively participating in the struggle against AIDS. We don't need to transcend the epidemic; we need to end it.

What might such a cultural practice be? One example appeared in November 1987 in the window on Broadway of New York's New Museum of Contemporary Art. Entitled *Let the Record Show . . .* , it is the collective work of ACT UP (the AIDS Coalition to Unleash Power), which is – I repeat what is stated at the beginning of every Monday night meeting – "a nonpartisan group of diverse individuals united in anger and committed to direct action to end the AIDS crisis" [see plate 8]. More precisely, *Let the Record Show . . .* is the work of an ad hoc committee within ACT UP that responded to the New Museum's offer to create the window installation. The offer was tendered by curator Bill Olander, himself a participant in ACT UP. Olander wrote:

> I first became aware of ACT UP, like many other New Yorkers, when I saw a poster appear on lower Broadway with the equation: SILENCE = DEATH. Accompanying these words, sited on a black background, was a pink triangle – the symbol of homosexual persecution during the Nazi period and, since the 1960s, the emblem of gay liberation. For anyone conversant with this iconography, there was no question that this was a poster designed to provoke and heighten awareness of the AIDS crisis. To me, it was more than that: it was among the most significant works of art that had yet been done which was inspired and produced within the arms of the crisis.[8]

That symbol, made of neon, occupied the curved portion of the New Museum's arched window. Below it, in the background and bathed in soft, even light, was a photomural of the Nuremberg Trials (in addition to prosecuting Nazi war criminals, those trials established our present-day code of medical ethics, involving such things as informed consent to experimental medical procedures). In front of this giant photo were six life-size silhouetted photographs of "AIDS criminals" in separate, boxed-in

spaces, and below each one the words by which he or she may be judged by history, cast – literally – in concrete. As the light went on in each of these separate boxed spaces, we could see the face and read the words:

The logical outcome of testing is a quarantine of those infected.

Jesse Helms, US Senator

It is patriotic to have the AIDS test and be negative.

Cory Servaas, Presidential AIDS Commission

We used to hate faggots on an emotional basis. Now we have a good reason.

anonymous surgeon

AIDS is God's judgment of a society that does not live by His rules.

Jerry Falwell, televangelist

Everyone detected with AIDS should be tattooed in the upper forearm, to protect common needle users, and on the buttocks to prevent the victimization of other homosexuals.

William F. Buckley, columnist

And finally, there was a blank slab of concrete, above which was the silhouetted photograph of President Reagan. We looked up from this blank slab and saw, once again, the neon sign: SILENCE = DEATH.

But there was more. Suspended above this rogues' gallery was an electronic information display programmed with a running text, portions of which read as follows:

Let the record show . . . William F. Buckley deflects criticism of the government's slow response to the epidemic through calculations: "At most three years were lost . . . Those three years have killed approximately 15,000 people; if we are talking 50 million dead, then the cost of delay is not heavy. . . ."

Let the record show . . . The Pentagon spends in one day more than the government spent in the last five years for AIDS research and education.

Let the record show . . . In June 1986, $47 million was allocated for new drug trials to include 10,000 people with AIDS. One year later only 1,000 people are currently enrolled. In that time, over 9,000 Americans have died of AIDS.

Let the record show . . . In 1986, Dr Cory Servaas, editor of the *Saturday Evening Post*, announced that after working closely with the National Institutes of Health, she had found a cure for AIDS. At the time, the National Institutes of Health officials said that they had never heard of Dr Cory Servaas. In 1987, President Reagan appointed Dr Cory Servaas to the Presidential AIDS Commission.

Let the record show . . . In October of 1986, $80 million was allocated for public educa-
tion about AIDS. 13 months later there is still no national education program. In that
time, over 15,000 new cases have been reported.

Let the record show . . . 54% of the people with AIDS in New York City are black and
Hispanic. The incidence of heterosexually transmitted AIDS is 17 times higher among
blacks than whites, 15 times higher among Hispanics than whites. 88% of babies with
AIDS are black and Hispanic. 6% of the US AIDS education budget has been targeted
for the minority community.

And finally:

By Thanksgiving 1981, 244 known dead . . . AIDS . . . no word from the President.

By Thanksgiving 1982, 1,123 known dead . . . AIDS . . . no word from the President.

The text continues like this, always with no word from the President, until finally:

By Thanksgiving 1987, 25,644 known dead . . . AIDS . . . President Reagan: "I have asked
the Department of Health and Human Services to determine as soon as possible the
extent to which the AIDS virus has penetrated our society."

After each of these bits of information, the sign flashed, "Act Up, Fight Back, Fight
AIDS," a standard slogan at ACT UP demonstrations. Documentary footage from
some of these demonstrations could be seen in the videotape *Testing the Limits*,
programmed at the New Museum simultaneously with the window display. The
video about AIDS activism in New York City is the work of a collective (also called
Testing the Limits) "formed to document emerging forms of activism arising out of
people's response to government inaction in the global AIDS epidemic."

The SILENCE = DEATH Project, the group from ACT UP who made *Let the
Record Show* . . . , and Testing the Limits share important premises that can teach us
much about engaged art practices. First, they are *collective* endeavors. Second, these
practices are employed by their collectives' members as an essential part of their
AIDS activism. This is not to say that the individuals involved are not artists in the
more conventional sense of the word; many of these people work within the pre-
cincts of the traditional art world and its institutions. But involvement in the AIDS
crisis has not left their relation to that world unaltered. After making *Let the Record
Show* . . . for the New Museum, for example, the group from ACT UP reconvened
and decided to continue their work (soon adopting the name Gran Fury). Among the
general principles discussed at their first meeting, one was unanimously voiced: "We
have to get out of Soho, get out of the art world."

The New Museum has been more hospitable than most art institutions to socially
and politically committed art practices, and it was very courageous of the museum to
offer space to an activist organization rather than to an artist. It is also very useful

that the museum has a window on lower Broadway that is passed by many people who would never set foot in an art museum. But if we think about art in relation to the AIDS epidemic – in relation, that is, to the communities most drastically affected by AIDS, especially poor and minority communities where AIDS is spreading much faster than elsewhere – we will realize that no work made within the confines of the art world as it is currently constituted will reach these people. Activist art therefore involves questions not only of the nature of cultural production but also of the location, or the means of distribution, of that production. *Let the Record Show . . .* was made for an art-world location, and it appears to have been made largely for an art-world audience. By providing information about government inaction and repressive intentions in the context of shocking statistics, its purpose is to inform – and thereby to mobilize – its presumably sophisticated audience (an audience presumed, for example, to be able to recognize a photograph of the Nuremberg Trials).[9] Such information and mobilization *can* (contra Rosenblum) save lives; indeed, until a cure for AIDS is developed, *only* information and mobilization can save lives.

In New York City, virtually every official campaign of highly visible public information about AIDS – whether AIDS education for schools, public service announcements on TV, or posters in the subways – must meet with the approval of, among others, the immensely powerful and reactionary Cardinal John J. O'Connor. This has resulted in a murderous regime of silence and disinformation that virtually guarantees the mounting deaths of sexually active young people – gay and straight – and of IV drug users, their sex partners, and their children, most of them from poor, minority populations. Recognizing this, small coalitions of cultural workers, including a group calling itself the Metropolitan Health Association and Gran Fury, have taken to the streets and subways to mount education campaigns of their own. Employing sophisticated graphics and explicit information, printed in English and Spanish, these artists and activists are attempting to get the unambiguous word out about how safe sex and clean works can protect people from contracting HIV. Even apart from the possibility of arrest, the difficulties faced by these people are daunting. Their work demands a total reevaluation of the nature and purpose of cultural practices in conjunction with an understanding of the political goals of AIDS activism. It requires, in addition, a comprehensive knowledge of routes of HIV transmission and means of prevention, as well as sensitivity to cultural specificity – to, say, the street language of Puerto Ricans as opposed to that of Spanish-speaking immigrants from Central or South America.

Even having adopted new priorities and accumulated new forms of knowledge, the task of cultural producers working within the struggle against AIDS will be difficult. The ignorance and confusion enforced by government and the dominant media; the disenfranchisement and immiseration of many of the people thus far hardest hit by AIDS; and the psychic resistance to confronting sex, disease, and death in a society where those subjects are largely taboo – all of these conditions must be faced by anyone doing work on AIDS. Cultural activism is only now beginning; also just beginning is the recognition and support of this work by art-world institutions.

To date, a majority of cultural producers working in the struggle against AIDS have used the video medium. There are a number of reasons for this. Much of the dominant discourse on AIDS has been conveyed through television, and this discourse has generated a critical counter-practice in the same medium; video can sustain a fairly complex array of information; and cable access and the widespread use of VCRs provide the potential for a large audience for this work.[10] In October 1987, the American Film Institute Video Festival included a series entitled "Only Human: Sex, Gender, and Other Misrepresentations," organized by Bill Horrigan and B. Ruby Rich. Of eight programs in the series, three were devoted to videotapes about AIDS. Among the more than twenty videos shown, a full range of independent work was represented, including tapes made for broadcast TV (*AIDS in the Arts*), AIDS education tapes (*Sex, Drugs, and AIDS*, made for the New York City School system), "art" tapes (*News from Home* by Tom Kalin and Stathis Lagoudakis), music videos (*The AIDS Epidemic* by John Greyson), documentaries (*Testing the Limits*), and critiques of the media (*A Plague on You* by the Lesbian and Gay Media Group). The intention of the program was not to select work on the basis of aesthetic merit but to show something of the range of representations and counterrepresentations of AIDS. As B. Ruby Rich stated in the program:

> To speak of sexuality and the body, and not speak of AIDS, would be, well, obscene. At the same time, the peculiarly key role being played by the media in this scenario makes it urgent that counterimages and counterrhetoric be created and articulated. To this end, we have grouped the AIDS tapes together in three special programs to allow the dynamic of their interaction to produce its own discourse – and to allow the inveterate viewer to begin making the aesthetic diagnosis that is quickly becoming every bit as urgent as (particularly in the absence of) the medical one.[11]

My preparation of a special issue of *October* on AIDS stemmed initially from encounters with several works of or about media: Simon Watney's book *Policing Desire: AIDS, Pornography, and the Media* (Minnesota University Press, 1987); Stuart Marshall's video *Bright Eyes*, made for Britain's Channel 4 television; and the documentary about AIDS activism in New York City *Testing the Limits*. My intention was to show, through discussion of these works, that there was a critical, theoretical, activist alternative to the personal, elegiac expressions that appeared to dominate the art-world response to AIDS. What seemed to me essential was a vastly expanded view of culture in relation to crisis. But the full extent to which this view would have to be expanded became clear only through further engagement with the issues. AIDS intersects with and requires a critical rethinking of all of culture: of language and representation, science and medicine, health and illness, sex and death, the public and private realms. AIDS is a central issue for gay men, of course, but also for lesbians. AIDS is an issue for women generally, but especially for poor and minority women, child-bearing women, and women working in the health care system. AIDS is an issue for drug users, for prisoners, and for sex workers. At some point, even "ordinary" heterosexual men will have to learn that AIDS is an issue for them, and not simply because they might be susceptible to "contagion."

Notes

1 François Delaporte, *Disease and Civilization: The Cholera in Paris, 1832*, trans. Arthur Goldhammer (Cambridge: MIT Press, 1986), p. 6.

2 David Kaufman, "AIDS: The Creative Response," *Horizon* 30, no. 9 (November 1987), pp. 13–20.

3 Denneny is the editor of Randy Shilts's *And the Band Played On*, a discussion of which appears in "How to Have Promiscuity in an Epidemic," in Douglas Crimp, ed., *Melancholia and Moralism: Essays on AIDS and Queer Politics* (Cambridge: MIT Press, 2002).

4 Redemption, of course, necessitates a prior sin – the sin of homosexuality, of promiscuity, of drug use – and thus a program such as "AIDS in the Arts" contributes to the media's distribution of innocence and guilt according to who you are and how you contracted HIV. Promiscuous gay men and IV drug users are unquestionably guilty in this construction, but so are all people from poor minority populations. The special attention paid to artists and other celebrities with AIDS is nevertheless contradictory. While a TV program such as "AIDS in the Arts" virtually beatifies the stricken artist, for personalities such as Rock Hudson and Liberace the scandal of being found guilty of homosexuality tarnishes the halo of their celebrity status.

5 Robert Rosenblum, "Life Versus Death: The Art World in Crisis," in *Art against AIDS* (New York: American Foundation for AIDS Research, 1987), p. 32.

6 Ibid., p. 28. I hope we can assume that Rosenblum intends his remarks about "pariahs" and "moral discrimination" ironically, although this is hardly what I would call politically sensitive writing. It could easily be read without irony, since it so faithfully reproduces what is written in the press virtually every day. And the implication of the "even women" in the category distinct from "homosexuals" is, once again, that there's no such thing as a lesbian. But can we expect political sensitivity from someone who cannot see that AIDS is political? That *science* is political? It was science, after all, that conceptualized AIDS as a gay disease and wasted precious time scrutinizing our sex lives, theorizing about killer sperm, and giving megadoses of poppers to mice at the CDC – all the while taking little notice of the others who were dying of AIDS, and thus allowing HIV to be injected into the veins of vast numbers of IV drug users, as well as of hemophiliacs and other people requiring blood transfusions.

7 I do not wish to cast suspicion on AmFAR, but rather to suggest that no organization can be seen as neutral or objective. See in this regard the exchange of letters on AmFAR's rejection of the Community Research Initiative's funding applications in the *PWA Coalition Newsline* 30 (January 1988), pp. 3–7.

8 Bill Olander, "The Window on Broadway by ACT UP," in *On View* (New York: New Museum of Contemporary Art, 1987), p. 1. The logo that Olander describes is not the work of ACT UP, but of a design collective called the SILENCE = DEATH Project, which lent the logo to ACT UP.

9 Whether or not the audience was also presumed to be able to see a connection between *Let the Record Show . . .* and the procedures and devices of artists such as Hans Haacke, Jenny Holzer, and Barbara Kruger is an open question.

10 For a good overview of both commercial television and independent video productions about AIDS, see Timothy Landers, "Bodies and Anti-Bodies: A Crisis in Representation," *Independent* 11, no. 1 (January–February 1988), pp. 18–24.

11 B. Ruby Rich, "Only Human: Sex, Gender, and Other Misrepresentations," in *1987 American Film Institute Video Festival*, Los Angeles, p. 42.

12 Architecture of the Evicted

Rosalyn Deutsche

O ver the last decade, an enthusiasm for the past has steadily permeated New York's aesthetic vocabulary until, at the present moment, terms such as "tradition," "preservation," indeed "history" itself, have become catchwords of the cultural practices manufacturing our built environment. Official discourses about history circulate in the specialized institutions of the professions that, collectively, are the architects of the city. Architects, planners, designers, and public artists materialize history in such recent urban programs as landmark preservation, contextual zoning, historic district simulations, neighborhood "revivals" and civic art restorations.

Rarely, however, do the projects executed under the aegis of these programs – the "renaissance" of Union Square in Lower Manhattan or of the Upper West Side, for instance – actually return their sites to an earlier, and certainly not to an "original," state. Instead, they refurbish antique details while extensively reconfiguring space in accordance with the exigencies of our own historical conjuncture. For instance, park restorations may restore existing sculptures or street furniture but redesign space as reverse panopticons – Foucauldian spatial mechanisms that permit the policing of inhabitants through principles of compulsory visibility.[1] Projects such as Battery Park City, exemplar of the return to convention in city planning, literally fabricate traditional neighborhoods anew.[2] And even when redevelopment schemes utilize old

From *Strategies* 3 (1990): 159–83. Reproduced with kind permission of Taylor & Francis Ltd, <www.tandf.co.uk/journals>. A version of this essay first appeared in the catalogue of *Krzysztof Wodiczko: New York City Tableaux and The Homeless Vehicle Project*, New York, Exit Art, September 23–October 28, 1989.

terrains and structures, as in the renewal of South Street Seaport, they also engineer wholesale change in the area's uses. Advertising campaigns in the mass media, cultural journals, real-estate brochures, and speeches by public officials try to lend an aura of authenticity to such initiatives by emphasizing the restoration of "real" historical elements. Primarily, however, they invoke a past existing only in the realm of the imaginary, eliciting from readers and viewers nostalgia, bound up with objects, for a flawless environment. An external "guarantee" of an equally flawless self, their image of the city is, of course, a fantasy from the start.

The preservation of this image therefore exacts a cost in representational violence: the city can only be constructed as a coherent entity by expelling the conflicts within it and, more importantly, those that produce it. Yet when the nostalgic image is bestowed on New York's actual construction projects, its fantasy status helps those projects resist critical challenges. Accordingly, celebratory accounts of real estate- or state-sponsored architectural plans do not confine themselves to describing the historical character of individual restorations or even to suggesting that such projects reinstate the pleasures of some distant era. They intimate further that projects undertaken in the name of preservation represent advances in a struggle to restore – against disruptive forces – a model city from the more remote past, one that is harmonious in its entirety. Such a unitary urban condition, even if it never characterized New York, is said to have distinguished our heritage of earlier cities, for example, "the larger order of monumental Paris,"[3] London, or ancient Greece or Rome.

If a prototype cannot be found in earlier physical spaces, the desire for a harmonious environment can be further displaced onto a historicist narrative of urbanism, a story of urban planning as an attempt to produce an ideal human environment. Alluding to far-reaching restorative goals and conjuring a past that never existed, the newly conservative urban aesthetic explains its own contradictions – between, for one, its preservationist rhetoric and destructive acts. It aims, much like the modernist utopias it holds in contempt, to produce a unified spatial order, but one that, unlike modernist visions, also respects existing physical conditions – or so we are told. The preservationist outlook, then, presents itself as conservator of past and present. More, it projects a vision of the future, one foretold in the economic "renaissance" that New York purportedly experienced in the 1980s. Yet within the traditionalist perspective, the city's architectural expansion does not appear as an effect of economic growth alone. Rather, architecture that adheres to traditional principles of planning and design is said to reflect and engender social stability.

Indeed, the historical mentality that guided the spatial and visual production of the city went hand in hand with intensified economic and social restructuring, by means of which, it is routinely held, New York recovered its balance, which had been severely shaken by the "fiscal" crisis of the mid-1970s as well as by regional racial conflicts in the late 1960s. But restructuring does not represent a neutral solution to objective problems. The reverse is closer to the truth: driven by the imperatives to facilitate capital accumulation and enhance social control, it is legitimated by prevailing *constructions* of social "realities." The city's redevelopment, as an aspect of broader

restructuring, does extensively transform New York: not, however, into an environment that serves the needs of a monolithic body of residents but into a center for the executive functions of finance corporations and related services. It is part of a globally reordered division of labor in which multinational corporations shift productive activities and low-level clerical jobs outside metropolitan centers, a shift that in turn alters employment patterns within cities like New York, which occupy the upper ranks of a reconstituted international urban hierarchy. Redevelopment and its residential component, gentrification, which is to say, upward changes in the class composition of neighborhoods, systematically destroy the physical conditions of survival – housing and services – for redundant blue-collar workers, while creating luxury housing, office towers, and recreational facilities to serve the new corporate workforce and tourist industries.

Gentrification also fosters gross real-estate speculation, as land is exploited for superprofits, an exploitation that is further encouraged by crises in troubled sectors of capital that encourage investment in the built environment. Since maximum profits in real estate depend on previous devalorizations of land, which creates a gap between present and potential values, the gentrification of the city is geographically, as well as economically, uneven: deterioration of low-income housing and neighborhoods sets the stage for subsequent investment for "higher," more profitable uses. The resulting displacement of low-income residents (who are already marginalized by the loss of jobs) through direct eviction or the exclusionary conversion of neighborhoods into areas they can no longer afford is, therefore, no accidental by-product of prosperity. It is caused by the conditions of growth under advanced capitalism, which requires unevenness.

Far from a period of stability, then, the era of redevelopment entails a wrenching reorganization of the economy, changing patterns of employment, class and racial polarization, destruction of communities, and the forcible dislocation of masses of immiserated New Yorkers. Along with proliferating condominium towers, lavish corporate headquarters, convention centers, and mixed-use luxury developments – signs of New York's prosperity – the most visible symptoms of this reorganization are abandoned apartments, deteriorating neighborhoods, and, especially, thousands of displaced homeless residents, who are the product of an urban policy that simultaneously creates and abandons responsibility for basic social needs as it responds to capital's search for profits. And far from conserving the physical city, redevelopment threatens to change the scenery altogether. What, then, is the nature of the stability conjured by architecture as it attempts to preserve traditional appearances? How do aesthetic practices that proclaim devotion to history function within the actual historical conditions of redevelopment? How might counter-practices remake this history?

Krzysztof Wodiczko has raised and responded to these questions in a series of projects – public artworks, proposals, gallery installations – shown in New York beginning in 1984. Three slide projections – *The New Museum/Astor Building Projection* (1984), *The Homeless Projection: A Proposal for the City of New York* (1986), *The Real-Estate Projection* (1988) – as well as the ongoing *Homeless Vehicle Project*, first exhibited

in 1988, deal directly with real estate and housing and establish their importance to New York's aesthetic landscape. The first three works consisted of images projected onto the surfaces of buildings or sculptures in Lower Manhattan neighborhoods that have been targeted for redevelopment: Lower Broadway, Union Square, the Lower East Side. The subject matter of Wodiczko's images connected the architectural structures to their surrounding areas and, by virtue of attention to social concerns, revealed that these areas were immersed in broader spatial situations.

Only by recognizing that the effects of redevelopment in individual urban spaces are not circumscribed but radiate outward and that redevelopment projects are part of larger, indeed global, spatial patterns can we discern, beneath the appearance that gentrification is random and spontaneous, its systematic character and extensive proportions. But to fully analyze restructuring, our field of vision cannot simply be widened to encompass lateral extensions of physical space; it must also expand conceptually to perceive space as social, as, that is, an economic, political, and cultural construction. Since the late 1960s, critical urban theorists have adopted an approach to the urban object that integrates spatial and social relations. During the same years, the dimensions of aesthetic thought have expanded in similar directions: criticism has positioned art objects geographically, which is to say, within broader spaces, and has also spatialized the art object itself by treating it as a social relationship itself. Wodiczko combines insights from the two fields in his urban-aesthetic practice. Relating art and architecture to urban conditions, he does not merely stretch the boundaries of art by placing "inside" buildings and institutions images of socio-spatial issues purported to lie "outside." Rather, he investigates how the outside always resides within, constituted by and, at the same time constituting, not simply influencing, the identities of institutions. The manner in which his projected images infiltrate physical surfaces, dissolving yet calling attention to the boundaries of architectural or spatial structures, gives literal form to the ambiguous status of the line that divides interior and exterior.

Each of Wodiczko's Lower Manhattan projections explored a network of spatial relations by examining the function of specific cultural institutions – museum, art gallery, public art – in the mechanism of gentrification. The New Museum of Contemporary Art, site of the artist's 1984 projection, is an exhibition space occupying the ground floor of the Astor Building on Lower Broadway. Inserted into the building and into the gentrifying district, however, the New Museum itself is an exhibition. It displays to future luxury tenants the high-status as well as high-income character of the area. More, the museum creates an image of redevelopment as a whole, legitimating it as a positive force that brings cultural benefits to all New Yorkers. Likewise, in the 1980s, East Village art galleries both elevated property values and legitimated gentrification on the Lower East Side, imparting at the same time a Bohemian atmosphere to the area that encouraged a disavowal of social conditions.[4] The restoration of Union Square Park and its four neoclassical sculptures, the centerpiece of Union Square gentrification, provided the same aesthetic alibi for the economic interests benefiting from that area's redevelopment. "High culture" performs these economic and ideological functions effectively, since, presupposed to lie outside socio-material conditions, it merges populist and elitist sentiments. Its presence establishes proof of

a wealthy neighborhood's "real" elite status and, at the same time, offers evidence of redevelopment's public accountability, even "democratic" character.

When, however, utilizing techniques of slide projection and montage, Wodiczko infiltrated the surfaces of physical structures embodying "culture" with images alluding to the social consequences of gentrification, he challenged the idealist separation of aesthetics from the material conditions of its existence. He focused the images on concrete art institutions: locks and chains on the warehoused Astor Building and the New Museum; windows with a view of devastated low-income apartment houses on the walls of a renovated Lower East Side gallery; the attributes and tools of survival of homeless residents on the Union Square monuments. But because the images eroded the rigid dualisms erected by idealist aesthetics, they challenged art *as* an institution: a mode of production and reception, discursive formation, and signifying practice.

In this respect, the recent New York projections pursued the aims that unite all the projections Wodiczko has engineered since 1979. As a description of Wodiczko's practice, the word "projection" refers first to the process of exhibiting slides on a screen, in this case, on the surfaces of buildings, spaces, or monuments. "Projection" has multiple definitions, however, and denotes more than a technical procedure. It describes, for instance, a symbolic operation by which concepts are visualized as external realities and, further, a rhetorical device for speaking with clarity at a distance. In these senses, projection refers to the procedural dimension of language. Indeed, the success of Wodiczko's work depends on the degree to which it disrupts the seeming naturalness of the built environment – its appearance of simply being there – and mobilizes in its audience an awareness that the architecture on which it projects images is not merely a collection of beautiful or functional objects but, rather, a set of signifying objects transmitting messages about the meaning of the city. The very existence of such messages depends on the presence of spectators who receive them. To counteract architecture's conventional rhetoric, Wodiczko's projections must therefore disengage viewers from habitual modes of perceiving and inhabiting the city, of passively receiving its messages. They must reposition viewers so as to alter the nature of social space. Calling attention to and manipulating architecture's language, Wodiczko's works disrupt the city's speech. They do not only interfere with the conscious perceptions of sociologically defined spectators; they also subvert the fantasy projections of viewing subjects, who, through the modes of identification solicited by traditional architecture, "ensure" an imaginary self-coherence by looking at naturalized images of the city. Wodiczko's performances are, then, projections onto projections.

Architectural representations gain their authority and seeming inevitability either by denying that they speak at all or by disavowing the social and psychical mechanisms through which meaning is produced by and attributed to physical objects. Within a functionalist perspective, instrumental purpose – the mere fulfillment of "natural needs" – is believed to be the only meaning signified by the built environment. In the image of the utilitarian city constructed by functionalism, the city speaks for itself. Aestheticism, by contrast, holds that the visual components of the city – monuments, buildings, parks, artworks – contain inherent, fixed and autonomous

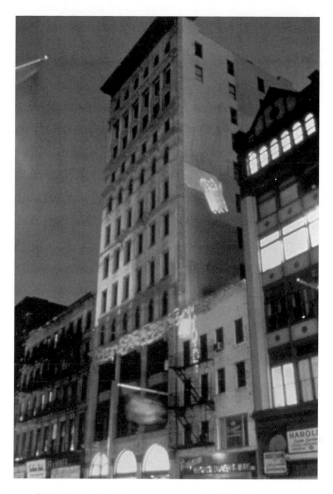

Figure 12.1 Krzysztof Wodiczko, *Projection*, 1984. Astor Building/New Museum of Contemporary Art. Courtesy of Galerie Lelong, New York.

aesthetic meaning. The "beautiful city" by definition has no social function other than the ahistorical one of nourishing the transcendent inner visions of the unchanging human spirit. Yet another point of view openly celebrates the symbolism of urban objects but believes that they express values and beliefs adhered to by a unitary society. All these idealist notions, projected *onto* architecture, disavow the social production of meaning. When in turn they are projected *by* architecture they are instrumental in securing consent to urban political processes such as, most recently, redevelopment. Environments shaped by the particular interests of profit and control appear to be determined by the universal interests of utility, beauty and truth.

To challenge the authority of architecture Wodiczko's projections disrupt the apparent naturalness and homogeneity of its speech. Like the image of the flawless city, unruptured by conflicts or differences, the image of symbolic structures as

embodiments of social cohesion can only be built by repressing the relations of domination that have produced them as symbols of unity. Current uses of neo-classical buildings and monuments illustrate the process. Nineteenth-century munici-pal art movements placed such structures in United States cities as part of an attempt to establish social order and conceal contradictions because neoclassical aesthetic codes signified tradition, order, timelessness and moral perfection.[5] Today, redevel-opment projects capitalize on earlier connotations when they refurbish neoclassical monuments, projecting new meanings onto old structures that survive in transformed conditions.

In Union Square, for example, to provide amenities to subsidize the area's luxury development, city government restored Union Square Park and its four sculptural monuments. They carried out the restoration in the name of a return to the tradi-tional city. Like all redevelopment schemes, Union Square "revitalization" added untold numbers of people to the ranks of the city's homeless population through exclusionary displacement. Further, the park renovation tried to remove the home-less who already resided in the park. Given the goals and effects of Union Square redevelopment, the neoclassical statues and the park itself can only be presented as symbols of redevelopment's preservation of shared, enduring values through sup-pression. The relations that produced the monuments in their new incarnation – real estate, private property, the commodity form of housing provision – and the most dire consequence of these relations – homelessness – must be constituted as cate-gories distinct from gentrification. The homeless must therefore be evicted not only from redeveloped spaces but also from the image of redevelopment.

However, it is not necessary to eliminate the visible evidence of homelessness to bring about this repression. Visibility has ambiguous and multiple effects. While it can create legitimation problems for local government, it can promote a disciplinary agenda to ward off demands from the poor.[6] The repression of redevelopment's contradictions does require that the links between homelessness and the city's trans-formation be severed on the register of appearances. Massive propaganda campaigns about alcohol, mental illness, and drug-related reasons for homelessness effect this separation when they represent such "causes" as distinct from housing issues or as themselves unrelated to the city's redevelopment. So does former Parks Commis-sioner Henry Stern's contention, in support of regulations that bar the homeless from using city parks for survival needs, that the parks cannot "solve" the homeless problem. This defense denies the fact that, as a major facet of redevelopment, the gentrification of city parks produces homelessness.

Wodiczko counteracts the suppression of social conflicts in architectural images of redevelopment by projecting back onto gentrified structures counter-images alluding to conflicts. His Union Square project, for instance, was a proposal to pro-ject onto the façades of the park monuments attributes of the homeless – their tools of survival – so that the figurative sculptures themselves would appear to be evicted. Visualizing the absences on which the traditional image of redevelopment is structured, Wodiczko's projects are genuine acts of architectural restoration: they

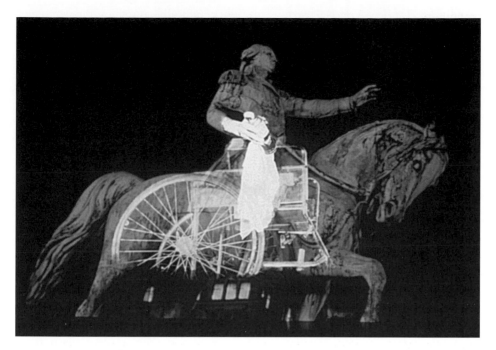

Figure 12.2 Krzysztof Wodiczko, *Proposal for Union Square*, 1986. Courtesy of Galerie Lelong, New York.

reinstate the memory of events and people expelled in the construction of stable meanings. Integrated with the architecture, Wodiczko's images heal the breaches created by violent expulsions, especially as the absences remain visible on the monuments, lingering in viewers' memories after the slide machines are switched off.

Consequently, Wodiczko's projections accommodate themselves to the architectural syntax of the buildings they criticize, manipulating them from within. By doing so the images force spectators' attention to the structures' own language. Formal congruence between image and architecture also renders the projection more astonishing as excluded material returns within the familiar vehicles of its expulsion. The surprise engendered by this uncanny impression alters the viewer's relation to urban objects. For if dominant representations imprint their messages on receivers through an immediate identification with an image so "natural" it seems to be uncoded, Wodiczko's transformed images have the opposite effect: they impede one-way communication and, restoring memories, require us to critically read the environment, fostering the creative consumption of the city.

As New York redevelops and its contradictions deepen, the necessity for such readings has become more urgent and the conditions for developing critical urban practices more complicated than ever before. In the face of an urban situation whose ramifications are only now becoming manifest Wodiczko has engaged in a new work

called *The Homeless Vehicle Project*.[7] This work radically amplifies the strategies employed in the projections but adapts them to confront redevelopment's threat to occupy space entirely. *The Homeless Vehicle Project* is a projection in the sense of a plan, a proposal to produce a vehicle designed by Wodiczko in consultation with homeless men. Designed to aid residents who make a living by collecting cans and bottles to be exchanged for deposits, the vehicle would also enhance the ability of this group of homeless people to live, work and move through the streets of New York. The project is, then, an action supporting the right of evicted residents to resist relegation to intolerable shelters and to the city's periphery. It legitimates the status of these residents as members of the urban community.

Preliminary presentations of the vehicle have utilized the discursive forms of architectural and planning – drawings, models, photomontages – to picture the object's effect on the existing city. When the vehicle circulates in the parks, streets and spaces of the city itself, however, it actualizes these preliminary projections, creating a tension between its practical and symbolic functions, which cannot be pried apart. Like the artist's slide projections, the *Homeless Vehicle Project* disrupts the official architecture of the city, but its mobility extends the work's context to urban space as a whole, defining architecture as the city itself. This wider geographical network is the work's potential site. As a tool with which those evicted by redevelopment can pursue their daily lives, the *Homeless Vehicle Project* is also, then, a weapon in a struggle waged by residents to appropriate a city dominated by profit and state interventions. As a symbolic and temporary weapon, however, it does not offer itself as a solution for the homeless but helps elucidate the mechanisms by which space is dominated and the domination resisted.

Critical challenges to redevelopment stem from the recognition that in addition to an economic restructuring, New York's transformation tries to reconcile social contradictions by refortifying a spatial hierarchy. The arrangement of redeveloped space is not determined by inevitable evolutions – technological, biological, organic, or social. Neither does it fulfill the natural needs of individuals aggregated in cities. Such essential views of urban organization perform a political function by obstructing the perception that the forms, uses and meanings assigned to space fulfill the needs of specific societies structured on relations of power. The construction of the city, then, is conflictual, not uniform, and its conflicts are political, not inevitable. As Henri Lefebvre says, space is a social product, an arena for the reproduction of social relations and itself a social relation. New York's present restructuring perpetuates the production of a distinctive historical space: an economic and political space both of which "converge," in the words of Lefebvre, "toward the elimination of all differences."[8]

Homogenization – of space, history, culture, and society – characterizes all facets of the redevelopment process. Restructuring strives to create in New York's physical environment a condition that Paul Feyerabend, referring to international tendencies toward the destruction of cultural variety, calls a "brave new monotony."[9] The global conquest of differences that Feyerabend considers the distinguishing feature

of the contemporary world and that Lefebvre sees as the key feature of the spatial exercise of power is manifested in New York. Homogenization takes place forcibly when social groups are literally expelled from the city. It also works discursively by inscribing the absence of groups in representations of the city. Further, it functions ideologically, neutralizing antagonisms among competing visions of the city by substituting arbitrary differences or simple dualisms for genuine conflicts. These homogenizing procedures consolidate the city as territory, constructing a domain over which power is exercised by controlling relations of inclusion/exclusion and presence/absence.

For Lefebvre, the homogenization of space produces an economic and political geography serving the dual, sometimes conflicting, interests of profit and state control. In accordance with the general leveling tendencies of capitalism, spatial production fragments land into interchangeable units that can be exchanged as a commodity – real estate – and, contradictorily, organizes space into vast networks that function efficiently as force of production within a world economy. The exploitation of space by tourist and leisure businesses also has a homogenizing effect since such industries preserve diversities only insofar as they are generalized from the specific social realities of inhabitants and reconstituted as objects of consumption. Abstracting space from subjects in multiple ways, the relations of spatial production under advanced capitalism withdraw from users of space the power to control its production. So does government domination of urban planning and architecture. New York is thus alienated from its users by various means: the private property relation through which it is owned as land and appropriated for profit; the privatization and bureaucratization of land-use decisions; technocratic city planning that produces space as an external framework into which people are passively inserted; inequitable distribution of spatial resources by government agencies; planning decisions that construct a city racially, economically, and functionally segregated into centers of wealth and decision-making power insulated from impoverished and voiceless peripheries.

As a result, the production of New York both literally deterritorializes huge numbers of residents and causes public space to atrophy into private or state-controlled areas that tolerate little resistance to approved uses. These deterritorializations destroy the material ground of public life even as the provision of "public" space by redevelopment projects continues to be heralded as a triumph for the public. Redeveloped public spaces legitimate and provide amenities for profitable investment.[10] What is threatened with extinction in New York is not government involvement in the production of space, as some critics believe. Rather, the nature of that production undermines the conditions for situating a public sphere – at once a concrete spatial form and a social arena of democratic political debate. "The public sphere is in this sense what one might call the factory of politics – its site of production," writes Alexander Kluge, proposing the establishment of a public sphere that opposes the exclusionary rights of private property and state control.[11] To illuminate the present dangers posed to such an arena, Kluge compares today's loss of a public sphere with the appropriation of common land by feudal lords:

The loss of land also means a loss of community because if there is no land on which the farmers may assemble, it is no longer possible to develop a community. The same thing is happening again, on a historically higher plane, in people's heads when they are deprived of the public sphere.[12]

Ultimately, redevelopment is a twofold program. It homogenizes and deterritorializes. New York's homeless are evictees in a broad sense: refugees from the city's transformation. They are expelled from homes, communities, parks, the economy, the city and society. Because homogenization of conflicting concerns can only be brought about through exclusions, redevelopment is structured on relations of eviction by means of which its stability comes into existence. For this reason, the architecture of redevelopment does not transparently reveal the city's social stability. Its defenders are right: it has real social effects. It assumes, for one thing, the task of maintaining ideological stability. The preservationist aesthetic is ideally suited to this job because, under its direction, architecture can fulfill capitalism's need to continuously change the built environment and yet explain those disruptions in terms of enduring values. Moreover, by evoking the nostalgic image of the coherent city, the preservationist outlook presents disruptions as the essential precondition for reestablishing harmony. The paradoxical admission that enduring tradition is vulnerable to extinction justifies attacks on, even the elimination of, those groups that contest the values represented by the dominant city. The traditional city is, therefore, a picture of society as a harmonious "we" who hold eternal values. But since the image of a monolithic society depends on controlling differences, New York's "restoration" becomes an act of "reclaiming" the city from those it marginalizes.[13]

History in New York, as in other areas, is, then, less a process of memory than an attempt to forget. More precisely, the architecture of redevelopment constructs the built environment as a medium, one we literally inhabit, that monopolizes popular memory by controlling the representation of its own history. It is an evicting architecture. Not only is it sponsored by economic and political forces bent on expulsion, confinement, and ghettoization, and not only does it relinquish responsibility for basic needs; it also attempts to direct the representation of social life by silencing conflicts and rendering entire social groups absent from the city. One can easily detect who is consigned to oblivion and who is addressed as the subject of a unitary city in media constructions that debate whether or not the homeless are "ordinary, middle-class folks" and "people like us." The exclusionary gesture is equally clear when, in an article designed to comfort New Yorkers by praising the virtues of new "public" benefits, we read:

> New Yorkers suddenly can't seem to find anything good to say about their city. . . .
> Beggars stalk the sidewalks, prices keep soaring, the homeless are everywhere . . . and it still takes four months to get a seat at The Phantom of the Opera.[14]

"In some cases," the author of this statement adds, the "renewal" he celebrates "has pushed out longtime tenants and businesses."[15] But this caveat, the obligatory mention

of displacement, only intensifies the effects of disingenuous portrayals of gentrification and redevelopment as the sources of civic "improvements." Evictions are not unfortunate by-products of actions undertaken for the general good. Such depictions conceal the structural link between homelessness and redevelopment, perpetuating the causes of New York's worst problems by portraying them as solutions.

Despite the repressive mechanisms that dominate current constructions of the city, space continues to be appropriated for purposes of daily life as people live and work in the city from which they have been evicted. As Lefebvre argued, the city that homogenizes differences produces them in the process. Resistance to the spread of abstract space springs from this contradiction. For Lefebvre, meaning is invented in the processes of everyday life, and since social space is always situated – never existing independently of material forms – the space of everyday life, which counters real estate and state space, contains the potential for social criticism as it reasserts itself in the dominated space. This informs the approach to space adopted by Wodiczko in the *Homeless Vehicle Project*, which, helping the marginalized survive in the streets they already inhabit, connects homelessness to the contradictions inherent in the city's transformation. Against an evicting architecture, the *Homeless Vehicle* calls for, rather than provides, an architecture of the evicted. Given current forms of urbanism, such an oppositional construction of the city demands attention to social needs against the needs of profit. It supports the production of a democratic public space that, in Claude Lefort's words, is "large enough to accommodate only those who recognize one another within it and who give it a meaning."[16] Oppositional urban proposals also defend the production of space by users against the imposition of abstract space and attempt to meet differences in relations other than those of conquest. Aesthetic practices engaged in this struggle for an improved environment speak with, not about, marginalized members of the urban community and create representations countering the meanings projected onto the city by real-estate and state aesthetics.

Routinely, now, we are assaulted with these projections. Optimistic statements remind us of municipal "improvements." Invariably, they praise urban places built under the aegis of the historical aesthetic – park revivals, landmark preservations and neighborhood restorations. Without exception, they mobilize a historicist version of history marked by the same desire for unity as the image of a cohesive city they defend: history as the invariant survival of common traditions, an idealist narrative of cultural progress, the evolution of a homogenous society. For them, the city, as an expression of urban history, achieves its form in constant battle against the "inevitable" disruptions attendant on the need to harmonize the differences characterizing any society. Within such a writing of history, the existence of disturbing urban conditions – homelessness, for one – comes as something of a surprise; it appears to be inconsistent with our advanced stage of social, technological and cultural development. Unable to explain this condition as the product of political relations, adherents of historicism may, from a conservative point of view, see homelessness as proof of the inherent inferiority of particular individuals and groups, or, from a liberal humanist one, of the astonishing, yet persistent, inhumanity of which we still remain capable. Yet, as Walter Benjamin observed in 1940 about the latter response when it

Figure 12.3 Krzysztof Wodiczko, *Homeless Vehicle in New York City*, 1988–9. Courtesy of Galerie Lelong, New York.

was adopted toward barbaric events in Nazi Germany, "the current amazement that the things we are experiencing are 'still' possible in the twentieth century is not philosophical" nor is it "the beginning of knowledge."[17] Given the historical causes of homelessness in our social relations of exploitation, property, and difference, and given the concrete urban events of the last twenty years – social service cutbacks, subsidies for luxury and corporate development, mass evictions – homelessness, in fact, comes as no surprise. It is, rather, a predictable outcome, which is not to deny how shocking it is to those who find themselves without homes. For now, as in Benjamin's day, "The state of emergency in which we live is not the exception but the rule."[18] Discarding official tradition and learning instead from "the tradition of the oppressed," Benjamin held that "we must attain to a conception of history that is in keeping with this insight."[19]

Today, the view of history that disavows injustice as a structural, rather than exceptional, feature of our society, is commemorated in a built environment that makes homelessness appear to be a surprise by attempting to conceal the actual shocks produced by the city's transformation. This history is intentionally embodied, for instance, in old civic monuments. Responding, more than a hundred years ago, to another state-imposed urban metamorphosis – Baron Haussmann's renovation of Second Empire Paris – members of the Paris Commune attacked such univocal constructions when, attaining to a revolutionary conception of history, they demolished one of these monuments, the Vendome Column, pronouncing it "a monument to

barbarism . . . a permanent insult to the vanquished by the victors."[20] But the Commune recognized that the spatial configuration of Paris itself was also such a monument, concretizing the victories of powerful sectors within a divided French society. They set about to demolish this monument as well, leveling the spatial hierarchy produced by Haussmann's city plan. "Class division is also the division of the city into active and passive zones, into privileged places where decisions are made in secret, and places where these decisions are executed afterwards," writes Kristin Ross, describing the production of the dominated space against which the Commune rebelled:

> The rise of the bourgeoisie throughout the nineteenth century was inscribed on the city of Paris in the form of Baron Haussmann's architectural and social reorganization, which gradually removed workers from the center of the city to its northeastern peripheries.[21]

The Commune, as Ross, following Lefebvre, interprets it, represented an appropriation of that space:

> The workers' redescent into the center of Paris followed in part from the political significance of the city center within a tradition of popular insurgency, and in part from their desire to reclaim the public space from which they had been expelled, to reoccupy streets that once were theirs.[22]

Haussmann's restructuring is echoed in current efforts to shape New York into a segregated and polarized city. Yet awareness of this transformation is mediated for New Yorkers by the physical environment it produces. Presided over by the architecture of redevelopment, that environment throws a blanket of amnesia over urban history. It is constructed, as Wodiczko puts it, "in gross contradiction to the lived experience, communicative needs and rights of most of society."[23] Seen in light of a tradition of urban resistance, Wodiczko's projections onto the city's gentrified monuments and buildings revive, under changed conditions, the symbolic battle waged during the Commune against architectural representations of power. Visualizing the events those representations repress – eviction – the projections reveal that municipal monuments intending to memorialize the city's stability, in fact, commemorate its barbarism. The *Homeless Vehicle*, too, preserves such symbolic strategies but bases them on the insight, also gained during the Commune, that the physical city is as much a monument as individual structures within the city, if, to borrow a term from Alois Riegl, an "unintentional" one.[24] A landmark of history, the spatial organization of New York commemorates urban events, constituting, just as intentional monuments do, "a permanent insult to the vanquished by the victors." Applying architectural principles to an object designed to support the activities of the evicted, the *Homeless Vehicle Project* projects onto the city the condition of a monument and, like Wodiczko's other New York works, projects onto this monument, the social contradictions of the city. When Wodiczko restores to visibility the absences structuring

intentional and unintentional monuments, he forces them to acknowledge what they never intended to: the impossibility of their stability.

Notes

1 For a discussion of this kind of park renovation, see Rosalyn Deutsche, "Krzysztof Wodiczko's *Homeless Projection and the Site of Urban 'Revitalization,'*" in Deutsche, *Evictions: Art and Spatial Politics* (Cambridge, MA: MIT Press, 1996).

2 For an account of Battery Park City, see "Uneven Development: Public Art in New York City," in Deutsche, *Evictions: Art and Spatial Politics*.

3 Paul Goldberger, "Can Architects Serve the Public Good?" *New York Times*, June 25, 1989, p. H1.

4 Rosalyn Deutsche and Cara Gendel Ryan, "The Fine Art of Gentrification," *October* 31 (winter 1984): 91–111.

5 M. Christine Boyer's *Dreaming the Rational City: The Myth of American City Planning* (Cambridge, MA: MIT Press, 1983) analyzes the use of neoclassical architecture by American municipal art movements of the late nineteenth and early twentieth centuries.

6 Kim Hopper and Jill Hamberg suggest that current housing policies are part of such a disciplinary agenda in their "The Making of America's Homeless: From Skid Row to New Poor, 1945–1984," in Rachel Bratt, Chester Hartman, and Ann Meyerson (eds.), *Critical Perspectives on Housing* (Philadelphia: Temple University Press, 1986), pp. 12–40.

7 This project is discussed in greater detail in Deutsche, "Uneven Development: Public Art in New York City."

8 Henri Lefebvre, "Space: Social Product and Use Value," in J. W. Freiberg (ed.), *Critical Sociology: European Perspectives* (New York: Irvington Publishers, 1979), pp. 285–95.

9 Paul Feyerabend, "Cultural Pluralism or Brave New Monotony," in *Farewell to Reason* (London and New York: Verso, 1987), pp. 273–9.

10 For a discussion of the uses of the "public" in apologies for redevelopment, see Deutsche, "Uneven Development: Public Art in New York City."

11 Alexander Kluge, "On Film and the Public Sphere," *New German Critique* 24–5 (fall/winter 1981–2): 213.

12 Ibid.

13 David Whitman, "Shattering Myths about the Homeless," *US News & World Report*, March 20, 1989, p. 28. I am thankful to Martha Rosler and John Strauss for bringing this article to my attention.

14 Peter Hellman, "What's Better Now," *New York*, May 22, 1989, p. 33.

15 Ibid.

16 Claude Lefort, *Democracy and Political Theory* (Minneapolis: University of Minnesota Press, 1988), p. 41.

17 Walter Benjamin, "Theses on the Philosophy of History," in *Illuminations*, trans. Harry Zohn (New York: Schocken, 1969), p. 257.

18 Ibid.

19 Ibid.

20 The Commune's decree is contained in Catulle Mendès, *Les 73 Journées de la Commune* (Paris: E. Lachaud, 1897), pp. 149–50; quoted in Kristin Ross, *The Emergence of Social Space: Rimbaud and the Paris Commune* (Minneapolis: University of Minnesota Press, 1988), p. 8.

21 Ross, *The Emergence of Social Space.*

22 Ibid.

23 Krzysztof Wodiczko, statement in brochure accompanying *Krzysztof Wodiczko/Matric 103*, Wadsworth Atheneum, Hartford, Connecticut, January 27–March 29, 1989.

24 Riegl divides monuments into intentional and unintentional ones in his "The Modern Cult of Monuments: Its Character and Its Origin" (1928), *Oppositions* (fall 1982): 21–51.

13 Gender is Burning
Questions of Appropriation and Subversion

Judith Butler

We all have friends who, when they knock on the door and we ask, through the door, the question, "Who's there?," answer (since "it's obvious") "It's me." And we recognize that "it is him," or "her" [my emphasis].

Louis Althusser, "Ideology and Ideological State Apparatuses"

The purpose of "law" is absolutely the last thing to employ in the history of the origin of law: on the contrary . . . the cause of the origin of a thing and its eventual utility, its actual employment and place in a system of purposes, lie worlds apart; whatever exists, having somehow come into being, is again and again reinterpreted to new ends, taken over, transformed, and redirected.

Friedrich Nietzsche, *On the Genealogy of Morals*

In Althusser's notion of interpellation, it is the police who initiate the call or address by which a subject becomes socially constituted. There is the policeman, the one who not only represents the law but whose address "Hey you!" has the effect of binding the law to the one who is hailed. This "one" who appears not to be in a condition of trespass prior to the call (for whom the call establishes a given practice as a trespass) is not fully a social subject, is not fully subjectivated, for he or she is not yet reprimanded. The reprimand does not merely repress or control the subject, but forms a crucial part of the juridical and social

From *Bodies That Matter* (New York and London: Routledge, 1993), pp. 121–40. Reproduced by permission of Routledge/Taylor & Francis Books, Inc.

formation of the subject. The call is formative, if not *performative*, precisely because it initiates the individual into the subjected status of the subject.

Althusser conjectures this "hailing" or "interpellation" as a unilateral act, as the power and force of the law to compel fear at the same time that it offers recognition at an expense. In the reprimand the subject not only receives recognition, but attains as well a certain order of social existence, in being transferred from an outer region of indifferent, questionable, or impossible being to the discursive or social domain of the subject. But does this subjectivation take place as a direct effect of the reprimanding utterance or must the utterance wield the power to compel the fear of punishment and, from that compulsion, to produce a compliance and obedience to the law? Are there other ways of being addressed and constituted by the law, ways of being occupied and occupying the law, that disarticulate the power of punishment from the power of recognition?

Althusser underscores the Lacanian contribution to a structural analysis of this kind, and argues that a relation of misrecognition persists between the law and the subject it compels.[1] Although he refers to the possibility of "bad subjects," he does not consider the range of *disobedience* that such an interpellating law might produce. The law might not only be refused, but it might also be ruptured, forced into a rearticulation that calls into question the monotheistic force of its own unilateral operation. Where the uniformity of the subject is expected, where the behavioral conformity of the subject is commanded, there might be produced the refusal of the law in the form of the parodic inhabiting of conformity that subtly calls into question the legitimacy of the command, a repetition of the law into hyperbole, a rearticulation of the law against the authority of the one who delivers it. Here the performative, the call by the law which seeks to produce a lawful subject, produces a set of consequences that exceed and confound what appears to be the disciplining intention motivating the law. Interpellation thus loses its status as a simple performative, an act of discourse with the power to create that to which it refers, and creates more than it ever meant to, signifying in excess of any intended referent.

It is this constitutive failure of the performative, this slippage between discursive command and its appropriated effect, which provides the linguistic occasion and index for a consequential disobedience.

Consider that the use of language is itself enabled by first having been *called a name*; the occupation of the name is that by which one is, quite without choice, situated within discourse. This "I," which is produced through the accumulation and convergence of such "calls," cannot extract itself from the historicity of that chain or raise itself up and confront that chain as if it were an object opposed to me, which is not me, but only what others have made of me; for that estrangement or division produced by the mesh of interpellating calls and the "I" who is its site is not only violating, but enabling as well, what Gayatri Spivak refers to as "an enabling violation." The "I" who would oppose its construction is always in some sense drawing from that construction to articulate its opposition; further, the "I" draws what is called its "agency" in part through being implicated in the very relations of power that it seeks to oppose. To be *implicated* in the relations of power, indeed, enabled by the relations

of power that the "I" opposes is not, as a consequence, to be reducible to their existing forms.

You will note that in the making of this formulation, I bracket this "I" in quotation marks, but I am still here. And I should add that this is an "I" that I produce here for you in response to a certain suspicion that this theoretical project has lost the person, the author, the life; over and against this claim, or rather, in response to having been called the site of such an evacuation, I write that this kind of bracketing of the "I" may well be crucial to the thinking through of the constitutive ambivalence of being socially constituted, where "constitution" carries both the enabling and violating sense of "subjection." If one comes into discursive life through being called or hailed in injurious terms, how might one occupy the interpellation by which one is already occupied to direct the possibilities of resignification against the aims of violation?

This is not the same as censoring or prohibiting the use of the "I" or of the auto-biographical as such; on the contrary, it is the inquiry into the ambivalent relations of power that make that use possible. What does it mean to have such uses repeated in one's very being, "messages implied in one's being," as Patricia Williams claims, only to repeat those uses such that subversion might be derived from the very conditions of violation. In this sense, the argument that the category of "sex" is the instrument or effect of "sexism" or its interpellating moment, that "race" is the instrument and effect of "racism" or its interpellating moment, that "gender" only exists in the service of heterosexism, does *not* entail that we ought never to make use of such terms, as if such terms could only and always reconsolidate the oppressive regimes of power by which they are spawned. On the contrary, precisely because such terms have been produced and constrained within such regimes, they ought to be repeated in directions that reverse and displace their originating aims. One does not stand at an instrumental distance from the terms by which one experiences violation. Occupied by such terms and yet occupying them oneself risks a complicity, a repetition, a relapse into injury, but it is also the occasion to work the mobilizing power of injury, of an interpellation one never chose. Where one might understand violation as a trauma which can only induce a destructive repetition compulsion (and surely this is a powerful consequence of violation), it seems equally possible to acknowledge the force of repetition as the very condition of an affirmative response to violation. The compulsion to repeat an injury is not necessarily the compulsion to repeat the injury in the same way or to stay fully within the traumatic orbit of that injury. The force of repetition in language may be the paradoxical condition by which a certain agency – not linked to a fiction of the ego as master of circumstance – is derived from the *impossibility* of choice.

It is in this sense that Irigaray's critical mime of Plato, the fiction of the lesbian phallus, and the rearticulation of kinship in *Paris Is Burning* might be understood as repetitions of hegemonic forms of power which fail to repeat loyally and, in that failure, open possibilities for resignifying the terms of violation against their violating aims. Cather's occupation of the paternal name, Larsen's inquiry into the painful and fatal mime that is passing for white, and the reworking of "queer" from abjection to politicized affiliation will interrogate similar sites of ambivalence produced at the limits of discursive legitimacy.

The temporal structure of such a subject is chiasmic in this sense: in the place of a substantial or self-determining "subject," this juncture of discursive demands is something like a "crossroads," to use Gloria Anzaldúa's phrase, a crossroads of cultural and political discursive forces, which she herself claims cannot be understood through the notion of the "subject."[2] There is no subject prior to its constructions, and neither is the subject determined by those constructions; it is always the nexus, the non-space of cultural collision, in which the demand to resignify or repeat the very terms which constitute the "we" cannot be summarily refused, but neither can they be followed in strict obedience. It is the space of this ambivalence which opens up the possibility of a reworking of the very terms by which subjectivation proceeds – and fails to proceed.

Ambivalent Drag

From this formulation, then, I would like to move to a consideration of the film *Paris Is Burning*, to what it suggests about the simultaneous production and subjugation of subjects in a culture which appears to arrange always and in every way for the annihilation of queers, but which nevertheless produces occasional spaces in which those annihilating norms, those killing ideals of gender and race, are mimed, reworked, resignified. As much as there is defiance and affirmation, the creation of kinship and of glory in that film, there is also the kind of reiteration of norms which cannot be called subversive, but which lead to the death of Venus Xtravaganza, a Latina/ preoperative transsexual, cross-dresser, prostitute, and member of the "House of Xtravaganza." To what set of interpellating calls does Venus respond, and how is the reiteration of the law to be read in the manner of her response?

Venus, and *Paris Is Burning* more generally, calls into question whether parodying the dominant norms is enough to displace them; indeed, whether the denaturalization of gender cannot be the very vehicle for a reconsolidation of hegemonic norms. Although many readers understood *Gender Trouble* to be arguing for the proliferation of drag performances as a way of subverting dominant gender norms, I want to underscore that there is no necessary relation between drag and subversion, and that drag may well be used in the service of both the denaturalization and reidealization of hyperbolic heterosexual gender norms. At best, it seems, drag is a site of a certain ambivalence, one which reflects the more general situation of being implicated in the regimes of power by which one is constituted and, hence, of being implicated in the very regimes of power that one opposes.

To claim that all gender is like drag, or is drag, is to suggest that "imitation" is at the heart of the *heterosexual* project and its gender binarisms, that drag is not a secondary imitation that presupposes a prior and original gender, but that hegemonic heterosexuality is itself a constant and repeated effort to imitate its own idealizations. That it must repeat this imitation, that it sets up pathologizing practices and normalizing sciences in order to produce and consecrate its own claim on originality and propriety, suggests that heterosexual performativity is beset by an anxiety that it can

never fully overcome, that its effort to become its own idealizations can never be finally or fully achieved, and that it is consistently haunted by that domain of sexual possibility that must be excluded for heterosexualized gender to produce itself. In this sense, then, drag is subversive to the extent that it reflects on the imitative structure by which hegemonic gender is itself produced and disputes heterosexuality's claim on naturalness and originality.

But here it seems that I am obliged to add an important qualification: heterosexual privilege operates in many ways, and two ways in which it operates include naturalizing itself and rendering itself as the original and the norm. But these are not the only ways in which it works, for it is clear that there are domains in which heterosexuality can concede its lack of originality and naturalness but still hold on to its power. Thus, there are forms of drag that heterosexual culture produces for itself – we might think of Julie Andrews in *Victor, Victoria* or Dustin Hoffmann in *Tootsie* or Jack Lemmon in *Some Like It Hot* where the anxiety over a possible homosexual consequence is both produced and deflected within the narrative trajectory of the films. These are films which produce and contain the homosexual excess of any given drag performance, the fear that an apparently heterosexual contact might be made before the discovery of a nonapparent homosexuality. This is drag as high het entertainment, and though these films are surely important to read as cultural texts in which homophobia and homosexual panic are negotiated,[3] I would be reticent to call them subversive. Indeed, one might argue that such films are functional in providing a ritualistic release for a heterosexual economy that must constantly police its own boundaries against the invasion of queerness, and that this displaced production and resolution of homosexual panic actually fortifies the heterosexual regime in its self-perpetuating task.

In her provocative review of *Paris Is Burning*, bell hooks criticized some productions of gay male drag as misogynist, and here she allied herself in part with feminist theorists such as Marilyn Frye and Janice Raymond.[4] This tradition within feminist thought has argued that drag is offensive to women and that it is an imitation based in ridicule and degradation. Raymond, in particular, places drag on a continuum with cross-dressing and transsexualism, ignoring the important differences between them, maintaining that in each practice women are the object of hatred and appropriation, and that there is nothing in the identification that is respectful or elevating. As a rejoinder, one might consider that identification is always an ambivalent process. Identifying with a gender under contemporary regimes of power involves identifying with a set of norms that are and are not realizable, and whose power and status precede the identifications by which they are insistently approximated. This "being a man" and this "being a woman" are internally unstable affairs. They are always beset by ambivalence precisely because there is a cost in every identification, the loss of some other set of identifications, the forcible approximation of a norm one never chooses, a norm that chooses us, but which we occupy, reverse, resignify to the extent that the norm fails to determine us completely.

The problem with the analysis of drag as only misogyny is, of course, that it figures male-to-female transsexuality, cross-dressing, and drag as male homosexual

activities – which they are not always – and it further diagnoses male homosexuality as rooted in misogyny. The feminist analysis thus makes male homosexuality *about* women, and one might argue that at its extreme, this kind of analysis is in fact a colonization in reverse, a way for feminist women to make themselves into the center of male homosexual activity (and thus to reinscribe the heterosexual matrix, paradoxically, at the heart of the radical feminist position). Such an accusation follows the same kind of logic as those homophobic remarks that often follow upon the discovery that one is a lesbian: a lesbian is one who must have had a bad experience with men, or who has not yet found the right one. These diagnoses presume that lesbianism is acquired by virtue of some failure in the heterosexual machinery, thereby continuing to install heterosexuality as the "cause" of lesbian desire; lesbian desire is figured as the fatal effect of a derailed heterosexual causality. In this framework, heterosexual desire is always true, and lesbian desire is always and only a mask and forever false. In the radical feminist argument against drag, the displacement of women is figured as the aim and effect of male-to-female drag; in the homophobic dismissal of lesbian desire, the disappointment with and displacement of men is understood as the cause and final truth of lesbian desire. According to these views, drag is nothing but the displacement and appropriation of "women," and hence fundamentally based in a misogyny, a hatred of women; and lesbianism is nothing but the displacement and appropriation of men, and so fundamentally a matter of hating men – misandry.

These explanations of displacement can only proceed by accomplishing yet another set of displacements: of desire, of phantasmatic pleasures, and of forms of love that are not reducible to a heterosexual matrix and the logic of repudiation. Indeed, the only place love is to be found is *for* the ostensibly repudiated object, where love is understood to be strictly produced through a logic of repudiation; hence, drag is nothing but the effect of a love embittered by disappointment or rejection, the incorporation of the Other whom one originally desired, but now hates. And lesbianism is nothing other than the effect of a love embittered by disappointment or rejection, and of a recoil from that love, a defense against it or, in the case of butchness, the appropriation of the masculine position that one originally loved.

This logic of repudiation installs heterosexual love as the origin and truth of both drag and lesbianism, and it interprets both practices as symptoms of thwarted love. But what is displaced in this explanation of displacement is the notion that there might be pleasure, desire, and love that is not solely determined by what it repudiates.[5] Now it may seem at first that the way to oppose these reductions and degradations of queer practices is to assert their radical specificity, to claim that there is a lesbian desire radically different from a heterosexual one, with *no* relation to it, that is neither the repudiation nor the appropriation of heterosexuality, and that has radically other origins than those which sustain heterosexuality. Or one might be tempted to argue that drag is not related to the ridicule or degradation or appropriation of women: when it is men in drag as women, what we have is the destabilization of gender itself, a destabilization that is denaturalizing and that calls into question the claims of normativity and originality by which gender and sexual oppression sometimes

operate. But what if the situation is neither exclusively one nor the other; certainly, some lesbians have wanted to retain the notion that their sexual practice is rooted in part in a repudiation of heterosexuality, but also to claim that this repudiation does not account for lesbian desire, and cannot therefore be identified as the hidden or original "truth" of lesbian desire. And the case of drag is difficult in yet another way, for it seems clear to me that there is both a sense of defeat and a sense of insurrection to be had from the drag pageantry in *Paris Is Burning*, that the drag we see, the drag which is after all framed for us, filmed for us, is one which both appropriates and subverts racist, misogynist, and homophobic norms of oppression. How are we to account for this ambivalence? This is not first an appropriation and then a subversion. Sometimes it is both at once; sometimes it remains caught in an irresolvable tension, and sometimes a fatally unsubversive appropriation takes place.

Paris Is Burning (1991) is a film produced and directed by Jennie Livingston about drag balls in New York City, in Harlem, attended by, performed by "men" who are either African-American or Latino. The balls are contests in which the contestants compete under a variety of categories. The categories include a variety of social norms, many of which are established in white culture as signs of class, like that of the "executive" and the Ivy League student; some of which are marked as feminine, ranging from high drag to butch queen; and some of them, like that of the "bangie," are taken from straight black masculine street culture. Not all of the categories, then, are taken from white culture; some of them are replications of a straightness which is not white, and some of them are focused on class, especially those which almost require that expensive women's clothing be "mopped" or stolen for the occasion. The competition in military garb shifts to yet another register of legitimacy, which enacts the performative and gestural conformity to a masculinity which parallels the performative or reiterative production of femininity in other categories. "Realness" is not exactly a category in which one competes; it is a standard that is used to judge any given performance within the established categories. And yet what determines the effect of realness is the ability to compel belief, to produce the naturalized effect. This effect is itself the result of an embodiment of norms, a reiteration of norms, an impersonation of a racial and class norm, a norm which is at once a figure, a figure of a body, which is no particular body, but a morphological ideal that remains the standard which regulates the performance, but which no performance fully approximates.

Significantly, this is a performance that works, that effects realness, to the extent that it *cannot* be read. For "reading" means taking someone down, exposing what fails to work at the level of appearance, insulting or deriding someone. For a performance to work, then, means that a reading is no longer possible, or that a reading, an interpretation, appears to be a kind of transparent seeing, where what appears and what it means coincide. On the contrary, when what appears and how it is "read" diverge, the artifice of the performance can be read as artifice; the ideal splits off from its appropriation. But the impossibility of reading means that the artifice works, the approximation of realness appears to be achieved, the body performing and the ideal performed appear indistinguishable.

But what is the status of this ideal? Of what is it composed? What reading does the film encourage, and what does the film conceal? Does the denaturalization of the norm succeed in subverting the norm, or is this a denaturalization in the service of a perpetual reidealization, one that can only oppress, even as, or precisely when, it is embodied most effectively? Consider the different fates of Venus Xtravaganza. She "passes" as a light-skinned woman, but is – by virtue of a certain failure to pass completely – clearly vulnerable to homophobic violence; ultimately, her life is taken presumably by a client who, upon the discovery of what she calls her "little secret," mutilates her for having seduced him. On the other hand, Willi Ninja can pass as straight; his voguing becomes foregrounded in het video productions with Madonna et al., and he achieves post-legendary status on an international scale. There is passing and then there is passing, and it is – as we used to say – "no accident" that Willi Ninja ascends and Venus Xtravaganza dies.

Now Venus, Venus Xtravaganza, she seeks a certain transubstantiation of gender in order to find an imaginary man who will designate a class and race privilege that promises a permanent shelter from racism, homophobia, and poverty. And it would not be enough to claim that for Venus gender is *marked by* race and class, for gender is not the substance or primary substrate and race and class the qualifying attributes. In this instance, gender is the vehicle for the phantasmatic transformation of that nexus of race and class, the site of its articulation. Indeed, in *Paris Is Burning*, becoming real, becoming a real woman, although not everyone's desire (some children want merely to "do" realness, and that, only within the confines of the ball), constitutes the site of the phantasmatic promise of a rescue from poverty, homophobia, and racist delegitimation.

The contest (which we might read as a "contesting of realness") involves the phantasmatic attempt to approximate realness, but it also exposes the norms that regulate realness as *themselves* phantasmatically instituted and sustained. The rules that regulate and legitimate realness (shall we call them symbolic?) constitute the mechanism by which certain sanctioned fantasies, sanctioned imaginaries, are insidiously elevated as the parameters of realness. We could, within conventional Lacanian parlance, call this the ruling of the symbolic, except that the symbolic assumes the primacy of sexual difference in the constitution of the subject. What *Paris Is Burning* suggests, however, is that the order of sexual difference is not prior to that of race or class in the constitution of the subject; indeed, that the symbolic is also and at once a racializing set of norms, and that norms of realness by which the subject is produced are racially informed conceptions of "sex" (this underscores the importance of subjecting the entire psychoanalytic paradigm to this insight).[6]

This double movement of approximating and exposing the phantasmatic status of the realness norm, the symbolic norm, is reinforced by the diagetic movement of the film in which clips of so-called "real" people moving in and out of expensive stores are juxtaposed against the ballroom drag scenes.

In the drag ball productions of realness, we witness and produce the phantasmatic constitution of a subject, a subject who repeats and mimes the legitimating norms by which it itself has been degraded, a subject founded in the project of mastery that

compels and disrupts its own repetitions. This is not a subject who stands back from its identifications and decides instrumentally how or whether to work each of them today; on the contrary, the subject is the incoherent and mobilized imbrication of identifications; it is constituted in and through the iterability of its performance, a repetition which works at once to legitimate and delegitimate the realness norms by which it is produced.

In the pursuit of realness this subject is produced, a phantasmatic pursuit that mobilizes identifications, underscoring the phantasmatic promise that constitutes any identificatory move – a promise which, taken too seriously, can culminate only in disappointment and disidentification. A fantasy that for Venus, because she dies – killed apparently by one of her clients, perhaps after the discovery of those remaining organs – cannot be translated into the symbolic. This is a killing that is performed by a symbolic that would eradicate those phenomena that require an opening up of the possibilities for the resignification of sex. If Venus wants to become a woman, and cannot overcome being a Latina, then Venus is treated by the symbolic in precisely the ways in which women of color are treated. Her death thus testifies to a tragic misreading of the social map of power, a misreading orchestrated by that very map according to which the sites for a phantasmatic self-overcoming are constantly re-solved into disappointment. If the signifiers of whiteness and femaleness – as well as some forms of hegemonic maleness constructed through class privilege – are sites of phantasmatic promise, then it is clear that women of color and lesbians are not only everywhere excluded from this scene, but constitute a site of identification that is consistently refused and abjected in the collective phantasmatic pursuit of a transub-stantiation into various forms of drag, transsexualism, and uncritical miming of the hegemonic. That this fantasy involves becoming in part like women and, for some of the children, becoming like black women, falsely constitutes black women as a site of privilege; they can catch a man and be protected by him, an impossible idealization which of course works to deny the situation of the great numbers of poor black women who are single mothers without the support of men. In this sense, the "identification" is composed of a denial, an envy, which is the envy of a phantasm of black women, an idealization that produces a denial. On the other hand, insofar as black men who are queer can become feminized by hegemonic straight culture, there is in the performative dimension of the ball a significant *reworking* of that feminization, an occupation of the identification that is, as it were, *already* made between faggots and women, the feminization of the faggot, the feminization of the black faggot, which is the black feminization of the faggot.

The performance is thus a kind of talking back, one that remains largely con-strained by the terms of the original assailment: If a white homophobic hegemony considers the black drag ball queen to be a woman, that woman, constituted already by that hegemony, will become the occasion for the rearticulation of its terms; embodying the excess of that production, the queen will out-woman women, and in the process confuse and seduce an audience whose gaze must to some degree be structured through those hegemonies, an audience who, through the hyperbolic staging of the scene, will be drawn into the abjection it wants both to resist and to

overcome. The phantasmatic excess of this production constitutes the site of women not only as marketable goods within an erotic economy of exchange,[7] but as goods which, as it were, are also privileged consumers with access to wealth and social privilege and protection. This is a full-scale phantasmatic transfiguration not only of the plight of poor black and Latino gay men, but of poor black women and Latinas, who are the figures for the abjection that the drag ball scene elevates as a site of idealized identification. It would, I think, be too simple to reduce this identificatory move to black male misogyny, as if that were a discrete typology, for the feminization of the poor black man and, most trenchantly, of the poor, black, gay, man, is a strategy of abjection that is already underway, originating in the complex of racist, homophobic, misogynist, and classist constructions that belong to larger hegemonies of oppression.

These hegemonies operate, as Gramsci insisted, through *rearticulation*, but here is where the accumulated force of a historically entrenched and entrenching rearticulation overwhelms the more fragile effort to build an alternative cultural configuration from or against that more powerful regime. Importantly, however, that prior hegemony also works through and as its "resistance" so that the relation between the marginalized community and the dominative is not, strictly speaking, oppositional. The citing of the dominant norm does not, in this instance, displace that norm; rather, it becomes the means by which that dominant norm is most painfully reiterated as the very desire and the performance of those it subjects.

Clearly, the denaturalization of sex, in its multiple senses, does not imply a liberation from hegemonic constraint: when Venus speaks her desire to become a whole woman, to find a man and have a house in the suburbs with a washing machine, we may well question whether the denaturalization of gender and sexuality that she performs, and performs well, culminates in a reworking of the normative framework of heterosexuality. The painfulness of her death at the end of the film suggests as well that there are cruel and fatal social constraints on denaturalization. As much as she crosses gender, sexuality, and race performatively, the hegemony that reinscribes the privileges of normative femininity and whiteness wields the final power to *re*naturalize Venus's body and cross out that prior crossing, an erasure that is her death. Of course, the film brings Venus back, as it were, into visibility, although not to life, and thus constitutes a kind of cinematic performativity. Paradoxically, the film brings fame and recognition not only to Venus but also to the other drag ball children who are depicted in the film as able only to attain local legendary status while longing for wider recognition.

The camera, of course, plays precisely to this desire, and so is implicitly installed in the film as the promise of legendary status. And yet, is there a filmic effort to take stock of the place of the camera in the trajectory of desire that it not only records, but also incites? In her critical review of the film, bell hooks raises the question not only of the place of the camera, but also that of the filmmaker, Jennie Livingston, a white lesbian (in other contexts called "a white Jewish lesbian from Yale," an interpellation which also implicates this author in its sweep), in relation to the drag ball community that she entered and filmed. hooks remarks that,

Jennie Livingston approaches her subject matter as an outsider looking in. Since her presence as white woman/lesbian filmmaker is "absent" from *Paris Is Burning*, it is easy for viewers to imagine that they are watching an ethnographic film documenting the life of black gay "natives" and not recognize that they are watching a work shaped and formed from a perspective and standpoint specific to Livingston. By cinematically masking this reality (we hear her ask questions but never see her) Livingston does not oppose the way hegemonic whiteness "represents" blackness, but rather assumes an imperial overseeing position that is in no way progressive or counterhegemonic.

Later in the same essay, hooks raises the question of not merely whether or not the cultural location of the filmmaker is absent from the film, but whether this absence operates to form tacitly the focus and effect of the film, exploiting the colonialist trope of an "innocent" ethnographic gaze: "Too many critics and inter-viewers," hooks argues, ". . . act as though she somehow did this marginalized black gay subculture a favor by bringing their experience to a wider public. Such a stance obscures the substantial rewards she has received for this work. Since so many of the black gay men in the film express the desire to be big stars, it is easy to place Livingston in the role of benefactor, offering these 'poor black souls' a way to realize their dreams" (63).

Although hooks restricts her remarks to black men in the film, most of the members of the House of Xtravaganza are Latino, some of whom are light-skinned, some of whom engage in crossing and passing, some of who only do the ball, some who are engaged in life projects to effect a full transubstantiation into femininity and/or into whiteness. The "houses" are organized in part along ethnic lines. This seems crucial to underscore precisely because neither Livingston nor hooks considers the place and force of ethnicity in the articulation of kinship relations.

To the extent that a transubstantiation into legendary status, into an idealized domain of gender and race, structures the phantasmatic trajectory of the drag ball culture, Livingston's camera enters this world as the promise of phantasmatic fulfillment: a wider audience, national and international fame. If Livingston is the white girl with the camera, she is both the object and vehicle of desire; and yet, as a lesbian, she apparently maintains some kind of identificatory bond with the gay men in the film and also, it seems, with the kinship system, replete with "houses," "mothers," and "children," that sustains the drag ball scene and is itself organized by it. The one instance where Livingston's body might be said to appear allegorically on camera is when Octavia St Laurent is posing for the camera, as a moving model would for a photographer. We hear a voice tell her that she's terrific, and it is unclear whether it is a man shooting the film as a proxy for Livingston, or Livingston herself. What is suggested by this sudden intrusion of the camera into the film is something of the camera's desire, the desire that motivates the camera, in which a white lesbian phallically organized by the use of the camera (elevated to the status of disembodied gaze, holding out the promise of erotic recognition) eroticizes a black male-to-female transsexual – presumably preoperative – who "works" perceptually as a woman.

What would it mean to say that Octavia is Jennie Livingston's kind of girl? Is the category or, indeed, "the position" of white lesbian disrupted by such a claim? If this is the production of the black transsexual for an exoticizing white gaze, is it not also the transsexualization of lesbian desire? Livingston incites Octavia to become a woman for Livingston's own camera, and Livingston thereby assumes the power of "having the phallus," i.e., the ability to confer that femininity, to anoint Octavia as model woman. But to the extent that Octavia receives and is produced by that recognition, the camera itself is empowered as phallic instrument. Moreover, the camera acts as surgical instrument and operation, the vehicle through which the transubstantiation occurs. Livingston thus becomes the one with the power to turn men into women who, then, depend on the power of her gaze to become and remain women. Having asked about the transsexualization of lesbian desire, then, it follows that we might ask more particularly: what is the status of the desire to feminize black and Latino men that the film enacts? Does this not serve the purpose, among others, of a visual pacification of subjects by whom white women are imagined to be socially endangered?

Does the camera promise a transubstantiation of sorts? Is it the token of that promise to deliver economic privilege and the transcendence of social abjection? What does it mean to eroticize the holding out of that promise, as hooks asks, when the film will do well, but the lives that they record will remain substantially un-altered? And if the camera is the vehicle for that transubstantiation, what is the power assumed by the one who wields the camera, drawing on that desire and exploiting it? Is this not its own fantasy, one in which the filmmaker wields the power to transform what she records? And is this fantasy of the camera's power not directly counter to the ethnographic conceit that structures the film?

hooks is right to argue that within this culture the ethnographic conceit of a neutral gaze will always be a white gaze, an unmarked white gaze, one which passes its own perspective off as the omniscient, one which presumes upon and enacts its own perspective as if it were no perspective at all. But what does it mean to think about this camera as an instrument and effect of lesbian desire? I would have liked to have seen the question of Livingston's cinematic desire reflexively thematized in the film itself, her intrusions into the frame as "intrusions," the camera *implicated* in the trajectory of desire that it seems compelled to incite. To the extent that the camera figures tacitly as the instrument of transubstantiation, it assumes the place of the phallus, as that which controls the field of signification. The camera thus trades on the masculine privilege of the disembodied gaze, the gaze that has the power to produce bodies, but which is itself no body.

But is this cinematic gaze only white and phallic, or is there in this film a decentered place for the camera as well? hooks points to two competing narrative trajectories in the film, one that focuses on the pageantry of the balls and another that focuses on the lives of the participants. She argues that the spectacle of the pageantry arrives to quell the portraits of suffering that these men relate about their lives outside the ball. And in her rendition, the pageantry represents a life of pleasurable fantasy, and the lives outside the drag ball are the painful "reality" that the pageantry seeks

phantasmatically to overcome. hooks claims that "at no point in Livingston's film are the men asked to speak about their connections to a world of family and community beyond the drag ball. The cinematic narrative makes the ball the center of their lives. And yet who determines this? Is this the way the black men view their reality or is this the reality that Livingston constructs?"

Clearly, this *is* the way that Livingston constructs their "reality," and the insights into their lives that we do get are still tied in to the ball. We hear about the ways in which the various houses prepare for the ball, we see "mopping;" and we see the differences among those who walk in the ball as men, those who do drag inside the parameters of the ball, those who cross-dress all the time in the ball and on the street and, among the cross-dressers, those who resist transsexuality, and those who are transsexual in varying degrees. What becomes clear in the enumeration of the kinship system that surrounds the ball is not only that the "houses" and the "mothers" and the "children" sustain the ball, but that the ball is itself an occasion for the building of a set of kinship relations that manage and sustain those who belong to the houses in the face of dislocation, poverty, homelessness. These men "mother" one another, "house" one another, "rear" one another, and the resignification of the family through these terms is not a vain or useless imitation, but the social and discursive building of community, a community that binds, cares, and teaches, that shelters and enables. This is doubtless a cultural reelaboration of kinship that anyone outside of the privilege of heterosexual family (and those within those "privileges" who suffer there) needs to see, to know, and to learn from, a task that makes none of us who are outside of heterosexual "family" into absolute outsiders to this film. Significantly, it is in the elaboration of kinship forged through a resignification of the very terms which effect our exclusion and abjection that such a resignification creates the discursive and social space for community, that we see an appropriation of the terms of domination that turns them toward a more enabling future.

In these senses, then, *Paris Is Burning* documents neither an efficacious insurrection nor a painful resubordination, but an unstable coexistence of both. The film attests to the painful pleasures of eroticizing and miming the very norms that wield their power by foreclosing the very reverse-occupations that the children nevertheless perform.

This is not an appropriation of dominant culture in order to remain subordinated by its terms, but an appropriation that seeks to make over the terms of domination, a making over which is itself a kind of agency, a power in and as discourse, in and as performance, which repeats in order to remake – and sometimes succeeds. But this is a film that cannot achieve this effect without implicating its spectators in the act; to watch this film means to enter into a logic of fetishization which installs the ambivalence of that "performance" as related to our own. If the ethnographic conceit allows the performance to become an exotic fetish, one from which the audience absents itself, the commodification of heterosexual gender ideals will be, in that instance, complete. But if the film establishes the ambivalence of embodying – and failing to embody – that which one sees, then a distance will be opened up *between* that hegemonic call to normativizing gender and its critical appropriation.

Symbolic Reiterations

The resignification of the symbolic terms of kinship in *Paris Is Burning* and in the cultures of sexual minorities represented and occluded by the film raises the question of how precisely the apparently static workings of the symbolic order become vulnerable to subversive repetition and resignification. To understand how this resignification works in the fiction of Willa Cather, a recapitulation of the psychoanalytic account of the formation of sexed bodies is needed. The turn to Cather's fiction involves bringing the question of the bodily ego in Freud and the status of sexual differentiation in Lacan to bear on the question of naming and, particularly, the force of the name in fiction. Freud's contention that the ego is always a bodily ego is elaborated with the further insight that this bodily ego is projected in a field of visual alterity. Lacan insists that the body as a visual projection or imaginary formation cannot be sustained except through submitting to the name, where the "name" stands for the Name of the Father, the law of sexual differentiation. In "The Mirror Stage," Lacan remarks that the ego is produced "in a fictional direction," that its contouring and projection are psychic works of fiction; this fictional directionality is arrested and immobilized through the emergence of a symbolic order that legitimates sexually differentiated fictions as "positions." As a visual fiction, the ego is inevitably a site of *méconnaissance*; the sexing of the ego by the symbolic seeks to subdue this instability of the ego, understood as an imaginary formation.

Here it seems crucial to ask where and how language emerges to effect this stabilizing function, particularly for the fixing of sexed positions. The capacity of language to fix such positions, that is, to enact its symbolic effects, depends upon the permanence and fixity of the symbolic domain itself, the domain of signifiability or intelligibility.[8] If, for Lacan, the name secures the bodily ego in time, renders it identical through time, and this "conferring" power of the name is derived from the conferring power of the symbolic more generally, then it follows that a crisis in the symbolic will entail a crisis in this identity-conferring function of the name, and in the stabilizing of bodily contours according to sex allegedly performed by the symbolic. *The crisis in the symbolic, understood as a crisis over what constitutes the limits of intelligibility, will register as a crisis in the name and in the morphological stability that the name is said to confer.*

The phallus functions as a synecdoche, for insofar as it is a figure of the penis, it constitutes an idealization and isolation of a body part and, further, the investment of that part with the force of symbolic law. If bodies are differentiated according to the symbolic positions that they occupy, and those symbolic positions consist in either having or being the phallus, bodies are thus differentiated and sustained in their differentiation by being subjected to the Law of the Father which dictates the "being" and "having" positions; men become men by approximating the "having of the phallus," which is to say they are compelled to approximate a "position" which is itself the result of a synecdochal collapse of masculinity into its "part" and a corollary idealization of that synecdoche as the governing symbol of the symbolic order.

According to the symbolic, then, the assumption of sex takes place through an approximation of this synecdochal reduction. This is the means by which a body assumes sexed integrity as masculine or feminine: the sexed integrity of the body is paradoxically achieved through an identification with its reduction into idealized synecdoche ("having" or "being" the phallus). The body which fails to submit to the law or occupies that law in a mode contrary to its dictate thus loses its sure footing – its cultural gravity – in the symbolic and reappears in its imaginary tenuousness, its fictional direction. Such bodies contest the norms that govern the intelligibility of sex.

Is the distinction between the symbolic and the imaginary a stable distinction? And what of the distinction between the name and the bodily ego? Does the name, understood as the linguistic token which designates sex, only work to *cover over* its fictiveness, or are there occasions in which *the fictive and unstable status of that bodily ego trouble the name, expose the name as a crisis in referentiality*? Further, if body parts do not reduce to their phallic idealizations, that is, if they become vectors for other sorts of phantasmatic investments, then to what extent does the synecdochal logic through which the phallus operates lose its differentiating capacity? In other words, the phallus itself presupposes the regulation and reduction of phantasmatic investment such that the penis is either idealized as the phallus or mourned as the scene of castration, and desired in the mode of an impossible compensation. If these investments are deregulated or, indeed, diminished, to what extent can having/being the phallus still function as that which secures the differentiation of the sexes?

In Cather's fiction, the name not only designates a gender uncertainty, but produces a crisis in the figuration of sexed morphology as well. In this sense, Cather's fiction can be read as the foundering and unraveling of the symbolic on its own impossible demands. What happens when the name and the part produce divergent and conflicting sets of sexual expectations? To what extent do the unstable descriptions of gendered bodies and body parts produce a crisis in the referentiality of the name, the name itself as the very fiction it seeks to cover? If the heterosexism of the Lacanian symbolic depends on a set of rigid and prescribed identifications, and if those identifications are precisely what Cather's fiction works through and against the symbolically invested name, then the contingency of the symbolic – and the heterosexist parameters of what qualifies as "sex" – undergo a rearticulation that works the fictive grounding of what only appears as the fixed limits of intelligibility.

Cather cites the paternal law, but in places and ways that mobilize a subversion under the guise of loyalty. Names fail fully to gender the characters whose femininity and masculinity they are expected to secure. The name fails to sustain the identity of the body within the terms of cultural intelligibility; body parts disengage from any common center, pull away from each other, lead separate lives, become sites of phantasmatic investments that refuse to reduce to singular sexualities. And though it appears that the normativizing law prevails by forcing suicide, the sacrifice of homosexual eroticism, or closeting homosexuality, the text exceeds the text, the life of the law exceeds the teleology of the law, enabling an erotic contestation and disruptive repetition of its own terms.

Notes

1 Louis Althusser, "Ideology and Ideological State Apparatuses (Notes Towards an Investigation)," in *Lenin and Philosophy and Other Essays* (New York: Monthly Review Press, 1971), pp. 170–7; first published in La Pensée, 1970. See also "Freud and Lacan," in the same volume, pp. 189–220.

2 Gloria Anzaldúa writes, "that focal point of fulcrum, that juncture where the mestiza stands, is where phenomena tend to collide" ("La Conciencia de la Mestiza," *Borderlands/ La Frontera* (San Francisco: Spinsters, Aunt Lute, 1987), p. 79) and, later, "the work of *mestiza* consciousness is to break down the subject–object duality that keeps her a prisoner" (ibid., p. 80).

3 See Marjorie Garber, *Vested Interests: Cross-Dressing and Cultural Anxiety* (New York: Routledge, 1992), p. 40.

4 bell hooks, "Is Paris Burning?" Z, Sisters of the Yam column (June 1991): 61.

5 Whereas I accept the psychoanalytic formulation that both the object and aim of love are formed *in part* by those objects and aims that are repudiated, I consider it a cynical and homophobic use of that insight to claim that homosexuality is nothing other than repudiated heterosexuality. Given the culturally repudiated status of homosexuality as a form of love, the argument that seeks to reduce homosexuality to the inversion or deflection of heterosexuality functions to reconsolidate heterosexual hegemony. This is also why the analysis of homosexual melancholy cannot be regarded as symmetrical to the analysis of heterosexual melancholy. The latter is culturally enforced in ways that the former clearly is not, except within separatist communities which cannot wield the same power of prohibition as communities of compulsory heterosexism.

6 Kobena Mercer has offered rich work on this question and its relation to a psychoanalytic notion of "ambivalence." See "Looking for Trouble," reprinted in Henry Abelove, Michèle Barale, and David M. Halperin, eds., *The Lesbian and Gay Studies Reader* (New York: Routledge, 1993), pp. 350–9. Originally published in *Transition* 51 (1991); "Skin Head Sex Thing: Racial Difference and the Homoerotic Imaginary," in Bad-Object Choices, ed., *How Do I Look? Queer Film and Video* (Seattle: Bay Press, 1991), pp. 169–210; "Engendered Species," *Artforum* 30, 10 (summer 1992): 74–8. See also on the relationship between psychoanalysis, race, and ambivalence, Homi Bhabha, "Of Mimicry and Man: The Ambivalence of Colonial Discourse," *October* 28 (spring 1984): 125–33.

7 See Linda Singer, *Erotic Welfare: Sexual Theory and Politics in the Age of Epidemic* (New York: Routledge, 1992).

8 For an argument against the construal of the Lacanian symbolic as static and immutable, see Teresa Brennan, *History After Lacan* (London: Routledge, 1993).

14 Cornered
A Video Installation Project

Adrian Piper

I'm black.

Now, let's deal with this social fact, and the fact of my stating it, together. Maybe you don't see why we have to deal with them together. Maybe you think it's just my problem, and that I should deal with it by myself.

But it's not just my problem. It's our problem.

For example, it's our problem if you feel that I'm making an unnecessary fuss about my racial identity, if you don't see why I have to announce it like this.

Well, if you feel that my letting people know I'm not white is making an unnecessary fuss, you must feel that the right and proper course of action for me to take is to pass for white.

Now this kind of thinking presupposes the belief that it's inherently better to be identified as white. It bespeaks an inability to imagine or recognize the intrinsic value of being black. Perhaps you even take my rejection of a white identity as a sign that I'm hostile to whites. If you think any of these things, then I would say you have a problem.

But if you then respond to me accordingly, as though I had somehow insulted you by refusing to join your racial club, then you make it our problem. It's our problem because your hostile reaction to my identifying myself as black virtually destroys our chances for a relationship of mutual trust and good will.

It's also our problem if you think I'm telling you I'm black in order to exploit an advantage, get publicity, or make it big as an artist.

From *Movement Research Performance Journal* 4 (winter/spring 1992): 10.

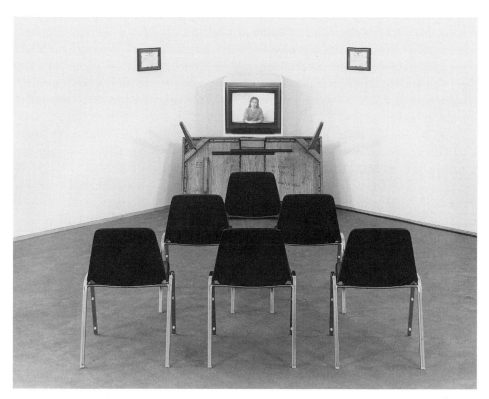

Figure 14.1 Adrian Piper, *Cornered*, 1988. Video installation with birth certificates, videotape, monitor, table, ten chairs; dimensions variable. Collection Museum of Contemporary Art, Chicago, Bernice and Kenneth Newberger Fund. Photo © MCA Chicago. Photo by Joe Ziolkowski.

If you think this, obviously you must be feeling pretty antagonized and turned off by what I'm saying. So I'd be interested in hearing more about exactly how you think antagonizing and turning off my audience is going to help me make it big as an artist.

But the larger problem would be your feeling antagonized and turned off at all. Why does my telling you who I am have that effect? Do you feel affronted? Or embarrassed? Or accused?

I think we need to look more closely at why my identifying myself as black seems to you to be making a fuss. I think we need to keep in mind that it's a fuss only if it disturbs your presumption that I'm white. So perhaps the solution is for you not to make that presumption. About anyone.

That certainly would be better for me, because I don't look forward to your confusion and hostility at all. I'd really prefer not to disturb you.

But you see, I have no choice. I'm cornered. If I tell you who I am, you become nervous and uncomfortable, or antagonized. But if I don't tell you who I am, I have to pass for white. And why should I have to do that?

The problem with passing for white is not just that it's based on sick values, which it is. It also creates a degrading situation in which I may have to listen to insulting remarks about blacks, made by whites who mistakenly believe there are no blacks present. That's asking a bit much. I'm sure you agree.

So you see, the problem is not simply my personal one, about my racial identity. It's also your problem, *if* you have a tendency to behave in a derogatory or insensitive manner toward blacks when you see none present.

Now if you have no such tendency, then you won't regard my letting you know I'm black as a problem at all. Because you won't have to worry about being embarrassed or shamed by your own behavior.

In that case I'm simply telling you something about who I am, on par with where I was born or how old I am, which you may or may not find of interest.

Furthermore, it's our problem if you think that the social fact of my racial identity is in any event just a personal, special fact about me. It's not. It's a fact about us.

Because if someone can look and sound like me and still be black, then no one is safely, unquestionably white. No one.

In fact, some researchers estimate that almost all purportedly white Americans have between 5% and 20% black ancestry.

Now, this country's entrenched conventions classify a person as black if they have any black ancestry. So most purportedly white Americans are, in fact, black.

Think what this means for your own racial classification. If you've been identifying yourself as white, then the chances are really quite good that you're in fact black.

What are you going to do about it?

Are you going to research your family ancestry, to find out whether you're among the white "elite"? Or whether perhaps a mistake has been made, and you and your family are, after all, among the black majority?

And what are you going to do if a mistake has been made? Are you going to tell your friends, your colleagues, your employer that you are in fact black, not white, as everyone had supposed?

Or perhaps you're going to keep quiet about it, and continue enjoying the privileges of white society, while inwardly depicting yourself as a "quiet revolutionary" who rejects this country's entrenched conventions anyway?

Or maybe combine your silence and continued enjoyment of these privileges with compensatory social activism on behalf of the disadvantaged?

Or will you try to discredit the researchers who made this estimate in the first place?

On the other hand, what if your research into your family tree reveals that you are, after all, among the white minority, who really do have no black ancestry? Then what?

Will you find a way to mention this fact, casually, in the course of most conversations? Perhaps you'll narrate your European family history with great enthusiasm and detail at parties?

How will you feel about being certifiably white? Relieved? Proud? Will you get annoyed or irritated when someone mentions the proximity to Africa of Spain, France, Italy, Greece, and Israel?

Or will you feel disappointed, deprived of something special? Perhaps you'll even lie, and tell people you're black, even if you're not? There's a nice, subversive strategy for you! As long as you don't blow your cover when things get hot, which they inevitably will.

Or are you going to do no research, indeed nothing at all about your black ancestry? Are you going to just pass out of this room, after this videotape is over – or perhaps even before – and into your socially preordained future?

Are you going to simply put this information about your black identity out of your mind? Or perhaps relegate it to that corner of your mind you reserve for interesting art experiences that bear no relation to your personal life?

Or maybe dismiss the whole business as just another hoax an artist is trying to put over on a gullible public?

Obviously, the choices that now confront you are not easy ones. They're so problematic that you may be finding it difficult to think seriously about them at all right now. It may not be penetrating, as you're listening to this, that you really do have some serious, hard decisions to make.

But remember: Now that you have this information about your black ancestry, *whatever* you do counts as a choice.

So. Which choice will you make?

You may feel that no choice is required. You may believe that anyone who can pass for white has no moral right to call themselves black, because they haven't suffered the way visibly black Americans have.

Of course if we're going to distribute justice and moral rectitude on the basis of suffering, then happy idiots and successful Uncle Toms don't get any anyway, no matter how visibly black they are, right?

Besides, if you've been identifying yourself as white, and you think light-skinned blacks don't suffer enough, then you have nothing to lose by publicly affirming your own black identity. So why not try it? Just to test out your hypothesis that light-skinned blacks don't suffer enough?

Or you may think people like me identify ourselves as black in order to get the institutionalized rewards of being black – like affirmative action programs, while avoiding the daily experience of racism that visibly black Americans have to cope with all the time.

Well, let's see what we can do about that. Now that you know you're probably black, you, too, have the option of publicly proclaiming your black identity in order to get into affirmative action programs.

Lucky you. Are you going to do it? No? Why not? Think about all the "institutionalized rewards of being black" you're passing up!

Obviously, there are much better reasons than that to affirm your black identity.

Of course you may disagree. You may have different values, different priorities. If you don't recognize the importance of black American culture, you may find it easy to reject.

And, if you're very attached to the rewards and privileges of identifying yourself as white, you may find it virtually impossible to reject those rewards and privileges.

If you feel this way, you may be reacting to what I'm saying here as nothing but an empty academic exercise that has nothing to do with you.

But let's at least be clear about one thing: This is not an empty academic exercise. This is real. And it has everything to do with you.

It's a genetic and social fact that, according to the entrenched conventions of racial classification in this country, you are probably black.

So if I choose to identify myself as black whereas you do not, that's not just a special, personal fact about me. It's a fact about us. It's our problem to solve.

Now, how do you propose we solve it? What are you going to do?

[Fifteen-second pause. Slow fade out to black. White letters appear on black]

WELCOME TO THE STRUGGLE!

15 The Mythology of Difference

Vulgar Identity Politics at the Whitney Biennial

Charles A. Wright, Jr.

E very two years art enthusiasts, critics, dealers and artists relish the opportunity to pass judgment on the Whitney Museum of American Art's biannual exhibition of "significant" art work produced during the previous two years. Critical sentiments run the gamut from simplistic accusations of trendiness on the part of the Museum to condemnations of a virulent market system controlled by a handful of dealers, as well as to questions of quality leveled at exhibiting artists. These critical tendencies are, of course, not exclusive to any single ideological camp. Rather, they straddle the boundaries set, on the one hand, by a conservative establishment that insists on traditional aesthetic values predicated on Enlightenment assumptions of taste, decorum, and quality. And, on the other, by a liberalist front dedicated to an embattled questioning of such culturally ingrained beliefs and committed to reconstructing historical understandings of aesthetic value through the achievements of cultural parity.

Not uncharacteristically, both extremes often remain decidedly reactionary and as a consequence it is the work of the artists that is put on trial, at once the center of attention and yet peripherally situated as exemplars for propagandizing agendas – leaving the museum modestly poised as a disinterested progenitor of the field. Once the exhibition is removed from view and everyone has pronounced their verdict, it is the represented artists that bear the marks of validation or its obverse, while the agents and apparatuses that orchestrated or exacerbated the conflict proceed to conduct business as usual.

From *Afterimage* 21 (September 1993): 4–8. Reprinted by permission of the publisher.

In the last ten years art historians and cultural critics have turned their attention to the museum or gallery as an ideologically charged site. Despite this, however, one need only survey much of the commentary leveled at this year's exhibition for evidence of the paucity of direct address of the Whitney's engagement of its own historical and philosophical status as a nexus in the contest of ideologies that subsumed this year's Biennial. Neither will one find any thoroughgoing examination of the pedagogical nature of curatorial practice as a medium for elucidating the museum's institutional alignments and interests. While reviewers were quick to praise or denounce, few questioned the underlying institutional impetus for the topical focus for the show (aside from accusations of "political correctness"), nor sought to foreground the implications of the museum's relationship to the ideas and concerns it professed to "celebrate."[1] Can the mere fact of inclusion necessarily constitute a celebration of diversity? And how has the host of such a culturefest manufactured its own relation to the celebrants?

The fact that representation in any exhibition is predicated on necessary exclusions is rarely broached beyond evaluative pronouncements, but rather remains an untheorized given within the context of most art criticism. The role of the curator, therefore, takes on a kind of naturalized authority. Contrary to the benign assumptions that conceive curatorial practice as mere custodial stewardship, our contemporary setting requires an understanding of curatorship not as a kind of unmediated presentation but as a practice in which specific choices are made – determined by ideological interests whether institutional or individual. To this end, it may prove more fortuitous to acknowledge the absolute constructedness inherent in curatorial practice in general and to recognize that the careers and aspirations of artists lie in the balance. Since, at the time of this writing, the Biennial has closed, and its unprecedentedly text-heavy catalog remains the only surviving document, I have attempted to focus my comments on the operative textual ethos of the show rather than fully recount the merits of specific works and artists.[2]

Whether in the form of a survey or thematic presentation we need to be reminded that within curatorial practice what is excluded is as profoundly instructive as what is included. This holds true not only for artists represented but also for the specific works selected. And in light of this, two points must be made from the start. First, unlike previous exhibitions, the 1993 Biennial is neither clearly a survey nor a thematic exhibition. Rather, this show offers a representative selection of works by previously marginalized artists loosely professing an interest in "questions of identity," while at the same time neglecting to address the identity of the inquiring institution. Second, as a result, this inquiry quite unproblematically installs the notion of cultural diversity as its curatorial objective in the absence of any thoroughgoing historical reflection. The exhibition refuses to address a fundamental, albeit reductive, homogenizing question that has plagued the museum since its founding: what is "American" in American Art?

Concurrent with the 1987 Biennial, the exhibition, "Guerrilla Girls Review the Whitney" at The Clocktower in New York City sought to expose what was American at the Whitney – and in their account "American" did not include women.[3] In the

Charles A. Wright, Jr.

manner of many of the direct disclosures of art-world discrimination taken by this anonymous collective, the exhibition was a stark, wryly humorous indictment of the historical record of the museum's historically conditioned notion of American Art – a tradition that clearly privileges white male artists. The exhibited series of charts and graphs provided statistics on issues of exhibition inclusion, curatorial sensitivity, and museum acquisition along gender and racial lines as reflected in Biennial presentations since 1973. Indeed, for the present discussion, 1973 constitutes a relevant marker in the Whitney's performance on the issue of cultural diversity. It is discernible from the Guerrilla Girl report that the range of artists from various constituencies (women, blacks, Asians, Latino/as and Native Americans) was at its peak in 1973, only to take a drastic downward turn in the years that followed.[4] That this abrupt acknowledgement of minority artists in 1973 was produced in the aftermath of the civil rights skirmishes of the 1960s as well as in response to pressure by underrepresented groups leveled at the museum is unquestionably plausible. However, as evidenced in the Clocktower show, whatever notion of "Americanness" proffered the 1973 Biennial, that floodgate closed almost as quickly as it opened. In a multiculturalist 1990s, exactly 20 years later, the Whitney once again takes up the gauntlet of "American Art" under the guise of cultural inclusion cum identity politics, this time feigning historical amnesia to suffuse that legacy of cultural indifference. Critical skeptics, I think, would ask whether or not this most recent effort of inclusion marks a significant reversal of that history or a conciliatory rehearsal of that twenty-year cycle.

In his introductory remarks, David Ross, the Whitney's recently installed Director, states:

> As a museum of American art, the idea of community is literally inscribed into our name. There is no single set of questions with more relevance at this moment, no set of shared concerns with more resonance *of* this moment than those raised by artists concerned with identity and community. If the act of questioning is an aggressive act or a demand, it is also a means of questioning the nature of control. (emphasis original)[5]

Ross at once states the obvious feature of the Whitney's pedigree. This skeletal framework for critical reflection assumes, however, that the museum's relationship to notions of Americanness and community is unproblematic. But, while the concerns of many of the artists in the show speak to the urgency of issues affecting their lives, how are we to locate the museum's ideological investment in the matter as outlined by Ross? Furthermore, regardless of what Ross perceives as having "relevance for this moment," the concerns raised by the exhibiting artists did not emerge yesterday, but are the product of historical and political conditions that have sustained the cultural marginalization of minorities and women in American society. Lastly, what agent of "control" is being interrogated? It is apparent that Ross does not recognize the museum's own role as such an agent and presumes it to be neutral.

Camouflaged by the ubiquitous nonsequitor "community," Ross remains firmly ensconced within a rhetoric that has informed the limited and limiting pantheon of

mostly male, mostly white artists. Assuaging melting-pot pronouncements, this year's exhibition wrestles with issues of cultural identity, opting for a splintered address of the elusive construction "Americanness" by way of what its curatorial staff understands – given the Whitney's exclusionary history – as not-American (for example, black, Latino/a, gay, etc.). Such a maneuver affects a kind of reparational gesture, presumably not drastically dissimilar from its curatorial position two decades previous. However, it is not enough today to claim inclusion as an unqualified remedy to simple neglect. Rather, one must question the how and the why of that inclusion and distinguish it from other unsustained efforts to accomplish parity. Ross's conceptual sleight-of-hand posits an agenda that perceives the current cultural climate as one in which "the problems of identity and the representation of community extend well beyond the art world." "We are," he continues:

> living in a time when the form and formation of self and community is tested daily. Communities are at war, both with and at their borders. Issues of nation and nationality, ethnic essentialism, cultural diversity, dissolution and the politics of identity hang heavy in the representation of community.[6]

It is no exaggeration that this war is being fought beyond Madison Avenue. Indeed, the selection of George Holliday's infamous eyewitness video of the Rodney King beating is probably the most poignant manifestation of the gravity of that national conflict. And the war that Ross refers to was restaged on the battlefield staked out on the five floors that housed the exhibition. More than a demonstration of generalized societal conflicts, the exhibition structurally alludes to political and philosophical collisions within the institution itself.

This year's presentation generated embattled criticisms that emphatically drew lines between art and politics as well as cultural inclusion and exclusion. The productive discursive value of the show was consumed in a proverbial cloud of smoke cast by the artillery of disparate camps and contending factions. In the name of diversity, the call to arms was raised and all combatants were readied to defeat the respective foe(s). One thing seems certain, however. The smoke was so thick that, in the end, no one was able to see what they were shooting at. Who is the enemy and where is he/she to be found?

Popular media critics recognized the enemy and that enemy was themselves, a mythologically constructed "straight, white, male" – the preeminent protector of culture. Recoiling with disgust they dismissed the show claiming that it sacrificed aesthetics in favor of collective political self-interest. These critics remained sternly reluctant to acknowledge that all forms of cultural production have historically embodied some relation to sociopolitical conditions: Serge Guilbaut's analysis of the role played by American abstraction of the 1950s as a reflection of prevalent assertions of American freedom after World War II is a relevant example.[7] Yet, this form of inquiry was not afforded to any of the objects presented in the Whitney's galleries. Rather than privilege overarching nationalist claims this year's Biennial revolved around the question of American freedom for whom? – the result of reigning anxieties

within American national identity, rather than a Cold War identity projection on an international scale.

With headlines as biting as "Culture War at the Whitney," "A Fiesta of Whining," and "Fade from White" gracing pages in the popular press, reviewers vehemently revealed a century old Kantian trump card of aesthetic value, rather than rigorously examining the rancorous discomfort the exhibition produced. John Leo's review in *US News and World Report* considered the exercise an irreverent meditation on political correctness with "occasional dollops of actual art and great helpings of trendy propaganda about victimization, imperialism, patriarchy and the dreadful stigma of white skin," while *Time* magazine's Robert Hughes dubbed it "a long-winded immersion course in marginality – the only cultural condition, as far as its reborn curators are concerned, that matters in the '90s." The art press, on the other hand, proved a bit more diverse in its assessment preferring a more restrained, though pointed consideration. *Artforum* went so far as to not entrust a single writer to discuss the show, but 11.[8] Jan Avgikos's contribution to this compendium of responses hauntingly articulates the intensity of the ideological casualties of this Biennial. Avgikos's article is an account of an exchange with a museum guard during one of the opening receptions for the exhibition where, after refusing to adjust the audio component of an installation work on view (Jack Pierson's *Diamond Life*, 1990), she heard him whisperingly retort "Kill All White People" as he continued his rounds. Eleanor Heartney's *Art in America* review stands among the most glowing reports. She writes:

> Rejecting the frivolity of Biennials past, with their Day-Glo bathrooms [Kenny Scharf, 1985] and stainless steel bunnies [Jeff Koons, 1987], the 1993 Biennial declares itself as sober and instructive as the times demand. . . . Can this really be the same exhibition which the Guerrilla Girls targeted in 1987 for its longstanding practice of racial and sexual exclusion?[9]

This spectrum of opinions is evidence of the "war" Ross cites. The underlying commonality among these critics is that each contributes to a cacophanous set of victimized positions: on the one hand, a defensive hegemony perceiving the threat of having to legitimate itself and on the other a persistent, multi-faceted and disparate coalition whose divergent motivations declare its right to be recognized and heeded. The reigning presumption, of course, is that either party will seize and impose power over the other. The material stakes in this argumentative exchange are so high that Michel Foucault's analysis of power as a field of contestation and negotiation would, presumably, be of little use. As a result, whether or not this Biennial proves to have offered an understanding of the art of our time, it instigated a discursive battle over claims of cultural rights on all sides. In fact, art making doesn't seem to be the issue at all but simply a pretext for acting on trenchant chauvinistic prejudices. Denunciatory and affirmative zealotries aside, as I have suggested, this very well may be, for all intents and purposes, the same exhibition that the Whitney mounted in 1973 – a magnanimous, but unrigorous multiculturalist web of institutional double-speak in which the museum is haplessly entangled.

Ross and his curators seem to have anticipated these various defensive stances, staking a wide territory in the demarcation of the contestatory terrain:

> the art in the Biennial, like all art related to the important issues of our time – our identities, allegiances, environment, relationship to technology – must be considered with three important criteria in mind. First of all, despite a widespread belief to the contrary, art committed to ideas is not lacking in what are thought of as the traditional aesthetic qualities, for instance, sensuality, contradiction, visual pleasure, humor, ambiguity, desire or metaphor. . . . Second, works of art that are related to particular cultural positions are not unchanging . . . [thirdly, one must have] a willingness to redefine the art world in more realistic terms – not as a seamless, homogeneous entity but as a collectivity of cultures involved in a process of exchange and difference.[10]

But can such a field allow for a responsible address of issues of ethnicity, gender and sexuality and the multiple positions available to all subjects within these unspecified "realistic" terms? This apologetic realm appears too circumscribed and the options for the negotiation of subject positions too few. Having artists as representatives of specific cultural interests, the museum places itself within a double bind: the show's overdetermined emphasis on articulating difference in fact limits the possibility of exchange among its various agents. From a curatorial standpoint, the artists stand in testimony to the cultural constituencies they are said to represent. While certainly such conditions may inform their work, evidently black artists speak only for blacks, women speak only for women, and gays only for gays, bound by a constrained notion of community. The conceptual thrust of the entire show relegates artists to cultural essences: regardless of the overall concerns specific to the production of any single artist exhibited, there is no acknowledgement of the actual possibility that one could be black, gay, and female for example. In addition, if cultural enfranchisement proved to be the motivating factor for the museum, the question of class stratification within American culture is thoroughly ignored.

Instead, the Biennial curators opted for what Paul Smith calls a "cerning" of subjects, a kind of discursive circumscription that limits the "definition of the human agent in order to be able to call him/her the 'subject' [rather than] argue that the human agent exceeds the 'subject' as it is constructed in and by much poststructuralist theory."[11] The consequence of this operative understanding of subjectivity is that it proffers singularly forced readings of the works on view in the exhibition. For example, Byron Kim's monochromatic canvases become specified as a commentary on race rather than an exegesis on the efficacy of contemporary abstraction; Lari Pittman's decadent allegories are confined to pronouncements on male homosexual ennui; Kiki Smith's metaphorical meditation on the female body stands as an indictment of patriarchy. This localization of meaning extends even to the contextual regulation of entire oeuvres. Robert Gober's altered newspaper bundles and the mock organizational banners of Mike Kelley are posited as illustrations of societal ills in deference to the more ironical twists that characterize their overall production. Through a suspension of the necessarily tenuous situatedness of individuals and the

possibilities of negotiation and play in identity formation to foreground social urgency, the curators sacrificed the communicative resonance of much of the work on view. Herein lies the overall conceptual weakness of the exhibition. While Ross's metaphor of war may be apropos, the exhibition's curatorial conscription of the artist as cultural worker/warrior does not account for the particular complexity of the positions to which they address themselves. The decidedly imperative character of much of the work on view this year, from Pat Ward Williams's combative black males in *What You Lookn At?* (1992) to Sue Williams's pseudo-hysterical assaults on sexual dejection, foreground the negative impact of the issues they address. This is a battle, but what are the consequences of confining the various perspectives presented by the artists under a single institutional banner whose assumptions are couched in overdetermined liberalist ambitions of inclusion as a necessary criterion?

The ploy is two-fold, to allow for the reinscription of an entrenched institutional model against a rarefied aesthetic complacency while attempting to accomplish this through a kind of divisive pigeon-holing that diminishes the forcefulness of individuating discourses. The exhibition projects a mercenary gloss on issues of difference as its thematic impetus, incorporating "others" in an effort to idealize an alleged egalitarianism. What is surprising is that the implications of this strategy are not allowed to contribute to an overall understanding of the exhibition or the communities and issues it is supposedly attempting to serve. It is in this context that one recognizes the Whitney as the proverbial conservative sheep in liberal clothing: a strategy reminiscent of Christopher Newfield's recent consideration of "flexible management" as a productive modus for conservative ascriptions of diversity within the humanities. Concerned with an address of institutional racism within university curricula, Newfield argues that

> the humanities as a search for ordered freedom has a couple of liabilities. It has tended to found its unity on exclusion, and there is little dispute at least about the basic facts of its history of celebrating universal reason even as it divides the cultural globe along lines of gender, race, nation, sexuality and so on. And it does not rise above the centralizing hierarchical aspect of management but retains and idealizes it. The conservative humanities might manage to pluralize itself by broadening its universals or reexamining previously rejected candidates for inclusion, but this would not prevent it from sustaining the comforts of authoritarian governance.[12]

In the name of diversity, I would argue that this Biennial is an exercise in rhetorical cultural management. Refusing to acknowledge its culpability as a bastion of internalized conservative values or to clearly articulate fundamental changes in its relation to underrecognized groups, any substantive distinction between Biennials of the past and this year's show have been grossly exaggerated in the liberal press. We may not accuse the Whitney of mere tokenism, but of an orchestrated conceptual obfuscation of an ingrained exclusionary history. This is the same show that the Guerrilla Girls vehemently criticized in 1987; although the terms and boundaries may have expanded, they continue to be operative.

By extension, the touted organizational structure for the exhibition begs some questioning as to the ambivalent institutional controls that permeate the show.

> Instead of selecting works by consensus vote among a curatorial team, this year's Biennial was determined by a group of curators led by a single curator-in-charge. The difference is more than symbolic. It reflects our desire to produce an exhibition that projects a personal curatorial perspective within an institutional framework – an organizational structure reflective of the issues of individual and community identity embedded in this Biennial.[13]

What does this convoluted statement really signify? And, in the institutionally reflective atmosphere of "exchange and difference," what form of power relation is invoked? This line of questioning is not meant to dismiss the logical relevance of the personal tastes of a single curator in building an exhibition. In fact, if a single curator had organized the show such a query might be a non-issue. What is curious here is that this configuration prompts a hierarchical procedure that highlights Ross's conception of the liberal democratic processes that underlie the institution's duplicitous reflection on cultural authority, enfranchisement and diversity. For all that ailed previous Biennials the consensus methodology allowed respective curators to vote their consciences, however contentious. Conversely, this extra-symbolic gesture prefigures a kind of auto-egalitarianism that underlies that Americanness embedded in the museum's very name: one is (artist and curator alike) permitted to speak and be heard only in so far as one is allowed. Again, profoundly "American." In addition, this authoritative trope is active in the curatorial dynamic of the exhibition itself.

Even while the diversity of opinions among the curatorial team may be tolerated within the organizational scope of the exhibition, these presumed subordinants are obliged to yield to a "curator-in-charge" who regimentally enforces the objectives and material limits of their activity. A transposition of this militaristic model, based on Newfield's assessment of flexible management, reveals a condition in which "Differences are encouraged so long as basic rules and values circulate through the corporation's every subculture without impedance."

> Diversity does not subvert this general economy; in fact, the background uniformities of the general economy depend on a recognition of diversity in order to function, for they must encourage a sense of inclusion, individuality and participation . . . flexible management guarantees that top-down authority, while it does not appear in the old form of sovereignty.[14]

This Biennial was however a group effort marshaled by Elizabeth Sussman, with a strike force (maintaining Ross's jargon) that included curator Lisa Phillips, associate curator Thelma Golden, and John Hanhardt, curator of film and video.[15] Within this organizational scenario one is to assume that Sussman held veto power in the selection of artists and works – favoring individual curatorial sovereignty by auto-egalitarian means and thwarting consensus. However, where one hopes to locate the unified front, "the single curatorial perspective" advertised in the exhibition's press release, there

Charles A. Wright, Jr.

is none to be found. A careful reading of the catalog reveals not one, but three shows. In effect, this document embodies a conceptual mutiny in which the respective curators assert their discursive autonomy. This is one of the most interesting as well as problematic aspects of the exhibition. Devoted to elucidating the discourse of difference, each of the curatorial texts included in the catalog constructs views on the machinations of identity politics from disparate perspectives. They each share a common concern for notions of "community" but interpretive allegiances appear to end there. Any unifying coherence among the texts is clouded by a lack of a sustained critical vocabulary for addressing the issues raised by the work and any thematic reconciliation is relegated to evacuated signifiers of diversity and community. Issues of context, that the show is presented by a museum dedicated to American art, again remains an unproblematic given. The result is a patchwork of often repetitively overlapping texts, where each selects her or his favorite artists from the prescribed assortment, staking some claim to curatorial individuality and authority.

Playing the consummate leader, Sussman attempts to delimit the scope of the exhibition stating that "although sexual, ethnic, and gendered subjects motivate the content of recent art, these identities fragment but do not destroy the social fabric. Paradoxically, identities declare communities and produce a decentered whole that may have to be described as a community of communities."[16] Throughout, the operative concept of community is nowhere defined or analyzed, a floating signifier lacking critical bearing. There is, however, more at stake in the above to which I take issue. First, Sussman's most glaring misrecognition is that the identities to which she refers are not to be configured as extraneous to the social fabric, but are integrally interwoven into it. Such a presumption necessarily casts the artists within the very same frame that conservative critics assigned them – social malcontents poised for assault. And, if this threat is real, Sussman effectively abdicates responsibility to position herself within the discourse, either as a gendered subject or as a representative of the museum, a cultural authority within that presumed tapestry. Second, while the designations black, Chicano, gay, etc. connote a vulgar taxonomy of essentialized identities, such expedient partitioning is far from the complex reality of lives lived within and among these parties. Relishing the eloquent turn of phrase, Sussman's "community of communities" more resembles three rings and a tent – lions, tigers and bears awaiting the prodding of their trainer – than a genuine interrogation of difference.

A seasoned veteran of Whitney Biennials past, Phillips takes a patently art historical approach, articulating distinctions reflected in style and outlook in recent art practice from work considered in previous years. In contradistinction to Sussman's apologies for the works on display as "propaganda or agitprop," Phillips conceives a reasoned interpretation of the predominance of social concerns articulated in recent art practice.

> Now a new cry has arisen. The dictates of the [art] market are said to have been replaced by those of the political arena. . . . Today everybody's talking about gender, identity and power the way they talked about the grid in the late sixties. The issues of context and presentation are paramount and formal invention has taken a back seat to the interpretive function of art and the priorities of content.[17]

Rather than fixating on the activist impulses, Phillips is intent on an assessment of politically motivated artwork as another in a long line of significant artistic endeavors in American art. Phillips gives priority to artists' personal interests with recourse to the recent ascription "patheticism," which "deliberately renounces success and power in favor of the degraded and the dysfunctional, transforming deficiencies into something positive . . . we encounter a wasteland America, a bleak, chaotic, non-site of enervation, anomie, anger, confusion, poverty, frustration and abjection: dead zone, a no-man's land."[18] Uninterested in proposing agendas, Phillips's survey of the American cultural landscape approaches artists works as though engaged in a process, rather than as static antagonistic incitements.

The most polemical curatorial essay is offered by Golden, who takes a position which is, by all accounts, a battle cry for artists of color. Golden squarely aims her sights within the terms set by Ross's notion of a cultural militia, and the exhibition's prodigious conflict. In fact, this essay articulates the flip-side of the underlining peculiarities of the exhibition by naming its adversary in its very title "What's White . . . ?"

Focused primarily on a number of artists of color included in the exhibition, the essay stakes out its culprit – "whiteness is a signifier of power." For Golden, this whiteness is posed in opposition to difference which, quoting Cornel West, is concerned with "exterminism, empire, class, race, gender, sexual orientation, age, nation, nature, region" and, in Golden's words "is positioned as different from whiteness, which as we enter this discourse, is almost impossible to define."[19] This observer would think so. The quotation is culled from the introductory paragraph of West's essay, "The New Cultural Politics of Difference" and it is the aggressive spirit of these remarks that spur Golden on:

> The distinctive features of the new cultural politics of difference are *to trash* the monolithic and homogeneous in the name of diversity, multiplicity, and heterogeneity; *to reject* the abstract, general, and universal in light of the concrete, specific, and particular; and *to historicize, contextualize, and pluralize* by highlighting the contingent, provisional, variable, tentative, shifting and changing. (my emphasis)[20]

The first two infinitive clauses of the citation constitute the thrust of Golden's essay, an emphasis that I believe is misleading in the context of West's essay. Reading further West asserts that his politics:

> are neither simply oppositional in contesting the mainstream (or *malestream*) for inclusion, nor transgressive in the avant-gardist sense of shocking conventional bourgeois audiences. Rather, they are distinct articulations of talented (and usually privileged) contributors to culture who desire to align themselves with demoralized, demobilized, depoliticized, and disorganized people in order to empower and enable social action and if possible, to enlist collective insurgency for the expansion of freedom, democracy and individuality.[21]

There is a subtlety of argument here that suggests a much more sophisticated navigation than Golden is willing to admit. Political urgency here is tempered by a self-

Charles A. Wright, Jr.

consciousness of its partisaned adherents whose ability to reclaim and redistribute cultural capital requires that each must acknowledge the multivalence of their own positions within this process. As an enactment of West's program, however, this Biennial fails (1) at the level of contestation, (2) owing to the curatorial imposition of an asphyxiating binary framing of issues and artists, and (3) through its lack of any institutionally self-reflective address that might effect a substantive alteration of the overall philosophical, social, and economic status of the museum on the question of American diversity.

To this end, Golden's invocation of West's program is overly simplistic. What is, I think, emblematic in her argument is that "whiteness" stands as the necessary oppositional node, while difference is conceived of as an interactive combination of contending and complementary subject positions. But this strategy actually vitiates difference. As presented, such a curatorial perspective constructs an oppositional framing of subjects that encumbers the critical efficacy of much of the work presented and discussed. Meaning is circumscribed by an emphasis on, for example, race, gender, and sexual preference, each formidably in contrast to "whiteness." The analogy of whiteness with power assumes monolithic proportions, subsuming all that lies in its wake. How can such a reductive formulation benefit productive exchange among diverse subjects: not just people of color, but caucasians as well?

While one cannot deny the weight of what is implied in Golden's essay, her argument allows no space for a negotiative posture: no space for entry into the multivalent positions inscribed within the discourse of difference. In fact while Golden's text admits that its project is "not simply about race," the question of race looms large not only throughout the catalog, but in the exhibition as well. A critical formulation of race, though only one aspect within the spectrum of difference, is crucial to this year's Biennial. This is particularly the case as racial identity may be said to be intricately connected with other differential inscriptions: gender, class, sexual orientation, etc. A recognition of the necessary inter-dependence of all positions and agents within the context of difference is not fully acknowledged or theorized by the curators of the exhibition, who insistently present difference as produced in opposition to, rather than as negotiated among subjects.

While I might agree, in part, with Golden who cites cultural critic Lisa Jones that race "is really about hair texture," Barbara Jeanne Fields's assessment seems more to the point, particularly with regard to the issues of ethnic distinction touched on by the exhibition. In her essay "Slavery, Race and Ideology in the United States of America," Fields, tracing the discursive history of "race," insists that:

> race is just the name assigned to the phenomenon, which it no more "explains" than the judicial review "explains" why the United States Supreme Court can declare acts of Congress unconstitutional, or than the Civil War "explains" why Americans fought each other between 1861 and 1865.[22]

In delineating a genealogy of slavery (both indentured and forced, white and black, respectively) in the US since the early 1600s, Fields attempts to displace the common

indictment of "race" as a founding premise for the abuses of servitude in America. Fields examines the status of slavery in colonial America as part of an evolving economic system informed by notions of American freedom legislatively based on property ownership. Pointing out that it was possible for both whites and blacks to become slaves in colonial America, she notes that the predicates for freedom "did not formally recognize the condition of perpetual slavery or systematically mark out servants of African descent for special treatment until 1661."[23] And it is, according to Fields, the institutionalization of slavery that produced the decisive entry of "race" as a discriminatory marker in the United States. Rather than rehearse this discourse in our contemporary setting, Fields suggests that "race" can be understood as an historically ritualized repetition of an ideology that sustains oppression through its distinctions:

> If race lives today, it does not live on because we have inherited it from our forbearers of the seventeenth century or the eighteenth century or nineteenth, but because we continue to create it today. Nothing handed down from the past could keep race alive if we did not constantly reinvent and re-ritualize it to fit our own terrain. If race lives on today, it can do so only because we continue to create and re-create it in our social life, continue to verify it, and thus continue to need a social vocabulary that will allow us to make sense, not of what our ancestors did then, but what we ourselves choose to do now.[24]

Fields here argues for a relinquishing of the bounds of such well-worn ideology, and for thinking of the history of "race" as a necessarily flawed construction that functions only to reinstitute an oppressive dialectic in which all actors are complicit. Refusing to conceive the ideology of "race" as a form of false-consciousness, but rather as a force shaping the real conditions of people's lives, Fields's comments on the subject implicate all who persist in invoking it: the restrictive imposition of "race" by oppressors as well as the oppresseds' discursive imposition of their own oppression under the rubric of "race."

With this in mind, Golden in like manner re-invents race through a conflation of this categorization with difference. I am not arguing here (and I do not believe Fields would either) for an out-of-hand dismissal of ethnic distinction within the political economy of difference; it's not a question of simply hoping that if one ignores them, the struggles of people of color within the United States will simply go away. However, Fields admits the absolute constructedness of "race" and as a result alludes to a more delicate articulation that historicizes our perceptions of its limiting impact.

The matter of "whiteness" as a kind of master signifier within the theoretical framework of the Biennial does not end with Golden. In fact, it finds its most immediate, if not divisive, articulation in an interactive work (*Museum Tags: Second Movement (Overture) or Overture con Claque – Overture with Hired Audience Members*, 1993) by Daniel Martinez that sets the tone for the overall combative nature of the exhibition for every gallery visitor. Martinez has replaced the museum's insignia admission buttons with an inscription of his own. As enigmatic as Golden's query on race is, Martinez's button activates the whiteness/power equation with the admonition "I can't imagine

ever wanting to be white." The force of his pronouncement is undercut by this phrase being broken up and printed on successive admission tags so that the viewers / wearers are required to reconstruct the phrase through a recognition of their fellow gallery visitors: each holding a piece to a charged word-puzzle that activates the multiplicity of subjective relations, again predicated on "whiteness" as a predominant signifier. But who is speaking here? Where do we find the "I" embedded in this denunciative act? Is this simply Martinez's own recalcitrant desideratum of racial distinction: an effort to prioritize, and thus foreground the innate value of his own cultural identity? Is this an institutional "I" of the museum whose exhibiting history has rarely acknowledged its lack of recognition of artists of color, ideologically distancing itself from that history by issuing blame to an unspecified, arbitrarily universalized "white" subject? Or, does the distribution of the tags and the fact that one is required to wear them while viewing the exhibition signify an attempt to problematize racial specificity through implied accusation: invoking a kind of guilt by association? Certainly, this "I" identifies a variety of actors, all posited (whether affirmatively or negatively) against the qualifier "white" that is admittedly "unimaginable."

In her remarks on this work, Golden writes:

> This statement has radically different connotations depending on the wearer's race and attitude toward race. The button is an affirmative declaration that reverses decades of negativism about all that is not white. It also requires museum visitors to acknowledge the level of control inherent in museum practice and presentation and absolve themselves of some of the privilege of cultural imperialism.[25]

The piece, in these terms, attempts to enact a reversal in the position to which participants are assigned relative to a position of "otherness": "I," the determinant other of a white, imperialist power constituted as subject. An absolute reversal of the hegemony of "whiteness" as a defining category is sought. Again, the enemy is identified through a self-imposed imaginary "otherness" unable or unwilling to posit itself as an acting subject. The slippages are at the crux of Golden's and Martinez's understanding of difference, in which one perceives oneself as thoroughly "other" and thus defers all agency to "whiteness" as an oppressing and oppressive subject position. While the lines of discursive opposition constructed in the Martinez work articulate specific boundaries between self and other, the combative nature of the address does not allow for communication between what he conceives as "not-white" and the privileged position he assigns to "whiteness." Indeed, the conceptual binds that constrict Martinez's work are not predicated on any form of exchange but instead enforce a binarism where each agent (or group of agents) misrecognize their necessary conditional co-dependence on the other for their own existence.

What I am interested in demonstrating through this analysis is that Ross's war metaphor, particularly as it permeates the very foundation of the Biennial exhibition, should not be understood as a call for mediation and celebration of difference, but rather as an exposition in comparative oppression studies. The dialectical form of address assumed within the context of the exhibition is so emphatically dependent on

assigning artists and audience within specific frames of reference that it virtually presupposes conflict, rather than acknowledging the operative complexity of these positions. In this context, one is cast as a discretely black, Latino/a, straight, gay, female, male subject, etc. in a way that denies the fluidity and dialogical relation that actually functions among these very markers.

Michael Holquist, elaborating on the nature of subject construction in *Dialogism: Bakhtin and His World* (1990), offers a particularly insightful discussion of the relation of self to other within a broad outline of the work of Mikhail Bakhtin. In his discussion, Holquist demonstrates what might be considered a differential encounter between speaking subjects in which all agents could be understood as successively and/or simultaneously occupying the roles of self and other. He writes:

> Every human subject is not only highly conscious, but . . . that his or her cognitive space is coordinated by the same I/other distinctions that organize my own: there is in fact no way "I" can be completely transgredient to another living subject, nor can he or she be completely transgredient to me.[26]

That instance of transgredience, a position from which the subjects may perceive themselves as an object from the "outside," for Holquist via Bakhtin becomes a kind of barrier that marks the extreme tenuousness of intersubjective identification. And it is this condition that, with the exception of Phillips, the Biennial's meditation on difference chooses overwhelmingly to omit. The dialogical capacities of the subject positions presented in the exhibition are confined by a unidirectional discursive address that devolves into a malevolent contest of disparate cultural agents and entities. As a result, there is a reification of subject positions in which an undifferentiated difference is pitted against a projected, imagined and otherwise unified (white) subject.

Homi Bhabha offers a lucid, and often poetic discussion of the ambivalent dynamics implicit in cross-cultural identification as presented in a number of works included in this year's Biennial. His discussion of nationalist discourses in an earlier work, "DissemiNation: time, narrative and the margins of modern nation," draws a distinction between what he calls the national subject's "double inscription as pedagogical objects and performative subjects" that is particularly germane to our present consideration of the differential politics portrayed in the exhibition. Curatorially, either through sheer arrogance or lack of conceptual diligence, no one appears concerned to functionally broach the subject of what it has historically meant to be an American subject or what that designation can mean within our multiculturalist present. What is even more surprising, however, is that such a consideration seems crucial to the museum's capacity to equitably contribute to the national culture. Rather, the overall scope of the exhibition concentrates heavily on the first aspect of Bhabha's duality of subjective national identity: to address artworks, artists, and audience solely as rarefied objects and not as agents continuously engaged in negotiative practices at all levels of the cultural spectrum. And, it may be that this exhibition demonstrates that the realities of cultural identity and community are too complex to be adequately articulated in the convenient terms that the museum chose to present them in. With

this in mind, Bhabha's characterization posits the cultural other as an active agent in the construction of their identity beyond the scope of a totalizing national identity. Bhabha asserts that the nation as a collective identification is a "complex rhetorical strategy of social reference where the

> claim to be representative provokes a crisis within the process of signification and discursive address. We then have a contested cultural territory where the people must be thought in a double time – the people are the historical objects of a nationalist pedagogy, giving the discourse an authority that is based on the pre-given or constituted historical origin or event; the people are also the subjects of a process of signification that must erase any prior or originary presence of the nation-people to demonstrate the prodigious living principle of the people as a continual process by which the national life is redeemed and signified as a repeating and reproductive process.[27]

It is this reproductive impulse that is sacrificed in much of the Biennial's ruminations on the nature of difference in general. If we allow Bhabha's formulation to stand in for the manner in which the historical specificity of "whiteness," and for that matter all subject positions manifested in the exhibition, participate in a perpetual relation, the field of debate among subjects is afforded productive efficacy. It is bounded by an impulse to cultural specificity while simultaneously in continuous dialogue and negotiation with it. The overdetermined subjective posturing assigned to the work of the artists in the exhibition by the curators become "paranoid projections 'outward' [that] return to haunt and split the place from which they are made. So long as a firm boundary is maintained between the territories, and the narcissistic wound is contained, the aggressivity will be projected onto the Other or the Outside."[28]

Golden's and Martinez's epithet "whiteness," for example, assumes an historically situated equivalence between whiteness and Americanness: as discursive markers of an oppressive agent. However, are we to understand this as a marker of racial distinction? What is the "whiteness" that is to be reviled? Certainly, the connective tissue here amounts to more than simply a matter of melanin ratios, but is instead a projection of socioeconomic casting cloaked in racial ideologies. More to the point, we are all (black, white, or otherwise) "othered" by this inscription. Metaphorically, Chris Burden's installation *Fist of Light* (1992–3) proved highly suggestive of the apparently real discursive destructiveness inherent in refusing to recognize the ramifications of this condition: one that emblematically infuses the rampant confusions, obfuscations, and inconsistencies that permeate this year's Whitney Biennial. The work itself was unassuming. It constituted a proposal for a sealed, air conditioned chamber housing more than a thousand 500-watt light bulbs, the goal being "to totally saturate the entire space with light, attempting to remove all color in a visual analog of fission."[29] Sussman discussed the nuclear implications of this piece. Golden chose not to acknowledge it. However, this work embodied that concealed "whiteness" that she found "almost impossible to define." An intangible homogenizing force to which exposure would consume all "others" who entered: that is identity politics according to the Whitney Museum of American Art.

Notes

1 For an exception to this see Arthur Danto, "The 1993 Whitney Biennial," *The Nation*, April 19, 1993, pp. 533–6. Danto objects to the museum's institutional attribution of artistic value to George Holliday's Rodney King video footage.

2 *1993 Biennial Exhibition* (New York: Whitney Museum of American Art in association with Harry N. Abrams, Inc., 1993). Unlike previous Biennial publications, this document includes essays by each of the participating staff curators working on the exhibition: Thelma Golden, John Hanhardt, Lisa Phillips, Elizabeth Sussman, and Jeanette Vuocolo. In addition, critics were also invited to submit works for publication. They include Homi K. Bhabha, Coco Fusco, B. Ruby Rich, and Avital Ronell.

3 "Guerrilla Girls Review the Whitney," The Clocktower, April 16–May 17, 1987.

4 The chart entitled "The Color Blind Test" relates that the cumulative number of non-white men included in the show since 1973 stood at 3 Asians, 17 Blacks, 8 Hispanics and 0 Native Americans and of non-white women included 2 Asians, 0 Blacks, 0 Hispanics and 0 Native Americans.

5 David Ross, "Introduction," *1993 Biennial Exhibition*, p. 9.

6 Ibid.

7 See Serge Guilbaut, *How New York Stole the Idea of Modern Art: Abstract Expressionism, Freedom, and the Cold War* (University of Chicago Press, 1983).

8 See John Leo, "Culture War at the Whitney," *US News and World Report*, March 22, 1993; Robert Hughes, "A Fiesta of Whining," *Time*, March 22, 1993; and Peter Plagens, "Fade From White," *Newsweek*, March 15, 1993. Also see *Artforum*, May 1993. Coverage includes essays by Hilton Als, Glenn O'Brien, Bruce W. Ferguson, David Rimanelli, Jan Avgikos, Greg Tate, Dan Cameron, David Deitcher, Thomas McEvilley, Liz Kotz, and Lawrence Chua.

9 Eleanor Heartney, "Report from New York: Identity Politics at the Whitney," *Art in America*, May 1993, p. 43.

10 Sussman, "Coming Together in Parts: Positive Power in Art of the Nineties," in *1993 Biennial Exhibition*, pp. 14–15.

11 Paul Smith, *Discerning the Subject* (Minneapolis: University of Minnesota Press, 1988), p. xxx.

12 Christopher Newfield, "What Was Political Correctness?: Race, Right, and Managerial Democracy in the Humanities," *Critical Inquiry* (Winter 1993), pp. 329–30.

13 Ross, "Introduction," p. 10.

14 Newfield, "What Was Political Correctness?", p. 327.

15 As this essay focused primarily on the visual arts aspect of the exhibition, I have restricted my discussion to texts by curators whose predominant interests are in the visual arts: Sussman, Phillips and Golden.

16 Sussman, "Coming Together in Parts," p. 11.

17 Lisa Phillips, "No Man's Land," in *1993 Biennial Exhibition*, p. 52.

18 Ibid., p. 54.

19 Thelma Golden, "What's White . . . ?," *1993 Biennial Exhibition*, p. 26.

20 Ibid., p. 27. West citation from "The New Cultural Politics of Difference," *Out There: Marginalization and Contemporary Cultures*, Russell Ferguson, Martha Gever, Trinh T. Minh-ha and Cornel West, eds. (New York: The New Museum of Contemporary Art; Cambridge, Massachusetts: MIT Press, 1990).

21 Cornel West, "The New Cultural Politics of Difference," *October* 53 (1990), p. 94.

22 Barbara Jeanne Fields, "Slavery, Race and Ideology in the United States of America," *New Left Review* 181 (May–June 1990), p. 101.

23 Ibid., p. 104.

24 Ibid., p. 117.

25 Golden, "What's White . . . ?" pp. 34–5.

26 Michael Holquist, *Dialogism: Bakhtin and His World* (London: Routledge, 1990), p. 33.

27 Homi K. Bhabha, "DissemiNation: time, narrative and the margins of the modern nation," in *Nation and Narration*, ed. Homi K. Bhabha (London: Routledge, 1990), p. 297.

28 Ibid., p. 300.

29 Chris Burden, Statement from *Study for Fist of Light*, 1991 in *1993 Biennial Exhibition*, p. 125.

16 Haunted TV

Avital Ronell

Channel 12

Media technology has made an irreversible incursion into the domain of American "politics." The crisis that has ensued concerns not so much the nature of fictioning – politics has always been subject to representation, rhetoric, artifice – as the newly intrusive effects of law. This is not to say that the law has ever been zoned outside of us, but thanks to the media, different maps of arrest have been drawn up: the subject is being arrested according to altogether new protocols of containment. And practically everybody in homeless America is under house arrest. Few episodes have exploded into the polity more decisively or borne more singularly on our understanding of the relationship between media and state politics than has the Rodney G. King "event." Beyond the outrage that this episode has produced, its persistent visibility has forced us to ask tough questions about American scenes of violence. Are these scenes already *effects* of the media when they pass into the media and graduate into "events"? To what extent is serial killing an *effect* of serial television – of its imprinting on a national unconscious? Or, to return to our channel, what is the relationship between replicant racism (today's racism is not the same as yesterday's; it is constituted by a different transmitter) and the media, which appear to resist older forms of racism? One may wonder why it was the case that the LAPD, and not an equally pernicious police force, became the object of

From *Artforum* 31, 1 (September 1992): 70–3. Reproduced with permission of *Artforum*. Copyright © 1992 by *Artforum*.

coverage by television. On some crucial level, television owns and recognizes itself in the LAPD, if only because television first produced the mythic dimension of policing through popular television series such as *Dragnet*. The LAPD is divided by referential effects of historical and televisual narration. That the one is constantly exposed by the other, flashing its badge or serial number, is something we now need to interrogate. But as exposed as the LAPD appears to be, it is always covered by television. What is television covering? This mediation seems to bring us a long way from the question of politics in America. Indeed, owing to the teletopies created by television when it maps political sites, we no longer know where to locate the polis, much less "home." This is why we must begin with the most relentless of home fronts.

Channel 11

Some of you think that it is the hour of TV-guided destitution. Inside and outside the home the time has come to think about the wasted, condemned bodies that crumble before a television. What kinds of evaluations, political and moral, can be ascribed to the evacuated gleam of one who is wasting time – or wasted by time? There is perhaps little that is more innocent, or more neutral, than the passivity of the telespectator, the one who has become a storage device for things that can be controlled only remotely.

Headline news

My contention (and others have argued this according to different impulses and grammars) is that television has always been related to the law, which it locates at the site of crucial trauma. Even when it is not performing metonymies of law it is producing some cognition around its traumatic diffusions: thus even the laugh track, programming the traumatic experience of laughter, can be understood to function as a shock absorber. It signals the obsessive distraction that links laughter to history, within which Baudelaire located the loss of balance and "mankind's universal fallen condition" ("On the Essence of Laughter"). With loss of balance and the condition of falling, we are back to the unreadable blur that is said to project the step – or the charge – taken by Mr. Rodney King on March 3, 1991.

Channel 10

Unlike telephony, cinema, or locomotion, television emerged as a prominent figure of our time only after World War II. There are many reasons for this (the Nazis voted in radio as the transferential agency par excellence; television was canceled out of the secret service of fascistold transfixion). The mass invasion of television occurred after

the war: it was served on the cold war platter, which is to say that in one way or another TV is not so much the beginning of something new, but is instead the residue of an unassimilable history. Television is linked crucially to the enigma of survival. It inhabits the contiguous neighborhoods of broken experience and rerouted memory. Refusing in its discourse and values to record, preferring instead to play out the myths of liveness, living color, being there, television will have produced a counterphobic perspective to an interrupted history. I hope to scan the way TV acts as a shock absorber to the incomprehension of survival, being "live" or outliving as the critical enigma of our time.

Walter Benjamin theorized the difference between surviving and merely living on. Television plays out the tensions between these modalities of being by producing narratives that compulsively turn around crime. These narratives, traveling between real and fictive reference, allow for no loose ends but suture and resolve the enigmas they name. Television produces corpses that need not be mourned because, in part, of the status of surviving that is shown. Still, television itself is cut up, lacerated, seriated, commercial-broken, so that its heterogeneous corpus can let something other than itself leak out. I would like to explore in slo-mo the status of crime-time that has saturated television, if only to name an unreadable relation to the incomprehensibility of survival and its relation to law.

Channel 9

The death of God has left us with a lot of appliances. Indeed, the historical event we call the death of God is inscribed within the last metaphysical spasm of our history as it is interrogated by the question of technology. The event of the death of God, which dispersed and channeled the sacred according to altogether new protocols, is circuited through much of technology, occasionally giving rise to electric shocks. I am referring to God because, despite everything, He in part was the guarantor of absolute representability and the transparent rendering of truth. In an era of constitutive opaqueness – there is no transcendental light shining upon us, we dwell in the shadows of mediation and withdrawal, there will be no revelation, can be no manifestation as such – things have to be tuned in, adjusted, subjected to double takes, and they are dominated by amnesia. Without recourse to any dialectic of incarnation, something yet beams through, as though the interruption itself were the thing to watch.

Channel 8

Among the things that TV has insisted upon, little is more prevalent than interruption or the hiatus for which it speaks and of which it is a part. The hiatus persists in a permanent state of urgency, whence the necessity of the series. The series, or seriature, extradites television to a mode of reading in which interruption insists, even if it does

so as an interrupted discourse the aim of which is to recapture its own rupture. If we are going to attempt to read the interruption as such, there is still the necessity of enchaining the intervals; still, it would be absurd to produce a dialectical summation of all the series, i.e. interruptions, that tie up TV.

So, in the space of interruption – an atopos or interruption that used to be called "television land" – there exists a muted injunction to read the hiatus and let oneself be marked by the hiatus. If TV has taught us anything – and I think it is helpful to locate it, as Margaret Morse has done, somewhere between Kansas and Oz, an internal spread of exteriority, an interruption precisely of the phantasmatic difference between interiority and exteriority – it principally concerns, I think, the *impossibility of staying at home*. In fact, the more local it gets, the more uncanny, not-at-home it appears. Television, which Martin Heidegger once associated with the essence of his thinking, chaining you and fascinating you by its neutral gleam, is about being-not-at-home, telling you that you are chained to the deracinating grid of being-in-the-world. Perhaps this explains why, during his broadcast season, Jacques Lacan spoke of *homme-sickness*. We miss being-at-home in the world, which never happened anyway, and missing home, Lacan suggests, has everything to do with being sick of *homme*. So: where were we? asks the scholar.

Channel 7

We have no way of stabilizing or locating with certainty the "in" of being-in-the-world, no matter how much channel surfing we are capable of sustaining. Television exposes that constitutive outside that you have to let into the house of being, inundating and saturating you, even when it is "off." While television, regardless of its content or signified, tends toward an ontologization of its status – no matter what's on, I daresay, it is emptied of any signified, it is a site of evacuation, the hemorrhaging of meaning. Ever disrupting its semantic fields and phenomenal activities of showing – television participates as a trace in the articulation of sheer uncanniness. This is what Heidegger understands as our fundamental predicament of being-not-at-home in this world (which we have yet to locate and which technology helps to map in terms of teletopies, which is of no help). While television's tendential urge guides it toward ontology, however, there are internal limits that freeze-frame the ontological urge into an ethical compulsion. One of these internal limits that is lodged at once outside and inside TV is a certain type of monitoring – the nomadic, aleatory, unpredictable eruption we sometimes call video.

Channel 6

TV has always been under surveillance. From credit attributions to ratings, television swerves from the ontological tendency to the establishment of legitimacy, which

places it under the pressures of an entirely other obligation. It is no wonder television keeps on interrupting itself and replaying to itself the serial crime-stories that establish some provisional adjudication between what can be seen and an ethico-legal resolution to the programs of showing. Oedipus has never stopped running through television, but I'll get to the violence of legitimation and patricidal shooting momentarily. At any rate, the crime-stories that TV compulsively tells itself have been charged with possession of a mimetic trigger; in other words, as TV allegorizes its interrupted relation to law, it is charged with producing a contagion of violence. A perpetual matter of dispute, the relation of television to violence is, however, neither contingent nor arbitrary but zooms in on the absent, evacuated center of televisual seriature. At the core of a hiatus that pulses television, I am placing the mutism of video, the strategy of its silence and concealment. Though I recognize the radically different usages to which they have been put and the divergent syntaxes that govern their behavior, I am more interested in the interpellation that takes place between television and video, the way the one calls the other to order, which is one way of calling the other to itself. In fact, where nomadic or testimonial video practices a strategy of silence, concealment, and unrehearsed semantics, installed as it is in television as bug or parasite, watching (out) for television, it at times produces the Ethical Scream that television has massively interrupted.

This Ethical Scream that interrupts a discourse of effacement (even if that effacement should indeed thematize crime and its legal, moral, or police resolutions), this Ethical Scream – and video means for us "I saw it" – perforates television from an inner periphery, instituting a break in the compulsive effacement that in fact engages television (I am not speaking of the politically correct gestures that TV has produced by star-trekking interracial and interspecial specials: these are on the order of thematic considerations that have been sufficiently interpreted elsewhere). When testimonial video breaks out of concealment and into the television programming, which it occasionally supersedes, it is acting as the call of conscience of television. This is why, also, when television wants to simulate a call of conscience (the call of conscience (*Gewissensruf*) is the aphonic call discussed in Heidegger's *Being and Time*), it itself reverts to video. The abyssal inclusion of video as call of conscience offers no easy transparency but requires a reading; it calls for a discourse. As we have been shown with singular clarity in the Rodney King case and, in particular, with the trial, what is called for when video acts as the call of conscience is not so much a viewing of a spectacle, but a reading; and, instead of voyeurism, an exegesis. When you're on television, as its spectral subject on either side of the screen, you've been trashed, even if watching television is only a metonymy of being wasted in the form, for instance, of "wasting time."

Haunted TV: the phantom of the Gulf War, bleeding through the body of King. Haunted TV: showing by not showing what lay at our feet, the step out of line. Haunted TV: focusing the limitless figure of the police, this index of a phantomlike violence because they are everywhere. "The police aren't just the police (today more or less than ever)," writes Jacques Derrida; "they are . . . the . . . *figure sans figure*."[1] They cut a "faceless figure," a violence without a form, as Benjamin puts it: *gestaltlos*.

This formless, ungraspable figure of the police, even as it is metonymized, spectralized, and even if it installs its haunting presence everywhere, would remain, if Benjamin had his way, a determinable figure proper to the civilized states.[2]

The Rodney King event not only forces a reading of force and enforcement of law, but requires citation and the reading precisely of the phantom body of the police. The police become hallucinatory and spectral because they haunt everything. They are everywhere, even where they are not. Their present is not presence: *they are television*. But when they come after you and beat you, they are like those televisions that explode into a human *Dasein* and break into a heterotopy that stings. Always on, they are on your case, in your face.

Channel 5

What video teaches, something that television knows but cannot as such articulate, is that every medium is related in some crucial way to specters. This ghostly relationship that the image produces between phenomenal and referential effects of language and image is what makes ethical phrasing as precarious as it is necessary. Because of its transmission of ghostly figures, interruption, and seriature, television would be hard to assimilate to the Frankfurt School's vision of it, where the regime of the visual is associated with mass media and the threat of a culture of fascism. This threat always exists, but I would like to read the way television in its couple with video offers a picture of numbed resistance to the unlacerated regimes of fascist media.

Channel 4

One problem with television is that it exists in trauma, or rather trauma is on television. This presents us with considerable technical difficulty, to the extent that trauma can be experienced in at least two ways: as a memory that one cannot integrate into one's own experience, and as a catastrophic knowledge that one cannot communicate to others. If television cannot be hooked up to what we commonly understand by experience, and if it cannot communicate, even telecommunicate, a catastrophic knowledge but can only – perhaps – signal the transmission of a gap (at times a yawn), a dark abyss, or the black box of talking survival – then what is it doing? Also, why does it at once induce the response of nonresponse and get strapped with charges of violent inducement?

Channel 3

I have to admit that initially, when adjusting myself to technology, I was more seriously drawn in by the umbilicus of the telephone, whose speculative logic kept

me on a rather short leash. On first sight, television appeared to be a corruption, as in the case of supercessions, of telephony; it seemed like a low-grade transferential apparatus, and I felt television and telephone fight it out as in the battle in *Robocop* between mere robot (his majesty the ego) and the highly complex cyborg (who came equipped with memory traces, superego, id, and – ever displacing the ego – a crypt). In yet another idiom, telephony was for me linked to the Old Testament (the polite relation to God, as Nietzsche says), where television seemed like the image-laden New Testament (where one rudely assumes an intimacy with God and makes one of his images appear on the screen of our historical memory). Needless to say, I was on the side of the more remote, less controlled, audible sacred, to the extent that its technical mutation can be figured as the telephone. The Old Testament unfolds a drama of listening and inscription of law, the New Testament produces a kind of videodrome revision of some of the themes, topoi, and localities of its ancestral test. Now, I am not referring us to these texts in order to expose a conversion of any sort, but merely for the purpose of turning the dial and switching the ways in which our being has been modalized by a technology that works according to a different proto-col of ethical attunement. If I refer us to the twin Testaments, this in part is to explore the site of testimony that television, despite and beside itself, initiates. It is no accident that television – owing to the dramas we have come to associate with the names of Lacan, Elvis, Heidegger, Anita Hill, Rodney King, Lee Harvey Oswald, Vietnam (fill in the blanks), and Desert Storm – has become the locus of testimony, even if we are faced with false testimony or resolute noncoverage. In a moment I will try to show, to the extent that anything can be shown, why the Gulf War was presented to us as a discourse of effacement, in other words, why at moments of referential need, the experience of the image is left behind. This has everything to do with the interruptive status of death, but also with the problematic of thematization. In other words, I believe there is a concurrent mark of an invisible channel in televi-sion that *says* the problematic of thematization, which makes the rhetoricity of the televisual image collapse into a blank stare.

At such moments of collapse – most manifestly, the seriated nothing that was on during the Gulf War – television takes a major commercial break as it runs interfer-ence with its semantic and thematic dimensions. This interference that television runs with itself, and continues to rerun on a secret track, points us to something like the essence of television. One may argue that the Rodney King event, which forced an image, though not as stabilized narration, back on the screen, presented that which was unpresentable during the war – Rodney King, the black body under attack by a massive show of force, showed what would not be shown in its generalized form: the American police force attacking helpless brown bodies in Iraq. Now it so happens that the Rodney King trial is about force itself. Thematically, what was being measured, tested, and judged in the televised trial was the question of force, one of excessive police force. And there's the catch; we saw it blown up and cut down in the Anita Hill case: force can never be perceived. This is a persistent ques-tion circulating in the more or less robust corpus of philosophical inquiry. The ques-tion now is, How can philosophy talk about force?

Channel 2

The question par excellence in the Rodney King trial treats the regulation of force, its constitution and performance, in terms of an ethics of dosage. While TV was under the covers, nomadic video captured the images of brute force committed by the LAPD. Now, anyone who has been watching the trial knows that the referential stability of the images has been blown out of the water. Witnesses were reading blurs and were blurring images. The status of the image as a semantic shooting range has been severely undermined as TV conducts an interrogation of force. This interrogation was forced upon TV – it involves an interrogation, I would submit, about its own textual performance in the production of force. What comes out provisionally, at least, is the fact that video, nomadic video – aleatory, unpredictable, vigilant, testimonial video – emerges as the call of conscience of broadcast TV.

Channel 1

The defense-team takedown involved approaching George Holliday's videotape by replicating the violence that had been done to Mr. Rodney King. The unquestioned premise upon which the team of lawyers based their defense of the police called for an interpretation of the video in terms of a "frame by frame" procedure. No one questioned this act of framing, and the verdict that ensued unleashed the violence that would explode the frames set up by the court. In the blow-by-blow account, counting and recounting the event of the beating, the defense presented the sequentiality of photographs, the rhythm of articulation of which was beaten into the court records. The chilling effects of warping video into freeze-frame photography cannot be underestimated.[3] The temporization that reading video entails was halted by spatial determinations that were bound to refigure the violence to which Mr. Rodney King was submitted. No one needs to read Derrida's work on framing in order to know that justice was not served in Simi Valley, California. But, possibly, if one had concerned oneself with the entire problematic of the frame, its installation and effects of violence – indeed the *excessive force* that acts of framing always imply – then it would have been something of an imperative to understand what it means to convert in a court of law a videotape into a photograph. For the photograph, from the readings of Benjamin, Roland Barthes, Derrida, and a number of others, draws upon phantomal anxieties as well as the subject's inexorable arrest. I need not stress to what extent the black body in the history of racist phantasms has been associated with the ghost or zombie.

In order to get in gear, the police force had to imagine that their suspect was on PCP. What does it mean to say that the police force was hallucinating drugs? The Rodney King event was articulated as a metonymy of the war on drugs; this war constitutes an act of ethnocide by hallucinating mainstreamers. But the Rodney

King event is also an eruption of the effaced Gulf War. When television collapsed into a blank stare, whiting out the Gulf War, nomadic video flashed a metonymy of police action perpetrated upon a black body.

Television is being switched on out of a number of considerations. Despite and beside itself, TV has become the atopical locus of the ethical implant. Not when it is itself, if that should ever occur or stabilize, but when it jumps up and down on the static machine, interfering as an alterity of a constant disbandment.

Notes

1 Jacques Derrida, "Force of Law: The 'Mystical Foundations of Authority,'" trans. Mary Quaintance, in *Cardozo Law Review*, 11 no. 5–6 (July/August 1990), p. 1009.
2 Walter Benjamin, "Critique of Violence," in *Reflections: Essays, Aphorisms, Autobiographical Writings*, ed. Peter Demetz, trans. Edmund Jephcott (New York: Schocken Books, 1986), pp. 270–300.
3 I owe these reflections to remarks made in Berkeley and Oakland by Professors Fred Moten and Peter T. Connor at the time of the LA riots, April 30 and May 1, 1992.

Part III Postcolonial Critiques

Introduction to Part III

S ince the early 1980s, the discourses of postcolonialism and cultural studies
have entered the field of art. For example, journals such as *Third Text*, which
began publication in 1987, have sought to forefront the histories of colonial-
ism, anti-imperialism, and Eurocentrism in relation to contemporary art. Thinkers in
postcolonial and cultural theory who laid the groundwork for this recent practice
in art and theory – Franz Fanon, C. L. R. James, Edward Said, Gayatri Spivak, Homi
Bhabha, and Stuart Hall – gained a substantial readership in the art world. The essays
in Part III address some of the main concerns of postcolonialist and cultural theory in
the art context: postmodernism and its relevance to non-European contexts; the
construction of identity; notions of difference; the critique of essentialism; the "primi-
tive" and the "exotic"; West/non-West binarism; and the globalization of a "society
of the spectacle."

Beginning this section, Gerardo Mosquera's essay, "The Marco Polo Syndrome,"
frames the critique of Eurocentrism within the problematic of intercultural com-
munication. In relation to art, Mosquera argues that the contemporary conception of
art is a product of Western culture, always presenting non-Western artists with a
dilemma – to have to choose between "derivative" production (never considered as
good as the European model) or a display of one's otherness. In suggesting how to
break out of this bind, he states: "the de-Eurocentralisation in art is not about return-
ing to purity, but about adopting postcolonial 'impurity' through which we might
free ourselves and express our own thought." This requires rejection of the West's
demands for "authenticity," tradition, and "purity" in favor of decentralization, and a
move toward adopting artistic strategies of recontextualization, appropriation, and
recycling.

In his essay, "In the 'Heart of Darkness'," Olu Oguibe takes up some of Mosquera's concerns regarding Eurocentrism within the context of Africa, specifically demanding that the fictiveness of "Africanity" be acknowledged, while recognizing the "multiplicity and culture-specificity of modernisms and the plurality of centers." Speaking on the need for outsiders such as anthropologists, aid organizations, and policy-makers to maintain the fiction of Africanity, Oguibe points out that "to undermine the idea of The African is to exterminate a whole discursive and referential system and endanger whole agendas." Through critiquing the constructed category of "sub-Saharan Africa," Oguibe throws into question the viability of the terminology of art-historical language as generally applied to art of the African continent. He points out: "If Africa is not some easily definable species or category that yields to anthropology's classifications and labels, neither are its cultural manifestations."

Elaborating on both Mosquera's and Oguibe's essays, in "The Syncretic Turn" Jean Fisher focuses on the challenge of considering the recent art of non-European and black artists within traditional art-historical frameworks. She acknowledges the need to step outside traditional art-historical boundaries in order to consider the variety of contemporary art, but characterizes as inadequate the adaptation of methods and approaches from anthropology, literary criticism, and other fields upon which art criticism has drawn in recent decades. Distinguishing art from other forms of cultural production, Fisher states, "Visual art remains a materially based process, functioning on the level of *affect*, not purely semiotics – i.e., a synaesthetic relation is established between work and viewer, which is *in excess of visuality*." Fisher describes briefly some of the strategies of black and non-European artists in the 1970s and '80s, pointing out their usefulness as well as their limits. As a way to transcend the trap of art based solely in "otherness," Fisher rejects Homi Bhabha's use of a once critical term which has lost its efficacy, "hybridity," in favor of a concept of "syncretism" elaborated by Marcos Becquer and José Gatti, suggesting that the latter allows for an element of untranslatability as a potential space for productive renewal.

Lee Weng Choy extends the prior critiques of Eurocentrism to "New Asia" in order to question what he characterizes as a new Asian cultural essentialism. This form of essentialism, made visible in the spectacularization of contemporary Singaporean society, is exemplified for Lee by Channel NewsAsia, a Singapore television station which trades in the stylized commodification of Asia. Serving its role as the model for New Asia, Lee asserts: "Singapore is *Sign-apore*, a society of the spectacle par excellence, the all-appropriating agent, modernity's idealized tabula rasa." Drawing on Guy Debord's theory of the spectacle, Lee puts forth his central question: how to engage effectively in a critique of the spectacle. While offering Ong Keng Sen's theatrical version of Lear as an example of strategic Asian essentialism, where Orientalism is practiced from within, Lee cites the work of artists Simryn Gill and Amanda Heng, in their evocations of a complex "time-out-of-joint," as opening up the possibilities for counter narratives to the essentialization and spectacularization of a "new Asia."

Trinh T. Minh-Ha, like Lee, draws on Debord's theory of the spectacle in her essay "All-Owning Spectatorship," in this case to unmask the coercive mechanisms of spectatorship whose rules, according to Trinh, are set according to a unilateral foreclosure

of alternative critical interpretations of visual texts. In these rules, critical readings of and by multivocal occupiers of the margins, whether women, those of the "Third World," or the poor, are disallowed. Using the porousness in the cultural meanings of color as a central motif and example, Trinh poses a theory of reception based on the complex meeting of history, language, culture, and sexuality. While focusing primarily on the discourse of film, Trinh points out the inevitable "mediating subject-ivity of the spectator as reading subject" and argues for an ethics of "reading as a creative responsibility" in encountering the work of art.

17 The Marco Polo Syndrome

Some Problems around Art and Eurocentrism

Gerardo Mosquera

The second Habana Biennial, in 1986, included an installation by the Cuban artist Flavio Garciandía entitled *El Síndrome de Marco Polo*. Various ambiguous images depicted the adventures of a popular character from the comics – a captain in the wars of independence in the 19th century and a symbol of Cubanness – during and after a trip to China. The work, drawing on forms of orientalist kitsch, humorously questioned the problems of intercultural communication. The character, like Marco Polo, was a pioneer in the experience of understanding the Other, but his chances of bridging two cultures were lost through the suspicion provoked from both sides, especially from his.

We had to wait until the end of the millennium to discover that we were suffering from the Marco Polo Syndrome. What is monstrous about this syndrome is that it perceives whatever is different as the carrier of life-threatening viruses rather than nutritional elements. And although it does not scare us as much as another prevalent syndrome, it has brought a lot of death to culture. Only now has an understanding of cultural pluralism and the usefulness of dialogue begun to spread to such an extent that the intercultural problematic has become a major issue.

The possibility of a more diversified consciousness has been opened up, while the question of ethnicity and nationality fills the new maps with many colours. Dominant Eurocentrism – the main symptom of the disease – is undergoing a critical treatment increasingly more effective in its power of persuasion. All these mutations have

From *Third Text* 21 (winter 1992/3): 35–41, translated from the Spanish by Jaime Flórez. Reproduced with kind permission of *Third Text*.

targeted art, presenting it with urgent and very complicated problems. Only some of them will be touched upon here.

The notion of Eurocentrism is very recent. In anthropology we find an acknowledgement of ethnocentrism in the 18th century,[1] and a consolidation of the idea of cultural relativism by Boas before the end of the 19th century. But, until recently, this idea had not significantly infiltrated the studies and interpretations of art and literature, centred as they were in criteria of values linked to the myth of the "universal". The discourses called postmodern, with their interest in alterity, have gradually introduced a more relativist attitude to the scene. A new consciousness of ethnicity is taking shape as a result of several contemporary processes, among them decolonisation, the greater space gained by the Third World in the international arena, the influence of ethnic groups from the margins in the great northern cities, the increase of information and improved facilities in travel and communication. Postmodernism itself, as Geeta Kapur suggests, could be regarded as a consequence and not as a description of a "realigned universe" through the praxis of societies previously completely marginalised.[2]

Eurocentrism is different to ethnocentrism. It refers not only to the ethnocentrism exercised by a specific culture, but to the often forgotten fact that the world-wide hegemony of that culture has imposed its ethnocentrism as a universal value, and has persuaded us of it for a long time.[3]

Here we leave the rather aseptic field of cultural relativism to come up against social problems and issues of power. The fact is that, from the Industrial Revolution, the global expansion of capitalism began to involve the whole world in an economic process which had Europe as its centre, and which, from then on, determined the course of the planet. Western metaculture established itself through colonisation, domination, and even the need to articulate it in order to confront the new situation within itself. Even so, Amílcar Cabral went as far as to say that imperialist domination "was not only a negative reality", and that "it gave new worlds to the world".[4] Modernity, full of good intentions, contributed not a little to this planetary cultural revolution, although Adorno, Horkheimer and Huyssen have connected its negative aspect with imperialism.[5]

Ethnocentrism always suggests the naive vanity of a villager who, as José Martí said, assumes that "the whole world is his village", believing everything originated there even if it were imposed on him through conquest. Eurocentrism is the only ethnocentrism universalised through actual world-wide domination by a metaculture, and based on a traumatic transformation of the world through economic, social and political processes centred in one small part of it. As a result, many elements of this metaculture cease to be "ethnic" and become internationalised as intrinsic components of a world shaped by Western development. But if these components are irrefutable, so should be the need to end the lack of focus, limitation, boredom and injustice of planning the world like a one-way street.

The very fact of the rise of the idea of Eurocentrism demonstrates an awareness of the monocultural trap in which we have all found ourselves prisoners. I say "all" because Eurocentrism affects not only non-Western cultures but the West itself,

given the widespread impoverishment of perspective inherent to any monism. The tragedy is that the notion of Eurocentrism is also *Made in the West*, even though, as Desiderio Navarro has pointed out, it is starting to take shape, especially in Eastern Europe,[6] at those peripheries exposed to closer contact with non-Western countries.[7] Colonialism brought about a split whereby non-Western countries took on board the problems of their own cultures in the sphere of traditions isolated from the contemporary scene, at the same time as they adopted those of the West, without making a connection capable of transforming both of them to the benefit of their own interests and values in the existing global situation.[8] This has started to change. Roughly, three moments can be summarised. Firstly, the cultures that we currently call traditional were "arrested" by Western expansion, which carried forward, according to its point of view, the great centrifugal development of art and science from the 18th century, generalising it as "universal". Secondly, the realisation by one fraction of thought in the Western world of the absurdity of this situation. "Not a single Ibn in the index to *Literary Theory!*" René Etiemble eloquently exclaimed, thereby disqualifying the classical work of Wellek and Warren.[9] Thirdly, anti-Eurocentrism from non-Western positions has begun to be systematised.

This does not mean a return to a past prior to Western globalisation, but the construction of a contemporary culture – one capable of acting in today's reality – from a plurality of perspectives. This development is a matter of some urgency since we are running the risk that the West, apart from anything else, may also give the Third World a philosophy of intercultural exchange and a critique of Eurocentrism. Such an autocritique, despite its good intentions and its indisputable value, would perpetuate the distortion produced by its single perspective and existing circuits of power.

Postmodern interest in the Other has opened some space in the "high art" circuits for vernacular and non-Western cultures. But it has introduced a new thirst for exoticism, the carrier of either a passive or a second-class Eurocentrism which, instead of universalising its paradigms, conditions certain cultural productions from the periphery according to paradigms that are expected of it for consumption by the centres. Many artists, critics and Latin American curators seem to be quite willing to become "othered" for the West.

The problematic of Eurocentrism and the relations amongst different cultures is particularly complex in the contemporary visual arts, where the Marco Polo Syndrome embodies a double-edged sword. Art, in today's conception of a self-sufficient activity based on aesthetics, is also a product of Western culture exported to others. Its full definition is also very recent, no older than the end of the 18th century. The aesthetic tradition of other cultures, like that of the West in other periods, was a different kind of production, determined by religious, representational and commemorative functions, and so on. Today's art in these cultures is not the result of an evolution of traditional aesthetics: its very concept was received from the West through colonialism.

This generates contradictions and brings the evils of dependency on and mimicry of the centres. But it forms part of the postcolonial challenge, because our cultures should not lock themselves in isolating traditions if they want to take part in today's

dynamic and offer solutions to their own problems. Instead, what should be done is to make traditions work within the new epoch. The problem is not preserving them but vigorously adapting them. The question is how we may also *make* contemporary art from our own values, sensitivities and interests. The de-Eurocentralisation in art is not about returning to purity, but about adopting postcolonial "impurity" through which we might free ourselves and express our own thought.

A paradigmatic case of these complexities can be seen in the Cuban artist José Bedia. White and blue-eyed, this artist of popular origin practices the *palo monte*, an Afro-Cuban religious and cultural complex of Kongo origin. A graduate and ex-professor of the Instituto Superior de Arte de La Habana, Bedia is a sophisticated, well-informed Western artist with a wide range of resources at his command. But his conceptually oriented work, in its content rather than in its language, is mostly based on the cosmology of the Kongo still alive in Cuba, a result of his interest in a contemporary reflection on the problems of the human being derived from the Kongo's interpretation of the world. His work intelligently takes advantage of openings, resources and sensitivities from current art of the centres, to confront us with a different vision. This syncretism also occurs in his technique, effortlessly integrating technological, natural and cultural elements, drawing and photography, ritual and mass-cultural objects, all within the sobriety of an analytic discourse. He also appropriates "primitive" techniques, but not in order to reproduce their programmes: he creates elements with them that articulate his personal discourse and iconography. Bedia is making Western culture from non-Western sources, and therefore transforming it towards a de-Europeanisation of contemporary culture. But simultaneously we could say that he is making postmodern Kongo culture. Besides which, he opens himself up to so-called "primitive" cultures in what he has called a voluntary transculturalisation in reverse: from his "high art" education to a "primitive" one.[10] Although this is an intellectual process, it is also interiorised in the artist, given the *mestizo* character of his own cultural background.

The Marco Polo Syndrome is a complex disease that often disguises its symptoms. The struggle against Eurocentrism should not burden art with a myth of authenticity which, paradoxically, may add to the discrimination that Third World visual art suffers in the international circuits. This myth precludes its appreciation as a living response to contradictions and postcolonial hybridities, and demands instead an "originality" defined according to tradition and old cultures corresponding to a situation long since passed. More plausible is to analyse how current art in a given country or region satisfies the aesthetic, cultural, social and communicative demands of the community from and for which it is made. Its response is mostly mixed, relational, appropriative – anyway, "inauthentic", and therefore more adequate to face today's reality.

One of the great Eurocentric prejudices in the critique and history of art is its complete undervaluing of this production as "derivative" of the West. Third World artists are constantly asked to display their identity, to be *fantastic*, to look like no one else or to look like Frida . . . The relatively high prices achieved by Latin American art at the great auctions have been assigned to painters who satisfy the expectations

of a more or less stereotyped Latin-Americanicity, able to fulfil the new demand for exoticism at the centres. As a consequence, Rivera is valued well above Orozco, Remedios Varo more than Torres García, and Botero considerably more than Reverón.[11] In other cases all contemporary practice is discredited as spurious. Let's see the opinion of an eminent Africanist: "Authentic African art is that produced by a traditional artist for traditional purposes and according to traditional forms."[12]

In this view, Africa is tradition not the present. An anti-Eurocentrism like this freezes all African cultures, relegating them to a museum, without understanding that they are living organisms which need to respond actively to the reality of their time. If we have to fight relentlessly against colonialism, which castrates much contemporary art from the Third World, we should not do it through nostalgia for the mask and the pyramid.

Extreme relativism constitutes another danger. It is said that a village may be ignorant of what happens in the neighbouring village, but knows what happens in New York. Anyone who has ever travelled through Africa knows that it is often easier to go from one country to the next via Europe. One of the worst problems of the Southern Hemisphere is its lack of internal integration and horizontal communication, in contrast with its vertical – and subaltern – connection with the North. The cultures of the South, so diverse, confront common problems derived from the postcolonial situation, and this has determined structural similarities in the mosaic. "Speaking about the Third World and wrapping up in the same package Colombia, India and Turkey"[13] is as rhetorical as ignoring what unites, or might unite them, in their confrontation with hegemonic power, even if it is just poverty.[14] These cultures urgently need to know and think of each other, to exchange experiences, to embark on common projects. A radical conception of relativism should not exacerbate their isolation, separating them from our efforts to approach the Other and learn from him or her (even about things we don't like, as Venturi would say). If postmodernity places otherness in the foreground it does so through a process of infinite differentiation which eliminates even the necessity of choice.[15] The strategy of the dominated moves towards integration through what unites them, and activates their difference "in the face of international postmodern dominance."[16] The South-South "Robinsonism" benefits only the centres by entrenching North-South verticalism. If the translation of one culture into another in all its nuances is impossible, this should not preclude their capacity for mutual closeness, enrichment and solidarity. Jorge Luis Borges said that Quixote is still winning battles against his translators.[17]

The myth of universal value in art, and the establishment of a hierarchy of works based in their "universality", is one of the heritages of Eurocentrism that continues to survive, despite our becoming less naive with respect to the "universal", which has so frequently been a disguise for the "Western". But this should not disable our reception of artwork beyond the culture which made it; even if that response is "incorrect",[18] it may still generate new meanings. Art is very linked to cultural specificity, but possesses a polysemic ambiguity, open to very diverse readings. We live in "a great time of hybrids", as a Mexican rock star sang,[19] which offers an unconventional challenge by reinterpreting instead of rejecting dependency on the great circuits. In contemporary

experience, contextualisation, recycling, appropriation and re-semanticisation gain more and more power as a consequence of increased interaction among cultures.

The critique of Eurocentrism forms part of a new awareness towards the ethnic, the consolidation of which would sense, for the first time, the possibility of a global dialogue among cultures, capable of facilitating a cure for the syndrome. However, in the visual arts, little progress has been made in this direction. Contemporary, non-traditional production from the South finds few outlets. Excluded from the great centres and supposedly international circuits, its presence in exhibitions like *"Primitivism" in 20th Century Art* or *Magiciens de la terre* is insignificant, despite the fact that it could have contributed a lot more, especially by deepening and problematising their perspectives.[20] The "contemporary artistic scene" is a very centralised system of *apartheid*.[21] More than being Eurocentric it is Manhattan-centric. But, I insist, the barrier is not just South-North due to centre-periphery relations of power, but South-South, as a consequence of a postcolonial deformation.

Despite its deformed structure, the dictates from the centre and the imposition of their arrogant judgements of art, the diversification of artistic circuits clashes with the difficulties of intercultural evaluation already pointed out. Critics, curators and historians have a great responsibility in this sense. To paraphrase Harold Rosenberg, we should realise that the way towards an intercultural evaluation of the work of art is not just a question of seeing, but also of listening. Careful account should be taken of how artwork functions in its context, what values are recognised there, what sensibility it satisfies, what perspectives it opens, what it contributes . . . Only after such thorough understanding would we recognise the messages of interest that art can communicate to the viewers addressed by the exhibitions, and how it can contribute towards a general enrichment. Given that it has been demonstrated that the role of the viewer is fundamental in art and literature, this does not mean that one only sees from one's self and one's own circumstance, but also that reception is active and therefore capable of expanding.

The fundamental problem for exhibitions and texts with an intercultural meaning is communication. On the one hand to inform and contextualise; and on the other to orientate towards what interests new receivers. As mediators they must accept compromise, but need to make an effort to avoid centrisms and clichéd expectations. It is easy to say it, but in practice we are far from possessing exemplary solutions.

Apart from polyfocal, multiethnic decentralisation, one last problem is that the dismantling of Eurocentrism demands an equally pluralistic revision of Western culture. When Robert Farris Thompson assigned Fu-Kiau Bunseki, a traditional Kongo expert, to comment on the "Africanist" painting of Picasso,[22] he was not simply making a gesture of deconstructing in reverse the appropriation of African sculpture by modernism, and making eloquent the ingenuity of his concerns with universality. He was also opening up a pluralistic methodological perspective. Not only in the sense of an erudite explanation of traditional Africa through others inspired by it. Bunseki's analyses deepen our appreciation of those works, and even of a Western point of view. Cubism revolutionised the visual culture of the West by appropriating formal resources from Africa. But these forms were not free-floating; they were

designed to support specific meanings which, on a more general level, can also function within the coded system of Picasso's paintings. Those forms belong to a cosmic vision whose perceptual foundations continue to be present in the new vision by which the Cubists transformed Western painting, even without their acknowledging the functions and meanings of their African models.

Intercultural involvement consists not only of accepting the Other in an attempt to understand him or her and to enrich myself with his or her diversity. It also implies that the Other does the same with me, problematising my self-awareness. The cure for the Marco Polo Syndrome entails overcoming centrisms with enlightenment from a myriad of different sources.

Notes

Translated from the Spanish by Jaime Flórez.

1 For instance, see Hunter, "Inaugural Disputation on the Varieties of Man", 1775, in T. Bendyshe (ed. and trans.), *The Anthropological Treatises of Johann Friedrich Blumenback* (London, 1865), pp. 357–94.

2 Geeta Kapur, "Tradición y Contemporaneidad en las Bellas Artes del Tercer Mundo", in Open Debate, "Tradición y Contemporaneidad en la Plástica del Tercer Mundo", 3rd Bienal de La Habana (1989), p. 12.

3 Gerardo Mosquera, *El diseño se definió en Octubre* (La Habana, 1989), pp. 31–3.

4 Amílcar Cabral, "O papel de cultura na luta pela independencia", in *Obras escolhidas de Amílcar Cabral*, vol. 1 (Lisbon, 1978), pp. 234, 235.

5 "Despite all its noble aspirations and achievements, we should acknowledge that the culture of modernity . . . has also been always (but not exclusively) a culture of interior and exterior imperialism." Andreas Huyssen, "Cartográfica de postmodernismo", in Josep Picó (ed.), *Modernidad y postmodernidad* (Madrid, 1988), p. 239.

6 In literary theory the first warnings appear with the Russian Zhirmunski (1924); in the *Tesis* of the Linguistic Circle of Prague; in the Russian Konrad (1957); in the French Etiemble (1958); in the Polish Swarczynska (1965); Ingarden and Ossowski (1966). Desiderio Navarro, "Un ejemplo de lucha contra el esquematismo eurocentrista en la ciencia literaria de la America Latina y Europa", *Casa de las Americas*, vol. XXI, no. 122 (La Habana, September–October 1980), pp. 83–5.

7 About the double condition of European borders, Western bastion and contact zone, see Leopoldo Zea, *América en la historia* (Mexico and Buenos Aires, 1957), pp. 118–54.

8 The processes of transculturation occurred above all in daily life and artistic-literary culture. Western discourse transformed very little within intellectual thought. It is connected with that cultural dichotomy, pointed out by Shuichi Kato, between a native ego and a Western superego, according to Dufrenne. Mikel Dufrenne et al., *Main Trends in Aesthetics and the Sciences of Art* (New York and London, 1979), pp. 37–8.

9 Rene Etiemble, *Essais de littérature (vraiment) général* (Paris, 1974), p. 9. The Marxists are in no better a position. For instance, the four volumes of Lukács, under the all-encompassing title *Aesthetics*, do not take a single non-Western work into account. And even worse, the Soviet manuals of literary theory ignored the Oriental literatures of their own country (Desiderio Navarro, "Un ejemplo de lucha", pp. 88–90); and socialist realism

in art and literature was imposed from Western canons. All these are evidence of the Russocentric politics towards other nationalities which, together with other factors, provoked the dismemberment of the union.

10 See his testimony in *Made in Habana: Contemporary Art from Cuba* (Art Gallery of New South Wales, 1988), p. 20.

11 A critical interpretation of Botero from this perspective can be read in Luis Camnitzer, "Boteros: falsos y auténticos", *Brecha* Montevideo, 16 August 1991, p. 20.

12 Joseph Cornet, "African Art and Authenticity", *African Arts*, vol. 9, no. 1 (Los Angeles, 1975), p. 55.

13 Nestor García Canclini, "Modernismo sin modernización?", *Revista Mexicana de Sociología*, vol. LI, no. 3 (Mexico, July–September 1989), p. 170.

14 Mirko Lauer, "Notas sobre plastica, dentidad y pobreza en el tercer mundo", in *Debate Abierto . . .*, pp. 19–27.

15 Geeta Kapur, "Tradición y Contemporaneidad", p. 11.

16 Nelly Richard, "Latinoamerica y la postmodernidad", *Revista de crítica cultural*, Santiago de Chile, vol. 2, no. 3 (April 1991), p. 15. What must be extended to include the whole south is the recognition of Latin America as a "zone of experience (be it called marginalization, dependency, subalternity, decentredness) common to all countries situated at the periphery of the Western dominated model of centred modernity".

17 Jorge Luis Borges, "La supersticiosa etica del lector", in his *Páginas escogidas* (La Habana, 1988), p. 105.

18 Boris Bernstein, "Algunas consideraciones en relación con el problema 'arte y etnos'", *Criterios*, nos. 5–13 (La Habana, January 1983–December 1984), pp. 266–7.

19 Gerardo Mosquera, "Speakeasy", *New Art Examiner*, vol. 17, no. 3 (Chicago, November 1989), pp. 13–14.

20 Rodrigo González changed his old Castillian aristocratic name into Rockdrigo, and became one of those who transformed rock into a vehicle of expression of marginal youth and lower classes in Mexico City, by using international rhythms for local ends.

21 Rasheed Araeen, "Our Bauhaus, Others' Mudhouse", *Third Text*, no. 6 (London, spring 1989), pp. 3–4; James Clifford, "Histories of the Tribal and the Modern", *Art in America* (April 1985, New York), pp. 164–77, included in *The Predicament of Culture* (Cambridge and London, 1988); Gerardo Mosquera, "'Primitivismo' y 'contemporaneidad' en jovenes artistas cubanos", *La revista del sur*, Malmo, vol. 2, no. 3–4 (1985), pp. 52–5 and *Universidad de La Habana*, no. 227 (January–June 1986), pp. 133–9.

22 Robert Farris Thompson, "Breakshadow Art (Pasula Klini): Towards an African Reading of 'Modernist Primitivism'", in *Rediscovered Masterpieces of African Art* (Paris, 1988), pp. 65–73.

18 In the "Heart of Darkness"

Olu Oguibe

I

Prehistory. History. Post-history. It is evidence of the arrogance of occidental culture and discourse that even the concept of history should be turned into a colony whose borders, validities, structures and configurations, even life tenure are solely and entirely decided by the West. This way history is constructed as a validating privilege which it is the West's to grant, like United Nations recognition, to sections, nations, moments, discourses, cultures, phenomena, realities, peoples. In the past fifty years, as occidental individualism grew with industrial hyperreality, it has indeed become more and more the privilege of individual discourses and schools of thought to grant, deny, concede, and retract the right to history. Time and history, we are instructed, are no longer given. Indeed history is to be distinguished from History, and the latter reserved for free-market civilisation, which, depending on the school of thought, would either die or triumph with it. Though they both share a belief in consolidating systematisation as a condition of historicism, Francis Fukuyama in the 1980s and Arnold Gehlen in the immediate post-Nazi period differ on the specificities of the question. While on the one hand Fukuyama believes that the triumph of free-market systematisation over regulated economies marks the end of History, Gehlen and the subsequent school of post-Nazi pessimism posited that the triumph of liberal democracy over fascism marked the end of History and the beginning of *Post-histoire*.

From *Third Text* 23 (summer 1993): 3–8. Reproduced with kind permission of *Third Text*.

In both cases what comes out very clearly, despite the fundamental differences which define and preoccupy the discourse on the fate of History, is the consignment of the rest of humanity outside the Old and New West into inconsequence. For Gehlen, who had a better and stronger sense of history as well as intellectual integrity than Fukuyama can claim, the entirety of humanity was victim to a universal syncretism which subverts the essence of history. For Fukuyama this universality is to be taken for granted, although the majority of humanity is indeed, factually and historically speaking, hardly strictly subject to liberal democracy. Humanity is synonymous with the Group of Seven and Eastern Europe. Under Reaganism-Thatcherism even the spacial definition of history severely retracts to the Pre-Columbian.

The contest for History is central to the struggle for a redefinition and eventual decimation of centrism and its engendering discourse. Without restituting History to other than just the Occident, or more accurately, recognising the universality of the concept of History while perhaps leaving its specific configurations to individual cultures, it is untenable and unrealistic to place such other temporal and ideological concepts as Modernism, Modernity, Contemporaneity, Development, in the arena. If Time is a colony, then nothing is free.

II

Premodernism. Modernism. Postmodernism. For the West erase Premodernism. For the rest replace with Primitivism. It is tempting to dwell on the denial of modernity to Africa or cultures other than the West. The underlying necessity to consign the rest of humanity to antiquity and atrophy so as to cast the West in the light of progress and civilisation has been sufficiently explored by scholars. If not for the continuing and pervading powers and implications of what Edward Said has described as structures of reference, it would be improper to spend time on the question. It is important to understand that while counter-centrist discourse has a responsibility to explore and expose these structures, there is an element of concessionism in tethering all discourse to the role and place of the outside. To counter perpetually a centre is to recognise it. In other words discourse – our discourse – should begin to move in the direction of dismissing, at least in discursive terms, the concept of a centre, not by moving it, as Ngugi has suggested, but in superseding it. It is in this context that any meaningful discussion of modernity and "modernism" in Africa must be conducted, not in relation to the idea of an existing centre or a "Modernism" against which we must all read our bearings, but in recognition of the multiplicity and culture-specificity of modernisms and the plurality of centres. The history of development in African societies has metamorphosed quite considerably over the centuries, varying from the accounts of Arab scholars and adventurers as well as internal records of royalties and kingdoms, to the subversive colonialist narratives and anthropological mega-narratives. Recent times have witnessed revisions in earlier texts, and a growing willingness to admit the shortcomings of outsider narratives. Countering discourses

have replaced history, with all its inconsistencies and vulnerabilities, in the hands of each owning society, and shown how carefully we must tread.

III

It is equally in the above light that the concept of an African culture, or an Africanity, which is quite often taken for granted, is problematic. It seems to me that we cannot discuss an African modernity or "modernism" without agreeing first on either the fictiveness of "Africanity" or the imperative of a plurality of "modernisms" in Africa.

Of course one may well be wrong here. Yet it is to be recognised that, like Europe, the specificities of which are still in the making and the collective history of which does not date earlier than Napoleon – the idea of Rome and Greece is dishonest – Africa is a historical construct rather than a definitive. Many have argued, prominent among them the Afrocentrist school, the antiquity of a Black or African identity, an argument which falls flat upon examination. On the other hand, history reveals the necessity for such unifying narratives in the manufacture of cultures of affirmation and resistance. The danger in not recognising the essential fictiveness of such constructs, however, is that a certain fundamentalism, a mega-nationalism, emerges – all the more dangerous for its vagueness – which excises, elides, confiscates, imposes and distorts. Some will argue that history, after all, is perception, in other words, distortion. But if we were to accept this wholesale and without question, we would have no business trying to "correct" history, unless, also, to correct is merely to reconfigure, to counter-distort.

We already recognise the dangerous potential of such fictions in the hands of the invading outsider. The spate of pseudo-scholarly interest in "African" life, culture and art during and immediately after colonialism illustrates this. While in the beginning the totalising construct was employed to underline the peculiarity of the "savage" mind and thus justify outsider intervention, it has continued to be in use in justifying the changing face of that mission. From redeeming Christianity to salvage anthropology, it has remained essential to maintain this invention. Indeed, the need seems greater now than ever before as the collapse of colonialism and the rise of contesting discourses place anthropology, the handmaid of Empire, in danger. Anthropology's crisis of relevance, coupled with characteristic Western career opportunism, has necessitated the gradual re-invention of a singular and unique Africanity worthy of the Outside Gaze. The new manufacture finds ready clients in scholars, policy makers, non-governmental and aid organisations seeking objects of charity. Unless there is a singular Africanity, distinct and doomed, how else do we justify the pity which must put us ahead and on top? If the Other has no form, the One ceases to exist? It is for this reason that recent Outsider texts on African culture remain only extensions and mild revisions of existing fictions. To undermine the idea of The African is to exterminate a whole discursive and referential system and endanger whole agendas.

IV

The history, or histories, of what we severally refer to as "modern" or "contemporary" "African" art illustrates the above problems and dangers. From the point when it became acceptable to speak of a "history of contemporary African" art, attempts at this history have run into often unacknowledged tight corners by ducking into the safety of earlier fictions of "Africa". The most obvious manifestation of this is in the seeming racio-geographical delineation of the "African", which, we are often told, basically refers to sub-Saharan Africa. The obvious intent of this definition, of course, is to distinguish the African from the Arab, although the spacial boundaries specified by the register, sub-Saharan, effectively ridicule this intent. A less apparent intent, and indeed a more important one, is to place the Arab a notch above the "African" on the scale of cultural evolution.

It is sufficient not to question this intent here, but to point out that the signifying register proves grossly inadequate. Not only does it wholly ignore the impossibility of hard edges between cultures and societies in the region it describes, and the long history of Arab-Negro interaction, together with all the subtleties and undecidables of racial translations, indeed the impurity of designates, it equally ignores internal disparities within the so-called "African" cultures. To play on the surface, it is never quite clear where East Africa fits on this cultural map of Africa, given not only the territorial problems of locating Somalia below the Sahara, but also of eliding Zanzibar's long history of Arabisation. In a significant sense, then, the construction of a "sub-Saharan" Africa not only ignores geographical inconsistencies but equally ignores accepted discursive positions in the West which not only recognise the triumph of History as the Impure but underlie the construction of Europe.

We see double standards. But that is hardly the most important point. We also find that essential tendency to ignore indigenous historical perceptions and constructs. The Outsider, whether occidental scholarship or Diasporic Negro discourse, quickly established delineations without acknowledging the possibility that these may not be shared by those whose histories are at the centre of discourse.

On the other hand, what we see are not double standards at all but a consistent referent. For, when we examine the continual construction of Europe such discrepancies are equally apparent. The most interesting examples are the ready admission of Israel into Europe and the struggle to exclude Turkey. In other words, in the end, the use of the designate, "sub-Saharan" in the definition of the "African" is only a cheap ruse masking other, less innocent referents. The bottom is not only race, but history as well. History as vassal.

Needless to say, white people in South Africa, Asians in Uganda, as well as other diasporic populations and communities, fall outside of this definition. Cultural Africa, therefore, is no longer contained by that lame composite, sub-Saharan, which now needs a further qualifier: "excluding white [South] Africans". But then, how would the Outside justify the condescension toward Africans, or its employment of The

African in the satisfaction of its need for the exotic, if Arabs, with their "long history" of civilisation, or white [South] Africans were to be part of that construct?

On the political front, however, arguments have been stronger on the side of an all-embracing Africanity which supersedes disparities and differences and aspires towards the construction, not invention, of a new and credible Africanity. This is the position of Nkrumah's Pan-Africanism, and remains the ground argument of the Pan-African movement. Culturally, the argument is not only to recognise a plurality of Africanities but also aspire towards the active formulation of a singular African "identity", somewhat along the lines of Pan-Europeanism and the construction of the West. For Outsider cultural historians and culture brokers, however, such strategies must be reserved for Europe.

V

For the African cultural historian, the problems here are plenty. For instance, based on the above construction of Africa, it is increasingly fashionable to begin the history of "modern" or so-called contemporary art in Africa from the turn of the last century, that is, from the Nigerian painter Aina Onabolu. On the other hand, earlier practitioners of "modern" art exist in the Maghreb and Egypt, and strains of "modernism" are discernible in the art of white South Africans from earlier than Onabolu. Also, if "African" is a race-specific qualification, it would be proper to remember that artists of Negro descent were practising in the contemporary styles of their time in Europe and America much earlier than the turn of the century. Where then does one locate the break with the past which the idea of a "modernism" insinuates? In discussing "modern" African art, does one continue to exclude half the continent? Is it realistic, otherwise, to discuss a modern culture that defies existing invented boundaries? Are there grounds in the present, which did not exist in the past, to justify a unifying discourse, or is it safer to pursue a plurality of discourses? Along what specific lines must such discourses run? Or shall we merely conclude, like Anthony Appiah, on the fictiveness of a singular cultural identity?

VI

Several other problems and questions hinge on the above. If, after all, we reject the "sub-Saharan" qualifier, we effectively subvert a host of other qualifiers and paradigmatic premises. The "peculiarities" and particularities attributed to "sub-Saharan" art which in turn sustain temporal and formalistic categorisations become untenable. Such conveniences of Outsider scholarship as the "problems of transition" from the "traditional" or the "African" to the modern, or the question of Africa's "identity crisis" and concern over the endangerment of "authentic" African culture, all prove very

problematic indeed. If Africa is not some easily definable species or category that yields to anthropology's classifications and labels, neither are its cultural manifestations.

"Transition" from "antiquity" to the modern ceases to amaze and exoticise or evoke voyeuristic admiration or pity because antiquity ceases to exist. The supposed distress of Africans caught in a no-man's land between Europe and their "authentic" selves becomes a lot more difficult to locate or explicate. Ethnographic categories usually applied with ease to sequester "African" culture into temporal boxes are no longer easy to administer. What, for instance, would we qualify as "transitional" art in Egypt that we cannot locate in Spain? What is client-driven art within the minority community of South Africa? How easily would we lament the "corrosive influences" of Europe on the Somali of the Northern coast?

That is to pull one leg from the stool. In strict discursive terms, of course, none of the categories, delineations and constructs mentioned above has any relevance even within the context of a delimited "Africa", especially since none of them is ever applied in the description and study of Europe or the West. African scholars could have bought into any of them, and indeed still do, but that is hardly the issue. The point, instead, is that such constructs as sequester specific societies and cultures and not others emanate from less innocent structures of reference the briefs of which are to create foils and negations of the Occident. So we can speak about "transitional" art in Africa, and never in Europe. We may speak of "Township" art in Africa, or at times of "popular art", and these would connote different forms and manifestations from those in Europe. We may qualify nearly a century of artforms in Africa as "contemporary" while applying the same term to only a strain of current art and discourse in Europe. We may take modernism in Europe for granted and have great difficulty in finding the same in Africa. The assimilation of Outsider culture into European art is considered the most significant revolution of its time while the same is bemoaned in Africa as a sign of the disintegration and corrosion of the native by civilisation. Or, on the other hand, Africans are to be patted on the head for making a "successful transition" into modernity. Why, whoever thought they could emerge unscathed!

To discuss the "problems" of modernity and modernism in Africa is simply to buy into the existing structures of reference which not only peculiarise modernity in Africa but also forbode crisis. What needs to be done is to reject that peculiarisation and all those structures and ideational constructs that underlie it.

VII

To reject the exoticisation of Africa is to destroy an entire world-view carefully and painstakingly fabricated over several centuries. This is the imperative for any meaningful appreciation of culture in Africa today, and it would be unrealistic to expect it easily from those who invented the old Africa for their convenience. It dismisses an existing discourse and signifies a reclaiming process which leaves history and the

discursive territory to those who have the privileged knowledge and understanding of their societies to formulate and own discourse. This is not to suggest an exclusionist politic, but to reassert what is taken for granted by the West and terminate the ridiculous notion of the "intimate outsider" speaking for the native. It recognises that there is always an ongoing discourse and the contemplation of life and its socio-cultural manifestations is not dependent on self-appointed outsiders.

Otherisation is unavoidable, and for every One, the Other is the Heart of Darkness. The West is as much the Heart of Darkness to the Rest as the latter is to the West. Invention and contemplation of the Other is a continuous process evident in all cultures and societies. But in contemplating the Other, it is necessary to exhibit modesty and admit relative handicap since the peripheral location of the contemplator precludes a complete understanding. This ineluctability is the Darkness.

Modernity as a concept is not unique. Every new epoch is modern till it is superseded by another, and this is common to all societies. Modernity equally involves, quite inescapably, the appropriation and assimilation of novel elements. Often these are from the outside. In the past millennium the West has salvaged and scrounged from cultures far removed from the boundaries which it so desperately seeks to simulate. The notion of tradition, also, is not peculiar to any society or people, nor is the contest between the past and the present. To configure these as peculiar and curious is to be simpleminded. It is interesting, necessary even, to study and understand the details of each society's modernity, yet any such study must be free from the veils of Darkness to claim prime legitimacy. To valorise one's modernity while denying the imperative of transition in an Other is to denigrate and disparage.

The West may require an originary backwoods, the "Heart of Darkness" against which to gauge its progress. Contemporary discourse hardly proves to the contrary. However, such darkness is only a simulacrum, only a vision through our own dark glasses. In reality, there is always a lot of light in the "Heart of Darkness".

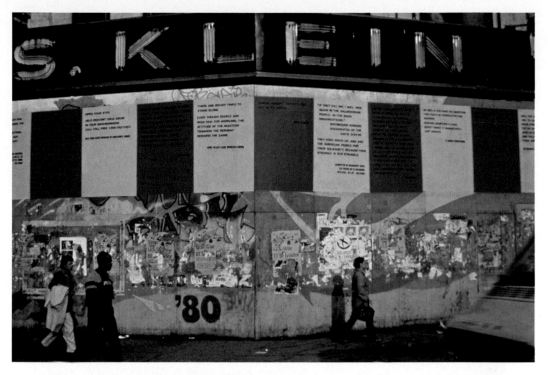

Plate 1 Group Material, *DaZiBaos*, 1982, poster project at Union Square, New York City. Photograph courtesy of Group Material; reprinted with permission of Doug Ashford.

Plate 2 Christian Philipp Müller, *Illegal Border Crossing Between Austria and Principality of Liechtenstein*, April 1993, performance view at border between Bangs, Austria and Ruggell, Liechtenstein, one of eight "border crossings" for the Austrian contribution to the Venice Biennale, 1993. Photo courtesy of American Fine Arts, New York.

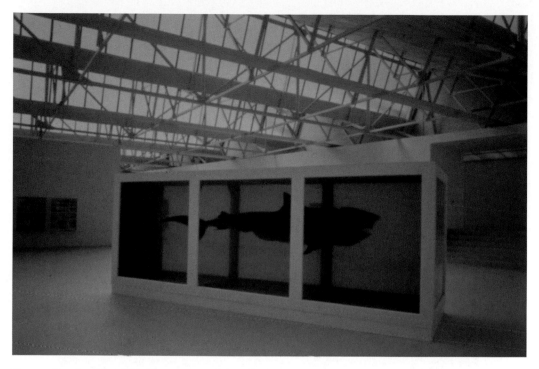

Plate 3 Damien Hirst, *The Physical Impossibility of Death in the Mind of Someone Living*, 1991, glass, steel, silicone, shark, and 5% formaldehyde solution, 84 × 252 × 84 in. (213.4 × 1333.5 × 213.4 cm). Copyright © Damien Hirst c/o Science Ltd. Courtesy Jay Jopling/White Cube (London). Photograph by Anthony Oliver.

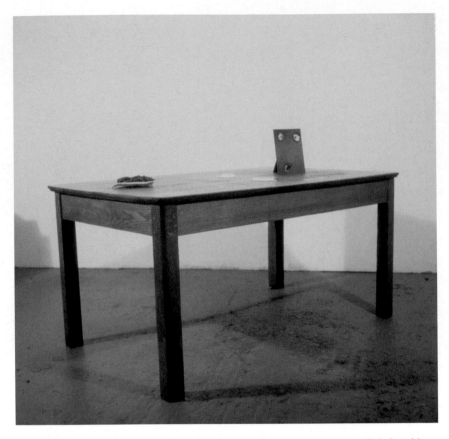

Plate 4 Sarah Lucas, *Two Fried Eggs and a Kebab*, 1992, photograph, eggs, kebab, table. Courtesy Barbara Gladstone.

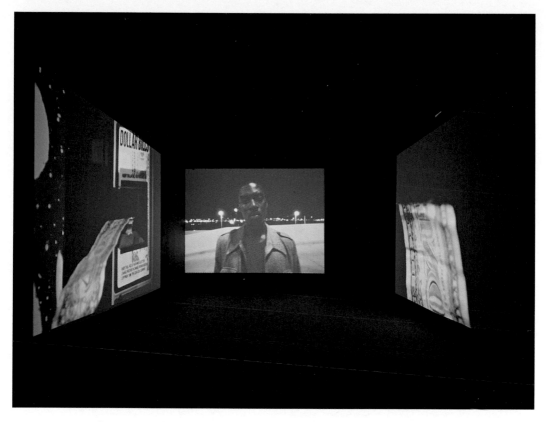

Plate 5 Doug Aitken, *Electric Earth*, 1999, installation view at Venice Biennale, 8-laserdisc installation, dimensions variable. Courtesy of 303 Gallery, New York; Galerie Hauser & Wirth & Presenhuber, Zurich; Victoria Miro Gallery, London.

Plate 6 Diana Thater, *Oo-Fifi: Five Days in Claude Monet's Garden*, 1992, 3-projector video installation at 1301, Santa Monica, California, August 1992: 3 video projectors; 1 laserdisc player; 1 laserdisc, film gels and existing architecture. Courtesy of the artist, 1301, Santa Monica and David Zwirner, New York.

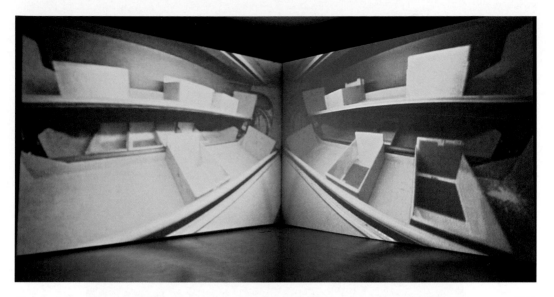

Plate 7 Jane and Louise Wilson, *Stasi City*, 1997. 4-channel video installation, 5-minute loop. Courtesy of 303 Gallery, New York.

Plate 8 ACT UP (Gran Fury), *Let the Record Show* . . . , 1987, installation view, New Museum Window on Broadway. Collection of the New Museum of Contemporary Art, New York.

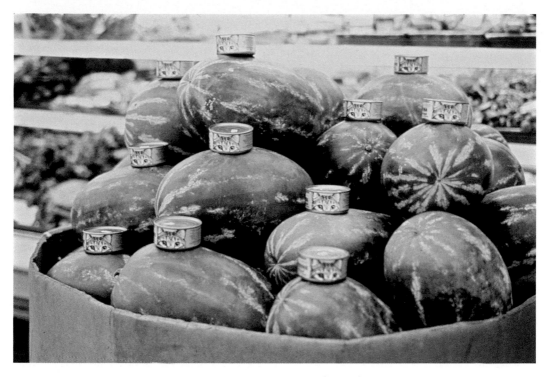

Plate 9 Gabriel Orozco, *Cats and Watermelons*, 1992, C-print, 21$^{1/2}$ × 27$^{3/4}$ in. (54.6 × 70.5 cm). Courtesy Marian Goodman Gallery, New York.

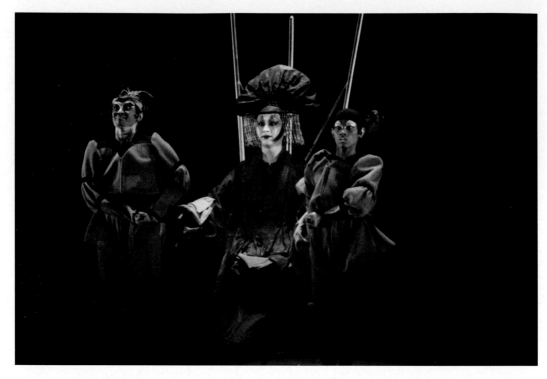

Plate 10 LEAR: A Japan Foundation Asia Center Production. Conceived and directed by ONG Keng Sen (Artistic Director, TheatreWorks (S) Ltd). Photo courtesy of TheatreWorks, 1998, Kallang Theatre, Singapore.

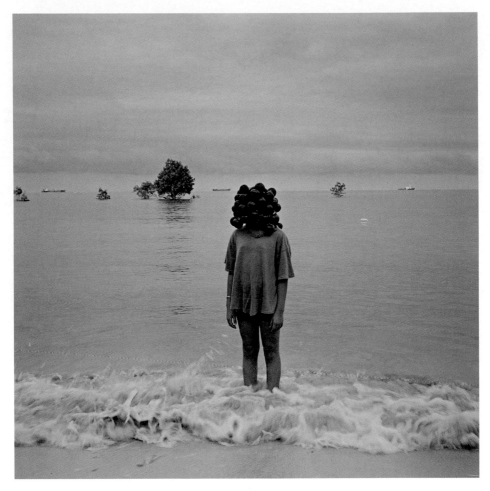

Plate 11 Simryn Gill, #1 from the series *A Small Town at the Turn of the Century*, 1999–2000, C-type print, 90 × 90 cm. Courtesy of the artist.

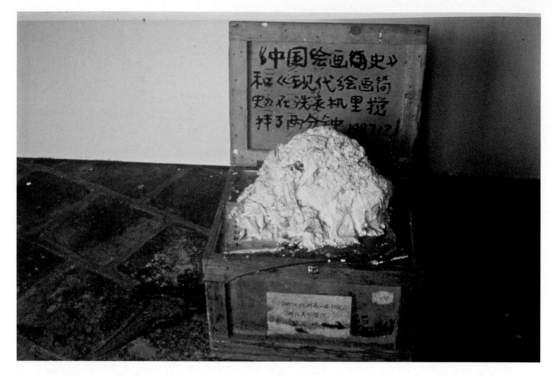

Plate 12 Huang Yong Ping, *"A History of Chinese Painting" and "A Concise History of Modern Painting"*
Washed in a Washing Machine for Two Minutes, 1987, installation view, paper pulp; approx. 31 × 20 × 20 in.
(80 × 50 × 50 cm); destroyed.

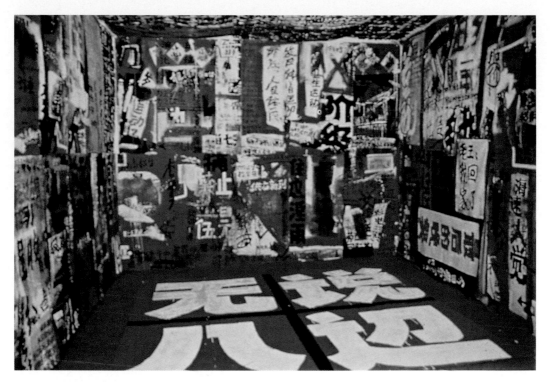

Plate 13 Wu Shan Zhuan, *Red Characters*, 1987.

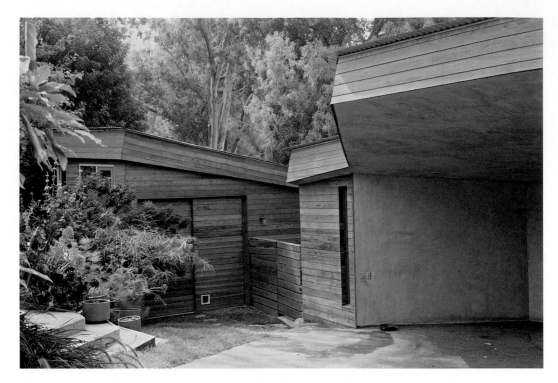

Plate 14　Jorge Pardo, *4166 Sea View Lane*, 1998. Photo by Simon Leung.

Plate 15 Cindy Sherman, *Untitled #175*, 1987. Courtesy of the artist and Metro Pictures.

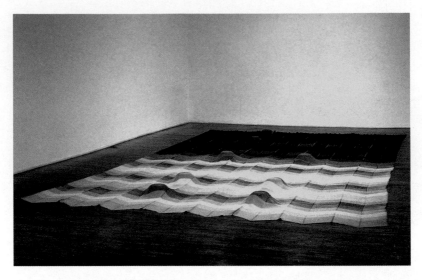

Plate 16 Mike Kelley, *Riddle of the Sphinx*, 1992. Courtesy of the artist and Metro Pictures.

19 The Syncretic Turn

Cross-Cultural Practices in the
Age of Multiculturalism

Jean Fisher

I n part, the trajectory of this inquiry has been prompted by two related "blindspots" in the debates on cultural identity and "multiculturalism" as they relate to the work of the black and non-European artist, both of which lead back to a question of the efficacy of art itself. The first involves the overall failure of "mainstream" art criticism and aesthetics to conceptualize art beyond the boundaries of Eurocentric aesthetic theories and their hierarchical value systems. A case in point was the posthumous retrospective of the Brazilian artist Hélio Oiticica at the Witte de With in Rotterdam in 1992. There, a European art critic was overheard commenting that Oiticica's work was "incoherent" since it covered a plurality of practices and thus "wasn't art" – a surprising assessment if only considering the protean neo-Duchampian/Dadaist gestures of the late 1960s and '70s, where Oiticica's work may be partly situated. Other critics recognized Oiticica's relation to conceptualism, but dismissed this as "inauthentic" – his practice was merely a reflection of Euroamerican tendencies and therefore wasn't authentically "Brazilian." That European critics, with little experience of other cultures, assume they are qualified to make such assertions is a problem yet to be addressed. Such attitudes are commonplace: on the one hand, the erection of an exoticizing/marginalizing screen through which the work of the non-European is "read," distracting attention away from its particular aesthetic concerns; and, on the other, an ignorance of the diversity of modernisms each inflected differently through the specific contexts of cultures outside the northern metropolises.

This is a slightly revised version of an essay that appeared in Lia Gangitano and Steven Nelson (eds.), *New Histories: The Institute of Contemporary Art* (Boston: The Institute, 1996), pp. 32–9. Reproduced with kind permission of ICA.

As it happens, Oiticica himself refused to call his work "art" for the very reason that the term is tainted with academicism. His project was to bring art out of the private domain of the studio into the public arena, using both local vernaculars and modernist languages, in the belief that the essence of art was not in creative genius or the unique object, but in the processes of thought and action – in invention, play, and transformation – in which both artist and viewer were participants. Of course, if one's idea of art was as the privileged bearer of some transcendental meaning, then Oiticica's work was *not* "art." We have here, then, two irreconcilable concepts of art: one, the academic museum object with strictly defined codes, and the other, a trans-formative and open-ended *process*.

The second "blindspot" involves the discussion of context itself. By the late 1970s, many art writers, myself included, impatient with the lack of intellectual rigor of art criticism and the narrow perspective of art history, began to adopt an interdisciplin-ary approach that extended outside the field of art. Aesthetic theory has been slow to radicalize itself relative to these other fields, such that questions of the aesthetic efficacy of a work have tended to be overshadowed by those of context – national or ethnic identity, sociopolitics, and so forth. I am not advocating a return to some hermetic formalist critique, but asking how we might more effectively understand the processes of art, especially where cross-cultural symbolic orders are employed, with-out making them a sub-category of, say, anthropology or sociology. Visual art remains a materially based process, functioning on the level of *affect*, not purely semiotics – i.e., a synaesthetic relation is established between work and viewer, which is *in excess of visuality*. It involves rather enigmatic sensations such as the vibrations of rhythm and spatiality, a sense of scale and volume, of touch and smell, of lightness, stillness, silence or noise, all of which resonate with the body and its reminiscences and oper-ate on the level of "sense" not "meaning." For such reasons alone the work of art cannot be grasped in reproduction. Whilst this is obvious to a practitioner, it is not always so for an anthropologist or literary theorist, for whom art is more a cultural product than a dynamic *process* or complex set of immanent and sensuous relations. If one adds to this the fact that work springs from an articulation between whatever minimal "codes" produce the recognition of a process or thing as "art," together with the particular psychosocial history of its maker, then ultimately the meaning of any artwork is not strictly determinable and is potentially as nuanced as the number of viewers who interact with it. Insofar as it draws on local vernaculars or experience, repetitions, the "grain of the voice," and the response of the receiver, art is closer to the *parole* of oral storytelling than most other visual or literary forms (it *is* difficult to avoid linguistic analogies!) Non-academic art is a speaking not an already spoken. In short, art criticism tends not to look at or address the experience of the work but at a commodifiable level of context.

This has deeply affected the relation between art from the black or non-European artist and the Western art system – its historiography, market, aesthetic, and critical values – where the greater the work's visibility in terms of racial or ethnic context, the less it is able to speak as an individual utterance. The galleries and museums have responded to the demand to end cultural marginality simply by exhibiting more

non-European artists, although on a selective and representative basis, provided that they demonstrate appropriate signs of cultural difference. This is to exoticize. Globe-trotting has become a popular curatorial pastime, resulting in "geo-ethnic entertain-ments" that maintain the unequal intellectual hierarchies between the art practices of the European and non-European, whilst also masking their unequal economic and power relations. Above all, they evade the complex negotiations that must take place between European aesthetic languages and those of the rest of the world. For the West to frame and evaluate all cultural productions through its own criteria and stereotypes of otherness is to reduce them to a spectacle of essentialist racial or ethnic typology and to ignore their *individual insights and human values* – a treatment not meted out to the work of white European artists.

Thus, one side of the problem has been institutional – a conservatism of tradi-tional Western critical and curatorial practices that have assumed the universality of their own criteria, that any form of making can be translated unproblematically into Western terms of reference, and that any work incorporating cross-cultural codes is *ipso facto* "inauthentic" and inferior to a "pure" cultural identity (the "blind spot" of Magiciens de la terre in 1989). What is valued by art institutions becomes national patrimony, which in turn is intimately tied to myths of an idealized national identity, not only on the level of assumed ethnic characteristics but also through a consensus of what constitutes a sophisticated internationalism (one which pertains throughout the élite of Lagos and São Paulo as well as London and Paris). But the internation-alism in question is also Eurocentric – a universalist language of value judgments. Until this is broken down, and Western culture accepts itself as a *parochialism* amongst many others, then we cannot have a true multiculturalism in which all perspectives have equal value.

At the same time, for reasons of artistic and economic survival, black and non-European artists have had to acquiesce to promotion through the commodified signs of ethnicity, which renders them complicit with the Western desire for the exotic other, against which it can measure its own superiority. The exoticized artist is marked not as a thinking subject and individual innovator in his and her own right, but as a bearer of prescribed and homogenized cultural signs and meanings. To be locked into the frame of ethnicity is also to be locked *out* of a rigorous philosophical and historical debate that risks crippling the work's intellectual development and exclud-ing it from the global circuit of ideas where it rightfully belongs. But the problem remains how *to create a place* from which it is possible to speak and to be heard without compromising one's life experience whatever its source(s).

A rather perverse turn of thought is required that reconceptualizes cultural mar-ginality no longer as a problem of invisibility but one of an excessive *visibility* in terms of a reading of cultural difference that is too readily marketable. This also relates to the tendency in colonial thought to equate what is visually verifiable with "truth," where superficial characteristics reflect the inner truth of being. The fact that black and non-European artists are still "expected" to produce either "ethnic" or "political" art, whilst other positions are tacitly ignored, suggests that "visibility" alone has not been adequate to provide the conditions for an independent speaking subject. Aside

from the problem of institutional "indifference," we might also look at the strategies of art practice itself.

Much art of the late 1970s and '80s with a deliberate gender, sex, or racial political agenda coming from within the Western system focused on *visibility* in the form of autobiography: a "bearing witness" to an individual experience of the world to point out that the official version of reality was *not universal*. At the time this strategy had legitimacy, since, within the master narratives of Western art, other realities were excluded and this needed to be debated. However, the autobiographical in itself is no guarantee of an "authentic voice," much less a critique of the determinations of the symbolic order, since the self is inescapably social in its formation. However, if there was no essential, "authentic" self, then, as has often been said, what was already a construct could be reconstructed to self-determinable ends.

Promotion through a politics of racial difference during the early 1980s, inspired in Britain by the frustration of a young generation of black artists emerging from art schools into an art system from which they were excluded, had limited success; a deliberately provocative tactic of cultural essentialism helped to force cultural studies onto the academic map and siphoned some institutional money toward so-called "ethnic arts," galleries, and magazines. However, these strategies have also been counter-productive *for art*; where the work has been incorporated exclusively into identity politics, it has tended to become a sub-category of sociology or anthropology, diminishing its aesthetic or critical efficacy. Where art takes up an essentialist position – even if this is a masquerading tactic – it risks becoming excluded by the exclusion-ary politics it proffers, addressing a limited constituency which cannot alone sustain an adequate production or promotional support system. An absurd situation arises in which black artists are expected to make art only about "black" issues – as if, for instance, racism was not a subject for representation in dominant white culture. Moreover, these issues are already institutionalized in the rhetoric of the mass media, and hence "containable."

The problem of identity debated through the conventionally circulating signs of "otherness" creates a visibility that is measurable, thereby foreclosing that enigmatic space in which the coherence of my selfhood could be challenged, or different and common realities imagined. The value of such work was that it reclaimed art from its entrapment in the ahistorical space of formalism and gave back historical and geo-graphic specificity; its failure rested in its inability to enter a more philosophical and aesthetic debate that would interrogate the deep structures of our relations to reality. Perhaps, one needs to think of cultural expression not on the level of the sign but in terms of concept and deep structure: to consider the work's internal rationale and what governs the aesthetic choices an artist might make about materials and process, and, in particular, like Hélio Oiticica, to pay attention to the *structures of reception* – the work's psychosomatic relation with the viewer. Artworks from symbolic systems alien to our own *do* have an effect on us, but we will not mutually benefit from such encounters if we allow the prescribed screens of ethnicity or anthropology to inter-pret aesthetic experience for us.

Over the past few years, the most popularly cited model of cross-cultural expression has been Homi Bhabha's notion of hybridity.[1] On the face of it, this seems a useful model (if it is also possible to imagine that somewhere in this alienating world a human being exists in a "non-hybrid" state). Sarat Maharaj points out, however, that in its popularity hybridity risks becoming an essentialist opposite to the now denigrated "cultural purity."[2] Hybridity is, moreover, a term still fraught with connotations of origins and redemption: two discrete entities combine to produce a third that is capable of resolving its "parental" contradictions. Hybridity, however, in this schema does not extricate us from a self/other dualism and the implication of loss and redemption in the formation of the third term.

In looking for a way out of such reductionism, Marcos Becquer and José Gatti proposed that we reconsider the notion of syncretism, which is not synonymous with hybridity.[3] They argue that syncretism has the advantage of implying not fixed elements but a contingent affiliation of disparate terms capable of shifting positions or altering relations depending on circumstances, and whose boundaries are permeable. They also argue that the term be re-politicized from its de-politicized passage through religious discourse, as a way to think through the possibility of individual agency. In any case, conceived as a dynamic process, syncretism allows that between disparate factors there is no simple translation, but an element of untranslatability, which is a potential space of productive renewal.

It is difficult to make a clear distinction between hybridity and syncretism in a work of art; but I want to offer one in a rather anecdotal way. The Mexican film of 1992, *Nuevo mundo*, concerned the miraculous appearance of the Virgin of Guadalupe in sixteenth-century Mexico, proposing, somewhat heretically, that it was the Catholic Church itself that invented her out of political expediency. The bishop discovers Aztec "idols" hidden behind the images of Catholic saints in the church, assuming that his Indians had not, after all, been converted. His interrogations fail to produce a culprit. The clergy, abstaining from punishing the Indians for fear of another uprising, hit on a compromise: the Catholic icon-maker was to paint an image of the Madonna using an Indian model, take it secretly to the shrine of Tonanzin, the Aztec "earth mother," and then claim that he had painted it from a vision. In fact, the "Indianized" Virgin did serve to pacify some of the unrest amongst the colonized Mexicans and Spanish colonials fretting about their forced allegiances to Spain: Guadalupe was a Mexican-born symbol with which all could identify, and as such, redemptive. It was, nonetheless, a "hybrid" manufactured (in this account) by the Church and seamlessly translated into Christian orthodoxy as if Tonanzin's identity had been absorbed by the Virgin. What remains syncretic in this tale, however, is the tactic of the Indian painter, who was indeed the maker of both Aztec and Catholic icons, and whose masquerading shrines – a doubled system – gave the Indians a spiritual choice.

The Americas as well as Africa are replete with such examples in which resistance to the aggressively imposed culture takes the form of a conscious but concealed masquerade, where the alien sign is used to disguise the meaning of the repressed

referent, or where only those signs whose meanings can be remotivated to the subordinated symbolic order are adopted. It may look like ambivalence from the "outside," but it is a subversive statement for those on the "inside." Such tactics do not necessarily produce a loss of cultural meaning, but an *elaboration*; the repressed elements survive in some form within the interstices of the institutionalized language, contaminating it with a pulsion or murmur always ready to destabilize its syntactical and semantic fields, and hence, its established meanings.

Without substituting one imperfect cultural model for another, we can begin to speculate that whereas hybridity hinges on the visibility of a sign that seeks to establish itself and attempt to resolve ambiguity, syncretism is concerned with constantly mobile relations that operate on the structure of languages and at the level of *performance*.

Art practice that seeks a place from which to speak and be heard almost inevitably means dissenting from the prevailing institutionalized language. The issue at stake is the structure of spectatorship – the mode of address by which art seeks a rapport with its audience. Where radicality is assumed to lie simply in the "message," we are in the territory of already circulating signs and meanings, of "information," of the language of the already known (even if unacknowledged) together with its attendant value judgments, which does not open a new space of the imagination. To produce the latter means finding a way of speaking that cannot lie only in the common patterns of signification, but in attending to how the receiver inhabits language itself.

Here I should like to touch on the work of three artists, Jimmie Durham, Gabriel Orozco, and Santi Quesada, who live and work among a plurality of cultural signs. Durham recognized that it was precisely the commodified forms of language that somehow needed to be challenged. He played a number of rhetorical strategies throughout the 1980s, one of which was to parody the metalanguage of ethnography – a Western academic discipline historically complicit with the repression of native American cultures – exemplified by the installation of *faux*-ethnographic artifacts, *On Loan from the Museum of the American Indian*, 1985. While the work satisfied a notion that the "othered" artist might speak through disguise or masquerade, as Durham himself realized, it was still too dependent for effect on visible signs of otherness, even if these were reflections of Eurocentric stereotypes. The same problem was inherent in his attempts at undermining Western aesthetics through a strategy of neo-primitivism – playing the *idiot sauvage*, or expressing a child-like incompetence, as in the series of drawings on Caliban's struggle with the identity imposed by Prospero. For Durham, the neo-primitivist aspect of the work was ultimately too appealing to a white audience seeking a redemptive pre-industrial utopia.

Durham has played out the problem of cultural identity to its limits as an infinite mirroring of selves and others, multiplying and inverting expected identities, all of which pointed out the fundamental *inauthenticity* of any identity. The sign as standing in for or representing what is crucially absent or an imaginary phantasm can be nothing but inauthentic. *Not Lothar Baumgarten's Cherokee* presented the incommensurability between the phantasmic self and other through the juxtaposition of two marginalized languages, Finnish and Cherokee. It signaled a space of untranslatability

Figure 19.1 Jimmie Durham, *Untitled*, 1992. Pencil on paper (22 × 15 in.) from a series of 14 drawings, JD65(f). Private collection, Belgium. Photo courtesy Nicole Klagsbrun Gallery, New York.

that refused to allow us to map ourselves as coherent subjects of knowledge, exposing our own otherness or discontinuity within Durham's discursive field. At base, Durham's work is less about "cultural identity" than about effects of language, shifting the debate from the all-too-visible exotic and therefore silenced body to the speaking body.

Gabriel Orozco made a virtue out of near invisibility and transience in much of his work of the early 1990s. His materials have included dust, a trace of breath on a piano, consumer items rearranged in a supermarket, or sand balls camouflaged in rocks. The work emerges out of a pre-given substratum that one might imagine as either an effect of a viral contamination or the logical effect of energy on matter – art *is* nothing if not the mutual articulation of thought, matter, and body. And this is

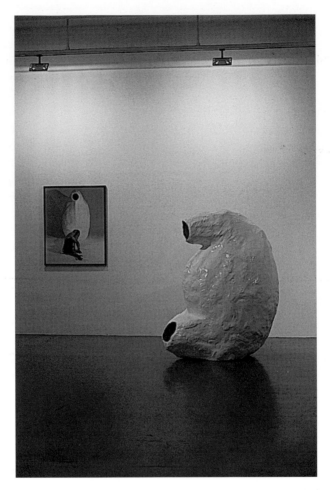

Figure 19.2 Santi Quesada, *Three Faces and One Ideology*, 1996. B/w photo (100 × 80 cm) and polyester sculpture (163 × 135 × 110 cm). Courtesy of the artist.

what is expressed in *Mis manos son mi corazón*, 1990: a lump of brick clay squeezed in the hands and fired to produce a bony heart. It figures the process of art-making, as well as the ossification of the over-worn bleeding heart symbol of Mexico. The process of recycling, or remotivation of signs, alludes moreover to culture's processes of return and transformation, and to the salvaging practices in countries where waste and shit are part of the life process [see plate 9].

That culture is a process of renewal, transformed through imaginative work, individual and collective, on language, is central to the work of Santi Quesada, an artist who relocated from Cuba to Britain, from Spanish to English. An early painting shows two figures sitting on a beach, an overload of lines drawn into the paint making uncertain their boundaries. A third, stick-like figure emerges energetically between them disturbing their tranquillity with an invective of neologisms.

What these and other structural maneuvers suggest is an understanding of existence not through the objective world in itself but in the sometimes obscured structures of its relations – in the transactions and transformative processes that ensue from our encounters between things and people, or from the continuous recycling of shit and waste into new products – a metaphor for the continuous reinvention of language from common resources. This imagination that seeks a syncretic solution without the signs of otherness produces chimeras, as in *Fourteen Drawings and One Ideology*, 1995: drawn and sculptural forms that derive from the artist's invention of an "*ur*-figure" that could stand for the multidirectional potency of life. Or the forms may allude to the circuit of life, death, and resurrection. The related *Three Faces and One Ideology*, 1996, in which a syntactical relation is made between the image of the artist photographed "emerging" from the object together with the sculpture itself, would seem to figure the concept of death and resurrection in language itself. The object, primordial and not-yet-codifiable, itself inhabits that space between potentiality and realization, realized, ultimately, through the viewer's imaginative intervention: identity born of the syncretic imagination may follow many pathways.

This site of the as-yet-unnameable provides no privileged locus in terms of origin or destination and hence no "authentic" or visible identity by which to trap the subject. It is the "no-place" where language falters, where it exposes its own indeterminacy, and therefore is the space of *trans-action* from which one can begin again, in the spirit of Hélio Oiticica, the collaborative work of aesthetic invention, play, and transformation.

Notes

1 For his discussion of hybridity, see Homi Bhabha, "Signs Taken for Wonders: Questions of Ambivalence and Authority Under a Tree Outside Delhi, May 1817," in *"Race," Writing and Difference*, ed. Henry Louis Gates, Jr. (Chicago: The University of Chicago Press, 1986), pp. 163–84.

2 Sarat Maharaj, "Perfidious Fidelity: The Untranslatability of the Other," in *Global Visions: Towards a New Internationalism in the Visual Arts*, ed. J. Fisher (London: inIVA and Kala Press, 1994), pp. 28–35.

3 Marcos Becquer and José Gatti, "Elements of Vogue," *Third Text* 16/17 (1991): 65–81.

20 Authenticity, Reflexivity, and Spectacle

Or, the Rise of New Asia is not the End of the World

Lee Weng Choy

Channel NewsAsia

C hannel NewsAsia (CNA) – the Singapore television station with ambitions of becoming the CNN for "Asia" – is, like any other big business, predicated on manufacturing an endless stream of promotional images of itself. If, to paraphrase Guy Debord, the business of business really is the production of spectacles, it's also worth noting that a central preoccupation of management today is "branding" – which entails, among other things, the rationalization of this unbridled output. (And could there be a nation more well "branded" as a model of economic success than Singapore?) Without presuming to know the job of the well-paid corporate consultant, I'd like to encapsulate CNA by selecting a few images that are especially revealing of the desires of this government-controlled enterprise.[1]

At the launch of its international telecast, CEO Shaun Seow said: "We offer more airtime on Asia than any other channel. Through our unique offering of global and regional news from an Asian standpoint, we enable viewers to form their own perspectives and obtain a deeper understanding of current developments, and the impact on their lives."[2] This Asian-news-by-Asian-reporters-for-Asian-viewers branding-*cum*-ideology was absurdly epitomized by the following commercial: a picture frame hovers over a blank white screen, inside which flash different images of "exotic" Asian women, such as the Padong of Burma who wear brass rings around their necks.

This is a shortened version of an essay published in Joan Kee (ed.), *Inhabiting the Intersection: New Issues in Contemporary Asian Visual Art*, a special issue of *Positions: East Asia Cultures Critique* 12, 1 (Durham: Duke University Press, 2004). Reproduced with kind permission of Duke University Press. All rights reserved.

The tag-line? "It takes one to know one." Then there are two minimalist advertise-ments for the website; each stages a simple action rendered in slow motion, set against a black background. One ad begins with a close-up on a black leather gloved hand cocking a pistol. The pistol fires; the camera zooms out. As the bullet emerges, a white line of text appears above the pistol: "Violence breaks out in an Asian city." The bullet traces a straight line, then stops in its tracks: "Violence reported." The promo cuts to the tag-line, "real-time online," and concludes with an image of the logo and a soundbite of a scream. In the other ad, the object is a metal bucket, and water gets thrown: "An Asian country hit by floods"; "Floods reported"; soundbite of "hordes" drowning.

It's not just the vacuous orientalizing gaze of Asian elites directed at a "primitive" and "chaotic" Asia that makes these commercials obscene, the blatant trivializing of violence as "infotainment," or the lust for instantaneity.[3] Nor is it the total stylization and fetishization, the complete spectacularization of violence and power that is so vulgar. These commercials are exemplary of the covert spectacle[4] of late capitalist society, this time laid bare in Asian cultural essentialism. The ascendancy of Channel NewsAsia conflates with the desire for *New Asia*'s arrival, and this, moreover, is signified, made metaphorical, through the appropriation of "real time."

The Seduction of *Telos*

"Anecdote," Benjamin writes in the *Arcades Project*,

> brings things closer to us in space, allows them to enter into our lives. Anecdote represents the extreme opposite of history – which demands an "empathy" that renders everything abstract. Empathy amounts to the same thing as reading newspapers. The true method of making things present is: to imagine them in our space (and not to imagine ourselves in their space).[5]

To empathize, that is, to imagine ourselves in an Other's space, is, at some level, to colonize that Other space. What Benjamin seeks is the opposite: to let the Other inhabit "our" space and open it up. He opposes the prevailing view of history which presumes a cumulative and progressive narrative, where time flows continuously from past to future. For Benjamin, anecdote lays bare the writing of history as a reconstruction, not of the past, but of a present;[6] it is the making of montage, where any moment may be juxtaposed, made suddenly *adjacent* with another.

Much as I am attracted to Benjamin's alternative historiography, the story of contemporary art and Singapore I want to tell is still conjoined with the overpower-ing idea of progress, an idea embedded in my subtitle. So what do I mean by say-ing that the rise of "New Asia" is not the end of the world? I am referring to a thesis that various commentators on Singapore, myself included, have articulated in some shape or form:[7] Singapore is *Sign-apore*, a society of the spectacle par excellence, the

all-appropriating agent, modernity's idealized tabula rasa. Singapore imagines itself not just as taking the best from the East and the West – the inheritor of the great traditions and the latest technologies – but, by offering itself as the paradigm of "New Asia,"[8] Singapore stakes a claim as part of the avant-garde of the next stage of global capitalism. This image, Ray Langenbach has pointed out, is a seductive one: "your argument not only lays out 'appropriation' as Singapore, but your own [desire] . . . and other people's [desire] to appropriate Singapore. . . . Singapore remains the place that everyone believes can be defined, described, nutshelled, reduced, objectified."[9] My subtitle then is a slight self-parody, of being seduced by my own theorization/ critique of Singapore/New Asia as the *telos* of capitalism. To read Singapore as exemplary is a tendency that I want to unpack, but at the same time indulge. For to tell a story about Singapore *art* without engaging the idea of *Singapore*, and the ideas of the Singapore *state*, seems untenable, given that global capitalism and the state are so predominant in all aspects of life here. Therefore, what I will attempt is to read the metonymic tensions in "Singapore *art*," "*Singapore*," and the "Singapore *state*."

There are other axes of tensions I want to read: between different "ends" and "nows." For Arthur Danto, what exemplifies contemporary art is its radical plurality. Anything can be, and does, get cited and re-sited as art. If art is *now* no longer framed by notions of advance or progress, then a certain history of art has come to an *end*; hence his notion of the "End of Art."[10] "We" – a radically inclusive "we," if this pluralism is indeed *radical* – are, as Danto puts it, in a *post*-historical phase. And if I offer "Singapore" as exemplary of this "post" of endless sighting, citing, and siting, it is because the contradictory cultural logics of Singapore are revealing of a fundamental *crisis*, if that's not too strong a word, in contemporary art. Singapore appropriates plurally and radically; it is totally committed to progress and an Asian essentialism that has less to do with advocating cultural diversity than with disciplining its society to be economically competitive. The question is: can Danto's "end/post" accommodate a theory and practice of art that is a critique of what, for the sake of a short hand, is called the "society of the spectacle"?

If my subtitle suggests progress, it also alludes to its apparent opposite. The "end" not only signifies *telos*, but also signals "catastrophe." What if all of "Asia" were to become as "developed" as Singapore, wouldn't the demands on our ecology be unsustainable?[11] For Benjamin, the catastrophe is not what is to come, but what is happening now;[12] it is because modern society is predicated on a particular kind of progress that there is crisis. In contrast, for Francis Fukuyama, whose *The End of History and the Last Man*[13] is ineluctably invoked by my subtitle, that "the end is now" is the good news. "We" – an essentially exclusive "we" – have arrived; free-market capitalism has triumphed. Then again, for someone who lived through the 1950s and 1960s in France, when eschatological themes were the "daily bread" of the times, Fukuyama's discourse "looks most often like a tiresome anachronism." In "Specters of Marx," Jacques Derrida maintains that Fukuyama's arrival has not, and cannot, quite arrive: "those who abandon themselves to that discourse with the jubilation of youthful enthusiasm, they look like latecomers, a little as if it were possible still to take the last train after the last train – and still be late to an end of history."[14]

Derrida opens his essay with an epigraph from *Hamlet*: "The time is out of joint." In a very different context, at a conference held in Singapore called "We Asians: Between Past and Future," Dipesh Chakrabarty evokes this same theme: "that is my argument about the plurality of the times – that the time is not one. Derrida's argument is that the present is discontinuous with itself."[15] However, as I have argued elsewhere, Singapore is the one place I know where the present feels *almost* entirely continuous with itself. Whenever I visit other places, my experience is of multiple times; there are always neighborhoods that seem significantly unchanged. In Singapore there appears to be only one time – a peculiar present, in a hurry, on the verge of tomorrow. Life may be more hectic elsewhere, in Hong Kong or New York, but I know of no other place where it feels like everyone marches in the same step. Practically everything here is subjected to economic development – hills have been flattened, cemeteries unearthed. The pace, while not the fastest on the planet, is possibly the most persistent. This relentless present is of course not entirely omnipresent; if it were, then this truly would be utopia. But in Singapore it is an intensely pervasive and spectacularized ideal. As insinuated in my anecdote about Channel NewsAsia, *now* is the time of New Asia. But what is this *now*? It is not quite the "present" itself. It is the obverse of Benjamin's catastrophe.[16] Facing forward, it is what's *next*, the near future; indeed, there is something spectral about it. On the one hand, Derrida says: "the specter is the future, it is always to come, it presents itself only as that which could come or come back"; on the other hand, "[i]f there is something like spectrality, there are reasons to doubt this reassuring order of presents and, especially, the border between the present . . . and everything that can be opposed to it: absence, non-presence . . . or even simulacrum in general."[17] The specter of New Asia, then, is *only on the one hand* the *next* revision of the triumphalism of free-market capitalism that Fukuyama puts forth as gospel in his *End of History*.

In his criticism of Fukuyama, Derrida insists on remembering inheritances and debts: "An inheritance is always the reaffirmation of a debt, but a critical, selective, and filtering reaffirmation. . . . Deconstruction has never had any sense or interest, in my view at least, except as a radicalization, which is to say also *in the tradition* of a certain Marxism, in a certain *spirit* of Marxism."[18] But why only now, in the face of a simultaneously celebratory and pathological discourse like Fukuyama's, has Derrida decided to articulate a debt to Marx? Is he not also a latecomer of sorts? Deconstruction has been often criticized as being apolitical or even reactionary. Many of these criticisms, I would argue, have more to do with failed encounter than with a convincing critique of deconstruction.[19] While my purpose here is not to debate deconstruction, this question of its politics intersects with the question that haunts my text: how to theorize and practice, in art, a critique of the spectacle?

There is another, particularly literal debt that Derrida cites: "all the questions concerning democracy, the universal discourse on human rights, the future of humanity, and so forth, will give rise only to formal, right-thinking, and hypocritical alibis as long as the 'foreign debt' has not been treated head-on."[20] Singapore Senior Minister Lee Kuan Yew has rather different opinions about colonial legacies and foreign debts. In a *New York Times* interview reported in the local press:

Mr Lee said that writing off or reducing the debt of developing nations . . . may only make nations look perennially uncreditworthy and unattractive to investors. Too many Third-World leaders, Mr Lee said, had bought into fashionable theories of development that were more political than pragmatic. . . . "Somebody like Nelson Mandela should show the other way, and say . . . 'Look, let's work with the people who have oppressed us.' We need them, they need us. Without them, who's going to run all these huge, intricate corporations? But that takes courage and character, and there are not very many Nelson Mandelas."[21]

If we hear Lee, the specter of New Asia, *on the other hand*, is still embedded in a *not-yet-now* thinking. At the "We Asians" conference Chakrabarty spoke of the "Not Yet" version of history: "the classic exposition of this in the 19th century was in John Stuart Mill's writings. . . . [T]he argument that Mill deploys in favor of denying Africans, Indians, or other 'rude' nations of the world self-government, which he otherwise extolled as the highest form of government, is the fact that they are 'Not Yet' ready for it."[22] But since when has "readiness" ever been *the* criterion for self-determination? It seems that Lee every now and then conveniently forgets that Singapore was, in his own estimation, "not yet" ready for independence when it nevertheless came.[23]

There is something not yet made explicit enough in the discussion above – the specters of Debord. In his critique of late capitalism, his analysis of "time" is *fundamental*: "The spectacle, being the reigning social organization of a paralyzed history, of a paralyzed memory . . . is in effect a *false consciousness of time*."[24] What makes his critique especially pertinent is that it is precariously positioned at the very edge of the possibility of the end of history: capitalism's seemingly last stage of virtualization. While Debord's moment was historically singular – the situation of France in the 1960s – it is also reiterable, available to Singapore now because ours is a moment which, in its claims to be the *next* stage of capitalism, in its reiteration of eschatological themes, further exemplifies the spectacle – in Anselm Jappe's words – as "the reign of an eternal present that claims to be history's last word."[25]

So, having set the scene of a double seduction (Singapore is seduced by a certain *telos*, and the theorization of Singapore as *telos* is itself another seduction), having conjured many "ends" and "nows," and placed into sudden adjacency such different discourses – now what? While I've started unpacking my subtitle, what about the title? How are "authenticity," "reflexivity," and "spectacle" related to each other and to Singapore? What I will attempt next is to pursue these questions in the field of contemporary art.

Art as Late

In Debord's analysis, art and culture represent "the meaning of an insufficiently meaningful world"; art *"always came on the scene too late, speaking to others of what*

had been experienced without any real dialogue. . . . The greatness of art makes its appearance only as dusk begins to fall over life."[26] The proliferation of art that is "explicitly presented as a moment of authentic life whose cyclical return we are supposed to look forward to" – and in advanced consumerist societies some of the most popular art is, unsurprisingly, that which rails against consumerism – what these "special moments" turn out to be is "merely a life more *authentically spectacular*."[27] For Debord, the function of the spectacle is "*to bury history in culture*."[28]

Again, it is tempting to offer Singapore as exemplary of these theses: the state's self-orientalizing "Asian Values" have been highly effective at "define and rule" and extending the colonial legacy's disciplinary technologies precisely because of its *claims to authenticity*.[29] Moreover, since the 1990s, the state has endeavored to subsume the very terms of "art" and "culture" in the service of capitalism. What's next for Singapore is to become a "Renaissance City." Art and culture are coveted, but only now, in the "last phase" of national development, in order to fully arrive as a "world class" society with all the trappings of "gracious living,"[30] and to generate a creative workforce that can compete in the top tier of the global knowledge-based economy.

Perhaps more than any other arts group, TheatreWorks represents the complexities of the Singapore desire for arrival in the international arts scene. In 1996, TheatreWorks inaugurated *The Flying Circus Project* (FCP), a biennial intercultural workshop. *Lear*, one of the most widely discussed artistic productions from Singapore,[31] developed from this first FCP [see plate 10]. Funded by the Japan Foundation Asia Center, it premiered in Tokyo in 1997, and has played to the international theater circuit, including Singapore. Nominally based on Shakespeare's tragedy, *Lear* was conceived and directed by TheatreWorks's Ong Keng Sen, with an entirely new script by Japanese playwright Rio Kishida, and an all-Asian cast, many of whom played their roles in the different Asian performance languages and traditions in which they were trained. Lear, simply named the "old man" in the script, was played by a Japanese *Noh* performer, the "elder daughter" by a Beijing opera performer, the "younger daughter" by a Thai *Khon* court-dancer, and the king's retainers by dancers versed in the Indonesian martial art of *Silat*. "Contemporary" Singapore performers played the "shadows," and a contemporary Japanese performer played Lear's fool. In Ong's version, the text, plot and personages are so minimalized that *Lear* effectively unfolds as a series of juxtapositions of images and oppositions – of good and silent younger daughter versus scheming and shrill elder daughter, or patriarchal old man versus next-generation female usurper.

In a documentary on the third FCP,[32] a participant talked about how wonderful it is to have an "Asia-for-Asians" intercultural workshop, contrasting this with the old days when the only intercultural frameworks were Western-based and predicated on power – as if Japan, China, and Singapore do not exercise their power in Asia. This is not to say that interculturalism in Asia has no place in global cultural politics; Rustom Bharucha, for instance, eloquently articulates his commitments to intercultural theater.[33] But when it comes to *Lear*, Bharucha is critical of Ong's unequivocal "surrender to spectacle":

Instead of problematizing the two primary principles of his intercultural aesthetics – "juxtaposition" and "rupture" – he illustrates them relentlessly, building one image after another. This spectacle is a victim of time in its metronomic precision and carefully calculated speed. It is almost as if the production is running a race with itself. It refuses to rest till it gets to the end. Consistently mercurial, and therefore predictable, its impact also results in an impasse, which bears some resemblance to what Guy Debord has described as the spectacle's "essential character" – "a negation of life that has *invented a visual form for itself*."[34]

For Lucy Davis, this project which "set out to reflexively present a nuanced 'for Asians by Asians' representation of an intercultural New Asia" *illustrates* "the complexities of formulating resistances within a culturalist discursive order – *Lear* illustrates the difficulties of attempting to critique late capitalist culturalisms without reproducing their very spectacular logic."[35] In my own reading here, I want to go further and offer *Lear* as *exemplary*, to employ that term one last time, not only of Davis's problematic, but of *Singapore* and Singapore *art* as well. Ong, in Davis's analysis, responds to hegemonic Western representations of Asia by insisting on maintaining Asian differences. He rejects the universalist interculturalism of Peter Brook, whom, he contends, "demands that performers 'strip' their 'own' culturally-specific performance techniques in search for a basic universal human theater language."[36] At the same time, he refuses the dichotomy of Europe-America equals modernity and Asia equals static authentic tradition. *Lear* is an attempt to advance "New Asia" as contemporary; as Ong says, "I have consciously avoided a search for authentic tradition in this production."[37] Indeed, those familiar with the forms that he orchestrates in *Lear* will recognize improvisations and innovations. But, as Davis astutely points out, this disavowal of traditional authenticity is displaced by an essentialism of the "new": Ong claims to represent the new young Asian artist exploring his roots and identity through Western and Asian perspectives.

While Ong's strategic Asian essentialism may ostensibly be articulated as a critique of Western cultural hegemony, *Lear* reproduces the same logic of appropriation and accumulation underlying the Singaporean ideology of taking the best of East and West in its construction of "New Asia." Davis argues that *Lear* reduces reflexivity to a trope, to a "staged reflexivity"; it stages an intersection of mutually constitutive gazes for "New Asia," from both "East" and "West." "New Asia" is constituted as the latest in Othering – the latest object of desire – desired by both the "Asians" (self-orientalizing or otherwise) who articulate or embrace it, and the "Westerners" who desire the Asian Other, but forever deny themselves any real understanding so that it always remains an Other for consumption. Bharucha, speaking of another TheatreWorks production, comments on how, "[u]ltimately, Ong would seem to accept that there is no other choice available but to 'consume the Other'":

To the credit of Ong and his colleagues at TheatreWorks, they have tried to respond to [the] predicament of the workers, but on their own terms. Unfortunately, the trap of self-reflexivity is so intense that under the pretext of examining the Other, the director and actors ultimately land up talking about themselves. Thus, what comes through in

Workhorse Afloat is not so much the dehumanization of foreign labor but, once again, a coming to terms with the hybrid cultural identities of contemporary (Chinese) Singaporeans, who no longer need the "authenticity" of the mainland as a point of reference.[38]

In *Workhorse,* Ong reflects on his own desire and privileged gaze, problematizing them for a moment, but it's a moment foreclosed; reflexivity becomes an alibi to appropriate "Asia." I would contend that in *Workhorse* and *Lear* Ong has not read anything that closely yet; that happens when the forms and themes have been inhabited by the artist and the forms and themes have likewise inhabited the artistic processes. What Ong seems to have done with virtuosity is appropriate, not inhabit.

If one takes the participants of FCP at their word when they privilege the workshop over the production, if one even supposes the strategy was to use spectacle to fund the workshop's intimate intercultural processes, then what kind of cultural politics is this, that purportedly provides an "authentic" experience to the insider-participant-performer, while being complicit in the propagation of authenticity as spectacle for the mere arts consumer (and critic)? Further questions regarding the cultural politics of *Lear* lie in the missed opportunities that Bharucha and Davis point out. Why not problematize the techniques of juxtaposition and rupture? Why not problematize the culturalist logic that underpins this brand of interculturalism? Perhaps what is most telling about the cultural politics of "New Asia" is that it exhibits no indebtedness to history, no commitment to the task of critically reworking inheritances, but is content to authenticate itself through its own spectacular reflection.

Looking About Singapore

In representing *Lear* as both exemplary and spectacle, in representing the spectacle as representative of Singapore and vice versa, I have meant to maintain a tension. If I have spoken the language of the exemplary, if I have risked essentializing the spectacle as the ultimate abstraction, it is, on the one hand, because I am sympathetic to Debord – for whom the only option was to struggle to speak an outside or Other while being within the spectacle, of "talking its language to some degree"[39] – and, on the other hand, it is in order to maintain a tension: between the exemplary and the anecdotal.[40]

I would like to draw to a close by juxtaposing this image that I have been repeatedly invoking, a New Asia as the *telos* of late capitalism, with other images. The contradictions are not just in the relentless appropriations and strategic New Asian essentialisms, the claims to authenticity and staged reflexivities, or the apparent lack of plurality of Singapore time and the unwavering commitment to globalization. I would like to deepen those contradictions, multiply those representations. It would not suffice to juxtapose a New Asian *Lear* with one other art work, but perhaps two might set in motion a process, and that is about all that I can offer in this remaining space – two

anecdotes. In writing about a work of art, my hope is to put into crisis the concepts and arguments with which I approach an interpretation. Such a crisis may not happen here in this essay. Still, another "crisis" may be at stake – again, if that's not too eschatological a word to describe the condition of contemporary art.[41] To reiterate the question that has haunted this text: how – in a time when everything can be art, when history is rendered abstract through endless appropriations and citations – can art resist becoming part of the constant "negation of life that has *invented a visual form for itself*"?[42]

1 Amanda Heng was part of a triple bill in the September 2000 session of [names changed to protect the innocent], The Necessary Stage's platform for experimental performance. An audience of around 40 gathered at the theater company, and, escorted by staff, ambled towards the nearby Parkway Parade shopping/office complex and hawker center/food court.[43] I'm sure that many, like myself, while not terribly eager with anticipation, were curious about what was going to happen. Since the piece was part of the series *Let's Walk*, there was an expectation that it would involve, obviously, some walking. (In an earlier piece, Heng, with the aid of a mirror, walked backwards around the LaSalle-SIA College of the Arts with a shoe in her mouth.) I think it's safe to say that everyone was surprised, when we arrived at the busy hawker center, to find Heng laying pink table cloths on the normally unadorned, plastic-coated table tops. Some of the hawker center crowd must have been wondering what this woman was doing; I am certain no one knew her as a "major" contemporary artist.[44] And then the two groups of people recognized each other. The hawker center crowd saw "us," the just arrived art audience, and we saw them, as *already there, already looking*. Some of the art audience began sitting down. Heng finished covering tables, and proceeded to serve food. She asked a member of the art audience to cut through her t-shirt and retrieve a packet, inside which was some money, and she repaid members of the audience the price of admission for the evening's performances. Finally, she led us back to The Necessary Stage, laying a long strip of red carpet on the ground for us to walk on.

For me, that moment of arrival at the hawker center revealed so much that is at stake in "looking" in art. The audience sees itself looking, and sees another "audience," this one unmarked as an audience, let alone an "art" audience, which then also sees itself looking. It was a moment where a slightly odd gesture of "adding value for the consumer" – an unexpected gift or present – is revealed to be a work of art, and both the art audience and the hawker center crowd see this transformation happening then and there. A fine moment that cuts between – yet at the same time welds – public and art spaces, everyday objects, moments and crowds, and the complex game of looks, frames, and privileges that is art. But then, for me at least, the rest of Heng's performance diffused that moment. When she began serving us free food, it seemed that her "performance" had started. And her repaying the admission price seemed less a continuation of the gift, or even the repayment of a debt, but instead split the "audience" from the "crowd." If she had stopped when she finished laying the last table cloth, perhaps the "performance" as a separate thing would never

have materialized, and there would not have been that split. But, for a moment, everyone would have been intersected by mutually constitutive gazes – each group recognizing itself as the other's Other, and each group's space inhabited by the other's.

But why dispose of what seem like moments of weakness in the work? Aren't the contradictions what make it possible to speak to the work critically in the first place? Moreover, why privilege only one reading of Heng's performance? There were other negotiations besides the different looks between the hawker center crowd and the art audience – for instance, the negotiations between Heng and the theater company, between her and the people at the hawker center, her and the passers-by on the walk back to the theater, and so on. Nevertheless, in this case, I believe that the most interesting rupture was at the level of the performance as spectacle – the issue of the look. Still, the point is that too often interpretations offer a single reading of a work – and shouldn't the purpose of an interpretation be to open up multiple readings of a work? These questions are also questions about how to write anecdotes, how to single out and emphasize, but they are questions which I can only leave open for now.

2 While she now lives in Sydney, Australia, Simryn Gill's "hometown," as it were, has always been Port Dickson, Malaysia. She was, however, born in Singapore, and for a time in the 1990s this was where she lived and practiced art – for instance, her first major work employing photography, *Forest* (1997),[45] a series of large black-and-white photographs of installations, was partly produced here. (In citing Gill as part of my story about contemporary art and Singapore, a number of issues surface: once again Gill's "biography" and "location" are points of consideration; then there is the matter of Singapore and Malaysia being each other's Others, as well as their intersecting colonial pasts being their present-day Others.[46] While I can't elaborate on those topics here, one issue is pertinent to my purpose – that of locating Gill's presence in my narrative through an anecdotal link. Which is also to argue that "inhabiting" isn't about an essential connection to that which is inhabited, but about commitments and meaningful encounters.) *Forest* itself could be seen as part of a series of photographic series; it was followed by *Vegetation* (1999), then *Rampant* (1999), and, recently, *A Small Town at the Turn of the Century* [see plate 11]. Exhibited at the Perth Institute of Contemporary Art in early 2001 as a set of type C prints, each about 36 by 36 inches, *A Small Town* was earlier published in late 2000 as a limited edition book by the Center for Contemporary Art, Kitakyushu, Japan (the photos in the textless book are a little smaller than 4 by 4 inches). Shot entirely in Port Dickson, each photo is of a single, a pair, or small group of friends, relatives, or acquaintances, standing or sitting portrait-like in their homes, by the seaside, in a parking lot, rubber plantation, golf club, coffee shop, or some other spot in or about town. The subjects pose facing the viewer – as if "they" are looking right back at "us" – the only thing is that their faces are obscured by masks constructed from tropical fruits: mangosteen, durian, rambutan, pineapple, and so on.

To look at Gill's photographic art work, from *Forest* to *A Small Town*, is to encounter the simultaneous singularity and multiplicity within the photographic image. Her

mises-en-scène are staged, to be sure; they are documents of painstakingly constructed installations. In talking about her coming to photography, after years of practice in other media, Gill recalls how a photograph always seemed so complete in itself, as if it were confirming some natural truth about the subject in the picture. Then when she started taking photos, the endless possibilities became sometimes daunting. For Gill this only revealed that the essential constructedness of pictures is nevertheless consistent with their appearing whole.[47] Or perhaps, rather than a consistency, what is at stake is a tension between the singular apparent completeness of the image and the radically multiple possibilities of its construction. Gill's photographic works hitherto have employed a common structure: a particular intervention is repeated in different places. Why the sets of repetitions? In my reading, what happens is that through repetition, firstly, a pictorial grammar is established, and, secondly, a tension is maintained between each individual image and the whole set. It is as if the repetitions were an absurd attempt to naturalize an absurd intervention. The question of number becomes crucial: after how many repetitions is the tension no longer maintained, but dissipated? Furthermore, I take this tension to suggest that Gill's photos, which can evoke so many narratives – anthropological, ethnological, colonial, post-colonial, national, racial, class, botanical, nostalgic, and personal – do not so much accumulate to become a counter-narrative, but, like anecdotes, comprise and refract and possibly even rupture these larger narratives.

Besides repetition, scale plays a key role in all Gill's photographic work. In *A small town*, the masks block out every portrait sitter's face and gaze, thus partially erasing their identities, but it is as if the exotic variety of the masks then perversely over-ethnicizes these subjects. If the scale of the images were much larger, their subversive humor – which, among other things, pokes fun at anthropology-as-taxonomy – might be undermined, and the series susceptible to looking like a spectacle of the artist-as-ethnographer. But presented in a small book, their diminutive size gives them a lightness; they are like puns with all the gravity of throwaway family polaroids. Peering into the pictures may seem like an act of intruding into the spaces of these fruited people, but photography often works by the paradox of seeming to allow us entry into an Other space, only to put that Other into our space – especially when the pictures are in a book in hand. And, of course, the book is the exemplary form of narrative. Gill's book, however, is punctuated by erasures; the question is, are these erasures like openings, or are they made seamless by the very spectacle of photography? My incomplete answer is framed by my reading of how Gill's pictures deal with the dimension of time.

A Small Town refers not just to the *latest*, but, at particular moments, is haunted by the *previous* turn of the century as well. The work spans both ends of a century; it looks backwards and forwards. Indeed, a certain desire for "the future" – that characteristically modern fantasy of a distant tomorrow as a better if not outright utopian place – is a peculiar blend of nostalgia and historicism. It is a dreaming for what is to come that belies a dreaming of what is to come back. We may recognize that "progress" has its social and ecological costs, but underlying our pact with modernity is a desire that some day in "the future," there will be a time when the unity of life

will be restored. This "unity" is only conceivable to us now, in our epoch of speed and spectacle, as an idyllic longing. Benjamin says that "Historicism gives the 'eternal' image of the past."[48] Chakrabarty argues that historicism persists; the nineteenth century is not gone; the relationship between the "Not Yet" and the "Now" is not a binary opposition, an "Either/Or," rather, it is an "And."[49] Gill's pictures represent the multiplicity of our present time by *conjoining* the nineteenth, twentieth, and twenty-first centuries. Yet precisely because of this multiplicity, there is a certain time-out-of-jointedness about *A Small Town at the Turn of the Century*. Derrida begins "Specters" by "Maintaining now the specters of Marx. (But maintaining now . . . without conjuncture. A disjointed or disadjusted now, 'out of joint,' a disajointed now that always risks maintaining nothing together in the assured conjunction of some context whose border would still be determinable.)"[50] Gill's pictures also evoke a singularly, radically open time: a *now* without "and" or "end."

Notes

The writer would like to thank Rustom Bharucha, Kevin Chua, and Ray Langenbach for their comments on the text.

1 In a news telecast on September 28, 2000, Channel NewsAsia reported that "Deputy Prime Minister Lee Hsien Loong is confident that Singapore-grown news channel, Channel NewsAsia, has what it takes to make it in the region despite doubts some may have about its editorial independence. . . . General Lee said: 'Some might harbor doubts about Channel NewsAsia's editorial independence, given that it is a subsidiary of MediaCorp which is wholly owned by the Singapore Government. We plan to list MediaCorp soon and subject it to the discipline and rules of a private company.'" The report is available at <www.channelnewsasia.com>

2 See "Asian official launch of Channel NewsAsia (International) achieves phase one objective of reaching 5.5 million households in Asia," September 28, 2000, at <www.channelnewsasia.com>

3 As Debord once said: "the administration of society and all contact between people now depends on the intervention of such 'instant' communication". Guy Debord, *The Society of the Spectacle*, trans. Donald Nicholson-Smith (New York: Zone Books, 1994), p. 19. He also noted that: "The reality of time has been replaced by its *publicity*," p. 113.

4 My use of the term "covert spectacle" derives from Ray Langenbach, an American performance artist and theorist who has been based in Malaysia and Singapore for more than ten years. Langenbach uses the term to describe the already gazing at spectacle of late capitalist propaganda. By explicitly shouting at you that it is propaganda, it becomes, paradoxically, *invisible*; it becomes even more sophisticated propaganda. In Singapore, the ultra-panoptic state is likewise always already looking at you before you look at it. Singaporean propaganda, by an almost ridiculous self-evidence, interpellates an ironic recognition that *this is propaganda*, while nevertheless remaining a blind spot in the subject's imagining of his or her own identity.

5 Walter Benjamin, quoted in Richard Sieburth, "Benjamin the Scrivener," in *Benjamin: Philosophy, Aesthetics, History*, ed. Gary Smith (Chicago: University of Chicago Press, 1989), p. 23.

6 Benjamin writes: "History is the subject of a structure whose site is not homogeneous empty time, but time filled by the presence of the now [*Jetztzeit*]." See "Theses on the Philosophy of History," in *Illuminations*, ed. Hannah Arendt, trans. Harry Zohn (New York: Schocken Books, 1969), p. 261.

7 See, for instance, Lee Weng Choy, "McNationalism in Singapore," in *House of Glass: Culture, Modernity, and the State in Southeast Asia*, ed. Yao Souchou (Singapore: Institute of Southeast Asian Studies, 2001), pp. 95–116, and "Just What Is It that Makes the Term Global-Local So Widely Cited, Yet So Annoying?" in *Flight Patterns*, exhibition catalog, ed. Cornelia H. Butler (Los Angeles: Museum of Contemporary Art, 2000), pp. 134–43.

8 "Singapore is New Asia" is a slogan for the Singapore Tourism Board (STB) and the National Arts Council (NAC). Tourism, of course, plays a part in every nationalism, but in Singapore the STB wields enormous power over the country's cultural development. A case in point: when the Chinatown district was earmarked for redevelopment, it was not the National Heritage Board, or the Ministry of Community Development, but the STB that was responsible for envisioning a revitalized Chinatown. The consequence, as critics of the STB's plans contend, is that Chinatown will be turned into a theme park of itself. As for the NAC's formulation of "New Asia," a recent brochure for promoting local performing arts proclaimed: "Singapore is New Asia, a thriving Asian city with a busy arts scene influenced by the traditional Asian heritage of its multicultural population and the contemporary beat of a young cosmopolitan city. Emerging from this confluence is a dynamism of artistic energy where tradition and modernity both co-exist and fuse in fresh and exciting forms of dance, music and theater." From *New Asia on Stage: Performing Arts Singapore* (Singapore: National Arts Council, 2000).

9 Langenbach, quoted from "Just What Is It," pp. 141–2. In my citation for the present essay, I have substituted my word "desire" for his word "need."

10 See Arthur C. Danto, *After the End of Art: Contemporary Art and the Pale of History* (Princeton: Princeton University Press, 1997), and *The Wake of Art: Criticism, Philosophy, and the Ends of Taste* (Amsterdam: G&B Arts International, 1998).

11 In the early 1990s, Singapore's leaders and various other pundits entertained the fantasy – expressed in the discourse of "Asian Values" – that this island city-state might be *the* model for China's future. For a discussion on "Asian Values," see, for instance, "Asian Ways: Asian Values Revisited," ed. Raul Pertierra, *Sojourn: Journal of Social Issues in Southeast Asia* 14, 2 (October 1999).

12 Benjamin: "The concept of progress should be grounded in the idea of catastrophe. That things 'just keep on going' is the catastrophe. Not something that is impending at any particular time ahead, but something that is always given." See "N [RE THE THEORY OF KNOWLEDGE, THEORY OF PROGRESS]," in *Benjamin: Philosophy, Aesthetics, History*, p. 64.

13 Francis Fukuyama, *The End of History and the Last Man* (New York: The Free Press, 1992).

14 Jacques Derrida, "Specters of Marx," *New Left Review* 205 (May–June 1994): 33–4. See also *Specters of Marx: The State of the Debt, the Work of Mourning, and the New International*, trans. Peggy Kamuf (New York: Routledge, 1994).

15 Dipesh Chakrabarty, "Opening Keynote Address," in *"We Asians": Between Past and Future*, ed. Kwok Kian Woon, et al. (Singapore: Singapore Heritage Society, 2000), p. 39.

16 In "Theses on the Philosophy of History," pp. 257–8, Benjamin provides a caption for Paul Klee's painting, *Angelus Novus*: "His eyes are staring, his mouth is open, his wings are spread. This is how one pictures the angel of history. His face is turned toward the past.

Where we perceive a chain of events, he sees one single catastrophe which keeps piling wreckage upon wreckage and hurls it in front of his feet. The angel would like to stay, awaken the dead, and make whole what has been smashed. But a storm is blowing from Paradise; it has got caught in his wings with such violence that the angel can no longer close them. This storm irresistibly propels him into the future to which his back is turned, while the pile of debris before him grows skyward. This storm is what we call progress."

17 Derrida, "Specters of Marx," p. 36.

18 Ibid., pp. 55–6.

19 For a discussion of the failed encounter or *"faux bond"* between Derrida and his critics, and a general investigation of his Anglo-American reception see Herman Rapaport, *The Theory Mess: Deconstruction in Eclipse* (New York: Columbia University Press, 2001).

20 Derrida, "Specters of Marx," p. 58.

21 "SM Lee cautions developing nations on pitfalls of debt relief," *The Straits Times*, October 17, 2000.

22 Chakrabarty, "Opening Keynote Address," p. 23.

23 Lee Kuan Yew argued for merger with the Peninsula during the struggles for independence from Britain, and has asserted that Singapore's separation from Malaysia was at first unimaginable for him – it was not yet ready to face the world on its own, without a domestic market for its economic output. Of course, Singapore since independence has proved otherwise, thriving on the basis of its export-oriented economic growth. See the first volume of Lee's memoirs *The Singapore Story* (Singapore: Times Editions, 1998). For a discussion on the importance of "forgetting" in Singapore nationalism, see Janadas Devan, "My Country and My People: Forgetting to Remember," in *Our Place in Time: Exploring Heritage and Memory in Singapore*, ed. Kwok Kian Woon, et al. (Singapore: Singapore Heritage Society, 1999), pp. 21–33.

24 Debord, *The Society of the Spectacle*, p. 114.

25 Anselm Jappe, *Guy Debord* (Berkeley: University of California Press, 1999), p. 34.

26 Debord, *The Society of the Spectacle*, pp. 131–3.

27 Ibid., p. 112.

28 Ibid., p. 137.

29 Janadas Devan argues that "Asian Values" constitutes

> an ideological machinery that is continuous with the Orientalism of imperial metropolitan powers. Singapore, indeed, may well be the most perfect modern fulfillment of the Orientalist project – conceived and executed, this time, by "Orientals" themselves. No other Asian country has created as efficient a mechanism for selecting, defining and controlling an "Asian" identity that is so fully consonant with the requirements of a modern market, even as it sets aside as waste what it deems decadent and dangerous in the West. . . . The logic is impeccable: Singapore fears becoming like America, not because it fears losing its Asian soul, but because becoming like America will weaken its ability to compete successfully in the global market, become a full-blown developed economy, and thereby become like America. Singapore, in other words, has to remain Asian in order to become Western.

From "Strange Bedfellows: Lee Kuan Yew and Samuel Huntington" (unpublished article, written in 1997). As for my formulation of "define and rule" and claims to authenticity,

this derives from Lucy Davis, "Making Difference – So Easy to Enjoy So Hard to Forget," her dissertation on culturalism, visual culture, and political-aesthetic strategies in Singapore (Roskilde University, Denmark, 2001).

30 For a discussion of Singapore's fixation with becoming "world class," see, for instance, Lee, "Just What Is It." As for "gracious living," the term has been used by everyone from the Prime Minister to advertisers of private condominiums to denote the recent national emphasis on becoming a "global city for the arts" – yet another popular catch-phrase that signifies the aspirations of a newly wealthy Singapore. Victor R. Savage, for instance, notes that "as Singaporeans climb the development ladder, arts programming has to be positioned for better-educated, wider-experienced and articulate communities looking to 'gracious living' and expanding social participation." See Savage, "Renaissance City: Crossing Boundaries for the Arts," in *inform.educate.entertain@sg: Arts & Media in Singapore*, ed. Koh Siong Ling et al. (Singapore: Ministry of Information and the Arts, 2000), p. 20.

31 In addition to Rustom Bharucha and Lucy Davis, whom I cite in this essay, other commentaries include: C. J. W.-L. Wee, "The 'New Asian' Modern in the Theatre: Cultural fragments, the Singaporean eunuch & the Asian Lear," Centre for Advanced Studies Research Paper No. 29 (Singapore: National University of Singapore, 2001), a dissertation by Lee Chee Keng (National University of Singapore, 2000), and Lee Weng Choy, "Ong Ken Sen's Lear and the Appropriate 'New Asia'," in *Substance* (Singapore: The Substation, May–June 1999), pp. 13–15.

32 Aired on MediaCorp TV12 Arts Central, February 25, 2001.

33 Bharucha, *The Politics of Cultural Practice: Thinking through Theater in an Age of Globalization* (London: The Athlone Press (Continuum Publishers), 2000, and Hanover: Wesleyan University Press, 2000).

34 Bharucha, "Consumed in Singapore: the Intercultural Spectacle of Lear," Center for Advanced Studies Research Paper No. 21 (Singapore: National University of Singapore, 2000), p. 37.

35 Lucy Davis, "Making Difference – So Easy to Enjoy So Hard to Forget"; all citations are from section II, trope 1, chapter 2.

36 Quoted in ibid.

37 Ibid.

38 Bharucha, "Consumed," pp. 44–6.

39 Debord, *The Society of the Spectacle*, p. 15.

40 Or, in other words, between what the French call the *grand récit* and what Joel Fineman calls the *historeme*, "the smallest minimal unit of the historiographic fact"; see Joel Fineman, "The History of the Anecdote: Fiction and Fiction," in *The New Historicism*, ed. H. Aram Vesser (New York: Routledge, 1989), p. 57. Fineman proposes that "the anecdote is the literary form that uniquely *lets history happen* by virtue of the way it introduces an opening into the teleological, and therefore timeless, narration of beginning, middle, and end. The anecdote produces the effect of the real, the occurrence of contingency, by establishing an event as an event within and yet without the framing context of historical successivity, i.e., it does so only in so far as its narration both comprises and refracts the narration it reports," p. 61. However, I have been using the word "exemplary" in a different sense than he has: by "exemplary" I do not mean, as he does, what is historically significant and representative. For Fineman, the purpose of an anecdote is to single out an exemplary event, since not all events are equally representative or significant. In

contrast, what I mean by the exemplary is that it is essentially teleological; it is singular not so much by being interesting or typical or contingent, but in signaling the narrative closure of a *telos*, it both telescopes and collapses time into a singularity. To write history in terms of the exemplary is to predicate history on the teleological, which is the opposite of what I want to do in telling this story of contemporary art and Singapore.

41 Fineman notes that Thucydides conceived his history based upon the model of the medical case history, where the notion of "crisis" – a technical medical term for the moment when a disease completes its predetermined and internally directed course – translates into a dramatic climax of events. The purpose of the medical case history was to enable physicians to predict prognoses of an illness before it ran its full course, and thus treat the disease. Not surprisingly "crisis" plays a fundamental role in Singapore's imagining of itself. Former Minister for Information and the Arts George Yeo has said: "There's always a certain anxiety in Singapore that our geographic, economic, and political positions are vulnerable. This anxiety is also a galvanizing force . . . Our success is the result of anxiety, and the anxiety is never assuaged by the success." (Quoted from Louis Kraar, "Singapore – a model for the world?" reprinted in *The Straits Times*, July 15, 1997.) And Sanjay Krishnan writes: "These are fast times. Singapore has openly come to see itself as expecting the worst. Thus it constantly subjects itself to change in order to anticipate and prevent the worst from happening. We are obsessed with maintaining our 'cutting edge,' fighting 'complacency,' and being 'the best.' . . . These developments, and what I have called the philosophy of 'speed,' are part of the logic of progress that we have used to define our primary objective as a nation . . . But the success of speed or progress is based on the idea of perpetual crisis (that is, phenomenal profit is the only thing that keeps away 'starvation') which, because it believes itself permanently threatened, will not allow us to consider our present and immediate past as a basis for genuine communal and social understanding." See "Two Stories at the Cost of One City," *Commentary* 10 (Singapore: National University of Singapore Society, 1992), pp. 79–87.

42 Debord, *The Society of the Spectacle*, p. 14.

43 Hawker centers are the cheapest and most popular places to eat in Singapore; they are sheltered food courts with several stalls, and a common eating area with basic tables and stools, often affixed to the ground, lined in rows. Many of the old hawker centers have been torn down to make way for more "modern," airconditioned food courts.

44 The term "major artist" certainly needs unpacking, but if being "major" means participation in a number of international art exhibitions like the Fukuoka Triennial, the Havana Biennale or the Queensland Art Gallery's Asia-Pacific Triennial, and appearing in international art publications, then Heng fits the bill. For more about Heng, see, for instance, Natalie King, "Performing Bodies," *ART AsiaPacific* 3, 2 (1996): 81–5, and Susie Lingham, "In Her Image," *Beyond the Future: The Third Asia-Pacific Triennial of Contemporary Art* exhibition catalog (Brisbane: Queensland Art Gallery, 1999), p. 128.

45 The 30-odd installations photographed in *Forest* are of bits of text embedded in vegetation: various books cut up and pasted together into long strips hanging like aerial roots from a ficus tree, or torn into shapes and grafted onto leaves. The photos are of a large scale; in every case one can always read some of the text. Kevin Chua's essay on *Forest*, "Simryn Gill and Migration's Capital," *Art Journal* 61, 4 (2002): 5–21, offers an excellent reading of the work.

46 See Lee Weng Choy, "Local Coconuts: Simryn Gill and the politics of identity," *ART AsiaPacific* 16 (1997): 56–63, for a critique of the biographical approach to Gill's work.

"Provide an interpretation of the art, then tie it to biography – a significant proportion of writing about Simryn Gill makes the point both to explain her biography and use it as an explanation. She is of course not the only artist to get such treatment. . . . The return of biography's authority . . . has become symptomatic of a larger turn in contemporary social discourse, where identity and culture have subsumed everything political. Politics has become reduced to the performance of representations [and, one might add, location]. My own discussion of Gill attempts to problematize this politics of representation. Rather than use her to represent postcoloniality, yet again, my aim is to examine some of our presumptions when we project this function onto her and her work" (p. 58).

47 From unpublished MFA thesis draft by Simryn Gill, University of Western Sydney, 2001.
48 Benjamin, "Theses on the Philosophy of History," p. 262.
49 Chakrabarty, "Opening Keynote Address," p. 26.
50 Derrida, "Specters of Marx," p. 31.

21 All-Owning Spectatorship

Trinh T. Minh-Ha

. . . Of late, a friend's mother died. One day the family chanced to eat steamed sorghum,
which was of a reddish color. A local pedant felt that while in mourning it was inappropriate
to have a meal with the main course in so gay a color, so he took up this point with them,
pointing out that red was always indicative of happy events, such as weddings. The friend
replied: "Well, I suppose all those people eating white rice every day are doing so because they
are in mourning!"[1] In classical Chinese humor a position of indirection is assumed;
a reaction to social conditions is woven in the fabric of an anecdote; a laughter
momentarily releases demonstration from its demonstrative attribute. In the world
of Western film production, some would call such an opening a "directorial trick,"
highly valued among feature-story makers. Others would mumble "clumsy dramatic
devices," "poor exposition," "muddy connectives," "lack of clear thought." Public
opinion usually prefers immediate communication, for quantified exchange domin-
ates in a world of reification. To have knowledge, more and more knowledge, often
takes precedence over knowing. The creed constantly reads: if one has nothing, one
is nothing.

A mother died. What holds the reader? What motivates the story and generates
the action? A reddish color; a family's attempt; a local pedant; a "steamed" meal;
people's white rice . . . in mourning. Red is the color of life. Its hue is that of blood,
of the ruby, of the rose. And when the world sees red, white could become the

From *When the Moon Waxes Red* (New York and London: Routledge, 1991), pp. 81–105. This essay was
first published in *Quarterly Review of Film & Video* 13, 1 and 2 (January 1991), while portions also appeared
as "Black Bamboo," in *CineAction!* (Canada), a special issue on imperialism and film, no. 18 (fall 1989).
Reproduced with permission of Taylor & Francis Ltd.

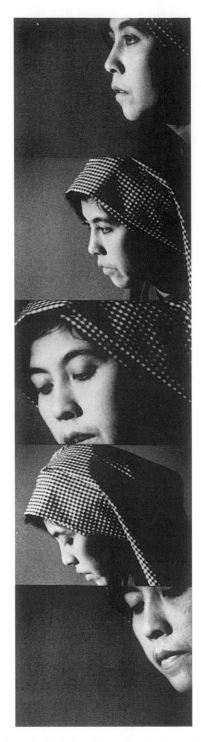

Figure 21.1 Film still from *Surname Viet Given Name Nam* by Trinh T. Minh-Ha, 1989, 108 min.

international color of mourning. Conventionally a bridal color in many Western societies, white is indeed the funeral color in numerous African and Asian cultures. Passionate reds and pinks also populate the joyful decor of weddings, but they cut across the borderlines of both Western and Eastern cultural traditions. Even the bride is clad in red in the latter parts of the world. Whoever has taken a stroll in Chinatown on Chinese New Year's days cannot have missed the sight of doorways vividly adorned with red scrolls and of streets thickly coated with the red refuse of firecrackers. Children are accordingly greeted with red envelopes with lucky bank-notes inside and words of Luck, Prosperity, and Happiness on the outside. The return of spring is celebrated as a renewal of life, growth, and emancipation. After days of intense preparation, women are allowed to enjoy five days of idleness when, in order to preserve good luck, they are spared the drudgery of cooking, washing, and sweeping (since during this period, all such drudgery means throwing away a happy fortune). At once an unlimited and profoundly subjective color, red can physio- or psychologically close in as well as open up. It points to both a person's boundless inner voyage, and the indeterminate outer burning of the worlds of war. Through centuries, it remains the badge of revolution.

Here is where the earth becomes blue like an orange.[2] To say red, to show red, is already to open up vistas of disagreement. Not only because red conveys different meanings in different contexts, but also because red comes in many hues, satura-tions, and brightnesses, and no two reds are alike. In addition to the varying symbols implied, there is the unavoidable plurality of language. And since no history can exhaust the meaning of red, such plurality is not a mere matter of relativist approach to the evershifting mores of the individual moment and of cultural diversification; it is inherent to the process of producing meaning; it is a way of life. The symbol of red lies not simply in the image, but in the radical plurality of meanings. Taking literal-ness for naturalness seems, indeed, to be as normal as claiming the sun is white and not red. Thus, should the need for banal concrete examples arise, it could be said that society cannot be experienced as objective and fully constituted in its order; rather, only as incessantly recomposed of diverging forces wherein the war of interpreta-tions reigns.

Seeing red is a matter of reading. And reading is properly symbolic. In a guide listing the elements of screenwriting, a voice of authority dutifully calls attention to cultural differences and the many ensuing contradictory behaviors of characters in relation to an event; but it further warns: "If ten viewers can walk away from a film with ten different interpretations, maybe the film was about nothing specific. Per-haps, they were looking at the proverbial emperor's new clothes. The marks of the artsy-craftsy film are withholding basic exposition and leaving the viewer confused. The illusion of profundity is not the same as being profound."[3] True, in a world where the will to say prevails (a "good" work is invariably believed to be a work "that *has* something to say"), the skill at excluding gaps and cracks which reveal language in its nakedness – its very void – can always be measured, and the criteria for good and bad will always exert its power. The emperor's new clothes are only invoked because the emperor is an emperor. But what if profundity neither makes

sense nor constitutes a non-sense? Where, for example, does profundity stand in: "A, black; E, white; I, red"?[4]

More likely to persist in bordering on both profundity and absurdity, the work of saying in unsaying, or of unsaying in saying again what is already said and unsaid, seems always uneasily and provocatively fragile. Playing between "absurdities," anecdotes, and decisive analysis, or between non-sense and critical languages, it often runs the risk of being mistaken immediately for the-sky-is-blue-the-grass-is-green type of work, and can be both condemned and praised within that very reading. It is easy to commit an outrage on those (men) who fulminate against what they call "those school *boyish* evidences" (referring here to statements in a film uttered by women's voices), when the work succeeds to lure them into a spectacle that shows neither spectacular beings nor sensational actions; offers neither a personal nor a professional point of view; provides no encased knowledge to the acquisitive mind; and has no single story to tell nor any central message to spread, except the unconcealed one(s) about the spectators themselves as related to each specific context.

The inability to think symbolically or to apprehend language in its very symbolic nature is commonly validated as an attribute of "realistic," clear, and accomplished thinking. The cards are readily shifted so as to turn a limit, if not an impoverishment of dominant thinking into a virtue, a legitimate stance in mass communication, therefore a tool for political demagogy to appeal to widely naturalized prejudices. Since clarity is always ideological and reality always adaptive, such a demand for clear communication often proves to be nothing else but an intolerance for any language other than the one approved by the dominant ideology. At times obscured and other times blatant, this inability and unwillingness to deal with the unfamiliar, or with a language different from one's own, is, in fact, a trait that intimately belongs to the man of coercive power. It is a reputable form of colonial discrimination, one in which difference can only be admitted once it is appropriated, that is, when it operates within the Master's sphere of having. Activities that aim at producing a different hearing and a renewed viewing are undifferentiatingly confused with obscurantism and hastily dismissed as sheer incompetency or deficiency. They are often accused of being incoherent, inarticulate, amateurish ("it looks like my *mother*'s first film," says a young to-be-professional male), or when the initiating source of these activities happens to be both female and "articulate," of "intellectualism" – the unvarying target of attack of those for whom thinking (which involves reflection and reexamination) and moreover thinking differently within differences remains a male ability and justifiably, an unwarranted threat. As the proverbial line goes, He only hears (sees) what He wants to hear (see), and certainly, there are none so deaf (blind) as those who don't want to hear (see).

"All the prejudice against intellectuals originates from the narrow-mindedness of small producers," wrote the *Beijing Review* not long ago to rectify the "Left" mistakes perpetuated from the time of the Cultural Revolution.[5] The moment she opens her mouth, she is immediately asked to show her identification number and to tell the (reluctant) listener in whose name she is speaking. ("Is this a semiological approach?" "Who taught you?" "Whose work do you like?" "What I find badly missing in your

talk are the models! Where do we go without models?" "If it is a deliberate attempt at breaking *the rules*, then I certainly applaud you, but I doubt it is consciously done, and if it is *just a subjective approach*, then I don't see where it leads us . . .") If she relies on names, she finds herself walking in line both with "the penis-envy" women and "the colored-skin-white-mask" oppressed who blindly praise their oppressor's deeds. If she distrusts names and names no master, she will, whether she likes it or not, be given one or several, depending on the donor's whims ("The film reminds me of Kubelka's *Unsere Afrikareise* and of Chris Marker's *Sans Soleil*"; "How different are these films from Godard's?"); otherwise, she is bound to face fiery charges of circulating "schoolboyish evidences." This type of charge repeats itself endlessly in varying faces. Knowledge is no knowledge until it bears the seal of the Master's approval ("She doesn't really know what she does"). Without the Name, the product is valueless in a society of acquisition. (Thus, after having, for example, taken over the floor during the entire length of a film debate session, where angry reactions were continuously thrown out at a woman filmmaker, a number of men approached her individually afterwards to intimate: "All that is very *cute* . . . and I *commend* you for your effort, but . . . ," "You can't *have* an answer for every question!")

She is both inarticulate and too articulate. *"Although one can speak of intellectuals, one cannot speak of non-intellectuals, because [they] do not exist. . . . There is no human activity from which every form of intellectual participation can be excluded"* (Antonio Gramsci).[6] Standardization and sameness in variations is the unacknowledged agenda of media suppliers and consumers who, under the banner of "accessibility," work at leveling out differences to defend their property, whether this property takes the form of mercantile monopoly, or of political tenure. While the craving for *accession* to power seems to underlie every intolerance for alternatives that may expose the totalizing character of their discourses (whether rightist or leftist), the goal is to render power sufficiently invisible so as to control more efficaciously the widest number down to the smallest details of existence. ("Self-help" and "Do-it-yourself" systems are an example.) The literal mind has to dominate if accessibility were to be equated with efficacity. Literal and linear readings are thus not simply favored; they are championed and validated as the only ones "accessible" to the wide number, in all media work, whether documentary or narrative. (Even Francis Coppola who is "the best of what *We have* in America" is blamed for emphasizing the visuals at the cost of a good story line.) Mass production, as Gandhi defined it, is production by the fewest possible number. The needs (for orderly literal thinking) created by the few and voiced back in chorus by the many are normalized to the extent that not only consumers come to internalize the suppliers' exploitative rationale, but the latter more often than not become the victims of their own practices. "The greatest error I've committed in my career is to have once made a film for people who think," says a respected Hollywood director (not to name any names); "it featured in all the festivals, but never made it at the box office. . . . Don't forget that people in the media are all very smart and creative, but the audience is invariably simple-minded."

With such a rationale, the hackneyed question of elitism arises again, albeit reversed and slightly displaced: who appears more elitist here? The institutional producer who

caters to the needs of the "masses" while down- and de-grading their mentality in the interest of mercantilism (the Master's sphere of having)? Or the "independent" producer who disturbs while soliciting the audience's participation in rethinking the conditions of this "society of the spectacle," and therefore neither pleases the large number nor expects to make it at the box office? My admittedly biased question should probably remain without an answer after all, for in a situation where the suppliers are victims of their own supplies, no clear-cut division operates between makers and consumers. Only the *humanism of the commodity* reigns, and the vicious circle continuously reactivated provides no response to inquiries such as: "Is it the media which induces fascination in the masses, or is it the masses which divert the media into spectacle?"[7] The media's message may condemn war, violence, and blood-shed, for example, but its language fundamentally operates as a form of fascination with war; and war scenes persist in dominating the spectacle. (The only way to represent war or to speak about it in the language of commodified humanism, is to show war scenes; any form of indirection and of non-literalness in approaching the subject of war is immediately viewed as a form of absence of war.) Thus, under the regime of commodities, even the distinction between institutionalized and independent (or mainstream and alternative) producers becomes problematic; and within the realm of independent filmmaking there are nuances to bring out, there are varied ramifications, and there are crucial differences.

If Hollywood films are consistently condemned for their capitalist enterprise and "apolitical" commitment to film as an industry, "political" films (or "issue films" as Hollywood members call them) are looked down upon by mainstream feature producers as representative of the unimaginative mediocres' domain: "Don't apply the criteria of today's politics in feature films, otherwise they will all look like PBS products, which are boring as hell!" Whether political, educational, or cultural (if one can momentarily accept these conventional categories), rational linear-literal communication has been the vehicle of quantified exchange. The imperative to produce meaning according to established rationales presents itself repeatedly in the form of moralizing information: every film made should inform the masses, raise their cultural level, and give an objective, scientific foundation to all explanations of society. *"The revolutionary view point of a movement which thinks it can dominate current history by means of scientific knowledge remains bourgeois"* (Guy Debord).[8] Here, there is almost never any question of challenging rational communication with its normalized filmic codes and prevailing objectivist, deterministic-scientific discourse; only a relentless unfolding of pros and cons, and of "facts" delivered with a *sense of urgency*, which present themselves as liberal but imperative; neutral and value-free; objective or universal.

> Yesterday's anti-colonialists are trying to humanize today's generalized colonialism. They become its watchdogs in the cleverest way: by barking at all the after-effects of past inhumanity. (Raoul Vaneigem)[9]

Red is the color of life. Nearly all cultures attribute a greater potency to red, but red can never be assigned a unitary character. Giving the physiological impression

of "advancing" toward the viewer rather than receding, it is analyzed as having "a great wealth of modulations because it can be widely varied between cold and warm, dull and clear, light and dark, without destroying its character of redness. From demonic, sinister red-orange on black to sweet angelic pink, red can express all intermediate degrees between the infernal and the sublime."[10] Thus, whether red radiates luminous warmth or not depends on its contextual placement in relation to other colors. On white it looks dark, while on black it glows; with yellow, it can be intensified to fiery strength. In the costuming and make-up of Vietnamese opera, red symbolizes anger; black, boldness; and white, treachery. In classical Chinese symbolics, red characterizes Summer and the south; black, Winter and the north; green, the color of virtue and goodness, represents Spring and the east; and white, the color of war and penalty, stands for Fall and the west. The color of life and of revolution may thus remain a transnational sign of warmth and anger, but whether or not it is associated with war, violence, and bloodshed – as it is unfailingly so in the modern concept of revolution – depends largely on one's praxis of revolution. To think that red is red, no matter whether the red is that of blood or that of a rose, is to forget that there is no red without non-red elements, and no single essential red among reds.

If, in the opening Chinese anecdote, red humoristically incurs the risk of being fixed as a sign "always indicative of happy events" by "a local pedant," in Dogon (Mali) cosmology, red is one of the three fundamental colors (with black and white) whose complex symbolism exceeds all linear interpretations and remains inexhaustible. A sign opening constantly onto other signs, it is read in practice with all its signifying subtlety and density. The Dogon myth of the red sorghum tells us, for example, that its grains grew at the time when the pond had become impure, its water having served to wash the corpse of the ancestor Dyongou Serou – the first human dead, also called the "great mask." The impurity of death had tainted the pond, and the color red of the sorghum is a manifestation of this contamination. Red is also the glare of the sun. The latter is associated with putrefaction and death (it rots Dyongou Serou's corpse), although it remains absolutely necessary to agriculture and plants; in other words, to the growth of life.[11] The sun is essentially feminine in Dogon mythology, and its ambivalent character reflects back upon the ambivalent character of the notion of femininity in the culture's symbolics.

Red as the Sun is both beneficial and maleficial. Women, who are the bearers and givers of life, are also the cyclical producers of "impurity." Dogon societies abound with rituals in which the "bad blood" – menstruation, the blood shed at childbirth, the dark blood that clots – is distinguished from the bright healthy blood that flows in the body. The latter, which is evoked when a wife is pregnant ("your body's blood is good"), is also identified with men's semen; it is said to represent the successful, fecund sexual act, while the former results from a failure of the couple to reproduce. Yet the bright red flowers of the Kapok tree are associated with menstruation and death, and it is with its wood that masks are carved. Women are raised to fear "the mask with a red eye," for the masks are the men's domain and he who is angry is said to have "the red eye," while he whose anger gets violent has "the red heart."

However, men are also referred to as "having their periods" when their blood runs during circumcision time or when they carve the masks and tint the fibers red. Their words are then "impure" and women are strictly forbidden to come near them while they carry out these tasks. Paradoxically, to decorate the masks and to tint the fibers amount to nursing the sick; for the white wood and fibers do not look healthy – just like sick people – and to paint and tint them with vivid colors is to "heal" them.[12]

The reading of red as impurity and death proves appropriate to the eating of red sorghum during mourning time in the Chinese anecdote. Should the friend of the dead mother remember this, he or she would have more than one witty answer to reply to the pedant. And depending on the context, this friend could also decide whether or not it is at all necessary to resort to another color for comparison. ("Remember" is here adequate, for even without knowledge of Dogon cosmology, the relation commonly drawn between red and blood evokes meanings that cut across cultural borderlines.) Rich in significations and symbols, red defies any literal elucidation. Not only do its values vary between one culture and another, but they also proliferate within each culture itself. The complexities are further multiplied when reading takes into consideration the question of gender. "Impurity" is the interval in which the impure subject is feared and alienated for her or his potential to pollute other clean(sed) and clear(ed) subjects. It is also the state in which gender division exerts its power. (Just as women are excluded from the tinting process of the masks, no Dogon man can witness a woman giving birth, nor can he come near her when she has her period. For, like many women from other parts of the world, Dogon women temporarily separate themselves from the community during menstruation, living in confinement – or rather, in differentness – in a dwelling built for that very purpose.)

Many of us working at bringing about change in our lives and in others' in contexts of oppression have looked upon red as a passionate sign of life and have relied on its decisive healing attributes. But as history goes, every time the sign of life is brandished, the sign of death also appears, the latter at times more compelling than the former. This does not mean that red can no longer stand for life, but that everywhere red is affirmed, it impurifies itself, it necessarily renounces its idealized unitary character, and the war of meanings never ceases between reds and non-reds and among reds themselves. The reading of "bad blood" and "good blood" continues to engender savage controversies, for what is at stake in every battle of ideologies are territories and possessions. While in conservative milieux, the heat and anger surrounding the debates generate from the emblem of red itself ("What can you expect but hostilities? You are waving a red flag in front of the bull!"), in (pseudo-)progressist milieux they have more likely to do with sanctified territories and reified power. The dogmatic mind proceeds with ready-made formulas which it pounds hard into whoever's ear it can catch. It validates itself through its own network of law-makers and recruited followers, and constantly seeks to institute itself as an ideological authority. Always ready to oppose obvious forms of power but fundamentally uncritical towards its own, it also works at eliminating all differences other than those

pre-formulated; and when it speaks, it prescribes. It preaches revolution in the form of commands, in the steeped-in-convention language of linear rationality and clarity. At length, it never fails to speak *for* the masses, *on behalf of* the working class, *or in the name of* "the American people."

"*Nazism and fascism were only possible insofar as there could exist within the masses a relatively large section which took on the responsibility for a number of state functions of repression, control, policing, etc. This, I believe, is a crucial characteristic of Nazism; that is, its deep penetration inside the masses and the fact that a part of the power was actually delegated to a specific fringe of the masses . . . You have to bear in mind the way power was delegated, distributed within the very heart of the population. . . . It wasn't simply the intensified central power of the military*" (Michel Foucault).[13] Power is at once repulsive *and* intoxicating. Oppositional practices which thrive on binary thinking have always worked at preserving the old dichotomy of oppressor and oppressed, even though it has become more and more difficult today to establish a safe line between the government and the people, or the institution and the individual. When it is a question of desire and power, there are no possible short-cuts in dealing with the system of rationality that imprisons both the body politic and the people, and regulates their relationship. There are, in other words, no "innocent people," no subjects untouched in the play of power. Although repression cannot simply be denied, its always-duplicative-never-original sources cannot be merely pointed at from a safe articulatory position either. As has been noted, in the society of the spectacle (where the idea of opposition and the representation of oppression are themselves commodified) "the commodity contemplates itself in a world it has created."[14]

> A woman viewer: By having the women re-enact the interviews, you have defeated your own purpose in the film!
> The woman filmmaker: What is my purpose? What do you think it is?
> The viewer, irritated: To show women's power, of course!

Every spectator mediates a text to his or her own reality. To repeat such a banality in this context is to remember that although everyone *knows* this, every time an interpretation of a work implicitly presents itself as a mere (obvious or objective) decoding of the producer's message, there is an explicit reiteration of the fetishistic language of the spectacle; in other words, a blind denial of the mediating subjectivity of the spectator as reading subject and meaning maker-contributor. The same applies to producers who consider their works to be transparent descriptions or immediate experiences of Reality "as it is" ("This is *the* reality of the poor people"; "the reality of the nine-to-five working class is that they have no time to think about 'issues' in their lives"). Literal translations are particularly fond of "evident truths," and the more they take themselves for granted, the more readily they mouth truisms and view themselves as *the* ones and the only *right* ones. The self-permitting voice of authority is common in interpretation, yet every decoding implies choice and is interpellated by ideology, whether spoken or not. Reading as a creative responsibility is crucial to every attempt at thwarting "the humanism of commodity." Although important in

any enterprise, it is pivotal in works that break off the habit of the Spectacle by asking questions aloud; by addressing the reality of representations and entering explicitly into dialogue with the viewer/reader. Each work has its own sets of constraints, its own limits and its own rules, and although "anything could be said" in relation to it, this "anything" should be rooted in the specific reality of the work itself. The interpreters' conventional role is disrupted since their function is not to tell "what the work is all about," but to complete and "co-produce" it by addressing their own language and representational subjectivity.

"The Text is a little like a score of this new kind: it solicits from the reader a practical collaboration. . . . The reduction of reading to consumption is obviously responsible for the 'boredom' many feel in the presence of the modern ('unreadable') text, the avant-garde film or painting: to be bored means one cannot produce the text, play it, release it, make it go" (Roland Barthes).[15] Ironically enough, both the all-too-familiar (PBS conventions according to Hollywood standards) and the unfamiliar have been qualified as boring. In one case, the question is that of instituting representational habits and of providing alibis of ownership, while in the other, that of disturbing and dispossessing them of their evident attributes. Yet what links these two "boring" modes of production is precisely this lack: that of the Spectacular, the very power to appeal. In the first instance such a lack usually derives from a normalized deficiency: the (involuntary, hence lesser) spectacle never admits to itself, that it is a spectacle; in the second instance, it results from an ambiguous rupture: the spectacle(on-trial) fractures its own unicity by holding a mirror to itself as spectacle. Being the site where all the fragments are diversely collected, the viewer/reader remains, in this situation of rupture, intimately involved in a dialogue with the work. The latter's legibility and unity lie therefore as much in its origin as in its destination – which in this case cannot be righteously predetermined, otherwise Commodity and its vicious circle would triumphantly reappear on the scene. With such emphasis laid on the spectator's creative role and critical resistance to consumption, it is amazing (although not in the least surprising) to hear the unfamiliar or different/autonomous work morally condemned in the name of a humanism which hypocritically demands respect for the viewers/readers, claiming, sure enough, to speak on their behalf and advocate their rights.

Among the many realms of occupied territories, one of particular relevance to the problems of reading here is the concept of the "political." Although much has already been said and done concerning the "apolitical" character of the narrow "political," it is still interesting to observe the endlessly varying ways the boundaries of "the political" are being obsessively guarded and reassigned to the exclusive realm of politics-by-politicians. Thus, despite the effectiveness and persistence of the women's movement in deconstructing the opposition between nature (female) and culture (male) or between the private (personal) and the public (political); despite the growing visibility of numerous Third Worldist activities in de-commodifying ethnicity, displacing thereby all divisions of Self and Other or of margin and center based on geographical arbitrations and racial essences; despite all these attacks on pre-defined territories, a "political" work continues unvaryingly for many to be one which opposes

(hence remains particularly dependent upon) institutions and personalities from the body politic, and mechanically "barks at all the after-effects of past inhumanity" – in other words, which safely counteracts within the limits of pre-formulated, codified forms of resistance.

Particularly intriguing here are the kinds of questions and expectations repeatedly voiced whenever films made on and by members of the Third World are concerned. Generally speaking, there is an excessive tendency to focus on economic matters in "underdeveloped" or "developing" contexts among members of overdeveloping nations. It is as if, by some tacit consent, "Third World" can/must only be defined in terms of hierarchical economic development in relation to "First World" achievements in this domain. And, it is as if the presence and the sight of imported Western products being "misused" in non-Western contexts remain highly compelling and recomforting to the Western viewer on imaginary foreign land. The incorporation (if not emphasis) of recognizable signs of Westernization even in the most remote parts of Third World countrysides is binding; for exoticism can only be consumed when it is salvaged, that is, reappropriated and translated into the Master's language of authenticity and otherness. A difference that *defies while not defying* is not exotic, it is not even recognized as difference, it is simply no language to the dominant's ear (only sheer charlatanism – a "mother's first [attempt]"; a something that infuriated the men asking: "What is it!?" "What can you *do* with such a film?"). Any film that fails to display these signs of "planned poverty" in its images and to adopt the *diagnostic* language of economic-deterministic rationale, is often immediately classified as "apolitical." The devices set up by the Master's liberals to correct his own mistakes thus become naturalized rules, which exercise their power irrespective of the differences of context.

The political is hereby *not* this "permanent task inherent in all social existence" which, as Michel Foucault suggests, "cannot be reduced to the study of a series of institutions, not even to the study of all those institutions which would merit the name 'political,'" but pertains to "the analysis, elaboration, and bringing into question of power relations and the 'agonism' between power relations and the intransitivity of freedom."[16] *The political becomes compulsively instead "the legislative, institutional, executive mirror of the social."*[17] In this exclusive realm of politics by politicians, the political is systematically de-politicized. The more "self-evident" the location of politics, the easier it is to claim knowledge, to gain control, and to acquire territory. The progressive "First World" thus takes as much pride in its "Third World" underdeveloped as the church used to take pride in its poor. (As it has been astutely pointed out, the humanitarianism advocated through all the "feed the poor" images of Africa and the "do good" messages of the television missionaries may ease the consciences of the rich, but what they hide are precisely the ties between world hunger and imperialism.[18]) Not only all films related to the Third World must show the people's poverty, but whatever they put forth in their critical stance vis-à-vis oppression should not depart from the Master's image of progress, for it is only in terms of progress – more particularly acquisitive, quantified progress – that he conceives of "revolution" and transformation.

A woman viewer: In dealing with socialist Vietnam, why don't you show what has been acquired through the Revolution?

The woman filmmaker: The women in the film wouldn't have spoken as they did without the Revolution.

The viewer: . . . True, but I mean real acquisitions, real attainments . . . something tangible! Do you understand me?

Poverty and class. Even the notion of class is commodified. Again, it is almost exclusively in the context of films on and by people of color that middle-class viewers become suddenly over(t)ly concerned with the question of class – more as a classifying term however, than as a way of rethinking production relations. Class, which is reduced to a fixed and categorized meaning in its common use among the viewers mentioned, has apparently never been their preoccupation in contexts other than the one that concerns "their" poor. (For they do not seem to have any qualms going to the movies whose dominating attractions are the love stories of the Western petty bourgeoisie; nor are they disturbed every time they switch their television set on, whose visual symbols and chatter are governed by the myths of the upwardly mobile and the tastes of the very affluent.)

[The] attachment to the new insures that television will be a vaguely leftist medium, no matter who its personnel might be. Insofar as it debunks traditions and institutions . . . television serves the purposes of that larger movement within which left and right (in America, at least) are rather like the two legs of locomotion: the movement of modernization. . . . Television is a parade of experts instructing the unenlightened about the weather, aspirins, toothpastes, the latest books or proposals for social reform, and the correct attitudes to have with respect to race, poverty, social conflict, and new moralities. (Michael Novak)[19]

The mandatory concern for class in the exclusive context of films on and by Third World members *is in itself a class issue*. The complexity of the problem often goes unnoticed, as the class bias many of us project onto others is often masked by the apparent righteousness of these "correct attitudes" popularized in relation to race and poverty. The tendency to identify Third World with mere economic poverty is always lurking below questions such as: "The film is beautiful. But some people look as if they have starched their clothes [*sic*] for the camera. Why do they dress so well?" (concerning a documentary shot in villages of Senegal); or else: "I am surprised to see how beautiful the women are. Here [in the US], they would have been fashion models. You have obviously selected them!" Such a tendency is further recognizable in the way the difference in dress codes is often ignored. While among many progressist middle-class women today it is important to signal publicly, through the very casual way one often dresses, that one is sufficiently secure to enact the downwardly mobile, the situation is rather the reverse in the working class. "Most black women don't dress like this [in slacks and shirt]," observes Julia Lesage, "nor do most trade union women, if they are gathering in public for a meeting. Many, if not most, women in the US cherish a notion of dressing up in public or dressing up out of

respect for other people. . . . [Blacks] do not have a legacy of pride in dressing down."[20] Nor do most Asians in the US or elsewhere (including post-Mao China) – especially when it is a question of appearing on camera for the thousands of (respected) others, and of "saving face" for one's own family and community. Thus, in a film where both Asian middle-class and working-class women are featured, a woman viewer remarks for example: "All the women in the film are middle class. Can you talk about this?" The woman filmmaker: "Oh! . . . How do you see them all as middle class?" The viewer: "Aren't they?! . . . the way they dress! . . ." Whose middle class is it finally? In refusing to situate its own legacy in dress codes, hence to acknowledge the problem of class in dealing with class, middle-class spectatorship believes it can simply evacuate class content from its safe observer's post by reiterating the objectifying Look – the Spectacle's totalitarian monologue.

So gay a color . . . in mourning. Not too long ago (1986), in an issue of the weekly *Figaro-Magazine*, one reads in large bold letters the following title of a feature article by a famed French reporter who is said to have spent twenty years covering the war in Vietnam: *"Mon" Viet-nam d'aujourd'hui, c'est la désolation* ("My" Vietnam Today Is a Desolation). Vietnam: a sacred territory and an ideal subject for generalized colonialism. A widely unknown people, but an exceptionally famed name; all the more unforgettable as every attempt at appropriating it through the re-justification of motives and goals of the war only succeeds in setting into relief the political vacuum of a system, whose desperate desire to re-deploy its power and to correct its world image in a situation of bitter "defeat" unfolds itself through the supremacy of war as mass spectacle. Every spectator owns a Vietnam of his or her own. If France only remembers its ex-colony to expatiate forever on it being the model of a successful revolutionary struggle against the largest world power, America is particularly eager to recall its predecessor's defeat at Dien Bien Phu and Vietnam's ensuing independence from French colonialism, whose desperate effort to cling to their Asian possession had led to the American involvement in the war. It is by denouncing past colonialism that today's generalized colonialism presents itself as more humane. North and South Vietnam are alternately attributed the role of the Good and the Bad according to the time, to suit the ideological whims of the two foreign powers. And the latter carefully take turns in siding with the "winner," for it is always historically more uplifting to endorse the "enemy" who wins than the "friend" who loses.

"Yes, we defeated the United States. But now we are plagued by problems. We do not have enough to eat. We are a poor, underdeveloped nation. . . . Waging a war is simple, but running a country is very difficult" (Pham Van Dong).[21] For general Western spectatorship, Vietnam does not exist outside of the war. And she no longer exists since the war has ended, except as a name, an exemplary model of revolution, or a nostalgic cult object for those who, while admiring unconditionally the revolution, do not seem to take any genuine, sustained interest in the troubled reality of Vietnam in her social and cultural autonomy. The more Vietnam is mystified, the more invisible she becomes. The longer Vietnam is extolled as the unequal model of the struggle against Imperialism, the more convenient it is for the rest of the world to close their

eyes on the harrowing difficulties the nation, governed by a large post-revolutionary bureaucracy, continues to face in trying to cope with the challenge of recovery. (Even when the possessive pronoun "my" is liberalistically bracketed), whose Vietnam is the Vietnam depicted in Hollywood films, as well as in the daily news and television series that offer "fresh action from Vietnam into our living rooms each evening" (Time-Life Books brochure on *Vietnam: A Television History*) and claim to deliver "the entire story of what really happened in Vietnam" in a few hours for VCR owners? Whose Vietnam is the one presented in *The Vietnam Experience* book series, "the definitive work on the Vietnam conflict . . . the whole explosive story . . . the whole astonishing truth. . . . More colorful than any novel, more comprehensive than any encyclopedia"? Whose conflict triumphantly features in "The TV war"? Whose experience finally does Time-Life Books posters herald in its large, bold title-letters as being exclusively that of: "The Men, The Weapons, The Battles"?

Contrary to what has been affirmed by certain Vietnam experts, America's concept of its own "exceptionalism," which is said to have nurtured the roots of American intervention in the war, did not die on the shores of Vietnam. It is still well and alive even in its most negative aspects. Vietnam as spectacle remains passionately an owned territory. Presented through the mediation of the dominant world forces, she only exists within the latter's binarism; hence the inability to conceive of her outside (or rather, in the gaps and fissures, in the to-and-fro movement across the boundaries of) the pro-communist/anti-communist opposition. Every effort at challenging such reductive paternal bilateralism and at producing a different viewing of Vietnam is immediately recuperated within the limit of the totalized discourse of red is red and white is white. Not every Vietnam anti-war demonstration effort was based on an advocacy of socialism, or on an elaborate questioning (instead of a mere moral condemning) of imperialism. Nor was every demonstration based on an extensive interrogation of the territorial and numerical principle of the war machine whereby the earth becomes an object. It is interesting to note the extent to which common reactions presented as oppositions to the government's stance often involuntarily met the latter's ultimate objective in its foreign interventions, which was that of defending and promoting a specific lifestyle – the world of reification. Thus, despite the anti-war denotation of such a comment as: "It seems like we're always getting pulled in by other people's problems. We've got enough problems of our own to deal with," what is also connoted is a certain myopic view of America's "goodwill," which reduces the rest of the world to "beggars" whose misery does not concern us, because *We have our own* beggars here at home.

While in Vietnam, Party officials readily acknowledge the severity of their economic crisis and even feel the urge recently to publicly declare that "only when we no longer refuse, out of fear, to admit our own failures and oversights, only when we can squarely face the truth, even if it is sad, only then can we learn how to win" (Secretary General Nguyen Van Linh, October 1988); while in Vietnam, women reject the heroic-fighter image the world retains of them, and vocally condemn the notion of heroism as being monstrously inhuman,[22] numerous foreign sympathizers continue to hold fast to the image of an exemplary model of revolutionary society

and to deny the multifacet problems the regime has been facing. Thus, all reflections on socialist Vietnam which do not abide by a certain socialist orthodoxy, positively embrace the system, and postulate the validity of its social organization, are crudely distorted as they are forced into the mold of hegemonic worldview and its lifelong infatuation with binary classifications: pro-communist/anti-communist, left/right, good/bad, victory/failure. *"I am not a Marxist!" exclaimed Marx in despair of his disciples.*[23] In fact, it is imperative that socialist Vietnam remains "pure" and that it continues to be unconditionally praised, for, through past denunciations of "America's most controversial war," America can still prove that it is not entirely wrong, that "the Vietnam failure" should be attributed to a guilty government but not to "the American people." The West's friendliness and benevolence toward its Others often consists of granting itself the omnipotent rights to counteract its government and to choose, as circumstances dictate, when to endorse or when to detach itself from its institutions, while members from the Third World are required to stand by their kinsmen – government and people alike – and urged to show the official seal of approval "back home" wherever they go, in whatever enterprise they undertake . . .

The Commodity contemplates itself in a world it has created. And this world it has created is *boldly* that of "The Men, the Weapons, the Battles." To say that the spectacle is always masterly owned and that it aspires to genderlessness is to indulge again and again in redundancy. But repetition is at times necessary, for it has a function to fulfill, especially when it does not present itself as the mechanical recurrence of sameness, but rather, as the persistence of sameness in difference. If in Dogon rituals men also "have their periods" and their days of "impurity," no such reversal seems to be tolerated in a male-centered context where the concept of gender is irremediably reduced to a question of sexual difference or of universal sex opposition. And since in such opposition, priority is always given to literal reading and to the validation of "evidences" (essences), rather than to the interrogation of representation, the tools of (gender) production are bound to remain the Master's (invisible) tools. (Thus, reacting to a film in which women's sufferings have been commented upon by numerous women viewers as being "very intense and depressive," a male viewer blurted out, after having uneasily tried to put forth a lengthy weasel-worded question he has embarked upon: ". . . The subject of the film is so partial . . . Don't you think it overshadows the rest of the issues? . . . I mean, how can one make a film on Vietnam, where there is so much sufferings [*sic*] and focus on women?" A number of women in the audience express their approval, others hiss.) While the male-is-norm world continues to be taken for granted as the objective, comprehensive societal world, the world of women subjects(ivities) can only be viewed in terms of partiality, individuality, and incompleteness. The tendency is to *obscure* the issue of women's oppression or of women's autonomy in a relation of mutual exclusiveness rather than of interdependency. The impetus of the positivist project is first and foremost to supply answers, hence the need to level out all forms of oppression into one. *"Not only has the question of women's liberation traditionally been bypassed by revolutionary organizations in the Third World (as it has in the West), but (again this applies to groups in the West) it has also become a target for hostility from the Left. . . ."* (Miranda Davies).[24]

In the society of the male-centered spectacle, gender will always be denied, even and especially when the spectacle exalts feminism (heroic workers who are also good mothers and good wives). For, what the humanism of commodity markets is not two, three, but one, only One feminism. One package at a time in a policy of mutual exclusion. *"To deny gender, first of all, is to deny the social relations of gender that constitute and validate the sexual oppression of women; and second, to deny gender is to remain 'in ideology,' an ideology which . . . is manifestly self-serving to the male-gendered subject"* (Teresa de Lauretis).[25] The dogmatic, hence genderless mind has never been eager to ask why, for example, the bright red flowers of the Kapok tree are associated with menstruation and death in a context where "bad blood" is identified with dark, coagulated blood. As mentioned earlier, "impurity" is the interval in which the impure subject is feared and alienated. It is the state in which the issue of gender prevails, for if red defies all literal, male-centered elucidation, it is because it intimately belongs to women's domain, in other words, to women's struggles. To say this is simply to recognize that the impure subject cannot but challenge hegemonic divisions and boundaries. Bound to other marginalized groups, women are often "impure" because their red necessarily exceeds totalized discourses. In a society where they remain constantly at odds on occupied territories, women can only situate their social spaces precariously in the interstices of diverse systems of ownership. Their elsewhere is never a pure elsewhere, but only a no-escape-elsewhere, an elsewhere-within-here that enters in at the same time as it breaks with the circle of omnispectatorship, in which women always incur the risk of remaining endlessly a spectator, whether to an object, an event, an attribute, a duty, an adherence, a classification, or a social process. The challenge of modifying frontiers is also that of producing a situated, shifting, and contingent difference in which the only constant is the emphasis on the irresistible to-and-fro movement across (sexual and political) boundaries: margins and centers, red and white. It has often been noted that in China ink painting there is a "lack of interest in natural color." One day, someone asked a painter why he painted his bamboos in red. When the painter replied "What color should they be?," the answer came: "Black, of course."

Notes

1 In *Wit and Humor from Old Cathay*, trans. J. Kowallis (Beijing: Panda Books, 1986), p. 63.

2 A sentence borrowed from Paul Eluard's poem "La Terre est bleue," in *Capitale de la douleur* (1926; rpt., Paris: Gallimard, 1966), p. 153.

3 Irwin R. Blacker, *The Elements of Screen-writing: A Guide for Film and Television Writing* (New York: Collier Books, 1986), p. 48.

4 From Arthur Rimbaud's poem "Voyelles," in *Rimbaud: Complete Works*, trans. W. Fowlie (Chicago: Chicago University Press, 1966), p. 121.

5 In *China After Mao: A Collection of Eighty Topical Essays by the editors of Beijing Review* (Beijing: Beijing Review, 1983), p. 115.

6 *Antonio Gramsci: Selected Writings 1916–1935*, ed. D. Forgacs (New York: Schocken Books, 1988), p. 321.

7 Jean Baudrillard, *In the Shadow of the Silent Majority* (New York: Semiotext(e), 1981), p. 105.

8 Guy Debord, *Society of the Spectacle* (1967; rpt., Detroit: Black & Red, 1983), p. 82.

9 Raoul Vaneigem, *The Revolution of Everyday Life*, trans. D. Nicholson-Smith (London: Left Bank Books & Rebel Press, 1983), p. 23.

10 Johannes Itten, *The Elements of Color*, trans. E. Van Hagen (New York: Van Nostrand Reinhold, 1970), p. 86.

11 For more information, see Geneviève Calame-Griaule, *Ethnologie et langage: La Parole chez les Dogon* (Paris: Institut d'ethnologie, 1987), pp. 136, 246.

12 Discussion of the symbolics of red among the Dogon is based on the above book by G. Calame-Griaule.

13 In *Foucault Live: Interviews 1966–84*, trans. J. Johnston, ed. S. Lotringer (New York: Semiotext(e), 1989), pp. 99–100.

14 Debord, *Society of the Spectacle*, p. 53.

15 Roland Barthes, *The Rustle of Language*, trans. R. Howard (New York: Hill & Wang, 1986), p. 63.

16 Michel Foucault, "The Subject and Power," in *Art After Modernism, Rethinking Representation*, ed. B. Wallis (New York: The New Museum of Contemporary Art and MIT Press, 1984), pp. 429–30.

17 Baudrillard, *The Silent Majority*, p. 18.

18 See Julia Lesage, "Why Christian Television Is Good TV," *The Independent*, vol. 10, no. 4 (May 1987): 18.

19 Michael Novak, "Television Shapes the Soul," in *Television: The Critical View*, ed. H. Newcomb (New York: Oxford University Press, 1982), pp. 343, 346.

20 Lesage, "Christian Television," p. 15.

21 Quoted in Stanley Karnow, *Vietnam: A History* (New York: Penguin, 1983), pp. 27–8.

22 See interviews with Thu Van and Anh in Mai Thu Van, *Vietnam, un peuple, des voix* (Paris: Editions Pierre Horay, 1982).

23 Quoted in *Marxism and Art*, ed. Maynard Solomon (Detroit: Wayne State University Press, 1979), p. 12.

24 Miranda Davies, ed., *Third World Second Sex: Women's Struggles and National Liberation* (London: Zed, 1983), p. iv.

25 Teresa de Lauretis, *Technologies of Gender* (Bloomington: Indiana University Press, 1987), p. 15.

Part IV Rethinking Aesthetics

Introduction to Part IV

S ince postmodern thought brought forth a re-evaluation of modern supposi-
tions of originality, authenticity, and transcendental Western, masculine sub-
jectivity, art discourse in general has been marked by an emphasis on the
institutional and historical condition of reception, and the production of meaning
outside of a fictional universal standard. Aesthetics, likewise, have been submitted to
a rethinking that challenges the criteria under which modern art was judged. The
relationship between form and meaning, crucial to the foundation of aesthetic judg-
ment, lies at the center of these texts. Yet each argument here is augmented by a
deeper problem, namely: how do the recent developments and theorizations of art-
istic forms affect the formation of aesthetic categories and judgments? In this sense, the
rethinking of aesthetics is intrinsically linked to an expansion of consciousness previ-
ously uncharted within the medium-specific areas of expertise under which modernism
was organized. Ranging from historical materialist to deconstructionist perspectives,
the essays in this section ask the reader to think across categories: photography and
painting; formalist aesthetics and the politics of difference; Western avant-garde and
postcolonial history; architecture and art; and modernist and postmodernist concepts
of subjectivity and site.

Over the course of the last two decades, Gerhard Richter emerged as one of the
most significant painters of our time. Born in East Germany, Richter moved to the
West shortly before the erection of the Berlin Wall, and has since produced a body
of paintings that reflect on the art-historical legacies of the last 40 years. In a short
essay entitled "A Note on Gerhard Richter's *October 18, 1977*," art historian and critic
Benjamin H. D. Buchloh, who has written extensively on Richter, discusses a set of
paintings completed in 1988. For Buchloh, *October 18, 1977*, based on photographic

images of a 1970s terrorist group called the Baader-Meinhof Group, is a significant event in both Richter's oeuvre and in the history of painting. Buchloh asserts that in taking a recent historical event, the memory of which was strongly repressed by the West German state, and in transforming that event into a project that reflects on painting, photography, and historical consciousness in equal parts, *October 18, 1977* achieves the difficult task of "history painting," considered challenging in light of the invention of photography, and almost impossible in the age of mass-media dominated by "the culture industry."

David Joselit's essay, "Notes on Surface: Toward a Genealogy of Flatness," continues the historical debate around painting. The story of the progress of the visual in modern art is intrinsically tied to painting's ability to perform representation outside itself. The development of non-representational, abstract painting – the formal, material analogue to the notion of "aesthetic autonomy" under modernism – was theorized by Clement Greenberg as the emphasis on an engagement with the flat surface of the painting's canvas over its traditional task of mimesis. For Greenberg, the aesthetic withdrawal from illusion toward a concentration on the inner logic of the medium was a means to combat the ubiquitous onslaught of kitsch mass culture imposed on society since industrialization. Joselit's essay takes this Greenbergian legacy to task not by disputing his modernist argument, but by closely analyzing the meaning of flatness and surface in Greenberg's writings and juxtaposing it with an altogether different postmodern interpretation. His discussion of four artists' explorations of flatness, in the work of Jackson Pollock, Jasper Johns, David Hammons, and Kara Walker, follows Michel Foucault's theorization of disciplinary effects on the modern body. Joselit argues that the flatness of postmodernism's surface, developed in the age of technological info-media, posits it as a primary political site of our time. For Joselit, in order to function in the realms of postmodern politics and aesthetics, we must confer upon the metaphor of surface a deeper appreciation and understanding, for the trading in surface has become "the necessary condition of entering the public sphere in the world of late capitalism."

If for Joselit flatness and surface are an example of the interrelationship between content and form at the complex ideological juncture of the modern and postmodern, for Wu Hung, the figures of "the ruin" and "fragmentation" function similarly within the recent history of Chinese art. His text, "Ruins, Fragmentation, and the Chinese Modern/Postmodern," demonstrates that the rigorous study of "form" from a historical perspective produces for us new questions about the migration of aesthetic influence and authority. In the absence of what Alois Riegl called a "modern cult of the ruin," or a revolutionary heroism and invention associated in the West with fragmentation in Western historical modernism, the same signs as deployed by contemporary Chinese artists such as Zhan Wang and Huang Yong Ping function with a related but distinct set of meanings. The genealogical signposts that mark the circulation of these aesthetic themes are starkly related to Chinese history: the domination of China by foreign forces, twentieth-century internal strife, the Cultural Revolution, and rapid economic growth. Wu Hung's tracing of the development of form and

motif can thus be read not only in relation to the subject of contemporary Chinese art, but also as a reminder of the asymmetric development of form across cultures.

Continuing the rethinking of aesthetics, Nana Last, an architect and architectural theorist, addresses the contemporary dialectic between art and architecture. During the last decade, design and architecture have entered into the collective consciousness as never before. The rise of architecture as a signifier for cultural capital coincided with the turn of the new millennium, when museums and other cultural institutions began to diversify their functions and lend their cultural legitimacy to state and corporate interests and programs of urban renewal. Since the 1990s, and into the twenty-first century, perhaps one of the most effective ways for a city (e.g. Bilbao or Berlin) to rehabilitate its identity in the age of corporate expansion was to commission a new building (often a museum) by a well-known architect. The advent of new technologies allowed for previously unbuildable structures to take form, thus facilitating the realization of a host of buildings oriented increasingly around visual rather than architectonic concerns. During this time the work of many artists also followed a similar logic, and the blurred distinction between art and architecture became a focus of the discourses in both fields.

Against this backdrop, Nana Last's essay "Function and Field" re-engages a debate set in motion by Peter Eisenman 30 years earlier. In the early 1970s Eisenman, captivated by conceptual art and how it radicalized art practice, proposed a similar re-evaluation of architectural practice by outlining a treatise on "conceptual architecture." However, at the same time that Eisenman called for a radicalization, he was anxious about the loss of architecture's identity. To guard against this dissolution, Eisenman posited "function" as the irreducible term under which architecture must organize itself. Last's critique centers on this ideology of "functionalism," concentrating in particular on how it operates to limit conceptual and aesthetic possibilities. Focusing on the critical reception of the work of Jorge Pardo, whose art practice overlaps substantially with design and architecture, Last interrogates the inherently conservative impulses at work in both art and architectural discourses, and asks for a reappraisal of the potential of meaningful conceptual practice across art and architecture.

The provocative title of Juli Carson's text, "1989," refers to a historical moment discussed elsewhere in this volume by Carole Vance, when the conservative attack on public funding for the arts was at its peak. This political moment sets the stage for the nominal event in Carson's text – the removal of "Tilted Arc," a public sculpture by Richard Serra, after a rancorous decade-long trial. Indeed, before minority sexuality became the settled-upon scapegoat of far right attacks, questions about the legitimacy of public art funding found their target in "Tilted Arc." The argument in Carson's text revolves around a gap between the theorization of Serra's concept of "site-specificity," based on a modernist notion of presence, and the defensive claims made for it in the midst of its trial. Tracing the genealogy of form in the expanded field of sculpture, Carson claims that Serra's site-specific practice is a transitional model between the modern and the postmodern. Although Serra set up his practice against Greenbergian modernism, Carson asserts that it in fact reinstates modern

aesthetic criteria in its demand for a unitary subject of an abstract public space. Conceived not as a negative pronouncement on Serra's practice but as a close reading of its philosophical foundations, "1989" is a formulation of a "theory of reception," characteristic of the historical transition into contemporary thinking on aesthetics.

22 A Note on Gerhard Richter's *October 18, 1977*

Benjamin H. D. Buchloh

Even amnesia suffers from the compulsion of being unable to forget; that is what we call repression.

<div align="right">

Jürgen Habermas, "Keine Normalisierung der Vergangenheit"

</div>

The group of paintings entitled *October 18, 1977* that Gerhard Richter completed in the late fall of 1988 immediately confronts its viewers with the question of the very possibility of representing history, both in contemporary painting and in modernism in general. Despite their apparent continuity with Richter's early photopaintings,[1] these paintings in fact constitute the first attempt in Richter's oeuvre to address historically specific public experience. The two earlier series of paintings that one could most easily identify as the precedent for the new series would be the *Eight Student Nurses* (1966) and the *48 Portraits* (1971–2). As depictions of recent murder victims,[2] on the one hand, and as presentations of figures of public history, on the other, however, a comparison with these two groups instantly clarifies their distance and their difference from the paintings *October 18, 1977*. Richter's recent decision to represent current public history, that is, simultaneously to violate the prohibition against representing historical subjects in modern painting and to break the taboo against remembering this particular episode of recent German history – the activities of the Baader-Meinhof Group and the murder of its members in Stammheim Prison – distinguish these paintings from all earlier works by Richter.

From *October* 48 (spring 1989): 88–109. Copyright © 1989 by October Magazine Ltd and the Massachusetts Institute of Technology.

Figure 22.1 Gerhard Richter, *Confrontation 2 (Gegenuberstellung 2)* 44 × 40¹⁄₄ in. (112 × 102 cm), from *October 18, 1977 (18. Oktober 1977)*, fifteen paintings, oil on canvas; installation variable, 1988. Courtesy Marian Goodman Gallery, New York.

That this group of paintings was first exhibited in a building by Mies van der Rohe seems an appropriate historical accident,[3] for Mies is the architect who constructed the only German contribution to public monumental sculpture in the twentieth century, devoting it to the memory of the philosopher Rosa Luxemburg and the revolutionary Karl Liebknecht, both of whom had been murdered by the Berlin police. This coincidence establishes a continuity between a bourgeois architect in the Weimar state of the 1920s and a bourgeois painter in the West Germany of the 1980s. And indeed both artists differ from most of their contemporaries in their ability to tolerate, in public view, challenges to the very political and economic system with which they identify as artists. Moreover, through their acts of aesthetic commemoration, they resist the constantly renewed collective prosecution of those victims in the form of their eradication from current memory, thereby dignifying the victims of a state whose opponents they had become because of their public challenge.

The first temptation is to respond to the shock these paintings generate with an art-historical reflex, deflecting their impact by an excursion into the history of history painting. This is especially true because two works within *October 18, 1977 (Funeral* and *Dead Woman)* seem explicitly to establish a reference to two of the central images from the complex prehistory of the destruction of history painting in the nineteenth century.[4]

But the history of history painting is itself a history of the withdrawal of a subject from painting's ability to represent, a withdrawal that ultimately generated the modernist notion of aesthetic autonomy. In this development, forms of traditional representation were divided into, on the one hand, a referential function based on resemblance (a function that photography would increasingly and more convincingly assume beginning in the mid-nineteenth century) and, on the other, the complementary formation, that of a liberation of painterly means, whose lasting and only triumph was to become the systematic negation of the functions of representation. In their refusal either to give up painting for photography *tout court* or to accept the supposed lucidity of photography's focused gaze, Richter's photopaintings have consistently opposed the universal presence of that gaze and its ubiquitous instrumentalization of the look. This has particular importance within the group *October 18, 1977* in relation to a gaze that, in the police-commissioned press photographs that served Richter as a point of departure, seems ritualistically to assure itself of the final liquidation of the enemies of the state. But at the same time this group resists the modernist restriction of painting to a mediation of historical experience exclusively in the discursive reflection on the evolution, the materials, and the procedures of the pictorial medium itself. It is in the construction of this dilemma, marked by both the conflict in medium – painting/photography – and the conflict in ideas about representability – the painting's self-referenciality/photography's "transparency" to the event – that Richter's work testifies to the contemporary difficulties in the production of historical representation in painting.

The inability of painting to represent contemporary history resulted first of all from the transformation of historical experience into an experience of collective catastrophe. It therefore seemed that only photography, in its putative access to facticity and objectivity, could qualify as an instrument of historical representation. Secondly, insofar as catastrophe democratizes historical experience, it also destroys the artistic claim to a privileged mode of seeing and of historical interpretation. This has become most evident in the work of Andy Warhol, in which the long and complicated process of the democratic experience of catastrophe and the mechanical representation of death are integrated. In his work, heroes and victims are equally the objects of photographic representation; their only difference lies in the distinction between "famous deaths and anonymous deaths." The nearly unbearable cruelty of the photographic detail in Warhol's paintings (Warhol selected archival photos of accidents which had even been rejected as unpublishable by the tabloids) goes hand in hand with the laconic and affectless execution of the representation. The de-differentiation of the artistic process corresponds to the arbitrary fatality and the utter desublimation of the experience of death.

Since the mid-1960s Richter has been engaged in a dialogue with Warhol's painting, a dialogue in which the differences have been occasionally obscured by an emphasis on the parallels between their points of departure. The construction of an "iconography of death" by art historians concerned with this period – an "iconography" that supposedly links the work of the two artists – has especially failed to clarify how Richter's *48 Portraits* should be distinguished from Warhol's *13 Most-Wanted Men*

Figure 22.2 Gerhard Richter, *Man Shot Down 1 (Erschossner 1)*, 39¹/₂ × 55¹/₄ in. (100.5 × 140.5 cm) from *October 18, 1977 (18. Oktober 1977)*, fifteen paintings, oil on canvas; installation variable, 1988. Courtesy Marian Goodman Gallery, New York.

(1964). Nor is this construction able to address the manner in which the new series, *October 18, 1977*, redeems this dialogue with the 1960s, especially the implied anni-hilation in Warhol's work of the last possibility of constructing historical memory through the means of painting.

In distinct contrast to Warhol's work, the victims in Richter's recent paintings are not the victims of anonymous accidents, but are agents within a historically specific moment. In further contrast to Warhol's, Richter's paintings do not affirm collective amnesia of the experience of death; rather they attempt to construct a pictorial representation of the act of recalling and understanding personal experience in its relation to history. In this respect Richter's paintings constitute a European inversion of Warhol's position of anomy with regard to history. Inasmuch as they emphasize the individual's capacity to act (both that of the individuals depicted and that of the individual depicting, the painter), they insist on this capacity as a necessary condition of contemporary artistic production. In that respect *October 18, 1977* resembles the representation of Stephen Biko, the South African revolutionary, in Hans Haacke's work *Voici Alcan* (1983), a relationship which Richter's painting generally would not have called to mind.

If Richter's *October 18, 1977* works reflect the difficulties of painting to engage now in the representation of contemporary history, their very unexpected commitment to historical subject matter also comments implicitly on other contemporary practices

Figure 22.3 Gerhard Richter, *Hanged (Erhangte)* 6′7⅛″ × 55⅛″/201 × 140 cm from *October 18, 1977 (18. Oktober 1977)*, fifteen paintings, oil on canvas; installation variable, 1988. Courtesy Marian Goodman Gallery, New York.

of history painting in Germany. Clearly Richter's struggle with the issue of historical representation begins in his assumption that the historical dimension of painting is primarily the discursive history of the medium. By contrast, recent German history painting, the type of "polit-kitsch" produced by a new generation of German artists, has no such struggle to contend with, since it appears to insist that the negation of historical representation in twentieth-century painting was at best a brief interlude, a failure that has to be redressed – as though such artists as Mondrian and Newman had voluntarily deprived themselves of the capacity to represent the "historical."[5]

Richter has articulated his explicit resistance to this type of historical grave-robbery, especially in the last six years, by recuperating historically inaccessible pictorial types such as the still-life-as-*memento mori*, to which his *Skulls* and *Candle* paintings refer. This recuperation, however, acts explicitly as a resistance to false immediacy and

to the claim that the irreversible loss of these categories of painterly commemoration could be redeemed. What is convincing in Richter's *Skulls* and *Candle* paintings is their character as grotesques: they brilliantly perform the purely technical availability of these pictorial types while at the same time they publicly invalidate any actual experience once conveyed by this genre. But since the paintings *October 18, 1977* are as different from this mode of the grotesque as they are from the early photopaintings to which at first glance they seem to return, it seems all the more difficult to clarify their attitude toward the historical subject. Unlike most contemporary German painting, which simply ignores the fact that the prohibition of representation itself has become an irreversible historical reality that can only be ignored at the price of mythicizing painting, Richter's nonetheless insists on transcending that irreversible historical fact with the very means of painting.

But if painting's own recent history raises barriers to the accessibility of a language with which to represent historical and political fact, the historical field itself is riddled with instances of amnesia about specific events, making it clear that history's own accessibility to itself is at issue. "Polit-kitsch" painting is as unconcerned with this second issue as it is with the first, having settled into the comfort of a repetitively enacted, gratuitous ritual of engaging with history without even addressing the concrete instances of actual recent repression.

Richter's shift from the current fashion within German painting – the fashion for pointing to the history of fascism – to an attempt to recall the seemingly inaccessible moment of extra-parliamentary opposition and its terrorist consequences in the history of the Baader-Meinhof Group and the Red Army Faction thereby also implies a criticism of the irresponsible dabbling in the history of German fascism with the meagre means of generally incompetent painting. At the same time, it is also an attempt to reflect upon the actual power of contemporary repression and, through Richter's own pictorial means, to transform this power of repression into the question of its very representability.

The extent to which the Baader-Meinhof Group has in fact become the object of collective repression (or the object of internalized state censorship) is reflected in the fact that only rarely – as in the case of Joseph Beuys's spontaneous declamation *"Dürer, I will personally guide Baader and Meinhof through Documenta V"* (1972) and Alexander Kluge's cooperative film project *Germany in Autumn* (1977–8) – has an artistic project addressed this particular subject. The film *Introduction to Arnold Schönberg's Accompaniment to a Cinematographic Scene* (1972), by Jean-Marie Straub and Danièle Huillet, was banned from German television because it was dedicated to the memory of Holger Meins, a young film director who had participated in the activities of the Baader-Meinhof Group and became one of the victims of the events at Stammheim Prison (events surrounding the deaths of the five members of the group, which were presented as a collective suicide, but were suspected of having been, instead, a state-ordered police assassination).

In order to recall the collective inability of West Germans to reflect upon the history of the most radical challenge to their postwar economic and political order,

we should compare it to the way the Italian government succeeded in treating an incomparably larger, more efficiently organized anarchistic opposition movement at the same time. The astonishment of the German reader at this comparison (perhaps also that reader's secret shudder at the contemplation of Italian liberality in the treatment of the enemies of the state) becomes apparent in a recently published essay by the German historian Arnulf Baring:

> One consequence was the enormous movement of left-wing terrorism haunting Italy in the 1970s. . . . One almost spoke of an armed party. The number of arrests surpassed several thousands. State-of-emergency laws were introduced, and one of the most important politicians of Italy, Aldo Moro, was kidnapped and murdered. It is all the more remarkable to see to what extent the Italian state remained willing to communicate and negotiate: after only a few years the conflict that had approached civil war was successfully defused and finally resolved. According to Bolaffi it was the intervention of the Catholic church in particular that allowed for a reconciliation within a brief period of time. The sentences of those convicted were reduced, their living conditions in the prisons were improved, and many of them were granted early release.

In comparison it seems that throughout the 1970s the German state was unable to afford such a degree of tolerance. Even at the end of the 1980s its citizens seem to have difficulty developing even the mnemonic basis for reconciliation. The intended effect of the elimination of this group, however, was clearly accomplished: not only has their history become the object of collective repression, but, at the same time, the project of an extra-parliamentary opposition and the active presence of a radical, interventionist critique of the social order (euphemistically called the society of consumption) has been eradicated.

Richter's *October 18, 1977* attempts to initiate a reflective commemoration of these individuals, whose supposed crimes remained to a large degree unproven (despite years of pretrial investigation, which never even resulted in an indictment), as was that crime (never even investigated) whose victims they became. These paintings contradict the present historical moment, which prohibits reflection on the activities of one of the most important left-wing journalists and pacifists of postwar Germany, Ulrike Meinhof, a young literary historian, Gudrun Ensslin, and a young film director, Holger Meins.

In their engagement with a historical subject the new paintings are no more desperate than are Richter's abstract paintings in *their* engagement with the very possibility of painting. Since, therefore, both series are focused on the crisis of contemporary *painting*, that crisis is reflected upon along its various axes: production no less than reception. In his explicit refusal to break the group of paintings *October 18, 1977* into individual objects or to have them enter into the usual channels of market distribution, Richter contests, even if in a singular construction of an exceptional situation, the current modes of consumption as the exclusive form of responding to artistic practice.

Figure 22.4 Gerhard Richter, *Funeral (Beerdiggung)* 6′6³/₄″ × 10′6″ (200 × 320 cm) from *October 18, 1977 (18. Oktober 1977)*, fifteen paintings, oil on canvas; installation variable, 1988. Courtesy Marian Goodman Gallery, New York.

Notes

1 *Photopainting* is the term Richter uses for that type of painting – appearing in his oeuvre since 1962 – based on the projection of found photographs.

2 *Eight Student Nurses* is a group of portraits based on newspaper images of the victims of the Chicago mass murderer Richard Speck.

3 *Oktober 18, 1977* was first shown at the Museum Haus Esters, Krefeld; see the catalogue *Gerhard Richter/18. Oktober 1977*, Cologne, Verlag der Buchhandlung Walther König, 1988, in which the present text originally appeared together with essays by Stefan Germer and Gerhard Storck.

4 The former has inevitable associations with Courbet's *Burial at Ornans* (1849–50), the latter with Manet's *Dead Toreador* (1864).

5 "It seems that the one attitude starts from the assumption that the work of distanciation and comprehension opens up a space for commemoration and the autonomous confrontation with ambivalent historical legacies, while the other attitude would like to employ a revisionist history in order to revamp its concept of traditional identity for the sake of reconstituting a national history" (Jürgen Habermas, "Apologetische Tendenzen," in *Eine Art Schadensabwicklung* (Frankfurt/Main: Suhrkamp, 1987), p. 133). Anselm Kiefer is only the most prominent of the German artists who have modeled themselves on concepts that Habermas has defined as "traditional identity." In the course of their restoration of these concepts, these artists have produced a type of work – now widely disseminated and producing its own kind of fall-out in North America as well – that can best be identified as

polit-kitsch. Its attraction seems not only to be its reconstitution of traditional identity for the generation of West Germans who wish to abandon the long and difficult process of reflection upon a post-traditional identity. The attraction of polit-kitsch also appears to be – and herein lies its international appeal – its reconstitution of the *artistic* privilege associated with the traditional identity, i.e., the claim to have privileged access to "seeing" and "representing" history.

During the planning stages of the recent Anselm Kiefer retrospective – the largest and most important commitment, ever, to a postwar European artist by the four major American museums involved – one of the curators gave me an unforgettable answer to a naive question. Having asked whether, as an art historian, he did not first feel the need to exhibit the work of a major artist of the '60s generation – an artist such as Gerhard Richter – before according such an enormous retrospective to a relatively young artist of the current generation, he said briskly, "Kiefer is sexier than Richter." The quip has stayed with me for several reasons. First, it constituted my initial encounter with the language of the new managerial type of curator, a type that has increasingly replaced the traditional curator, who perceived him- or herself essentially as a scholar in the service of an institution of the public sphere. Condensed as this casual remark may have been, it nevertheless indicated that the managerial curator would conceive exhibitions on the model of the advertising campaign and seasonally determined product innovation.

Second, the quip suggested to me that expectations for and responses to certain contemporary art production exceeded even the most pessimistic predictions for the future of high culture by, for example, the Situationists. The particular fusion (and confusion) of separate modes of experience that the curatorial quip performed proved that the social tendency that forces the work of art to function as a mere fetish of sign exchange-value had already been fully accepted as a commonplace.

23 Notes on Surface

Toward a Genealogy of Flatness[1]

David Joselit

I

When I think about *surface* I think of an advertisement I have seen in several of the gay publications which are distributed free in my Los Angeles neighbourhood. It shows a man with gelled hair, dramatic eyes and high cheek bones, whose face is framed by the following text: "Beautiful? Sure./ Real? Who cares!" The ad is one of many promotions for elective plastic surgery published in the popular press – gay and straight alike – of southern California. What fascinates me about this particular exhortation to remake the body pivots on the word *real*. Clearly, for the ad writer (as well as for the man represented and for the presumed readers), the *real* does not carry the Lacanian perfume it may emanate for readers of this text. Rather, it is intended to signify "authentic", and authenticity is dismissed with a campy shrug: "Who cares!" But if this exclamation is accurate – if no one cares – then why does the ad take pains to preempt the anxieties it appears to disavow? For indeed, the question the advertisement asks in spite of itself – its repressed returning – is the following: "If your face isn't real, what is?" This is a question whose significance I believe goes far beyond the precincts of the pulp press. If our bodies are as malleable as the surgeons wish us to believe and if genetic science has proven that the texture of our organic envelope is in fact a code, then where is it that we can lodge the self? Is it, as popular psychology has it, some interior essence – some inner child – or does it inhere in the changeable surfaces of the body? The

From *Art History* 23, 1 (March 2000): 19–34. Reproduced with permission of Blackwell Publishing Ltd.

radical possibility encoded in the "Who cares!" of our advertisement is the collapse of this dichotomy. Forget about the real, it does not exist, or it is everything that exists: *Who cares!*

This, I think, is the ethical riddle which haunts a complex and contradictory field of discourses on flatness and depth within art history. It is well known but little acknowledged that flatness, which is traditionally associated with a teleological progress toward self-referentiality within modern painting, has also served as the reigning metaphor of its supposed negation, postmodernism. Listen to Fredric Jameson:

> A new kind of flatness or depthlessness, a new kind of superficiality in the most literal sense [is] perhaps the supreme formal feature of all the postmodernisms to which we will have occasion to return. . . .[2]

The kind of flatness Jameson theorizes is characterized by pastiche and simulation: it is the postmodern face of the surgically enhanced model in the advertisement I have been describing. But is Jameson's flatness the same species of flatness that Clement Greenberg posited as a fundamental characteristic of modern painting? My answer to this question is "yes and no" and the purpose of this essay is to sketch such a response. For in my view the "flatness" of modernism is not merely an optical event: the emergence of the flat painting marks a transformation in spectatorship in which mimetic identification with the picture is displaced by the private kinesthetic experience of the viewer. The event, as it were, moves from the conscious to the unconscious. To put it schematically, abstraction functions as a machine for recording the psychological responses of the artist in order to produce (perhaps dramatically different) psychological responses in the viewer. The depth it exhibits, I will be arguing, is psychological. In art designated as *post*modern on the other hand, a different articulation of flatness and depth arises. In such works not only optical but *psychological* depth undergoes deflation, resulting in a visuality in which identity manifests itself as a culturally conditioned play of stereotype.

Because the term *flatness* seems to have stealthily crossed and recrossed the modern/ postmodern divide, I have chosen it as a wedge with which to break apart what I see as a false opposition between movements. While the concept of flatness has traditionally served to balkanize modernism, I intend to maintain its several and contradictory meanings in order to weave together a different account of twentieth-century art. I regard such an analytic project as more than an exercise in re-categorization. In order to dislodge accounts of modern art from the impacted Greenbergian tradition which persists as much in its ritual negation as in its much rarer affirmation, it is necessary to re-articulate his critical terms. But rethinking modernism is only one of the benefits of engaging once more with flatness: the term possesses significant explanatory force in analysing so-called postmodern art as well. There is a great deal at stake in acknowledging that the flatness or depthlessness we experience in our globalized world is more than an optical effect. I will argue that flatness may serve as a powerful metaphor for the price we pay in transforming ourselves into images – a compulsory self-spectacularization which is the necessary condition of entering the public sphere in the world of late capitalism.

II

Clement Greenberg understood that even in the flattest of modernist paintings a spectator's perception and expectation of depth could not be banished. Instead, depth was encoded, displaced, or signified within the shallow surface of the painting. One of his greatest contributions as a critic was to develop a sophisticated lexicon of such strategies. I will enumerate three of them. Firstly, he saw in collage the elaboration of what might be called a "reverse-depth": a literal building-out from the picture plane rather than an illusionist recession beyond it. As he wrote in 1948, in a review of the exhibition *Collage*:

> the next step in the denial of illusion was to lift the extraneous elements above the surface of the picture and secure the effects of depths and volumes by bringing this or that part of the picture physically close to the eye, as in bas-relief.[3]

The second form of optical displacement Greenberg identifies is what he calls "tautness of feeling", or a compression into shallow relief of the deep illusionistic spaces of pre-modernist painting. In a 1952 essay he describes it in this way:

> Tautness of feeling, not "depth," characterizes what is strongest in post-Cubist art. The taking up of slack, the flattening out of convexities and concavities – the ambitious contemporary artist presents, supposedly, only that which he can vouch for with complete certainty; he does not necessarily exclude, but he distrusts more and more of his emotions.[4]

The third means of displacing depth is to transpose illusionistic recession into lateral extension. Greenberg elaborates this concept in his important essay "'American-Type' Painting", originally published in 1955. In this text he writes:

> That these pictures were big was no cause for surprise: the abstract expressionists were being compelled to do huge canvases by the fact that they had increasingly renounced an illusion of depth within which they could develop pictorial incident without crowding; the flattening surfaces of their canvases compelled them to move along the picture plane laterally and seek in its sheer physical size the space necessary for the telling of their kind of pictorial story.[5]

This triple enumeration of a vestigial depth within "American-Type" painting – in the "reverse-depth" of collage, through spatial compression or "tautness", and in the lateral extensions of monumental canvases – is both prescient and convincing. But Greenberg's exclusive focus on the optical occludes an equally, if not more important allegorical dimension of depth in Abstract Expressionism – one which is fundamental to the painting of Jackson Pollock.

This allegory arises from the conviction, shared equally by Pollock and his critics, that gestural painting emerges from an inner source – a *psychological depth*. Pollock's

interest in the unconscious is well documented, as is his assertion, in a statement of 1951, that "The method of painting is the natural growth out of a need. I want to express my feelings rather than illustrate them. Technique is just a means of arriving at a statement."[6] Despite the hundreds, if not thousands, of times this equation between emotion and abstraction has been cited in describing Pollock's art, I do not know if its significance has ever truly been appreciated. How is it that a series of splashes and puddles of paint, handprints and crushed cigarette butts could come, in 1951, to stand for the psychic undergirding of the self? Greenberg was well aware of the paradoxical nature of this association between painterly matter and human emotion. In his defensive review of Pollock's 1948 exhibition at Betty Parsons he wrote:

> As before, [Pollock's] new work offers a puzzle to all those not sincerely in touch with contemporary painting. I already hear: "wallpaper patterns," "the picture does not finish inside the canvas," "raw, uncultivated emotion," and so on and so on.[7]

The list of potential condemnations Greenberg imagines ranges from a form of representation absolutely bereft of affect – wallpaper – to one consisting of nothing but undisciplined affect: "raw, uncultivated emotion". The fact that Greenberg *knows* that a spectator might plausibly have either response (or perhaps both) to Pollock's work leads us to the crux of the problem with an exclusively optical analysis of depth and flatness. For, as is clear in his passage on the "tautness of feeling", which I cited earlier, the three means he identifies of displacing depth onto surface – the reverse-depth of collage, surface tension, and lateral extension of the canvas – are all underwritten by an insistence on *psychological* depth. It is worth revisiting the second passage I cited above to clarify my point:

> Tautness of feeling, not "depth," characterizes what is strongest in post-Cubist art. The taking up of slack, the flattening out of convexities and concavities – the ambitious contemporary artist presents, supposedly, only that which he can vouch for with complete certainty; he does not necessarily exclude, but he distrusts more and more of his emotions.

Greenberg establishes a chain of equivalences between optical qualities and emotional states: tautness of *feeling* is opposed to depth, the "flattening out of convexities and concavities" is linked to what the artist "can vouch for", which turns out to be his authentic emotions – those which have narrowly escaped "exclusion". Flatness here is imagined as a density or even an impaction of feeling. Consequently, depth is bifurcated into emotional and optical registers, and these are engaged in a zero-sum game. According to Greenbergian modernism, the expression of *psychological* depth requires the sublimation of *optical* depth. If, in Pollock's eyes, abstraction was a technique for performing an emotional need, in Greenberg's formulation the converse is true: optical modernism is legitimated by the painter's emotions. It is only those emotions which the painter "can vouch for with complete certainty' which transform apocalyptic wallpaper into some of the greatest painting of the twentieth century. If what I say is correct, Greenberg's cocky advocacy of flatness veils a profound anxiety

over the "legitimacy" of abstraction. For, in this art, optical flatness is validated by psychological depth.

We can describe Greenbergian modernism, then, as a painterly practice in which the artist's unconscious is mortgaged to form. Such a proposition, linking the architecture of selfhood to the invention of aesthetic vocabularies, begs the question of visuality, or the historically specific nature of visibility within the social field. The term *visuality* is a critical category which points to articulations of visual form with extra-aesthetic determinants such as cultural institutions and psychic formations. Visuality consequently encompasses two distinct registers which are thoroughly imbricated in one another: the spectator and the spectacle, patterns of looking as well as habits of form. In my discussion of Greenbergian modernism I have raised an issue which bears on the latter dimension of visuality: What is the association between abstraction and psychic affect? This venerable question in twentieth-century art history and cultural criticism has produced an array of responses ranging between two theoretical positions. On the one hand, there is the Lukácsian condemnation of abstraction as an effect of the alienation – or the *abstraction* – of social relations under capitalism.[8] In this view abstract art transposes the law of universal exchangeability into the arena of arbitrary symbolic form. On the other hand, a tradition runs from Kandinsky to Bretonian surrealism right up to the painters of the New York school, which associates abstraction with the translation of imagination, or the unconscious, into colour and shape. The visuality of early- and mid-twentieth-century abstraction thus emerges from alternating charges of alienation and liberation. But, as Foucault's notion of the "disciplinary" suggests, these qualities form two sides of the same coin: in his analysis the training of docile bodies is shown to be inextricable from the imperative placed upon them to narrate themselves, to "liberate" themselves by putting their desire into discourse.[9]

How might we locate Pollock's painting in this force-field of twentieth-century abstraction? His art of 1948 to 1951 is characterized by an insistent materiality of paint organized into overlapping nets of propelled colour, each reverberating against the others. Encountering these works for the first time a viewer unfamiliar with the history of twentieth-century art might have trouble perceiving anything but a mess of colour resembling the stains on a studio floor.[10] Further attention might reveal a pulsating optical emanation, sometimes dense and glittering, sometimes loopy and dry. But in order to understand what Greenberg or Pollock saw in these paintings one would have to ascribe to them a particular historically specific link between form and emotion. Such a way of seeing, which is neither arbitrary nor inevitable, is what the category of visuality points to. An analysis of Greenbergian visuality must thus make sense of phrases such as "tautness of feeling" with their particular alchemy of the optical and the psychological. To accomplish this I propose bringing one of Foucault's most powerful analyses of the modern body to bear on Pollock's painting. In describing the epistemological shift from spectacular forms of public torture to the rationally administered bureaucracy of the prison, Foucault theorizes a particular link between body and soul. He suggests that rather than the soul animating the body as a kind of transpersonal kernel of spirituality, it instead arises as the effect of a body's seizure by power:

David Joselit

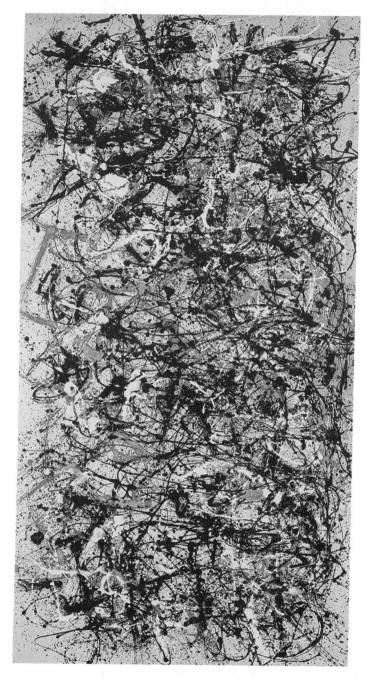

Figure 23.1 Jackson Pollock, *Autumn Rhythm*, 1950, oil on canvas, 105 × 207 in. The Metropolitan Museum of Art, George A. Hearn Fund, 1957 (57.92). © 2002 The Pollock-Krasner Foundation / Artists Rights Society (ARS), New York.

Rather than seeing this soul as the reactivated remnants of an ideology, one would see it as the present correlative of a certain technology of power over the body. It would be wrong to say that the soul is an illusion, or an ideological effect. On the contrary, it exists, it has a reality, it is produced permanently around, on, within the body by the functioning of a power. . . . A "soul" inhabits [man] and brings him to existence, which is itself a factor in the mastery that power exercises over the body. The soul is the effect and instrument of a political anatomy; the soul is the prison of the body.[11]

By declaring that "the soul is the prison of the body", Foucault points to a logic of introjection in which disciplinary regimes directed at the body from outside are encoded and perpetuated from "within" through the psychic imperatives of the soul. Such a formulation sheds light on the articulation of painterly gesture and psychic affect in Pollock's art. If not quite the codified movements of the factory worker, the rhythmic actions which Pollock's body registers in paint pivot on a disciplinary beat of repetition.[12] The force of his canvases derives largely from how they simultaneously put pressure on the limits of intelligibility while suggesting the emergence of order from chaos. If, as I am suggesting, Foucault allows us to see the modern unconscious as an effect of bodily discipline, the link established by both Pollock and Greenberg between psychic affect and painterly form attains a certain epistemological sense. In Pollock's art the crassly physical – his gruff choreography, the flung paint, the bits of refuse – is made to signify the emotional, the unconscious. It is worth pausing to remark on this association for despite its familiarity, it is far from self-evident. Like Foucault's definition of the disciplinary, the visuality of Pollock and Greenberg presumes that a soul is constituted through bodily inscription – it is not above or beyond the body, but its simple correlative. If this is the case, painterly depth, as practised from the Renaissance onward, loses its special force. When interiority is found to be co-extensive with the body an art of surfaces – of flatness – would seem to be inevitable.

A series of drawings by Jasper Johns each entitled *Study for Skin* is such an art of the surface. In these works, Johns literally unwraps his own skin. The drawings were made by applying oil to his head and hands, and then pressing these parts of himself onto sheets of paper, over which he subsequently rubbed charcoal. The *Skin* series was produced in preparation for an unrealized project which Johns described in a notebook entry of 1960:

Make a plaster negative of a whole head.
Make a thin rubber positive of this.
Cut this so it can be (stretched) laid
on a board fairly flatly. Have it cast in
bronze and title it *Skin*.[13]

Like a collapsed balloon, Johns proposes deflating a three-dimensional head, and stretching it out into a "fairly flat" surface. In this literal equation between skin and surface he enacts what I have identified as a mortgaging of the self to painterly form in the art of Jackson Pollock: it is "captured" in and on the picture plane. As Max Kozloff has memorably written, "Nowhere in Johns' work has there been a more

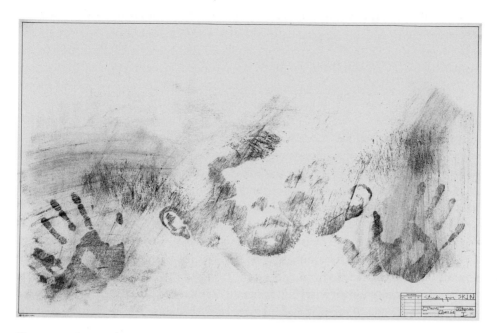

Figure 23.2 Jasper Johns, *Study for "Skin 1,"* 1962, charcoal on drafting paper, 22 × 34 in. © Jasper Johns/Licensed by VAGA, New York, NY. Photo by Dorothy Zeidman.

poignant effect of imprisonment, of the artist himself striving to break free from the physical limits of a work of art into which he has willfully impregnated his own image."[14] The metaphor of imprisonment in this passage is worthy of remark. For in the decade intervening between Pollock's gestural painting and Johns's *Skin* drawings the implicitly disciplinary nature of the former has given way to the explicitly repressive containment of the latter.

Although seemingly exceptional in Johns's career, and while seldom discussed at length in the literature on his art, the *Skin* drawings belong squarely within his concerns of the late 1950s and '60s. I will suggest just two of several ways in which this is so. Firstly, the skin drawings are consistent with Johns's persistent inclusion of plaster casts in his paintings. In fact, they explore in different terms the relationship between pictorial and sculptural values which had been introduced in works such as *Target with Four Faces* (1955) and, later, *Watchman* of 1964. Secondly, there is evidence that Johns came to associate wax with the look and texture of flesh – consequently his longstanding use of an encaustic technique might be interpreted as an effort to associate the surface of a painting with the surface of the body. In a 1964 interview, for instance, he remarked,

> The idea for [*Watchman*] first occurred to me two years ago, when I visited Madame Tussaud's, in London. The image of flesh, the image of skin – images I had never used before. I have tried since then to include those images in my work, but in vain. The idea of the leg of a person sitting on a chair came to me about a year ago.[15]

Despite his not-quite-accurate declaration that he had not yet utilized images of flesh, this interview is useful in suggesting the association Johns made between wax – the medium of Mme Tussaud – and the appearance of skin. Perhaps his attraction to the exhibits of a wax museum was as much a retrospective recognition of earlier concerns as it was the impetus toward a new direction in his art.

If, as Kozloff suggests, Johns's adequation of skin and painterly surface thematizes an imprisoned body welling up from just below the paper's surface like a distorted reflection on a pool of water, in their formal structure these works also produce an allegory of the mind, or memory. In a sketchbook note of 1970–1 Johns wrote:

> Devise technique/to imitate "magic picture pad" – image printed in invisible size on/ paper becomes/visible when/scribbled over/with pencil. . . . (This was already done in the/*skin* drawings./Using oil.)[16]

The allusion to a "magic picture pad", set off in quotations in Johns's text, recalls Freud's utilization of a child's toy, the "Mystic Writing-Pad", as a metaphor for the relationship between perception and memory. The mystic writing pad is composed of transparent layers of plastic and thin paper attached to the top end of a tablet with a malleable surface – in Freud's day the underlying tablet was wax. When a child writes or draws on the mystic pad with a stylus, letters and lines appear where the thin surface paper is pressed against the soft medium below. These images may be erased by pulling the transparent sheets apart from the underlying tablet but, as Freud insists, a trace of each inscription remains in the surface below. The allegory is simple and elegant: in the realm of consciousness, one perception follows another, each fading away in order to make room for the next, while in an underlying register of the unconscious this chain of ephemeral conscious stimuli lays down lasting memory traces. In the process of making his *Skin* drawings Johns embraced the duality – and delay – characteristic of the psychic topography described by Freud, but in reverse. The laying down of the original inscription, which in the mystic writing pad is visible, is virtually invisible in Johns's drawings, consisting as it does in the oily imprint of his face and hands on paper. It is the *belated* painterly gesture of applying charcoal onto the stained surface which reveals the initial indexical traces of the body. Johns's "magic picture pad" is thus the converse of Freud's "mystic writing pad". In Freud's allegory, perception leaves an unconscious or preconscious trace, but in Johns's version, such invisible or inaccessible marks are recuperated through the gestural application of medium.

If what I say is true, Johns, like Pollock, had invented an art of surfaces in which the body and its unconscious are articulated in a distinctively disciplinary fashion. In both artists' works traces of the body are generated through performative processes which allegorize the mind. If, in Pollock's art, the beat of repetition only implicitly suggested a Foucauldian regimentation, such a disciplinary experience is made explicit in the skin drawings through what Kozloff called a "poignant effect of imprisonment". And yet the body in Johns's *Skin* series remains largely unmarked, seemingly universal. This is not the case in a series of strikingly analogous works by

the African-American artist David Hammons, also made by rubbing his greased body against paper and then working medium into the oiled surface. In one of Hammons's body prints, *Spade* (1974), the non-specific ethos of imprisonment Kozloff noted in Johns's *Skin* series is associated with a particular source: a vicious racist epithet. *Spade* consists of an imprint of the artist's lips and nose beneath two perfectly circular rings which read as eyes. This abstracted face is pressed within the contours of the playing-card icon of a spade, as though the body had been sliced by a cookie cutter whose inverted heart-shaped top forms a head rising from a stem-shaped "neck". Hammons addresses his fascination with the spade in a 1986 interview:

> I was trying to figure out why Black people were called spades, as opposed to clubs. Because I remember being called a spade once, and I didn't know what it meant; nigger I knew but spade I still don't. So I just took the shape and started painting it. I started dealing with the spade the way Jim Dine was using the heart.[17]

In this work the *violence* of form – its real capacity for injurious identification – is made explicit. In *Spade* the artist's occupation of a stereotype is enacted through the binding or limitation of his imprinted body by a readymade contour. This encounter between an unwrapped expanse of flesh and a precise iconic outline allegorizes the collision of two models of identity: one in which subjectivity is immanent to the body, and one in which the architecture of selfhood is imposed from without. I have argued that a disciplinary logic characterizes even Pollock's art, but the fact remains that in his own view, and in that of his closest critics, Pollock's canvases marked the difficult emergence of an inner "freedom". No such myth remains in the body prints of David Hammons. Here optical flatness does not simply dramatize the co-extensivity of body and unconscious, but rather performs a coercive process through which selves are *flattened* into types. In repeating his racist interpellation as "spade", Hammons makes explicit the price we pay – in unequal measure according to our race, gender and sexuality – in having to exist as images for others, and in having to adjust to the images others have of us. If the disciplinary nature of the body mortgaged to form is largely veiled in the critical reception of Pollock's art, Hammons leaves no doubt as to its political nature. In his work flatness signifies identification, and identification is a violent process indeed.

III

Spade begs a vexing question which haunts much of the art produced over the past twenty-five years: what is the place of stereotype in visual culture? One thing is clear: the repetition and re-framing of normative images drawn from the media and else-where has become a dominant postmodern strategy. More than that, such repeti-tions are regularly regarded as political acts – as "subversions" – both by artists themselves and by art critics. In the case of *Spade*, for instance, Hammons's citation

Figure 23.3　David Hammons, *Injustice Case*, 1970. Mixed media: body print (margarine, powdered pigment), and United States flag, 63 × 40½ in. Los Angeles County Museum of Art, Museum Acquisition Fund, M.71.7. Photograph © 2002 Museum Associates/LACMA.

of a racist epithet can be interpreted as an instance of hate set against itself. But his reiterative gesture can just as easily be condemned for re-circulating an offensive slur within publics, such as the art world, which do not normally traffic openly in such crude characterizations. Precisely such a debate has arisen around the work of Kara Walker, a young African-American artist whose best-known projects consist of large-scale black paper cut-outs which form tableaux of fictionalized scenes inspired by the antebellum south. These works are full of exaggerated racial attributes, perverse eroticism and frank scatology resembling the phantasmatic transmogrifications of history which occur in romance novels. Walker's summary of one of these pulp novels sounds like a description of her own work: "There's this novel, *The Clansman*, which describes the deep South in a gothic Victorian style, all sorts of tantalizing creatures with grotesquely large lips, whose dirty hair is tied with dirty ribbons; catlike."[18] After Walker had won a prestigious MacArthur award a few years ago, a letter campaign was initiated by African-American artists of an older generation, including Betye Saar and Howardina Pindell, protesting the "negative images" her work disseminated. One of the strongest accusations launched against Walker was that her work pandered to the largely white establishment of art critics, curators and collectors serving up racist messages in the guise of avant-garde experimentation. The African-American artist Thom Shaw, whose assessment of Walker's art is more judicious than some, was one of several to point this out:

> The works are obviously targeted at whites. It's ironic that they buy it. I do have a problem with some of the curators. One can make a substantial argument that they're only showing the stereotypes.
> We're still looked at as Sambos. So when you see them, bigger than life, frozen in time, it does hurt.[19]

My intention here is not to adjudicate this debate – or even to suggest that such judgement is possible. As someone who is granted the racial invisibility that comes with whiteness in the United States, I cannot know what it is to be marked as people of colour are whenever they enter the public sphere. And yet, I do wish to point to the burden of stereotype which is unequally shared by all of us – even, increasingly, heterosexual white men. What the controversy surrounding Walker's art makes clear is that stereotypes are particularly charged representational units against which individual identities are produced. The struggle to reframe stereotypical images is thus central to an anti-racist, anti-homophobic and feminist politics. But how exactly can this be accomplished visually? I return to the question I posed earlier: is reiterating a stereotype a subversive act or does it merely extend the violence of a crude slur? Walker's critics point to this dilemma when they accuse her of irresponsibly disseminating negative images of slavery. The art historian Lizzetta Lefalle-Collins has stated this position unequivocally: "Derogatory imagery should not be put out without explanation. If you use it, you have to use it with some responsibility."[20] But what exactly constitutes such explanation and such responsibility? Must controversial images be framed institutionally with interpretive materials, such as artist's statements, wall

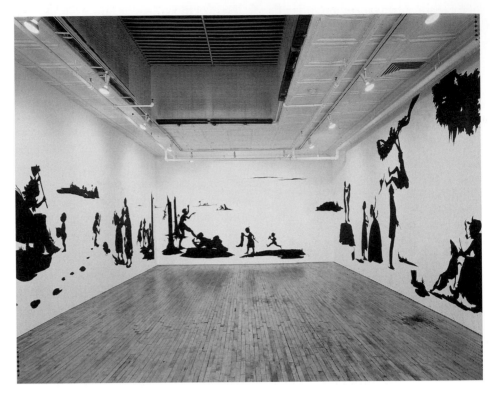

Figure 23.4 Kara Walker, *From the Bowels to the Bosom*, 1996, installation view. Courtesy Brent Sikkema, New York.

labels, or symposia, in order to clarify their author's intentions, or should such positioning be immanent to the visual object itself?

By way of addressing this dilemma I want to return to the issue of flatness. For indeed, Walker's works are physically flat: they are simple monochromatic cut-outs placed flush against the wall. But they are also blank – *flat* in their visual presentation, which eschews all detail except for the intricate contours of their cuts. Once again, Walker's own account is eloquent. Of the silhouette, she claims "[i]t's a blank space, but it is not at all a blank space, it is both there and not there."[21] This formal oscillation between positive and negative, body and shadow, black and white, captures the insidious nature of the stereotype. Stereotypes, like Walker's silhouettes, are always "both there and not there"; they are blank in their generality, and yet powerfully present in their introjection by the stereotyped subjects and their racial others. Walker's works present themselves as malfunctioning templates, switching on and off from presence to absence. Her reiterative act is therefore unstable, allowing – even perhaps calling – for an interruption in its operations. But this does not fully explain – or explain away – the venality of the slave scenarios she represents. In these works there is a sharp sadistic pleasure evinced in scenes of bodies cut up, combined in polymorphous sexual configurations, and exploding piles of shit. Walker is frank in her

David Joselit

desire both to occupy and pulverize the abjection of slavery: her statements, like her art, demonstrate a desire for, as well as a disgust with, the stereotype. She has stated:

> I figured out that I was a milestone in people's sexual experience – to have made it with a black woman was one of those things to check off on your list of personal accomplishments. That already has a slightly masochistic effect: to have just been the body for somebody's life story. I guess that's when I decided to offer up my side-long glances: to be a slave just a little bit. . . . So I used this mythic, fictional, kind of slave character to justify myself, to reinvent myself in some other situations.[22]

What this passage insistently suggests is that the stereotype is not external to either the objectified subject or her racial other. The reified slave is not only a locus of oppression – though this is its strongest and most pernicious characteristic – but also a site of *desire*. In the example provided by Walker, the slave woman is an object of fascination for a white lover, *but also for herself*, who, as a well-educated middle-class African-American woman living in the late twentieth century, should "know better" (as her critics have repeatedly claimed). According to this account, the racist stereotype is introjected and partially digested, but also partially expelled – an expulsion Walker hints at when, asked about the prevalence of scatological scenes in her art, she responds: "Really it is about finding one's voice in the wrong end; searching for one's voice and having it come out the wrong way."[23] In Walker's art, the stability of stereotypes is violently undermined: she animates them in order to break them apart literally and phantasmatically. Her cut-outs constitute an instance not of *reiteration*, but of *rearticulation*.

The political theorists Ernesto Laclau and Chantal Mouffe have used the term *articulation* to signify the possibility of political action in the dispersed social field of late capitalism. For them, the simple oppositions of class conflict central to orthodox Marxian analysis have been eclipsed by a plurality of *subject positions* founded in various attributes of gender, race, sexuality, religion and nationality. Politics proceeds by producing and articulating new identities which arise in order to make new democratic demands. The Civil Rights movement, feminism and gay liberation are exemplary. But despite their emphasis on identity, Laclau and Mouffe posit a radically anti-essentialist model of subjectivity; for them identities are differential, constituted only in the moment of articulation:

> A no-man's-land thus emerges, making the articulatory practice possible. In this case, there is no social identity fully protected from a discursive exterior which deforms it and prevents it becoming fully sutured. Both the identities and the relations lose their necessary character. As a systematic structural ensemble, the relations are unable to absorb the identities; but as the identities are purely relational, this is but another way of saying that there is no identity which can be fully constituted.[24]

Laclau and Mouffe bring us back to *flatness*, the central concern of this essay. Their understanding of identity politics is *lateral* in that it arises from a differential economy of coexisting subject positions rather than emerging from an essential human depth.

This shift from a model of subjectivity founded in interiority to one in which the self is constituted through a play of surfaces is what I have designated as psychological flatness. And indeed, just as I have analysed various ways in which psychological and optical flatness are articulated with one another in twentieth-century art, the tropes Laclau and Mouffe repeatedly return to are visual, often focusing on surfaces and planes. One example will suffice to capture the flavour of their language. In discussing the concept of hegemony – a politics founded in differential articulations and coalitions rather than in stable class oppositions – they write:

> the diverse surfaces of emergence of the hegemonic relation do not harmoniously come together. . . . On the contrary, some of them would seem to be surfaces of *dissolution* of the concept: for the relational character of every social identity implies a breaking-up of the differentiation of planes, of the unevenness between articulator and articulated, on which the hegemonic link is founded.[25]

Articulations of identity are characterized by a "breaking-up of the differentiation of planes". The language of political theory approaches the idiom of art criticism. Laclau and Mouffe could be describing a painting by Pollock.

IV

As I hope my analysis suggests, both the followers of Greenberg and those who would supersede his legacy have misunderstood flatness, even though Greenberg himself had an anxious inkling of how modernist opticality was mortgaged to psychological depth. I have attempted to defamiliarize the qualities of flatness and depth by demonstrating that, within them, the psychological, the optical and the political are intricately interwoven. We live in a world in which identity is form, and form is identity: proof of this is everywhere, from the evening news to the internet. But art historians persist in dividing the art of form – modernist painting – from the art of identity politics – postmodernism. This essay is an attempt to trouble such a false division by showing that both "modern" and "postmodern" art struggle over the same stakes – namely, how to locate subjectivity in the disciplinary world of late capitalism. One of the primary lessons of modern art has been its paradoxical demonstration of the depth of surfaces. It is a lesson from which we still have much to learn.

Notes

1 An early version of this paper was given at Stanford University in May of 1998 in a conference titled "The Object Inside: Looking within the Space of Art History." I would like to thank the conference organizers, Alexander Nemerov and especially Pam Lee, for inviting me to participate and for their useful feedback.

2 Fredric Jameson, *Postmodernism or, The Cultural Logic of Late Capitalism* (Durham: Duke University Press, 1991), p. 9.

3 Clement Greenberg, "Review of the Exhibition *Collage*", in *The Nation*, 27 November 1948, reprinted in Greenberg, *The Collected Essays and Criticism; Volume 2: Arrogant Purpose, 1945–1949*, ed. John O'Brian (Chicago: University of Chicago Press, 1986), p. 260.

4 Clement Greenberg, "Feeling is All", in *Partisan Review*, January–February 1952, reprinted in Greenberg, *The Collected Essays and Criticism; Volume 3: Affirmations and Refusals, 1950–1956*, ed. John O'Brian (Chicago: University of Chicago Press, 1993), p. 102.

5 Clement Greenberg, "'American-Type' Painting", in *Partisan Review* (spring 1955), reprinted in ibid., p. 226.

6 Jackson Pollock, from the narration for the film *Jackson Pollock* (1951), by Hans Namuth and Paul Falkenberg, in Herschel B. Chipp (ed.), *Theories of Modern Art: A Source Book by Artists and Critics* (Berkeley: University of California Press, 1968), p. 548.

7 Clement Greenberg, "Review of Exhibitions of Worden Day, Carl Holty, and Jackson Pollock", in the *Nation*, 24 January 1948, reprinted in *The Collected Essays and Criticism; Volume 2*, p. 201.

8 Fredric Jameson summarizes this position concisely: "The framework of the work of art is individual lived experience, and it is in terms of these limits that the outside world remains stubbornly alienated. When we pass from individual experience to that collective dimension, that sociological or historical focus in which human institutions slowly become transparent for us once again, we have entered the realm of disembodied abstract thought and have left the work of art behind us. And this life on two irreconcilable levels corresponds to a basic fault in the very structure of the modern world: what we can understand as abstract minds we are incapable of living directly in our individual lives and experiences. Our world, our works of art, are henceforth *abstract*." Fredric Jameson, *Marxism and Form: Twentieth-Century Dialectical Theories of Literature* (Princeton, New Jersey: Princeton University Press, 1971), p. 169.

9 It is Foucault's well-known thesis that the imperative to speak our sexuality which is associated with various "liberatory" feminisms and lesbian, gay and transgendered struggles since the 1960s, is also and equally a way of laying ourselves open for colonization and discipline by various technologies of power. See Michel Foucault, *The History of Sexuality: Volume 1: An Introduction*, trans. Robert Hurley (New York: Vintage Books, 1978).

10 The organizers of the recent Pollock retrospective at the Museum of Modern Art seem to agree: a photograph of the floor of Pollock's studio on Long Island was included as supplementary information.

11 Michel Foucault, *Discipline and Punish: The Birth of the Prison*, trans. Alan Sheridan (New York: Vintage Books, 1979), pp. 29–30.

12 It may seem paradoxical to consider Pollock's painterly style, typically understood as an expression of the artist's creative (and political) freedom, in terms of discipline. However, it is well known that Pollock's technique was the product of a great deal of skill. In fact, it is precisely the disjunction between its ostensibly freewheeling nature and the almost classical balance of many of his compositions which lend a certain force to my argument that these paintings are as much about controlling as they are about expressing psychic effect.

13 Jasper Johns, sketchbook note, Book A, p. 23, *c.*1960, reprinted in Kirk Varnedoe (ed.), *Jasper Johns: Writings, Sketchbook Notes, Interviews*, compiled by Christel Hollevoet (New York: The Museum of Modern Art (distributed by Harry N. Abrams, Inc.), New York, 1996), pp. 50–1.

14 Max Kozloff, *Jasper Johns* (New York: Harry N. Abrams, Inc., 1968), p. 47.

15 Yoshiaki Tono, "I Want Images to Free Themselves from Me" (in Japanese), in *Geijutsu Shincho*, Tokyo, 15, 8 (August 1964), pp. 54–7; reprinted in Varnedoe, *Jasper Johns*, p. 96.

16 Jasper Johns, sketchbook note, Book C, *c.*1970–71; reprinted in Varnedoe, *Jasper Johns*, pp. 73–4.

17 Kellie Jones, "David Hammons", in *Real Life* 16 (Autumn 1986): 2–9, reprinted in Russell Ferguson et al. (eds), *Discourses: Conversations in Postmodern Art and Culture* (New York: The New Museum of Contemporary Art; Cambridge: MIT Press, 1990), p. 210.

18 Jerry Saltz, "Kara Walker: Ill-Will and Desire" [interview], in *Flash Art* 29, 191 (December 1996), p. 82.

19 Quoted in "Extreme Times Call for Extreme Heroes", in *The International Review of African American Art* 14, 3 (1997), p. 13.

20 Ibid., p. 14.

21 Saltz, "Kara Walker: Ill-Will and Desire", p. 82.

22 Ibid., p. 86.

23 Ibid., p. 84.

24 Ernesto Laclau and Chantal Mouffe, *Hegemony & Socialist Strategy: Towards a Radical Democratic Politics* (London: Verso, 1985), pp. 110–11.

25 Ibid., p. 93.

24 Ruins, Fragmentation, and the Chinese Modern/Postmodern

Wu Hung

This essay reflects upon the meaning of modernity and postmodernity in Chinese art from a particular angle. I have chosen *ruin*, and by extension *fragmentation*, as my focus for two reasons: first, it has been frequently noted that fragmentation characterizes both modernist and postmodernist art movements in the West, and a large body of literature has been devoted to this subject. Second, ruin and fragmentation are also important concepts in twentieth-century Chinese art, but their implications, and hence the notion of the modern and the postmodern, must be understood in relation to China's cultural tradition and political experience.

Whether discussing classical ruins or modern photography, western criticism generally links fragmentation to artistic creativity and imagination. This positive attitude grew out of a long tradition in Europe, in which ruins were represented from at least the Middle Ages. Beginning in the sixteenth century, ruins, both actual remains and fabricated ones, were installed in gardens. In the eighteenth century, according to Kurt W. Forster, ruins "became an intriguing category of building in themselves: the more strictly specialized and type-cast architecture became, the more ruins – structures which have outlasted their usefulness – it was bound to produce over time."[1] Sentiment toward ruins penetrated every cultural realm: "They were sung by Gray, described by Gibbon, painted by Wilson, Lambert, Turner, Girtin and scores of others; they adorned the sweeps and the concave slopes of gardens designed by Kent

From *Inside/Out: New Chinese Art* (Berkeley and Los Angeles: University of California Press, 1998), pp. 59–65. Copyright © by San Francisco Museum of Modern Art. Reproduced with permission of San Francisco Museum of Modern Art.

and Brown; they inspired hermits; they fired the zeal of antiquarians; they graced the pages of hundreds of sketchbooks and provided a suitable background to the portraits of many virtuosi."[2] It was this tradition that led Alois Riegl to write his theoretical meditation on the "modern cult" of ruins at the turn of the century.[3] The same tradition also underlies many modernist and postmodernist theories, which, taken as a whole, elucidate a progressive internalization of fragmentation from reality to art itself: the subject of fragmentation has gradually changed from the external world to the language, imagery, and medium of representation.

China's situation was different in two respects. First, in China, ruin sentiment was primarily a premodern phenomenon; in the modern era ruins acquired a dominant negative symbolism. Second, even in traditional China, the aestheticization of ruins took place mainly in poetry; visual images of ruins virtually did not exist. I reached this second conclusion after an exhausting but unproductive search for "ruin pictures" and "ruin architecture."[4] Among all the traditional Chinese paintings I have checked, fewer than five depict not just old, but *ruined* buildings. As for actual "ruin architecture," I have not yet found a single premodern Chinese case in which a building was preserved not for its historical value but for a ruinous appearance that would show, as Riegl has theorized in the West, the "age value" of a manufactured form.[5] There was indeed a taboo in premodern China against preserving and portraying ruins: although abandoned cities or fallen palaces were lamented in words, their images, if painted, would imply inauspiciousness and danger.

When this Chinese tradition encountered European "ruin" culture, two things happened: on the one hand, this encounter led to the creation of ruin images in Chinese art and architecture; on the other, these images, as modern memory sites, evoked the calamities that had befallen the Chinese nation. The first effort to document architectural ruins was made by European photographers beginning in the mid-nineteenth century. Their works mixed western sentiment for decayed buildings, orientalistic fascination with "old China," and archaeological or ethnographic interests. Although these works can be generally characterized as "orientalistic" or "colonialist," their impact on China can hardly be exaggerated because they initiated a modern visual culture. What ensued has been a separate history of ruins in China. Ruin images were legitimated; but what made them "modern" (i.e., what distinguished them from classical Chinese ruin poetry) was their emphasis on the present, their fascination with violence and destruction, their embodiment of a critical gaze, and their mass circulation. These features characterize an anonymous photograph that shows a street scene during wartime in the early twentieth century (fig. 24.1). The subject of the picture is a devastating destruction. First, the ruined buildings are still "raw", not yet sunk into the depth of historical memory; we may thus call them "ashes" to distinguish them from those aestheticized ruin images in classical poems. Second, the picture poses as a snapshot and hence captures a fragmentary visual experience. As a photographic image, it self-consciously preserves the transience of the present in a stable and reproducible form. Third, although the photographer is unknown, the intrinsic gaze, embodied by the street onlooker in the scene, is Chinese.

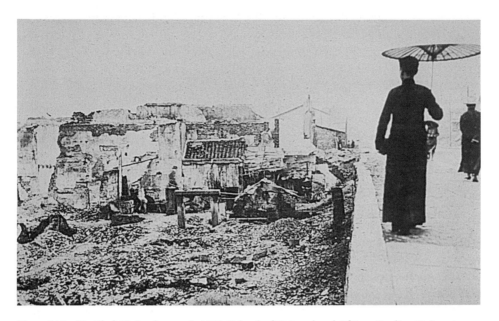

Figure 24.1 Untitled (Ruined streets), 1911. School of Oriental and African Studies, University of London.

The last of these features makes this photograph a metapicture: the ruins are scrutinized and qualified by a Chinese gaze, and this gaze – a historic one, I must emphasize – had already been thoroughly politicized by the time the picture was taken. The same gaze, in fact, created the first and most important modern ruin in China: the remains of the Yuanming Yuan, a group of famous gardens of the Manchu royal house outside Beijing that were destroyed in 1860 by the joint forces of the British and French armies (fig. 24.2). Only in recent years has this ruin been made into a public park. For most of the twentieth century, images of the destroyed gardens were known to the public largely through photographs. Articles and poems accompanying these photographs emphasized the gardens' symbolism as a "witness of foreign evils"; their anti-colonialist and nationalist sentiment separated them from traditional ruin poetry. In a more fundamental sense, these expressions signified the emergence of a modern Chinese conception of ruins, that architectural remains surviving from war or other human calamities were "living proof" of the "dark ages" caused by foreign invasion, internal turmoil, political repression, or any destruction of massive, historic proportions. This conception also made the Yuanming Yuan a symbol shared by individuals and the state. After the establishment of the People's Republic of China, the remains of the gardens were preserved as a "memorial to national shame in the pre-Revolutionary era." But when the unofficial art group the Star emerged after the Cultural Revolution, its members also painted the Yuanming Yuan and held poetry readings among the gardens' dilapidated stones [. . .].

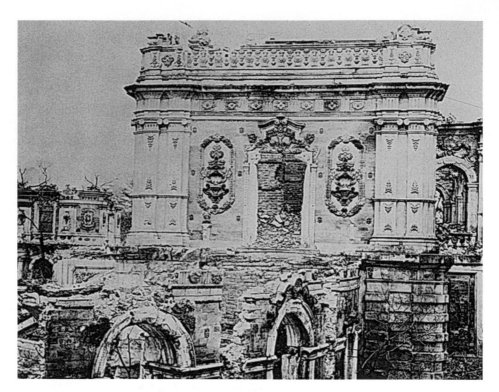

Figure 24.2　Ruins of the Yuanming Yuan, gardens of the Manchu royal house outside Beijing, which were destroyed in 1860.

This new conception of ruins explains the wide appeal of fragmented images in contemporary Chinese art after the Great Proletarian Cultural Revolution, the most recent human calamity (commonly recognized as the most severe political persecution in the country's long history). As in many other regards, the Star's inclination for ruins anticipated a major direction of the '85 Movement (or New Wave), which surfaced in 1984 and soon spread across the entire country. The extraordinary significance and complexity of this "avant-garde" movement still await further discussion. What matters for this essay is that for the first time in Chinese art, ruin images were created with frequency and intensity in various art forms, including painting, photography, installation, and happenings.

Wu Shan Zhuan's 1986 installation in Hangzhou, *Red Humor*, exemplifies one major tendency to evoke situations or experiences typical of the Cultural Revolution [. . .]. A windowless room covered by layers of torn paper and pieces of writing, this work alludes to Big Character Posters, a major form of political writing during the Cultural Revolution. This connection becomes visible not only in the work's general visual imagery but also in medium (ink and "poster paints" on paper), color scheme (predominately red), production (random participation of the "masses"), and psychological impact (sense of suffocation produced by chaotic signs in a sealed space). But Wu was not simply restaging a vanished historical episode; instead he tried to create

a new vocabulary of ruin images – forms that have been removed from the original context and begun to convey new social meaning. As Lü Peng and Yi Dan have observed, the words on the walls are not the revolutionary slogans fashionable during the sixties and seventies, but commercial ads that began to fill Chinese newspapers from the mid-eighties. In Wu's simulation of Big Character Posters, therefore, ruins as remains of the past have become part of the present.

In this way, Wu Shan Zhuan separated himself from the previous "Scar" or "Wounded" (*Shanghen*) artists, who attacked the Cultural Revolution through their realistic but sentimental historical paintings. While these artists single-mindedly criticized the past and finally merged with official propaganda, Wu found the past *in* the present. In a broad sense, his art represents a radical departure from the traditional conception of ruins. According to Stephen Owen, "the master figure [of classical ruins poetry] is synecdoche: the part that leads to the whole, some enduring fragment from which we try to reconstruct the lost totality."[6] Wu Shan Zhuan's ruin imagery did not lead to the reconstruction of a "lost totality" in the imagination, but only to further fragmentation of the past as well as the present.

This critical spirit was shared by Huang Yong Ping but manifested itself in a different form. The name of the art group Huang and his colleagues formed in 1986, "Xiamen Dada" or "Dadaists of Xiamen," highlights their strategy of "quoting" (i.e., transplanting) names and formulas in a new context – a dislocation that critiques both the quotation and the situation. The public burning of their works at the end of their first group exhibition may have been inspired by Dadaist nihilism; but the photographic record of the burning [. . .] – the only surviving image of the event to reach a larger public – unmistakably recalled the burning of books and artworks during the Cultural Revolution. Huang's *"A History of Chinese Painting" and "A Concise History of Modern Painting" Washed in a Washing Machine for Two Minutes*, 1987/1993, shifted the focus from destruction to a "still life" of ruins: a conglomeration of paper paste – the remains of the two books – piled on a piece of broken glass supported by an old wooden trunk [see plate 12]. The washing machine is not shown and the destruction of the books is only implied. Again, this work, when viewed in the post-Cultural Revolution context, delivers two overlapping messages: according to Huang himself, it expresses his negation of any formal knowledge, ancient or modern, eastern or western; but viewers who had gone through the Cultural Revolution still remember clearly how "knowledge" was negated and how similar art books were destined to be destroyed during the political turmoil.[7]

Related to these ruin images was an intense interest among many '85 Movement artists in disembodied *signs* – Chinese characters often, but also including isolated visual elements such as "standardized" colors, imprints, or figures. It is tempting to link this interest to the postmodern discourse on "language games" and the deconstruction of the "grand narrative" of modernity. Indeed some Chinese artists expressed their ideas with terms borrowed from theories of postmodernism introduced to China in the middle and late eighties. It should be emphasized, however, that the Chinese interest in the fragmentation of language had its indigenous origin in the Cultural Revolution. That decade produced innumerable copies of a few sets of images and

texts – mainly Mao's portraits, his writings, and his sayings – in every written and visual form [. . .]. The chief technologies of cultural production during that period were *repetition* and *duplication* – two essential methods used to fill up a huge time/space with limited images and words, thereby creating a coercive, homogeneous verbal and visual language in a most static form. The metalanguage of the Cultural Revolution was therefore never a metanarrative. Consequently, the target of "postmodern" deconstruction mobilized by young Chinese artists was not really a Marxist scheme of grand social evolutionism, but the cultural production and visual language of the Cultural Revolution.

In addition to written characters, other material for repetition and duplication during the Cultural Revolution – including Mao's portraits, typical images in propaganda posters, and the color red – was reduced to isolated and hence illogical fragments. These forms were extracted from the original process of production and reproduction, distorted at wish for any possible formalist or ideological reason, and mixed with signs from heterogeneous sources. Such practices have become so common in Chinese art since the 1980s that they transcend the differences between individual trends (e.g., Political Pop, Cynical Realism, or Critical Symbolism) and actually unite these trends into a single movement. In fact, from a broad historical perspective, we could call mainstream Chinese art from the late seventies to the mid-nineties "Post-Cultural Revolution Art" because the basic means and goals of this art were to recycle, criticize, and transform the visual language of the Cultural Revolution. An important component of this art, fragmentation is "an attitude as well as a technique, a perception as well as a procedure."[8] But with the Cultural Revolution gradually receding into the past, images derived from this era were used increasingly less for political criticism and increasingly more for visual, intellectual, or even commercial purposes.

From the middle to the late eighties, images "fragmented" from the Cultural Revolution repertory, such as Wu Shan Zhuan's red stamps and flags, 1987 [see plate 13], and Wang Guangyi's *Mao Zedong No. 1*, 1988 (fig. 24.3), still provided definite references to their prototypes. But gradually such references were complicated or disguised. Works of Political Pop, arguably the predominant trend in the early and mid-nineties, did not simply cite and deface Cultural Revolution images but also distorted them and combined them with signs from heterogeneous sources: commercial trademarks and advertisements [. . .], textile patterns (Yu Youhan), sexual symbols [. . .], computer images (Feng Mengbo), legendary and folklore figures (Liu Dahong), and family portraits [. . .]. Although largely mixing and appropriating existing images, these works should not be simply equated with Jamesonian "pastiches,"[9] because in these works the Cultural Revolution images remain central, and because artists were still trying to forge a distinguishable "style" and an artistic individuality.

Political Pop marked the end of Post-Cultural Revolution Art and ushered in a recent change in Chinese art around the mid-nineties: many artists have finally bid farewell to the Cultural Revolution and all its visual and mental baggage. Their works directly respond to China's current transformation, not to history or memory. It is perhaps still too early to summarize the general tendencies of these works; but some of them

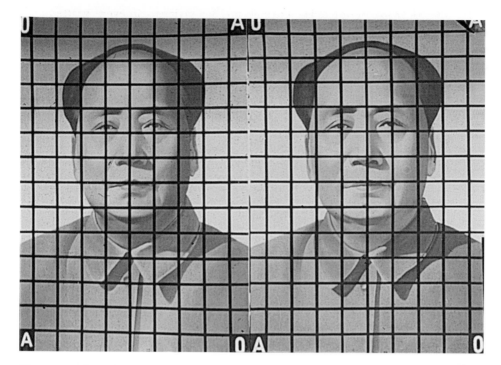

Figure 24.3 Wang Guangyi, *Mao Zedong No. 1*, 1988, oil on canvas, 59 × 141 in. (150 × 120 cm). Private collection.

reflect a clear attempt to document the ongoing fragmentation of Chinese society. The Guangzhou installation artist Xu Dan, for example, combines disfigured plastic mannequins, war souvenirs, and an enormous image of a smiling policewoman in a work titled *New Order* [. . .]. Viewers are confused by the random mixture of media, the incoherent size relationship of images, and the casual association between fashion and violence. The illogicality of this installation, according to Hou Hanru, mirrors "the fact that reality is full of conflicts and incidents, while chaos, entropy and permanent precariousness are the real 'rules.'"[10]

An important aspect of China's transformation in recent years is the rapid growth of the city. At the same time, the city has become increasingly incoherent and incomprehensible; its growth is visible from the forest of cranes and scaffolding, the roaring sound of bulldozers, the dust and mud – signifiers of a never-ending destruction and construction. Old houses are coming down every day to make room for new buildings, often glittering highrises in so-called postmodern styles. To some city residents, demolition means forced relocation; to others it means a deepening alienation of people from the city. The feelings of helplessness and frustration generated in this process are expressed in Zhan Wang's *Ruin Cleaning Project '94* (fig. 24.4): he chose a section in a half-demolished building for "restoration." He first washed it carefully and then painted doors and windows on it. But scarcely had he finished when the building was razed.[11]

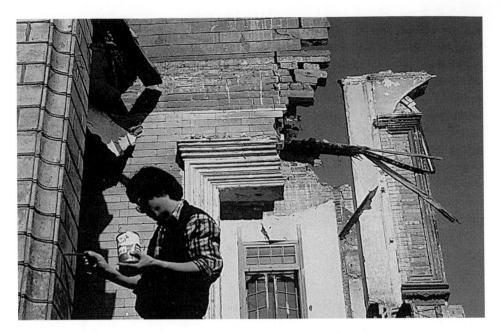

Figure 24.4 Zhan Wang, *Ruin Cleaning Project '94*, 1994, action and installation in Beijing.

Uncertainty in the external world forces people to turn to a smaller, private space. Indeed "interior furnishing" (*shinei zhuangzhi*) has become one of the most profitable businesses in recent years. New shops selling western-style furniture, modern kitchen and bathroom equipment, and fancy light fixtures are seen everywhere in Chinese cities, and one can find all sorts of "interior decoration" guides in bookstores. The common wisdom of interior decoration, however, still centers on the notion of a *jian* or "piece." A "big *jian*" means a piece of furniture or equipment that has acquired a conventional social meaning: it not only fulfills the need for convenience or comfort, but also demonstrates the owner's sophistication, social connections, and financial status. A well-furnished apartment is essentially a collection of such "big *jian*," which are sought-after goods but often prohibitively expensive even for a family of middle-level income. The accumulation of these *jian* thus demands long-term planning and hard work. This social practice has created a specific sense of interiority – a private environment in which men and women are linked with (and identified by) their "fragmentary" belongings. This "postmodern" sense of interiority is the subject of a series of oil paintings which Zeng Hao created between 1995 and 1997 [. . .]. In each painting, isolated pieces of stylish furniture and audio-video equipment, like miniatures made for a dollhouse, are scattered on a flat background. Young urban professionals dressed in neat, western-style clothes are randomly situated amidst these enviable belongings, staring blankly at the empty space before them. In an interview, the artist related these fragmentary images to his experience in Guangzhou: "Every day you see, in home after home, everyone is filling his [or her] home with fancy stuff. It feels weird in such an environment."[12]

But to Zeng, what is weird – what has become fragmentary in present China – is not only space and objects, but also time and subjectivity. The title of each of his "interior" paintings indicates a moment: *31 December*; *Thursday Afternoon*; *Yesterday*; *Friday 5:00 p.m.*; or *17:05, 11 July*. There is no continuity between these moments; and we do not even know which moment is earlier or later because the year is never given. These titles thus function as fragmented signifiers which fail to link experiences into a coherent sequence. As a result, the interior space, with its fragmentary figures and things, is always in a perpetual present. These and similar works are the artists' direct observations and critiques of new social spaces now emerging in China's urban centers – spaces of commodity, privacy, and interiority. Related to this new social landscape are changing conceptions of time, place, and human relationships, which are given visual images.

Notes

1 Kurt W. Forster, "Monument/Memory and the Mortality of Architecture," in K. W. Forster, ed., *Monument/Memory* special issue, *Oppositions* 25 (1982): 11.

2 Michel Baridon, "Ruins as a Mental Construct," *Journal of Garden History* 5, 1 (January–March 1985): 84.

3 Alois Riegl, "The Modern Cult of Monuments: Its Character and Its Origin" (1903), trans. K. W. Forster and D. Chirardo, in Forster, ed., *Monument/Memory*, pp. 20–51.

4 I did this research for my paper "Ruins in Chinese Art: Site, Trace, Fragment," delivered at the symposium "Ruins in Chinese Visual Culture," held at the University of Chicago on May 17, 1997.

5 Riegl, "Modern Cult of Monuments," pp. 31–4.

6 Stephen Owen, *Remembrances: The Experience of the Past in Classical Chinese Literature* (Cambridge, Mass.: Harvard University Press, 1986), p. 2.

7 The meaning of such projects changed when Huang Yong Ping continued them outside China. For example, in 1991, at the Carnegie Library at Pittsburgh, he showed "book ruins" made from hundreds of old art journals that he had soaked and put through a mincer. Divorced from the Chinese context, this project simply expressed his own negation of "book knowledge."

8 Craig Owens, "The Allegorical Impulse: Toward a Theory of Postmodernism," in Brian Wallis, ed., *Art After Modernism: Rethinking Representation* (New York: New Museum of Contemporary Art, 1984), p. 204.

9 See Fredric Jameson, "Postmodernism, or the Cultural Logic of Capital," *New Left Review* 146 (July/August 1984): 53–92, and esp. 64–5.

10 Hou Hanru, "Towards an Un-Unofficial Art: De-ideologicalization of China's Contemporary Art in the 1990s," *Third Text* 34 (spring 1996): 37–52; p. 50.

11 See ibid.

12 Quoted from Li Xianting, "*Pingmion er shuli di richang jingguan: Zeng Hao zuopin jigi xiangguan huati* (Flat and detached scenes in ordinary life: Zeng Hao's work and some related topics)," in *Zeng Hao* (Beijing: Zhongyang meishu xueyuan hualang, 1996), p. 1.

25 Function and Field
Demarcating Conceptual Practices

Nana Last

I n a 1971 article entitled "Notes on Conceptual Architecture: Towards a Definition," Peter Eisenman attempted to define the parameters by which architecture might be remade following the model of conceptual art without at the same time erasing the distinction between art and architecture, conceptual or otherwise. During the succeeding decades conceptual art itself came to implicitly rewrite this question, asking not what happens if architecture is remade *following* conceptual art practices *but as a conceptual art practice*. Some 30 years after the publication of Eisenman's article, the success of the production of a conceptualism within architecture is unclear. Conceptual art, however, has gone on to produce its second and third incarnations, a striking number of which appropriate a vast array of architecture's methods, scope, practices, and objects. These appropriations, beginning in the late 1960s, range from the often cited early work of Robert Smithson to the extensive interest in site-specificity in the 1980s and on to a great number of direct appropriations of architectural forms by artists ranging from Rachel Whiteread and Siah Armajani to more recent additions from Glen Seator, James Casebere, Rirkrit Tiravanija, and Jorge Pardo. Pardo's work in particular produces art as architecture in a form indistinguishable from the products and services of the design arts, including furniture design, interior design, and architecture.

Central in Eisenman's maintaining of the distinction between art and architecture was his immutable and a priori definition that architecture – unlike art – must be responsive to function and "the idea of an object presence."[1] According to Eisenman, whether in built form or not, there can be "no conceptual aspect in architecture

Published here for the first time.

which can be thought of without the concept of pragmatic and functional objects, otherwise it is not an architectural conception."[2] This definition, designed to draw an absolute and unquestioned boundary between an art located outside of the confines of use and object status, and an architecture defined by both of these, points to the paradoxical position Eisenman was constructing for any potential conceptual architecture. Unable to fully define such a practice, Eisenman devoted the closing lines of the article to posit an explicit challenge for the production of a conceptual architecture that follows art's shift to conceptualism without copying its specific recoding procedures.[3]

> The task for a conceptual architecture as opposed to conceptual art would be not so much to find such a sign system or a coding device, where each form in a particular context has an agreed-upon meaning, but rather . . . to investigate the nature of . . . formal universals which are inherent in any form or formal construct. . . . These deep structures . . . might give to functional requirements a primary conceptual aspect and further a potential for new meaning . . . A more difficult task would be to find a way of giving these conceptual structures the capacity to engender more precise and complex meanings merely through the manipulation of form and space. This would require some form of transformational method – where the universals of the conceptual structure are transformed by some device to a surface structure and thus capable of receiving meaning. Whether it is possible to develop such transformational methods and at the same time to reduce both the existing semantic and cultural context of any architecture to produce a structure for new meaning, without developing a new sign system, seems to be a central problem for a conceptual architecture.[4]

Eisenman's stated challenge, conjoined with the attributes that he deemed essential components of architecture, together present a dilemma that pits the desire to follow the model of conceptual art against the (unstated) understanding that the advent and influences of conceptual art (really of conceptualism) present a threat to the independence of the arts and therefore to the integrity of architecture.[5] The specifics of the challenge, Eisenman's emphasis on architecture as an autonomous practice added to his goal of a conceptual architecture produced solely through formal and spatial manipulations, further widen this dilemma. With architectural practice seemingly at stake, Eisenman repeatedly attempted to shore up the art/architecture distinction in the hopes of further containing any transformation of the object along with whatever new meanings such transformations may engender.

From within conceptual art practices, maintaining the distinction between art and architecture is not seemingly a priority. A number of current art practices have developed by mining the slippages along this boundary in various ways. Glen Seator's work, for example, appropriates architectural objects by replicating and relocating pre-existent architectural spaces – usually a part of a gallery or museum – into adjoining parts of the institution. One end of his practice involves a diagrammatic marking of a space onto itself, while at the other extreme Seator has exactly reproduced a small room – usually a back office of a gallery – within an adjoining exhibition space. The reproduced rooms themselves are further disoriented by being placed on their side or tilted up at an angle. These relocated rooms change the structure and space of

the gallery by both revealing what is normally not seen and disrupting the space and movement of the public exhibition space that has traditionally allowed unimpeded movement of its viewers. The best-known piece of his in this series is Seator's upended replica of the Whitney Museum director's office which was exhibited at the Whitney Biennial of 1997. As with his other relocated rooms, the director's office cannot be entered but can only be viewed from the outside, showcasing the studs and wiring that make up the interior of the walls and allowing glimpses through the door into the still unenterable office.

Seator has also relocated the exterior of the gallery indoors in his "Approach" at The Capp Street Project in San Francisco, and has reconstructed an East LA check-cashing storefront at the Gagosian Gallery in Beverly Hills. These projects are designed to reveal the hermetic world of the hidden power structure of the museum by both showing it to the public and – by not allowing entry – reiterating how that world is in fact off limits to the public it presumably invites in. As such, Seator's work operates as institutional critique, turning the museum from form into content.

Rirkrit Tiravanija has also appropriated architectural objects and practices in both his redefining of the space and use of the gallery and in his direct appropriations and recontextualizations of iconic architectural projects. In the first group for which he is best known, Tiravanija has reconceived gallery use and space by cooking within it and serving the food he prepares to the gallery's visitors. As part of this practice Tiravanija frequently redefines or reconfigures the gallery space involved. This reconfiguration has ranged from stripping elements such as doors and window shades from the gallery and setting up a make-shift kitchen in the back office space to reconstructing his own apartment – kitchen and all – in the space of the gallery.

The other form of architectural appropriation by Tiravanija began in the mid-1990s and involves the use of architectural icons ranging from Le Corbusier's 1914 prototypical Maison Domino at LACMA to rebuilding a scaled-down Johnson Glass House at MOMA's sculpture garden. While these works speak to the role of architecture in the construction of the relation between the private and the public and in the construction of the authority of the institution, the architectural objects, owing to their scale change and ready recognizability, are marked as clearly appropriated for the purposes of his projects.

While both Seator's and Tiravanija's practices employ architectural elements to refer to and talk about the museum as an institution or the manner in which architecture functions, Jorge Pardo's work, by operating as architecture, collapses any remaining distance between art and architecture. There is no shift of scale or any obviously reworked or jarring juxtaposition and recontextualization. With Pardo, the scope of appropriation is seemingly complete, leaving his work – whatever its success otherwise – to lie fully within the scope of architectural practice. Instead, architecture supersedes conceptual art to become the framework for the work's functioning.

Pardo's works incorporate a wide range of design and architectural practices in their production and resulting discourse. Beginning in the early 1990s, Pardo completed a series of installations that repeatedly question the relationship between art, architecture, and design, potentially eroding the boundaries between these practices

by incorporating one within the other. Because of this, his work as a conceptual practice explicitly raises the question of the potential demise of the division between art and architecture under conceptualism. Pardo's work takes two fundamental forms. The first type incorporates such objects as chairs, tables, lamps, stereo equipment, and a sailboat as elements presented singularly or grouped together in various installations. The second group even more nearly replicates the typical practices of architecture in the design of a pier, and a reading room; a house commissioned by the Museum of Contemporary Art in Los Angeles; and what amounts to a renovation of the ground floor space of the Dia Center for the Arts in New York.

Examples of the first group include a series of exhibitions in which Pardo installed various pieces of furniture that he had designed, including chairs, tables, and light fixtures. The pieces themselves frequently refer to icons of twentieth-century furniture design such as Aalto, Noguchi, Saarinen, Jacobsen, and Gehry, with Pardo at times integrating parts or concepts from different origins, so that the objects at once appear familiar but leave the viewer unable to specifically name them. Specific installations of furniture by Pardo range from the office furniture he designed for the gallery that represents him in Berlin, to the Museum Van Beuningen in Rotterdam where Pardo installed 105 gas lamps, to the 1996 Leipzig New Trade Fair where, amongst the trade exhibits, Pardo installed furniture for a café. In discussions, these pieces are typically referred to as "furniture objects," nomenclature meant to designate their dual status as artworks and as functional furniture. By not referring to the objects as what they, on the simplest level, are – i.e. chairs, or furniture – the designation is also meant to illustrate the distinction between art and design. As such, these designations serve to define what is believed to be the relevant aesthetic discourse.

Pardo's execution of a series of larger-scale projects more distinctly enters the typical territory of architecture. These include the large C-shaped table, lamps, and stools created for a museum reading room; the pier Pardo designed during the summer of 1997 as part of the Munster Sculpture Project; and his most recent commission, the redesign for a 2000–1 exhibition of the ground floor space for the Dia Center for the Arts. The redesign for Dia includes its entrance lobby, bookshop, and ground floor gallery. For the space, Pardo chose well-known furniture mixed with elements of his own design, including a frieze on paper. But it is not the furniture here that attracts the most attention, visual or otherwise. Rather, it is the field of ceramic tiles that cover the floor and columns throughout the installation. The pattern is composed of tiles in four different sizes and shades of yellow, orange, red, brown, and green. While Pardo set the geometric sequence of the tiles, the color sequence was left to the installers. Set against this pattern, Pardo, acting also as curator, chose to exhibit a 1:1 scale model of the new Volkswagen Beetle.

Central to much of the discussion of Pardo's work, however, is the 1998 house that LA MOCA commissioned[6] Pardo to build [see plate 14]. The house, along with the Dia project, conforms to a model of practice and production central to the discipline of architecture. The house was open to the public for an initial period during which it contained an exhibition that Pardo curated – a show of 39 of his lamps on loan from another exhibition. Following the exhibition period, Pardo moved into the

house. The idea for the house itself first took form as a 22-page clothbound fold-out book conceived of as both a sculpture in its own right and as plans for a house. It was created in an edition of ten in 1994 for the *Ten People Ten Books* exhibition at Friedrich Petzel in New York, inscribing the work as emerging from both art and architecture practices. Other house elements, such as kitchen cabinetry, repeated this dual status of appearing in exhibitions occurring between the house's inception and its construction.[7]

The house itself is a flat-roofed, single-story, wood-clad structure occupying a sloping site in the Mount Washington section of Los Angeles. The construction of a largely homogeneous and extensive field, as with the ceramic tiles at Dia or the wooden pier at Munster, is here evident in the wood cladding that is pervasive on the exterior and extends to the interior where it defines a number of surfaces, including several walls and ceilings. The plan of the house also reiterates one of Pardo's main formal investigations, found previously, for example, in the continuous curve of the reading-room table. Beginning with the garage and ending at the studio, the rooms of the house form a long curving chain that follow in sequence, each overlooking the other, as the house turns inward. Movement through the house is along the front/street edge of the building parallel to the rooms. Along that edge there are no windows. Instead, all glazing (much of it floor to ceiling) faces onto the inner courtyard formed by the house's faceted curvature. In all, the house contains a garage, a glass study, an entry area, a kitchen with a large sunken sitting area (often referred to as a conversation pit, with many noting that discourse itself is the content of the house), two bathrooms, and a bedroom.

As these projects were undertaken by a conceptual artist, despite the specifics of the objects themselves, the work is not discussed primarily around design or architectural constructs. Instead, the work is seen to raise a series of (usually) dichotomous issues about the status of art in relation to life, the museum as institution, the relationship between public and private, art and artist, art and design, and the everyday as opposed to, variously, art exhibitions, aesthetic experience, and aesthetic objects. The terms of this debate as they arise around Pardo's appropriation of architectural practices or their incorporation into his conceptual art, however, recall and challenge Eisenman's quest for a conceptual architecture by focusing on the boundary drawn by function that Eisenman insisted separated art from architecture and prevented the production of a conceptual art in direct accordance with conceptual art-based procedures.

The threat that Eisenman perceived to architecture's integrity – that which threatened to turn architecture into art by robbing it of its object presence and its utility – comes from the transformative potential of conceptualism in the visual arts. While conceptualism in art has become an umbrella term offered to cover a range of production from the linguistic and dematerialized versions that originally drew the title to various forms of process art and institutional critique, in very general terms, conceptual art practices work to de-emphasize the aesthetic object in order to shift focus away from a more mute and inward-turning formalism potentially to practices based explicitly in "outside" content. Conceptual art thus raises the issue of the limits of the content of art more than it does the limits of art's formal boundaries. As a

result, the transformations produced under conceptualism do not simply open the door for wide-scale appropriations of methods and practices from other disciplines, but, rather, such appropriations are often the basis for conceptual transformations, transformations which cannot be limited to the appropriating field of art itself – but which extend into the appropriated disciplines.

The question of a conceptual architecture modeled on the idea of conceptual art, with its certain transformation of the aesthetic object and its potential toward the dematerialization of it, escalates the difficulty of maintaining the art/architecture distinction as it has so frequently been defined. The threat of the dissolution of the art/architecture boundary – always at least latent within architectural discourse – becomes further heightened as conceptualism's focus away from the aesthetic object explicitly opens aesthetic practices up to a new range of content including philosophy, linguistics, psychoanalysis, and so on – fields that Eisenman himself turned to in order to reconceive architecture.[8] By basing the essay in linguistics he thus heightens the competing allure and threat of conceptual practices for architecture.

Conceptualism, by challenging how the fields of art define themselves in and through other disciplines, equally challenges the disciplines and methods appropriated. In so doing, conceptualism's redefinition of the territory of the arts threatens not simply architecture's autonomy as it is often defined through the emphasis on objecthood and functionality, but, further still, the logical implication of this boundary shift potentially challenges the twentieth century's priority on function upon which that boundary is often defined. While this situation can be and often is understood as a disciplinary territorial battle, that debate serves largely to mask the premises upon which those territorial lines are drawn. Whereas the question can be what distinguishes the functional from the non-functional arts, or even whether such a distinction can be drawn, the more interesting concern lies around the mechanisms whereby utility is set up – and repressed – as the criterion of evaluation, the content that remains unrecognized and unquestioned.

While conceptual practices pose a renewed threat to the independence of various disciplines, architecture in the twentieth century has internalized that threat, defining itself in a continual search for an autonomous practice and a clearly defined territory. In this search art has frequently been declared to be on the opposite side of the boundary of use from architecture. While on the one hand this has amounted to the repeated assertion of architecture's distinction from the non-functional epithet of "art," there is more to this insistence than a simple parsing of terms into various categories.

Although architecture has a history of association with various specific contents, such as the social ideals attributed to modernism, much of that history has been suppressed under the overarching epistemological demands of twentieth-century functionalism in architecture and the associated philosophical tenets of logical positivism. This coupling of functionalism and logical positivism is more than a shared bit of zeitgeist, however; it is also the product of a relation bolstered by a shared epistemology which requires a one-to-one correspondence of form to meaning.

Logical positivism was the single most pervasive philosophical movement of the first decades of the twentieth century. The term refers to forms of linguistic and conceptual

analysis simultaneously based in the empirical tradition and in logico-mathematical theory. Initially formulated as an attack on metaphysics and theology, central to much of logical positivist thought is some form of verification theory which deems meaningful only that which is either directly verifiable through experience or that which is the product of mathematics and logic. Logic and mathematics are only accepted as meaningful, however, at the cost of being declared tautological. Everything else – ranging from metaphysical and ontological propositions about the nature of reality to aesthetic and ethical propositions – is understood to be unverifiable, and therefore meaningless. Meaninglessness, it should be noted, is not solely associated here with an emptying of meaning, but also with an indeterminacy of meaning. It is around the problematic status of the indeterminacy of meaning that the anti-metaphysical virtues of the aims of positivism become themselves entangled with a too limited view of the functioning of language and production of meaning, and this is where functionalism enters the discourse.

Functionalism, in arguing that the requirements of function serve as the necessary and sufficient determinates for the production of architectural form, attempted to define a similarly determinate position by which to analyze and produce architecture. In this view, the demands of function translate directly into built form. The operative assumption behind this approach is that by constructing a detailed and precise description of the programmatic intent of a given project – including issues such as space, light, mechanical, and adjacency requirements – and by adhering to that program and method throughout the design process, the architect should be able to directly transpose those functional constraints into a unique formal solution.[9] Form follows function, function is seen to produce form.

Within functionalist methodology, function is understood to be both primary cause and content of architectural form. This means that a specific content is associated with a specific form in a one-to-one relation that transforms a design approach into a method of producing meaning. In a manner akin to logical positivist theories of language, in order for functionalism to be successful, the function of an element or aspect of the architecture must be unquestionably legible. To achieve legibility, the architectural form needs to act as a direct or transparent sign of the building's various functions: entrance, circulation, gathering, and service spaces are all meant to be self-apparent along with the placement of windows, structure, and so on. These built signs are understood to transmit meaning without need of any additional interpretation, thereby realizing the architect's idealist dream of a self-explanatory architecture, one in need neither of critical interpretation nor of the literal "intrusion" of the linguistic in the form of additional signage within the building.

While functionalism is offered as rational, neutral, and natural – and therefore not in need of legitimation – the goal of producing a transparency of use to meaning – or more importantly of understanding a building's meaning as its program – is neither neutral nor natural. Functionalism operates by in effect naturalizing specific forms, programs, and relations. This transparency of form to function was fused early on with the social democratizing dimension of modernism. Not only was form then to be transparent to its function, but the meaning – as a product of that association

– was to be a direct translation of the needs of a more democratic and modern society, a direct translation of society's needs.

While functionalism and logical positivism succeeded in rejecting many problematic nineteenth-century constructs, advancing architecture and philosophy as a result, their legacies – a direct result of their successes – have created new problems. Taken together, the dual epistemologies of logical positivism in philosophy and functionalism in architecture mark most aesthetic practices as non-functional twice over: functionalism through its priority on a determinate form of utility and logical positivism through its declaration that aesthetics are meaningless. Both of these states define conditions that architecture traditionally abhors.

Conceptual aesthetic practices have shown the potential to challenge this one-to-one relation of content and form. Through the de-emphasizing of the form or the object, the relation between form and content is itself redefined in more complex and ambiguous terms, terms that frequently focus on the range of relations between the visual and the verbal as central to this process. While the requirements of functionalism make content and form both inseparable and a product of the priority of utility, the constructs of conceptualism upset that power structure by allowing for the possibility of the eradication of the distinction between content and form; between something being an artwork and a piece of philosophy; between a logical axiom and a professional service. In so doing, the distinctions, as previously drawn between art, architecture, and design, are themselves brought into question.

Because Eisenman's challenge to produce a conceptual architecture requires a transformation in accordance with the demands of a conceptualism that potentially threatens to disrupt the very understanding of what constitutes architecture, such a conceptual transformation of architecture threatens to turn what were believed to be essential aspects of architecture into contingent ones. Whereas formal and spatial issues might seem the first elements of architecture to be challenged in such a transformation, at risk are such potentially definitive traits as objecthood and utility. Regarding Eisenman, Robin Evans noted in the mid-1980s that despite the challenge constituted by the transformative processes that Eisenman exalts (such as topological geometry), these processes are kept in check through the rectilinear frameworks of the grids and cubes synonymous with rationality that continually dominate all aspects of Eisenman's work.[10] This domination serves to reaffirm quintessential architectural properties despite what challenges to the architectural object his work seem to suggest.[11] This same pattern of attempting to keep architecture in check through regulative frameworks is evident in the essay on conceptual architecture where, despite the possibilities and challenges that Eisenman sets forth, the definitive framework used to predetermine what constitutes architecture impedes architecture's conceptual transformation. This is the case not simply by Eisenman's understanding architecture to be responsive to function, but by his reiterating that function is the primary characteristic separating architecture from art.

A transformative process, as Evans points out, requires a thoroughgoing, unified distortion of the architecture object, one that alters the relations between architectural elements rather than transforming individual elements as if they were in isolation.

Such a transformation is akin to the transformative processes found in the shift from a formal to a conceptually based art or architecture. What this means is that the function relation itself – if as part of architecture as Eisenman demands – must therefore also be subject to this thoroughgoing change. By being inherent to architecture and therefore fundamental to defining both form *and* the relation between forms, *function itself is a relation and subject to transformation*. This is the paradox at the heart of Eisenman's essay that impedes his progress towards a conceptual architecture. Indeed, a (conceptual) architecture might in some manifestations be indecipherable from art or language, a possibility that threatens the defined field of architecture at least as much as the object itself.

What happens then when architectural practice or the architecture object is appropriated within an established conceptual art practice? Repeatedly the questions surrounding Pardo's work are ontological ones formulated in the guise of aesthetic, discursive, and institutional concerns. The understanding here is that context in the form of institutions or discourses typically determines what is and what is not art. Yet, what is asked amounts to a set of essentialist issues uttered in the face of a challenge to the (un)certain status of art. The house Pardo designed, for example, has been described as "more an ontological oddity: a private space with public aspirations, an art object with blatant use value, a museum exhibition in the absence of a museum, if not of its institutional procedures and ritual objects – uniformed guards, official hours, and a show on loan from another museum (an exhibition of Pardo's hand-blown glass lights, borrowed from the Museum Boijman Van Beuningen in Rotterdam)."[12] But what is offered as an ontological instability, the concern with the form of existence of art in this case, when analyzed, is often the result of a particular form of epistemology. In other words, what is suggested is a view of the work as unstable. However, this condition is itself a way of viewing art that is all too stable. This situation creates an odd paradox that pits the success of the work against the criticism that defines it. Consequently, as much as Pardo's work is described as calling into question the traditional boundaries of art, the responses to the work are strangely reaffirming of those precise categories the work is said to challenge.

If Pardo's work (along with other conceptual art practices) is indeed about, defined by, or coincident with the discourse it produces, then the success of the work is forever tied for its ability to affect that discourse. Yet discussions of Pardo's work repeatedly reiterate that art is art by virtue of context, intent, discourse, institution, temporality, or afunctionality. Consequently, despite praising the ability of the work to challenge these very same standards and categories, those boundaries are left undisturbed, art is returned to its place, aesthetically, ontologically, epistemologically, and linguistically. Initially, this return suggests two main possibilities. The first is that work perceived as challenging must be subjected to the curtailing forces of criticism, institutional or otherwise; while the second suggests that the work itself must be understood as failing in its challenge to redraw the current boundaries and definitions of art. Failure, however, in either location, is not simply because the boundaries and barriers in question were not eradicated or otherwise dismantled, but because the questions set forth and the discourse around the work (or said to comprise the

work) typically do not fully describe the revised problematics at play. That is, they do not fully embrace the ramifications of the conceptual shift to the entire category of aesthetic and other discourse, which is to say, the content of conceptual practices is repeatedly suppressed to disguised formalist and essentialist concerns toward maintaining existing disciplinary discourse and debates. The work is thus discussed to the extent to which it redefines "itself" rather than its content.

For example, Joel Sanders points to the potential of Pardo's work to challenge architectural practices; the focus of his critique is based on the understanding that Pardo in the end is functioning as a sculptor (Pardo a sculptor?) – with a traditional sculptor's focus on perception, light, and the body in contrast to a traditional architect's focus on use and construction.[13] Thus Sanders, while acknowledging the possibility for one discipline to challenge and positively affect another, ignores the conceptual focus of Pardo's work. In this way, Sander's critique is functionally equivalent to Eisenman's intent nearly 30 years earlier to remake architecture without changing its "essential" definition, its functioning, or its form of existence.

Similarly, Kate Bush declared:

> Part of the indeterminacy and complexity of the house's identity rests in the fact that Pardo is clearly not a professional architect . . . It has the effect of liberating the house from normative architectural discourse, allowing it to evade evaluation in terms of efficient functionalism, or technological innovation, or social utopianism or any of modernism's other concerns.[14]

This approach, again, only serves to reinscribe the work into traditional (modernist) views of art and architecture without considering how this and other work may have changed those very disciplines.

The house that Pardo designed is seen to raise this series of issues as a result of its dual standing as a private dwelling and a public exhibition venue. This framing of the discourse is all the more interesting as Pardo moved into the house only following its exhibition period. Which is to say that the house on view was not yet his (or anyone's) private residence, a point emphasized by the fact that exhibition objects were on view. The expected view of the private house is thus thwarted and replaced with a public exhibition. Social norms are displaced by familiar aesthetic codes. As the objects themselves on display are also in doubt as to their functional status, the entirety of the space is in a form of programmatic suspension.

Specifically, Pardo's work is understood to place its utilitarian aspects in dialogue with or in contrast to its aesthetic aspects, with that distinction often seen as the defining aspect of the work. One reviewer wrote: "but it is precisely the space between art and not, between furniture and not, that Pardo's art occurs."[15] Another review outlined this problematic from the other side of the art/world divide: "Our relationship with everyday objects is questioned: the more we look for human presence, the more we notice its absence in the isolation of the White Cube."[16] Pardo himself has alluded to this split between aesthetic objects and the world: "There is a lot more interesting stuff around here than my work, but my work is a model to look at this stuff."[17]

Pardo's objects do challenge the concept of utility, some because of their context in exhibitions, the "furniture objects," for example, others, such as the light fixtures, additionally because they themselves seem only marginally functional. One early furniture piece stands out from this norm by the extent to which it presents itself as non-functional: Pardo's 1990 Le Corbusier sofa made of welded copper pipes. Unlike many of his other works, for this piece Pardo did not borrow formal concepts or components, but, rather, he directly appropriated the architect Le Corbusier's design, leaving the form of the metal frame intact, but changing its material to copper and leaving the cushions out altogether. The result renders the sofa useless as a piece of furniture upon which to sit. Utility is thus countered by virtue of the object's design rather than solely through its context. Utility, however, plays another role in Pardo's work – one beyond the art/not art debate.

Part of the problem with the split between art and the world directly issues from the question of utility. In the division that leaves art on one side of the divide and the world of everyday objects and operations (including architecture) on the other, useful objects – that is, objects with specifically and explicitly delineated purposes – are understood to be part of the world until they are removed to within the confines of an exhibition space, where their utility is vanquished and their role becomes that of exhibition, their status that of art. Although the white walls of the museum, as the work's context, are described as the usual culprits in this, they are only part of the story, one that operates with an epistemology akin to both positivism and functionalism that require an object's "use" to be both determinate and transparent.

Although the art/world split understands that art itself may be useful (socially for example) it also frequently suggests that art's removal from the world provides the (critical) distance deemed necessary for the work's function as art. In either approach the question and privileging of use (social, functional, everyday, etc.) are presented as an unquestioned and unquestionably rational construct. What this does is suggest that use itself is a construct without history and that it is in need of neither validation, mediation, nor explanation. This pervasive privileging of function operates by instituting a criterion for judgment – utility – that seems unquestionable. This framework leaves the object, concept, discourse, etc. defined around the construct of use, as though it provided the one criterion in need of fulfillment. Use thus offers itself as an uncontested rationality definitive of the object in question.

Added to the initial demand that something (or someone, some construct, some discourse, etc.) be functional to be part of the world is the operative epistemology regarding use, the belief that the use of an object, discourse, etc. be transparent, and that this use provides its meaning or value. This transparency does not so much require that the use be immediately obvious to the observer as that, once revealed, the object's utility be determinate – and definitive. And this is the crux of the problem, the place where the functionalist and positivist demand for determinant meaning, *seemingly banished by post-structuralist thought*, is shown still to be operative.

Returning to Pardo, the potential of his work (intentional or not) lies in its ability to place the pervasive issue of function in a state of suspension where we are not sure whether it is privileged or not, whether it is active or not. The work's content is

derived from the continual oscillation between the museum and the everyday, thereby straddling the art/life boundary as it is constructed. This makes the issue of utility palpable while leaving its actual operation latent. Caught between these two poles, the question of function, in and of itself, becomes the work's foremost content. The effect at once makes apparent and removes the usual footholds and premises upon which the question of function rests. The work, which operates despite itself at times by employing twentieth-century art's history of questioning its own boundaries, succeeds not in the manner it seemingly prescribes. That is, not by redefining art's disciplinary or the museum's institutional boundaries. Instead, it succeeds in examining larger concepts implicit in the formation of the art/not art boundary in society. Of the constructs that form that boundary, utility is the foremost one at play in Pardo's work.

By placing the work variously on the border between art and design or art and architecture or art and service, the issue of function is continually brought to the forefront as the criteria by which we make these designations. That said, the designations can be placed in question around the utility of these objects and services. In other words, not being certain what the objects are – furniture or aesthetic objects, say – or to what discourse they belong, does not have to be seen solely as concerning the definition of aesthetic practice. Designating the work as art or not is not the only or the most interesting issue involved. Instead, Pardo's appropriation of various design practices and objects employs aesthetic practice as a way of raising the issues and concerns that the work constructs. This means entering into the content of the discourse of the work in question, rather than solely understanding it to be focused on discipline-defining discourses that can only refocus the content back onto the defining boundaries of aesthetic practice, as if caught in some ever-widening perpetual loop. This shift instituted by conceptualism requires seeing how a work functions beyond what it functions *as*. To simply recategorize the work and make its content about its ontological standing by attempting to designate on which side of the boundary the work lands misses the fundamental potential of the work by disregarding the criteria by which the aesthetic boundaries at stake are formed. If we want to accept work as conceptual, we need to not continually discuss it as though it were a formalist undertaking with its main focus directed inward at its own standing in the discipline. For conceptual aesthetic practices to be meaningful, their content cannot simply be ignored or made secondary to their relation to the history of aesthetic practices.

Notes

1 Peter Eisenman, "Notes on Conceptual Architecture: Towards a Definition," *Casabella* 359–60 (Dec. 1971): 51.

2 Ibid.

3 The attempt to remake a discipline by following the advances made in another field (related or not) is not something new. In the late eighteenth century for example, the philosopher Immanuel Kant, bothered by the manner in which philosophy had become

mired in a set of self-created problems and responses, turned to the advances made in the sciences by Newton for a model to regenerate philosophy, stating: "This attempt to alter the procedure which has hitherto prevailed in metaphysics, by completely revolutionizing it in accordance with the example set by the geometers and physicists, forms indeed the main purpose of this critique of pure speculative reason." In the mid-twentieth century structuralism has perhaps been the foremost example of a methodology progressively developed from one field to the next, from linguistics to anthropology to literary criticism, art history and finally to architecture itself.

4 Eisenman, "Notes on Conceptual Architecture," pp. 54–5.

5 This is all the more interesting as the art which Eisenman discusses (Morris, Le Witt, Johns, and Noland) does not in any way seem to impinge on the category of architecture. Le Witt's grids may come closest as architecture tends to think that it owns the grid, but none of these touches upon the necessity of object presence and pragmatics that Eisenman stresses as definitive of architecture.

6 Commissioned here translates (in economic terms) into MOCA having contributed $10,000 to the approximately $350,000 cost of the house.

7 One such exhibition was MOCA's "Pure Beauty" exhibition in 1994 in Los Angeles.

8 While Eisenman's essay does not make this explicit, it clearly operates as if threatened by the dissolution of some art/architecture boundary.

9 The 1920s work of the architect Hannes Meyer is one example of functionalist thinking.

10 See Robin Evans, "Not to be Used for Wrapping Purposes: A Review of the Exhibition of Peter Eisenman's Find'Ou T HouS" (1985), in Evans, *Translations from Drawing to Building and Other Essays* (Cambridge, MA: MIT Press, 1997), pp. 119–25.

11 Evans notes one remarkable exception to this: the final stage of House X produced an axonometric model that occupied a place between drawing and model.

12 Susan Kandel, "Home Work," *Artforum* 37, 3 (November 1998): 93.

13 Joel Sanders, "Frames of Mind," *Artforum* 38, 3 (November 1999): 126–31.

14 Kate Bush, "4166 Sea View Lane," *Parkett* 56 (1999): 153.

15 Kate Bush, "Design for Life," *Frieze* 36 (September/October 1997): 55.

16 Christina Vegh, "The Tonality of Contradictory Settings," *Parkett* 56 (1999): 138.

17 Uta Grosenick and Burkhard Riemschneider, eds., *Art at the Turn of the Millennium* (London: Taschen, 1999), p. 374.

26 1989

Juli Carson

I don't make portable objects; I don't make works that can be relocated or site adjusted.
I make works that deal with the environmental components of given places . . . As [the]
phrase implies, site-specific sculpture is one conceived and created in relation to the
particular conditions of a specific site, and only to those conditions. To remove Tilted
Arc, *therefore, is to destroy it.*

<div align="right">Richard Serra, Statement at the hearings to remove Tilted Arc</div>

*T*ilted Arc, a wall about which we have read so much, one that most of us in
fact know only *through* such readings, is the referential "site" for the fol-
lowing story. In 1985, William Diamond, the New York Regional Admin-
istrator for the General Services Administration (GSA), recommended that Richard
Serra's *Tilted Arc* be removed from the Federal Plaza in Downtown New York
City. Four years and several failed appeals later, *Tilted Arc* was removed, or, in Serra's
own words, "destroyed." Shortly thereafter, in 1991, *The Destruction of "Tilted Arc":*
Documents was published by MIT Press, officially entering the controversy surrounding
the hearings into art-historical discourse. Indeed, the hearings from 1985 were a ready-
made for such a book, as scholars, artists, and critics, ranging from Claes Oldenburg,
Douglas Crimp, Abigail Solomon-Godeau, Rosalind Krauss, Benjamin Buchloh, Annette
Michelson, Frank Stella, and Roberta Smith all spoke in defense of Serra's project.[1]

Since then, the plethora of critical writings engendered by the controversy has
underscored the nature in which *Tilted Arc*, in fact, is merely a site for "a story that

Published here for the first time.

acts as if the site preceded it," as Mark Wigley has said in relation to other self-proclaimed "site-specific" projects.[2] For it was a book produced under Serra's supervision – one that ironically sought to document the manner in which his project was destroyed upon its *physical* removal from its site – that illustrated the manner in which *Tilted Arc*'s "site-specificity" was always *already* discursive. The most important contribution of *The Destruction of "Tilted Arc,"* therefore, was not the historical record of the work's physical whereabouts that it purported to preserve. What is more striking is the manner in which the book performatively demonstrates how *Tilted Arc*'s "presence" is inextricably bound up with the rhetoric from which it was conceived (late modernist, phenomenological notions of site-specificity) and to which it contributed (postmodernist notions of the discursive site). Indeed, there was a destruction of Serra's *Tilted Arc* in the works here; however, it wasn't merely the physical object destroyed at the hands of those policemen who removed it in the middle of the night. For the "object" destroyed was the very one borne within the modernist dialectic over a work's *physical* site-specificity, bound up, as it were, in the logic of transcendence – a dialectic between a work seen to transcend any physical *union* with its site and a work seen to transcend any physical *contradiction* with its site. Borne as such, *Tilted Arc*'s "death" occurred at the instance that it was *discursively* bound (and for many, first received) *off*-site, first in the hearings, then concretized in the pages of *The Destruction of "Tilted Arc."* Which is to say, quite simply, *Titled Arc*'s *raison d'être* ended the *moment* that it was *written*.

At the core of Serra's dilemma is thus the contradiction of presence that Jacques Derrida writes about in his critique of logocentrism. What Derrida refers to as that "logos of being" relies upon the difference between a signifier and a signified such that a transcendental signified – pure presence, pure voice – could primordially pre-exist all subsequent signification. And yet, in the very instance of logos being *known*, it first had to be *reiterated*, which is to say, it had to be presented as that *thing-not-itself*. This, of course, is what bothered Greek philosophers about writing in the first place, that one would "repeat without knowing" the truth of that very presence they sought to document, such that the "truth" of writing would in fact be *non*-truth. This is the same contradiction in writing that Derrida called the "pharmakon," following Socrates' fable about the invention of writing as recounted by Plato in the *Phaedrus*.[3] To recount the fable again: Thamus, the King of Egypt, the representative of Ammon, God of all Gods, is offered a pharmakon (a recipe) for memory and wisdom: writing itself. The king or God can thus be seen as the origin of writing's value, a practice that comes to him from elsewhere. For the God as speaker-of-the-word, of course, doesn't write. And as such, the "God who speaks," according to Derrida, acts as the Father who treats the pharmakon (given as a gift or remedy) with great suspicion because it simultaneously threatens the *value* of his presence in the very instance of dutifully *recording* it.

The God's derision of writing can thus be seen as a paternal act, one which accords with the Platonic notion of logos that assigns the power of speech to the paternal position. As such, the Father is not logos itself; rather, the origin of the power of speech (as logos) is always the Father. He thus gives birth to living logos in the form of the son who wants dutifully to record his spoken word. But in the very

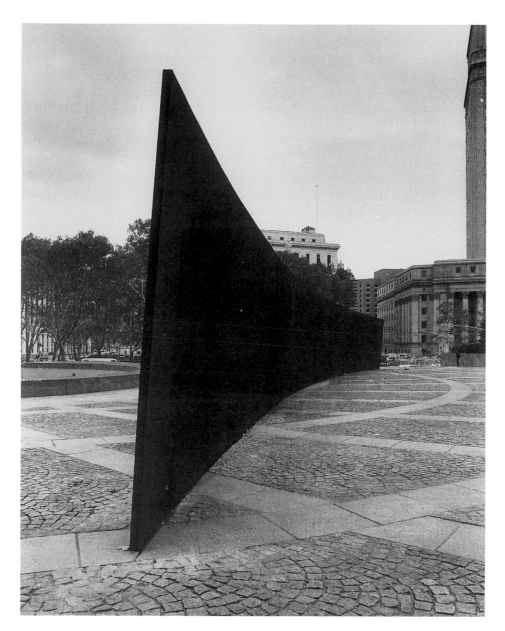

Figure 26.1 Richard Serra, *Tilted Arc*, 1981, weatherproof steel, 12′ × 120′ × 2½″. Collection: General Services Administration; installed Federal Plaza NYC, destroyed 1989. © 2002 Richard Serra/Artists Rights Society (ARS), New York. Photograph by Dith Prahn, NYC.

attempt to record the Father's spoken word, to make *good* on it, there is the threat of producing what Derrida calls the "orphaned" text: that piece of writing separated at birth from its Father, whereupon the orphan forever forth becomes "his own man." Derrida analogizes the Father/Son/Orphan relationship to the positions of presence, speech, and writing this way:

Father	Son	Orphan
The Origin	Speech	Writing
The Good	Living Logos	Supplement
The Source	Mneme	Anamnesis

We can see that the graphic mark is none other than writing separated at birth from the Father at the very moment of inscription. As such, writing stands opposed to living logos, the latter of which is the dutiful transcriber of active speech, maintaining a closer proximity to the Father in order to make a good "return" on his "source of capital." Logos thus relies upon, while simultaneously producing, the binaristic tension between speech (operating upon the prohibition of perversion) and writing (the everlasting threat of patricide). For speech, transcribed, purports to *remember* accurately the word of the Father, while writing, orphaned, inevitably threatens to *forget* it.[4]

The Son Begets the Father

Who then begets whom, Derrida asks, following the Nietzschian principle of chrono-logical reversal[5] – the Father or the Son? For the Father, as that metaphor for pure presence, can only be conceived *after* the fact in the form of what he has made to represent him – the Son – even if that Son is the one who unwittingly becomes orphaned in the space of dutifully recording the Father's word. For simply, how can there be a Father if at *first* there is already not a Son? In the case of Serra, *The Destruction of "Tilted Arc"* ironically registered the split of a (postmodern) discursive practice from minimalism, one that would put under erasure the very notion of presence (in the form of site-specificity) that the book was meant to record and preserve. But isn't this split, this accidental "birth by negation," consistent with the very terms of Serra's own project to begin with? Which is to say, isn't Greenberg-the-Father still lurking somewhere in Serra's (residually) modernist project, albeit in oppositional terms? For Serra's project rhetorically *begets* Greenberg's modernism in the act of negating him in the first place, inasmuch as the (postmodern) record of *Tilted Arc* begets and reveals Serra's own (modernist) project. As such, is Serra's defense of *Tilted Arc*, in the late year of 1989, not a pivotal instance of modernism's last living logos?

I look to Rosalind Krauss's well-known essay on site-specificity, "Sculpture in the Expanded Field," which lays the structuralist foundation for my assertion here (a foundation that is too readily dismissed or willfully forgotten in current discourse). Modernist sculpture, the brand with which Serra's work dialectically engaged, asserted an inherent site*lessness*, one that in the hands of Brancusi, for example, made claims to being functionally placeless and self-referential, as base and sculpture were sub-sumed into a single transportable form. But, as Krauss argues, it was a limited practice, exhausting itself mid-century as the belief in the "positive" self-referentiality of form

began to be experienced as pure negativity. "At this point," Krauss argues, "modernist sculpture appeared as a kind of black hole in the space of consciousness, something whose positive content was increasingly difficult to define, something that was possible to locate only in terms of what it was not."[6] What it "was not," of course, was the site itself in which sculpture was posited. As such, sculpture – in positive terms – could only be defined as *neither* architecture *nor* landscape.

The nature of modernist thought about form, the idea that something would be defined as *that which it is not*, involved more than just sculpture. Greenberg made this explicit in his essay "Modernist Painting," when he definitively associated modernism with "the intensification, almost exacerbation of a self-critical tendency . . . [whereby] the characteristic methods of a discipline . . . [would be used] to entrench it more firmly in its area of competence." Each art form, then, "had to determine, through operations peculiar to itself, the effects peculiar and exclusive to itself." The cost, Greenberg admits, may have been that a given art form would limit its area of competence, but the ends justified the means here, for at the same time "it would make its *possession of this area* all the more secure."[7]

As we know, the discrete instance of an aesthetic form's *coming into being* lent itself to a certain belief in the transcendence of experience, for the artwork was not just distinct from other forms in the world, it was distinct from the body of the viewer himself. Such was the backbone of Greenberg's theorization of the visual field in the guise of a disembodied eye, which Krauss lyrically recalls in her book *The Optical Unconscious*. Here is her anecdote of what a work must disavow in that moment of presumed transcendence that pivots off the "look":

> And were we to ask Clement Greenberg about his own description of "the look," the look that art solicits, the look that is the medium of the transactions between viewer and work? The time of that look is important, he claims, because it must be time annihilated. "With many paintings and pieces of sculpture," he has insisted, "it is as if you had to catch them by surprise in order to grasp them as wholes – their maximum being packed into the instantaneous shock of sight. Whereas if you plant yourself too firmly before looking at a picture and then gaze at it too long you are likely to end by having it merely gaze back at you."

She continues, explaining the body's intervention in the field of vision, when time is not properly annihilated:

> And when time has not been thus suspended . . . then the trajectory of the gaze that runs between viewer and painting begins to track the dimensions of real time and real space. The viewer discovers that he or she has a body that supports this gaze . . . and that the picture, also embodied, is poorly lit so that its frame casts a distracting shadow over its surface now perceived as glassy with too much varnish. What Clem refers to as "the 'full meaning' of a picture – i.e., its aesthetic fact" – drains out of this situation, relocated as it is in the all too real. And the result is that instead of generating an "aesthetic fact," the picture, now reified, simply returns the look, merely gazing "blankly" back at you.[8]

It was precisely *against* this disembodied eye – the eye of the viewer as much as the eye of the work – that an "expanded field" would challenge not only the definition of form but also the space of its experiential limitations. Which is to say, should we shift the space of viewing to an *embodied* perspective, sculpture would no longer be defined *itself* as that which it *is not* (that which "you back up into when you look at a paint-ing," as Krauss cites Barnett Newman as saying). Rather, sculpture (as a negation of Greenberg's negation) would *possess* that which modernist form had adamantly disavowed: the mundane materialist aspects of its physical site. And in doing so, it would only ever be *itself in its site*.

And here, then, we have a dialectical reversal within the logic of modernist form, one best demonstrated by Robert Morris's *Corner Piece* of 1964. If for Greenberg modernist painting discretely possessed its *disciplinary area* of competence, dialectic-ally, minimalist sculpture presumed to completely possess the *physical site* common to the object and beholder with the intention of provoking a subversive intrusion within Greenberg's transcendent, disembodied field of vision. For the corner of the corner piece, being at once the corner of the gallery, subtracts from us a space *in which* we stand. Space, wall, floor, and the beholder's body are now each, in this "expanded field," one term among others that *stand* to define the object, an object that we willfully and necessarily recognize as "staring back at us." It is an effect made even more directly by Morris's four mirrored cubes of the same period, in which the work literally constitutes itself vis-à-vis the reflection of surrounding space, wall, floor, and beholder. [9]

The reader, here, may protest my assertion that there is a convergence between a site-specific artwork permanently located in the world – be it in the form of an earthwork like Michael Heizer's *Double Negative*, Robert Smithson's *Spiral Jetty* (both of 1970), or Serra's urban projects – and site-specific artworks like Morris's four mirrored cubes that are mobile by nature. What these projects nevertheless have in common is the focus of this essay: the assertion of "site" as a transcendental signified, be it permanent *or* mobile, based upon an essentialist, positivistic notion of "experi-ence." [10] It is a concept that will implicate even more intellectually discordant prac-tices in architecture, to which I will now turn.

Within the "internal logic" of sculpture in the expanded field, operating as it did upon a closed structure of oppositional terms, the notion of "site" is still a physical, materialist one (an operation maintained precisely *through* minimalism's dialectical challenge of the modernist assertion of a Cartesian mind/body split). It shouldn't surprise us, then, that a residual effect of this materialist "anti-modernist" sculpture – a negation of a negation – positively continued the rhetoric of modernist architec-ture. This rhetoric (to the chagrin of minimalist intellectualism) echoed Frank Lloyd Wright's more romantic notion of site-specificity as providing a heavenly bond between a given structure and its physical environment, about which he swooned to his students at Taliesin West:

> . . . now you are released by way of glass and the cantilever and the sense of space which becomes operative. Now you are related to the landscape . . . You are as much

part of it as the trees, the flowers, the ground . . . You are now free to become a natural feature of your environment and that, I believe, was intended by our maker.[11]

On the level of intentionality, the citation of Wright's project in the context of minimalism constitutes a form of heresy to the proponents of either practice. For, of course, the minimalists' intention of fusing sculpture with landscape and architecture was one of critical (or even political) subversion, against the romantic, idyllic intentions of Wright's conservative site-specificity.[12] Nevertheless, the philosophic terms of such a work's fusion within its environment are remarkably similar, particularly when we consider the late instances of minimalism's project in the hands of artists like Serra, engaged as they were in the ideal of "public works of art" constituting a social expansion of an already "expanded field."

Within the time frame of *Tilted Arc*'s controversy, the philosophic convergence of these two models – high modernist architecture and late minimalist sculpture – is demonstrated by arguments for and against the project, both of which state their claims in terms of a fusion between project and site. As for those against the project, high modernist architectural paradigms of site were evoked. I am thinking in particular of testimony given by Margo Jacobs, the wife of Robert Allen Jacobs, the latter of whom was one of the architects for the Federal Office Building and International Court of Trade. For what Jacobs argued at the hearings concerned who best *occupied* the site, the sculpture, or the plaza, which is to say, who occupied the site *first*. She stated:

[T]he sculpture does not belong in the Federal Plaza because it is hostile both to its environment and hostile to the public, since it acts as a barrier to their free movements. The plaza is both an *integral part* of the design of the Federal Office Building and Court house and, at the same time, an *extension of* Foley Square Park. (my emphasis)

She continues to assess the damage that *Tilted Arc* enacts on the plaza's harmonious placement within the site of an idyllic public sphere: "This plaza was not designed to be an empty space, but it was designed as a place for people and for their public assembly. The plaza is a site-specific work of art incorporating a geometric pavement design, now destroyed."[13]

In tandem with Jacobs's testimony, compare here again Serra's defense of *Tilted Arc* positioned against the modernists in minimalist terms, all the while dialectically maintaining modernism's basic suppositions about site:

The specificity of site-oriented works means that they are conceived for, dependent upon, and inseparable from their locations. The scale, the size, and the placement of sculptural elements result from an analysis of the particular environmental components of a given context . . . Based on the interdependence of work and site, site-specific works address their context, entering into dialogue with their surroundings. Unlike Modernist works [i.e. those made by Brancusi and others] that give the illusion of being autonomous from their surroundings, and which function critically only in relation to the language of their own medium, site-specific works emphasize the comparison

between two separate languages and can therefore use the language of one to criticize the language of the other.[14]

This belief in a closed dialogue between two things – a work and its site – is consistent in both Serra's and Wright's defense of their respective projects, regardless of the intellectual divergences of their claims. Which is to say, each claim hegemonically privileges one side of this dialogue – the position of the speaking subject in the space of the work, who (which) *first* identifies a site and *then* enters it. A transcendent dialogue is then presumed to take place between artist and site, one unhindered by any possibility of the cacophony of other voices that might contradict the artist's projection that a site ontologically exists a priori to his engagement with it. A projection, in fact, that represses the manner in which one's engagement with a site retroactively constitutes that site, stemming from what one subjectively invests as *being* "there." What this repression maintains of modernism's initial belief in transcendence, albeit by negation, is not the art work's anti-materialist (or site-less) condition, but the belief in an art work's unadulterated experience in the form of a dialogic, *non*-contradictory existence *in situ*. This belief, of course, maintains (as much as it is maintained by) classic tautological form, founded (here) upon the logic that a one-to-one dialogue exists *solely* between two languages because two languages are put into dialogue with each other. But, as we know, the logic of tautologies is that they exist because they say *nothing* of the world, and since all signification takes place within the world (i.e., all *utterances* are *spoken* in the world), tautologies – be they Serra's or not – can never really *show* themselves.

We must ask, then, if Serra is the speaking subject in this context, of whom does he *really* speak? Ostensibly he attempts to speak *for* himself and the work, but, as we see, he unwittingly contradicts himself, breaking ranks with his own tautological assertions by speaking *instead* of Greenberg by negation and Wright by discursive association. He thus begets, again, the Father in the space of modernism *through* his very attempt to denounce him/it. For he is still within the snares of his/its logic about site. Serra here is the good son he does not want to be, which we see even more when the "other" speaks back. Not because the other is right, but because the "other" inevitably *will* speak, even and *especially* when that other is spoken unwittingly by the author himself, the one who thus revenges himself upon his own closed definition of site-specificity.

That Dangerous Supplement

What happens when the "other" is something in the space of the expanded field that speaks *back*? This "other" may be the government in the form of power lines that were installed in the vista of Taliesin West, prompting Wright's letter campaign to the President in an attempt to have them removed. The attempt, of course, failed, prompting Wright defiantly to reconfigure Taliesin's living quarters to face its opposite vista:

the blank side of the hill from which it was *intended* to spring forth. Or the other may be the performative instance of a *disharmonious* public.[15]

For *Tilted Arc*, as we know, it was the GSA that first spoke back in 1984 when William Diamond pressed for a public hearing to relocate the work. One year later, from March 6 to 8, a hearing was held, at which time 122 people spoke in favor of retaining *Tilted Arc* and 58 spoke against it. Through this litigation, *Tilted Arc* became a wall that heterogeneously signified contradictory political and aesthetic ideologies. According to the GSA's security specialist, Vickie O'Dougherty, who conjured up the specter of a criminal public indexed by the sculpture's graffiti, combined with its encouragement of loitering and its obstruction of the government's visual surveillance of the plaza, *Tilted Arc* was a security hazard.[16] For Harry Watson, an employee of the Bureau of Investigations of the State of New York, *Tilted Arc* was an index of the government's wasteful insanity, a "rusted metal wall" for which the government paid $175,000, but which could be sold "to a scrap metal farm for maybe fifty dollars."[17] And for Shirley Paris, a private citizen, *Tilted Arc* was, simply, "the Berlin Wall of Foley Square."[18] A claim of violence being inflicted upon "the public" (in tandem with the fantasy that the sculpture would further encourage more violence) thus supplanted Krauss's assertion at the hearings that *Tilted Arc* "invest[ed] a major portion of its site with a use we must call aesthetic."[19] Indeed, this was the modernist signified *of which* the *Arc* (turned mere wall) contingently "spoke," but *for which* it was not a suitable "representation."

As appeals failed, *Tilted Arc* met its final demise in 1989. It is a moment Serra recalls in terms that phantasmatically evoke the trauma of a public execution:

> Once my own say in the fate of the sculpture had been finally denied by the federal courts, William Diamond, the regional administrator of the GSA and the man most responsible for the campaign against *Tilted Arc*, acted immediately to have the sculpture removed. In a sinister all-night session on March 15, overtime work crews labored to dismantle *Tilted Arc*, brutally sawing and torching the piece. Finally around 4:30 a.m., *Tilted Arc* was reduced to raw materials, to be carted off and stored in Brooklyn, reportedly pending relocation. "This is a day for the people to rejoice," said Diamond, "because now the plaza returns rightfully to the people."[20]

The discursive evocation here of the body's violation in the metaphoric space of the *Arc*'s "public execution" is unequivocally present in Serra's account: the denied attempt to stay the inevitable sentence, the subsequent midnight action, the "brutal sawing and torching" of the piece, the reduction to raw material parts, and finally the (phantasmatic) cheering mob. It was, of course, the very terms of minimalism's *embodied* essence of production and reception that in part afforded (if not secured) the inevitably *personal* violation felt by Serra; for what was reduced to fragmented and discarded parts, shipped off-site, and locked away was not just the presence of a work of art, but (by metonymic association) the logic of Serra's authorship itself. But what of the *other* destruction that metonymically took place here, that of the author's presence/authority behind his own word? For Serra, it was the very moment at

which *his own say in the fate of the sculpture had been finally denied* that the execution began. And in written defense of the integrity of this physical body, and in protest against its wronged execution, there emerged another body – the *corpus* of writing as both the executor and progeny of Serra's *own* word in (and on) the space of "site-specificity."

Let's return again to Plato, intertextually through our reading of Derrida's "Pharmacy" essay, whereupon we encounter another (even more familiar) wall. Of logos, as *the* Father or Source, it is impossible to speak directly, any more than it is possible to look directly into the sun. And it is here that Derrida directs us to revisit Plato's famous passage from the *Republic*, in which the following scenario is played out:

> Picture men dwelling in a sort of subterranean cavern with a long entrance open to the light on its entire width. Conceive of them as having their legs and necks fettered from childhood, so that they remain in the same spot, able to look forward only, and prevented by the fetters from turning their heads. Picture further the light from a fire burning higher up and at a distance behind them, and between the fire and the prisoners and above them a road along which a low wall has been built, as the exhibitors of puppet shows have partitions before the men themselves, above which they show the puppets . . . See also, then, men carrying past the wall implements of all kinds that rise above the wall, and human images and shapes of animals as well, wrought in stone and wood and every material, some of these bearers presumably speaking and others silent.

What the men see, therefore, is not each other nor the men behind them, but only the shadow cast from the fire onto the wall of the cave that is in front of them. That is what constitutes reality for them – the shadows on the wall. The scenario continues:

> Consider, then, what [would happen when] one was freed from his fetters and compelled to stand up suddenly and turn his head around and walk and to lift up his eyes to the light? . . . And if he were compelled to look at the light itself, would not that pain his eyes, and would he not turn away and flee to those things which he is able to discern and regard them as in very deed more clear and exact than the objects pointed out?[21]

For Derrida, the mythic Father-as-Source of logos is located here in the place of that blinding light, the visible-invisible figure of the Sun as the origin of all "onta" (or Being). The shadows on the wall function as the logos, which represents him by proxy along the logic of a penumbra: *that partial shadow, as in an eclipse, which allows something to be partially seen by blocking it out.* But in doing so, the penumbra, as a type of pharmakon or supplement, is a toxin in the very space of presence it means to relay.

Herein lies the paradox of signification in general, and writing in specific: the necessity of a representation to signify pure presence through *blocking* that which such representation means to preserve (the very definition of writing). This paradox was, of course, a basic post-structuralist lesson in linguistics that intrigued a branch of postmodern artists (Sherrie Levine, Silvia Kolbowski, Cindy Sherman) in the very decade that Serra sought to defend the *presence* of his project through the *truthfulness*

of his written record. And it was the same paradox that produced the aporic site of *Tilted Arc,* a site in which the controversy that logically succeeded it could, in fact, be understood as simultaneously producing it. For, without the controversy, transcribed into writing, "Tilted Arc," the last living artifact of modernism's logos of site-specificity, could never have been directly *seen.* Unwittingly, however, through the very act of being *written,* "Tilted Arc" became that wall within Plato's cave upon which reflections of modernism's belief in the transcendence of site – in the form of a minimalist dialectical reversal – were projected and thus enacted. Of course, without the written supplement, such an *"Arc"* would never have existed. It would have remained sited in another signifying order, and as such it would have stood as that rusted, steel wall, merely punctuating the end of an "embodied" sculpture's transgressive expansion.

What we have, then, is Derrida's legacy of logos enacted by Serra in the following manner:

Father	*Son*	*Orphan*
Minimalism	Expanded field	Supplement
Embodied presence	Site-specificity	Discursive site
Serra	*Tilted Arc*	*The Destruction of "Tilted Arc"*

First, we have what Serra intends, his word to mean something in the living logos of his minimalist form, against which a dangerous (postmodern) subject is born in the form of the discursive site that undercuts the authority of his own word (on site). This is the instance in which Serra enacts the Platonic fear of speaking without knowing. But in the same gesture we have a dialectical reversal, a negation of a negation, which puts Serra's word in the mimetic space of Greenberg's. Serra, as a man of his word in the late moment of minimalism's last gasp, thus exists as a pivot between high modernism and postmodernism, and against all *intentions* he at once begets one inasmuch as he is begot by the other:

Father	*Son*	*Orphan*
Transcendence	Expanded field	Supplement
Disembodied sitelessness	Site-specificity	Discursive site
Greenberg	Serra	*Tilted Arc*

A boomerang effect is thus in play here, one in which the minimalist claim against authorial intentionality is undercut by the inherent intentionality of such a claim. For the work never simply *is.* Rather, it begets as much as it is begot by the other that it is not, something *Tilted Arc* demonstrated through the legal, social, and philosophic fields in which it was inextricably entangled. And in the course of all this we experience the strange turn of events, a chronological reversal, whereby *Tilted Arc* gets away from Serra insofar as he moves uncomfortably closer to Greenberg's modernism, as the prodigal son.

My use of the term "boomerang" is knowingly ironic, as it is the title of a video made by Serra himself that demonstrated the operation I am describing here; simply,

that a subject is never located *only* in the place from which he/she speaks. *Boomerang* (1974) records Nancy Holt speaking with a slightly delayed audio feedback delivered to her through the headphones she wears. The video is called "boomerang" because it aptly demonstrates the state in which the subject experiences the temporal and psychic effect of chronological reversal. For Holt's own words come *to* her as much as they come *from* her. Increasingly, as the tape records ten minutes of this operation, we are confronted with the fact that there is no speaking subject *behind* the word, only a subject spoken retroactively *by* one's own word. Likewise, if *Tilted Arc* is therefore a model of the last living logos of Greenberg, as I've been arguing, it isn't due to Serra's authorial intention. Rather, it is due to a certain time-delayed feedback of its own. Moreover, the point should be made even more clearly that the author's intention for a given project's criticality does nothing to secure its function as such. For as regressive as I am arguing *Tilted Arc* to be, Serra's own *Boomerang* video just as clearly makes the case for an orphaned model of time that undermines the branch of modernism to which Greenberg has been attached and for which (in the end) Serra's *Tilted Arc* unwittingly speaks.

Notes

1 Clara Weyergraf-Serra and Martha Buskirk, eds., *The Destruction of "Tilted Arc": Documents* (Cambridge, MA: MIT Press, 1991). The book includes an introduction by Richard Serra.

2 Mark Wigley, "On Site," unpublished manuscript (at the time of this writing).

3 Jacques Derrida, "Plato's Pharmacy," collected in *Dissemination*, trans. Barbara Johnson (Chicago: University of Chicago Press, 1981).

4 The chart should make it clear that there are two concepts of writing. One is borne of the "good" son, a transcriber who invents a transparent form of writing through which speech comes to be. This is why the category "speech" is positioned under "Son." Another is borne of the "orphaned" son, one who invents an opaque form of writing through which the purity of the speaker's word comes to be corrupted. This is why the category "writing" is positioned under "Orphan."

5 Jonathan Culler synopsizes Nietzsche's notion of *chronologische Umdrehun* this way: "Suppose one feels a pain. This causes one to look for a cause and spying, perhaps, a pin, one posits a link and reverses the perceptual or phenomenal order, *pain . . . pin*, to produce a causal sequence, *pin . . . pain*." In *Werke*, Nietzsche thus derives the following temporal dilemma: "The fragment of the outside world of which we become conscious comes after the effect that has been produced on us and is projected *a posteriori* as its 'cause.' In the phenomenalism of the 'inner world' we invert the chronology of cause and effect. The basic fact of 'inner experience' is that the cause gets imagined after the effect has occurred." (Friedrich Nietzsche, *Werke*, vol. 3, ed. Karl Schlecter, Munich, 1986.) Cited in Culler, *On Deconstruction: Theory and Criticism after Structuralism* (Ithaca: Cornell University Press, 1982), p. 86.

6 Rosalind Krauss, "Sculpture in the Expanded Field," collected in Hal Foster, ed., *The Anti-Aesthetic* (Port Townsend: Bay Press, 1983), p. 36.

7 Clement Greenberg, "Modernist Painting," in *The Collected Essays and Criticism*, vol. 4, ed. John O'Brian (Chicago: University of Chicago Press, 1993), pp. 85–93; my emphasis.

8 Rosalind Krauss, *The Optical Unconscious* (Cambridge, MA: MIT Press, 1993), p. 98.

9 This claim for what Krauss would later call sculpture's embodied "expanded field" wasn't limited to proponents of minimalism. In fact, Michael Fried, Greenberg's main spokesman, based his critique of minimalist form *precisely* on the work's characteristic phenomenological occupation of the viewer's entire field of vision. In his classic essay, "Art and Objecthood," he clearly demonstrates his understanding of Morris's brand of minimalism, thus positioning himself dialectically against it: "[In minimalist work] the object, not the beholder, must remain the center or focus of the situation; but the situation itself *belongs* to the beholder – it is *his* situation. Or as Morris has remarked, 'I wish to emphasize that things are in a space with oneself, rather than . . . [that] one is in a space surrounded by things.' . . . It is, I think, worth remarking that 'the entire situation' means exactly that: *all* of it – including, it seems, the beholder's *body*. There is nothing within his field of vision – nothing that he takes note of in any way – that, as it were, declares its irrelevance to the situation, and therefore to the experience, in question." Michael Fried, "Art and Objecthood," collected in Gregory Battcock, ed., *Minimal Art: A Critical Anthology* (New York: E. P. Dutton, 1968), p. 127. See also Robert Morris's "Notes on Sculpture," collected in the same anthology.

10 As for those works occupying the "permanent" site, Heizer and Smithson have conventionally been lumped together within the category "earthworks." However, it should be noted that Smithson's entire project in general, and *Spiral Jetty* in specific, may be said to have challenged the very notion of site (as a transcendental signified) through which earthworks were (and still are) commonly understood. For a discussion of Smithson's interrogation of a transcendental notion of site-specificity, in tandem with a deconstruction of dialectical temporality, see my "On Critics, Sublimation, and the Drive: The Photographic Paradoxes of the Subject," in Parveen Adams, ed., *Sublimation or Symptom* (New York: The Other Press, 2003).

11 Cited in William J. R. Curtis, *Modern Architecture Since 1900* (Oxford: Phaidon Press, 1982), p. 200.

12 See Douglas Crimp's "Redefining Site Specificity," in *On the Museum's Ruins* (Cambridge, MA: MIT Press, 1993), pp. 150–86.

13 *The Destruction of "Tilted Arc,"* p. 124.

14 Ibid., p. 12.

15 For a specific discussion of how the controversy surrounding *Tilted Arc* served as an index of a disharmonious public sphere, one that is repressed by the notion of a utopian public borne of Enlightenment thought, see Rosalyn Deutsche's "*Tilted Arc* and the Uses of Democracy," in her *Evictions: Art and Spatial Politics* (Cambridge, MA: MIT Press, 1996).

16 *The Destruction of "Tilted Arc,"* p. 117.

17 Ibid., p. 120.

18 Ibid., p. 126.

19 Ibid., p. 81.

20 Ibid., p. 3.

21 *The Collected Dialogues of Plato*, ed. Edith Hamilton and Huntington Carins (Princeton: Princeton University Press, 1989), pp. 747–8.

Part V Theories after Postmodernism

Introduction to Part V

I f many of the most important theories of art produced in the 1970s to mid-'80s were engaged in a systematic refutation of the high modernist paradigm, theories since the mid-'80s began to chart the limits of the first wave of postmodern thought. The critique and relinquishment of postmodernism as a general theory took many forms as thinkers associated with it began to splinter widely, many of them calling into question the directions postmodernism had taken as an organizing principle, and in some cases jettisoning the ideological usefulness of the very term. The authors in this section contemplate art production and the wider cultural context at the moment when postmodernism replaced modernism as the theory in need of revision.

In "Postmodernism and Periphery," the Chilean critic Nelly Richard dissects the Eurocentrism of postmodern critical theory in the first wave of its wide circulation in art discourse in the mid-1980s. Richard, writing from a Latin American perspective, claims the limits of postmodern rhetoric lie, first and foremost, in its assumption about the model of the modern itself, particularly its universalizing conception of a "meta-subject" of the West who occupies a privileged, central position in relationship to culture. Historically, modernization in Latin America is equivalent to Europeanization, where the social and cultural elite's identification with European history filters modernism through a colonial lens. Modernism conceived in the geographical periphery of this culture, Richard asserts, is paradoxical and out of joint, because the Western modernist model of culture differs greatly from indigenous historical conditions in the periphery. Richard cautions against the same Eurocentric and colonial tendencies in relation to postmodern theory as it is transplanted into a peripheral context. For Richard, a meaningful engagement between postmodernism and "the

periphery" lies in an intellectual investment in the complexity of identity and culture in the periphery; in a reconsideration of what was "left unsaid," and rethinking "areas of opacity and resistance with the potential for new, as yet undiscovered, meanings."

The politics around race and sexuality and the controversies surrounding public funding for the arts in the late 1980s set the stage for Kobena Mercer's essay, "Looking for Trouble," a re-evaluation of his earlier views on the work of photographer Robert Mapplethorpe. Initially written on the occasion of an exhibition of Mapplethorpe's photographs, Mercer engages the reader in his ambivalence about the homoerotic depiction of black men in the photographer's portfolio. Drawing on feminist cultural theory and the work of Franz Fanon, whose writings on the psycho-sexual dimensions of racism helped give rise to postcolonial critical theory, Mercer charts the unbalanced power relation between the photographer and his subjects, and suggests that Mapplethorpe's photographs duplicate the conventionally objectifying, fetishistic white gaze conferred upon black bodies. Yet for Mercer, this reproach is mitigated by the very complexity of feeling the photographs arouse for the beholder of this gaze, among which is a "shock effect" that destabilizes a position of mastery, and the subsequent interrogation of the centrality of "white" subjectivity itself. The confluence of contradictions in Mapplethorpe's work, between popular sexual stereotype and fine art ideal, desire and objectification, homoeroticism and the colonial possession, for Mercer makes the meaning of the work "strictly undecidable," and therefore subject to continual reconsideration.

In the last two decades, the interdisciplinary field of cultural studies began to challenge the parameters of knowledge set by older academic disciplines such as art history, literary studies, sociology, anthropology, and political science. Central for the conception of cultural studies is the dissolution of a necessary distinction between mass and high culture. In her essay "Repossessing Popular Culture," Laura Kipnis traces the antipathy toward popular culture in modernist avant-garde theories of art as well as the historical basis of such theories. Concerned with the transition between material, economic developments such as industrialization, and the uses of social, cultural formations such as "the image sphere," Kipnis asserts that the ideological investment maintaining mass and high culture as binary opposites is the legacy of a modernist mode of thought associated with the Frankfurt School and Clement Greenberg, who in their defense of advanced art production ceded all claims to the popular to commodity, capitalist culture. Critiques challenging this modernist legacy nevertheless often maintain a high/low distinction between high and popular art, thereby re-establishing the class differences that such a distinction would imply. Kipnis calls for a theorization and practice of a radical left aesthetics that can produce popular culture, as distinguished from the "mass culture" associated with the logic of capital.

In "The Lightness of Theory," written in 1993, the philosopher John Rajchman postulates: "Postmodernism is receding from us to the point where one may well wonder what it once *was*." A critical reflection on the impact of postmodernist thought

on art discourse, Rajchman's essay is also a short treatise on a reinvigorated use of theory beyond the all-purpose shifting of words that characterized discussions on postmodernism the decade before. Outlining the discrepancy in the developments between French and American versions of postmodernist theory, both of which took on their own formulaic rhetoric, Rajchman questions the reliance on a doctrinaire application of theory that operates from assumptions of sameness and certitude. Instead, he emphasizes a spirit of experimentation, a "lightness" of imagination in the work of art and the invention of thought, returning "theory" to its etymological origin, as a tool through which to see.

Rajchman locates a possible antidote to the cynical rehearsal of theory in a prevalent trend of the time, the renewed centrality of the human body. Primarily depicted as simulacrum in the 1980s, by the early 1990s the body was reinvested with libidinal affect, fleshiness, and mortal frailty. Art critic and historian Rosalind Krauss, a key figure in the introduction of critical theory to the study of contemporary art, analyzes the less optimistic side of the trend toward abjection. The "abject art" displayed in museums and galleries during the 1980s was also characterized by the pervasive use and exhibition of scatological procedures and the depiction of related "lowly substances." For Krauss this tendency is indicative of a deeply flawed reception of critical theory that runs counter to the more radical intellectual origin of the ideas associated with the abject. Georges Bataille's use of the term "abjection" in his writings on formlessness constitutes the basis of Krauss's theory of the "informe," outlined in her essay "Informe without Conclusion."[1] Introducing the informe into the theorization of art, Krauss expands its importance beyond a dissertation on matter (excrement and the like) or a theme (the degradation of the feminine), arguing that it is a deep intrinsic operation that undoes the goal of social hierarchy. Writing on the work of Cindy Sherman and Mike Kelley, two artists whose work was grouped under the abject, Krauss demonstrates how the same artists' work can be understood using the more radical concept of the informe, outlining an alternative theoretical trajectory.

New media theorist Lev Manovich proposes that narrative – the privileged mode of expression in the novel and cinema – in the age of computers is superseded by the logic of a new aesthetic, "the database." In contrast to the flow of a linear timeframe one encounters in film, or the material presence of a traditional art object, a work in new media is created through structuring a collection of data, with which the artist and viewer share a non-hierarchical, rather than a predestined, relationship. In "The Database" Manovich explains that, in the construction of traditional cinema, the synthetic narrative (syntagm) is explicit and the raw data of what makes up the synthesis (paradigm) is hidden, but the reverse is now true in new media. Narrative plenitude is replaced by a plenitude of information – a purely indexical relationship already prevalent in minimal and conceptual art – that is accessible ad infinitum by means of the computer interface. For Manovich, although the database and narrative are "competing imaginations," the current task of new media is to find ways for the successful melding of the two. In conclusion, he returns to a work from the dawn of the cinematic age, Dziga Vertov's 1920s landmark film *Man with a Movie Camera* as a

revolutionary precursor of this accomplishment. In Vertov, Manovich sees the emergence of a new language for film, and he sees the promise for a similar development in what is referred to as the "new media" of our time.

Note

1 This essay was originally written on the occasion of "L'Informe: mode d'emploi," an exhibition Rosalind Krauss co-curated with Yves-Alain Bois at the Centre Georges Pompidou in 1996.

27 Postmodernism and Periphery

Nelly Richard

The Universalizing Model of Modernity

I t is well known that modernity (historical, philosophical, political, economic and cultural) generates its principles from a threefold wish for unity. The enlightenment ideals on which it is founded define modernity in terms of rationalization, as an "advance" in cognitive and instrumental reason. This produces particular categories and systems through which historical development and social evolution are conceptualized, based on the notion of progress as the guideline of a universalist project. It also assumes the objective consciousness of an absolute meta-subject. The principles of modernity generate specific representations of society by means of bureaucratic and technological networks which incorporate institutional practices into an overall scheme. The spread of a "civilizing" modernity is linked to a model of industrial progress and in this way it is part and parcel of the expansion of multinational capitalism and its logic of the market place, centred on the metropolis and its control of economic exchanges.

This threefold foundation of modernity's universalism suffices to show the link to the totalizing tendency of a hegemonic culture bent on producing and reproducing a consensus around the models of truth and consumption which it proposes. With regard to its economic programme and its cultural organization, this concept of modernity represents an effort to synthesize its progressive and emancipatory ideals into a globalizing, integrative vision of the individual's place in history and society. It rests

From *Third Text* 2 (winter 1987/88): 5–12. Reproduced with permission of *Third Text*.

on the assumption that there exists a legitimate centre – a unique and superior position from which to establish control and to determine hierarchies.

Traditionally, this position has been the privilege of Western patriarchal culture, whose representational apparatus has been the source of those homogenizing categories which apply to both language and identity:

> As recent analyses of the "enunciative" apparatus of visual representation – its poles of emission and reception – confirm, the representational systems of the West admit only one vision – that of the constitutive male subject – or, rather, they posit the subject of representation as absolutely centred, unitary, masculine.[1]

They suppress any notion of "difference" which might challenge the dominant model of subjectivity. All the extensions of the idea of modernity work towards confirming the position of privilege, and to this end negate any particular or localized expression which could possibly interfere with the fiction of universality.

Transferred to the geographical and socio-cultural map of economic and communicational exchanges, this fiction operates to control the adaptation to given models and so to standardize all identifying procedures. Any deviation from the norm is classified as an obstacle or brake to the dynamic of international distribution and consumption. Thus modernity conceives of the province or periphery as being out-of-step or backward. Consequently, this situation has to be overcome by means of absorption into the rationality of expansion proposed by the metropolis.

Colonization and Cultural Reproduction

What does contact with the international procedures and rhetoric of modernity imply for the province/periphery?

From the outset, modernization in Latin America unfolded as a process of Europeanization. All the models to be imitated and consumed (industrial and economic organization, political structures, social behaviour, artistic values) were based on European prototypes. The construction of history in terms of progress and linear temporality is doubly inappropriate when applied to Latin America. It is alien to the stratifications of Latin American experience because it cannot accommodate the discontinuities of a history marked by a multiplicity of pasts laid down like sediments in hybrid and fragmented memories. The ideology of the "New" as constructed in the discourses of modernity is founded on an idea of time which follows a sequence and rhythm that is completely foreign to Latin America. This is because the diachronic triggers articulating the logic of its periodicity do not have any equivalent in the clashing juxtaposition of the heterogeneous and intermittent processes which co-exist in our subcontinent. The gap between images or symbols of "progress" or "rupture" which are constantly proposed as revelations of the "New", and the fragility of the Latin American social and cultural environment that cannot usefully integrate

these notions of modernity, produces an experience of continuous disassociation. This is particularly true if one is searching for a coherent system by identifying that which is "one's own". In the field of culture – of art, literature and the history of ideas – this dependent and imitative relation to European modernism as transmitted through local elites has created a particular instance of the centre-periphery relationship: that of "reproduction".

> This model of reproduction is founded on what might be termed the constitutive evidence of Latin America: its relation to Europe and its belonging to the hegemonic world of the West from the time when it became part of world history. From this viewpoint, Latin American thought and culture have been obliged from colonial days, to reproduce those of Europe, to develop as a periphery of that other "universe" which, by dint of successive conquests, became one of the themes of its history . . .
>
> One of the aspects which illustrates this is the role of the enlightened elites or intellectuals, a defined group within Latin American society which, since independence, has been the expresser of foreign currents of thought.[2]

Thus, when references from the metropolis are brought to bear on the Latin American context, they become the objects of a process of cultural mimesis. This turns them into parodies or caricatures which lack their own operational dynamic because either they do not fit the context or are rejected by it. The application of this type of model becomes wholly cosmetic, since it is employed to forge an illusory identity, a fictional version of "one's own identity" in terms of "the other's desire". As a consequence, processes of identification produce substitutes in the form of series of imported masks.

> In the frequent periods during which the elites deny any Latin American cultural reality, the consequent lack of any underlying theoretical practice (identity) comes to be filled with problems, categories, and value judgements formulated elsewhere – in the metropolis . . . At a symbolic level, this contradiction is resolved by mimesis: a repetition of someone else's gesture, which entails the promotion of the pseudo-appropriation of that gesture's values: so a representation is made, and even lived out, of being what one is not . . . Mimesis because the gesture is represented without any awareness of its context: we copy the imported image without knowing about how it originally came into being, and also without any great concern as to whether or not it happened to be relevant to our own reality.[3]

The international model offers sham opportunities which are adopted as "responses" to questions which have not as yet even been formulated by the new context in which they are placed. This means that signs are rendered meaningless and inoperative since the mechanisms for a re-contextualization that would endow them with a critical function are totally lacking. These signs have not been digested and reformulated according to the contradictions which would complicate their insertion into the socio-cultural arena which so far simply legitimates their international prestige. As long as imported theories and cultural movements remain divorced from the opposition of forces which are the only means of lending specific importance and historical

density to the signs produced in Latin American cultures, they act as little more than orthopedic aides within the contexts of those cultures. Characteristically, this kind of production exhausts itself in mere formal repetitions or "doctrinal mannerism". It produces pseudo-theories which are disassociated from the intellectual struggle in which the original concepts and interpretations had to fight for supremacy. They are now no more than fetishes in what has become a merely ornamental construction.

Contradictions of Modernity from the Perspective of a Latin American Essence

Criticisms of modernity have come from a wide range of areas including the arts, literature, sociology and theology. These criticisms are based on differing cultural and ideological views of what constitutes a "Latin American identity". Certain tendencies within sociology and theology,[4] for example, put forward the view that modernity's homogenizing project destroys all memory of a birth-process which embodies a multiplicity of pasts which must be rescued from European historical reductionism, so that Latin America may finally achieve its true identity on the basis of its own experience of time. As a functionalist and secularizing proposal, modernity has not only erased all the ritual dimensions of a culture to which the philosophy of the Logos is profoundly alien, but it has also suppressed that culture's "Catholic substratum", a popular religiousness whose stock of symbols form an integral part of the Latin American "ethos". A symbolic upgrading of this ethos would provide the platform from which to combat the distorting effects of the international modernizing influence since "our cultural synthesis is Latin American, of mixed race, and ritual."[5] As far as art and literature are concerned, a whole current of thought about the alienating role of the idea of modernity as the purveyor of European fictions is grounded in a defence of Latin American culture as derived from autochthonous beginnings. This culture is linked to forms of identity – representations of "oneself" usually equated with the "indigenous" – that are taken to represent the authenticity of a "pure" culture. This purity is defined by the myth of its origins which predate modernity and the contaminating expansion of the culture industry of multinational capitalism. This view – both essentialist and metaphysical – of what constitutes a Latin American identity is mythologized and turned into folklore in any number of ways: indigenism, nationalism, thirdworldism. It consists of several kinds of primitivism in which Latin American identity is equated with a predetermined and fixed identity. The rediscovery of this identity therefore involves a mythical, backward-looking return to the sources and produces a static view of origin (the indigenous substratum) and memory (the mixed race past), turned into ritual and applied over the whole continent.

Even in the most up-to-date versions of this argument, the demands for a Latin American art or literature still conform to a dichotomy which usually posits essences against categories. These are drawn from the opposition between self (seen as internal identity) and the "other" (identity from outside); for instance, the regional (seen

as authentic) versus the international (seen as false), the past (the vernacular roots) versus the present (seen as the destruction of the binding sense of community), popular culture (as part of the tradition of belonging) versus a mass culture (as alienating communication), and so on. In this Manichean scheme of things, modernity is found guilty of having destroyed the characteristics of a true Latin American identity through a conglomeration of influences which are invariably regarded as threats, falsifications, or travesties of the region's original and authentic nucleus of culture.

Modernity and Postmodernity

What rupture does so-called postmodernism imply in this set-up? Does postmodernist criticism, interpreted as a crisis in the assumptions behind modernity, in any way modify our reading of the role which the province has hitherto played on the map of international dependencies?

Modernity has always been intimately linked to the idea and practice of writing. The storage of knowledge in books generated meaning and fixed reference points: the book as history is also history as the book. Postmodernity, on the other hand, declares itself concerned not with the question of establishing meanings, but with the challenging of the very concept of any monological or univalent structure of significa- tion. Instead it postulates the destabilization of meaning (as part of the crisis of refer- ence and a resulting de-legitimization of knowledge). Every utterance is submitted to a generalizing intertextuality in order to take apart and re-assemble its fragments. Postmodernist deconstruction as open-ended signification has a bearing not only on the illusion that utterances possess a single, definitive meaning, but is also and primarily aimed at combating the supposition that culture and society – understood as texts – still follow a historically and politically determined direction. Postmodernism states that all privileged points of view have been annulled, along with the dominant position which allowed the establishment of hierarchies of interpretation. To what extent can such a critique of the unidimensionality of meaning, aimed at the hegemonic system established by a self-centred culture, offer new approaches which might help the process of decolonization? This is the fundamental question raised by postmodern- ism in the periphery.

Postmodernism introduces a highly ambiguous set of co-ordinates into the worn- out context of modernity which has programmed backwardness – the province – in order to re-integrate it more readily into its framework of global consumption.

At first sight, it might appear as if postmodernism reformulates the old dependencies (centre/periphery, progress/backwardness) in a way which creates a new hierarchy. For almost the first time, Latin America finds itself in a privileged position, in the vanguard or what is seen as novel. Even though it only finds itself in this position within a theoretical framework formulated elsewhere, Latin American cultural prac- tices are deemed to have pre-figured the model now approved and legitimized by the term "postmodernism". The very heterogeneity of the experiences which have created

a Latin American space out of its multiple and hybrid pasts create, at least on the surface, the very qualities of fragmentation and dispersion associated with the semantic erosion characteristic of the crisis of modernity and modernism as its cultural dominant.

However, just as it appears that for once the Latin American periphery might have achieved the distinction of being postmodernist *avant la lettre*, no sooner does it attain a synchronicity of forms with the international cultural discourses, than that very same postmodernism abolishes any privilege which such a position might offer. Postmodernism dismantles the distinction between centre and periphery, and in so doing nullifies its significance. There are many instances in postmodernist discourse aimed at convincing one of the obsolescence of the opposition centre/periphery, and of the inappropriateness of continuing to see ourselves as the victims of colonialization. The significance of these categories has disappeared, the argument goes, as has the distinction between model and copy due to the "planetary spread" of technological culture; the mass media have obliterated the relation between original and reproduction.

> M. Periola, author of an original study on simulacra, notes that the planetary triumph of communications destroys any possible confrontation between models and the very idea of a secondary copy. This disappears in the dizzying reproduction of ways of life in places, times, and socio-cultural contexts which are totally different from those which gave rise to the originals, without this spread leading to any kind of unification but rather to a recognition of individual particularities.

and

> As its everyday use suggests, a copy is secondary to the original, depends on it, is less valuable, and so on. This viewpoint therefore belittles the whole of our continent's cultural efforts, and is at the root of the intellectual unease which is our theme. However, current European philosophy (Foucault, Derrida) is concerned to show that such hierarchies are unjustified. Why should it be true that what comes before is more valuable than what comes later, the model be worth more than the imitation, what is central be more important than the peripheral . . . ?[6]

Or again, the centre itself has become the periphery[7] since it has become fragmented into dissident micro-territories which fracture it into constellations of voices and a plurality of meanings.

Postmodernism's first claim then is that it offers room within itself for our Latin American space. This is the "decentred" space of the marginalized or peripheral subject faced with a crisis of centrality. It is adorned with the ciphers of plurality, heterogeneity and dissidence, confirming Lyotard's observation that postmodernism "refines our awareness of difference". The stress is placed on specificity and regionalism, social minorities and political projects which are local in scope, on surviving traditions and suppressed forms of knowledge.

The fact is, however, that no sooner are these differences – sexual, political, racial, cultural – posited and valued, than they become subsumed into the meta-category of

the "undifferentiated" which means that all singularities immediately become indistinguishable and interchangeable in a new, sophisticated economy of "sameness". Postmodernism defends itself against the destabilizing threat of the "other" by integrating it back into a framework which absorbs all differences and contradictions. The centre, though claiming to be in disintegration, still operates as a centre: filing away any divergences into a system of codes whose meanings, both semantically and territorially, it continues to administer by exclusive right.

Postmodernist Collage and Latin American Identity

Although this mechanism of the "thirdworldization of the metropolis" (a symptom of Eurocentrism's uneasy conscience) immediately resolves into a new trick of rhetoric which is easy enough to uncover, it is nonetheless tempting to see if any of the "concessions" made by postmodernism to the periphery can be of any critical value to us.

If postmodernism is an admission, on the international level, that a culture and society which previously saw itself as universal is now bankrupt, then those expressions which, merely by being peripheral to this scheme, were condemned to be constantly excluded, have no reason to feel threatened by this collapse. Nor is it necessary for them to feel the degree of perplexity or anguish which accompany the shattering of those dreams which have supported the illusion of a position of dominance. Latin Americans need not feel the weariness of belonging to a sated, over-consuming society, since their connection to that culture has invariably been one of dispossession. If the collapse of values of an entire historico-cultural construction known as modernity has dealt the dominant tradition of European thought such a hard blow, it is because that construction guaranteed its Eurocentric prerogatives. This is why there is such a narcissistic outcry at its loss. To what extent does this loss implicate Latin Americans, who have always been on the outside of the sphere of references and privileges? How far is it true that the destroying of illusions and the consequent weakening of a cultural identity whose tradition had been presented as the paradigm of authority can facilitate a more *uninhibited* review of the falsehoods and circular evidence on which its hypotheses of power were based?

By creating the possibility of a critical re-reading of modernity, postmodernism offers us the chance to reconsider all that was "left unsaid" and to inject its areas of opacity and resistance with the potential for new, as yet undiscovered, meanings. In the Latin American context, this review of modernity allows us, once again, to pose the question of our own identity, that of individuals born of and into the dialectic mixture of the different languages surrounding us, which have partially fused to produce a cultural identity experienced as a series of collisions. This identity can be understood as an unstable product of modernity's tropes which involves a continuous re-grouping, distorting and transforming of imported models, according to the specific pressures pertaining to the critical re-insertion of these models into a local

network. This active participation which the individual at the periphery performs emphasizes a creativity based almost exclusively on the re-use of previously existing materials which are available either as part of the Western tradition or, more recently, prefabricated by the international culture industry. Innovative responses to these materials are based on strategies of re-determining the use of fragments or remains in ways which differ from their original frame of reference.

Perhaps our Latin American identity, seen from the perspective of the postmodernist "collage", is no more than a rhetorical exacerbation of the strategies of decentralization and re-adaptation. The periphery has always made its own mark on the series of statements emitted by the dominant culture and has recycled them in different contexts in such a way that the original systemizations are subverted, and their claim to universality is undermined.

(Translated from Spanish by Nick Caistor)

Notes

This talk was given at the Latin American symposium on "Modernity and Province" organized by Gustavo Buntinx and Reynaldo Ledgard as part of the Third Biennial in Trujillo, Peru, in November 1987.

Participants in the symposium were: Juan Acha (Mexico), Galaor Carbonell (Colombia), Ticio Escobar (Paraguay), Gerardo Mosquera (Cuba), Nelly Richard (Chile), and Belgica Rodriguez (Venezuela). The following Peruvian researchers and critics also took part: Gustavo Buntinx, Alfonso Castrillon, Mirko Lauer, and Reynaldo Ledgard.

The symposium provided an excellent opportunity for the theoretical and critical exchange of views on the question of dependency and colonization (as a historico-cultural determinant) redefined as a strategy of discourse. The themes discussed included:

(a) questioning of the meaning of modernity from the viewpoint of its inadequacies, gaps, and distortions when transposed into a Latin American context;
(b) discussion of how the tensions between centre and periphery are to be reinterpreted in the current situation of Latin America;
(c) debate on the role of postmodernism as the official receptacle for the idea of "difference" (of "otherness") from the perspective of cultures marginalized by the hegemonic structures of international discourse and its dominant self-centred models of representation and identity.

1 Craig Owens, "The Discourse of Others: Feminists and Postmodernism", in *Postmodern Culture*, ed. Hal Foster (Pluto Press, London and Sydney (1983) 1985), p. 58.
2 Bernardo Subercaseaux, "La paprociación cultural en el pensamiento latinamericano", *CERC*, June 1987.
3 Christian Fernandez, "Identidad cultural y arquitectura en Chile", Catálogo *Chile Vive*, Madrid, January 1987.
4 Pedro Morande, *Cultura y Modernización en America Latina* (Universidad Catolica de Chile, 1984); see also his contribution to *Los debates sobre la modernidad y el futuro de America Latina*, ed. José Joaquín Brunner (Flasco, 1986).

5 Pedro Morande, *Cultura y Modernización en America Latina*.

6 Rosa Maria Ravera, "Modernismo y Postmodernismo en la plástica argentina", *Revista de Estética* 3 (Buenos Aires) and Roberto Schwarz, "Nacional por Sustracción", *Punto de Vista* 28 (Buenos Aires).

7 "Certainly, marginality is not now given as critical, for in effect the center has invaded the periphery and vice versa." Hal Foster, *Recodings* (Bay Press, Washington, 1985).

28 Looking for Trouble

Kobena Mercer

Lawd, Jesse, I can't believe what I'm seeing.

<div align="right">Mrs. Helms</div>

Look, a Negro! Mama, see the Negro! I'm frightened!

<div align="right">Frantz Fanon</div>

T
o shock was always the key verb in the avant-garde vocabulary. Over the past year, the shocking eroticism of Robert Mapplethorpe's exquisite and perverse photography has been at the center of a major controversy in the United States concerning public funding of contemporary art. Led by Senator Jesse Helms, the campaign to prevent the National Endowment for the Arts from funding exhibitions of so-called "obscene and indecent materials" has helped bring Mapplethorpe's work to the attention of a wider public audience. Paradoxically, Mapplethorpe, who died of AIDS in March 1989, now enjoys enhanced notoriety and a far wider audience than he ever did during his twenty years of art practice on the margins of the New York avant-garde. Based on the retrospective show held at the Whitney Museum of American Art in 1988, this paperback edition of the catalogue is therefore particularly timely as it makes it possible to stand back and reassess the aesthetic and political issues at stake in the recent exhibition history of Mapplethorpe's sublime "immoral trash."

From *Transition* 51 (1991): 184–97. Reproduced by permission of Duke University Press.

Undoubtedly, it is the question of sexual representation that intersects across the conflicting political readings which have been produced in response to Mapplethorpe's homoerotic work. More than the still lifes of dead flowers or the portraits of art-world celebrities, it is the photographs depicting gay sadomasochism and the nude studies of black men that have caused all the trouble. To enter into the "dark" world of pleasure and danger mapped out in Mapplethorpe's erotica, we cannot assume that black audiences are somehow exempt from its modernist "shock effect," although it seems black voices have been curiously silent and muted in the recent furor. In my own case, however, I can still quite vividly recall my first encounter with Mapplethorpe's black male nudes precisely because I was so shocked by what I saw! The profile of a black man, whose head was cropped or "decapitated," so to speak, holding his semitumescent penis through the y-fronts of his underpants: which is the first image that confronts you in *Black Males* (1982).

When a friend lent me his copy of the book it circulated between us as an illicit and highly problematic object of desire. We were fascinated by the beautiful bodies and drawn in by the pleasure of looking as we went over the repertoire of images again and again. We wanted to look, but we didn't always find what we wanted to see. We were, of course, disturbed by the racial dimension of the imagery and, above all, angered by the aesthetic objectification that reduced these black male bodies to abstract visual "things," silenced in their own right as subjects and serving only to enhance the name of the white gay male artist in the privileged world of art photography. In other words, we were stuck in an intransitive "structure of feeling"; caught out in a liminal experience of textual ambivalence.

In an attempt to make sense of this experience I drew on elements of feminist cultural theory to loosen the grip of this uncomfortable, and ambivalent, fascination. The first thing to notice about Mapplethorpe's black males – so obvious, it goes without saying – is that all the men are *nude*. Framed within such generic conventions of the fine art nude, their bodies are aestheticized and eroticized as "objects" of the gaze and thus offer an erotic source of pleasure in the act of looking. But whose pleasure is being served? Regarding the position of women in dominant regimes of visual representation, feminist theory has shown that the female image functions predominantly as a mirror image of what men want to see. In the mise-en-scène of heterosexual wish fulfillment, the visual depiction of the female nude serves primarily to stabilize the phallocentric fantasy in which the omnipotent male gaze sees but is never itself seen. The binary relations of seeing/being seen that structure dominant regimes of representation in Western traditions are organized by the subject/object dichotomy in which, to put it crudely, men look and women are there to be looked at. However, in Mapplethorpe's case, the fact that both artist and model are male sets up a tension of sameness which thereby transfers the frisson of "difference" from gendered to racialized polarity. The black/white duality overdetermines the subject/object dichotomy of seeing/being seen.

In this sense, what is represented in the pictorial space of Mapplethorpe's photographs is a "look," or a certain "way of looking," in which the pictures reveal more about the absent and invisible white male subject who is the agent of representation

than they do about the black men whose beautiful bodies we see depicted. Insofar as the nude studies facilitate the projection of certain sexual and racial fantasies about the "difference" that black masculinity is assumed to embody, they reveal the tracing of desire on the part of the I/eye placed at the center of the camera's monocular perspective. On this view, the position to which the spectator is invited to identify can be described as a white male subject-position, not so much because Robert Mapplethorpe is himself white and male, but because of the fantasy of mastery inscribed in the "look" which implies a hierarchical ordering of racial identity historically congruent with the power and privilege of hegemonic white masculinity. Through a combination of formal conventions – the posing and posture of the body in the studio; strong chiaroscuro lighting; the cropping, framing, and fragmentation of body parts – the fantasy of mastery in Mapplethorpe's "look" structures the viewer's affective disposition towards the image. Moreover, as any social or historical contextualization is effaced and withheld from the pictorial frame, the cool distance of the detached gaze enables the circulation of fantasies that saturate the black man's body in sexual predicates. Whereas the gay sadomasochism photographs portray a subcultural sexuality that consists of "doing" something, the black men are defined and confined to "being" purely sexual and nothing but sexual, hence hypersexual, endowed with an excess of sexuality. In pictures like *Man in a Polyester Suit* (1980), apart from his hands, it is the penis and the penis alone that identifies the model as a black man (figure 28.1).

Considering the way in which the glossy allure of the high-quality monochrome print becomes consubstantial with the shiny texture of black skin, I argued that fetishism is an important element in the pleasures (and displeasures) that Mapplethorpe brings into play. Such fetishism not only eroticizes the most visible aspect of racial difference – skin color – but also lubricates the ideological reproduction of "colonial fantasy" based on the desire for mastery and power over the racialized Other. Hence, alongside the codes of the fine art nude, Mapplethorpe seems to appropriate the regulative function of the commonplace stereotype – the black man as athlete, savage, or mugger – in order to stabilize the masculine economy of the "look" and to thereby "fix" the black subject in its place as the object that holds a mirror to white male fears and fantasies. According to the literary critic Homi Bhabha, "an important feature of colonial discourse is its dependence on the concept of 'fixity' in the ideological construction of otherness." As in the serialized shots of body-builder Lady Lisa Lyon, in which Mapplethorpe's "look" processes her body through a thousand cultural stereotypes of femininity, the obsessive undercurrent in his black nudes would appear to confirm this emphasis on fixity. The scopic fixation on the signifying difference of black skin thus implies a kind of "negrophilia," an aesthetic idealization of racial Otherness that merely inverts and reverses the binary axis of the repressed fears and anxieties that are projected onto the Other in the psychic representations of "negrophobia." Both positions, whether they overvalue or devalue the visible signs of blackness, inhabit the shared space of colonial fantasy. These elements for a psychoanalytic reading of racial fetishization in visual representation are forcefully brought together in a photograph such as *Man in a Polyester Suit*.

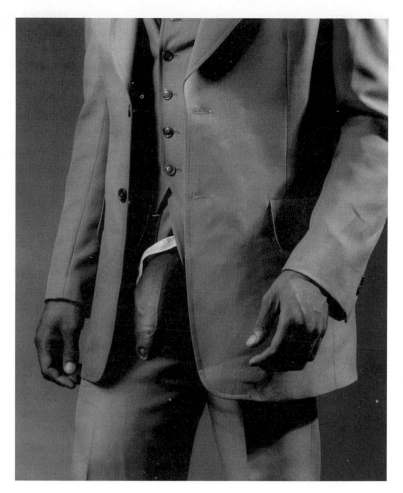

Figure 28.1 Robert Mapplethorpe, *Man in Polyester Suit*, 1980. Copyright © The Estate of Robert Mapplethorpe, used with permission.

The use of framing and scale emphasizes the sheer size of the big black penis. As Fanon said, diagnosing the terrifying figure of "the Negro" in the fantasies of his white psychiatric patients, "One is no longer aware of the Negro, but only of a penis: the Negro is eclipsed. He is turned into a penis. He *is* a penis." By virtue of the purely formal device of scale, Mapplethorpe summons up from the political unconscious one of the deepest mythological fears in the supremacist imagination: namely, the belief that all black men have monstrously huge willies. In the fantasmatic space of the supremacist imaginary, the big black phallus is perceived as a threat not only to the white master (who shrinks in impotence from the thought that the subordinate black male is more sexually powerful than he), but to civilization itself, since the "bad object" represents a danger to white womanhood and therefore the threat of miscegenation, eugenic pollution, and racial degeneration. Historically, white males eliminated the overwhelming anxiety which black male sexuality is constantly

constructed to incite through rituals of aggression and negation in which the lynching of black American men routinely involved the literal castration of the Other's strange fruit. The historical myth of penis size amounts to a "primal fantasy" in that it is shared and collective in nature and, moreover, so pervasive that the modern science of sexology repeatedly embarked upon the task of measuring empirical pricks to demonstrate its ideological untruth. Now that liberal orthodoxy provides no available legitimation for the phantasm of such racial folk myths, it is as if Mapplethorpe's picture enacts a disavowal of the wish fulfillment inscribed in the myth: *I know* (it's not true that all black guys have big willies), *but* (nevertheless, in my photographs they do).

In the picture, the binarisms of everyday racial discourse are reproduced by the jokey irony of the contrast between the black man's private parts and the public respectability signified by the three-piece business suit. The oppositions hidden/exposed and denuded/clothed play upon the Manichean oppositions of nature/culture and savage/civilized to bring about a condensation of libidinal looking. The binarisms repeat the assumption that hypersexuality is the essential "nature" of the black man, while the cheap and tacky polyester suit confirms his failure to gain access to "culture." The camouflage of respectability fails to conceal the fact that the Other originates, like his dick, from somewhere anterior to civilization. However, while the Freudian concept of fetishism allows us to investigate the fears and fantasies that make this picture so shocking to behold, because it is grounded in the Oedipal scenario that privileges the normative developmental path of heterosexual gender identity, it is not so useful as an analytic tool for opening the perverse economy of the homoerotic imaginary. The analogy drawn from feminism enables recognition of similar patterns in the objectification and "othering" of race and gender in dominant regimes of representation: but as a gay artist, Mapplethorpe is hardly representative of the hegemonic model of heterosexual white male identity which has historically been the privileged subject and agent in control of the apparatus of visual representation. Despite its value in cultural criticism, the residual moralistic connotation of the term *fetishism* tends to flatten out the affective ambivalence that viewers of Mapplethorpe's work experience as its characteristic "shock effect."

Indeed, in recognition of this intractable ambivalence that Mapplethorpe arouses with such perverse precision, I have come to change my mind about my earlier reading of his racial fetishism. To put it another way: the textual ambivalence of the black nude photographs is strictly undecidable because Mapplethorpe's photographs do not provide an unequivocal yes/no answer to the question of whether they reinforce or undermine commonplace racist stereotypes – rather, he throws the binary structure of the question back to the spectator, where it is torn apart in the disruptive "shock effect." The shock of recognition of the unconscious sex-race fantasies is experienced precisely as an emotional disturbance which troubles the spectator's secure sense of identity. As reader-response theory shows, we habitually attempt to resolve such textual ambivalence by appealing to authorial intentions; yet, as the "death of the author" argument put forward by poststructuralism has also shown, authorial intentions can never finally determine the meaning or value of a text because readers play

an interactive role in determining the range of meanings that can be derived from a polyvocal, modernist, text.

In our case, the recent actual death of the author entails a reconsideration of the subject-positions in Mapplethorpe's theater of racial/sexual fantasy, and requires that we move towards a more relational and dialogic view of the violent kind of ambivalence which arises at the interface between the social and the emotional.

Once we accept the role of the reader, I should come out with regard to the specificity of my own subject-position as a black gay reader in Mapplethorpe's text. Looking back at the angry tone of my earlier analysis of objectification and fetishization, it expressed only one aspect of the ambivalent structure of feeling I experienced in that initial "shock." On the one hand, I was angry and emphasized the implicitly exploitative process of racial othering because I felt identified with the black men depicted in the field of vision; an emotional tie or identification that might best be described, again in Fanon's words, as the feeling that "I am laid bare. I am overdetermined from without. I am the slave not of the 'idea' that others have of me but of my own appearance. I am being dissected under white eyes. I am *fixed* . . . Look, it's a Negro." Subject to the isolation effect, whereby it is only ever one black man who occupies the field of vision at any one time (thus enabling the fantasy of mastery by denying the representation of a collective and contextualized black male identity), the black models seemed to become mere raw material, to be sculpted and molded by the agency of the white artist into an abstract and idealized aesthetic form – as in the picture of Derrick Cross: with the tilt of the pelvis, the black man's bum becomes a Brancusi (figure 28.2). It was my anger at the process of "ironic" appropriation that informed the description of Mapplethorpe's fetishism as resulting in the reduction of beautiful black male bodies to abject, alienated "things," each enslaved like a juju doll in the white male imaginary to arouse its unspeakable fantasies of racial Otherness.

But now I am not so sure whether the perverse strategy of visual fetishism is necessarily a bad thing, in the sense that as the locus of the destabilizing "shock effect" it encourages the viewer to examine his or her own implication in the fantasies that the images arouse. Once I acknowledge my own implication in the image reservoir as a gay subject, as a desiring subject for whom the aestheticized object of the look represents an object choice already there in my own fantasies, then I am forced to confront the unwelcome fact that as a spectator I actually inhabit the same position in the fantasy of mastery which I said earlier was that of the hegemonic white male subject! There must be some way out of here, said the joker to the thief. I now wonder, as I wander back through the text, whether the anger was not also intermixed, on the other hand, with the expression of envy and jealousy?

If I shared the same desire to look, which would position me in the same place as that attributed to the white (gay) male author, the anger becomes intelligible as the expression of a certain aggressive rivalry over the same unobtainable object of desire, predicated on a shared homosexual identification. If this was the case, the implication is not simply that black subjects are equally "interpellated" into the psychic structures of social fantasy, but that by projecting my frustration onto the author I was myself involved in a denial or disavowal of the emotional disturbance that Mapplethorpe's

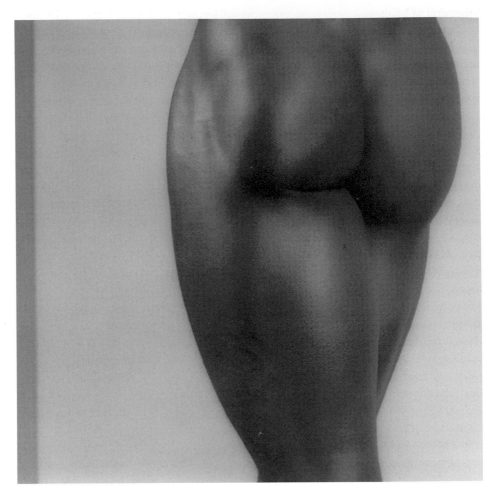

Figure 28.2 Robert Mapplethorpe, *Derrick Cross*, 1983. Copyright © The Estate of Robert Mapplethorpe, used with permission.

pictures provoked. I refuse to believe that black gay male readers somehow have privileged access to this uncomfortable structure of feeling – the point, rather, is to recognize that Mapplethorpe's work is powerful and disturbing precisely because it forces such acknowledgment of the ambivalence of identity and identification we actually inhabit in living with difference. In rereading the nude studies and changing my mind, I would say that my ambivalent positioning as a black gay reader entailed two contradictory identifications "lived" at one and the same time. Insofar as the anger and envy were an effect of my identifications with both object and subject of the look, I inhabited a "stereophonic" space (in Barthes's phrase) that was subject to closure in the earlier reading by simply projecting the ambivalence onto the author.

It was the death of the author, and the sense of loss by which the AIDS crisis has affected all our lives, that made me reread the subversive and deconstructive

dimension of Mapplethorpe's modernist erotica. Previously, I argued that the fixative function of the stereotype played the decisive role in reproducing colonial fantasy: now, however, in relation to Mapplethorpe's authorial identity as an explicitly gay artist (located, like other gay artists, on the margins of mainstream art-world institutions), it becomes possible, and necessary, to reverse that view and recognize the way in which his aesthetic strategy begins to subvert the hierarchy of the cultural codes that separate the pure and noble values of the fine art nude from the filthy and degraded form of the commonplace racist stereotype.

The nude is one of the most valued genres in Western art history because the human figure embodies the central values of liberal humanism. In this sense, the model of physical perfection embodied in classical Greek sculpture serves as the mythological origin of the ethnocentric fantasy that there was only one "race" of human beings who represented what was good and true and beautiful. In Enlightenment aesthetics, the Negro was none of these: ugly, animalistic, and ultimately inhuman, the black subject, whether male or female, was necessarily excluded from access to aesthetic idealization on account of its Otherness. The reason why that forgotten slogan of the sixties – "Black Is Beautiful" – had so much political and existential force was precisely because as a statement of ontology it subverted the naturalized hegemony of supremacist ideology which made the linguistic conjunction of the two terms logically "unthinkable." In the discourse of Western aesthetics, as Kant and Hegel both emphasized, it was unthinkable that Africans could embody the aesthetic ideal by which the narcissistic self-image of the West saw itself at the transcendental center of world civilization. The a priori exclusion of the racial Other was not unrelated to the hierarchical separation of "art" from "everyday life," as the value invested in high culture necessarily depends on the denial of value in what is regarded as low culture.

In his own perverse way, Mapplethorpe invites us to see hidden intertextual connections in the dominant regimes of the representation of racial and sexual difference. By virtue of a strategy of promiscuous intertextuality, whereby the over-valued genre of the fine art nude is "contaminated" by the connotative yield of racist fears and fantasies secreted into mass media stereotypes, he shows the interdependency between systems of representation at opposite ends of the hierarchy of aesthetic and cultural value. The pure and the polluted fold together in the same pictorial space, which is to suggest that what is experienced in the viewer's salient "shock effect" is the disruption of our normative expectations and the radical unfixing of the spectator's ideological positioning. The responses of Senator and Mrs. Helms would seem to confirm this view. What is so troubling about the black male nudes is that Mapplethorpe stages the return of the repressed in the ethnocentric unconscious. The psychic/social boundary that separates "high" and "low" culture is transgressed and decentered precisely by the superimposition of two ways of looking, which thus throws the spectator into the flux of uncertainty and undecidability, experienced as the feeling of ambivalence and disturbance in which one's subject-position has been called into question.

In social, economic, and political terms, black males constitute one of the "lowest" social classes in the United States: disenfranchised, disadvantaged, and disempowered

as a distinct group identity in the late capitalist underclass. Yet in Mapplethorpe's studio, some of the men who in all probability came from this underclass are elevated onto the pedestal of the transcendental Western aesthetic ideal. Paradoxically, the humanist model of physical beauty said to originate with the Greeks is brought to life by the grace of men who were probably too busy hustling a means of daily survival to be bothered with an appreciation of ancient sculptures in their local art museum. Mapplethorpe's supremely ironic achievement as a postmodern "society photographer" is to render visible such "invisible men" (in Ralph Ellison's phrase) within a cultural system of representation – art photography – that always historically denied their existence. As he put it in an interview before his death,

> At some point I started photographing black men. It was an area that hadn't been explored intensively. If you went through the history of nude male photography, there were very few black subjects. I found that I could take pictures of black men that were so subtle, and the form was so photographical.

As Ingrid Sischy notes, Mapplethorpe's passion as a photographer came "from subjects that have been forced by our culture to be hidden like secrets." Homosexuality is often forced into hiding as a dirty little secret (and not just in Western societies, either), and I would therefore add that what Mapplethorpe achieved in his art was not simply the making visible of the psychic and social splitting that is normally repressed into invisibility, but that he used his homosexuality as a creative resource with which to explore and open up a politics of marginality across the multiform relations of class, race, gender, and sexuality in which it is actually lived.

In this review I have focused on the black nudes, to the exclusion of other aspects of his oeuvre, for two reasons. First, because it seems to me they represent a culmination of an aesthetic strategy. During the 1970s, Mapplethorpe's homoerotica paralleled the development of an urban gay male subculture: what makes the "difficult" sadomasochism pictures from the late seventies so disturbing, after all, is the nonchalant matter-of-factness of the author's nonjudgmental stance, which throws the question of aesthetic or moral judgment back into the field of the spectator. During this period, Mapplethorpe kept the erotica separate from the formalist concerns seen in his sculptural approach to the pictorial frame and in the figuration of lighting in the floral still lifes. The black nude studies are shaped by a synthesis between these two tendencies: the sense of ambivalence is exacerbated by the way the "cool" technology of neoclassical lines and minimalist space is brought to bear on the "hot" eroticism of the sex-race phantasm that haunts the representational space of the scene.

In this respect, we should acknowledge the collaborative relationship between the privileged white male artist on the margins of the avant-garde and the anonymous black male models on the margins of the late modern underclass. It may not have been entirely equal, but in the specific historical context of the "imagined community" created by the new social movements over the past twenty years, the photographs can be read as a document of relations of mutuality under shared conditions of marginality, which is something Mapplethorpe alluded to when he remarked, "Most of

the blacks don't have health insurance and therefore can't afford AZT. They all died quickly, the blacks. If I go through my *Black Book*, half of them are dead." The AIDS crisis has changed all our lives, in the black communities of Europe and America as much as in Africa and the Caribbean. In this context, when mourning and melancholia become routine, what does it mean to acknowledge the loss of this strange, marginal, white gay male photographer?

By posing the question like this, I want to suggest that Mapplethorpe confronts black spectators and critics with a unique and difficult intellectual challenge. Can we afford to assume that black artists have privileged access to insights into the politics of race and racism simply by virtue of being black? Stuart Hall's often-quoted remarks on "the end of the innocent notion of the essential black subject" point to the legacy of essentialism in black cultural politics. His argument, that the aesthetic or political value of a text cannot be guaranteed by the racial or ethnic identity of the author who creates it, has disturbing consequences for the commonsense "theory" we habitually practice as black spectators, audiences, and critics: it means we can no longer have recourse to empirical evidence about the author's quotient of melanin to decide the aesthetic or political value of a text.

Recent works by black gay artists engage with these questions directly. Black British filmmaker Isaac Julien, whose *Looking for Langston* (1989) initiates an archeological inquiry into the enigmatic sexuality of Langston Hughes in the era of the Harlem Renaissance, and Nigerian-British photographer Rotimi Fani-Fayode, whose first published collection, *Black Male/White Male* (1988), opens an aperture onto an Afrocentric homoerotic image world, are directly engaged in a critically dialogic relationship with Mapplethorpe's work. It is through this critical dialogue that they have negotiated a mode of enunciation for black gay male subjectivity in the visual arts, which, against the quirky assumption that all black men are supposedly heterosexual, is something to celebrate indeed. But more than mere "celebration," this new wave of cultural work, which has developed in black lesbian and gay communities alongside the impact of black women's voices over the last decade, enables us to theorize a more pluralistic conception of identity in the cultural politics of race and ethnicity.

Robert Mapplethorpe was not a black artist: but on the rereading I have put forward, his subversive use of visual fetishism can be seen as a strategic move that reveals what is "unconscious" in the cultural construction of whiteness as a "racial" identity. By laying bare the supplementary relationship between the purified fine art nude and the polluted mass culture stereotype, he confronts white identity with its interdependency on the Otherness that allows it to be constituted as such. In other words, the trope of visual fetishism paradoxically decenters and denaturalizes whiteness by showing its dependence on what is denied as Other to it. Writing in the 1940s, an eccentric organic intellectual from the British West Indies, J. A. Rogers, assembled a heterogeneous collection of "facts" and narratives in evidence of the black presence in Western history, ordinarily effaced in school textbooks. In *Your History* (1940), one of these hidden stories concerns the origins of classical Greek sculpture – "Several sculptors and scientists have said that the finest physiques in the world are to be found among the Negro peoples. Dr. Sargeant, Director of Physical Culture at

Harvard University, said in 1903 that he thought the Greeks modeled the bodies of some of their finest statues from Negroes and that the Apollo Belvedere, the most superb of all, was modeled from a Negro." In the light of recent research such as Martin Bernal's *Black Athena*, there is probably no reason to be shocked or surprised at what Rogers uncovered: that Western ethnocentrism, predicated on the desire for mastery, entails the denial and disavowal of that upon which it depends for its existence and identity. Maybe Mapplethorpe has done something similar each time his images have shocked and frightened and disturbed us: by showing, and giving to be seen, that which is repressed and denied as Other as a condition of existence of an identity based on the desire for mastery.

I have another reason for concentrating on the nude studies, especially in the current context where the voices and visions of black lesbian and gay artists, among others, have widened and pluralized theoretical debates about sexuality, desire, and representation. A symptomatic reading of the relative silence of black voices in the Mapplethorpe/NEA controversy suggests that questions of repression, denial, and disavowal bear directly on the social relations of black culture itself. During the mid-eighties moral panic on AIDS, when media scapegoating switched from urban gays and turned in the direction of Haiti and Africa, one prevalent response within diaspora societies was a rhetoric of denial. All too often, the repudiation of racial stigmatization was based on the homophobic premise that homosexuality, and therefore AIDS, is a "white man's disease" – even though we could all see that black people were dying. This cruel rhetoric of denial, like the psychic mechanism of disavowal (the refusal to believe) on which it is based, can only imply a negation of diversity and difference in black society.

It was after Mapplethorpe's death that the New Right initiative began, first in protest against a second exhibition of "The Perfect Moment" in Philadelphia, and then given further momentum by the decision of the Corcoran Gallery in Washington to cancel its exhibition of the show, which was supported by NEA grants. Like the Salman Rushdie affair in Britain, the public debates about the politics of representation have tended to polarize into the stark dichotomy of censorship versus freedom of expression, yet this crude binary frontier serves only to obscure the complex field of antagonism, brought to light in Cincinnati earlier this year when antipornography feminists joined forces with the city police department in an attempt to foreclose the show. The politics at stake cannot be reduced to the stereotype of bigoted philistines on the one side versus cultured liberals on the other, because what is at stake in the everyday postmodern politics of difference is the fact that the new social actors of race, gender, ethnicity, and sexuality are just as capable of antidemocratic politics as the old social actors of class, party, and nation-state.

I should emphasize that I've changed my mind about Mapplethorpe's shocking eroticism not for the fun of it, but because I have no particular desire to form an alliance with the New Right. We have seen how the initial emancipatory aims of feminist antipornography arguments have been appropriated, translated, and rearticulated into the coercive cultural agenda of the New Right. Paradoxically, the success of late-seventies radical feminism lies in the way that reductive arguments about

representation have been literally translated into the official discourse of the state, such as the Report of the Meese Commission in 1986. Such alliances are rarely controlled by authorial intentions, yet feminist discourses have helped to strengthen and extend neoconservative definitions of "offensive" material into more and more areas of popular culture. In contemporary rap music, for instance, "explicit lyrics" warning labels indicate the extension of what should be censored by consent. The worrying thing about the original 1989 Helms amendment was that it sought a broader remit for cultural censorship not only on the traditional moral grounds of "obscenity and indecency," but on the new cultural grounds of "offensiveness" to minorities. Helms said he objected to publicly funded art that "denigrates, debases, or reviles a person, group, or class of citizens on the basis of race, creed, sex, handicap, or national origin." By means of such a rhetorical move the discourse of liberal antidiscrimination is reversed and reappropriated to promote a politics of coercion based on the denial of difference. With ambivalent adversaries like that, it becomes possible for a reductive "antiracist" reading of Mapplethorpe's racial fetishism, however progressively intended, to serve the antidemocratic aims of the Right.

The fact that Mapplethorpe's photographs are open to a range of antagonistic political readings means that different actors are in a struggle to hegemonize one preferred version over another. The risky business of ambivalence by which his images can elicit a homophobic reading as easily as a homoerotic one, can confirm a racist reading as much as produce an antiracist one, suggests that indeterminacy doesn't happen "inside" the text, but in the social relations of difference that different readers bring to bear on the text, in the worldly relations "between."

29 Repossessing Popular Culture

Laura Kipnis

I n September 1990 the *New York Times*, ever the cultural augur, announced the death of postmodernism after a decade's reign over the art world, noting as evidence the exhaustion of pomo's favored gestures of "stereotypes, repetition and media-derived experience," then pounding the nail into the coffin with its assessment that "appropriation and pastiche seem old hat."[1] While the haunted souls of the art world may have moved on to new and better idioms – "spirituality," suspects the man from the *Times* – perhaps we should interrupt the eulogy to point out that the corpse is still twitching. If you see postmodernism as having been reflected in the art world rather than created there you might look a bit further afield than West Broadway before announcing, so precipitously, its demise. And so if the aesthetic realm is not simply an autonomous sphere of passing fads and aesthetic tics, but is somewhat more intertwined with what is sometimes called "everyday life" – whether knowingly or not – the *Times* might be just a bit more attentive to the fact that the sorts of practices of appropriation and repetition it insists on reducing to art-world style *continue* to typify the signifying practices of so many other spheres, from mass culture to official political discourse itself. You don't have to be a lit crit or an art worker these days to be preoccupied with the circulation of signs whose meanings are subject to contestation – you could be Roger Ailes or even the Ayatollah Khomeini. And this should be of particular interest to those engaged in formulating a contestatory culture, as I would argue that any strategy for a cultural-political practice has to take its direction from the structure of which it is a moment (it is provisional), and that

From *Ecstasy Unlimited: On Sex, Capital, Gender, and Aesthetics* (Minneapolis: University of Minnesota Press, 1993), pp. 14–32, 296. Reproduced with permission of University of Minnesota Press.

what postmodernism has to tell us about oppositional practices is that being ahead of one's time, or avant-garde, is definitely passé. The purpose of this essay, then, is to outline the structural possibilities offered for an oppositional cultural practice at the present moment: to assess the possibilities given within the current conjuncture – which I'll be describing as postmodern – for cultural politics. Part of this argument entails describing why it is that the possible moment of a political and contestatory *modernism* – or any cultural politics that seeks some ground of autonomy, whether outside the present, outside the commodity, or, arguably, from outside dominant modes of representation – is no longer viable.

Brecht coined the phrase "functional transformation" (*Umfunktionierung*) to convey his position that intellectuals and artists shouldn't merely supply the production process but, rather, should attempt to transform it, along the lines of existing political struggle.[2] The fact is that capitalist culture is capable of assimilating even the most "revolutionary" sorts of themes without ever putting its own existence and continuation into question. Brecht dismissed as "hacks" and "revolutionary hacks" those artists who maintain an unwitting complicity with the political forms they aspire to transform by continuing to supply "new effects or sensations" for public consumption and entertainment, innovations that are immediately lapped up by the dominant and dominating culture in a feeding frenzy of the new. The sort of practice Brecht was suggesting, transforming what is already there – what I'll call "refunctioning" – should be quite recognizable to us here in what is known as late capitalism – or even more appropriately, media capitalism – because it seems so similar to what has, in fact, been a dominant cultural and discursive strategy in the production of social meaning for at least the last decade. This sort of practice gets described or denounced in numerous ways, but contrary to the Brechtian expectation, it now seems to make its appearance all over the political spectrum. However, let me start out by describing an early and paradigmatic example of refunctioning as a form of contestation before getting into its reappearance, in a seemingly apolitical guise, as the privileged signifying practice of postmodernism.

Toward the end of the seventies, almost overnight, it seemed, nearly every stop sign on the north side of Chicago was transformed by local women's groups (presumably at night and with stealth) to read "STOP RAPE," by the addition of the word "RAPE" spray-painted in reflective white paint directly under the word "STOP." The signs would remain in this altered state for a short time, until the city sent work crews out to obliterate the word "RAPE" with red paint, thus terminating the sign's brief career as a tool of feminist agitation and returning it to its prosaic function in traffic control. Sporadically, midnight spray-painting campaigns would renew the ongoing struggle between the city and women's groups for this highly visible site of address with its guaranteed audience, but the city's resources triumphed and there are very few STOP RAPE signs to be found anymore. In the mid-eighties, though, this same tactic was taken up by another movement (which continues to deploy it to this day), whose members affixed to stop signs *printed* stickers that read "US INVOLVEMENT

IN NICARAGUA" or "US SLAUGHTER IN CENTRAL AMERICA." These stickers, designed expressly for stop signs (and apparently with very strong glue), transform the interpellation of the signs to read "STOP US INVOLVEMENT IN NICARA-GUA" or "STOP US SLAUGHTER IN CENTRAL AMERICA." (Historians of left aesthetics will want to note the introduction of mechanical reproduction into this particular form of agitation.)

Using the term "interpellation" here deliberately invokes Louis Althusser's contention that the mechanism of all ideology is the interpellation, or hailing, of individuals as ideological subjects.[3] To cite the example of the bland and ubiquitous stop sign as an instance of ideological interpellation may seem eccentric (its elimination is not on even the most ultraleft program so far as I know, since even ultraleftists in this day and age fear gridlock; however, the intrepid free-enterprise anarchists of the Libertarian party have, in fact, announced their opposition to the stop sign).[4] But the STOP of the stop sign does uncannily echo Althusser's own ironic demonstration of the role of "recognition" in the process of constituting ideological subjects: the policeman who yells, "Hey, you there!" to the individual who cannot fail to *recognize* herself as the subject of the interpellation and automatically, guiltily, turns around. To simply stop at a stop sign then – a constant and automatic act for those of us with private transport – is to recognize oneself as the subject of the interpellation and to be ("always already") engaged in an ongoing process of transformation, from mere individual to legal-juridical subject. This example of the stop sign is even more apt in that it makes grimly clear the inseparability of ideological interpellation and agencies of state repression. As anyone who has ever been caught running a stop sign discovers, the entire array of what Althusser calls the Repressive State Apparatuses stands ready to enforce this interpellation should one fail to heed it. (And in Chicago it really is the *entire* array: periodically reports emerge of traffic violators routinely subjected to strip searches by particularly zealous defenders of the peace; in Los Angeles, enforcement includes savage beatings by armed, crazed bands of police-thugs.)

This struggle over the (stop) sign exemplifies political contestation precisely at the level of ideological interpellation. These anonymous agitational acts of appropriation and transformation enact a struggle over, and within, an ideological terrain, between a dominant discourse (Althusser regards the legal system as a part of both the Ideological and the Repressive State Apparatuses) and an oppositional discourse. To view a stop sign as something worth struggling over may seem politically unambitious, but there are two interesting implications here for a theory of a left popular culture. First, the prior interpellation, the "STOP" of state power, is mere "raw material." It derives its meaning only in relation to its articulation within a particular discourse, and in specific relation to the other elements of that discourse. It doesn't have a preassigned, essential meaning, and, moreover, its meaning can't be reduced to an expression of its class or national origins. The second implication, then, is that these raw materials can be appropriated and transformed by oppositional forces in order to express antagonisms and resistance to dominant discourses – a process also suggested by the phrase *disarticulation-rearticulation*, which occurs in the writing of the Argentinian Marxist, Ernesto Laclau.[5] In Laclau's terms, the stop sign is disarticulated

from the discourse of which it was formerly a part, and is rearticulated to a competing or antagonistic discourse. The important point here is that *any* of the materials of dominant culture can be subject to this process.

But why insist that this sort of refunctioning practice is either typically postmodern or quintessentially Brechtian? Or to ask the question in a more ass-backwards way, what is the break signaled by the "post" of postmodernism a break from? As the *Times* points out, an engagement with "media-derived experience" is typical of postmodernism. If we rephrase this as "an engagement with the experience of dominant culture," perhaps the point becomes clearer. What the *Times* fails to note is that while this new attention to media may describe the sort of historical turning point, specifically the *rejection*, that Pop Art and its postmodern successors marked from the modernist formal preoccupations of the previous part of the century, this localized account doesn't particularly weigh the sense of *shock* that all forays of both mass culture *and* mass-produced objects into high art have created throughout the century – from Synthetic Cubism, Surrealism, the work of Duchamp, on through Pop Art to the present. Mass culture crossover, or, in Brecht's terms, transforming what is already there – and what is more always already there than the media (now more than ever)? – always threatened to throw into disarray the founding assumptions of the traffic in high culture, from the sanctity of individual authorship – and all that it guarantees for the market in cultural objects – to the class divisions inherent in the spatial and monetary distinctions between mass and high culture (if not the spatial and monetary distinctions between their different audiences).

To think about why it is that mass culture so troubles high art it might be useful to look at the term "mass" itself, which, whether standing alone or paired with its buddy, "culture," is a term situated in contradiction. It carries sedimented and contrary implications, alluding as it does to that dubious entity "the people" – a presence coded variously: from the pejorative connotations of "low" or "vulgar" to the suggestion of a positive political and social force – a people acting together in solidarity, as in the *levée en masse* of the French revolution.[6] In that this current and contradictory usage became fully available in the mid-nineteenth century, with industrialization and the birth of modern class society in western Europe, the term arrives clearly burdened with a weighty historical residue: not only the evocation of the urban proletariat, but also, then, implicitly the proletariat's conditions of formation – that is, the economic ascendancy of the bourgeoisie and its attendant consolidation of political power. There are two things to say about this: first, the terms "mass" and, concomitantly, "mass culture" have a particular set of connotations specific to capitalist society that can't be evaded. (Or rather, the evasion is symptomatic, indicative of the sort of genial ahistoricism practiced by cultural conservatives of the *New Criterion* stripe.) Secondly, arguments, positions, and theories about mass *culture* are inevitably coded ways of talking about class.

These two points might shed a different light on the last decade's flurry of theoretical (and artistic) interest and investedness in popular culture, as well. Theory is never autonomous: critical discourse is not only a site of production of cultural

meanings, but is itself a product of the conditions it theorizes; transformations out-side theory deserve as much serious attention as is traditionally paid to the internal transformations and minutiae of intellectual history. The exponential growth of mass culture *studies* has occupied the same theoretical moment as what, in the decade prior to the collapse of Communism, was commonly referred to as the "crisis in Marxism" or the "crisis on the Left." The conjuncture of these two discursive spaces has a kind of poignancy, assuming a historically mediated reading of the term "mass": it connotes, in retrospect, something of a political denouement, with two historical moments as, roughly, bookends, or mirror images. In the first is the emergence of the urban proletariat, the seeds of the working-class movement, and socialist theory – all the previously mentioned sedimentation of the word "mass" – which marked the opening up of a determinate political space. In the second moment, that of the last decade, post-Marxism (as if anticipating the events of 1989–91) edges out the working class as the "privileged subject" of history and the anticipated agent of social transformation (not so coincidentally, just as union busting, declining wages, and capital flight were the dominant economic trends of the eighties). Here we find the emergence of mass *culture* as the privileged subject of left academia, hand in hand with the loss of any sort of previous assurance about what might be called the political subject, and, with the closing down of that earlier set of political pos-sibilities, a groping and stumbling through the murk of the present toward new political forms.

The last decade's theoretical preoccupation with popular culture marked a major shift from a period when mass culture was either not worth discussing or only worth denouncing. Whether it was mass cultural forms or contents being indicted, whether it was "kitsch" or "debased means–ends rationality" being dismissed, the practices of popular culture seemed incapable of being adequately theorized in the modernist era. Equally, mass culture content was banished from high art style during the mod-ernist heyday. The acceptability of introducing content from mass culture into high art has been an art-world given at least since Pop Art, which might be said to have terminated modernist cultural hegemony. The work of artists like Cindy Sherman, Dara Birnbaum, David Salle, and so many others working in the area of what the *Times* calls "media-derived experience" is familiar enough not to require elaborate description here. This cultural transformation – the crossing of the previously uncrossable chasm between high and mass culture, evidenced in this keen and nerv-ous attention to mass culture in the current production of both high culture and high theory – is a decisive feature of the postmodern, and is decisively different from the treatment of popular culture during the reign of modernism.

By invoking modernism's relation to the popular here, I want to begin to sketch out a sort of preliminary periodization of approaching the popular. Its current approachability – the inundation of scholarly books on the subject, the plethora of conferences and journals, a rewritten canon within universities, *and* the focus on popular forms on the left and in the art world – this burgeoning approachability is not only characteristic of *postmodernism*, but seems to indicate a certain urgency to theorization in this historical configuration.

If theory isn't autonomous, but there is a degree of interpenetration of theory and the object it theorizes, then transformations in the object itself (say, the field of culture) are what make possible transformations in our knowledge of that object. Peter Burger's *Theory of the Avant-Garde* offers a corollary: he argues that only "the full unfolding of the constituent elements in a field" makes possible "an adequate cognition of that field."[7] A further corollary is that these new theoretical developments always cart along with them a rewritten history: the conditions that allowed Marx to theorize capital – the emergence of the urban proletariat, the universal commodification of labor, and the reduction of difference to the common denominator of exchange value – simultaneously allowed precapitalist economic formations to be construed. Precursors of present developments only come into view at certain moments; they're discovered in retrospect rather than being already known. This would account for the last decade's spate of retheorizations of modernism (Burger's book being one); modernism comes into view differently through the emergence of postmodernism.

An onslaught of theorization works perhaps like a symptom: its etiology can be uncovered by working backward from its given components to discover its presuppositions. "The task is . . . simply to discover, in respect to a useless idea and a pointless action, the past situation in which the idea was justified and the action served a purpose," as Freud writes. One presupposition of intensified theorization about popular culture has been suggested: the shift from a refusal to an embrace of the popular in theoretical discourse marks a break between modernism and postmodernism. We might then, speculatively, surmise that the "purpose" of the "symptom" can be found in the paradigm of *transition* and the compensatory structures this puts into play. Evidence for a link between theorization and transition can also be found in Michael Taussig's *The Devil and Commodity Fetishism in South America*.[8] Based on Taussig's fieldwork, the book details the appearance of a particular set of mythic beliefs, or theorizations, which have arisen "at a particularly crucial and sensitive point of time in historical development" in distinct areas of rural South America. Regions of both Colombia and Bolivia are undergoing the transformation from what is often referred to as "traditional society" to "modern" or "industrial society" – from peasant-cultivator, use-value-based societies to societies of landless wage-laborers based on exchange-value. Local peasants have become proletarianized, often through violence and appropriation of land; they are driven to seek employment for wages in the sugar plantations of Colombia and tin mines of Bolivia.

An explanatory mythology has arisen independently in both these societies based on the figure of the devil, who is invoked "as part of the process of maintaining or increasing production." In Colombia, certain workers, it is believed, have entered into secret pacts with the devil to increase their production and earn more money. These contracts, though, are said to ultimately destroy those who enter into them, for devil's money is barren: if spent on such capital goods as land or livestock the land will become sterile and the animals will sicken and die. In Bolivia, Indians create work-group rituals to the devil, whom they believe to be the true owner of the tin mines. Although the devil is assigned the central role in sustaining production, he is

seen as a "gluttonous spirit bent on destruction and death." In both Bolivia and Colombia, while the devil is held to be the mainstay of production, this production is believed to be ultimately destructive of life. (And note that where the mysterious workings of capital are concerned how similar is the content of these myths – or theorizations – and the quasi-populist anti-big-business sentiments that permeate our own popular culture: our ambivalent fascination with devilish figures like Donald Trump, J. R. Ewing, and other assorted moguls, oil barons, and robber-tycoons.)

Late capitalism is not so much a postindustrial society as one marked by the complete industrialization of all segments of society.[9] Even the most "advanced" economic system, however, is composed of a discontinuous series of structures that develop unevenly – they are asynchronous. The area of high culture, for example, lags far behind, say, industry in capital penetration and mechanization, though these days we see all sectors subject to an increased penetration of capital and heightened mechanization. In the art world this sometimes appears as style: it's not much of a stretch to read the industrialized elements in the work of Warhol, the Minimalist sculptors, or the current *succès de poseur*, Mark Kostabi – to name but a few forward thinkers who have managed to merge Fordism and high culture – as the distant rumblings of the infrastructure around the perimeter of circled wagons erected by high culture, with its traditional disdainful autonomy from the hoi polloi and their dirty little assembly lines. Elements of older modes of production coexist with anticipations of future modes of production, with the result that different areas in any social order are, at any given moment, at quite different stages of development.

This suggests that observations or theories about one sphere of one social formation at a particular developmental stage might aptly be applied to a different sphere of a distinct social formation at a comparable stage of development. So to return to Taussig's fieldwork, a structurally similar relationship might exist between an outbreak of *theory* and social transformation in two dissimilar social formations. Taussig's fieldwork on the mediation of oppositions found in devil beliefs in South America – a set of practices at first glance quite distant from Western academic popular culture studies – might offer a paradigm for understanding current theorizing on popular culture as, in Taussig's words, the mediation "between two radically distinct ways of apprehending or evaluating the world of persons and things."

Like Michael Taussig, I'm concerned with tracing a *transition* between two points: a transition of industrialization and capital penetration. The transition outlined here, however, is in this social formation, and specifically in the sphere of culture: we might describe it as the historical moment running roughly from the point where Walter Benjamin notes the erosion of "aura" in painting as a correlate of proliferating photographic technology, to a current point, postmodernism, which has often been defined, following Guy Debord, as the complete commodification of the image sphere.[10]

In Debord's argument, the "spectacle" is the commodified form of the image. Like the commodity, it disguises what it really is – relationships between persons and classes – into an appearance of the objective and the natural. The spectacle is the capitalist colonization and monopolization of the image; it subjugates people to its

monopoly of appearance and proclaims: "That which appears is good, that which is good appears."

So while for Althusser the nature of ideology is, following Jacques Lacan, *specular*, mirrorlike – the interpellated subjects recognize themselves in a mirrorlike relationship with dominant ideology – for Debord ideology is *spectacular*: the spectacle is "the existing order's uninterrupted discourse about itself, its laudatory monologue." The privileged ideological form is, though, in both cases, the representation.

We hear an awful lot about the politics of representation these days – so much that one might be forgiven the impression that the representation is now the sole locale of the appearance of the political. One way of accounting for this new theoretical fixation is Debord's self-reflexive point that it is precisely that the spectacle has now become the universal category of society as a whole that both allows and provokes his own understanding of it as a category. But again, contemporary developments like these never arrive unescorted, but are accompanied by a rewritten history. This new awareness of the status of representation and its new approachability inevitably raise the question of its previous unavailability to analysis and of the *cordon sanitaire* erected around the popular in the modernist era. So postmodernism, it appears, not only allows, but dictates, a deconstruction of the binarism upon which modernism was enacted and of the problem of value that programmed the high culture/mass culture split.

The most interesting question in regard to the binary opposition high culture/ mass culture is, What is or was the ideological investment in its maintenance? That the dominant stylistic gesture of the postmodern is the increasing interpenetration of high culture and mass culture seems to indicate the attenuation of that ideological function, both institutionally and within individual cultural texts. Dismantling its ideological scaffold affords a rereading of modernism as constituted and produced solely within that split, and existing only so long as it could keep its Other – the popular, the low, the regional, and the impure – at bay. We might then, from this new historical vantage point, redefine modernism as the ideological necessity of erecting and maintaining exclusive standards of the literary and artistic against the constant threat of incursion or contamination, and the partial success of this project as what is generally given to us as the unity, modernism. What didn't conform was excluded from consideration. Without the binarism high/low in place – a displacement that can be staged only after the emergence of the postmodern – it's unclear whether modernism as such ever existed at all. (The ongoing project of feminist art history to provide an alternative account of the period is a simultaneous assault, and if the politicization of the literary canon by multiculturalists is any precedent, the academic field of modern art history is also going to have some rough waters ahead.)

It's pretty difficult to avoid the social implications of the terms high and low. If the adventures of the high/low culture dialectic are read against the dialectic of social classes, the narrative of transgression and suppression, rebellion and restoration that emerges suggests that the "political unconscious" lurking beneath the veneer of culture might not be unrelated to the larger ongoing drama of struggles between social

groups engendered by class society. At roughly the same moment at which we can mark the emergence of the "modern" in the visual arts, the *Salon des Refusés* of 1863, where Manet showed his *Olympia* – a contemporary prostitute painted in the pose of Titian's *Venus of Urbino* – at just about that same moment Matthew Arnold was earnestly erecting barricades *against* such incursions in his proclamation – the founding statement of modern academic criticism – that criticism should deal only "with the best that is known and thought in the world." This symbolic Arnold–Manet one-on-one set the stage for a century of contestation, not only between critical discourse and the "artistic text," but within the field of artistic practices, as well. Throughout the period we know as modernism, work that was greeted with "shock" (or work that fulfilled its avant-gardist mission) was work that introduced elements of the popular, the low, or elements untransformed by the artist's hand into the temple of Art: Synthetic Cubism, which used newspapers and wallpaper in painting to destroy painting as a "unified field"; Duchamp's readymades (including the infamous signed urinal); and the series of shocks and aesthetic aggressions gleefully administered by Dada and Surrealism, to name a few examples.

Clement Greenberg, the preeminent American theoretician of modernism, dismissed what he called "kitsch," which he opposed to the true "avant-garde"; he dismissed Synthetic Cubism to champion Analytic Cubism; and he termed Surrealism a "reactionary tendency" for introducing "outside" subject matter. Greenberg's teleology of art, reflected in his deployment of terms such as "reactionary" and "avant-garde," decreed a triumph of the pure over mixed parentage: it is cultural miscegenation that excited his shrillest and most dictatorial denunciations. He was still fighting these dragons throughout the sixties and well into the seventies. When confronted with proto-postmodernism in the form of Minimalism, Greenberg condemned it as "lacking aesthetic surprise," and he hoped to deal the death blow to Pop Art by dismissing it as "Novelty Art."[11] In culture rewritten as a binary field where quality battles crassness and the rightful inheritor contests the interloper, what else is being preserved, enforced? Yet in spite of Greenberg's protestations, the Other always threatened to close in, as if he were James Bond trapped in one of those tiny rooms where the walls are slowly closing together, and there he stands, heroically, pectorals straining, holding them apart by sheer muscle power mere seconds away from being squashed like a bug.

Even in recent serious retheorizations of modernism, the opposition high culture/mass culture remains in place. In order to posit the existence of this aesthetic field at all, the same exclusions seem necessarily to operate. Peter Burger's *Theory of the Avant-Garde* attempts to rewrite the unity, modernism, into two opposing fields: "aestheticism" and its superior rival, "the avant-garde." Burger's first point is that the emergence of aestheticism and its challenge by the avant-garde are developments in the *institutional* status of art and that the styles and contents of individual works – traditionally the site of art-historical endeavors – can only be understood through the mediation of the institution of art. His next move is to attempt to reclaim the political radicality of the term "avant-garde" against critics like Greenberg who collapse it

unproblematically into modernism. For Burger, "aestheticism," emerging in the late nineteenth century, denotes art that claims autonomy from the concerns of everyday life: form transpires to reflect this autonomy, becoming the sole content of art. In Burger's narrative, the avant-garde movements of the twenties began to question this autonomy and rebel against the enforced social impotence of art determined by its institutional status. But their move to reinsert art into the praxis of daily life failed, and Burger derides what he calls "post-avant-garde art" (singling out Warhol as the baddest bad guy) because this work revives techniques and procedures invented with political motives by the real avant-garde and now cynically appropriates them for a renewed aestheticism.

Interestingly, though, Burger manages to locate popular culture exactly where the Frankfurt School did, even while pointing out that the relation between high and mass culture (or in his words, "serious" and "pulp") is not adequately thematized in their writings. He recognizes that Adorno's separation of high culture and mass culture passively accepts the separation that is established within, and establishes, the institutions and marketplaces of art and literature, yet Burger, too, upholds the distinction in his own dismissals of the popular. His only direct attention to mass culture yields a somewhat familiar point about the relation between the development of photographic technology and the end of representation in painting (another example of the way in which high art within this period was forever running scared from the popular).

Another interesting attempt at revision of modernist history is Mary Kelly's "Re-Viewing Modernist Criticism."[12] Like Peter Burger, Kelly upholds modernist categories of the popular even while attempting to dismantle modernist ideology. She argues that modernist critical discourse functions to construct, out of disparate art practices, the category of the *artistic text*, the purpose of which is to express the essential creativity of the artistic subject. In painting, it does this by conjuring evidence of the human hand, of human action, to mark the subjectivity of the artist in artistic gesture: "It is above all the artistic gesture which constitutes, at least metaphorically, the imaginary signifier of 'Modern Art.'" The *work* of modernist critical discourse is to recover artistic subjecthood from essentially abstract work, and in a form that is fundamentally identical with the category of the bourgeois subject.

But according to Kelly, the production of the subjective image, imperative for modernist painting, is unfeasible for narrative film because "the cinematic apparatus is employed to remove the traces of its own steps," while in painting, on the other hand, "the painterly signifier is manipulated precisely to trace a passage, to give evidence of an essentially human action, to mark the subjectivity of the artist in the image itself." The end result is "a radical asymmetry in their respective modes of address."

So the opposition high culture/low culture is again upheld, here on the basis of the production of artistic subjecthood: the "trace of a passage, or the artistic gesture" recoverable only, says Kelly, in high art. That "the cinematic apparatus is employed to remove the traces of its own steps" is certainly true of the continuity system in general and the classic Hollywood film in particular – the object texts of most

contemporary film theory. But it is increasingly less self-evident in regard to contemporary film, and it should be emphasized that, in general, film theory as we know it emerged in a retrospective relation to the mass forms of the modernist era – classical narrative cinema. Current cinema, though, regularly displays a variety of the formal devices of discontinuity and rupture associated with avant-gardist high art, including direct address, nonseamless modes of editing, "making strange," and so on. Current mass culture has no fear of baring the device. (I should note here that I'm equally uninterested in investing these acts of baring the apparatus with value as in giving political weight to other sorts of materialist practices in writing or film, or attempts to break with ideologies of closure and identity through similar formal disruptions.)

Moreover, Kelly obviously knows, although she doesn't address it in her argument, that "auteur theory" is the most widespread informing theory in popular discourse on film, constructing the lowly movie *as* artistic text, effacing the reality of collaborative production by asserting the director as privileged artistic subject, recovering temperament, creativity, and subjectivity from the filmic text in the authorial gesture *and* giving it a signature. In addition, the discourse on and of popular culture saturates us with information precisely *on* the constructedness of the motion picture, including regular "behind-the-scenes" TV documentaries on the making of movies, like "The Making of *Gandhi*" or the now classic "Making of *The Deep*."

The techniques of modernist subjectification and the discourse of the artistic subject are not even confined to cinema, the high end of low culture: these devices are at work in TV commercials, as well. Ben Yagoda claims, only somewhat facetiously, that the only place avant-garde theatrical techniques can still be seen is not on the New York stage, but in TV ads. He finds "an ingenious appropriation of Pirandello's musings on appearance and reality" in a commercial where a man can't decide if he is listening to a live singer or a Memorex recording of one; he discusses the dilemma with an announcer who, it turns out, is on tape himself. And in those toilet paper ads that show characters "who seem to possess a hidden socially unacceptable urge to squeeze the merchandise," he sees the Ionescesque comedy of the absurd: "People with ridiculous values were engaged in a ridiculous activity, which for comic effect was treated as though it were absolutely normal." And there's the one where "a woman about to buy the high-priced spread is cruelly browbeaten by fellow shoppers, stock boys, and the assistant manager – the Theater of Confrontation such as it hasn't been seen since the '60s."[13]

As for the artistic subject, auteur theory is not only a marketing technique in commercial cinema ("auteurs" now include such cinematic luminaries as Russ Meyer, the director of soft-porn epics like *Vixen* and *Beyond the Valley of the Dolls*, and Roger Corman, the oft-touted genius behind New World Pictures), but even applies now to commercials themselves. *Esquire* magazine and others have run fawning cover stories on Joe Sedelmaier, the director-auteur of the classic Federal Express commercials and the Wendy's "Where's the Beef?" commercials, applying to him all the phrases *Cahiers du Cinéma* once did to John Ford. And the Sedelmaier commercial *is* instantly recognizable through characteristic and unique authorial gestures in his use of camera, the frontality of his mise-en-scène, his ironic approach to sound (sound tracks often

dominated by tuba), and signature idiosyncratic casting and direction of actors. *Esquire* describes him as too much his own man to go to Hollywood.

So if critical discourse produces the artistic subject for works of high art, as Mary Kelly writes, popular discourses do the same for mass culture. And let's not forget that the discourse of advertising itself is now permeated by this same rhetoric of imagination, rebellion, creativity, and free expression once associated with the figure of the artist. To become the quintessential artistic subject you don't have to paint your masterpiece, but only consume the right stuff. This language, originating in contestation, emanating as it does from the Romantic invention of the artistic subject at the moment that nascent industrialization threatened those forms of individuality, has now at least filtered down through the class system to achieve a sort of universality of artistic rebellion. So why should the language of artistic subjecthood be conserved only for the rebellions of the petite bourgeoisie? Since the kinds of claims that were once confined to the realm of high culture are now freely made with regard to commodified culture and commodities themselves, it becomes harder and harder to draw the kinds of distinctions between high culture and mass art that Burger and Kelly still maintain – not to mention the fact that the world of high culture is hardly immune from the imperatives of the market. It becomes less and less feasible to offer high culture as a potentially more critical and contestatory realm less marked by the shame and onus of commodification. And as these distinctions become harder and harder to enforce, so too do the class distinctions they buttress.

The calls by Habermas and others for a contestatory modernism are nostalgia-ridden disavowals of the knowledge that there is no transcendent, privileged cultural space on which to stand that is *outside* capitalist reification. There is particularly no such space that can be guaranteed strictly through particular cultural, aesthetic, or textual practices: not through a refusal or disruption of the signifying practices within which subject positions are said to be constructed, as suggested at different times by *Tel Quel*, *Screen*, or the cultural ministry of Lacanian psychoanalysis and its feminist wing, all of which promise, as Colin MacCabe has written, "the absolutely new and the absolutely different, right up to the gates of the university campus."[14]

I've been discussing the conjunction of a number of breaks: between modernism and postmodernism; between the remnants of an image sphere of use value and one completely permeated by commodification; between the previous unapproachability of popular culture in both high culture and high theory and its current urgent ubiquity. This aggregate set of transformations meets, I'd like to suggest, the criteria Peter Burger outlines in *Theory of the Avant-Garde* for the possibility of a genuinely contestatory political art: one whose potential critical role isn't neutralized in advance by its institutionally determined autonomy from everyday life.

The set of structural possibilities and structural limits that postmodernism makes available is a field of possibility that antagonistic social forces attempt to appropriate and utilize in opposing ways. By way of demonstration, let me offer a second example of refunctioning – one on the other end of the political spectrum from the opening example of the transformed stop signs – an antiabortion artwork by an artist named

Mary Cate Carroll, which became newsworthy when it was barred from an invitational show at her alma mater, a college in Virginia. Here is the piece described in the artist's words: "a 5' × 5' collage of a mother and father sitting on their couch. In the mother's lap is the outline – in red dotted lines – of a baby without any features. There is a door built into the middle of this baby and when you open that door there is a jar inside. A real jar, not a painting of a jar. In the jar, in formaldehyde, is a saline-aborted male child. A real five-month old fetus, not a painting of a fetus."[15] The title of the work is *American Liberty Upside Down*.

The piece obviously borrows from the favored tactic of antiabortionists who have effectively transformed the fetus into a semiotic weapon and are prone to assaulting women attempting to enter abortion clinics with its image in so-called "rescue operations." Carroll describes the inception of the work this way: "It seemed logical to me to find a fetus and put it in the painting." The controversy began when the college told her she couldn't show the piece unless she replaced the real fetus with a drawing of a fetus or some other artificial substitute.

The public hue and cry about the artwork ran the gamut from "What is art?" to the citation of laws concerning the uses to which dead bodies may or may not be put. (This last, Carroll considered a triumph: the college invoked a state ordinance against exhibiting dead bodies as the grounds for its censorship, yet the Supreme Court opinion legalizing abortion – as of this writing still tenuously in place – defines a fetus as "not a person." Carroll attempted to make a court case out of the contradiction, hoping that a court decision *would* actually declare her fetus a dead person.)

On the "What is art?" question, an art teacher at the college weighed in with her opinion that Carroll's piece *can* be considered a work of art. "However," she says, "the contents of a bottle that was placed on a shelf within the framework of the painting, namely a second trimester fetus, cannot by any standards be called a work of art." She affirms the right of artists to express themselves freely, but goes on, "I do not consider human tissue to be an article of mixed media. . . . What would the next step be following the display of a human fetus in a painting today? Would it be perhaps placing some other offensive morsel of human tissue, chosen by the whim of the artist, in a painting tomorrow?"

The hysterical edge provoked by Carroll's piece testifies to the agitation-potential of self-consciously political strategies to eliminate the distance between art and the world. This strategy alone doesn't guarantee the reception of the work, though, and Carroll's piece seems not necessarily to have worked as she intended: Nat Hentoff claims that the piece was censored for the "quintessential, visceral reason that some folks found [the fetus] disgusting," rather than because it was an automatically convincing antiabortion argument. Carroll's work wielded the fetus as if it were, in itself, an objective correlative of antiabortionism, as if it were, as T. S. Eliot describes the term, "the formula of that *particular* emotion" through which that emotion can be immediately evoked. For Eliot, the success or failure of a piece of art rests on the "adequacy" of the symbol or situation to the state it is meant to evoke.

The image of the fetus, deliberately detached from the mother, deliberately shunting aside the maternal body, is, in Eliot's terms, a fairly adequate symbol. It has been

a difficult image to contest. Prochoicers have rallied with a counterimage – the bloody coat hanger – and attempted to shift the ground of the argument back to the body of the woman and to contest the sentimentality of the fetus imagery with the cold reality of the consequences to women of illegal abortions, of no choice. The antiabortion movement's strategy, and it is a sophisticated strategy, has been to transform the fetus into an ideological element and appropriate it to their own discourse, performing their ideological interpellation in the name of, even in the voice of, the fetus.

Hegemony isn't imposed, it's won. While a single image can't make or break a political struggle, while unconscious processes are certainly mobilized in the reproduction of capitalist and patriarchal relations, the issue of how the popular imagination is captured is at the heart of the struggle for hegemony. The question, then, for the radical democratic Left, and for radical aesthetics, is of producing a *popular* culture. Left theorists have regularly opposed the conflation of the terms "mass culture" and "popular culture," arguing pristinely that mass culture is *capitalist* culture rather than one that is truly popular (which in the Old Left imagination seems to consist of sitting around a campfire and playing homemade musical instruments, far from the evil corrupting pleasures of commodity culture). While the Left argues terminology, the terrain of the popular is simply ceded *to* commodity culture. Like the antiabortionists' arrogation of the fetus, popular culture works by *transforming* elements from the culture at large – not through inventing or imposing arbitrary materials on a stunned and passive populace. It's not merely a siren song luring the masses onto the rocks of capitalist capitulation, it makes itself effective by appropriating meaningful cultural elements as its "raw materials" and transforming them in such a way that they express a capitalist hegemonic principle.

Ernesto Laclau makes a similar analysis of the structure of populism. Populism, a political mode often associated with the transition from a traditional to an industrial society, has, in Laclau's analysis, striking resonances with the sphere of culture in advanced Western economies.[16] In Laclau's structural reading, populism isn't defined through its particular class basis or specific stage of economic development, but through its mode of address – a series of "popular interpellations" that develop the antagonism between the people and the power bloc. In that the mass of "mass culture" still does contain echoes of "the people" – at the very least in its demographics – Laclau's analysis of populism might give us culturalists some insight into, or even better, some access to, the effectivity of popular culture, not as an instrument of domination, but as access to a counterhegemony.

A class becomes hegemonic not through its capacity for sheer domination, but through its ability to appropriate visions of the world and diverse cultural elements of its subordinated classes, but in forms that carefully neutralize any inherent or potential antagonism and transform these antagonisms into simple *difference*. Classes only exist as hegemonic forces to the extent that they can absorb the popular into their own discourse, but in such a way that "the people" as an oppositional force are neutralized.

Hegemony is always in process. Yet this *is* a process with cracks and openings. Dismissing popular culture as merely an instrument of capitalist domination rather

than a site to be struggled over simply cedes the territory of popular interpellations to capitalism. The theory of postmodernism presented here argues for a different cultural practice, one of appropriation, of transformation, of refunctioning. Certainly much of the success of capitalist hegemony comes from its exclusive claim to those elements in the culture that are socially meaningful (like narrative) and its transformation of those elements into the basis of the continuing appeal of an existing social order. According to Laclau, for dominated classes to win hegemony they must precipitate a crisis in dominant ideology, stripping the connotative power from its articulating principles. For this to happen the implicit antagonism of popular culture and popular interpellations must be developed to the point where the contradictions between "the people" and the power bloc are unassimilable.

Much capitalist popular culture obviously already expresses populist antagonism to "the system" – antigovernment, anticorporate, and antitechnology themes are far from rare. A left popular culture would undertake to articulate the antagonistic moments *already* there in popular culture into moments when radical democracy gets presented as an unassimilable option *against* the dominant. Laclau refers to this as the "ideological class struggle": it aims to provoke a crisis of dominant ideology and a crisis in the ability of the system to neutralize its dominated sectors: this, in Laclau's account of populism, precipitating a more general social crisis. Precisely because those contradictions can never be *totally* absorbed by any dominant class discourse, the articulation of an antagonistic moment characterizes populism, and the more radical the confrontation with the system, the less possible it is for a class to assert its hegemony without populism.

The imperative to produce a left *popular* culture accounts for the emphasis here toward conscious experience and the fact that my argument locates the work of popular culture somewhat closer to the level of the conscious subject than do many recent theorizations of mass culture. The focus on the intersections of the unconscious and the repressive social order, and on legitimation secured at the level of signification through the subject-effects of narrative and visual pleasure, represents the cultural and political field in terms that effectively foreclose in advance the significance of any cultural practices other than the most ultramodernist (read *elitist*) – those which are generally unpleasurable and clearly unpopular. I'm neither intrinsically against strategies of rupture, distance, or textuality nor theoretically biased in favor of ego psychology or American revisionism over psychoanalysis. I wouldn't want to dismiss important psychoanalytically derived theories on production of the subject within popular cultural forms. Rather, the focus on conscious experience is provisional, part of a provisional strategy for a provisional radical postmodernist popular cultural politics.

This vision of a left popular culture seems not so far from what Laclau calls populism, a political mobilization posing a challenge to capitalist hegemony, and without which no such challenge can be made. My aim is toward formulating a strategy for the *production* of a left popular culture rather than toward fostering critical strategies that provide *readings* of the antagonisms inherent in already existing popular culture. This

has marked the general limit of left involvement with popular culture: the rendering of interpretations that are produced and that circulate within the circumscribed domains of high culture and high theory. Much of this work is content to locate what it describes as moments of resistance and stop there. We need to produce those moments ourselves.

Both theorists of modernism and theorists of the unconscious have recoiled from popular culture. Attempts to interpret the popular from within these categories have yielded arcane and academicist interpretations that impute diminished intellectual or political credibility to its audience. Attempts to defy the popular via modernist or neomodernist aesthetic practices have produced an endless array of baffling and elitist sterilities. Postmodernism makes available the means to approach popular culture – and thus its audience – differently, to wrest its very popularity away from the dominant culture, in the process transforming it into a popular and *contestatory* mode of political address. Neither interpreting nor defying popular culture is enough; the point of the populist intervention outlined here is to change it.

Notes

1 Andy Grundberg, "As It Must to All, Death Comes to Post-Modernism," *New York Times*, September 16, 1990, p. 47.
2 Walter Benjamin, *Understanding Brecht* (London: New Left Books, 1973), pp. 93–4.
3 Louis Althusser, "Ideology and Ideological State Apparatuses," in *Lenin and Philosophy and Other Essays* (New York: Monthly Review Press, 1971), pp. 127–86.
4 Reported by CBS News from the 1984 Republican convention.
5 Ernesto Laclau, *Politics and Ideology in Marxist Theory* (London: New Left Books, 1977). See also Chantal Mouffe, "Hegemony and Ideology in Gramsci," in her *Gramsci and Marxist Theory* (London: Routledge and Kegan Paul, 1979), pp. 168–204.
6 Raymond Williams, *Keywords* (New York: Oxford University Press, 1976), pp. 158–63.
7 Peter Burger, *Theory of the Avant-Garde* (Minneapolis: University of Minnesota Press, 1984).
8 Michael Taussig, *The Devil and Commodity Fetishism in South America* (Chapel Hill: University of North Carolina Press, 1980).
9 See Ernest Mandel, *Late Capitalism* (London: New Left Books, 1975), p. 191 and passim.
10 Guy Debord, *Society of the Spectacle* (Detroit, Mich.: Black and Red, 1977).
11 Clement Greenberg, "Avant-Garde and Kitsch," in *Art and Culture: Critical Essays* (Boston: Beacon Press, 1964), pp. 3–21; "The Necessity of Formalism," *Lugano Review* (October 1972), pp. 105–6; and "The Recentness of Sculpture," in *American Sculpture of the Sixties* (Los Angeles County Museum of Art, 1967), pp. 24–6.
12 Mary Kelly, "Re-Viewing Modernist Criticism," *Screen* 22, no. 3 (1981): 41–62.
13 Ben Yagoda, "Don't Squeeze the Ionesco," *Village Voice*, December 4, 1978, p. 66.
14 Colin MacCabe, "Coming Down: Elements of an Intellectual Autobiography," in *Tracking the Signifier* (Minneapolis: University of Minnesota Press, 1985), p. 11.
15 Nat Hentoff, "If It's Not a Human Being, What's the Crime?" *Village Voice*, March 6, 1984, p. 6.
16 Laclau, "Toward a Theory of Populism," pp. 143–98.

30 The Lightness of Theory

John Rajchman

The question is how light or heavy we are – the problem of our "specific gravity."
 Friedrich Nietzsche, 1887

P.M. and M.C.

One critical reflection we might engage in today concerns what "theory" is or has become for us. Not so long ago, across much of "advanced" visual culture, a typical short answer to the question "What is theory?" would have been "post-Modern, ever more post-Modern!" I myself had little use for this category, and some years ago tried to analyze how it had arisen and become so prevalent.[1] The designation nevertheless lives on. But it has become too vague and elastic to mean much, and even journalists are growing less fond of it. In fact, post-Modernism is receding from us to the point where one may well wonder what it once *was*.

Thus, Jean-François Lyotard worries about the "contradictions of the post-Modern" in a work by that title to appear this fall in Paris, while Hal Foster's remarks, in a recent article, exemplify a discussion more typical of the US: the connection of the post-Modern and the multicultural. He encapsulates a symptomatic confusion when, looking back at post-Modernism, he declares that while French

From *Artforum* 31 (September 1993): 165–6, 206, 211. Copyright © 1993 by *Artforum*. Reproduced with permission of *Artforum*.

philosophers and critics in the '60s told us that the subject is dead, we owe it to their American followers to have shown us that the deceased subject is a "very particular one, not to be mourned by all: white, bourgeois, humanist, male, heterosexual."[2] This sort of "parallax vision" makes for very dubious intellectual history. For a basic point of the "question of the subject" in Paris thirty years ago was precisely to get away from the whole idea that we are all "subjects" of such rigid "predicates." Surely, now as then, we are more complicated, more strange, more mobile and "multiple" than that, as indeed some contemporary theorists of identity have tried to show.

Foster bases his readjusted view on Fredric Jameson. But it is a relief that Jameson does not himself feel the need to indulge in any such identity-political piety about dead subjects. He reacts to identity politics in another way, suggesting that contemporary cultural studies should go back to Sartre, for whom "identity" involved an unresolvable violence and enmity, unlike the class struggle, in which it is nevertheless rooted.[3] Jameson thus blithely continues to talk of post-Modernism, confident that it names a stage in "late capitalism" as discerned by Ernest Mandel many years ago, before the collapse of the Soviet Union. Today, however, it is fair to say that it is much less obvious that capitalism is in a late stage, about to pass into something else (what exactly?); it is unclear what even Mandel himself might have thought about the matter. Our problem is rather to *rethink* the ideas of class and class struggle, and, in particular, their relation to contemporary minority movements. In going back to older views, Jameson seems to want to make class a sure "identity," with none of the violence or "alterity" involved in the less certain, more mobile "identities" of minorities. And yet one may argue, on the contrary, that precisely what the "class struggle" showed us was that belonging to a class is no more an uncomplicated matter of "identity" than is belonging to a minority; class too carried the violence of something that was not yet defined, an "alterity" in social classification that invited movement and the imagination of other possibilities.[4] In particular, such movement was one reason why class became important for artists as well as for theoreticians, as is the case today for some concerned with the questions of "identity" and cultural "multiplicity." But what sort of theory allows for such mobility, such multiplicity?

"Multiculturalism" has now become as ubiquitous a term as "post-Modernism" once was, bearing the weight of conflicting meanings. Are we then going to say that M.C. just *is* P.M., or the latest stage of P.M.? Or is it not rather that our thinking itself needs to become more precise and more lean? The symptomatic and much maligned Whitney Biennial might serve as an indication of the problem: not that there was too much theory, but that there was a reliance on an unthinking and self-indulgent theory, unable and unconcerned to *see* the questions that in fact sometimes emerged from work. It was as though theory had become too *heavy* – top-heavy with its own self-importance – having lost the will or the ability to look with fresh eyes for what was real or singular or creative of new movement and possibilities.

It has now become hard even to remember that post-Modernism itself started out in this way, with a sense of new forces knocking at the door, new possibilities to try out, new forms or concepts to invent. For it has long since lost this vitality, its sense of wit, mobility, inventiveness – its lightness. Thus the real question is not how P.M.

became "correct" enough to give us M.C.; it is rather how post-Modern theory became so heavy that it lost even the desire to look for those real points that allow thought to move and recreate itself – in short, how it became so *dead*.

Dead/End

Although there were many earlier uses of the term, "the post-Modern" was invented in the '80s: a time of a wild debt-financed consumer extravaganza we have yet to pay for. It was as though a great sense of *irreality* had descended upon us, which extended into the realm of theory. We are only made-up things, we told ourselves, and live in a make-believe world: all is only "simulation," "hyperreality," "appropriation." Two great assurances arose. There was the notion that nothing new can happen, and that we must content ourselves with more or less "ironical" recombinations, juxtapositions, quotations of what has been. And so we were at the End – the end of Modernity, reality, truth, "the subject," and, of course, art, or, at least, the fine arts. Thus Hegel's depressive idea that we are the End of History gained new currency in one way through Arthur C. Danto, in another through Francis Fukuyama, along with variations on the old theme of "the death of art." Connected with this assurance about the End, there arose a second notion: that of the "simulacrum," which said that there is nothing real, nothing out there for words or images to refer to, and therefore, nothing can be true; all is play of illusion and manipulation of image. Armed with these assurances that all is over and nothing is real, theory oscillated between irony and complacency, boredom and despair. Depression was the dominant *affect* – at least that was something "real"!

In this climate the "image" of theory itself began to change along "post-Modern" lines:

(i) there would be no *new* theory, only recombinations of what had already been thought. Gradually theory stopped even *trying* to invent new concepts or raise new questions, and became instead a set of stock formulas to be thrown together in the computer at will without regard for origin or rigor in an ever more arbitrary and entangled quotational patchwork.

(ii) the two great assurances of the End and of the Unreal applied to our own personalities or identities: "the subject" is dead, we were told, "the subject" is unreal. What this meant was that we are only "images," only socially manipulated stereotypes, that we are thus not real but "socially constructed," and there is little to distinguish us from cyborgs. This idea was then introduced into thought itself: "theory" increasingly became the name of a familiar sort of performance in academic symposia for an audience delighted by the personality and the "affairs" of a proud new figure, the Theorist. The problem of subjectivity tended to be reduced to such performance of the personal, as one was invited to speak of him- or herself, in little dramas of great self-importance. In this way the academic conference began to assume the form of

the talkshow, allowing theory to find its way into the world of popular media, which, at the same time, it took as its special object.

(iii) At the end of the '30s, Clement Greenberg's formalism had taught that to protect itself, its "quality," or its purity from kitsch, art had to turn in on its own constitutive forms, forms that in turn would become the sole object of theory. In the depressive '80s, where nothing seemed real or alive any longer, there arose another type of internalization, another way of art turning in on itself. Social or political critique reverted to "internal critique," a great rage against the institutions of art, their selections and exclusions, their links to market or patronage: *they* were respons-ible for the fact that nothing was moving, that everything was over or dead. Thus some "new historians" of art began to work from the assumption that art had *always* been tied to immovable Contexts (known only to the historian), and to examine the ways in which art had tried (always unsuccessfully) to challenge its institutions. And yet the ensuing theoretical controversy in the discipline – which pitted social Context against artistic Form – proved rather sterile, as though this grand opposition was not so telling after all. For both of the opposed terms were linked to processes of internalization, formal or institutional, and there was little room for those forces of the *outside*, which don't fit into contexts, which complicate, deform, transform institutions, and so which cause art to invent new styles of formal articulation, and give theory the impetus to try out new questions.[5]

Thus in the '80s, an institutional critique deriding an older formalism joined together with a dead "subject" reduced to an empty play of images to create a familiar style and persona in theory. But amongst all this unreality, all this death, all this talk of the end, all this *consensus*, where were the forces of the future, the points of resistance against both form and institution, in which art and theory *live*?

The Art of the Real

In relation to California cyberpunk, Jameson coins a suggestive label – "dirty realism."[6] In part he seems to have in mind a rejection of the "clean idealism" of the manic power-fantasies associated with a "cyberspace," where the body is prosthetically cleansed of all but its "cognitive" functions, and so enters a realm where it can at last see without ever being seen, where nothing resists the wiring of the brain, and all reality has become "virtual." "Dirty" means that we need to understand even VR in terms of a messy reality or untidy materialism of our bodies and their forces. Only then might we hope to extract it from a stupefying barrage of simulacrum-hype, where, in a nice West Coast theory-cocktail, we are told that VR is going to solve the problems of M.C., since it will allow everyone, irrespective of origin or history, biology or income, to just make up who he or she or it is (don your data-gloves and disappear! . . .). Yet VR will only become interesting "theoretically" just when it is *not* content to "simulate" ourselves or our world, but, against the motives of military money, is used to describe something not given through our current representations

of space, time, and movement, something singular and as yet unknown. The idea of "dirty realism" may, however, be extended beyond this particular context.

Jacques Lacan is often credited with being the father of the widespread assurance that "gender is socially constructed," that sex is only mask and masquerade. But in fact not only did the psychoanalyst defend the perenniality of the phallic function, but his was an ethics of "the real." When he said "there is no prediscursive reality," he didn't mean there is nothing real at all; he had a keen sense that there exists in our bodies something prior and irreducible to our imaginary "roles" and symbolic "identities." Far from saying that sex images and identities are unreal social constructions, Lacan taught that sex is *le réel* itself. He saw the libidinal body as a disunified thing, dispersed by *objets a* (including the famous "gaze") into the stumbling symptomatic complexities of our bodily existence: and he thought that one of the singular destinies of such objects was to recur and intersect in the strangely public space called "sublimation," a space that includes "art" (as well as "antiart"). He said the very "function" of art, beyond patronage and market, is to re-create this singular bodily "real" we must otherwise repress.[7]

There is, then, a "realist" way of reading Lacan. It finds in the body something that is *not* just "image" or "identity," but, on the contrary, that takes us away from image and identity to those junctures where an "impossibility" arises in the ways we participate in our worlds, fictive and real, that may spur on artistic or theoretical creation. One use for such "realist" Lacanian theory has been in a revised history of modernism that sees a "base materialism" and a Duchampian nominalism directed against the pieties of the "higher" functions of art, against the supposed "purity" of abstraction, and, in this sense, against art as "sublimation."[8]

But perhaps in our own sort of "dirty realism" we may discern the signs of something similar today. We again see a concern with "abject" bodily functions, a need to expose what is intolerable in our society and our relations with ourselves and one another, a desire to speak again of "real" causes and movements. Such concerns, however, are no longer directed against the pretensions of a "sublimated" purity of abstraction, but against a no less fierce idealism: the terrible depressed unreality of our image-obsessed '80s. It is as though there were a cry of the body, of the real, a refusal to think all is image and identity behind which there is nothing. "A little reality, a little body, a little materiality, if not we shall die!" – such is the cry turned against the cynicism that knew that all is image and that art or theory is anything with a public that will "buy" it. It is a cry that requires that there be more to democracy than such consumer populism. And such is the *sort* of question that belongs to "theory" rather than knowledge or opinion: questions where "the real" is not a "reality" that is already given or envisaged in our representations, but, on the contrary, something unseen in them that disrupts them, and again sets them in motion. For theory is not a metadiscipline that supplies one ready-made the concepts for the critical analysis or formal appraisal of what we already know and see. It is not "internal critique" or rage against institutions, and the proposition that theory *is* practice must be understood in an experimental rather than a reductive way. Lightness in theory is this kind of experimentation not ordered by a given method, which arises

when the way is not given, and several things, several questions, must be tried out at once.

Experiment!

Time has come to *reinvent* theory. It is sometimes thought that theory falls to us prefabricated from the heavens, like a set of abstract edicts, whereas in fact it too is fabricated, invented here on earth, as new questions arise to displace habitual ways of thinking. Too long have we been content to live off theory that has already been made elsewhere by others, adopting its enunciatory positions, assuming the roles in its drama, rather than creating new ones for ourselves. Thus we have grown immobile and wearied, and can no longer distinguish our theory from journalism or "informed" middlebrow conversation. Without question and drama, we have become *heavy* with too much uncreative theory, and to move again we must disburden ourselves of its weight. We need the lightness of new beginnings. We need to create for ourselves the room and the time to ask again "What is theory?" In the words Nietzsche and Peirce helped introduce into philosophy, we must become "experimentors" or "attempters" in theory.

What would it then mean for theory to again become light and experimental? In the first place, we can afford to introduce a little uncertainty, a little lightness about *ourselves* or our "identities." We need to rescue the question of subjectivity from banal biography, from therapeutic narrative (in search of "role models" and "self-esteem"), and from predefined positions ("speaking as a . . ."), and rediscover the "innocence" of not knowing what we might yet become. We must again attain that point where to think is to *get away* from our "selves" and become "strangers to ourselves," where we have to "invent ourselves" just because we do *not* know who we are, since our origins and aims are too various, too complicated, too disunified. For it is then that there is a chance for the movement of something *not* already "represented" in our relations with ourselves and one another. We need to introduce such multiple movement into our very *concept* of democracy or pluralism, traditionally restricted to models of representation and participation.

In the second place, we must become more "empirical" – that is, we must *stop* theorizing. What Peirce called the "experimental spirit" in philosophy was not so much a method as a precept: *not* to start from Cartesian certainty or abstract postulates. In this respect, it is akin to Wittgenstein's cry: "Don't think, look!" Today we need to stop "thinking" so as to start again to *see* what we can't yet describe since we think too much. We need an art of description, precise critical description, of what is happening to us. But that art must itself become experimental: an art of "indefinite description" where the "real" is not an already given object, but the point of a gathering cluster of descriptions opening onto the unknown. We need to find that point where the "real" and the imagination of other possibilities are linked to one another, as when Proust says the true dreamer is the one who tries to go out and verify something.

There is, then, a third condition of "lightness" in theory: to lighten ourselves, to experiment, to offer "indefinite descriptions" of the real, is to suppose a certain attitude and relation to event and history. We must allow time in our midst for those events that complicate and multiply our relation to the past, connecting it to the forces of what is yet to come in what happens to us. Lightness is such movement without eternity or tradition, and that is why Zarathustra took as his arch enemy the spirit of gravity. Nietzsche is the one to have linked together the "lightness" of knowing and the "untimeliness" to which it is a force of the arts to give "body" and "space," inventing new affects and new precepts, new ways of experiencing and seeing:

> One has to be *very light* to drive one's will to knowledge into such a distance and, as it were, beyond one's time, to create for oneself eyes to survey millennia and, moreover, clear skies in these eyes.[9]

Notes

1 John Rajchman, "Postmodernism in a Nominalist Frame," *Flash Art International* 137 (November/December 1987). Reprinted in my book *Philosophical Events: Essays of the '80s* (New York and Oxford: Columbia University Press, 1991), pp. 118–25.
2 Hal Foster, "Post-Modernism in Parallax," *October* 63 (Winter 1993), p. 11.
3 Fredric Jameson, "On 'Cultural Studies,'" *Social Text* 43 (1993), pp. 17–53.
4 Jacques Rancière sketches this conception of the working class in history in "Politics, Identification, and Subjectivization," *October* 61 (Summer 1992), pp. 58–64. For an elaboration of the word "proletariat" as a "word of history" see Rancière's *The Words of History*, forthcoming from Minnesota University Press.
5 On this concept of "the outside" see Michel Foucault, "Maurice Blanchot: The Thought from Outside," in *Foucault/Blanchot* (New York: Zone, 1987), pp. 7–58.
6 Jameson, "Demographies of the Anonymous" in Cynthia Davidson, ed., *Anyone* (New York: Rizzoli, 1991).
7 I develop this view of Jacques Lacan in my *Truth and Eros: Foucault, Lacan, and the Question of Ethics* (New York and London: Routledge, 1991).
8 Rosalind Krauss explores the role of the eye or of the "visual body" in this rethinking of Modernism in *The Optical Unconscious* (Cambridge and London: MIT Press, 1993).
9 Friedrich Nietzsche, *The Gay Science*, trans. Walter Kaufmann (New York: Random House, 1974), p. 343, #380.

31 *Informe* without Conclusion

Rosalind Krauss

1. During the time the exhibition "Formless: A User's Guide" was in its planning stage at the Centre Georges Pompidou, a potentially competing project was announced by another Parisian institution under the title "From the *Informe* to the Abject," a title that clearly stated a belief that if the *informe* has a destiny that reaches beyond its conceptualization in the 1920s to find its fulfillment and completion within contemporary artistic production, this is in the domain of what is now understood as "abjection."[1]

Museum protocols being what they are, however, this latecomer was withdrawn, and the project with the seniority was retained in the form of the exhibition for which these texts serve as one section of the catalogue. And yet, that other, unrealized project might nonetheless continue to function in terms of an implicit protest against seniority understood by it in a wider and more injurious sense of the term: that of supporting the old against the new, of scanting current practice in favor of historical precedents, and thereby, of failing to acknowledge what it takes to be the case, namely, that the reason for the currency of present-day interest in the concept of the *informe* is to be found in the insistent spread of "abjection" as an expressive mode.

For indeed, this spread is easy enough to document within the cultural manifestations of the last several years. To name only some very recent ones, two respected spokesmen for contemporary art – David Sylvester and Robert Rosenblum – participated in *Artforum*'s annual survey of the best and worst exhibitions held in 1995 by nominating Gilbert & George's "Naked Shit Pictures" to the top of their lists, comparing this mammoth installation to Renaissance frescoes "in which the settings for

From *October* 78 (fall 1996): 89–105.

the groupings of nude figures were not the usual columns and arches but structures erected from enlargements of turds," thereby producing in their viewers a supposed rush "from the scatological to the eschatological."[2] Or, as another occasion, there was the Centre Pompidou's own *femininmasculin* exhibition, with its heavy complement of artists associated with American and English "abject art" – Kiki Smith, Robert Gober, Mike Kelley, Sue Williams, Nancy Spero, Gilbert & George, and in matriarchal place of honor, Louise Bourgeois – and its emphasis on contemporary production's fixation not simply on sexual organs but, as well, on all bodily orifices and their secretions – hence a strong showing of urinal-related art and fecal imagery, as in Paul-Armond Gette, Noritoshi Hirakawa, Jean-Michel Othoniel, Helen Chadwick.[3]

Perhaps, indeed, it is the occurrence of this latter exhibition and the fact that it and "Formless: A User's Guide" shared certain artists – Marcel Duchamp, Jean Fautrier, Cy Twombly, Claes Oldenburg, Mike Kelley, Robert Morris – though not the same genre of work by any of them, and in rare examples even shared the same objects – Giacometti's *Boule suspendu*, Man Ray's *Anatomies*, Eva Hesse's *Accession*, François Rouan's *Coquilles* – that forces us to be explicit on the subject of abjection, and to state why and in what way it must be differentiated in the strongest possible terms from the project of the *informe*.

> *The sacralization of the desired object submits desire to the law of contradictory injunctions for which the model (the pole of attraction) that he imitates is at the same time what constitutes the obstacle to his satisfaction (the pole of repulsion).*
>
> Denis Hollier, *Le Collège de Sociologie*[4]

2. This is not to deny, of course, that abjection was a term employed by Bataille himself, particularly in a group of unpublished texts from the mid-to-late 1930s under the title "Abjection et les formes misérables."[5] Nor is it to overlook the fact that insofar as these texts identify social abjection with a violent exclusionary force operating within modern State systems, one that strips the laboring masses of their human dignity and reproduces them as dehumanized social waste (its dregs, its refuse), they map the activity of abjection onto that of heterogeneity, which Bataille had developed elsewhere as another form of what a system cannot assimilate but must reject as excremental.[6] And further, it is not to ignore the fact that at around the same time Bataille was devising still another model of social cohesion under the rubric "Attraction and Repulsion," for which what is taken to be the most forceful centripetal pull of society is a power not of attraction, but one of repulsion, with the sacred core now a function of those very things that had before been classed as "abject."[7]

Indeed, it is this Durkheimian project, linking the sacred to horrific powers of impurity, that Julia Kristeva would take over from Bataille in her own development of a theory of abjection some fifty years later.[8] And interestingly, it is Kristeva's use of the term, not Bataille's, that has been influential in the recent theorization of this concept in relation to contemporary artistic practice.

That this should have been the case goes beyond the mere fact that Bataille's unpublished texts on abjection were relatively unknown, whereas Kristeva's *The*

Powers of Horror, disseminated in translation, was widely available. Kristeva's theorization of the abject had a very different starting point from Bataille's, one that was not primarily social – for all its chapters based on the anthropology of *Purity and Danger*[9] – but part philosophical and part psychoanalytic. For the question Kristeva had been posing since *Revolution in Poetic Language* had been how to conceive the connection between subject and object, whether subject be the psyche and object be the soma, or subject be a conscious being and object, its world. If those questions had been mainly pursued within a Lacano-Freudian context, they had also been elaborated within a Hegelian problematic, giving the passage from the subject to its object – understood as the work of *negation* – an overlay of diagrammatic abstraction.

Whether it was for reasons of schematic completeness, or, as has also been suggested, because the avant-garde's "revolution" could be posed in poetic language not just from the left (Artaud) but from the extreme, fascist right (Céline), itself seeming to demand from Kristeva's system of semiotic expressiveness a further explanation of how this could be so, *The Powers of Horror* now turned to a model articulated around the arrested passage from subject to object, *negation* functioning here like a kind of bone stuck in the throat. The abject would thus be this intermediary position – neither subject nor object – for which the psychiatric term "borderline" would prove to be extremely useful. And, indeed, "borderline" came increasingly to function as a form of explanation for a condition understood as the inability of a child to separate itself from its mother, so that, caught up within a suffocating, clinging maternal lining, the mucous-membranous surround of bodily odors and substances, the child's losing battle for autonomy is performed as a kind of mimicry of the impassibility of the body's own frontier, with freedom coming only delusively as the convulsive, retching evacuation of one's own insides, and thus an abjection of oneself.

The abject-as-intermediary is, in this account, thus a matter of both uncrossable boundaries and undifferentiable substances, which is to say a subject position that seems to cancel the very subject it is operating to locate, and an object relation from which the definability of the object (and thus its objecthood) disappears. In this, Kristeva's conception of the abject is curiously congruent with Sartre's characterization of the *visqueux* (slimy), a condition of matter that he analyzes as neither liquid nor solid, but somewhere midway between the two. A slow drag against the fluidity of liquid – "Sliminess is the agony of water," Sartre writes – this flaccid ooze may have some of the qualities of a solid – "a dawning triumph of the solid over the liquid" – but it does not have the resistance of solids; instead, as it clings stickily to the fingers, sucking at them, compromising them, it is "docile."[10] Solids, Sartre reasons, are like tools; they can be taken up and put down again, having served their purpose. But the slimy, in the form of the gagging suction of a leech-like past that will not release its grip, seems to contain its own form of possessiveness. It is, Sartre writes, "the revenge of the In-itself."[11]

Coming as it does from Sartre's project to ground psychoanalysis in a phenomenology of the object, the concern here to grasp forms of matter as ontological conditions ("Quality as a Revelation of Being") ultimately relates the metaphysical purport of sliminess to the way the autonomous subject is compromised by this

substance, which Sartre relentlessly characterizes as feminine – yielding, clinging, sweet, passive, possessive – producing yet one more parallel with the analysis Kristeva would come to produce.[12] For the ontological condition here, analyzed as a function of substances, has as its psychic component a threat to autonomy and self-definition due to the suffocating nearness of the mother.

> *Quality is the whole of being unveiling itself within the limitation of the* there is.
>
> Sartre[13]

3. The abject, understood as this undifferentiable maternal lining – a kind of feminine sublime, albeit composed of the infinite unspeakableness of bodily disgust: of blood, of excreta, of mucous membranes – is ultimately cast, within the theorization of abject art, as multiple forms of the wound. Because whether or not the feminine subject is actually at stake in a given work, it is the character of being wounded, victimized, traumatized, marginalized, that is seen as what is in play within this domain.

Accordingly, abjection is the term that Laura Mulvey uses to account for the point at which she feels Cindy Sherman's work had arrived in the series made in the late 1980s sometimes referred to as the "bulimia" pictures.[14] Tracing Sherman's development over the preceding decade from a form of masquerade, in which women assume a range of stereotypical guises that they wear as so many glittering veils, to this moment where the veil is finally dropped, Mulvey sees Sherman's progression as a steadily growing refusal of the role of fetish object. The cosmetic façades that fit over the heroines of the early work like so many glossy carapaces of perfection were organized, like the fetish itself, as a monument to Lack, as a cover-up for the fact that the castrated woman's body is the site of the "wound."

From the hardened outside – all image – of the film stills, to the idea of the feminine interior as limp, moist, formless, of the erotic reveries of the centerfold pictures, to the parodic fashion-plates that Sherman made in the early 1980s, and then the horrific fairy-tale illustrations from about the same time, Sherman is seen by Mulvey as playing on this inside/outside topography of the woman's being in which nothing can be imagined behind the cosmetic façade but a monstrous otherness, the wounded interior that results from the blow of a phantasmatic castration. Sherman, she says, is exploring this "iconography of misogyny," one that women themselves identify with not only in adopting the cosmetics of the masquerade but in pathologically attempting to expunge the physical marks of their own femininity: "The images of decaying food and vomit raise the specter of the anorexic girl," she writes, "who tragically acts out the fashion fetish of the female as an eviscerated, cosmetic and artificial construction designed to ward off the 'otherness' hidden in the 'interior.'"[15]

But it is in the body's final disappearance into the spread of waste and detritus, in the work of the late 1980s, that "the topography of exterior/interior is exhausted," since "these traces represent the end of the road, the secret stuff of bodily fluids that the cosmetic is designed to conceal."[16] With the removal of this final veil and the direct, unblinking confrontation of the wound – "the disgust of sexual detritus,

decaying food, vomit, slime, menstrual blood, hair" – the fetish now fails and with it the very possibility of meaning that the mark of the phallic signifier puts into play: "Cindy Sherman traces the abyss or morass that overwhelms the defetishized body, deprived of the fetish's semiotic, reduced to being 'unspeakable' and devoid of significance."[17] [See plate 15.]

Now it can certainly be claimed that Sherman's work, insofar as it had early on made a compact with the procedures – operational, structural – of the *informe*, had for some time been investigating ways of attacking "the fetish's semiotic," by dealing a low blow to the processes of *form*. One of these, begun with the elongated format of the centerfold series but continued into later groups organized around a plunging viewpoint, turned on the *horizontalization* of the picture, an operation carried out at the level of the signifiers of the image (format, point-of-view), far more importantly than on its signifieds.[18] For if the woman-as-fetish is to function, it must be not just as a perfect Gestalt, a whole body from the outlines of which nothing is "missing," but as a vertical one as well: the orientation that the Gestalt always assumes in the imaginary field, mirroring as it does the viewer's own bodily dimension. Indeed, it is this verticality, itself a signifier, that allows the "phallic signifier" to map itself onto the image-form, functioning thereafter in tandem to produce cognitive unity: the Gestalt as a unified whole guaranteeing that the mobility of the signifier will come to rest in a meaning, itself cut out as the unit of the signified. In attacking verticality, Sherman's work thus operates equally against the linked conditions of form, of which the woman-as-fetish is one of a set of homologous terms.

That her work with the horizontal need not configure itself through a literalization of formlessness – pictured as chaotic scatter, or detritus, or substances of disgust – is clear from the series she produced of Old Master Portraits, where the horizontal is played out as the work of gravity, pulling on the prosthetic devices attached to the bodies of the sitters, and thus disaggregating the formal wholes that high art holds together as within so many concentric frames. But here one must also note that the pull from "high" to "low" is not to be read as the revenge of mass-cultural values, since it is clear from Sherman's work that nothing operates to maintain the links between verticality, the Gestalt, the Phallus, and the woman-as-fetish so insistently as all forms of commercial culture, whether film, television, or advertising. So "low" is not low art as opposed to museum culture, since both are part of the system of form. Low is, instead, "lower-than-low," a principle, as we shall see further on, that was central to Bataille.

Yet another signifier of the /formless/ with which Sherman has worked could be summarized as wild light, or gleams: a kind of luminous dispersal that is not unlike what Jacques Lacan describes as Gaze, which he says "always participates in the ambiguity of the jewel."[19] This scattered light, which sometimes takes the form of abrupt highlights on bits of flesh or fabric popping out of an opaquely undifferentiated darkness, or at other times a use of backlighting that makes of the figure's hair a burning aureole around the invisible remains of the face, acts to prevent the coalescence of the Gestalt. In so doing, it also disrupts the operation of the model by which subject and object are put into reciprocity as two poles of unification: the unified ego

at one end and its object at the other. Lacan had called this model "geometral," and had identified its rules of perspective with the assumptions grounding the Cartesian subject. But the Gaze, as an irradiant surround, comes at the subject from all sides, producing the subject now as a *stain* rather than a cogito, a stain that maps itself, like one of Caillois's mimetic insects, onto the world's "picture," spreading into it, getting lost in it, becoming a function of it, like so much camouflage. As luminous but dispersive, this Gaze thus works against the Gestalt, against form. It is in this sense that to be "in the picture" within this alternative model is not to feel interpellated by society's *meaning*, is not to feel, that is, whole; it is to feel dispersed, subject to a picture organized not by form but by formlessness. The desire awakened by the impossibility of occupying all those multiple points of the luminous projection of the gaze is a desire that founds the subject in the realization of a point of view that is withheld, one(s) that he or she cannot occupy. And it is the very fragmentation of that "point" of view that prevents this invisible, unlocatable gaze from being the site of coherence, meaning, unity, Gestalt, *eidos*. Desire is thus not mapped here as the desire for form, and thus for sublimation (the vertical, the Gestalt, the law); desire is modeled in terms of a transgression against form. It is the force invested in desublimation.

Throughout the late 1980s Sherman continued to figure this field of the unlocatable gaze by means of gleams and wild light, often married to the /horizontal/ signifier in a combined drive toward the desublimation of the image. Whether this is the gleam of metal grating, or the dull glow of an imageless television set, or the refractive surface of water sparkling upward to meet the downwardly focused view of the spectator, the stabbing beams of the multiple points of light produce not the beautiful of sublimation but the formless pulsation of desire.

Thus these supports for the formless – the /horizontal/ the /gleams and reflections/ – had long been operating within Sherman's work to attack the smooth functioning of what Mulvey names "the fetish's semiotic"; they had been pitting themselves against meaning in the service of the "unspeakable." And this is to say that they had also been working against another avatar of /verticality/ and phallic wholeness: namely, the veil, standing as a substitute for or a marker of the place of Truth, the truth which, in the system of the fetish, is that the woman is castrated.

It is for this reason that the interpretive move Mulvey makes when she speaks of the "disgust" pictures as dropping the veil, and to which, citing Kristeva, she gives the label "abjection," produces the uncanny sense of a return of the repressed. For it is a return, in the place of the "unspeakable," of a Truth that is spoken again and again, the Truth that is the master signified of a system of meaning for which the wound is feminine and Truth is that the woman is wounded. Mulvey herself writes that "although both sexes are subject to abjection, it is women who can explore and analyze the phenomenon with greater equanimity, as it is the female body that has come, not exclusively but predominantly, to represent the shudder aroused by liquidity and decay." Thus when this interpretive structure of "abjection" finally has us lifting the veil to strip away the system of the fetish, what it shows us beneath it is another veil, another signified: the wound as woman.

The wound on which much of "abject art" is founded is thus produced in advance as semantic, as it thematizes the marginalized, the traumatized, the wounded, as an essence that is feminine by nature, and deliquescent by substance. The critique of this procedure was written over two decades ago, of course, in Derrida's attack on the surreptitious slipping of the "effect of *signification* in general" – the signified – over what had purported to be the purely differential operations of the signifier in Lacan's own analysis of the circulation of the marker-of-difference in Poe's story "The Purloined Letter." For there, too, the operations of unveiling work to produce Truth in an act of finding that always finds itself, since the Truth is the fetish-veil of the castrated woman: "It is, woman, a place unveiled as that of the lack of the penis, as the truth of the phallus, i.e., of castration. The truth of the purloined letter is the truth itself, its meaning is meaning, its law is law, the contract of truth with itself in the logos."[20]

That the reconsolidation of Sherman's images around the semantics of the wound acts contrary to their most radical and productive resources, which are themselves running in strong countercurrent to the constellation form/meaning, is to be seen in an operational understanding of her work. Which is to say that "abjection," in producing a thematics of essences and substances, is in the strongest contradiction with the idea of the *informe*.

In history as in nature, decay is the laboratory of life.
 Marx, as placed in an epigraph for "The 'Old Mole' and the Prefix *Sur*"[21]

4. What would it be, however, to think "abjection" apart from the objects of disgust – the filth, the rot, the vermin, the corpses – that Bataille himself enumerates, after all, in his own treatment of the subject? Well, as Bataille also shows us, it would be a matter of thinking the concept operationally, as a process of "alteration," in which there are no essentialized or fixed terms, but only energies within a force field, energies that, for example, operate on the very words that mark the poles of that field in such a way as to make them incapable of holding fast the terms of any opposition. So that just as the word *sacer* already undermines the place of the sacred, by revealing the damned within the very term for the holy, the designation for that part of the social field that has sunk into abjection – the word *misérables* – had started off as a term of pity ("the wretched") but then, caught up in a rage of revulsion, became a curse ("wretches!").[22]

Bataille is interested in this splitting apart of meaning from within, since as we know all acts of fission produce waste, the sun's very brightness, for example, piling up an unassimilable, excremental slag. And it is the inevitable waste of the meaning-system, the stuff that is no longer recyclable by the great processes of assimilation, whether these be intellectual – as in science or philosophy – or social – as in the operations of the State – that Bataille wants to explore by means of his own procedure, which he names "theoretical heterology." The meaning-systems, he argues, are devoted to the rationalization of social or conceptual space, to the process of homogenization, in order to support the orderly fabrication, consumption, and conservation

of products. "But the intellectual process automatically limits itself," he says, "by producing of its own accord its own waste products, thus liberating in a disordered way the heterogeneous excremental element. Heterology is restricted to taking up again, consciously and resolutely, this terminal process which up until now has been seen as the abortion and the shame of human thought."[23]

In describing the heterogeneous product as "excremental," Bataille leads us to imagine that heterology will concentrate – as one of its related terms, *scatology*, would indicate – on what is untouchably low. And yet Bataille will also point out that if the lowest parts of society have become untouchable (abject) through wretchedness, the very summit of that same society is also separated out as untouchable, as kings and popes are precipitated out of the top of the homogeneous structure to form that very exception of which the rule is the product, but from which the sovereign himself is exempt. Sovereignty and the sacred are thus also the unassimilable forms of heterogeneity that the homogeneous forces of lawlike equivalence and representation must create.

It is precisely in the way that these two ends of the spectrum can be brought around to meet each other in a circle that short-circuits the system of rules and regulated oppositions that Bataille sees heterology producing the scandal of thought. At certain times he maps this in the psychosexual domain as a paradoxical notion of castration that is just the opposite of a loss of manliness, since, as the mark of the child's challenge to the heights of the father's power, it becomes the very emblem – in all its bloody lowness – of virility. At other times he constructs this as a politics of the *Lumpen*, which is to say a thought about the consequences of homogeneous society's having forcibly excluded a mass of the population from the processes of representation to the point where it can no longer think itself as a class. Indeed the *Lumpenproletariat*, which Marx identifies in *The Eighteenth Brumaire of Louis Bonaparte* as "the scum, offal, refuse of all classes," is what falls outside the dialectical opposition between the high of the bourgeoisie and low of the proletariat:

> Alongside decayed *roués* with dubious means of subsistence and dubious origin, alongside ruined and reckless cast-offs of the *bourgeoisie*, were vagabonds, discharged soldiers, discharged jailbirds, escaped galley-slaves, swindlers, impostors, *lazzaroni*, pickpockets, bamboozlers, gamblers, *maquereaux*, brothel keepers, porters, literary hacks, organ-grinders, rag-pickers, knife-grinders, tinkers, beggars – in short the whole amorphous disintegrated mass of flotsam and jetsam the French call *la bohème*.[24]

For Marx, the scandal of Louis Bonaparte, surrounded by this trash, was the emergence of something lower-than-low, that represented *nothing*, going to the top. But Bataille saw something powerful emerging from this scandal of the nonrepresentational. As Denis Hollier has written:

> The shift of Bataille's writing in the direction of politics is itself a heterological gesture. But it is heterological only on condition that it follow the subversive route (the old

mole's route), that is, on condition that it be addressed to a proletariat defined by its total and unopposed exclusion (its "abjection") from the balanced system of social exchange. The proletariat, therefore, would be expelled yet, just the same, still not constitute a general equivalent or represent the society that does the expelling. It is to the *Lumpenproletariat*, the nonrepresentative waste product, that Bataille's political texts refer. The shift toward a political ground is useless as a transgression of the rules of literary activity unless it is backed up with political scatology.[25]

When, as in the "Abjection" essay, Bataille brings the political and the psychosexual together, it is to demonstrate the scandal of the identification between the two heterological, untouchable elements: the very high and the lower-than-low. It is to describe, that is, the collapse into a single couplet of anality and sadism, as the sovereign assumes his role as sacrificial and thus projects himself into the place of the victim, so that what is at the top (within the structure of the anal-sadistic) is the lower-than-low.

> I think [people] see the manufactured object, by virtue of its "untouched" quality, as a perfect object. And as it is the model for the craft object – rather than something that predated it – all craft objects become failures in respect to it. I'm interested in objects that try to play up that schism – between the idealized notion behind the object and the failure of the object to attain that.
>
> Mike Kelley[26]

5. If Mike Kelley has been embraced as the key example of "abjection" as a mode of artistic practice, his work has not been placed in relation to Bataille,[27] except to locate Kelley as "excremental artist" in tandem with what André Breton had sneeringly labeled Bataille by calling him "excremental philosopher."[28] When it *is* evoked, the scatological is simply traced in the work's preoccupation with excrement both as bodily waste and as the traces of infantile use that stain the stuffed toy animals that make up a major part of Kelley's "production" since 1987. And both of these cast scatology in the familiar terms of "abject art," as gender (the handmade toy a manifestation of woman's work) and degradation (the body's substances as filth) are joined in what is seen as an art of failure, an aesthetic of the low.

But Kelley himself has said, "I have a problem with the terms 'high and low.'" The term "low," he explains, seems to refer to an absolute, rather than a process; and so he prefers to invoke the concept of repression.[29]

That Kelley's notions of repression, and of the challenge to repressive forces through the structural operations of the lower-than-low, not only coincide with Bataille's but directly invoke them is to be found in various places in his work. Besides the inclusion of Bataille's portrait in the cycle of *Pay for Your Pleasure*, an obvious index of this is Kelley's work *Monkey Island* (1982–3) – particularly its poster *Ass Insect*, in which symmetrically linked monkey profiles generate the image of leering eyes from the animals' paired anuses, in a direct allusion to the role of the monkey in the whole series of "Pineal Eye" texts, as well as "La Jésuve."[30]

But as Hollier has insisted, Bataille's discussion of the monkey's roseate anus, blooming in the midst of its black backside and displacing interest from the face downward, is not conducted in the service of the obscene *thing*, but in the interests of the "jésuvian" process, in some places described as the castration complex, in others, that of Icarus's challenge to the sun, a process of a movement upward as a defiance of the top that, in its very ridiculousness, becomes powerfully attractive, attractive *because* repellent, high because lower-than-low.[31] And in still other places, we remember, Bataille's discussion turns to the forces of exclusion in the field of the social and takes the path of Marx's old mole, which, Bataille says, "begins in the bowels of the earth, as in the materialist bowels of proletarians."[32]

So it is not surprising that Kelley should have done a work called *Lumpenprol* (1991), which with its slightly smaller version, *Riddle of the Sphinx* (1992) [see plate 16], stages the jésuvian process, and does so precisely because the "low" occurs here not as a substance (excrement) or as a theme (abjection understood as gender and degradation),[33] but as the functional factor in an operation.[34] To secure its condition as function, the "lumps" in these two works are generalized as invasive conditions, erupting within the horizontal field of the work.

Since that field itself is an afghan, spread rug-like on the floor, it seems to begin by fixing the pole of lowness within a stable opposition of high/low, and thus operating as a positional absolute. But beneath it is the lower-than-low, which, though we can imagine these obscure lumps to be anything we want – the stuffed animals of the works called *Arena*, for instance, in which these dirty, handcrafted toys sit on crocheted blankets like so many soiled underbellies of elite culture; or to use the German word for turd, the *lumpf*-like objects that appear in some of Kelley's drawings – owe their capacity for subversion in Bataille's sense, which is to say the operation of transgression from beneath, to their very indeterminacy. It is this indeterminacy that is both *productive* and a *result* of their being *below* the surface, not part of a visible space, but jettisoned into the heterological position of nonlogical difference.

Thus if abjection is to be invoked in relation to Kelley, it must be done (as is the case with Sherman) in a far more operational way than is currently available within the discourse of the art world, with its insistence on themes and substances.[35] And no one makes this clearer than Kelley himself, as, for instance, in the work called *Craft Morphology Flow Chart* (1991), in which sixty found, handmade stuffed animals are laid out on thirty-two tables in an arrangement reminiscent of the one evoked by Foucault in the preface to *Les mots et les choses*: some are grouped according to pattern (stripes), some according to texture (loops), some according to size, others according to no perceptible similarity at all, still others – becoming a category of the "unique" – into a grouping of one. And to reinforce the crazed taxonomic drift of this process of organization, each doll is photographed separately lying next to a ruler, thereby producing it as an "individual" within a statistical set that is being established by means of measurement in order – as in some kind of weird riff on physical anthropology – to produce a norm.

All the operations of statistics – from intelligence tests, to police activities such as fingerprinting, to medical record keeping, to political census taking – form the

Figure 31.1 Mike Kelley, *Craft Morphology Flow Chart*, 1991. Courtesy of the artist and Metro Pictures.

conditions of social control that Foucault would call "discipline" and Bataille would identify with the words "assimilation" and "homogeneity." But where there would be a divergence between Bataille and Foucault would be in relation to the results of this process, which Foucault links to the very constitution of the "individual" within societies of control. Because for Foucault this individual is wrought, shaped, by the forces of normalization, of which statistics is the procedural tool. Whereas for Bataille things are slightly more complicated, given the fact that assimilation cannot work without producing its own waste, and thus opening up the very category of the "normal" from within.

How this might occur is sketched in the few paragraphs that compose Bataille's essay "The Deviations of Nature," in which he produces an actual demonstration of statistical averaging in the field of the visual. Beginning by a reference to freaks, nature's own "inversion" or negation of the processes of homogeneity within species – "deviations," as he says, "for which nature is incontestably responsible" – Bataille turns to the phenomenon of the composite photographs produced in the late nineteenth century by Francis Galton. Here superimpositions of normal examples – twenty ordinary faces, say, or, in another example used by Galton, a series of heads portrayed on Roman coins – can yield a single, perfected shape, an averaging that can end up, as Bataille points out, with the Hermes of Praxiteles: "If one photographs a large number of similarly sized but differently shaped pebbles, it is impossible to obtain anything other than a sphere: in other words, a geometric figure. It is enough

to note that a common measure necessarily approaches the regularity of geometric figures." Lowering classicism's Platonic ideal in this way to the "norm," and placing "beauty at the mercy" of the *mesure commun*," Bataille makes his next, scatological move. If the making of the average produces the "ideal," it must also generate its own waste, and that over the very field of the formerly homogeneous. For "each individual form escapes this common measure and is, to a certain degree, a monster." The inevitable production of the monstrous, or the heterogeneous, by the very same process that is constructed to exclude the nongeneralizable, this is the force that creates nonlogical difference out of the categories that are constructed to manage difference logically.[36]

The other word to which Bataille turned to evoke this process of "deviance" was *informe*, a *déclassement* in all senses of the term: in the separations between space and time (pulse); in the systems of spatial mapping (horizontalization, the production of the lower-than-low); in the qualifications of matter (base materialism); in the structural order of systems (entropy). As this entire project has worked to demonstrate, these processes marked out by the *informe* are not assimilable to what the world of art currently understands as *abjection*. And further, it is our position that the *informe* has its own legacy to fulfill, its own destiny – which is partly that of liberating our thinking from the semantic, the servitude to thematics to which abject art seems so relentlessly indentured. The present project is only one chapter in that continuation.

Notes

1 This project was initiated by Claude Gintz for the Musée d'Art Moderne de la Ville de Paris.
2 See "Exhibitions," *Artforum* 34 (December 1995), pp. 62–3.
3 The longstanding concern with "abjection" in the American context begins with a Whitney Museum exhibition in 1992 called "Dirt and Domesticity: Constructions of the Feminine," followed by another one year later, called "Abject Art: Repulsion and Desire in American Art."
4 Denis Hollier, *Le Collège de Sociologie* (Paris: Gallimard, 1995), p. 122.
5 Georges Bataille, *Oeuvres complètes*, vol. 2 (Paris: Gallimard, 1970), pp. 217–21 (hereafter cited as *OC*).
6 See Georges Bataille, "The Use Value of D.A.F. de Sade," in *Visions of Excess*, trans. Allan Stoekl (Minneapolis: University of Minnesota Press, 1985).
7 Bataille, *OC*, vol. 2, pp. 307–48; and *The College of Sociology: 1937–1939*, ed. Hollier, trans. Betsy Wing (Minneapolis: University of Minnesota Press, 1988), pp. 103–24.
8 Kristeva, *The Powers of Horror*, trans. Leon S. Roudiez (New York: Columbia University Press, 1982).
9 Mary Douglas, *Purity and Danger: An Analysis of the Concepts of Pollution and Taboo* (New York: Routledge, 1966).
10 Jean-Paul Sartre, *Being and Nothingness*, trans. Hazel E. Barnes (New York: Washington Square Press, 1956), pp. 774, 776.
11 Ibid., p. 777.

12 "Slime is the revenge of the In-itself. A sickly-sweet, feminine revenge which will be symbolized on another level by the quality 'sugary'" (ibid.).

13 Ibid., p. 769.

14 Laura Mulvey, "A Phantasmagoria of the Female Body: The World of Cindy Sherman," *New Left Review* 188 (July/August 1991).

15 Ibid., p. 146.

16 Ibid., p. 148.

17 Ibid.

18 This discussion of the work on the signifier and the operations against form is elaborated in my *Cindy Sherman: 1975–1993* (New York: Rizzoli, 1993), passim.

19 Jacques Lacan, *The Four Fundamental Concepts of Psychoanalysis*, trans. Alan Sheridan (New York: Norton, 1977), p. 96.

20 Jacques Derrida, *The Postcard*, trans. Alan Bass (Chicago: University of Chicago Press, 1987), p. 439.

21 *OC*, vol. 2, p. 91.

22 Bataille, "L'abjection," in ibid., p. 218.

23 Bataille, *Visions of Excess*, p. 97.

24 *Der achtzehnte Brumaire des Louis Bonaparte* in *Werke*, vol. 8 (Berlin: Dietz Verlag, 1960), p. 161; as cited in Jeffrey Mehlman, *Revolution and Repetition* (Berkeley: University of California Press, 1977), p. 13.

25 Denis Hollier, *Against Architecture*, trans. Betsy Wing (Cambridge: MIT Press, 1989), p. 125.

26 Mike Kelley and Julie Sylvester, "Talking Failure," *Parkett* 31 (1992), p. 100.

27 The exception is Pam Lee's excellent essay, "Mike Kelley's Name Dropping," submitted as a seminar paper to Yve-Alain Bois, Harvard University, 1993.

28 Laurie Palmer, "Review: Mike Kelley," *Artforum* (September 1988).

29 Kelley and Sylvester, "Talking Failure," p. 103.

30 Lee, "Mike Kelley's Name Dropping," p. 5.

31 This structure is discussed in Hollier, *Against Architecture*, in the section on "The Pineal Eye," pp. 115–29; see also Hollier, "Auteur de livres que Bataille n'a pas écrit," *La Part de l'oeil*, no. 10 (1994).

32 Bataille, *Visions of Excess*, p. 35.

33 This is the burden of Elizabeth Sussman's introductory essay in *Mike Kelley: Catholic Tastes* (New York: Whitney Museum of American Art, 1993), pp. 27–9.

34 Hal Foster first pointed out to me the consistency of the connection Kelley's work makes between the political and scatological dimensions of the "lump." See his discussion in "Obscene, Abject, Traumatic" (in this issue), where he characterizes Kelley's use of *lumpen* as "a third term between the *informe* (of Bataille) and the abject (of Kristeva)."

35 The exception here is Hal Foster, who has mapped so-called abject art (but this of course includes Sherman and Kelley) far more complexly and operationally than any account to date, in *The Return of the Real* (Cambridge: MIT Press, 1996).

36 See Georges Didi-Hubermann, *La ressemblance informe ou le savoir visuel selon Georges Bataille* (Paris: Macula, 1995), pp. 280–5, 297, for a very different reading of Bataille's use of the Galton example, one in which Bataille is not understood as seeing the statistical process as dogged by its own negation, as an unconscious but productive countercurrent, but rather needing its negation to come from another practice entirely, here Eisenstein's procedures of *montage*.

32 The Database

Lev Manovich

The Database Logic

After the novel, and subsequently cinema, privileged narrative as the key form of cultural expression of the modern age, the computer age introduces its correlate – the database. Many new media objects do not tell stories; they do not have a beginning or end; in fact, they do not have any development, thematically, formally, or otherwise that would organize their elements into a sequence. Instead, they are collections of individual items, with every item possessing the same significance as any other.

Why does new media favor the database form over others? Can we explain its popularity by analyzing the specificity of the digital medium and of computer programming? What is the relationship between the database and another form that has traditionally dominated human culture – narrative? These are the questions I will address in this section.

Before proceeding, I need to comment on my use of the word *database*. In computer science, *database* is defined as a structured collection of data. The data stored in a database is organized for fast search and retrieval by a computer and therefore, it is anything but a simple collection of items. Different types of databases – hierarchical, network, relational, and object-oriented – use different models to organize data. For

From *The Language of New Media* (Cambridge, Mass.: MIT Press, 2001), pp. 218–43. Reproduced with permission of MIT Press.

instance, the records in hierarchical databases are organized in a treelike structure. Object-oriented databases store complex data structures, called "objects," which are organized into hierarchical classes that may inherit properties from classes higher in the chain.[1] New media objects may or may not employ these highly structured database models; however, from the point of view of the user's experience, a large proportion of them are databases in a more basic sense. They appear as collections of items on which the user can perform various operations – view, navigate, search. The user's experience of such computerized collections is, therefore, quite distinct from reading a narrative or watching a film or navigating an architectural site. Similarly, a literary or cinematic narrative, an architectural plan, and a database each present a different model of what a world is like. It is this sense of database as a cultural form of its own that I want to address here. Following art historian Ervin Panofsky's analysis of linear perspective as a "symbolic form" of the modern age, we may even call database a new symbolic form of the computer age (or, as philosopher Jean-François Lyotard called it in his famous 1979 book *The Postmodern Condition*, "computerized society"),[2] a new way to structure our experience of ourselves and of the world. Indeed, if after the death of God (Nietzsche), the end of grand Narratives of Enlightenment (Lyotard), and the arrival of the Web (Tim Berners-Lee), the world appears to us as an endless and unstructured collection of images, texts, and other data records, it is only appropriate that we will be moved to model it as a database. But it is also appropriate that we would want to develop a poetics, aesthetics, and ethics of this database.

Let us begin by documenting the dominance of the database form in new media. The most obvious examples are popular multimedia encyclopedias, collections by definition, as well as other commercial CD-ROM (or DVD), that feature collections of recipes, quotations, photographs, and so on.[3] The identity of a CD-ROM as a storage medium is projected onto another plane, thereby becoming a cultural form in its own right. Multimedia works that have "cultural" content appear to particularly favor the database form. Consider, for instance, the "virtual museums" genre – CD-ROMs that take the user on a tour through a museum collection. A museum becomes a database of images representing its holdings, which can be accessed in different ways – chronologically, by country, or by artist. Although such CD-ROMs often simulate the traditional museum experience of moving from room to room in a continuous trajectory, this narrative method of access does not have any special status in comparison to other access methods offered by CD-ROMs. Thus narrative becomes just one method of accessing data among many. Another example of a database form is a multimedia genre that does not have an equivalent in traditional media – CD-ROMs devoted to a single cultural figure such as a famous architect, film director, or writer. Instead of a narrative biography, we are presented with a database of images, sound recordings, video clips, and/or texts that can be navigated in a variety of ways.

CD-ROMs and other digital storage media proved to be particularly receptive to traditional genres that already had a database-like structure, such as the photo album;

they also inspired new database genres, like the database biography. Where the database form really flourished, however, is the Internet. As defined by original HTML, a Web page is a sequential list of separate elements – text blocks, images, digital video clips, and links to other pages. It is always possible to add a new element to the list – all you have to do is to open a file and add a new line. As a result, most Web pages are collections of separate elements – texts, images, links to other pages, or sites. A home page is a collection of personal photographs. A site of a major search engine is a collection of numerous links to other sites (along with a search function, of course). A site of a Web-based TV or radio station offers a collection of video or audio programs along with the option to listen to the current broadcast, but this current program is just one choice among many other programs stored on the site. Thus the traditional broadcasting experience, which consists solely of a real-time transmission, becomes just one element in a collection of options. Similar to the CD-ROM medium, the Web offered fertile ground to already existing database genres (for instance, bibliography) and also inspired the creation of new ones such as sites devoted to a person or a phenomenon (Madonna, the Civil War, new media theory, etc.) that, even if they contain original material, inevitably center around a list of links to other Web pages on the same person or phenomenon.

The open nature of the Web as a medium (Web pages are computer files that can always be edited) means that Web sites never have to be complete; and they rarely are. They always grow. New links are continually added to what is already there. It is as easy to add new elements to the end of a list as it is to insert them anywhere in it. All this further contributes to the anti-narrative logic of the Web. If new elements are being added over time, the result is a collection, not a story. Indeed, how can one keep a coherent narrative or any other development trajectory through the material if it keeps changing?

Commercial producers have experimented with ways to explore the database form inherent to new media, with offerings ranging from multimedia encyclopedias to collections of software and collections of pornographic images. In contrast, many artists working with new media at first uncritically accepted the database form as a given. Thus they became blind victims of database logic. Numerous artists' Web sites are collections of multimedia elements documenting their works in other media. In the case of many early artists' CD-ROMs as well, the tendency was to fill all the available storage space with different material – the main work, documentation, related texts, previous works, and so on.

As the 1990s progressed, artists increasingly began to approach the database more critically.[4] A few examples of projects investigating database politics and possible aesthetics are Chris Marker's "IMMEMORY," Olga Lialina's "Anna Karenina Goes to Paradise,"[5] Stephen Mamber's "Digital Hitchcock," and Fabian Wagmister's ". . . two, three, many Guevaras." The artist who has explored the possibilities of a database most systematically is George Legrady. In a series of interactive multimedia works ("The Anecdoted Archive," 1994; "[the clearing]," 1994; "Slippery Traces," 1996; "Tracing," 1998) he used different types of databases to create "an information structure where stories/things are organized according to multiple thematic connections."[6]

Data and Algorithm

Of course, not all new media objects are explicitly databases. Computer games, for instance, are experienced by their players as narratives. In a game, the player is given a well-defined task – winning the match, being first in a race, reaching the last level, or attaining the highest score. It is this task that makes the player experience the game as a narrative. Everything that happens to her in a game, all the characters and objects she encounters, either take her closer to achieving the goal or further away from it. Thus, in contrast to a CD-ROM and Web database, which always appear arbitrary because the user knows additional material could have been added without modifying the logic, in a game, from the user's point of view, all the elements are motivated (i.e., their presence is justified).[7]

Often the narrative shell of a game ("You are the specially trained commando who has just landed on a lunar base; your task is to make your way to the headquarters occupied by the mutant base personnel . . .") masks a simple algorithm well-familiar to the player – kill all the enemies on the current level, while collecting all the treasures it contains; go to the next level and so on until you reach the last level. Other games have different algorithms. Here is the algorithm of the legendary *Tetris*: When a new block appears, rotate it in such a way so that it will complete the top layer of blocks on the bottom of the screen, thus making this layer disappear. The similarity between the actions expected of the player and computer algorithms is too uncanny to be dismissed. While computer games do not follow a database logic, they appear to be ruled by another logic – that of the algorithm. They demand that a player execute an algorithm in order to win.

An algorithm is the key to the game experience in a different sense as well. As the player proceeds through the game, she gradually discovers the rules that operate in the universe constructed by this game. She learns its hidden logic – in short, its algorithm. Therefore, in games in which the game play departs from following an algorithm, the player is still engaged with an algorithm albeit in another way: She is discovering the algorithm of the game itself. I mean this both metaphorically and literally: For instance, in a first-person shooter such as *Quake* the player may eventually notice that, under such and such conditions, the enemies will appear from the left; that is, she will literally reconstruct a part of the algorithm responsible for the game play. Or, in a different formulation of the legendary author of Sim games, Will Wright, "playing the game is a continuous loop between the user (viewing the outcomes and inputting decisions) and the computer (calculating outcomes and displaying them back to the user). The user is trying to build a mental model of the computer model."[8]

This is another example of the general principle of transcoding discussed in the first chapter – the projection of the ontology of a computer onto culture itself. If in physics the world is made of atoms and in genetics it is made of genes, computer programming encapsulates the world according to its own logic. The world is reduced to two kinds of software objects that are complementary to each other – data structures

and algorithms. Any process or task is reduced to an algorithm, a final sequence of simple operations that a computer can execute to accomplish a given task. And any object in the world – be it the population of a city, or the weather over the course of a century, or a chair, or a human brain – is modeled as a data structure, that is, data organized in a particular way for efficient search and retrieval.[9] Examples of data structures are arrays, linked lists, and graphs. Algorithms and data structures have a symbiotic relationship. The more complex the data structure of a computer program, the simpler the algorithm needs to be, and vice versa. Together, data structures and algorithms are two halves of the ontology of the world according to a computer.

The computerization of culture involves the projection of these two fundamental parts of computer software – and of the computer's unique ontology – onto the cultural sphere. If CD-ROMs and Web databases are cultural manifestations of one half of this ontology – data structures – then computer games are manifestations of the second half – algorithms. Games (sports, chess, cards, etc.) are one cultural form that require algorithm-like behavior from players; consequently, many traditional games were quickly simulated on computers. In parallel, new genres of computer games such as the first-person shooter came into existence. Thus, as was the case with database genres, computer games both mimic already existing games and create new game genres.

It may appear at first sight that data is passive and algorithms active – another example of the passive-active binary categories so loved by human cultures. A program reads in data, executes an algorithm, and writes out new data. We may recall that before "computer science" and "software engineering" became established names in the computer field, this was called "data processing" – a name which remained in use for the few decades during which computers were mainly associated with performing calculations over data. However, the passive/active distinction is not quite accurate because data does not just exist – it has to be generated. Data creators have to collect data and organize it, or create it from scratch. Texts need to be written, photographs need to be taken, video and audio material need to be recorded. Or they need to be digitized from already existing media. In the 1990s, when the new role of the computer as a Universal Media Machine became apparent, already computerized societies went into a digitizing craze. All existing books and videotapes, photographs, and audio recordings started to be fed into computers at an ever-increasing rate. Steven Spielberg created the Shoah Foundation, which videotaped and then digitized numerous interviews with Holocaust survivors; it would take one person forty years to watch all the recorded material. The editors of the journal *Mediamatic*, who devoted a whole issue to the topic of "the storage mania" (Summer 1994), wrote: "A growing number of organizations are embarking on ambitious projects. Everything is being collected: culture, asteroids, DNA patterns, credit records, telephone conversations; it doesn't matter."[10] In 1996, the financial company T. Rowe Price stored eight hundred gigabytes of data; by the fall of 1999 this number rose to ten terabytes.[11]

Once digitized, the data has to be cleaned up, organized, and indexed. The computer age brought with it a new cultural algorithm: reality→media→data→database. The rise of the Web, this gigantic and always changing data corpus, gave millions of

people a new hobby or profession – data indexing. There is hardly a Web site that does not feature at least a dozen links to other sites; therefore, every site is a type of database. And, with the rise of Internet commerce, most large-scale commercial sites have become real databases, or rather front-ends to company databases. For instance, in the fall of 1998, Amazon.com, an online bookstore, had three million books in its database; and the maker of the leading commercial database *Oracle* has offered *Oracle 8i*, fully integrated with the Internet and featuring unlimited database size, natural-language queries, and support for all multimedia data types.[12] Jorge Luis Borges's story about a map equal in size to the territory it represents is rewritten as a story about indexes and the data they index. But now the map has become larger than the territory. Sometimes, much larger. Porno Web sites exposed the logic of the Web at its extreme by constantly reusing the same photographs from other porno Web sites. Only rare sites featured the original content. On any given date, the same few dozen images would appear on thousands of sites. Thus, the same data would give rise to more indexes than the number of data elements themselves.

Database and Narrative

As a cultural form, the database represents the world as a list of items, and it refuses to order this list. In contrast, a narrative creates a cause-and-effect trajectory of seemingly unordered items (events). Therefore, database and narrative are natural enemies. Competing for the same territory of human culture, each claims an exclusive right to make meaning out of the world.

In contrast to most games, most narratives do not require algorithm-like behavior from their readers. However, narratives and games are similar in that the user must uncover their underlying logic while proceeding through them – their algorithm. Just like the game player, the reader of a novel gradually reconstructs the algorithm (here I use the term metaphorically) that the writer used to create the settings, the characters, and the events. From this perspective, I can rewrite my earlier equations between the two parts of the computer's ontology and its corresponding cultural forms. Data structures and algorithms drive different forms of computer culture. CD-ROMs, Web sites, and other new media objects organized as databases correspond to the data structure, whereas narratives, including computer games, correspond to algorithm.

In computer programming, data structures and algorithms need each other; they are equally important for a program to work. What happens in the cultural sphere? Do databases and narratives have the same status in computer culture?

Some media objects explicitly follow a database logic in their structure whereas others do not; but under the surface, practically all of them are databases. In general, creating a work in new media can be understood as the construction of an interface to a database. In the simplest case, the interface simply provides access to the underlying database. For instance, an image database can be represented as a page of miniature images; clicking on a miniature will retrieve the corresponding record. If a database is too large to display all of its records at once, a search engine can be

provided to allow the user to search for particular records. But the interface can also translate the underlying database into a very different user experience. The user may be navigating a virtual three-dimensional city composed from letters, as in Jeffrey Shaw's interactive installation "Legible City."[13] Or she may be traversing a black-and-white image of a naked body, activating pieces of text, audio, and video embedded in its skin (Harwood's CD-ROM "Rehearsal of Memory").[14] Or she may be playing with virtual animals that come closer or run away depending upon her movements (Scott Fisher et al., VR installation "Menagerie").[15] Although each of these works engages the user in a set of behaviors and cognitive activities that are quite distinct from going through the records of a database, all of them are databases. "Legible City" is a database of three-dimensional letters that make up a city. "Rehearsal of Memory" is a database of texts and audio and video clips that are accessed through the interface of a body. And "Menagerie" is a database of virtual animals, including their shapes, movements, and behaviors.

The database becomes the center of the creative process in the computer age. Historically, the artist made a unique work within a particular medium. Therefore the interface and the work were the same; in other words, the level of an interface did not exist. With new media, the content of the work and the interface are separated. It is therefore possible to create different interfaces to the same material. These interfaces may present different versions of the same work, as in David Blair's *WaxWeb*.[16] Or they may be radically different from each other, as in Olga Lialina's *Last Real Net Art Museum*.[17] This is one of the ways in which the principle of *variability* of new media manifests itself. But now we can give this principle a new formulation. *The new media object consists of one or more interfaces to a database of multimedia material.* If only one interface is constructed, the result will be similar to a traditional art object, but this is an exception rather than the norm.

This formulation places the opposition between database and narrative in a new light, thus redefining our concept of narrative. The "user" of a narrative is traversing a database, following links between its records as established by the database's creator. An interactive narrative (which can be also called a *hypernarrative* in an analogy with hypertext) can then be understood as the sum of multiple trajectories through a database. A traditional linear narrative is one among many other possible trajectories, that is, a particular choice made within a hypernarrative. Just as a traditional cultural object can now be seen as a particular case of a new media object (i.e., a new media object that has only one interface), traditional linear narrative can be seen as a particular case of hypernarrative.

This "technical," or "material," change in the definition of narrative does not mean that an arbitrary sequence of database records is a narrative. To qualify as a narrative, a cultural object has to satisfy a number of criteria, which literary theorist Mieke Bal defines as follows: It should contain both an actor and a narrator; it also should contain three distinct levels consisting of the text, the story, and the fabula; and its "contents" should be "a series of connected events caused or experienced by actors."[18] Obviously, not all cultural objects are narratives. However, in the world of new media, the word *narrative* is often used as an all-inclusive term, to cover up the fact

that we have not yet developed a language to describe these new strange objects. It is usually paired with another overused word – *interactive*. Thus a number of database records linked together so that more than one trajectory is possible is assumed to constitute an "interactive narrative." But merely to create these trajectories is of course not sufficient; the author also has to control the semantics of the elements and the logic of their connection so that the resulting object will meet the criteria of narrative as outlined above. Another erroneous assumption frequently made is that, by creating her own path (i.e., choosing the records from a database in a particular order), the user constructs her own unique narrative. However, if the user simply accesses different elements, one after another, in a usually random order, there is no reason to assume that these elements will form a narrative at all. Indeed, why should an arbitrary sequence of database records, constructed by the user, result in "a series of connected events caused or experienced by actors"?

In summary, database and narrative do not have the same status in computer culture. In the database/narrative pair, database is the unmarked term.[19] Regardless of whether new media objects present themselves as linear narratives, interactive narratives, databases, or something else, underneath, on the level of material organization, they are all databases. In new media, the database supports a variety of cultural forms that range from direct translation (i.e., a database stays a database) to a form whose logic is the opposite of the logic of the material form itself – narrative. More precisely, a database can support narrative, but there is nothing in the logic of the medium itself that would foster its generation. It is not surprising, then, that databases occupy a significant, if not the largest, territory of the new media landscape. What is more surprising is why the other end of the spectrum – narratives – still exist in new media.

Paradigm and Syntagm

The dynamics that exist between database and narrative are not unique in new media. The relation between the structure of a digital image and the languages of contemporary visual culture is characterized by the same dynamics. As defined by all computer software, a digital image consists of a number of separate layers, each layer containing particular visual elements. Throughout the production process, artists and designers manipulate each layer separately; they also delete layers and add new ones. Keeping each element as a separate layer allows the content and the composition of an image to be changed at any point – deleting a background, substituting one person for another, moving two people closer together, blurring an object, and so on. What would a typical image look like if the layers were merged together? The elements contained on different layers would become juxtaposed, resulting in a montage look. Montage is the default visual language of composite organization of an image. However, just as database supports both the database form and its opposite – narrative – a composite organization of an image on the material level

(and compositing software on the level of operations) supports two opposing visual languages. One is modernist-MTV montage – two-dimensional juxtaposition of visual elements designed to shock due to its impossibility in reality. The other is the representation of familiar reality as seen by a film camera (or its computer simulation, in the case of 3-D graphics). During the 1980s and 1990s, all image-making technologies became computer-based, thus turning all images into composites. In parallel, a renaissance of montage took place in visual culture, in print, broadcast design, and new media. This is not unexpected – after all, this is the visual language dictated by the composite organization. What needs to be explained is why photorealist images continue to occupy such a significant space in our computer-based visual culture.

It would be surprising, of course, if photorealist images suddenly disappeared completely. The history of culture does not contain such sudden breaks. Similarly, we should not expect that new media would completely replace narrative with database. New media does not radically break with the past; rather, it distributes weight differently between the categories that hold culture together, foregrounding what was in the background, and vice versa. As Frederic Jameson writes in his analysis of another shift, that from modernism to postmodernism: "Radical breaks between periods do not generally involve complete changes but rather the restructuration of a certain number of elements already given: features that in an earlier period of system were subordinate become dominant, and features that had been dominant again become secondary."[20]

The database/narrative opposition is a case in point. To further understand how computer culture redistributes weight between the two terms of opposition in computer culture, I will bring in the semiological theory of syntagm and paradigm. According to this model, originally formulated by Ferdinand de Saussure to describe natural languages such as English and later expanded by Roland Barthes and others to apply to other sign systems (narrative, fashion, food, etc.), the elements of a system can be related in two dimensions – the syntagmatic and paradigmatic. As defined by Barthes, "The syntagm is a combination of signs, which has space as a support."[21] To use the example of natural language, the speaker produces an utterance by stringing together elements, one after another, in a linear sequence. This is the syntagmatic dimension. Now let us look at the paradigmatic dimension. To continue with the example of the language user, each new element is chosen from a set of other related elements. For instance, all nouns form a set; all synonyms of a particular word form another set. In the original formulation of Saussure, "The units which have something in common are associated in theory and thus form groups within which various relationships can be found."[22] This is the paradigmatic dimension.

Elements in the syntagmatic dimension are related *in praesentia*, while elements in the paradigmatic dimension are related *in absentia*. For instance, in the case of a written sentence, the words that comprise it materially exist on a piece of paper, while the paradigmatic sets to which these words belong only exist in the writer's and reader's minds. Similarly, in the case of a fashion outfit, the elements that compose it, such as skirt, blouse, and jacket, are present in reality, while pieces of clothing that

could have been present instead – different skirt, different blouse, different jacket – exist only in the viewer's imagination. Thus, syntagm is explicit and paradigm is implicit; one is real and the other is imagined.

Literary and cinematic narratives work in the same way. Particular words, sentences, shots, and scenes that make up a narrative have a material existence; other elements that form the imaginary world of an author or a particular literary or cinematic style, and that could have appeared instead, exist only virtually. Put differently, the database of choices from which narrative is constructed (the paradigm) is implicit; while the actual narrative (the syntagm) is explicit.

New media reverse this relationship. Database (the paradigm) is given material existence, while narrative (the syntagm) is dematerialized. Paradigm is privileged, syntagm is downplayed. Paradigm is real; syntagm, virtual. To see this, consider the new media design process. The design of any new media object begins with assembling a database of possible elements to be used. (Macromedia Director calls this database "cast," Adobe Premiere calls it "project," ProTools calls it a "session," but the principle is the same.) This database is the center of the design process. It typically consists of a combination of original and stock material such as buttons, images, video and audio sequences, 3-D objects, behaviors, and so on. Throughout the design process, new elements are added to the database; existing elements are modified. The narrative is constructed by linking elements of this database in a particular order, that is by designing a trajectory leading from one element to another. On the material level, a narrative is just a set of links; the elements themselves remain stored in the database. Thus the narrative is virtual while the database exists materially.

The paradigm is privileged over syntagm in yet another way in interactive objects presenting the user with a number of choices at the same time – which is what typical interactive interfaces do. For instance, a screen may contain a few icons; clicking on each icon leads the user to a different screen. On the level of an individual screen, these choices form a paradigm of their own that is explicitly presented to the user. On the level of the whole object, the user is made aware that she is following one possible trajectory among many others. In other words, she is selecting one trajectory from the paradigm of all trajectories that are defined.

Other types of interactive interfaces make the paradigm even more explicit by presenting the user with an explicit menu of all available choices. In such interfaces, all of the categories are always available, just a mouse click away. The complete paradigm is present before the user, its elements neatly arranged in a menu. This is another example of how new media make explicit the psychological processes involved in cultural communication. Other examples include the (already discussed) shift from creation to selection, which externalizes and codifies the database of cultural elements existing in the creator's mind, as well as the very phenomena of interactive links. As I noted in chapter one, new media takes "interaction" literally, equating it with a strictly physical interaction between a user and a computer, at the expense of psychological interaction. The cognitive processes involved in understanding any cultural text are erroneously equated with an objectively existing structure of interactive links.

Interactive interfaces foreground the paradigmatic dimension and often make explicit paradigmatic sets. Yet they are still organized along the syntagmatic dimension. Although the user is making choices at each new screen, the end result is a linear sequence of screens that she follows. This is the classical syntagmatic experience. In fact, it can be compared to constructing a sentence in a natural language. Just as a language user constructs a sentence by choosing each successive word from a paradigm of other possible words, a new media user creates a sequence of screens by clicking on this or that icon at each screen. Obviously, there are many important differences between these two situations. For instance, in the case of a typical interactive interface, there is no grammar, and paradigms are much smaller. Yet the similarity of basic experience in both cases is quite interesting; in both cases, it unfolds along a syntagmatic dimension.

Why does new media insist on this language-like sequencing? My hypothesis is that they follow the dominant semiological order of the twentieth century – that of cinema. As I will discuss in more detail in the next chapter, cinema replaced all other modes of narration with a sequential narrative, an assembly line of shots that appear on the screen one at a time. For centuries, a spatialized narrative in which all images appear simultaneously dominated European visual culture; in the twentieth century it was relegated to "minor" cultural forms such as comics or technical illustrations. "Real" culture of the twentieth century came to speak in linear chains, aligning itself with the assembly line of the industrial society and the Turing machine of the postindustrial era. New media continue this mode, giving the user information one screen at a time. At least, this is the case when it tries to become "real" culture (interactive narratives, games); when it simply functions as an interface to information, it is not ashamed to present much more information on the screen at once, whether in the form of tables, normal or pull-down menus, or lists. In particular, the experience of a user filling in an online form can be compared to precinematic spatialized narrative: in both cases, the user follows a sequence of elements that are presented simultaneously.

A Database Complex

To what extent is the database form intrinsic to modern storage media? For instance, a typical music CD is a collection of individual tracks grouped together. The database impulse also drives much of photography throughout its history, from William Henry Fox Talbot's *Pencil of Nature* to August Sander's monumental typology of modern German society *Face of Our Time*, to Bernd and Hilla Becher's equally obsessive cataloging of water towers. Yet the connection between storage media and database forms is not universal. The prime exception is cinema. Here the storage media support the narrative imagination.[23] Why then, in the case of photography storage media, does technology sustain database, whereas in the case of cinema it

gives rise to a modern narrative form par excellence? Does this have to do with the method of media access? Shall we conclude that random-access media, such as computer storage formats (hard drives, removable disks, CD-ROMs, DVD), favor database, whereas sequential-access media, such as film, favor narrative? This does not hold either. For instance, a book, the perfect random-access medium, supports database forms such as photo albums as well as narrative forms such as novels.

Rather than trying to correlate database and narrative forms with modern media and information technologies, or deduce them from these technologies, I prefer to think of them as two competing imaginations, two basic creative impulses, two essential responses to the world. Both have existed long before modern media. The ancient Greeks produced long narratives, such as Homer's epic poems *The Iliad* and *The Odyssey*; they also produced encyclopedias. The first fragments of a Greek encyclopedia to have survived were the work of Speusippus, a nephew of Plato. Diderot wrote novels – and also was in charge of the monumental *Encyclopédie*, the largest publishing project of the eighteenth century. Competing to make meaning out of the world, database and narrative produce endless hybrids. It is hard to find a pure encyclopedia without any traces of a narrative in it and vice versa. For instance, until alphabetical organization became popular a few centuries ago, most encyclopedias were organized thematically, with topics covered in a particular order (typically, corresponding to the seven liberal arts). At the same time, many narratives, such as the novels by Cervantes and Swift, and even Homer's epic poems – the founding narratives of the Western tradition – traverse an imaginary encyclopedia.

Modern media is the new battlefield for the competition between database and narrative. It is tempting to read the history of this competition in dramatic terms. First, the medium of visual recording – photography – privileges catalogs, taxonomies, and lists. While the modern novel blossoms, and academicians continue to produce historical narrative paintings throughout the nineteenth century, in the realm of the new techno-image of photography, database rules. The next visual recording medium – film – privileges narrative. Almost all fictional films are narratives, with few exceptions. Magnetic tape used in video does not bring any substantial changes. Next, storage media – computer-controlled digital storage devices – privilege databases once again. Multimedia encyclopedias, virtual museums, pornography, artists' CD-ROMs, library databases, Web indexes, and, of course, the Web itself: The database is more popular than ever before.

The digital computer turns out to be the perfect medium for the database form. Like a virus, databases infect CD-ROMs and hard drives, servers and Web sites. Can we say that the database is the cultural form most characteristic of a computer? In her 1978 article "Video: The Aesthetics of Narcissism," probably the single most well-known article on video art, art historian Rosalind Krauss argued that video is not a physical medium but a psychological one. In her analysis, "Video's real medium is a psychological situation, the very terms of which are to withdraw attention from an external object – an Other – and invest it in the Self."[24] In short, video art is a support for the psychological condition of narcissism.[25] Does new media similarly function

to play out a particular psychological condition, something that might be called a "database complex"? In this respect, it is interesting that a database imagination has accompanied computer art from its very beginning. In the 1960s, artists working with computers wrote programs to systematically explore the combinations of different visual elements. In part, they were following art world trends such as minimalism. Minimalist artists executed works of art according to preexistent plans; they also created series of images or objects by systematically varying a single parameter. So when minimalist artist Sol LeWitt spoke of an artist's idea as "the machine which makes the work," it was only logical to substitute the human executing the idea with a computer.[26] At the same time, since the only way to make pictures with a computer was by writing a computer program, the logic of computer programming itself pushed computer artists in the same directions. Thus, for artist Frieder Nake, a computer was a "Universal Picture Generator," capable of producing every possible picture out of a combination of available picture elements and colors.[27] In 1967 he published a portfolio of twelve drawings that were obtained by successfully multiplying a square matrix by itself. Another early computer artist Manfred Mohr produced numerous images that recorded various transformations of a basic cube.

Even more remarkable were films by John Whitney, the pioneer of computer filmmaking. His films such as *Permutations* (1967), *Arabesque* (1975) and others systematically explored the transformations of geometric forms obtained by manipulating elementary mathematical functions. Thus they substituted successive accumulation of visual effects for narrative, figuration, or even formal development. Instead they presented the viewer with databases of effects. This principle reaches its extreme in Whitney's early film *Catalog*, which was made with an analog computer. In his important book on new forms of cinema of the 1960s entitled *Expanded Cinema* (1970), critic Gene Youngblood writes about this remarkable film: "The elder Whitney actually never produced a complete, coherent movie on the analog computer because he was continually developing and refining the machine while using it for commercial work. . . . However, Whitney did assemble a visual catalogue of the effects he had perfected over the years. This film, simply titled *Catalog*, was completed in 1961 and proved to be of such overwhelming beauty that many persons still prefer Whitney's analogue work over his digital computer films."[28] One is tempted to read *Catalog* as one of the founding moments of new media. As discussed in the "Selection" section, all software for media creation today arrives with endless "plug-ins" – the banks of effects that with a press of a button generate interesting images from any input whatsoever. In parallel, much of the aesthetics of computerized visual culture is effects-driven, especially when a new techno-genre (computer animation, multimedia, Web sites) is first becoming established. For instance, countless music videos are variations of Whitney's *Catalog* – the only difference is that the effects are applied to the images of human performers. This is yet another example of how the logic of a computer – in this case, the ability of a computer to produce endless variations of elements and to act as a filter, transforming its input to yield a new output – becomes the logic of culture at large.

Database Cinema: Greenaway and Vertov

Although the database form may be inherent to new media, countless attempts to create "interactive narratives" testify to our dissatisfaction with the computer in the sole role of encyclopedia or catalog of effects. We want new media narratives, and we want these narratives to be different from the narratives we have seen or read before. In fact, regardless of how often we repeat in public that the modernist notion of medium specificity ("every medium should develop its own unique language") is obsolete, we do expect computer narratives to showcase new aesthetic possibilities that did not exist before digital computers. In short, we want them to be new media specific. Given the dominance of the database in computer software and the key role it plays in the computer-based design process, perhaps we can arrive at new kinds of narrative by focusing our attention on how narrative and database can work together. How can a narrative take into account the fact that its elements are organized in a database? *How can our new abilities to store vast amounts of data, to automatically classify, index, link, search, and instantly retrieve it, lead to new kinds of narratives?*

Peter Greenaway, one of the few prominent film directors concerned with expanding cinema's language, once complained that "the linear pursuit – one story at a time told chronologically – is the standard format of cinema." Pointing out that cinema lags behind modern literature in experimenting with narrative, he asked: "Could it not travel on the road where Joyce, Eliot, Borges and Perec have already arrived?"[29] While Greenaway is right to direct filmmakers to more innovative literary narratives, new media artists working on the database-problem can learn from cinema "as it is." For cinema already exists right at the intersection between database and narrative. We can think of all the material accumulated during shooting as forming a database, especially since the shooting schedule usually does not follow the narrative of the film but is determined by production logistics. During editing, the editor constructs a film narrative out of this database, creating a unique trajectory through the conceptual space of all possible films that could have been constructed. From this perspective, every filmmaker engages with the database-narrative problem in every film, although only a few have done so self-consciously.

One exception is Greenaway himself. Throughout his career, he has been working on the problem of how to reconcile database and narrative forms. Many of his films progress by recounting a list of items, a catalog without any inherent order (for example, the different books in *Prospero's Books*). Working to undermine a linear narrative, Greenaway uses different systems to order his films. He wrote about this approach: "If a numerical, alphabetic color-coding system is employed, it is done deliberately as a device, a construct, to counteract, dilute, augment or complement the all-pervading obsessive cinema interest in plot, in narrative, in the 'I'm now going to tell you a story' school of film-making."[30] His favorite system is numbers. The sequence of numbers acts as a narrative shell that "convinces" the viewer that she is watching a narrative. In reality, the scenes that follow one another are not connected

in any logical way. By using numbers, Greenaway "wraps" a minimal narrative around a database. Although Greenaway's database logic was already present in his "avant-garde" films such as *The Falls* (1980), it has also structured his "commercial" films. The *Draughtsman's Contract* (1982) is centered around twelve drawings in the process of being made by a draftsman. They do not form any order; Greenaway emphasizes this by having the draftsman work on a few drawings at once. Eventually, Greenaway's desire to take "cinema out of cinema" led to his work on a series of installations and museum exhibitions in the 1990s. No longer obliged to conform to the linear medium of film, the elements of a database are spatialized within a museum or even a whole city. This move can be read as the desire to create a database in its most pure form – as a set of elements not ordered in any way. If the elements exist in one dimension (the time of a film, the list on a page), they will inevitably be ordered. So the only way to create a pure database is to spatialize it, distributing the elements in space. This is exactly the path that Greenaway took. Situated in a three-dimensional space that does not have an inherent narrative logic, the 1992 installation "100 Objects to Represent the World" by its very title proposes that the world should be understood through a catalog rather than a narrative. At the same time, Greenaway does not abandon narrative; he continues to investigate how database and narrative can work together. Having presented "100 Objects" as an installation, Greenaway next turned it into an opera set. In the opera, the narrator Thrope uses the objects to conduct Adam and Eve through the whole of human civilization, thus turning one hundred objects into a sequential narrative.[31] In another installation, "The Stairs, Munich, Projection" (1995), Greenaway put up a hundred screens – each representing one year in the history of cinema – throughout Munich. Again, Greenaway presents us with a spatialized database – but also with a narrative. By walking from one screen to another, one follows cinema's history. The project uses Greenaway's favorite principle of organization by numbers, pushing it to the extreme: The projections on the screens contain no figuration, just numbers. The screens are numbered from 1895 to 1995, one screen for each year of cinema's history. Along with numbers, Greenaway introduces another line of development: Each projection is slightly different in color.[32] The hundred colored squares form an abstract narrative of their own that runs in parallel to the linear narrative of cinema's history. Finally, Greenaway superimposes yet a third narrative by dividing the history of cinema into five sections, each section staged in a different part of the city. The apparent triviality of the basic narrative of the project – one hundred numbers, standing for one hundred years of cinema's history – "neutralizes" the narrative, forcing the viewer to focus on the phenomenon of the projected light itself, which is the actual subject of this project.

Along with Greenaway, Dziga Vertov can be thought of as a major "database filmmaker" of the twentieth century. *Man with a Movie Camera* is perhaps the most important example of a database imagination in modern media art. In one of the key shots, repeated a few times throughout the film, we see an editing room with a number of shelves used to keep and organize the shot material. The shelves are marked "machines," "club," "the movement of a city," "physical exercise," "an

illusionist," and so on. This is the database of the recorded material. The editor, Vertov's wife, Elizaveta Svilova, is shown working with this database – retrieving some reels, returning used reels, adding new ones.

Although I pointed out that film editing in general can be compared to creating a trajectory through a database, this comparison in the case of *Man with a Movie Camera* constitutes the very method of the film. Its subject is the filmmaker's struggle to reveal (social) structure among the multitude of observed phenomena. Its project is a brave attempt at an empirical epistemology that has but one tool – perception. The goal is to decode the world purely through the surfaces visible to the eye (natural sight enhanced, of course, by a movie camera). This is how the film's coauthor Mikhail Kaufman describes it:

> An ordinary person finds himself in some sort of environment, gets lost amidst the zillions of phenomena, and observes these phenomena from a bad vantage point. He registers one phenomenon very well, registers a second and a third, but has no idea of where they may lead. . . . But the man with a movie camera is infused with the particular thought that he is actually seeing the world for other people. Do you understand? He joins these phenomena with others, from elsewhere, which may not even have been filmed by him. Like a kind of scholar he is able to gather empirical observations in one place and then in another. And that is actually the way in which the world has come to be understood.[33]

Therefore, in contrast to standard film editing that consists of selection and ordering of previously shot material according to a preexistent script, here the process of relating shots to each other, ordering, and reordering them to discover the hidden order of the world constitutes the film's method. *Man with a Movie Camera* traverses its database in a particular order to construct an argument. Records drawn from a database and arranged in a particular order become a picture of modern life – but simultaneously an argument about this life, an interpretation of what these images, which we encounter every day, every second, actually mean.[34]

Was this brave attempt successful? The overall structure of the film is quite complex, and at first glance seems to have little to do with a database. Just as new media objects contain a hierarchy of levels (interface – content, operating system – application, Web page – HTML code, high-level programming language – assembly language – machine language), Vertov's film contains at least three levels. One level is the story of a cameraman shooting material for the film. The second level consists of the shots of the audience watching the finished film in a movie theater. The third level is the film itself, which consists of footage recorded in Moscow, Kiev, and Riga, arranged according to the progression of a single day: waking up – work – leisure activities. If this third level is a text, the other two can be thought of as its metatexts.[35] Vertov goes back and forth between the three levels, shifting between the text and its metatexts – between the production of the film, its reception, and the film itself. But if we focus on the film within the film (i.e., the level of the text) and disregard the special effects used to create many of the shots, we discover almost a linear printout,

so to speak, of a database – a number of shots showing machines, followed by a number of shots showing work activities, followed by different shots of leisure, and so on. The paradigm is projected onto the syntagm. The result is a banal, mechanical catalog of subjects that one could expect to find in the city of the 1920s – running trams, city beach, movie theaters, factories . . .

Of course, watching *Man with a Movie Camera* is anything but a banal experience. Even after the 1990s, when designers and video-makers systematically had exploited every avant-garde device, the original still looks striking. What makes it striking is not its subjects and the associations Vertov tries to establish between them to impose "the communist decoding of the world," but rather the most amazing catalog of film techniques contained within it. Fades and superimpositions, freeze-frames, acceleration, split screens, various types of rhythm and intercutting, different montage techniques[36] – what film scholar Annette Michelson has called "a summation of the resources and techniques of the silent cinema"[37] – and of course, a multitude of unusual, "constructivist" points of view are strung together with such density that the film cannot simply be labeled "avant-garde." If a "normal" avant-garde film still proposes a coherent language different from the language of mainstream cinema, that is, a small set of techniques that are repeated, *Man with a Movie Camera* never arrives at anything like a well-defined language. Rather, it proposes an untamed, and apparently endless, unwinding of techniques, or, to use contemporary language, "effects," as cinema's new way of speaking.

Traditionally, a personal artistic language or a style common to a group of cultural objects or a period requires a stability of paradigms and consistent expectations as to which elements of paradigmatic sets may appear in a given situation. For example, in the case of classic Hollywood style, a viewer may expect that a new scene will begin with an establishing shot or that a particular lighting convention such as high key or low key will be used throughout the film. (David Bordwell defines a Hollywood style in terms of paradigms ranked in terms of probabilities.)[38]

The endless new possibilities provided by computer software hold the promise of new cinematic languages, but at the same time they prevent such languages from coming into being. (I am using the example of film, but the same logic applies to all other areas of computer-based visual culture.) Since every software comes with numerous sets of transitions, 2-D filters, 3-D transformations, and other effects and "plug-ins," the artist, especially the beginner, is tempted to use many of them in the same work. In such a case, a paradigm becomes the syntagm; that is, rather than making singular choices from the sets of possible techniques, or, to use the term of Russian formalists, devices, and then repeating them throughout the work (for instance, using only cuts, or only cross-dissolves), the artist ends up using many options in the same work. Ultimately, a digital film becomes a list of different effects, which appear one after another. Whitney's *Catalog* is the extreme expression of this logic.

The possibility of creating a stable new language is also subverted by the constant introduction of new techniques over time. Thus the new media paradigms not only contain many more options than old media paradigms, but they also keep growing.

And in a culture ruled by the logic of fashion, that is, the demand for constant innovation, artists tend to adopt newly available options while simultaneously dropping already familiar ones. Every year, every month, new effects find their way into media works, displacing previously prominent ones and destabilizing any stable expectations that viewers might have begun to form.

And this is why Vertov's film has particular relevance to new media. It proves that it is possible to turn "effects" into a meaningful artistic language. Why is it that in Whitney's computer films and music videos effects are just effects, whereas in the hands of Vertov they acquire meaning? Because in Vertov's film they are motivated by a particular argument, which is that the new techniques of obtaining images and manipulating them, summed up by Vertov in his term "kino-eye," can be used to decode the world. As the film progresses, straight footage gives way to manipulated footage; newer techniques appear one after another, reaching a roller-coaster intensity by the film's end – a true orgy of cinematography. It is as though Vertov restages his discovery of the kino-eye for us, and along with him, we gradually realize the full range of possibilities offered by the camera. Vertov's goal is to seduce us into his way of seeing and thinking, to make us share his excitement, as he discovers a new language for film. This gradual process of discovery is film's main narrative, and it is told through a catalog of discoveries. Thus in the hands of Vertov, the database, this normally static and "objective" form, becomes dynamic and subjective. More important, Vertov is able to achieve something that new media designers and artists still have to learn – how to merge database and narrative into a new form.

Notes

1　"Database," *Encyclopedia Britannica Online*. <http://www.eb.com:180/cgi-bin/g?DocF= micro/160/23.html>

2　Jean-François Lyotard, *The Postmodern Condition: A Report on Knowledge*, trans. Geoff Bennington and Brian Massumi (Minneapolis: University of Minnesota Press, 1984), p. 3.

3　As early as 1985, Grolier, Inc. issued a text-only *Academic American Encyclopedia* on CD-ROM. The first multimedia encyclopedia was *Compton's MultiMedia Encyclopedia*, published in 1989.

4　See *AI and Society* 13.3, a special issue on database aesthetics, ed. Victoria Vesna (<http://arts.ucsb.edu/~vesna/AI_Society/>); *SWITCH* 5, no. 3, "The Database Issue" (<http://switch.sjsu.edu/>).

5　<http://www.teleportacia.org/anna>

6　George Legrady, personal communication, September 16, 1998.

7　Bordwell and Thompson define motivation in cinema in the following way: "Because films are human constructs, we can expect that any one element in a film will have some justification for being there. This justification is the motivation for that element." Here are some examples of motivation: "When Tom jumps from the balloon to chase a cat, we motivate his action by appealing to notions of how dogs are likely to act when cats are around"; "The movement of a character across a room may motivate the moving of the camera to follow the action and keep the character within a frame." David Bordwell and Kristin Thompson, *Film Art*, 5th edn. (New York: McGraw-Hill, 1997), p. 80.

8 Chris McGowan and Jim McCullaugh, *Entertainment in the Cyber Zone* (New York: Random House, 1995), p. 71.

9 This is true for a procedural programming paradigm. In an object-oriented programming paradigm, represented by such computer languages as Java and C++, algorithms and data structures are modeled together as objects.

10 *Mediamatic* 8, 1 (Summer 1994): 1860.

11 Bob Laird, "Information Age Losing Memory," *USA Today*, October 25, 1999.

12 <http://www.amazon.com/exec/obidos/subst/misc/company-info.html/>; <http://www.oracle.com/database/oracle8i/>

13 <http://artnetweb.com/guggenheim/mediascape/shaw.html>

14 Harwood, *Rehearsal of Memory*. CD-ROM (London: Artec and Bookworks, 1996).

15 <http://www.telepresence.com/MENAGERIE>

16 <http://jefferson.village.virginia.edu/wax/>

17 <http://myboyfriendcamebackfromth.ewar.ru>

18 Mieke Bal, *Narratology: Introduction to the Theory of Narrative* (Toronto: University of Toronto Press, 1985), p. 8.

19 The theory of markedness was first developed by linguists of the Prague School in relation to phonology, but subsequently applied to all levels of linguistic analysis. For example, "rooster" is a marked term and "chicken" an unmarked term. Whereas "rooster" is used only in relation to males, "chicken" is applicable to both males and females.

20 Fredric Jameson, "Postmodernism and Consumer Society," in *The Anti-Aesthetic: Essays on Postmodern Culture*, ed. Hal Foster (Seattle: Bay Press, 1983), p. 123.

21 Barthes, *Elements of Semiology* (London: Cape, 1967), p. 58.

22 Quoted in ibid.

23 Christian Metz, "The Fiction Film and Its Spectator: A Metapsychological Study," in *Apparatus*, ed. Theresa Hak Kyung Cha (New York: Tanam Press, 1980), p. 402.

24 Rosalind Krauss, "Video: The Aesthetics of Narcissism," in John Hanhardt, ed., *Video Culture* (Rochester: Visual Studies Workshop, 1987), p. 184.

25 This analysis can also be applied to many interactive computer installations. The user of such an installation is presented with her own image; the user is given the possibility to play with this image and also to observe how her movements trigger various effects. In a different sense, most new media, regardless of whether it represents to the user her image or not, can be said to activate the narcissistic condition because they represent to the user her actions and their results. In other words, it functions as a new kind of mirror that reflects not only the human image but human activities. This is a different kind of narcissism – not passive contemplation but action. The user moves the cursor around the screen, clicks on icons, presses the keys on the keyboard, and so on. The computer screen acts as a mirror of these activities. Often this mirror does not simply reflect but greatly amplifies the user's actions – a second difference from traditional narcissism. For instance, clicking on a folder icon activates an animation accompanied by sound; pressing a button on a game pad sends a character off to climb a mountain; and so on. But even without this amplification, the modern GUI functions as a mirror, always representing the image of the user in the form of a cursor moving around the screen.

26 Quoted in Sam Hunter and John Jacobus, *Modern Art: Painting, Sculpture, and Architecture*. 3rd edn. (New York: Abrams, 1992), p. 326.

27 Frank Dietrich, "Visual Intelligence: The First Decade of Computer Art (1965–1975)," *IEEE Computer Graphics and Applications* (July 1985), p. 39.

28 Gene Youngblood, *Expanded Cinema* (New York: E. P. Dutton and Co., 1970), p. 210.

29 Peter Greenaway, *The Stairs – Munich – Projection 2* (London: Merrell Holberton Publishers, 1995), p. 21.

30 Quoted in David Pascoe, *Peter Greenaway: Museums and Moving Images* (London: Reaktion Books, 1997), pp. 9–10.

31 <http://www.tem-nanterre.com/greenaway-100objects/>

32 Greenaway, *The Stairs, Munich, Projection 2*, pp. 47–53.

33 Mikhail Kaufman, "An Interview," *October* 11 (Winter 1979): 65.

34 It can be said that Vertov uses "the Kuleshov's effect" to give meaning to the database records by placing them in a particular order.

35 Linguistics, semiotics, and philosophy use the concept of metalanguage. Metalanguage is the language used for the analysis of object language. Thus a metalanguage may be thought of as a language about another language. A metatext is a text in metalanguage about a text in object language. For instance, an article in a fashion magazine is a metatext about the text of clothes. Or an HTML file is a metatext that describes the text of a Web page.

36 We should remember that various temporal montage techniques were still a novelty in the 1920s; they had the same status for viewers then as "special effects" such as 3-D characters have for viewers today. The original viewers of Vertov's film probably experienced it as one long special-effects sequence.

37 Ibid., p. 55.

38 David Bordwell, "Classical Hollywood Film," in Philip Rosen, ed., *Narrative, Apparatus, Ideology: Film Theory Reader* (New York: Columbia University Press, 1987).

Index

Note: Page numbers in *italics* indicate illustrations